D1203552

WYNDHAM LEWIS ON ART

WYNDHAM LEWIS
ON ART

Collected writings 1913-1956

EDITED AND INTRODUCED BY
WALTER MICHEL and C. J. FOX

THAMES AND HUDSON · LONDON

CONTENTS

ACKNOWLEDGMENTS

The editors wish to express their gratitude to Mrs Anne Wyndham Lewis for her generous help and the permission she has given for use of material for which she holds copyright. Thanks are due also to Raymond Rosenthal of New York and Hugh Gordon Porteus of London for their interest.

The editors also acknowledge permission to reprint the following material by Wyndham Lewis:

THE ARCHITECTURAL REVIEW: 'Plain Home-builder: Where Is Your Vorticist?' *The Architectural Review*, November 1934; 'The Kasbahs of the Atlas', *A.R.*, January 1933.

THE ARTS COUNCIL OF GREAT BRITAIN and THE TATE GALLERY: Introduction, Catalogue, *Wyndham Lewis and Vorticism*, Tate Gallery, London (1956).

BEAVERBROOK NEWSPAPERS LTD.: 'The Men Who Will Paint Hell. Modern War as a Theme for the Artist', *Daily Express*, 10 February 1919; 'The Coming Academy', *Sunday Express*, 24 April 1921.

THE BOOK SOCIETY, OF LONDON: 'Art in a Machine Age', *The Bookman*, July 1934.

THE BRITISH BROADCASTING CORPORATION: Articles that appeared in *The Listener* (1946–51); 'Art and Patronage', *BBC Annual*, 1935.

CATTO & WINDUS LTD.: Extracts from *Time and Western Man* (1927; Beacon Press, 1927); extracts from *The Diabolical Principle and the Dithyrambic Spectator* (1931), from *Paleface: the Philosophy of the 'Melting Pot'* (1929), and from *Harold Gilman: an Appreciation* (1919).

THE CONDÉ NAST PUBLICATIONS LTD.: 'The Vorticists', British *Vogue* (September 1956).

THE LIBRARY BOARD OF THE CORNELL UNIVERSITY LIBRARY: 'Religious Expression in Contemporary Art', from a manuscript in the Wyndham Lewis archive.

FABER AND FABER LTD.: 'Art Chronicle' and 'The Values of the Doctrine behind "Subjective" Art', *The Criterion* (1924 and 1927).

THE KENYON REVIEW: 'Picasso', *The Kenyon Review* (Spring 1940).

THE LEICESTER GALLERIES: Introduction, Catalogue to exhibition, *Tyros and Portraits*, Leicester Galleries, London (1921); Introduction, Catalogue, *Exhibition of Paintings by Wyndham Lewis*, Leicester Galleries (1937).

THE NEW REPUBLIC: 'After Abstract Art', *The New Republic* (8 July 1940).

NEW STATESMAN: 'Prevalent Design', *Athenaeum* (21 November 1919, 12 December 1919, 26 December 1919, 16 January 1920).

ODHAMS PRESS LIMITED: 'What It Feels Like To Be an Enemy', *Daily Herald* (30 May 1932).

MRS JOHN PIPER: 'Towards an Earth Culture, or The Eclectic Culture of the Transition', *The Pavilion* (1946).

THE REDFERN GALLERY: Introduction, Catalogue, *Exhibition of Paintings, Drawings and Watercolours by Wyndham Lewis*, Redfern Gallery, London (1949).

GERALD REITLINGER: 'A World Art and Tradition', *Drawing and Design* (February 1929).

THOMAS NELSON & SONS LTD.: *Beginnings* (by various hands), ed. L. A. G. Strong (1935).

TIME AND TIDE: 'Power-Feeling and Machine-Age Art', *Time and Tide* (20 October 1934).

INTRODUCTION

Wyndham Lewis was that rare combination, a painter and writer both, who sustained and developed these talents in parallel, producing two distinct *œuvres*. The two arts, which in his painting and imaginative writing he kept as separate as would seem possible in the productions of one person, come together in his art criticism. It is the distinction of the essays collected in this volume, that they present the happy conjunction of a writer's verbal gift and a painter's special feeling and craft knowledge.

One may ask whether Lewis was greater as a painter or as a novelist or essayist. There are some, even, who find his criticism his most unassailable achievement. Certainly, he combined to an unusual degree the qualities that make a good critic: intelligence, wit and sensibility, and the passion that gives them weight.

Lewis's home base was London. Here, in tiny flats in Kensington or Bayswater, he wrote essays which belong to a European tradition that began with Montaigne. As essayist he is the English counterpart of Gottfried Benn in Germany and Paul Valéry in France, each probably little acquainted with the others' work and strongly affected by his national character, yet all three concerned in much the same way about art, literature and the survival of these activities in the technological age.

As all except the most favoured artists, Lewis had the weaknesses of his strengths. He put ideas above persons, and could not see why anyone would be offended. He did not think man a very dignified animal. So his personal dignity was an assumed characteristic, and he stood upon it too rigidly at times. Holding that, to survive, the artist must concern himself with government, he analysed the subject with courage and originality but lapsed in his judgments of Hitler and some other aspects of the frenzied 1930's. It was a curious example of what he himself had acutely analysed earlier—the perils of transposing critical attitudes valid at the level of philosophy into terms appropriate to market-place pamphleteering.

As a person, he was fascinating. Everything was important to him, and he made things happen wherever he went. His imagination was so vivid, he could hardly believe anything was simple, except in art. He was the liveliest of companions, as reported in a number of published and some unpublished accounts.

Lewis's writings on art are a small but distinct part of his total *œuvre*. For the most part they are not 'criticism', in the sense of his literary essays in *Men Without Art*, nor 'analysis' such as offered in *Time and Western Man* or *The Art of Being Ruled*. Rather, they offer celebrations of the kind of art he admired, against a necessary background of scavenging to be done and pieces written for various occasions. To present them, as we have done, almost in their entirety, the deeply considered as well as the occasional pieces, is to present not only Lewis's thinking on art but also something of his person, and a reflection in that person of the history of art in the first half of the century.

Wyndham Lewis was born on his father's yacht off the coast of Nova Scotia, in 1882. His father was an American whose own ancestry was partly French-Canadian, his mother British. The boy was brought up in England, receiving his first training in painting at the Slade School of Art in London, which he entered at the age of sixteen. After two years at the Slade, where his drawing won him the Slade scholarship, he went to the Continent for a period of painting, writing and study, about which little is known, and returned to London in 1910.

A year later Lewis's painting began to show a strong Cubist influence, and during 1912 he developed an original style based upon the geometric and abstract idiom that had come out of Paris. In 1914–15 he edited *Blast*, the bulky and spectacular magazine which revealed to astonished Londoners the existence in their midst of a modern-art movement with claims to international stature. *Blast* expressed an attitude to life and art so provocative and lively that nearly everyone of talent in the British capital was swept along. It was the attitude for which Ezra Pound, a month before the appearance of the magazine, had invented the name 'Vorticism'.

In 1914, 'if you were a "movement" you were expected to shout', Lewis wrote later.[1] Hence quarrels, putsches and the sensational aspect of *Blast* and the 'Rebel Art Center' established by the Vorticists-to-be in Great Ormond Street, London. As leader of the Vorticist *bande*, or simply by the force of his exuberant personality, Lewis was, during the two years beginning in the summer of 1913, much in the public eye. 'In a rather silly way, I had been too successful,' he has said of the period.[2] But his purpose was a grand as well as serious one: to lay the ground-

[1] *Wyndham Lewis the Artist*, p. 83.
[2] *Blasting and Bombardiering*, p. 212.

work for the development of a British art and literature, which would build upon the revolutionary discoveries in painting made on the Continent in the first decade of the century. *Blast* urged nothing less than a rejuvenated European consciousness, worthy of the new way of seeing.

But the war came—'a cyclopean dividing wall in time: a thousand miles high and a thousand miles thick, a great barrier laid across our life.'[1] Lewis went to the Front, and the Vorticists were scattered. Having been witness to what he called 'this organized breakdown in our civilized manner', he sought to explain it to himself, a process he later described as the first step in his political education.

Lewis's self-education turned into a study of the contemporary Western world which occupied him during most of the twenties, taking in philosophy, literature and science. His pictures decreased in number, but they retained their intensity and bias toward the experimental and abstract, as seen, for example, in *Bagdad* and *Edith Sitwell*, both at the Tate Gallery. There was a large output of books, both imaginative writings and works of what he called 'philosophic analysis' of contemporary intellectual and artistic life.

Lewis's analyses were usually of artists and writers whose talents he respected, but who offended against the spirit of the wider movement in which he so strongly believed. Though his criticisms were always aimed at *ideas*, he did not hesitate to mention names, and his irresistible wit caused him to make a satirical spectacle of the intellectual weak spots of his opponents. It *was* wit, however, never the sheer unpleasantness so often indulged in by those who felt, or thought it politic to appear, offended by it; this included, thirty years later, Dame Edith Sitwell and Ernest Hemingway. Other targets, including Ezra Pound, the 'revolutionary simpleton' of *Time and Western Man*, or T. S. Eliot, designated, in *Men Without Art*, the 'pseudo-believer', did not mind Lewis's criticism, or even considered it salutary, though Joyce, it seems, was hurt and called *Time and Western Man* 'Spice and Westend Woman'. Others, unnamed, rightly or wrongly recognized their aggrandized image in the fictional characters of *The Apes of God*.

Quite at home in his role as critical gadfly, Lewis in the twenties called himself 'The Enemy', a figure which appears on the covers of his magazines or in advertisements as a bedizened horseman or other picturesque, masked puppet. The 'Enemy' figure is conceived partly in

[1] *The Writer and the Absolute*, p. 3.

mock-bravado, as a parody of his role and even satire of himself, as he had earlier painted his self-portrait as a 'Tyro' and would occasionally allow his 'Enemy' persona to assume some of the qualities of his opponents. It is this human involvement which makes his criticism so delightful.

He was partly taken in by the part he had assumed, and he thought his satires did him much more harm than, probably, they did. Undoubtedly, his politics in the thirties were much more damaging. Henceforth it became easy for those who had been his targets, or merely did not like—or even, did not know—his views, to put Lewis down or ignore him. A sentence of Sir John Rothenstein's summarizes this feeling, besides hinting (rather modestly) at the stature of Lewis's art criticism: 'There are circles who would regard the opinion that his contribution to art criticism was not less valuable than that of Fry not only as ludicrous but in some perhaps not readily definable way as unpleasant.'[1]

Lewis's painting at all times included what he called work 'from nature' as well as compositions from the imagination. Examples from the thirties are the well-known portrait of Ezra Pound and *The Surrender of Barcelona*, both at the Tate Gallery. But even Lewis's work 'from nature'—in which he always incorporated a geometric or at least linear stylization—was unacceptable to the public. Protesting readers caused the curtailment of a series of magnificent drawings of society beauties, published in the *Sketch* in the early twenties. And his painting of T. S. Eliot, now at Durban, South Africa, was rejected by the Royal Academy in 1938.[2] Lewis was not alone in this position. During the thirty years approximately from 1920 to 1950, an English painter working in a modern idiom could hardly expect to sell enough pictures to live. Lewis's chief source of income, almost throughout his career, was his books.

In 1929 he married G. Anne Hoskyns, the model for some of his greatest portraits from 1922 on, who stood by him for the rest of his life. His writings had to sustain not only his wife and himself, but also his painting. He worked with tremendous energy, producing throughout

[1] *Modern English Painters: Lewis to Moore*, London, 1952, New York, 1956, p. 17.

[2] An account of the affair, and letters from T. S. Eliot to Lewis, and from Lewis to the Editors of the *Daily Telegraph* and *The Times*, are given in *Letters*, pp. 260-7.

his career nearly fifty books, some hundred paintings and over a thousand drawings, many of which are now in the best-known collections in Britain. Owing to a protracted illness, requiring several operations, the thirties were a particularly difficult time for the artist. As the decade progressed, debts accumulated, with no improvement in sight. Lewis decided to try to recoup financially through a short period of painting, writing and lecturing in North America. The outbreak of the war, shortly after he and his wife had left for the New World, upset these plans. Funds for a return to England during wartime were not available. So it came that Lewis spent six war years in Canada and the United States, sustaining himself for the most part by occasional portrait commissions, often with bare survival all he could achieve.

When the war ended, the couple took the first passenger boat back to England. Lewis went on writing and painting, and made the rounds of the London art galleries as critic for *The Listener*. In 1949, painting his second portrait of T. S. Eliot, which now hangs in Magdalene College, Cambridge, he noticed that he was obliged to peer closely at his sitter every few minutes to make sure of details. In subsequent months the difficulty increased. Diagnosis revealed that an inoperable tumour was pressing on the optic nerve. In May 1951, Lewis's article 'The Sea Mists of the Winter' announced to readers of *The Listener* that the man to whom the eye had meant so much could no longer see. He was blind, but he continued writing. In the next few years he produced *The Human Age*, a last great metaphysical satire of modern man. He was writing the fourth and last volume of that book, when the brain tumour responsible for the loss of sight brought death, in March 1957.

Lewis's earliest writings on art took the form of the Manifestos, essays and reviews he contributed to *Blast*. They are among the most remarkable documents in the history of modern art criticism. For they give us a contemporary view of the seminal years of the modern movement in Europe, as seen by one who himself worked in the new visual idiom, but who looked with a critical eye at certain of the uses to which it had been put.

The artistic discoveries to which Lewis was drawn most were those of the first decade of the century, especially the period of early Cubism. He admired the vigorous emphasis on line and structure, and the freedom from the tyrannies both of formal dogma and naturalism, of the painting of this phase. Certain later developments he considered as only

the acrobatics of freedom, a vulgarization of the original, sterner impulse. Even in some of the tendencies of early Cubism he saw a yielding to the merely tasteful, or a preoccupation with the trivial. These weaknesses the English movement, heir of a more Northern sensibility—as set forth in the Manifestos of *Blast*—was to overcome.

Criticism, combined with eloquent advocacy of a 'heroic, that is energetic'[1] art, remained the basis of Lewis's expository writings. In the twenties, the 'destructive' aspect was uppermost. Lewis became the most outspoken critic in Britain of the tendencies which in his view threatened to produce a world of 'Men Without Art', the title of his 1934 volume of literary essays. In England, Lewis's was an isolated voice. But, certain that 'western civilization' was still uniquely potent and significant—an assumption which he later modified—he accepted the inevitability of isolation and maintained his critical barrage.

Since World War II, there has been a wave of enterprise in the arts, a by-product of affluence throughout the West. Relatively beneficent in terms of easy living, travel and education, the present period also has released the artist from the grip of monolithic ideology. The times seem akin to the years preceding World War I rather than to the twenties and thirties. In England, the new age began with work done in the later 1940s by a group of artists who—to use a Lewis formula—painted the 'reality of life', without being 'seduced by the natural platitude of the dimension of life'. Lewis, reviewing their shows for *The Listener*, wrote that for the first time he felt at home.

The best of the essays collected here are also the most profound—the *Blast* manifestos, the long essays of the early twenties and those of the later twenties which were by-products of the intensive thinking on the books. Other pieces have a narrower range and interest. They may demonstrate Lewis's development as an artist, his views of his own work or that of others, his reactions to current goings on or to such things as the buildings he encountered on a journey through the Atlas mountains. The exhibition reviews of the forties are models of their kind. At their best, these essays take on the fascination of Goethe's Conversations or Flaubert's Letters: a huge momentum, briefly channelled into a discursive vein. In many of them, argument is transformed, by a kind of clairvoyance, into imaginative and poetic truth.

[1] P. 70.

Most influential, of the writings on art, were probably the essays in *Blast*, both at the time of their original publication and again when reprinted in *Wyndham Lewis the Artist* (1939). On the first occasion, the effect was short-lived and is inseparable from that of Vorticism as a whole, which reverberated for some years in the work of a number of British painters. In their second appearance, now with the added weight of the philosophical books of the twenties and Lewis's painting of three decades behind them, they influenced a number of the young painters who made the late forties such an extraordinary period in English painting.

Lewis was too modest and independent himself to desire either to be an 'influence' or to be influenced. Even his polemics are philosophical analyses or manœuvres in support of what he, personally, was doing, not tracts designed to win adherents. Nevertheless, in a curiously underground way, he was probably the greatest single influence for British painting in the first half of the century.

His effect was due to his writing and painting, and the admiration one has for a man who is intelligent, passionately involved and true to his nature. His painting is reflected in specific ways in a number of specific painters, but his chief importance is more general. For, with Henry Moore, he was largely responsible for the survival of what became an indigenous tradition, perhaps the most important direction of British painting during his lifetime: the representation of the *figure*, in a contemporary idiom, without the benefit of social-realist or surrealist credentials.

Much of Lewis's writing on art appeared originally in the reviews edited by Lewis himself, or in periodicals such as T. S. Eliot's *Criterion*, the weekly *Listener* and even daily newspapers. Particular copies of these publications are now hard to find. We reproduce those essays on the visual arts which are no longer in print, including also the longer pieces which appeared in book form, and omitting only the most ephemeral material. Most of the pieces are reproduced in full. Omissions in their texts are indicated by three dots (. . .) with a fourth dot indicating a period. Dots reproduced without spaces (...) occur in those places where Lewis himself used dots. The final portion of this book is the only one presenting selections as such. These are made from the articles written for *The Listener* in the 1940s and 1950s.

PART I

The *Blast* Period

INTRODUCTION

Blast's contents include a short story by Ford Madox Hueffer, another by Rebecca West, poems and a 'Vortex' by Ezra Pound and translations by Edward Wadsworth from the writings of Kandinsky. But the contributions which stand out are the rest: Gaudier-Brzeska's 'Vortex', Lewis's essays and play 'The Enemy of the Stars' and the forty-odd pages of Manifestos, also largely from Lewis's hand. It is these pieces, by their style and conception, which give *Blast* its uniqueness. The nature of what we are encountering is suggested by Hugh Kenner's statement that 'If anything extended could be done with it, this early style would be one of the most impressive inventions of English literature'[1] and the recognition by another scholar that '*Blast* is, in itself, a Vorticist work of art, perhaps the most successful of all Vorticist works of art.'[2]

'Vortex' is the poetic notion of a focus in which life and art, or abstraction and the will meet. The word signified slightly more than such names as 'Cubism' or 'Fauvism'. For one, vortex-like forms are found in Lewis's painting from 1912 on, and in that of the other Vorticists in later years. Then the idea suggested by the word, of art as the still-point at the centre of the whirlpool, has some correspondences with Lewis's thinking. And finally, a Vorticist 'sense of form' may have influenced Pound's poetry.[3] But, beyond such correspondences, the 'Vortex' was never clearly defined in relation to the art of the group which used it for its name: Gaudier, Pound and the painters Wadsworth, Lewis, Frederick Etchells, William Roberts, Charles Hamilton, Jessica Dismorr and Helen Saunders.

Such *insouciance* about details of programme or organization, while one was trying to remake the soul of Europe, is characteristic of *Blast*'s attitude, which is a combination of a very high seriousness with an exuberant, even reckless humour. *Blast* was probably the most *intelligent* as it is the most entertaining, of the manifestos, almanacs and magazines of a period prolific in such publications. With its appearance, London, hitherto at most an onlooker, had overnight moved near the centre of

[1] *Wyndham Lewis* (Norfolk, Conn., 1954), p. 16.

[2] W. C. Wees, 'Ezra Pound as a Vorticist', *Wisconsin Review of Contemporary Literature*, 1965, pp. 56–72.

[3] W. C. Wees, *loc. cit.*

the events that were shaping what was 'contemporary' in art and literature.

The blasting of Britain into the modern age, which the magazine announced, would not have been possible had not London been ready for new departures. There was an air of expectancy, the result of a conjunction of many things. The exhibitions of Cubists, Fauvists and Futurists, organized between 1910 and 1913 by Roger Fry and the critic Frank Rutter, and the appearance of the Futurists themselves in 1912–14, had been a stimulus to some, notably to the painters David Bomberg and C. R. W. Nevinson, then still students at the Slade. Gaudier-Brzeska's and Jacob Epstein's geometric sculptures and Lewis's geometric, near-abstract works of 1912–13 had received considerable attention. The Omega Workshops, directed by Fry, had familiarized a small circle with abstract decoration and had, incidentally, brought together Wadsworth, Etchells and Lewis who, in October 1913, broke with Fry to form what became the *Blast* group.

Interest in the new art was furthered in the 'salons' held by the writer T. E. Hulme at the house of his patroness, Mrs Kibblewhite, and by the interest of Ford Madox Hueffer. *Rhythm*, the magazine of the Paris-based English Fauve painters, and publications such as the widely available German Expressionist weekly *Der Sturm* provided access to Continental developments in the arts. Ezra Pound, by his enthusiasm and influence, acted as a general leaven. He admired, and was friendly with, Gaudier and Epstein as well as Lewis. He knew the work of James Joyce and, between the two issues of *Blast*, became acquainted with that of Eliot. Neither of these two men had anything directly to do with Vorticism, though Joyce is 'blessed' in the first *Blast*, and Eliot was published in the second issue as early as anywhere.[1]

The effect of *Blast* in this atmosphere of scattered efforts vaguely pointing in new directions, and a public and press derisive, but curious, was electrifying. Here was an obviously brilliant publication, to which a number of the most talented people in London had contributed and whose Manifesto they had signed. The well-known international publisher John Lane of the Bodley Head had produced the expensively printed volume of 165 pages, a foot high, copies of which were assigned to all the capitals of Europe. Richard Aldington, reviewing *Blast* in *The Egoist*, was ecstatic and the London *Times*, finding the magazine

[1] He is represented in the magazine by two poems, 'Preludes' and 'Rhapsody of a Windy Night'.

contained more 'matter and originality than is to be found in the Futurist manifestos', respectful.[1] *The New Age*, deriding *Blast* in its best parochial manner, looked merely silly. For the first time, an *English* outpost had been established in twentieth-century art, substantial enough to serve as a focus of attention and rallying point. Through *Blast*, London acquired, for a year or two, a brilliance reminiscent in some ways of what the city had known in a period Lewis greatly admired —the Elizabethan.

The presence in *Blast* of 'The Enemy of the Stars', preceded by reproductions of Vorticist paintings, was highly deliberate. For Vorticism was to revivify literature as well as painting. Lewis recalled later he felt his literary comtemporaries were 'too bookish and not keeping pace with the visual revolution. A kind of play "The Enemy of the Stars" was my attempt to show them the way.'[2] In 1913, he saw, across Europe, a return to first principles. He conceived of the new painting as great enough in stature to affect all the arts. The new movement, initiated by the painters, would express the highest values of the West, as the great painters and sculptors of China, Egypt and the Renaissance had expressed those of their civilizations. In some of his most paradoxical and witty, yet deeply felt statements, he contends that England, newly exposed to the Continental discoveries, was precisely the place where a significant twentieth-century art could develop. Reading *Blast* one may feel that, but for the war, the robustness of the British movement might indeed have provided the starting point for such a development. Even fifty years later, the magazine seems to have lost little of its relevance. Not its least intriguing feature is the glimpse it provides of a civilization that 'has not materialized'[3]—the twentieth century as it could look before the first world war initiated a different future.

This collection's limitation to writings on art means that in the reprinting of material from the first number of *Blast* two of Lewis's pieces must be omitted which are important to any definition of Vorticism: 'The Enemy of the Stars' and the first 'Manifesto', in which various people and institutions are selected for 'Blasts' and 'Bless's'.

[1] No. 40,564, 1 July 1914, p. 8.
[2] *Rude Assignment*, p. 129.
[3] Lewis's phrase in *Blasting and Bombardiering* (p. 256 of the 1967 reissue).

Of Lewis's essays on art in the second *Blast*, we omit only a minor piece called 'Modern Caricature and Impressionism', arguing for the establishment of a good satirical periodical. Other contributions by Lewis in this issue are 'War Notes', topical pieces dealing with the war; and the first instalment of what was apparently to be a novel, 'The Crowd Master'.

All of the pieces in this section, except 'The Cubist Room' and 'The Vorticist Exhibition', are from *Blast*. The first three are from *Blast No. 1* and the remainder from the second issue.

LONG LIVE THE VORTEX!

Long live the great art vortex sprung up in the centre of this town!

We stand for the Reality of the Present—not for the sentimental Future, or the sacripant Past.

We want to leave Nature and Men alone.

We do not want to make people wear Futurist Patches, or fuss men to take to pink and sky-blue trousers.

We are not their wives or tailors.

The only way Humanity can help artists is to remain independent and work unconsciously.

WE NEED THE UNCONSCIOUSNESS OF HUMANITY—their stupidity, animalism and dreams.

We believe in no perfectibility except our own.

Intrinsic beauty is in the Interpreter and Seer, not in the object or content.

We do not want to change the appearance of the world, because we are not Naturalists, Impressionists or Futurists (the latest form of Impressionism), and do not depend on the appearance of the world for our art.

WE ONLY WANT THE WORLD TO LIVE, and to feel its crude energy flowing through us.

It may be said that great artists in England are always revolutionary, just as in France any really fine artist had a strong traditional vein.

Blast sets out to be an avenue for all those vivid and violent ideas that could reach the Public in no other way.

Blast will be popular, essentially. It will not appeal to any particular class, but to the fundamental and popular instincts in every class and description of people, TO THE INDIVIDUAL. The moment a man feels or realizes himself as an artist, he ceases to belong to any milieu or time. *Blast* is created for this timeless, fundamental Artist that exists in everybody.

The Man in the Street and the Gentleman are equally ignored.

Popular art does not mean the art of the poor people, as it is usually supposed to. It means the art of the individuals.

Education (art education and general education) tends to destroy the creative instinct. Therefore it is in times when education has been non-existent that art chiefly flourished.

But it is nothing to do with 'the People'.

It is a mere accident that that is the most favourable time for the individual to appear.

To make the rich of the community shed their education skin, to destroy politeness, standardization and academic, that is civilized, vision, is the task we have set ourselves.

We want to make in England not a popular art, not a revival of lost folk art, or a romantic fostering of such unactual conditions, but to make individuals, wherever found.

We will convert the King if possible.

A VORTICIST KING! WHY NOT?

DO YOU THINK LLOYD GEORGE HAS THE VORTEX IN HIM?

MAY WE HOPE FOR ART FROM LADY MOND?

We are against the glorification of 'the People', as we are against snobbery. It is not necessary to be an outcast bohemian, to be unkempt or poor, any more than it is necessary to be rich or handsome, to be an artist. Art is nothing to do with the coat you wear. A top-hat can well hold the Sistine. A cheap cap could hide the image of Kephren.

AUTOMOBILISM (Marinetteism) bores us. We don't want to go about making a hullo-bulloo about motor cars, any more than about knives and forks, elephants or gas-pipes.

Elephants are VERY BIG. Motor cars go quickly.

Wilde gushed twenty years ago about the beauty of machinery. Gissing, in his romantic delight with modern lodging houses, was futurist in this sense.

The futurist is a sensational and sentimental mixture of the aesthete of 1890 and the realist of 1870.

The 'Poor' are detestable animals! They are only picturesque and amusing for the sentimentalist or the romantic! The 'Rich' are bores without a single exception, *en tant que riches*!

We want those simple and great people found everywhere.

Blast presents an art of Individuals.

MANIFESTO

This is Manifesto II of the first issue of Blast.

I

1 Beyond Action and Reaction we would establish ourselves.

2 We start from opposite statements of a chosen world. Set up violent structure of adolescent clearness between two extremes.

3 We discharge ourselves on both sides.

4 We fight first on one side, then on the other, but always for the SAME cause, which is neither side or both sides and ours.

5 Mercenaries were always the best troops.

6 We are Primitive Mercenaries in the Modern World.

7 Our *Cause* is NO-MAN'S.

8 We set Humour at Humour's throat.
Stir up Civil War among peaceful apes.

9 We only want Humour if it has fought like Tragedy.

10 We only want Tragedy if it can clench its side-muscles like hands on its belly, and bring to the surface a laugh like a bomb.

II

1 We hear from America and the Continent all sorts of disagreeable things about England: 'the unmusical, anti-artistic, unphilosophic country'.

2 We quite agree.

3 Luxury, sport, the famous English 'Humour', the thrilling ascendancy and *idée fixe* of Class, producing the most intense snobbery in the World; heavy stagnant pools of Saxon blood, incapable of anything but the song of a frog, in home-counties: these phenomena give England a peculiar distinction, in the wrong sense, among the nations.

4 This is why England produces such good artists from time to time.

5 This is also the reason why a movement towards art and imagination could burst up here, from this lump of compressed life, with more force than anywhere else.

6 To believe that it is necessary for or conducive to art, to 'improve' life, for instance—make architecture, dress, ornament, in 'better taste', is absurd.

7 The Art-instinct is permanently primitive.

8 In a chaos of imperfection, discord, etc., it finds the same stimulus as in Nature.

9 The artist of the modern movement is a savage (in no sense an 'advanced', perfected, democratic, Futurist individual of Mr Marinetti's limited imagination): this enormous, jangling, journalistic, fairy desert of modern life serves him as Nature did more technically primitive man.

10 As the steppes and the rigours of the Russian winter, when the peasant has to lie for weeks in his hut, produce that extraordinary acuity of feeling and intelligence we associate with the Slav; so England is just now the most favourable country for the appearance of a great art.

III

1 We have made it quite clear that there is nothing Chauvinistic or picturesquely patriotic about our contentions.

2 But there is violent boredom with that feeble Europeanism, abasement of the miserable 'intellectual' before anything coming from Paris, Cosmopolitan sentimentality, which prevails in so many quarters.

3 Just as we believe that an Art must be organic with its Time,
So we insist that what is actual and vital for the South, is ineffectual and unactual in the North.

4 Fairies have disappeared from Ireland (despite foolish attempts to revive them) and the bull-ring languishes in Spain.

5 But mysticism on the one hand, gladiatorial instincts, blood and asceticism on the other, will be always actual, and springs of Creation for these two peoples.

6 The English Character is based on the Sea.

7 The particular qualities and characteristics that the sea always engenders in men are those that are, among the many diagnostics of our race, the most fundamentally English.

8 That unexpected universality as well, found in the completest English artists, is due to this.

IV

1 We assert that the art for these climates, then, must be a northern flower.

2 And we have implied what we believe should be the specific nature of the art destined to grow up in this country, and models of whose flue decorate the pages of this magazine.

3 It is not a question of the characterless material climate around us. Were that so the complication of the Jungle, dramatic Tropic growth, the vastness of American trees, would not be for us.

4 But our industries, and the Will that determined, face to face with its needs, the direction of the modern world, has reared up steel trees where the green ones were lacking; has exploded in useful growths, and found wilder intricacies than those of Nature.

V

1 We bring clearly forward the following points, before further defining the character of this necessary native art.

2 At the freest and most vigorous period of ENGLAND's history, her literature, then chief Art, was in many ways identical with that of France.

3 Chaucer was very much cousin of Villon as an artist.

4 Shakespeare and Montaigne formed one literature.

5 But Shakespeare reflected in his imagination a mysticism, madness and delicacy peculiar to the North, and brought equal quantities of Comic and Tragic together.

6 Humour is a phenomenon caused by sudden pouring of culture into Barbary.

7 It is intelligence electrified by flood of Naivety.

8 It is Chaos invading Concept and bursting it like nitrogen.

9 It is the Individual masquerading as Humanity like a child in clothes too big for him.

10 Tragic Humour is the birthright of the North.

11 Any great Northern Art will partake of this insidious and volcanic chaos.

12 No great ENGLISH Art need be ashamed to share some glory with France, tomorrow it may be with Germany, where the Elizabethans did before it.

13 But it will never be French, any more than Shakespeare was, the most catholic and subtle Englishman.

VI

1 The Modern World is due almost entirely to Anglo-Saxon genius—its appearance and its spirit.

2 Machinery, trains, steam-ships, all that distinguishes externally our time, came far more from here than anywhere else.

3 In dress, manners, mechanical inventions, LIFE, that is, ENGLAND, has influenced Europe in the same way that France has in Art.

4 But busy with this LIFE-EFFORT, she has been the last to become conscious of the Art that is an organism of this new Order and Will of Man.

5 Machinery is the greatest Earth-medium: incidentally it sweeps away the doctrines of a narrow and pedantic Realism at one stroke.

6 By mechanical inventiveness, too, just as Englishmen have spread themselves all over the Earth, they have brought all the hemispheres about them in their original island.

7 It cannot be said that the complication of the Jungle, dramatic tropic growths, the vastness of American trees, is not for us.

8 For, in the forms of machinery, Factories, new and vaster buildings, bridges and works, we have all that, naturally, around us.

VII

1 Once this consciousness towards the new possibilities of expression in present life has come, however, it will be more the legitimate property of Englishmen than of any other people in Europe.

2 It should also, as it is by origin theirs, inspire them more forcibly and directly.

3 They are the inventors of this bareness and hardness, and should be the great enemies of Romance.

4 The Romance peoples will always be, at bottom, its defenders.

5 The Latins are at present, for instance, in their 'discovery' of sport, their Futuristic gush over machines, aeroplanes, etc., the most romantic and sentimental 'moderns' to be found.

6 It is only the second-rate people in France or Italy who are thorough revolutionaries.

7 In England, on the other hand, there is no vulgarity in revolt.

8 Or, rather, there is no revolt, it is the normal state.

9 So often rebels of the North and the South are diametrically opposed species.

10 The nearest thing in England to a great traditional French artist, is a great revolutionary English one.

Signatures for Manifesto

R. Aldington	Arbuthnot	L. Atkinson	Gaudier Brzeska
J. Dismorr	C. Hamilton	E. Pound	W. Roberts
H. Sanders	E. Wadsworth	Wyndham Lewis.	

VORTICES AND NOTES

*The following twelve pieces (up to and including 'Our Vortex')
appeared under the above collective title. In* Wyndham Lewis the
Artist, *Lewis reprinted them, with the omission of 'The Melodrama
of Modernity', and with a number of changes in wording. The changes
do not alter the original meanings, but were evidently intended as
clarifications of the condensed wording of* Blast. *We have reproduced
the* Blast *version, correcting only obvious errors in spelling or mis-
prints. Where it was of special interest, the later version has been
given in a note.*

'LIFE IS THE IMPORTANT THING!'

*'In . . . "Life is the Important Thing", the "pure painter" snob is exposed,
and shown to be a person still under the spell of the French Impressionists,
rather than one belonging to the contemporary world. I contrast the creati-
vity of Daumier with the academic camera that was Degas.'* (Wyndham
Lewis the Artist, *1939*)

In the revolt against Formula, revolutionaries in art sell themselves to
Nature. Without Nature's aid the 'coup' could not be accomplished.
They, of course, become quite satisfied slaves of Nature, as their fathers
were of Formula. It never occurs to them that Nature is just as sterile a
Tyrant. This is what happened with the Impressionists.

An idea which haunts the head of many people is that 'Nature' is
synonymous with freshness, richness, constant renewal, life: 'Nature'
and natural art synonymous with 'Life'.

This idea, trotted out in various forms, reminds one of the sententious
pronouncement one so often hears: 'LIFE is the important thing!' It is
always said with an air of trenchant and final wisdom, the implication
being: 'You artists are so indirect and intellectual, worry your heads
about this and about that, while life is there all the time, etc., etc.'

If you ask these people what they mean by LIFE (for there are as many
Lives as there are people in the world), it becomes evident that they have
no profounder view of life in their mind than can be included in the
good dinner, good sleep, roll-in-the-grass category.

'After all, life is the important thing!' That is to live as nearly like a chicken or a King Charles as is compatible with having read *Sex and Character* and *L'Ile des Pingouins* in a translation.

This is the typical cowardly attitude of those who have failed with their minds, and are discouraged and unstrung before the problems of their Spirit; who fall back on their stomachs and the meaner working of their senses.

Nature will give you, then, grass enough for cow or sheep, any fleshly conquest you can compass. One thing she is unable to give, that that is peculiar to men. Such stranger stuff men must get out of themselves.

To consider for a moment this wide-spread notion, that 'Nature', as the majority mean it, is synonymous really with 'Life', and inexhaustible freshness of material:

NATURE IS NO MORE INEXHAUSTIBLE, FRESH, WELLING UP WITH INVENTION, ETC., THAN LIFE IS TO THE AVERAGE MAN OF FORTY, WITH HIS GROOVE, HIS DISILLUSION, AND HIS LITTLE ROUND OF HABITUAL DISTRACTIONS.

It is true, 'Life is there all the time.' But he cannot get at it except through himself. For him too, even—apart from his daily fodder—he has to draw out of himself any of that richness and fineness that is something more and different to the provender and the contentment of the cow.

For the suicide, with the pistol in his mouth, 'Life is there', as well, with its variety and possibilities. But a dissertation to that effect would not influence him; on the contrary.

For those men who look to Nature for support, she does not care.

'Life' is a hospital for the weak and incompetent.

'Life' is a retreat of the defeated.

It is very salubrious—The cooking is good—

Amusements are provided.

In the same way, Nature is a blessed retreat, in art, for those artists whose imagination is mean and feeble, whose vocation and instinct are unrobust. When they find themselves in front of Infinite Nature with their little paint-box, they squint their eyes at her professionally, and coo with lazy contentment and excitement to just so much effort as is hygienic and desirable. She does their thinking and seeing for them. Of course, when they commence painting, technical difficulties come along, they sweat a bit, and anxiety settles down on them. But then they regard themselves as martyrs and heroes. They are lusty workmen, grappling with the difficulties of their trade!

B

No wonder painting has been discredited! 'Life' IS the important thing, indeed, if much painting of Life that we see is the alternative. Who would not rather walk ten miles across country (yes, ten miles, my friend), and use his eyes, nose and muscles, than possess ten thousand Impressionist oil-paintings of that countryside?

There is only one thing better than 'Life'—than using your eyes, nose, ears and muscles—and that is something very abstruse and splendid, in no way directly dependent on 'Life'. It is no EQUIVALENT for Life, but ANOTHER life, as NECESSARY to existence as the former.

This NECESSITY is what the indolent and vulgar journalist mind chiefly denies it. All the accusations of 'mere intelligence' or 'cold intellectuality' centre round misconception of this fact.

Before leaving this beautiful useful phrase—of unctuous 'Life', etc.— I would prevent a confusion. I have been speaking so far of the Impressionist sensibility, and one of the arguments used by that sensibility to disparage the products of a new effort in Art.

Daumier, whose work was saturated with reference to Life, has been, for instance, used to support imitation of Nature, on grounds of a common realism. This man would have been no more capable of squatting down and imitating the forms of life day after day than he would have been able to copy one of his crowds.

It was Life that MOVED MUCH TOO QUICKLY FOR ANYTHING, BUT THE IMAGINATION that he lived for. He combined in his art great plastic gifts with great literary gifts, and was no doubt an impure painter, according to actual standards. But it was great literature, always, along with great art. And as far as 'Life' is concerned, the Impressionists produced nothing that was in any sense a progress from this great realist, though much that was a decadence. Many reproductions of Degas paintings it would be impossible, quite literally, to distinguish from photographs: and his pastels only less so because of the accident of the medium. The relative purity of their palette, and consequent habituating of the public to brighter colours, was their only useful innovation. Their analytic study of light led into the Pointilliste cul de sac—when it was found that although light can be decomposed, oil-paint is unfortunately not light.

FUTURISM, MAGIC AND LIFE

1 The Futurist theoretician should be a Professor of Hoffman Romance, and attempt the manufacture of a perfect being.

Art merges in Life again everywhere.

Leonardo was the first Futurist, and, incidentally, an airman among quattrocento angels.

His Mona Lisa eloped from the Louvre like any woman.

She is back again now, smiling, with complacent reticence, as before her escapade; no one can say when she will be off once more, she possesses so much vitality.

Her olive pigment is electric, so much more so than the carnivorous Belgian bumpkins by Rubens in a neighbouring room, who, besides, are so big they could not slip about in the same subtle fashion.

Rubens IMITATED Life—borrowed the colour of its crude blood, traced the sprawling and surging of its animal hulks.

Leonardo MADE NEW BEINGS, delicate and severe, with as ambitious an intention as any ingenious mediaeval Empiric.

He multiplied in himself, too, Life's possibilities. He was not content to be as an individual Artist alone, any more than he was content with Art.

Life won him with gifts and talents.

2 In Northern Europe (Germany, Scandinavia and Russia) for the last half century, the intellectual world has developed savagely in one direction—that of Life.

His war-talk, sententious elevation and much besides, Marinetti picked up from Nietzsche.

Strindberg, with his hysterical and puissant autobiographies, life-long tragic coquetry with Magic, extensive probing of female flesh and spirit, is the great Scandinavian figure best representing this tendency.

Bergson, the philosopher of Impressionism, stands for this new pre-science in France.

Everywhere LIFE is said instead of ART.

3 By 'Life' is not meant good dinner, sleep and copulation.

There is rather only room for ONE Life, in Existence, and Art has to behave itself and struggle.

Also Art has a selfish trick of cutting the connections.

The Wild Body and Primitive Brain have found a new outside art of their own.

The Artist pleasure-man is too naturalistic for this age of religion.

'The theatre is immoral, because a place where people go to enjoy other people's sufferings and tears' (to d'Alembert).

The soft stormy flood of Rousseauism, Dickens' sentimental ghoul-like gloating over the death of little Nell, the beastly and ridiculous spirit of Keats' lines:

> *If your mistress some RICH anger show,*
> *Imprison her soft hand and let her rave,*
> *While you feast long,* etc.

disgusted about 1870 people who had not got a corner in dogs' nerves or heart idling about the stomach instead of attending to its business of pump, and whose heads were, with an honest Birmingham screw, straightly riveted into their bodies.

The good artists, as well, repudiated the self-indulgent, special-privileged, priggish and cowardly role of 'Artist', and joined themselves to the Birmingham screws.

England emerged from Lupanars and Satanics about 1900, the Bourgeoisie having thoughtfully put Wilde in prison, and Swinburne being retired definitely to Putney.

This brings you to the famous age where we are at present gathered, in which Humanity's problem is 'live with minimum of pleasure possible for bare existence'.

4 Killing somebody must be the greatest pleasure in existence: either like killing yourself without being interfered with by the instinct of self-preservation—or exterminating the instinct of self-preservation itself!

But if you begin depositing your little titivations of pleasure in Humanity's Savings Bank, you want something for your trouble.

We all have a penetrative right over each other, to the tune of titivations lost, if not of heart blood.

5 Not many people have made up their minds yet as to the ultimate benefit or the reverse of this state of affairs.

Some people enjoy best by proxy, some by masturbation; others prefer to do things themselves, or in the direct regular partnership of existence.

You are fiercely secretive and shy: or dislike interference.

Most fine artists cannot keep themselves out of wood and iron, or printed sheets: they leave too much of themselves in their furniture.

For their universality a course of egotistic hardening, if anything, is required.

Buddha found that his disciples, good average disciples, required a severe discipline of expansion; he made them practise every day torpedoing East and West to inhabit other men, and become wise and gentle.

The Artist favours solitude, conditions where silence and purity are possible, as most men favour gregariousness where they shine and exist most.

But the Artist is compensated, at present, by a crown, and will eventually arrange things for the best.

6 It is all a matter of the most delicate adjustment between voracity of Art and digestive quality of Life.

The finest Art is not pure Abstraction, nor is it unorganized life.

Dreams come in the same category as the easy abstractions and sentimentalities of art known as 'Belgian'.

Great Artists with their pictures and books provide Nursing Homes for the Future, where Hypnotic Treatment is the principal stunt.

To dream is the same thing as to lie: anybody but an invalid or a *canaille* feels the discomfort and repugnance of something not clean in it.

There is much fug in the Past—due, no doubt, to the fact that most of the ordinary Ancients neglected their persons.

Realism is the cleanliness of the mind.

Actuality or 'fashionableness' is the desire to be spick and span, and be a man remade and burnished half-an-hour ago.

Surprise is the brilliant and prodigious fire-fly, that lives only twenty minutes: the excitement of seeing him burn through his existence like a wax-vesta makes you marvel at the slow-living world.

The most perishable colours in painting (such as Veronese green, Prussian Blue, Alizarin Crimson) are the most brilliant.

This is as it should be: we should hate other ages, and don't want to fetch £40,000, like a horse.

7 The actual approximation of Art to Nature, which one sees great signs of today, would negative effort equally.

The Artist, like Narcissus, gets his nose nearer and nearer the surface of Life.

He will get it nipped off if he is not careful, by some Pecksniff-shark sunning its lean belly near the surface, or other lurker beneath his image, who has been feeding on its radiance.

Reality is in the artist, the image only in life, and he should only approach so near as is necessary for a good view.

The question of focus depends on the power of his eyes, or their quality.

8 The Futurist statue will move: then it will live a little: but any idiot can do better than that with his good wife, round the corner.

Nature is definitely ahead of us in contrivances of that sort.

We must remain children, less scientific than a Boy Scout, but less naive than Flaubert *jeune*!

Nature is grown up.

WE could not make an Elephant.

9 With Picasso's revolution in the plastic arts, the figure of the Artist becomes still more blurred and uncertain.

Engineer or artist might conceivably become transposable terms, or one, at least, imply the other.

What is the definite character of the artist; obvious pleasure, as an element, shrinking daily, or rather approximating with Pleasure as it exists in every other form of invention?

Picasso has proved himself lately too amateurish a carpenter.

Book-making and joining also occur to one.

Or the artist will cease to be a workman, and take his place with the Composer and Architect?

The artist till now has been his own interpreter, improvisation and accidents of a definite medium playing a very important part.

Today there are a host of first rate interpreters: the few men with the invention and brains should have these at their disposal: but unfortunately they all want to be 'composers', and their skill and temperament allow them to do very good imitations.

But perhaps things are better as they are: for if you think of those stormy Jewish faces met in the corridors of the tube, Beethovenesque and femininely ferocious, on the concert-bills, or 'our great Shakespearean actors', you feel that Beethoven and Shakespeare are for the student, and not for the Bechstein Hall or the modern theatre.

At any period an artist should have been able to remain in his studio, imagining form, and provided he could transmit the substance and logic of his inventions to another man, could, without putting brush to canvas, be the best artist of his day.

NOTE ON SOME GERMAN WOODCUTS AT THE TWENTY-ONE GALLERY

At this miniature sculpture, the Woodcut, Germans have always excelled.

It is like the one-string fiddle of the African.

This art is African, in that it is sturdy, cutting through every time to the monotonous wall of space, and intense yet hale: permeated by Eternity, an atmosphere in which only the black core of Life rises and is silhouetted.

The black, nervous fluid of existence flows and forms into hard, stagnant masses in this white, luminous body. Or it is like a vivid sea pierced by rocks, on to the surface of which boned shapes rise and bask blackly.

It deals with Man and objects subject to him, on Royal white, cut out in black sadness.

White and Black are two elements. Their possible proportions and relations to each other are fixed.—All the subtleties of the Universe are driven into these two pens, one of which is black, the other white, with their multitude.

It is African black.

It is not black, invaded by colour, as in Beardsley, who was never simple enough for this blackness. But unvarying, vivid, harsh black of Africa.

The quality of the woodcut is rough and brutal, surgery of the senses, cutting and not scratching: extraordinarily limited and exasperating.

It is one of the greatest tests of fineness.

Where the Germans are best—disciplined, blunt, thick and brutal, with a black simple skeleton of organic emotion—they best qualify for this form of art.

All the things gathered here do not come within these definitions. Melzer is sculpture, too, but by suggestion, not in fact. The principle of his work is an infatuation for bronzes.

Pechstein has for nearest parallel the drawings and lithographs of Henri Matisse.

Marc, Bolz, Kandinsky, Helbig and Morgner would make a very solid show in one direction.

Bolz's 'Maskenfest' is a Kermesse of black strips and atoms of life. His other design, like a playing-card, is a nerve or woman, and attendant fascinated atoms, crushed or starred.

Morgner drifts into soft Arctic snow-patches.

Marc merges once more in leaves and sun-spotting the protective markings of animals, or in this process makes a forest into tigers.

Some woodcuts by Mr H. Wadsworth, though not part of the German show, are to be seen in the Gallery. One, of a port, is particularly fine, with its white excitement, and compression of clean metallic shapes in the well of the Harbour, as though in a broken cannon-mouth.

POLICEMAN AND ARTIST

1 In France no Artist is as good as 'the Policeman'.

Rousseau the Douanier, the best policeman, is better than Derain, the best French Artist.

Not until Art reaches the fresher strata of the People does it find a vigorous enough bed to flourish.

There is too much cultivation, and only the Man of the People escapes the softening and intellectualizing.

There is one exception—the crétin or sawney.

Cézanne was an imbecile, as Rousseau was a 'Policeman'.

Nature's defence for Cézanne against the deadly intelligence of his country was to make him a sort of idiot.

2 In England the Policeman is dull.

The People (witness dearth of Folk-song, ornament, dance, art of any sort, till you get to the Border or the Marches of Wales) is incapable of Art.

The Artist in England has the advantages and gifts possessed by the Policeman in France.

His position is very similar.

William Blake was our arch-Policeman.

Had Blake, instead of passing his time with Renaissance bogeys and athletes, painted his wife and himself naked in their conservatory (as, in a more realistic tradition, he quite conceivably might have done), the result would have been very similar to Rousseau's portraits.

The English Artist (unlike the Frenchman of the people) has no Artistic tradition in his blood.

His freshness and genius is apt to be obscured, therefore (as in the case of Blake, THE English Artist), by a borrowed Italian one.

3 It is almost as dangerous in England to be a sawney, as it is in France to be intelligent.

Cézanne in England would have to be a very intelligent fellow.

(You can't be too intelligent here!)

(It is the only place in Europe where that is the case.)

Blake in France would have been a Policeman.

It is finer to be an Artist than to be a Policeman!

FENG SHUI AND CONTEMPORARY FORM

Fêng shui (literally, 'winds water'), became the popular Chinese name for geomancy, the art of divination by means of signs derived from the earth. It originally signified the attention paid to wind and water conditions in selection of burial places, and by the time of the T'ang dynasty it also extended to the choice of residential sites.

1 That a mountain, river or person may not 'suit'—the air of the mountain, the character of the person—and so influence lives, most men see.

But that a hill or man can be definitely disastrous, and by mere existence be as unlucky as hemlock is poisonous, shame or stupidity prevents most from admitting.

A certain position of the eyes, their fires crossing; black (as a sort of red) as sinister; white the mourning colour of China; white flowers, in the West, signifying death—white, the radium among colours, and the colour that comes from farthest off: 13, a terrible number: such are much more important discoveries than gravitation.

The law of gravitation took its place in our common science following the fall of an apple on somebody's head, which induced reflection.

13 struck people down again and again like a ghost, till they ceased hunting for something human, but invisible, and found a Number betraying its tragic nature and destiny.

Some Numbers are like great suns, round which the whole of Humanity must turn.

But people have a special personal Numerical which for them in particular is an object of service and respect.

2 Telegraph poles were the gloomiest of all Western innovations for China: their height disturbed definitely the delicate equilibrium of lives.

They were consequently resisted with bitterness.

Any text-book on China becomes really eloquent in its scorn when it arrives at the ascendancy of the Geomancers.

Geomancy is the art by which the favourable influence of the shape of trees, weight of neighbouring water and its colour, height of surrounding houses, is determined.

'No Chinese street is built to form a line of uniform height' (H. A. Giles), the houses are of unequal heights to fit the destinies of the inhabitants.

I do not suppose that good Geomancers are more frequent than good artists.

But their functions and intellectual equipment should be very alike.

3 Sensitiveness to volume, to the life and passion of lines, meaning of water, hurried conversation of the sky, or silence, impossible propinquity of endless clay nothing will right, a mountain that is a genius (good or evil) or a bore, makes the artist; and the volume, quality, or luminosity of a star at birth of Astrologers is also a clairvoyance within the painter's gift.

In a painting certain forms MUST be SO; in the same meticulous, profound manner that your pen or a book must lie on the table at a certain angle, your clothes at night be arranged in a set personal symmetry, certain birds be avoided, a set of railings tapped with your hand as you pass, without missing one.

Personal tricks and ceremonies of this description are casual examples of the same senses' activity.

RELATIVISM AND PICASSO'S LATEST WORK

(Small structures in cardboard, wood, zinc, glass, string, etc., tacked, sown or stuck together is what Picasso has last shown as his.)

1 Picasso has become a miniature naturalistic sculptor of the vast *natures-mortes* of modern life.

Picasso has come out of the canvas and has commenced to build up his shadows against reality.

Reality is the Waterloo, Will o' the wisp, or siren of artistic genius.

'Reality' is to the Artist what 'Truth' is to the philosopher.

(The Artist's OBJECTIVE is Reality, as the Philosopher's is Truth.)

The 'Real Thing' is always Nothing. REALITY is the nearest conscious and safe place to 'Reality'. Once an Artist gets caught in that machinery, he is soon cut in half—literally so.

2 The moment an image steps from the convention of the canvas into life, its destiny is different.

The statue has been, for the most part, a stone-man.

An athletic and compact statue survives. (African, Egyptian Art, etc., where faces are flattened, limbs carved in the mass of the body for safety as well as sacredness.)

You can believe that a little patch of paint two inches high on a piece of canvas is a mountain. It is difficult to do so with a two inch clay or stone model of one.

3 These little models of Picasso's reproduce the surface and texture of objects. So directly so, that, should a portion of human form occur, he would hardly be content until he could include in his work a plot of human flesh.

But it is essentially NATURES-MORTES, the enamel of a kettle, wall-paper, a canary's cage, handle of mandoline or telephone.

4 These wayward little objects have a splendid air, starting up in pure creation, with their invariable and lofty detachment from any utilitarian end or purpose.

But they do not seem to possess the necessary physical stamina to survive.

You feel the glue will come unstuck and that you would only have to blow with your mouth to shatter them.

They imitate like children the large, unconscious, serious machines and contrivances of modern life.

So near them do they come, that they appear even a sort of new little parasite bred on machinery.

Finally, they lack the one purpose, or even necessity, of a work of Art: namely Life.

5 In the experiments of modern art we come face to face with the

question of the *raison d'être* of Art more acutely than often before, and the answer comes more clearly and unexpectedly.

Most of Picasso's latest work (on canvas as well) is a sort of machinery. Yet these machines neither propel nor make any known thing: they are machines without a purpose.

If you conceive them as carried out on a grand scale, as some elaborate work of engineering the paradox becomes more striking.

These machines would, in that case, before the perplexed and enraged questions of men, have only one answer and justification.

If they could suggest or convince that they were MACHINES OF LIFE, a sort of LIVING plastic geometry, then their existence would be justified.

6 To say WHY any particular man is alive is a difficult business: and we cannot obviously ask more of a picture than of a man.

A picture either IS or it IS NOT.

A work of art could not start from such a purpose as the manufacture of nibs or nails.

These mysterious machines of modern art are what they are TO BE ALIVE.

Many of Picasso's works answer this requirement.

But many, notably the latest small sculpture he has shown, attach themselves too coldly to OTHER machines of daily use and inferior significance.

Or, he practically MAKES little *natures-mortes*, a kettle, plate, and piece of wall-paper, for example.

He no longer so much interprets, as definitely MAKES, nature (and 'DEAD' nature at that).

A kettle is never as fine as a man.

This is a challenge to the kettles.

THE NEW EGOS

1 A civilized savage, in a desert-city, surrounded by very simple objects and restricted number of beings, reduces his Great Art down to the simple black human bullet.

His sculpture is monotonous. The one compact human form is his Tom-Tom.

We have nothing whatever to do with this individual and his bullet.

Our eyes sweep life horizontally.

Were they in the top of our head, and full of blank light, our art would be different, and more like that of the savage.

The African we have referred to cannot allow his personality to venture forth or amplify itself, for it would dissolve in vagueness of space.

It has to be swaddled up in a bullet-like lump.

But the modern town-dweller of our civilization sees everywhere fraternal moulds for his spirit, and interstices of a human world.

He also sees multitude, and infinite variety of means of life, a world and elements he controls.

Impersonality becomes a disease with him.

Socially, in a parallel manner, his egotism takes a different form.

Society is sufficiently organized for his ego to walk abroad.

Life is really no more secure, or his egotism less acute, but the frontiers interpenetrate, individual demarcations are confused and interests dispersed.

2 According to the most approved contemporary methods in boxing two men burrow into each other, and after an infinitude of little intimate pommels, one collapses.

In the old style, two distinct, heroic figures were confronted, and one ninepin tried to knock the other ninepin over.

We all today (possibly with a coldness reminiscent of the insect-world) are in each other's vitals—overlap, intersect, and are Siamese to any extent.

Promiscuity is normal; such separating things as love, hatred, friend ship are superseded by a more realistic and logical passion.

The human form still runs, like a wave, through the texture or body of existence, and therefore of art.

But just as the old form of egotism is no longer fit for such conditions as now prevail, so the isolated human figure of most ancient Art is an anachronism.

THE ACTUAL HUMAN BODY BECOMES OF LESS IMPORTANCE EVERY DAY.

It now, literally, EXISTS much less.

Love, hatred, etc., imply conventional limitations.

All clean, clear-cut emotions depend on the element of strangeness, and surprise and primitive detachment.

Dehumanization is the chief diagnostic of the Modern World.

One feels the immanence of some REALITY more than any former human beings can have felt it.

This superseding of specific passions and easily determinable emotions by such uniform, more animal, instinctively logical Passion of Life, of different temperatures, but similar in kind, is, then, the phenomenon to which we would relate the most fundamental tendencies in present art, and by which we would gauge its temper.

ORCHESTRA OF MEDIA

Painting, with the Venetians, was like pianoforte playing as compared to the extended complicated orchestra aspired to by the Artist today.

Sculpture of the single sententious or sentimental figure on the one hand, and painting as a dignified accomplished game on the other, is breaking up and caving in.

The medium (of oil-paint) is modifiable, like an instrument. Few today have forsaken it for the more varied instruments, or orchestra of media, but have contented themselves with violating it.

The reflection back on the present, however, of this imminent extension—or, at least the preparation for this taking-in of other media—has for effect a breaking up of the values of beauty, etc., in contemporary painting.

The surfaces of cheap manufactured goods, woods, steel, glass, etc., already appreciated for themselves, and their possibilities realized, have finished the days of fine paint.

Even if painting remains intact, it will be much more supple and extended, containing all the elements of discord and 'ugliness' consequent on the attack against traditional harmony.

The possibilities of colour, exploitation of discords, odious combinations, etc., have been little exploited.

A painter like Matisse has always been harmonious, with a scale of colour pleasantly Chinese.

Kandinsky at his best is much more original and bitter. But there are fields of discord untouched.

THE MELODRAMA OF MODERNITY

1 Of all the tags going, 'Futurist', for general application, serves as well as any for the active painters of today.

It is picturesque and easily inclusive.

It is especially justifiable here in England where no particular care or knowledge of the exact (or any other in matters of art) signification of this word exist.

In France, for instance, no one would be likely to apply the term 'Futurist' to Picasso or Derain; for everyone there is familiar with Marinetti's personality, the detail of his propaganda, and also the general history of the Cubist movement—Picasso's part, Derain's part, and the Futurists'.

On the other hand, here in England, Marquet, Vuillard, Besnard even, I expect, would be called 'Futurist' fairly often.

As 'Futurist', in England, does not mean anything more than a painter, either a little, or very much, occupying himself with questions of a renovation of art, and showing a tendency to rebellion against the domination of the Past, it is not necessary to correct it.

We may hope before long to find a new word.

If Kandinsky had found a better word than 'Expressionist' he might have supplied a useful alternative.

2 Futurism, as preached by Marinetti, is largely Impressionism up-to-date. To this is added his Automobilism and Nietzsche stunt.

With a lot of good sense and vitality at his disposal, he hammers away in the blatant mechanism of his Manifestos, at his *idée fixe* of Modernity.

From that harsh swarming of animal vitality in almost Eastern cities across the Alps, his is a characteristic voice, with execration making his teeth ragged, blood weltering and leaping round his eyes.

He snarls and bawls about the Past and Future with all his Italian practical directness.

This is of great use when one considers with what sort of person the artist today has to deal!

His certain success in England is similar to that of Giovanni Grasso. Any spectacular display of temperament carries away the English crowd. With an Italian crowd it has not the same effect. This popular orator again possesses qualities which attach him on the one hand to a vitality possessed by all artists a cut above the senile prig, and on the other hand he has access to the vitality of the People.

3 Futurism, then, in its narrow sense and in the history of modern Painting, is a picturesque, superficial and romantic rebellion of young Milanese painters against the Academism which surrounded them.

Gino Severini was the most important. Severini, with his little blocks, strips and triangles of colour, 'zones' of movement, etc., made many excellent plastic discoveries. I say 'was' because today there are practically no Futurists or, at least, Automobilists, left. Balla is the best painter of what was once the Automobilist group.

4 Modernity, for Severini, consisted in the night cafés of Paris. It is doubtful whether the Future (of his or any one else's ISM) will contain such places.

We all foresee, as I have argued in another place, in a century or so men and women being put to bed at 7 o'clock by a state nurse (in separate beds, of course!).

No *cocottes* for Ginos of the Future!

With their careful choice of motor omnibuses, cars, lifts, aeroplanes, etc., the Automobilist pictures were too 'picturesque', melodramatic and spectacular, besides being undigested and naturalistic to a fault.

Severini only seemed to me to escape, by his feeling for pattern, and certain clearness and restraint (even in the excesses of a gigantic set-piece).

The Melodrama of Modernity is the subject of these fanciful but rather conventional Italians.

Romance about science is a thing we have all been used to for many years, and we resent it being used as a sauce for a dish claiming to belong strictly to emancipated Futures.

A motor omnibus can be just as romantically seen as Carisbrooke Castle or Shakespeare's house at Stratford.

I do not hold a brief opposed to Romance, but most of the Futurist work is in essence as sentimental as Boccioni's large earlier picture at the Sackville Gallery Show, called the *Building of a City*.

This was sheer unadulterated Belgian romance: blue clouds of smoke, pawing horses, heroic grimy workers, sententious skyscrapers, factory chimneys, etc.

If, divested of this element of illustration, H. G. Wells romance, and pedantic naturalism, Marinetti's movement could produce profounder visions with this faith of novelty, something fine might be done.

For it does not matter what incentive the artist has to creation.

Schiller always kept a few rotten pears in his drawer, and when he felt the time had come to write another lyric, he would go to his drawer and take out a rotten pear. He would sniff and sniff. When he felt the

lyric rising from the depths of him in response, he would put the pear back and seize the pen.

If 'dynamic' considerations intoxicate Balla and make him produce significant patterns (as they do), all is well.

5 But as I have said, Balla is not a 'Futurist' in the Automobilist sense.

He is a rather violent and geometric sort of Expressionist.

His paintings are purely abstract: he does not give you bits of automobiles, or complete naturalistic fragments of noses and ears, or any of the Automobilist bag of tricks, in short.

So in the present and latest exhibition of Futurists at the Doré Gallery there are no Futurists left, except perhaps the faithful lieutenant Boccioni: although he too becomes less representative and more abstract every day.

As to the rest, they seem to have become quite conventional and dull Cubists or Picassoists, with nothing left of their still duller Automobilism but letters and bits of newspaper stuck all over the place.

6 Cannot Marinetti, sensible and energetic man that he is, be induced to throw over this sentimental rubbish about Automobiles and Aeroplanes, and follow his friend Balla into a purer region of art? Unless he wants to become a rapidly fossilizing monument of puerility, cheap reaction and sensationalism, he had better do so.

THE EXPLOITATION OF VULGARITY

When an ugly or uncomely person appeared on the horizon of their daily promenade, Ingres' careful wife would raise her shawl protectingly, and he would be spared a sight that would have offended him.

Today the Artist's attention would be drawn, on the contrary, to anything particularly hideous or banal, as a thing not to be missed.

Stupidity has always been exquisite and ugliness fine.

Aristophanes loved a fool as much as any man his shapely sweetheart.

Perhaps his weakness for fools dulled his appreciation of the Sages.

No doubt in a perfectly 'wholesome', classic state of existence, Humour would be almost absent, and discords would be scrupulously shunned, or exist only as a sacred disease that an occasional man was blighted with.

We don't want today things made entirely of gold (but gold mixed

with flint or grass, diamond with paste, etc.) any more than a monotonous paradise or security would be palatable.

But the condition of our enjoyment of vulgarity, discord, cheapness or noise is an unimpaired and keen disgust with it.

It depends, that is, on sufficient health, not to relinquish the consciousness of what is desirable and beneficial.

Rare and cheap, fine and poor, these contrasts are the male and female, the principle of creation today.

This pessimism is the triumphant note in modern art.

A man could make just as fine an art in discords, and with nothing but 'ugly' trivial and terrible materials, as any classic artist did with only 'beautiful' and pleasant means.

But it would have to be a very tragic and pure creative instinct.

Life today is giddily frank, and the fool is everywhere serene and blatant.

Human insanity has never flowered so colossally.

Our material of discord is to an unparalleled extent forcible and virulent.

Pleasantness, too, has an edge or a softness of unusual strength.

The world may, at any moment, take a turn, and become less vulgar and stupid.

The great artist must not miss this opportunity.

But he must not so dangerously identify himself with vulgarity as Picasso, for instance, inclines to identify himself with the appearance of Nature.

There are possibilities for the great artist in the picture postcard.

The ice is thin, and there is as well the perpetual peril of virtuosity.

THE IMPROVEMENT OF LIFE

In Wyndham Lewis the Artist, *Lewis suggests that this piece be read in conjunction with* The Caliph's Design.

1 The passion of his function to order and transmute, is exasperated in the artist of today, by vacuity and complication, as it was in the case of the imitators of Romanticism before 'Wild Nature'.

One of the most obvious questions that might have been put to any naturalistic painter of twenty years ago, or for that matter to Rembrandt or a Japanese, was this:

Is there no difference, or if so, what difference, between a bad piece of architecture or a good piece represented in a painting, or rather would it be a greater type of art that had for representative content objects finer in themselves?

This kind of argument, of course, refers only to the representative painter.

Rembrandt might have replied that there is no fine man or poor man, that vulgarity is as good as nobleness: that in his paintings all things were equal. But in taking Rembrandt the point may be confused by sentimentality about a great artist, 'touching' old beggar man, 'soul-painting', etc.

(Just as profound sentimentality might arise about Newness, Brand Newness, as about age, ruins, mould and dilapidation.)

Every one admits that the interior of an A.B.C. shop is not as fine as the interior of some building conceived by a great artist.

Yet it would probably inspire an artist today better than the more perfect building.

With its trivial ornamentation, mirrors, cheap marble tables, silly spacing, etc., it nevertheless suggests a thousand great possibilities for the painter.

Where is the advantage, then, for the painter today, for Rembrandt or for a Japanese, in having a better standard of taste in architecture, finer dresses, etc.?

2 If it were not that vulgarity and the host of cheap artisans compete in earning with the true artist immeasurably more than in a 'great period of art', the Present would be an ideal time for creative genius.

· Adverse climatic conditions—drastic Russian winters, for example—account for much thought and profundity.

England which stands for anti-Art, mediocrity and brainlessness among the nations of Europe, should be the most likely place for great Art to spring up.

England is just as unkind and inimical to Art as the Arctic zone is to Life.

This is the Siberia of the mind.

If you grant this, you will at once see the source and reason of my very genuine optimism.

OUR VORTEX

I. Our vortex is not afraid of the Past: it has forgotten its existence.

Our vortex regards the Future as sentimental as as the Past.

The Future is distant, like the Past, and therefore sentimental.

The mere element 'Past' must be retained to sponge up and absorb our melancholy.

Everything absent, remote, requiring projection in the veiled weakness of the mind, is sentimental.

The Present can be intensely sentimental—especially if you exclude the mere element 'Past'.

Our vortex does not deal in reactive Action only, nor identify the Present with numbing displays of vitality.

The new vortex plunges to the heart of the Present.

The chemistry of the Present is different to that of the Past. With this different chemistry we produce a New Living Abstraction.

The Rembrandt Vortex swamped the Netherlands with a flood of dreaming.

The Turner Vortex rushed at Europe with a wave of light.

We wish the Past and Future with us, the Past to mop up our melancholy, the Future to absorb our troublesome optimism.

With our Vortex the Present is the only active thing.

Life is the Past and the Future.

The Present is Art.

II. Our Vortex insists on water-tight compartments.

There is no Present—there is Past and Future, and there is Art.

Any moment not weakly relaxed and slipped back, or, on the other hand, dreaming optimistically, is Art.

'Just Life' or *soi-disant* 'Reality' is a fourth quantity, made up of the Past, the Future and Art.

This impure Present our Vortex despises and ignores.

For our Vortex is uncompromising.

We must have the Past and the Future, Life simple, that is, to discharge ourselves in, and keep us pure for non-life, that is Art.

The Past and Future are the prostitutes Nature has provided.

Art is periodic escapes from this Brothel.

Artists put as much vitality and delight into this saintliness, and escape out, as most men do their escapes into similar places from respectable existence.

The Vorticist is at his maximum point of energy when stillest.

The Vorticist is not the Slave of Commotion, but its Master.

The Vorticist does not suck up to Life.

He lets Life know its place in a Vorticist Universe!

III. In a Vorticist Universe we don't get excited at what we have invented.

If we did it would look as though it had been a fluke.

It is not a fluke.

We have no Verbotens.

There is one Truth, ourselves, and everything is permitted.

But we are not Templars.

We are proud, handsome and predatory.

We hunt machines, they are our favourite game.

We invent them and then hunt them down.

This is a great Vorticist age, a great still age of artists.

IV. As to the lean belated Impressionism at present attempting to eke out a little life in these islands:

Our Vortex is fed up with your dispersals, reasonable chicken-men.

Our Vortex is proud of its polished sides.

Our Vortex will not hear of anything but its disastrous polished dance.

Our Vortex desires the immobile rhythm of its swiftness.

Our Vortex rushes out like an angry dog at your Impressionistic fuss.

Our Vortex is white and abstract with its red-hot swiftness.

FREDERICK SPENCER GORE

Born in 1878, Gore died on March 27th, 1914, of pneumonia, after an illness of three days.

Had he lived, his dogged, almost romantic industry, his passion for the delicate objects set in the London atmosphere around him, his grey conception of the artist's life, his gentleness and fineness, would have matured into an abundant personal art, something like Corot and Gessing.

His habit of telling you of things he had his eye on and intended painting three years hence, and all his system of work was with reference to minute and persistent labour, implying a good spell of life, which almost retarded accomplishment.

He projected himself into the years of work before him, and organized queerly what was to be done. He possessed physically a busy time three years away, as much as today.

A boastfully confident attitude to Time's expanse, and absence of recognition of the common need to hurry, characterized him.

Death cut all this short to the dismay of those who had known him from the start, and regarded, confidently like him, this great artist and dear friend as a permanent thing in their lives, and his work as in safe hands and sure of due fulfilment. His leisureliness and confidence were infectious.

His painting as it is, although incomplete, is full of illustrations of a maturer future. His latest work, with an accentuation of structural qualities, a new and suave simplicity, might, in the case of several examples I know, be placed beside that of any of the definitely gracious artists in Europe.

The welter of pale and rather sombre colour filling London back-yards, the rather distant, still and sultry well-being of a Camden Town summer, in trivial crescents with tall trees and toy trains, was one of his favourite themes.

He was a painter of the London summer, of heavy dull sunlight, of exquisite, respectable and stodgy houses, more than anybody else.

The years he spent working on scenes from London music-halls brought to light a new world of witty illusion. I much prefer Gore's paintings of the theatre to Degas's. Gore gets everything that Degas with his hard and rather paltry science apparently did not see.

He had an admirable master for his drawing in Mr Walter Sickert, to whose advice and friendship he no doubt owed more than to anybody else's.

But he was quite independent of Mr Sickert, or of any group of artists, and even diametrically opposed to many of his friends in his feeling towards the latest movement in painting, which from the first he gave his word for. Some of his work towards the end belonged rather to this present movement than to any other.

The memorial exhibition of his work shortly to be held should, if possible, since the Cabaret Club has closed, contain the large paintings he did for that place.

ROOM III. THE CUBIST ROOM

One of two forewords to the catalogue of the 'Exhibition of English Post-Impressionists, Cubists and Others', held in Brighton, from November 1913 to January 1914. The other foreword, by J. B. Manson, represented the Camden Town element in the Exhibition. Later in 1914, the group which had organized the Exhibition adopted the name London Group.

Futurism, one of the alternative terms for modern painting, was patented in Milan. It means the Present, with the Past rigidly excluded, and flavoured strongly with H. G. Wells' dreams of the dance of monstrous and arrogant machinery, to the frenzied clapping of men's hands. But futurism will never mean anything else, in painting, than the art practised by the five or six Italian painters grouped beneath Marinetti's influence. Gino Severini, the foremost of them, has for subject matter the night resorts of Paris. This, as subject matter, is obviously not of the future. For we all foresee, in a century or so, everybody being put to bed at 7 o'clock in the evening by a state-nurse. Therefore the Pan Pan at the Monaco will be, for Ginos of the future, an archaistic experience.

Cubism means, chiefly, the art, superbly severe and so far morose, of those who have taken the genius of Cézanne as a starting point, and organized the character of the works he threw up in his indiscriminate and grand labour. It is the reconstruction of a simpler earth, left as choked and muddy fragments by him. Cubism includes much more than this, but the cube is implicit in that master's painting.

To be done with terms and tags, Post-Impressionism is an insipid and pointless name invented by a journalist, which has been naturally ousted by the better word 'Futurism' in public debate on modern art.

This room is chiefly composed of works by a group of painters, consisting of Frederick Etchells, Cuthbert Hamilton, Edward Wadsworth, C. R. W. Nevinson and the writer of this foreword. These painters are not accidentally associated here, but form a vertiginous, but not exotic, island in the placid and respectable archipelago of English art. This formation is undeniably of volcanic matter and even origin; for it appeared suddenly above the waves following certain seismic shakings beneath the surface. It is very closely knit and admirably adapted to

withstand the imperturbable Britannic breakers which roll pleasantly against its sides.

Beneath the Past and the Future the most sanguine would hardly expect a more different skeleton to exist than that respectively of ape and man. Man with an aeroplane is still merely a bad bird. But a man who passes his days amid the rigid lines of houses, a plague of cheap ornamentation, noisy street locomotion, the Bedlam of the press, will evidently possess a different habit of vision to a man living amongst the lines of a landscape. As to turning the back, most wise men, Egyptians, Chinese, or what not, have remained where they found themselves, their appetite for life sufficient to reconcile them, and allow them to create significant things. Suicide is the obvious course for the dreamer, who is a man without an anchor of sufficient weight.

The work of this group of artists for the most part underlines such geometric bases and structure of life and they would spend their energies rather in showing a different skeleton and abstraction than formerly could exist, than a different degree of hairiness or dress. All revolutionary painting today has in common the rigid reflections of steel and stone in the spirit of the artist; that desire for stability as though a machine were being built to fly or kill with; an alienation from the traditional photographer's trade and realization of the value of colour and form as such, independently of what recognizable form it covers or encloses. People are invited, in short, to entirely change their idea of the painter's mission, and penetrate, deferentially, with him into a transposed universe, as abstract as, though different to, the musicians....

Hung in this room as well are three drawings by Jacob Epstein, the only great sculptor at present working in England. He finds in the machinery of procreation a dynamo to work the deep atavism of his spirit. Symbolically strident above his work, or in the midst of it, is, like the Pathe cock, a new born baby, with a mystic but puissant crow. His latest work opens up a region of great possibilities, and new creation. David Bomberg's painting of a platform announces a colourist's temperament, something between the cold blond of Severini's earlier paintings and Vallotton. The form and subject matter are academic, but the structure of the criss-cross pattern new and extremely interesting.

A REVIEW OF CONTEMPORARY ART

This essay was reprinted in Wyndham Lewis the Artist *under the title 'Art Subject to Laws of Life' with omission of the introductory Note. In* Wyndham Lewis the Artist *Lewis writes as follows about it:*

By the way, 'Art subject to Laws of Life' contains a fair measure of tub-thumping, and I have felt it better, where that is going on, to retain the display-capitals. As to these methods of the mob-orator, they really had to be used: 1914 was not 1939—if you were a 'movement' you were expected to shout. One was surrounded—one was hemmed-in—by mob-orators. To lift his voice, in 1914, was as essential to a *chef de bande*, as it was in 1915 to a drill-sergeant. I made a marvellous 'bombardier', a year or so later. I had had a good deal of practice!

Lewis next quotes Section C (subsections 38–41) which define, he states, 'once and for all what a Royal Academy should be—namely a sort of Cubist *Academy.' He continues:*

I might have gone farther (as I at all events will go now) and have said that the limited, the immature, majority-person should be *compelled to paint primitive*; that 'child-art', in other words, had its uses. There is nothing strange in many grown-up people continuing to paint as if they were fifteen years old. They have never progressed intellectually beyond the standards of that age; therefore when they paint they should not worry to do anything too grown-up—too mature, or too 'professional'.

And in this connection I come to Mr Fry, who was all for the amateur, all for the eternal Child, and who wished to make of the painting-world of London a tight little right little world, safe for the amateur to live in. But I do not wish to say very much about Mr Fry, in this place. He makes his appearance inevitably in the course of these essays. Although I cannot eliminate him, I do not wish to go into all that now. Mr Fry is a sort of pink herring, merely (aesthetically, I mean, of course). Do not let us draw the great apostle of British amateurism across our trail in the present context.

NOTE

VORTICISM is the only word that has been used in this country and nowhere else for a certain new impulse in art.

FUTURISM has its peculiar meaning, and even its country, Italy.

CUBISM means the naturalistic abstract school of painters in Paris, who came, through Picasso, out of Cézanne. The word, even, CUBISM, is a heavy, lugubrious word. The Cubists' paintings have a large tincture of the deadness (as well as the weightiness) of Cézanne; they are static and representative, not swarming, exploding or burgeoning with life, as is the ideal of the Futurists, or electric with a more mastered, vivid vitality, which is the conception of their mission held by most of the Vorticists.

Because VORTICISM is a word first used here, that is no reason why it should be used rather than another, unless there are a group of painters who are so distinctive that they need a distinctive tag, and to whom this especial tag may aptly apply. I consider that there are. For the instruction of the small public interested in these matters, I will point out, to begin with, in the following notes, the way in which the English VORTICISTS differ from the French, German or Italian painters of kindred groups. (*The Vortex*, Spring, 1915.)

I

The painters have cut away and cut away warily, till they have trapped some essential. European painting today is like the laboratory of an anatomist: things stand up stark and denuded everywhere as the result of endless visionary examination. But Life, more life than ever before, is the objective; some romancing of elixirs, as the rawest student will: and all professing some branch of energy.

When they say LIFE, they do at least mean something complete, that can only be meant by dissociating vitality from beef and social vivacity on the one hand, and good dinners and every day acts of propagation on the other.

Painting has been given back its imaginative horizons without renouncing the scientific work of the Impressionists or returning, beyond that, to a perpetual pastiching of old forms of art, which in a hundred ways we cannot assimilate.*

* The fundamental qualities are the same, naturally, in the great art of every time. The only thing an artist has to learn of the art of another time is that fundamental excellence. But if he is a fine artist he contains this fundamental force and excellence, and therefore has no need to potter about Museums, especially as life supplies the rest, and is short.

There have grown up three distinct groups of artists in Europe. The most important, in the sense that it contains the most important artist, and has influenced more men of talent than any other, is the Cubist group. Pablo Picasso, a Spaniard living in Paris, is chiefly responsible for this movement. Definitely inspired by this group, but, with their Italian energy and initiative, carried off to a quite different, more pugnacious and effervescent, point of the compass, is the Futurist group, having in Balla, Severini and Boccioni (given in order of merit, as I think) three important artists.

The third group is that formed by the EXPRESSIONIST movement, that is, Kandinsky. We will consider these three groups critically; insisting on those aspects in which they do not finally satisfy the needs of modern painting that were responsible for their appearance.

II

The IMPRESSIONISTS carried naturalism to its most photographic extreme, in theory. The ROMANTICS, their predecessors, would have no Jupiters and Ariadnes, and substituted Don Juan and Gretchen. The IMPRES-SIONISTS, in their turn, hustled away all the Corsairs, Feudal rakes and Teutonic maidens, and installed their mistresses and landladies on the front of the stage. They had not, at first, much time to think of anything else, this heroic act occupying all their energies. In painting, the IMPRESSIONISTS wished in everything to be TRUTHFUL. It was the age of scientific truth. Colour out of the earth had to imitate the light. The pigment for its own sake and on its own merits as colour, was of no importance. It was only important in so far as it could reproduce the blendings of the prism. Then like a German in London not con-centrated, there was a sort of 5 mile limit beyond which a REALIST must not move. He must paint what is under his nose—'composition' or arrangement, that is, as understood by them—anything but scientific unmodified transcriptions are an academicism. Roughly speaking, your washing-stand or sideboard must be painted, with due attention to complementaries, and in form it must be Nature's empiric propor-tions and exactly Nature's usually insignificant arrangements. If the line becomes unruly and independent, it must be suppressed. If the colour insidiously suggests that it would be happier near some other colour, it must be listened to ONLY if it belongs to a body that can, while still appearing 'natural', be shifted nearer the objects dyed in the colour

desired by its own tint. But this would be a physical feat, very often, requiring unexampled ingenuity, so things were usually left as they were, or hustled into careless 'arrangement'. Degas by violent perspectives (the theatre seen from its *poulailler*) or Cézanne by distortion and 'bad drawing', escaped from this aesthetic legislation. So this pedantry, with its scornful and snobbish verbotens, may be seen establishing its academies.

III

This exposition may appear unnecessarily thorough. It is not, for the following reason: one of the most important features of the paintings of the CUBISTS, and Picasso's practice, is a tenet they have taken over wholesale and unmodified from the IMPRESSIONISTS. Picasso through the whole of his 'Cubist' period has always had for starting-point in his creations, however abstract, his studio-table with two apples and a mandoline, the portrait of a poet of his acquaintance, or what not. His starting-point is identical with that of Cézanne or Manet.

At the beginning of his 'Cubist' period he was momentarily diverted into a Gauguinism *à la* Derain. But after that the portraits of men with mandolines and apples and guitars succeeded each other with regularity.

But as regards this aspect of Picasso's later painting, it must always be remembered that he was first known as a painter of purely stylistic and scholarly pictures. They were El Greco or attenuated Daumier, and were 'composed' with a corresponding logic and rhythm. So Picasso, at the outset of his Cubism, was in the same position as the Impressionists, and felt the need to react violently against the languors and conventions of his earlier period. There was, again, the practical influence of the French. As to the rest of his Cubist colleagues, they are mostly converted Impressionists, and inclined naturally to cube over their first effort, merely, instead of making any fresh start. Others, not formerly Impressionists, suffer from a form of conscience similar to his.

To describe CUBISM, then, it is useful to lead off with its least picturesque attribute, that of naturalism. As to content and the character of its force-arrangements, it is essentially the same as Impressionism, largely dosed in many cases with a Michelangelizing of the every-day figure or scene. (Metzinger's 'Femme à la Tasse', etc.) For the great licence Cubism affords tempts the artist to slip back into facile and sententious formulas, and escape invention.

IV

The other link of CUBISM with IMPRESSIONISM is the especially scientific character of its experiments. Matisse, with his decoration, preceded the Cubists in reaction against scientific naturalism. But CUBISM, as well, though in a sense nearer the Impressionists than Matisse, rejects the accentless, invertebrate order of Nature seen *en petit*. Any portion of Nature we can observe is an unorganized and microscopic jumble, too profuse and too distributed to be significant. If we could see with larger eyes we should no doubt be satisfied. But to make any of these minute individual areas, or individuals, too proudly compact or monumental, is probably an equal stupidity. Finite and god-like lines are not for us but, rather, a powerful but remote suggestion of finality, or a momentary organization of a dark insect swarming, like the passing of a cloud's shadow or the path of a wind.

The moment the Plastic is impoverished for the Idea, we get out of direct contact with these intuitive waves of power, that only play on the rich surfaces where life is crowded and abundant.

We must constantly strive to ENRICH abstraction till it is almost plain life, or rather to get deeply enough immersed in material life to experience the shaping power amongst its vibrations, and to accentuate and perpetuate these.

So CUBISM pulled Nature about with her cubes, and organized on a natural posed model, rather than attempting to catch her every movement, and fix something fluent and secret. The word CUBISM at once, for me, conjures up a series of very solid, heavy and usually gloomy *Natures Mortes,*—several bitter and sententious apples (but VERY GOOD WEIGHT) a usually pyramidal composition of the various aspects of a Poet or a Man with a Mandoline, Egyptian in static solemnity, a woman nursing disconsolately a very heavy and thoughtful head, and several bare, obviously tremendously heavy objects crowded near her on a clumsy board,—a cup and saucer and probably apples.

I admire some of these paintings extremely. Only we must recognize that what produced these paintings was a marvellous enterprise and enthusiastic experimentation, and that if we are to show ourselves worthy of the lead given us by two or three great painters of the last fifteen years, we must not abate in our interrogation.

V

The FUTURISTS, briefly, took over the plastic and real, rather than the scientific, parts of the practice of the Cubists. Only they rejected the POSED MODEL, imitative and static side of CUBISM, and substituted the hurly-burly and exuberance of actual life. They have not brought a force of invention and taste equal to the best of the Paris group to bear on their modification of the Cubist formulas. Their work is very much prejudiced by Marinetti's propaganda, which is always too tyrannically literary, and insists on certain points that are not essential to their painting and is in itself rather stupid. His 'Automobilism' is simply an Impressionist pedantry. His War-ravings is the term of a local and limited pugnacity, romantic and rhetorical. He is a useful figure as a corrective of very genuine character. But the artist is NOT a useful figure, though he may be ornamental. In fact the moment he becomes USEFUL and active he ceases to be an artist. We most of us nowadays are forced to be much more useful than we ought to be. But our painting at least should be saved the odour of the communistic platform or the medicine chest.

None of the Futurists have got, or attempted, the grandness that CUBISM almost postulated. Their doctrine, even, of maximum fluidity and interpenetration precluded this. Again, they constituted themselves POPULAR ARTISTS. They are too observant, impressionist and scientific; they are too democratic and subjugated by indiscriminate objects, such as Marinetti's moustache. And they are too banally logical in their exclusions.

VI

The EXPRESSIONISTS finally, and most particularly Kandinsky, are ethereal, lyrical and cloud-like,—their fluidity that of the Blavatskyish soul, whereas the Futurists' is that of nineteenth-century science. Kandinsky is the only PURELY abstract painter in Europe. But he is so careful to be passive and medium-like, and is committed, by his theory, to avoid almost all powerful and definite forms, that he is, at the best, wandering and slack. You cannot make a form more than it is by the best intentions in the world. In many of his abstract canvasses there are lines and planes that form the figure of a man. But these accidents are often rather dull and insignificant regarded as pieces of representation.

You cannot avoid the conclusion that he would have done better to ACKNOWLEDGE that he had (by accident) reproduced a form in Nature, and have taken more trouble with it FOR ITS OWN SAKE AS A FRANKLY REPRESENTATIVE ITEM. A dull scribble of a *bonhomme* is always that and nothing else.

In the first show the FUTURISTS held in London, in the same way, from their jumble of real and half-real objects, a perfectly intelligible head or part of a figure would stick up suddenly. And this head or part of a figure, where isolated and making a picture by itself, you noticed was extremely conventional. It discredited the more abstract stuff around it, for those not capable of discriminating where abstractions are concerned.

VII

In addition to these three principal tendencies, there are several individuals and newer groups who are quite distinctive. Picabia, in France, reducing things to empty but very clean and precise mathematical blocks, coldly and wittily tinted like a milliner's shop-front, stands apart from the rest.

This reducing of things to bare and arid, not grandiose, but rather small and efficient, blocks of matter is on a par with a tendency in the work of several excellent painters in England, following the general Continental movement. Only in their case it is sculpturesque groups of lay figures, rather than more supple and chic mannequins. The Human Figure is, in the first place, exclusively chosen for treatment. Secondly, this is reduced to a series of matches, four for the legs and arms, one thick one for the trunk, and a pair of grappling irons added for the hands. Six or seven of these figures are then rhythmically built up into a centralized, easily organized, human pattern. However abstracted by dividing up into a mosaic, this bare and heroic statement is the starting point. The grandiose and sentimental traditionalism inculcated at the Slade School is largely responsible for this variety.

Less interesting than either Picabia or the English tendency I have described, is the Orphiste movement. Delaunay is the most conspicuous Orphiste. Matisse-like colour, rather symbolist forms, all on a large scale, make up these paintings.

These reviews of other and similar movements to the Vorticist movement appear disparaging. But in the first place this inspection was

undertaken, as I made clear at the start, to show the ways in which we
DIFFER, and the tendencies we would CORRECT, and not as an appreciation
of the other various groups, which would be quite another matter.
They are definitely a criticism, then, and not an appraisement.

In the several details suggested above in the course of these notes,
Vorticism is opposed to the various groups of continental painting. I
will recapitulate these points, and amplify them. In so doing I can best
tabulate and explain the aims of Vorticism today.

A

1 The Cubist, especially Picasso, founds his invention on the posed
model, or the posed Nature-Morte, using these models almost to the
extent of the Impressionist.

This practice Vorticism repudiates as an absurdity and sign of
relaxed initiative.

2 HOWEVER MUSICAL OR VEGETARIAN A MAN MAY BE, HIS LIFE IS NOT
SPENT EXCLUSIVELY AMONGST APPLES AND MANDOLINES. Therefore there
is something to be explained when he foregathers, in his paintings,
exclusively with these two objects.

3 We pretend that the explanation of this curious phenomenon is
merely the system of still-life painting that prevailed amongst the
imitators of nature of the last century, and that was re-adopted by
Picasso in violent reaction against his El Greco Athletes, aesthetic
Mumpers, and Maeterlinck-like Poor-Folk.

4 We assert that the extreme languor, sentimentalism and lack of
vitality in Picasso's early stylistic work was a WEAKNESS, as definite a
one as consumption or anaemia, and that therefore his reaction, and the
character of this reaction, should be discounted as a healthy influence in
modern painting, which it is not.

5 We further assert that the whole of the art based, from this angle, on
Picasso's unique personality is suspect.

6 The placid empty planes of Picasso's later 'natures-mortes' the bric-
à-brac of bits of wall-paper, pieces of cloth, etc., tastefully arranged,
wonderfully tastefully arranged, is a dead and unfruitful tendency.

7 These *tours-de-force* of taste, and DEAD ARRANGEMENTS BY THE
TASTEFUL HAND WITHOUT, not instinctive organizations by the living

C

will within, are too inactive and uninventive for our northern climates, and the same objections can be made to them as to Matisse DECORATION.

8 The most abject, anaemic, and amateurish manifestation of this Matisse 'decorativeness', or Picasso deadness and bland arrangement, could no doubt be found (if that were necessary or served any useful purpose) in Mr Fry's curtain and pincushion factory in Fitzroy Square.

9 The whole of the modern movement, then, is, we maintain, under a cloud.

10 That cloud is the exquisite and accomplished, but discouraged, sentimental and inactive, personality of Picasso.

11 We must disinculpate ourselves of Picasso at once

B

1 We applaud the vivacity and high-spirits of the Italian Futurists.

2 They have a merit similar to Strauss's Waltzes, or Rag-Time; the best modern Popular Art, that is.

3 Sometimes they sink below the Blue Danube, and My Home in Dixie. Sometimes (notably in Balla's paintings) they get into a higher line of invention, say that of Daumier.

4 The chief criticism that can be made as regards them is that that can be levelled at Kandinsky: that they are too much theorists and propagandists; and that to the great plastic qualities that the best Cubist pictures possess they never attain.

5 Their teaching, which should be quite useful for the public, they allow also to be a tyrant to themselves.

6 They are too mechanically reactive and impressionistic, and just as they do not master and keep in their places their ideas, so they do not sufficiently dominate the contents of their pictures.

7 Futurism is too much the art of Prisoners.

8 Prison-art has often been very good, but the art of the Free Man is better.

9 The Present DOES influence the finest artist: there is no OUGHT about it, except for the bad artists, who should justify their existence by obedience.

10 Futurism and identification with the crowd, is a huge hypocrisy.

11 The Futurist is a hypocrite, who takes himself in first: and this is very bad for his otherwise excellent health.

12 To produce the best pictures or books that can be made, a man requires all the peace and continuity of work that can be obtained in this troubled world, and nothing short of this will serve. So he cannot at the same time be a big game hunter, a social light or political agitator. Byron owed three-fourths of his success to his life and personality. But life and personality fade out of work like fugitive colours in painting.

13 The effervescent, Active-Man of the Futurist imagination would never be a first-rate artist.

14 Also, the lyrical shouts about the God-Automobile, etc., are a wrong tack, surely. THE AUTOMOBILE WOULD SMILE IF IT COULD. Such savage worship is on a par with Voodooism and Gauguin-Romance.

15 But there is no reason why an artist should not be active as an artist: every reason, rather, why he should.

16 Our point is that he CANNOT have to the full the excellent and efficient qualities we admire in the man of action unless he eschews action and sticks hard to thought.

17 The Futurist propaganda, in its pedantry, would tend to destroy initiative and development.

18 The leisure of an ancient Prince, the practical dignity required by an aristocratic function; a Guardsman stamping before he salutes his officer, the grace and strength of animals, are all things very seldom experienced today, but that it might be desirable to revive.

19 Should we not revive them at once?

20 In any case, 'the Monico' of Severini, night-clubs, automobiles, etc., are for the rich. May not the Rich gradually become less savage, even in England, and may not amplitude, 'Kultur', and ceremony be their lot and ambition tomorrow? Perhaps it would be well to make clear to them that the only condition of their remaining rich will be if they make this effort.

21 A democratic state of mind is cowardice or muddle-headedness. This is not to say that in certain periods, 'the people' are not far preferable, individually, to their masters.

22 The People are in the same position as the Automobile. They would smile sometimes, if they could!

23 But they cannot.

24 We go on calling them God.

C

1 In dealing with Kandinsky's doctrine, and tabulating differences, you come to the most important feature of this new synthesis I propose.

2 I indicated in my notes some pages back the nature of my objection to the particular theoretic abstraction of Kandinsky.

3 In what is one painting representative and another non-representative?

4 If a man is not representing people is he not representing clouds? If he is not representing clouds, is he not representing masses of bottles? If he is not representing masses of bottles is he not representing houses and masonry? Or is he not representing in his most seemingly abstract paintings, mixtures of these, or of something else? Always REPRESENTING, at all events.

5 Now, if he is representing masses of bottles in one 'abstract' picture, and masonry in another, the masses-of-bottles picture would, by ordinary human standards, be less interesting or important than the picture made up of masonry, because houses are more interesting, or rather dignified, things, for most folk, than bottles.

6 But, from the plastic and not-human point of view this deciding factor as to interest would not hold.

7 And it is no doubt wholesome, so long as the 'too great humanity' of humanity lasts, for critics to insist on this detached, not-human factor, and judge works of art according to it.

8 But this again is a human and reactive reason, and for an artist who has passed the test of seriousness in weeding sentiment out of his work, and has left it hard, clean and plastic, this consideration, proper, perhaps, to the critic, need be no part of his programme.

9 For the integrity of this movement, it is necessary to face all the objections of those who would hustle us off the severe platform where we have taken our stand.

10 But we must not provide reasonings for the compromisers and exploiters that any serious movement produces. On this dangerous ground we cannot be too precise.

11 Before proceeding, I would consider one point especially.

12 Kandinsky, docile to the intuitive fluctuations of his soul, and anxious to render his hand and mind elastic and receptive, follows this unreal entity into its cloud-world, out of the material and solid universe.

13 He allows the Bach-like will that resides in each good artist to be made war on by the slovenly and wandering spirit.

14 He allows the rigid chambers of his Brain to become a mystic house haunted by an automatic and puerile Spook, that leaves a delicate trail like a snail.

15 It is just as useless to employ this sort of Dead, as it is to have too many dealings with the Illustrious Professional Dead, known as Old Masters.

16 The Blavatskyish soul is another Spook which needs laying, if it gets a vogue, just as Michelangelo does. (Michelangelo is probably the worst spook in Europe, and haunts English art without respite.)

17 I return to the question of representation.

18 If it is impossible, then, to avoid representation in one form or another:

19 If, as objects, the objects in your most abstract picture always have their twins in the material world: they are always either a mass of bottles, clouds, or the square shapes of some masonry, for instance:

20 Is it, under these circumstances, a fault or a weakness if your shapes and objects correspond with a poetry or a sentiment, that in itself is not plastic, but sentimental?

21 I would draw your attention to two things in this connection.

22 Picasso, in his L'Homme à la clarinette (1912)—there are more striking examples, but I have not the titles—is giving you the portrait of a man.

23 But the character of the forms (that is the now famous Cubist formula) is that of masonry; plastically, to all intents and purposes this is a house: the colour, as well, helping to this effect.

24 The supple, soft and vital elements, which distinguish animals and men, and which in the essential rendering of a man or an animal would have to be fully given, if not insisted on, are here transformed into the stolid masonry of a common building.

25 The whole Cubist formula, in fact, in its pure state, is a plastic formula for stone or for brick-built houses.

26 It may be objected that all the grandest and most majestic art in the world, however (Egyptian, Central African, American) has rather divested man of his vital plastic qualities and changed him into a more durable, imposing and in every way harder machine; and that is true.

27 This dehumanizing has corresponded happily with the unhuman character, the plastic, architectural quality, of art itself.

28 A rigidity and simplification to a more tense and angular entity (as in the case of Mantegna) has not prejudiced their high place, or the admiration due to, several great artists.

29 It is natural for us to represent a man as we would wish him to be; artists have always represented men as more beautiful, more symmetrically muscular, with more commanding countenances than they usually, in nature, possess.

30 And in our time it is natural that an artist should wish to endow his 'bonhomme' when he makes one in the grip of an heroic emotion, with something of the fatality, grandeur and efficiency of a machine.

31 When you watch an electric crane, swinging up with extraordinary grace and ease a huge weight, your instinct to admire this power is, subconsciously, a selfish one. It is a pity that there are not men so strong that they can lift a house up, and fling it across a river.

32 In any heroic, that is, energetic representations of men today, this reflection of the immense power of machines will be reflected.

33 But, in the first place, Picasso's structures are not ENERGETIC ones, in the sense that they are very static dwelling houses. A machine is in a greater or less degree, a living thing. Its lines and masses imply force and action, whereas those of a dwelling do not.

34 This deadness in Picasso, is partly due to the naturalistic method, of 'cubing' on a posed model, which I have referred to before, instead of taking the life of the man or animal inside your work, and building with this life fluid, as it were.

35 We may say, this being so, that in Picasso's portrait the forms are those of masonry, and, properly, should only be used for such. They are inappropriate in the construction of a man, where, however rigid the form may be, there should be at least the suggestions of life and displacement that you get in a machine. If the method of work or temperament of the artist went towards vitality rather than a calculated deadness, this would not be the case.

36 A second point to underline is the disparity between the spectator's and the artist's capacity for impersonal vision, which must play a part in these considerations.

37 A Vorticist, lately, painted a picture in which a crowd of squarish shapes, at once suggesting windows, occurred. A sympathizer with the movement asked him, horror-struck, 'are not those windows?' 'Why not?' the Vorticist replied. 'A window is for you actually A WINDOW: for me it is a space, bounded by a square or oblong frame, by four bands or four lines, merely.'

38 The artist, in certain cases, is less scandalized at the comprehensible than is the Public.

39 And the fine artist could 'represent' where the bad artist should be forced to 'abstract'.

40 I am not quite sure, sometimes, whether it should not be the Royal Academy where the severity of the abstract reigns, and whether we should not be conspicuous for our 'Life' and 'Poetry'—always within the limits of plastic propriety. Life should be the prerogative of the alive.

41 To paint a recognizable human being should be the rarest privilege, bestowed as a sort of 'Freedom of Art'.

D

1 The human and sentimental side of things, then, is so important that it is only a question of how much, if at all, this cripples or perverts the inhuman plastic nature of painting. If this could be decided we should know where we were. For my part I would put the maximum amount of poetry into painting that the plastic vessel would stand without softening and deteriorating: the poetry, that is to say, that is inherent in matter.

2 There is an immense amount of poetry, and also of plastic qualities as fine as Rembrandt's, in Vincent Van Gogh. But they remain side by side, and are not assimilated perfectly to each other.

3 On the other hand, Kandinsky's spiritual values and musical analogies seem to be undesirable, even if feasible: just as, although believing in the existence of the supernatural, you may regard it as redundant and nothing to do with life. The art of painting, further, is for a living man, and the art most attached to life.

4 My soul has gone to live in my eyes, and like a bold young lady it lolls in those sunny windows. Colours and forms can therefore have no DIRECT effect on it. That, I consider, is why I am a painter, and not any-thing else so much as that.

5 The eyes are animals, and bask in an absurd contentment everywhere.

6 They will never forget that red is the colour of blood, though it may besides that have a special property of exasperation.

7 They have a great deal of the coldness of the cat, its supposed falsity and certain passion.

8 But they like heat and the colour yellow, because it warms them: the chemicals in the atmosphere that are good for the gloss of their fur move them deeply; and the 'soul' sentimentalizes them just so much as it may without causing their hair to drop out.

9 This being so, the moonlight and moon-rack of ultra-pure art or anything else too pure *se serait trompé de guichet* if it sought to move me.

10 But I have no reason to believe that any attempt of this sort has been made.

11 So much for my confession. I do not believe that this is only a matter of temperament. I consider that I have been describing the painter's temperament.

12 When I say poetry, too, I mean the warm and steaming poetry of the earth, of Van Gogh's rich and hypnotic sunsets, Rembrandt's specialized and golden crowds, or Balzac's brutal imagination. The painter's especial gift is a much more exquisite, and aristocratic affair than this female bed of raw emotionality. The two together, if they can only be reconciled, produce the best genius.

E

1 Having gone over these points, it will be easier to see what our position is towards this question of representation and non-representation.

2 If everything is representation, in one sense, even in the most 'abstract' paintings, the representation of a Vorticist and of an Impressionist are in different planets.

3 What I mean, first of all, by this unavoidable representative element, is not that any possible natural scene or person is definitely co-ordinated, but that the content, in detail, must be that of the material universe: that close swarming forms approach pebbles, or corn or leaves or the objects in some shop window somewhere in the world: that ample, bland forms are intrinsically either those of clouds, or spaces of masonry, or of sand deserts.

4 Secondly, the general character of the organizing lines and masses of the picture inevitably betray it into some category or other of an organized terrestrial scene or human grouping: especially as the logic and mathematics at the bottom of both are the same.

5 If you are enthusiastically for 'pure form' and Kandinsky you will resist this line of reasoning; if for the Goupil Salon or the Chenil Art Gallery you will assent with a smile of indecent triumph, soon to be chastened. We will assume consent, however, to the last line of argument.

6 In that case, why not approximate your work entirely to the appearance of surrounding Nature; landscape, houses and men?

7 Should you have a marked fundamental attachment to the shapes of bottles, and live in a land where there are only gourds (I live in a land where there are only 'gourds', in the slang sense) then realism is unnatural—if you are quite sure your love of bottles is not a romantic exoticism, but inborn and cold conceit. But these aberrations are infrequent.

8 The first reason for not imitating Nature is that you cannot convey the emotion you receive at the contact of Nature by imitating her, but only by becoming her. To sit down and copy a person or a scene with scientific exactitude is an absurd and gloomy waste of time. It would imply the most abject depths of intellectual vacuity were it not for the fact that certain compensations of professional amusement and little questions of workmanship make it into a monotonous and soothing game.

C 2

9 The essence of an object is beyond and often in contradiction to, its simple truth: and literal rendering in the fundamental matter of arrangement and logic will never hit the emotion intended by unintelligent imitation.

10 Not once in ten thousand times will it correspond.

11 It is always the POSSIBILITIES in the object, the IMAGINATION, as we say, in the spectator, that matters. Nature itself is of no importance.

12 The sense of objects, even, is a sense of the SIGNIFICANCE of the object, and not its avoirdupois and scientifically ascertainable shapes and perspectives.

13 If the material world were not empirical and matter simply for science, but were organized as in the imagination, we should live as though we were dreaming. Art's business is to show how, then, life would be: but not as Flaubert, for instance, writes, to be a repose and 'd'agir à la façon de la Nature', in giving sleep as well as dream.

15 The Imagination, not to be a ghost, but to have the vividness and warmth of life, and the atmosphere of a dream, uses, where best inspired, the pigment and material of nature.

16 For instance, because you live amongst houses, a 'town-dweller', that is no reason why you should not specialize in soft forms, reminiscent of the lines of hills and trees, except that familiarity with objects gives you a psychological mastery akin to the practised mastery of the workman's hand.

17 But there is, on the other hand, no reason why you should not use this neighbouring material, that of endless masonry and mechanical shapes, if you enjoy it: and, as a practical reason, most of the best artists have exploited the plastic suggestions found in life around them.

18 If you do not use shapes and colours characteristic of your environment, you will only use some others characteristic more or less of somebody else's environment, and certainly no better. And if you wish to escape from this, or from any environment at all, you soar into the clouds, merely. That will only, in its turn, result in your painting what the dicky-birds would if they painted. Perhaps airmen might even conceivably share this tendency with the lark.

19 Imitation, and inherently unselective registering of impressions, is an absurdity. It will never give you even the feeling of the weight of

the object, and certainly not the meaning of the object or scene, which is its spiritual weight.

20 But, to put against this, attempt to avoid all representative element is an equal absurdity. As much of the material poetry of Nature as the plastic vessel will stand should be included. But nowadays, when Nature finds itself expressed so universally in specialized mechanical counter-parts, and cities have modified our emotions, the plastic vessel, para-doxically, is more fragile. The less human it becomes, the more delicate, from this point of view.

21 There is no necessity to make a sycophantish hullabulloo about this state of affairs, or burn candles in front of your telephone apparatus or motor car. It is even preferable to have the greatest contempt for these useful contrivances, which are no better and no worse than men.

22 Da Vinci recommends you to watch and be observant of the grains and markings of wood, the patterns found in Nature everywhere.

23 The patterned grains of stones, marble, etc., the fibres of wood, have a rightness and inevitability that is similar to the rightness with which objects arrange themselves in life.

24 Have your breakfast in the ordinary way, and, as the result of your hunger and unconsciousness, on getting up you will find an air of inevitability about the way the various objects, plates, coffee-pot, etc., lie upon the table, that it would be very difficult to get consciously. It would be still more difficult to convince yourself that the deliberate arrangement was natural.

25 IN THE SAME WAY THAT SAVAGES, ANIMALS AND CHILDREN HAVE A 'RIGHTNESS', SO HAVE OBJECTS CO-ORDINATED BY UNCONSCIOUS LIFE AND USEFUL ACTIONS.

26 Use is always primitive.

27 This quality of ACCIDENTAL RIGHTNESS, is one of the principal elements in a good picture.

28 The finest artists—and this is what Art means—are those men who are so trained and sensitized that they have a perpetually renewed power of DOING WHAT NATURE DOES, only doing it with all the beauty of accident, without the certain futility that accident implies.

29 Beauty of workmanship in painting and sculpture is the appearance of Accident, in the sense of Nature's work, or rather of Growth, the best paintings being in the same category as flowers, insects and animals. And as Nature, with its glosses, tinting and logical structures, is as efficient as any machine and more wonderful; hand-made, as recommendation, means done by Nature.

30 Imperfect hands (most artists') produce what might be termed machine-made; as men were the first machines, just as insects were the first artists.

31 The best creation, further, is only the most highly developed selection and criticism.

32 It is well to study the patterns on a surface of marble. But the important thing is to be able to make patterns like them without the necessity of direct mechanical stimulus.

33 You must be able to organize the cups, saucers and people, or their abstract plastic equivalent, as naturally as Nature, only with the added personal logic of Art, that gives the grouping significance.

34 What is known as 'Decorative Art' is rightly despised by both the laborious and unenterprising imitators of Nature on the one hand, and the brilliant inventors and equals of Nature on the other.

35 The 'Decorative' artist (as examples, the sort of spirit that animates the Jugend, Rhythm, Mr Roger Fry's little belated Morris movement) is he who substitutes a banal and obvious human logic for the co-ordination and architectures that the infinite forces of Nature bring about.

36 These exterior 'arrangers', not living their work, have not even the reflected life that the photographer can claim.

37 The only people who have nothing to do with Nature and who as artists are most definitely inept and in the same box as the Romantic—who is half-way between the Vegetable and the God—are these between-men, with that most odious product of man, modern DECORATION.

F

1 To conclude: The Whole of art today can undoubtedly be modified in the direction of a greater imaginative freedom of work, and with renewed conception of aesthetics in sympathy with our time.

2 But I think a great deal of effort will automatically flow back into more natural forms from the barriers of the Abstract.

3 There have been so far in European painting Portrait, Landscape, Genre, Still-life.

4 Whatever happens, there is a new section that has already justified its existence, which is bound to influence, and mingle with the others, as they do with each other; that is, for want of a better word, the Abstract.

5 This extremely moderate claim and view of our endeavour does not however, suggest that it would be 'equally good' to paint Brangwyns, Nicholsons or Poynters.

6 The least and most vulgar Japanese print or Island-carving is a masterpiece compared to a Brangwyn, a Nicholson, or a Poynter.

7 The whole standard of art in our commercial, cheap, musical-comedy civilization is of the basest and most vitiated kind.

8 Practically nothing can be done, no Public formed, until these false and filthy standards are destroyed, and the place sanified.

9 The methods of Science, prevalent all through life, will gradually accomplish this. We, however, would hasten it.

10 What I said about only THE GOOD ARTISTS being allowed to 'represent', or do recognizable things, was not a jibe.

11 Actually, if Tube Posters, Magazine Covers, Advertisement and Commercial Art generally, were ABSTRACT, in the sense that our paintings at present are, they would be far less harmful to the EYE, and thence to the minds, of the Public.

12 There should be a Bill passed in Parliament at once FORBIDDING ANY IMAGE OR RECOGNIZABLE SHAPE TO BE STUCK UP IN ANY PUBLIC PLACE; or as advertisement of what-not, to be used in any way publicly.

13 Only after passing a most severe and esoteric Board and getting a CERTIFICATE, should a man be allowed to represent in his work Human Beings, Animals, or Trees.

14 Mr Brangwyn, Mr Nicholson and Sir Edward Poynter would not pass this Board: driven into the Vortex, there would be nothing left of them but a few Brangwynesque bubbles on the surface of the Abstract.

THE ART OF THE GREAT RACE

This essay was reprinted in Wyndham Lewis the Artist, *with the following comment:*

'The Art of the Great Race' contains some of the most characteristic vorticist doctrine. The vorticists are described as 'Primitives of a future equilibrium'. And you have a few lines farther on a forecast of the political revolutions that have swept the world since that time. Thus 'The only person who objects to uniformity and order (*One art—One Life*) is the man who knows that under those conditions his "individuality" would not survive. Every real individuality and excellence would welcome conditions where there would be hierarchy of power and vitality. The Best would then be Free. Under no other conditions is any true freedom at all possible.'

All times equally have witnessed what appeared to be a certain snobbish energy of Nature. Like a suburban Matron, men think they catch her plagiarizing their fashionable selves. They laugh faintly with a distracted vagueness, or they tug at their moustaches, and slowly shake their bottoms and trail their feet, according to the period. But Oscar Wilde publicly denounced her. In following the social syntheses masters of fiction throw up in their works, flesh and blood appears to have transformed itself, and become a tributary, blood-relation, and even twin of the shadow.

So Wilde eventually accused Nature point blank of plagiarism. 'Nature imitates Art, not Art Nature.' Let us take up this old aesthetic quip, and set ourselves the light holiday task of blasting it indolently away.

First, however, it is advisable to become fixed on one point. Artists do not, *en tant qu'artistes*, influence breathing humanity plastically. Bach moulded the respirations of his art and modified its organs; but the behaviour or appearance of the young Viennese was moulded by other and less precise hands. It is the human and literary side of plastic genius that affects contemporaries in this palpable way. In ideas, it is the reform element, and not the deep element (that is monotonous) which all of a sudden flings up a host of new characters. Goethe, with a book, set free the welt-schmerzen of the Suicidal Teuton. The razors flashed all over the Teuton world. The pistol-smoke went up from every village. He had pressed a nerve of a definite type of Teutonic man, and made a small desperate race suddenly active.

Bach stepped with the blank anonymity of Destiny. He squabbled with Monsieur un tel, got a job with some acumen in spite of somebody's efforts. But he did not turn Humanity into any new and equally futile way. No grocer talked more or less of his soul, or of his German soul, because of this master.

Painting, with its persistently representative element, has always had in the modern world more ethical effect. The artist has the same moral influence as the dressmaker. A bird-like hat in process of time produces a bird. Painting today, in renouncing more and more the picturesque and representative element, escapes also the embarrassments of its former influence, and the dangers of more and more plastic compromise.

To begin with, then, a Fabian young man, a John young lady (a painting young lady or a patronizing young lady), Oscar Wilde's now degenerate leavings, are not things that originally came from a pure fount of art.

What shall we say comes from a pure fount of art? Nothing, according to our notion, for the purest art is not tyrannic but is continuous, and Tourgenief's 'Six Unknown' always existed and always will exist.

Tourgenief, when asked whom he wrote for, said 'for the Six Unknown'. Tourgenief himself was merely one of them. He wore more lightly than any of his countrymen the overpowering psychic accoutrements that are the Russian spirited National Costume. He was an independent and permanent being.

Shakespeare, again, was a mighty mirror, and his contemporaries mirrors. His figures accumulated by a natural process, and for no reason. They dragged all sorts of burdens of power with them. They were immense outcasts, silhouetted at last in the sunshine of his plays. He whistled Music Hall airs as he worked. Shakespeare was one of the Six Unknown, though well enough known to the world. He was one of the easily numbered race who were the first and only certainly future men, who are unknown to each other. His effect on morals and appearances was as non-existent as Bach's.

Montaigne, Shakespeare's master, gives, in his books, a useless melancholy. Art is not active; it cuts away and isolates. It takes men as it finds them, a particular material, and works at it. It gets the best out of it, and it is the best that it isolates. The worst is still there too, to keep the man in touch with the World, and freer because of the separation. Perfect art insists on this duality, and develops it. It is for this reason and in this way, that the best art is always the nearest to its time, as

surely as it is the most independent of it. It does not condescend to lead. But often, an artist, simply because he takes hold of his time impassively, impartially, without fuss, appears to be a confirmed protester; since that actuality seems eccentric to those who wander and halt.

Another question, transpiring naturally from this first one, is whether the possession of this immediate popular influence is as surely the sign of the inferior artist as an eminence and unchallengeable power like Shakespeare's, combined with that large uncanny effacement, is the mark of the finest artist? That question can be best answered at the end of this essay.

Before the Aesthetic blarney with Nature, lending itself to mock diagnosis, could be used, it was necessary to establish the value of this influence to which Wilde referred.

As to Nature's unoriginality then, how long would it take Nature, in the form of her human children, to make a replica in flesh of the artist's work. She would have to begin imposing her will on the subject chosen very young. But in the case of the alleged imitation of Rossetti's type of woman by Nature, Rossetti in his young days was not known to Nature at large. It is at the moment of the artist's fame that these imitations suddenly appear. They appear at once on all hands like mushrooms. And if a painter of this human and political description be unknown one day and celebrated the next, these simulacra in flesh of his painted figures will appear as though by magic.

All goes to prove the pre-existence of these types and that the artist only calls together and congregates from the abysses of common life, a hitherto scattered race, in exalting one of its most characteristic types into a literary or artistic canon, and giving it the authority of his special genius. Miss Siddall languished behind the counter in the Haberdasher's in Leicester Square long before the young Italian could have influenced her, or Nature have got to work on her with plagiaristic ardour. The 'long necks' that Oscar Wilde speaks of, witnessed to the ideal tendency of their owners' minds centuries before Rossetti repeated them in his pictures.

I see every day in a certain A.B.C. Shop at least three girls who belong to a new and unknown race. They would furnish an artist looking for an origin with the model of a new mankind. And it would be as individual and apparently strange as that genre of Englishwoman that attracted Rossetti.

The John type of woman, our honoured and fair contemporary, more

or less, poured burning oil on the heads of plumed assailants from the brand-new walls of fourteenth-century castles. She was a wild camp follower in the rear of Pictish armies. And the Beardsley woman was a cause of scandal to our remotest forefathers. These genres have always existed. On the promotion of their type to a position of certain consideration in art circles, and gradually in wider spheres of life itself, they all emerge from their holes, and walk proudly for a decade—or several, according to the vitality of their protector—in the public eye. We have still amongst us many survivals of a gentler fashion.

If you are not one of the Six, corresponding in the things here written about to the Six Hundred golden beings of the West which the Statue of Liberty sheds its rays on; if you are of an as yet uncharted race, you will some day perhaps have the opportunity of testing for yourself the validity of these assertions. Imagine yourself going out one morning, and by the hesitating yet flattering glances of your fellow citizens, and various other signs and portents, you gradually become aware that your day has come. Some artist, you at once see, perhaps with shrinking, is busily employed in making your type of beauty prevail. Or you believe yourself, with your *chapeau melon* and your large, but insignificant library, beyond the reach of the Creator. But the Wet Nurses of Dickens' time thought the same. The Suburbs never dreamt of being conscripted by any Gissings or Wellses that the old Earth could make. They are now most drab but famous armies. If numbers were the decisive factor, they would certainly rout any host brought against them, except those gathered by a Religion.

The race that some of these political aesthetic creators call into life, overruns a city or a continent, a veritable invasion come out of the ground; risen in our midst, with the ferocious aspect of the mailed and bedizened bodyguard of some barbaric conqueror. Others come to us beneath the aegis of some perfumed chief, with mincing steps and languid masterfulness. The former one may sometimes see refining itself amongst the gentle influences of the town, though preserving its barbarous costume and nomenclature; the latter learning a certain roughness from the manners of newer invaders. That debile and sinister race of diabolic dandies and erotically bloated diablesses and their attendant abortions, of Yellow Book fame, that tyrannized over the London mind for several years, has withdrawn from the capital, not to the delicate savagery from which it was supposed to come, but certainly to a savage clime. In Germany some years ago I observed in youthful state many

figures of the Beardsley stock, as vigorous and vampire-like as when the ink was still undried on Smithers' catalogues.

When a man portrays and gives powerful literary expression to a certain type in a nation and milieu, he attracts to him that element in the race that he symbolizes. These movements are occasionally accompanied with an enthusiasm that resembles a national awakening or revival—but in such instances, of a race within the Race. In the case of a great writer, when it is usually a moral type that is celebrated, the commotion is often considerable. But when it is the personal appearance that is in question, the peace may be definitely disturbed. Every nation is composed of several or many very distinct types or groups, and each needs expression just as each nation does.

Each of these psychic groups has, like the classes, a psychology.

They are independent of class, too. When those freemasonries are awoken, they exist without reference to their poet. Some creators, in fact, find themselves in the position of the Old Woman Who Lived in a Shoe. This progeny may turn out to be a race of cannibals and proceed to eat their poet.

There is in every nation an inherently exotic element. But this 'foreign' element is usually the most energetic part, and that side on which the race is destined to expand and renew itself. The English have never been so insular and 'English' as at the present moment. When a people first comes in touch with neighbouring races, its obstinate characteristics become momentarily more pronounced than ever. A man travelling abroad for the first time becomes conscious of his walk, his colour, his prejudices. These peculiarities under the stress of this consciousness become accentuated. So it is with a people. In an age of ripe culture the different elements or races in a people become harmonized. It is then that the universal artists peacefully flourish. The universal artist, in fact, is in the exactest sense national. He gathers into one all the types of humanity at large that each country contains. We cannot have a universal poet when we cannot have a national one.

At present, in our Press-poisoned Imperialistic masses of men, called nations, where all art and manners jostle hopelessly, with insane waste of vitality and health and ignoble impossibility of conviction, the types are more than ever sharply defined.

You see, in a person's flat, the taste of Paris during the First Empire, and in another person's flat next door, a scheme of decoration neo-Pharaohesque; across the street a dwelling is decorated on the lines of

an Elizabethan home. This is currently known as 'individualism'. Hardly anywhere is there a sign of an 'actual' and contemporary state of mind or consciousness. There is not even an elementary climate and temperamental rightness in current popular Art. All this is because the 'present' is not ripe. There are no 'Futurists' at all (only a few Milanese automobilists). But there are some Primitives of a Future equilibrium. And Primitives are usually the most interesting artists. It is for that reason that I have praised in this paper the vulgarity and confusion of our Time. When all these vast communities have disintegrated; when economic conditions have adjusted themselves, and standards based on the necessities of the genius of the soil and the scope of life, have been fixed, there will be a period of balance again. But when the balance comes, the conditions are too favourable. This Russian winter of inanity and indifference, produces a consciousness that evaporates in the Southern brilliance of good conditions. The only person who objects to uniformity and order—One art, One life—is the man who knows that under these conditions his 'individuality' would not survive. Every real individuality and excellence would welcome conditions where there would inevitably be a hierarchy of power and vitality. The Best would then be Free. Under no other conditions is any Freedom at all possible.

In this connection, it is curious to remember that Rossetti, the famous Chief that Oscar was thinking of in his paradox, was an Italian. This shows the disruption and unreality at the root of this consciousness more vividly than anything else. Rossetti, the foreigner, found in England that intensely English type of feminine beauty, the 'Rossetti woman', and painted her with all the passion of the exotic sense. Yet he was supposed to have invented her, and Nature to have begun turning such out by the thousand!

One man living in a cave alone can be a universal poet. In fact solitude is art's atmosphere, and its heaven is the Individual's. The abstract artist is the most individual, just as genius is only sanity. Only it is the Individual, and not our contemporary 'Individualist', whose individualism consists in saying Booh! when you say Bah! Everyone should be impelled to say Booh! only or Bah! only. And it would then depend only on the intensity of expression, the strength of his lungs, or the delicacy of his ear, that would enable one man's Booh! to be more compelling than another's (Competition is necessary for isolation).

The actual National Poet is a folk poet, and the politically souled

Artist found at the head of local revivals or awakenings is also a sort of Folk Poet. This is his intellectual secret.

Folk Art, along with Music Hall Songs, and authors of Pagliaccis, Viennese Waltzes, etc., is very seducing and certainly the next best thing to Bach. (The officially 'serious' artists of any time, who practise *le grand Art*, come well below *My Home in Dixie*.) Thus 'folk-artists' form the section of art that is attached to life, and are of the same order and importance as the decorations on vases or carpets, ornaments, and things of use. They are the ornament and current commentary of every day life, the dance of the Fiesta, the madrigal and war-song.

This is the only exactly and narrowly National Art. All Nationality is a congealing and conventionalizing, a necessary and delightful rest for the many. It is Home, definitely, with its compromises and domestic genii.

The Great National Poet, like Shakespeare, is not national at all. The Germans speak of 'our Shakespeare', and play him and understand him far better than we do. But Shakespeare is not more German than English. Supposing English people became more used to using their intelligence. and grew to care more for art, they would not possess Shakespeare any more for that. They would play him and read him as much as the Germans, and there would be a 'National Theatre'. But a truer name for this would be 'Universal Theatre'. Only in a universal theatre could Shakespeare be adequately staged. No country can be possessive about a man like that, although Will may have been a gentle Englishman.

THE LONDON GROUP

*A review of the second exhibition of the London Group, which was
held at the Goupil Gallery in March 1915.*

I will confine myself principally to a consideration of the pictures in the
Vorticist or Cubist section. The two principal sections of this group are
in many ways contradictory in aim. If you arrange to exhibit together,
you also tacitly agree not to insist on these contradictions, but only on
the points of agreement or on nothing at all.

Mr Wadsworth, Mr Roberts, Mr Nevinson, or Mr Adeney, are the
painters I can speak about directly, without any general qualifications.

Mr Edward Wadsworth's *Blackpool* appears to me one of the finest
paintings he has done. Its striped ascending blocks are the elements of
a seaside scene, condensed into the simplest form possible for the retain-
ing of its vivacity. Its theme is that of five variegated cliffs. The striped
awnings of Cafés and shops, the stripes of bathing tents, the stripes of
bathing-machines, of toy trumpets, of dresses, are marshalled into a
dense essence of the scene. The harsh jarring and sunny yellows,
yellow-greens and reds are especially well used, with the series of com-
mercial blues.

One quality this painting has which I will draw especial attention to.
Much more than any work exhibited in the last year or so by any English
painter of Cubist of Futurist tendencies it has the quality of LIFE: much
more indeed, than Mr Wadsworth's own picture next to it. In most of the
best and most contemporary work, even, in England, there is a great
deal of the deadness and heaviness of wooden or of stone objects, rather
than of flashing and eager flesh, or shining metal, and heavy traces
everywhere of the too-thorough grounding in 'Old Master' art, which
has characterized the last decade in this country. Several of the Italian
Futurists have this quality of LIFE eminently: though their merit, very
often, consists in this and nothing else. Hardly any of the Paris Cubists
have, although it is true they don't desire to have it. To synthesize this
quality of LIFE with the significance or spiritual weight that is the mark
of all the greatest art, should be, from one angle, the work of the
Vorticists.

My own paintings require no description; the note on Vorticism gives
their direction.

Mr William Roberts has a very brilliant drawing (done some time

ago, I think) called *Dancers*. Infinitely laboured, like a fifteenth-century engraving in appearance, worked out with astonishing dexterity and scholarship, it displays a power that only the few best people possess in any decade. Michelangelo is unfortunately the guest of honour at this Lord's Supper. But Buonarroti is my Bête-Noir.

Mr Roberts' painting *Boatmen* is very different from the drawing. It is a very powerful, definitely centralized structure, based on a simple human group. All the limbs and heads, as well, have become, however, a conglomeration of cold and vivid springs bent together into one organized bunch. The line of colour exploited is the cold, effective, between-colours of modern Advertising art. The beauty of many of the Tube-posters—at least when seen together, and when organized by a curious mind—is a late discovery. The wide scale of colour and certain juxtapositions, in *Boatmen*, however, suggests flowers, as well. It is the most successful painting Mr Roberts has so far produced, I think.

As to Mr Nevinson's work, an artist can only receive fair treatment at the hands of one completely in sympathy with him. So it would not be fair for me to take Mr Nevinson's paintings for criticism, side by side with Wadsworth's, for instance. Nevertheless, I can say that his *Marching Soldiers* have a hurried and harassed melancholy and chilliness that is well seen. Also at the Alpine Club, Mr Nevinson's *Searchlights*, the best picture there, is perhaps, too, the best he has painted.

Mr Jacob Kramer shows us a new planet risen on our horizon: (he inaptly calls it the Earth, which it is not). It is still rather molten, and all sorts of objects and schools are in its melting-pot. It has fine passages of colour, and many possibilities as a future luminary. Several yellows and reds alone, and some of its more homogenous inhabitants, would make a fine painting. I have seen another thing of his that confirms me in this belief.

Mr Adeney, in pallid and solidified landscapes, brings us back to the 'Fauves'. He is not very like a wild beast, however. His gentle logic plays round the heaviness of Cézanne like summer-lightning. These pale green meditations in form have great personal charm.

Mr Jacob Epstein's *Rock drill* is one of the best things he has done. The nerve-like figure perched on the machinery, with its straining to one purpose, is a vivid illustration of the greatest function of life. I feel the combination of the white figure and the rock-drill is rather unfortunate and ghost-like. But its lack of logic has an effectiveness of its own. I feel that a logical co-ordination was not intended. It should be taken

rather as a monumental, bustling, and very personal whim. Had Mr Epstein in his marble group, *Mother and Child*, not made a Eugène Carrière in stone of the Mother, but treated that head, too, with the plastic solidity of the baby's head, I should have considered it among his best things. As it is, 'for the Baby's sake', it is very fine.

Gaudier-Brzeska is not very well represented. He is busy elsewhere, and of the two statues here, one is two or three years old, I should think. As an archaism it has considerable beauty. The other little one in red stone has a great deal of the plastic character we associate with his work. It is admirably condensed, and heavily sinuous. There is a suave, thick, quite PERSONAL character about his best work. It is this, that makes his sculpture what we would principally turn to in England to show the new forces and future of this art. His beautiful drawing from the trenches of a bursting shell is not only a fine design, but a curiosity. It is surely a pretty satisfactory answer to those who would kill us with Prussian bullets: who say, in short, that Germany, in attacking Europe, has killed spiritually all the Cubists, Vorticists and Futurists in the world. Here is one, a great artist, who makes drawings of those shells as they come towards him, and which, thank God, have not killed him or changed him yet.

I have now run through all the people I can more or less unconditionally admire. Among the Camden Town Group, I admire many qualities in Mr Gilman's and Mr Ginner's paintings. I still hope to find myself on common ground with these two painters one of these days. Given the limitations of their system of work, as I consider it, they yet stand out so notably among their co-sectionists, that I am optimistic as to this virtue soon changing their kind too.

I have noticed that the art-critics praise rather indiscriminately among the Camden Town Artists. Sometimes Mr This and Miss That is picked out: sometimes Mr That and Miss the other. I don't think they are altogether to be blamed. It must be rather difficult for converted reporters, who enjoy a good dinner far more than a good picture, and whose only reason, indeed, for lingering among pictures at all is because of their subtle connection (when written about) with good dinners, to discriminate between one genre painter of a numerous school and another. That Vorticists and Cubists should, like Chinamen 'look all the same', is equally natural. So, curiously enough, the members of both sections of this group have a strange family resemblance, among co-sectionists, for the critic.

There seems to be a certain confusion in the minds of some of my
friends on the Camden side of London as to the meaning of REALIST.
They seem to read into REALIST the attributes of the word NATURALIST:
for on various occasions they have called themselves NEO-REALISTS. By
REALIST they evidently mean a man who scientifically registers the objects
met in his every day life. But NATURALIST is the word for this particular
gentleman. Reality is not the result of scientific registration, but rather
NATURE. Mr Wadsworth, in his painting of *Blackpool*, is purely 'realistic'.
That is the REALITY, the essential truth, of a noisy, garish seaside. A
painting of Blackpool by a Camden Town Artist would be a corner of
the beach much as seen by the Camera. This would be only a symbol or
trophy of the scene, with the crudity of Time added to the spatial poor-
ness of the Camera.

An early Futurist painting (the developed-Impressionism of the
Sackville Galleries, that is) would get nearer to REALITY insomuch as
imitation is rejected by them, and they rebel against the static 'Moment
of Time', and launch into what they term simultaneous vision. But the
natural culmination of 'simultaneity' is the reformed and imaginatively
co-ordinated impression that is seen in a Vorticist picture. In Vorticism
the direct and hot impressions of life are mated with Abstraction, or the
combinations of the Will.

The critiques in the daily Press of this particular Exhibition have
been much the same as usual. Two of them, however, may be answered.
One of these, Mr Nevinson deals with elsewhere in this paper, in an
open letter. There remains the *Times* notice on 'Junkerism in Art'.

Many people tell me that to call you a 'Prussian' at the present junc-
ture is done with intent to harm, to cast a cloud over the movement, if
possible, and moreover that it is actionable. But I do not mind being
called a Prussian in the least. I am glad I am not one, however, and it
may be worth while to show how, aesthetically, I am not one either.
This critic relates the paintings by Mr Wadsworth, Mr Roberts and
myself to Prussian Junkerism: he also says, 'Should the Junker happily
take to painting, instead of disturbing the peace of Europe, he would
paint pictures very similar to those of Mr Wadsworth, Mr Roberts, and
Mr Wyndham Lewis.'

This last statement is a careless one: for the Junker, obviously, if he
painted, would do florid and disreputable canvasses of nymphs and
dryads, or very sentimental 'portraits of the Junker's mother'. But as to
the more general statement, it crystallizes, topically, a usual error as to

our aims. Because these paintings are rather strange at first sight, they are regarded as ferocious and unfriendly. They are neither, although they have no pretence to an excessive gentleness or especial love for the general public. We are not cannibals. Our rigid head-dresses and disciplined movements, which cause misgivings in the unobservant as to our intentions, are aesthetic phenomena: our goddess is Beauty, like any Royal Academician's though we have different ideas as to how she should be depicted or carved: and we eat beefsteaks, or what we can get (except human beings) like most people—As to goose-steps, (the critic compares 'rigidity' to 'goose-step') as an antidote to the slop of Cambridge Post Aestheticism (Post-Impressionism is an insult to Manet and Cézanne) or the Gypsy Botticellis of Mill Street, may not such 'rigidity' be welcomed? This rigidity, in the normal process of Nature, will flower like other things. THIS simple and massive trunk or stem may be watched. But we are not Hindu magicians to make our Mango tree grow in half an hour. It is too commonly suggested that rigidity cannot flower without 'renouncing' itself or may not in itself be beautiful. At the worst all the finest beauty is dependent on it for life.

HISTORY OF THE LARGEST
INDEPENDENT SOCIETY IN ENGLAND

The title refers to the Allied Artists' Association, which held annual non-jury shows between 1908 and 1919. The AAA was founded by the art critic Frank Rutter, in conjunction with some of the artists who later formed the Camden Town Group. Membership was open to anyone, and the exhibitions, held at the Albert Hall, were very large.

Most of us are agreed to see that the Allied Artists after the war proceed as usual. As an alternative promiscuous exhibition, and one especially where very large canvasses can legitimately be sent, it is of great use to many painters. At each exhibition fresh contingents of more or less lively young gentlemen and ladies come into it. Mr Frank Rutter's admirable initiative in starting it several years ago should be carried on and maintained by the now formidable society that has grown out of it.

But, in the nature of things, as the society has grown and so many new and very divergent elements are at present included in it, the machinery for organizing its exhibitions of 2 or 3 years is rather out of date, and does not answer to the new and considerable interests involved.

When the Society was founded, painting in this country was at a very different point of development to what it is today. The centres of energy have shifted. This will be easily seen, and incidentally another purpose served by a brief review of the successive rejuvenations of painting in England. Fifteen or sixteen years ago THE revolutionary society, the scandal of the day, was the New English Art Club. It was the home of a rather prettified and anglicized Impressionism. Mr Wilson Steer appeared an outrageous fellow to the critic of the day, in his Prussian-blue pastiches of John Constable. Mr Walter Sickert was a horrifying personage in illustrations of 'low life', with its cheap washing-stands and immodest artist's models squatting blankly and listlessly on beds.

It is difficult to understand, at this distance, the offence that these admirable gentlemen (and often quite good painters) could have caused. But then Whistler's very grave, beautiful and decorous painting of the Thames at night aroused fury when it was painted.

However, the earlier New English was about to receive a blow, in the shape of an eruption of new life. The day of that decade was done. A peculiar enthusiastic and school-boy like individual of the name of

Tonks told his students at the Slade School to go to the British Museum and copy Michelangelo and Andrea. They all did. In their youthful conclaves they all became figures of the Renaissance: they read Vasari; they used immense quantities of red Italian chalk in pastiching the Italian masters of the cinquecento.

One of them performed scholastic prodigies. This was Augustus John. He carried academic drawing farther than it had ever been carried in England, not excepting Alfred Stevens. But he did not, like Stevens, confine his attentions to the Sistine. He tried his hand at the whole of European art, from Giotto to Watteau and Constantin Guys. Rodin and Degas marked the limit of his scholastic appetite, I think.

I consider John, in the matter of his good gifts, and much of his accomplishment, a great artist. He is one of the most imaginative men I have met, and the one who suggested the greatest personal horizons.

But despite his incomparable power, he had not very great control of his moyens, and his genius seemed to prematurely exhaust him. He was aesthetically over-indulgent in his fury of scholastic precocity, and his Will was never equal to its mate. (There is no reference to Mr Rothenstein here.) At present he is sometimes strangely indistinguishable from Mr Nicholson, or an artist called, I think, Pride.

However it was John who inaugurated an era of imaginative art in England, and buried the mock naturalists and pseudo-impressionists of the New English Art Club under the ocean of genial eclecticism he bi-yearly belched forth. It was his Rembrandtesque drawings of stumpy brown people, followed by his tribes after tribes of archaic and romantic Gitanos and Gitanas that made him the legitimate successor to Beardsley and Wilde, and, in exploiting the inveterate exoticism of the educated Englishman and Englishwoman, stamped himself, barbaric chevelure and all, on what might be termed the Augustan decade. Oscar Wilde, even, had prepared the ground for him; the same charming and aesthetic stock that the Irish dilettante attracted were at hand for the reaction, and like all delicate and charming gentlemen and ladies, they were thrilled to the bone with the doctrine of 'wild life' and 'savage nature'.

About this time, just after John's first great success, Walter Sickert founded his Saturday afternoon gatherings in Fitzroy Street, which eventually led to the Camden Town Group.

Now new forces were stirring in Paris, which site Mr Sickert had vacated, and his idea no doubt was to retreat fighting to England, and gather and intrench in these slow-moving climes an impressionist

legion of his own: to withdraw amongst the Island fogs, which rather suited his special vision. A much more real and lively person than his New English colleagues, whom he temporarily deserted and criticized with great freedom, for a few years he controlled the most sensible and serious body of painters in England. As a local reaction back to impressionist 'Nature just as she is', they were a healthy little dyke against the pseudo-gypsy hordes John had launched against the town. They also helped to complete the destruction of the every day more effete New English Art Club cronies.

And it was about this time that the Allied Artists was founded (9 or 10 years ago).

Since then a great deal has happened. The gypsy hordes become more and more languid and John is an institution like Madame Tussaud's, never, I hope, to be pulled down. He quite deserves this classic eminence and habitual security.

The Camden Town element has served its purpose, and although intact and not at all deteriorated, it is as a section of the London Group that it survives. It contains, in my opinion, two excellent painters, Spencer Gore being dead, and Sickert in retirement. To contain two people who can be called 'excellent painters' is very considerable praise. I claim no solitary and unique importance for the Vorticist or Cubist painters. I do not see the contradiction that the Public appears to feel in a painting of Wadsworth's being hung in the same exhibition as a painting by Mr Gilman. As to their respective merits, that is a complicated and delicate matter, it is not necessary for the moment to go into. With Mr Steer's pretty young ladies on couches or Mr Nicholson's grey and 'tasteful' vulgarities, I have a definite quarrel. I resent Mr John's stage-gypsies emptying their properties over his severe and often splendid painter's gift. But with the two or three best of my Camden Town colleagues, I have no particular mental feud, though not agreeing with them. And if they would only allow me to alter their pictures a little, and would undergo a brief course of training prescribed by me, I would even AGREE with them.

Eight years ago, when there was really nothing in England but the Camden Town Group in the way of an organized body of modern and uncompromising painters, it was right and proper that they should take hold of the management of the Allied Artists' Association, and Mr Frank Rutter was fortunate in disposing of their services. But today, although this section of painters should certainly be represented there is no

longer any excuse for their almost exclusively controlling the management of the Society. It is a very large Society, and the newest additions to it are by no means the least alive. It is growing, that is, not only in size, but quality. Therefore, it could now do with a more representative artists' committee, each vital unit of tendency being adequately represented.

But it is not only the fact of the unnecessarily complete representation of Camden Town talent on the Committee to which I object. The Committee was originally elected on too friendly and closed-door a basis, the members who are not definitely Camden Town artists being, like Mr and Mrs Sund, not representative of any general interest or of any newer tendencies. The whole organization of the Society should be overhauled, and a completely new Committee elected.

To my thinking, Mr Gilman and Mr Ginner are by far the most important painters belonging to the Camden Town section. And that section would be admirably and adequately represented by them. Mr Epstein or Mr Brzeska could be intrusted with the sculpture. The Pompiers should have a couple of representatives, and most certainly the Vorticist and Futurist sections should be looked after by at least two people.

I am firmly convinced that this Society will never come into its own, and have its full weight, until it is HUNG IN SECTIONS. Imagine the Indépendants in Paris, for example, NOT hung in sections. It is only due to certain obstructionists who are shy at being herded with their fellows, or see a personal advantage in being scattered about, that this has not already happened. I do not happen to have discussed this point with Mr Rutter, but I am sure he would not be averse to this arrangement—of a show hung in sections of the different groups.

This is, in any case, a matter of individual opinion if not of individual interest. But what is certain is that until the Committee is completely re-organized the question of these reforms can never be usefully raised.

I may add to this article a note on the question of promiscuous voting by head. Must we stick to the system by which the dog with the biggest litter, though not necessarily the biggest dog, gets its way? The best is notoriously unprolific. And it is a fact, that in any open society like the Allied Artists (as indeed in any society of a considerable size at all) the disgusting and rabbit-like fecundity of the Bad overwhelms the exclusive quality of the Good. Were the Pompiers to begin voting, even Mr Sickert's numerous female progeny would be outnumbered

by 10 to 1. Yet Mr Sickert is better than a Pompier, though inferior to a Vorticist.

But very few King-Pompiers are numbered in this society. And that section is more or less listless.

For the health and possibility for future growth of the Allied Artists, they would do well to keep their 'advanced' members. And as Vorticists and Cubists are temperate propagators, their interests should not be measured by their numbers, as their utility to the State is not that of so many men-at-arms, but as individuals. They should be recognized as a necessarily self-governing community, and given privileges equal at least to the privileges of numbers.

LIFE HAS NO TASTE

The best artist is an imperfect artist.

The PERFECT artist, in the sense of 'artist' par excellence, and nothing else, is the dilettante or taster.

'Pure art', in the same way, is dilettante art: it cannot be anything else.

It is, in fact, rather the same thing to admire EVERYTHING in Nature around you—match-boxes, print dresses, ginger-beer bottles, lamp-posts, as to admire every aesthetic manifestation—examples of all schools of art.

Taste is dead emotion, or mentally-treated and preserved emotion. Taste is also a stronghold against barbarism of soul.

You should be emotional about everything, rather than sensitive.

You should be human about EVERYTHING: inhuman about only a few things.

Taste should become deeper and exclusive: definitely a STRONGHOLD —a point and not a line.

VORTICIST EXHIBITION

Note for the Catalogue of the Vorticist Exhibition, the only exhibition to be held by the Blast *group, which opened at the Doré Galleries, New Bond Street, on 10 June 1915.*

This is the first exhibition of a group of painters, to whom the name Vorticist has been given. Their work has been seen in various exhibitions, the London Group, The Allied Artists and elsewhere; also *Blast* was started principally as a vehicle for the propagation of their ideas, and as a sort of picture-gallery, too. But this is the first time in England that a gallery has been used for the special exhibition of nothing but the works of this tendency by English artists.

In addition to the Vorticist Group several other artists similar in aim have been invited to exhibit, and the show includes specimens of the work of every notable painter working at all in one or other of the new directions.

By Vorticism we mean (*a*) *Activity* as opposed to the tasteful *Passivity* of Picasso; (*b*) SIGNIFICANCE as opposed to the dull or anecdotal character to which the Naturalist is condemned; (*c*) ESSENTIAL MOVEMENT and ACTIVITY (such as the energy of a mind) as opposed to the imitative cinematography, the fuss and hysterics of the Futurists.

(*a*) Picasso in his latest work is rather in the same category as a dressmaker, he matches little bits of stuff he finds lying about. He puts no Life into the other pieces of cloth or paper he sticks side by side, but rather CONTEMPLATES THEIR BEAUTY, placing other things near them that please. His works are monuments of taste, but too much *naturesmortes* the whole time.

(*b*) The impression received on a hot afternoon on the quays of some port, made up of the smell of tar and fish, the heat of the sun, the history of the place, cannot be conveyed by any imitation of a corner of it. The influences weld themselves into a hallucination or dream (which all the highest art has always been) with a mathematic of its own. The significance of an object in nature (that is its spiritual weight) cannot be given by stating its avoirdupois. What a thing spiritually means to you can never be rendered in the terms of practical vision, or scientific imitation.

(c) Moods, ideas and visions have movements, associating themselves with objects or an object. An object also has an ESSENTIAL movement, an essential environment, however intimate and peculiar an object it may be—even a telephone receiver or an Alpine flower.

It is difficult to condense in a short foreword these ideas in such a way as to dispel the suspicion and puzzlement of the Public in looking at these pictures. In the second number of *Blast*, which is appearing in a week's time, there is a full and detailed exposition of them.

A point to insist on is that the latest movement in the arts is, as well as a great attempt to find the necessary formulas for our time, directed to reverting to ancient standards of taste, and by rigid propagandas, scavenging away the refuse that has accumulated for the last century or so.

Artists today have an immense commercialized mass of painting and every form of art to sanify or destroy. There has never been such a load of sugary, cheap, anecdotal and in every way pitiable muck poured out by the ton—or, rather, such a spectacle socially has never been witnessed before. There is not a little grocer in Balham, bromidic Baroness in Bayswater, or dejected Princess who has not a gross of artists closely attending to his or her needs, aesthetically.

Let us give a direct example of how this revolution will work in popular ways. In poster advertisement by far the most important point is a telling design. Were the walls of London carpeted with abstractions rather than the present mass of work that falls between two stools, the design usually weakened to explain some point, the effect architecturally would be much better, and the Public taste could thus be educated in a popular way to appreciate the essentials of design better than picture-galleries have ever done.

As to the popular acceptance of such abstract works as are found here, definite POPULAR acceptance should never be aimed at. But it must be readily admitted that the audience of modern music, of more thoughtful plays, etc., will need some other food, in the matter of painting, than the perpetual relaxed and pretty professional work found still in almost any contemporary Exhibition.

Regarding the present war as a culmination of a friction of civilizations, Germany, had she not an array of great artists, musicians and philosophers to point to, would be much more vulnerable to the attacks that her truculent methods of warfare call forth on all hands. England,

D

as a civilizing power, cannot make herself too strong in those idealler ways in which Germany traditionally excels. We feel that in efforts and initiative we are necessary to this country. After the war, Kultur (reform-kleids, Gluckesque nymphs, and melodramatic pedantry) demolished, England must no longer neglect her organization for Art and kindred things as has usually happened in the past.

PART II

World War I and the Early Twenties

INTRODUCTION

By the summer of 1915 the war had cast its shadow upon the Vorticist movement: the second issue of *Blast*, which appeared in July, printed Gaudier's 'Vortex' manifesto on sculpture, but had also to announce his death in action. Lewis took advantage of a prolonged illness to write what was to be his first published novel, *Tarr*, then volunteered for the Royal Artillery. He was a subaltern in a siege battery until, late in 1917, he was commissioned as an official war artist to the Canadian Corps headquarters. Two large paintings (the well-known *A Battery Shelled* at the Imperial War Museum, London, and *Canadian Gunpit*, at the National Gallery of Canada) and a series of drawings of gunners in action resulted from the assignment. The drawings were exhibited in his first one-man show, called 'Guns', held at the Goupil Gallery, London, in 1919.

For Lewis personally, the immediate post-war years were full of promise and excitement. For a time he seems to have felt he could take up again where he had left off in 1915. His officer's pay and the successful 'Guns' exhibition had put some money in his pocket. He expected to hold another show of his work in 1920. John Rodker published a portfolio of his drawings. The American collector John Quinn showed an interest in his painting, gratifyingly translated into numerous purchases. He started to work on set designs for a ballet from Rowlandson, which it was hoped Diaghilev could be persuaded to produce.

Supporters and friends were numerous. Lewis saw much of the Sitwells and the circle around them. He travelled in France with T. S. Eliot and, together with the poet, made the acquaintance of James Joyce, an occasion memorably related in *Blasting and Bombardiering*. In 1921 he rented a studio and began an intensive course of drawing from the imagination and from the model.

Between 1919 and 1923, Lewis's writing remained subsidiary to his painting, its subject almost invariably art. The major pieces of the time are the long ones: 'Prevalent Design', 'Essay on the Objective of Plastic Art in our Time', 'The Credentials of the Painter' and *The Caliph's Design*. The first three expand the characteristic amalgam of *Blast's* Manifesto II: analysis together with definition in an unforgettable poetic phrase ('baroque stasis', as Hugh Kenner has called it). *The Caliph's Design* adds to these elements criticism, along the lines of

Blast's 'A Review of Modern Art'. All four pieces contain magnificent passages, some of the best Lewis has written. *The Caliph's Design* is a grab bag of fertile ideas, linked together and flawed by a somewhat flimsy argument. In books such as this, Lewis could have used the advice of a good editor. (The compilers of the present collection have felt, in general, that such editing is not their role, and they have preferred to leave Lewis's pieces as far as possible as he published them.)

In 'What Art Now?' Lewis asks what effect the war should have on art. None, he argues, proposing the task of post-war art should be to take up again and continue to build upon the innovations pressed, he thought, to a conclusion before the war. He was active in the formation of the 'X-Group', an association of ten painters who subscribed to these purposes. The Group was formed in part as a reaction against the 'London Group', which was becoming increasingly conservative, under the influence of new members, Roger Fry and his associates. But though more than half of X-Group's members—Jessica Dismorr, Helen Saunders, Frederick Etchells, William Roberts, Edward Wadsworth, Charles Hamilton and Lewis himself—were former Vorticists, the Group made no attempt to revive the Vorticist label. All but one of the other members, in fact, were remote from Vorticism—the sculptor Frank Dobson, soon to become president of the London Group, Charles Ginner of the Camden Town Group and Neo-Realism, and the poster-pioneer McKnight Kauffer. Only John Turnbull, in wartime paintings of aeroplane scenes, which Lewis admired, had used a near-abstract, geometrical style. The half-heartedness indicated by the composition of the Group combined with the public's apathy to make it fall apart after a single exhibition in March 1920.

That the impulse of Vorticism, once crushed, could be revived in the frivolous post-war years was inconceivable. Ezra Pound, as also Ford Madox Ford, had left England, Pound urging Lewis to get T. S. Eliot out. But Lewis's instinct told him that his own battle station was London, and he stayed. He felt he needed to reappraise his painting and to analyse what was happening around him. Hence the weakness of his support of the X-Group, soon to be followed by a period of some years during which he did little painting.

The English post-war public's lack of interest in innovative art, which had been responsible in part for the quick decline of the X-Group, was due not only to the exhaustion of the war. For on the Continent the twenties brought the development of those characteristically

twentieth-century phenomena, Dadaism and Surrealism. If there was no such liveliness in England, the cause may have been a complex inter-action of two factors, Lewis's increasing preoccupation with his writing, and the undue influence of 'Bloomsbury', which in painting was embodied in the figure of Roger Fry. Since Fry is little read or studied today, few are aware of the traditionalism of his taste—which Lewis called Victorian—or of the immensely powerful position he had in the art world of England.

Fry favoured relatively traditional artists like Derain, Bonnard and Utrillo and was unsympathetic to Cubism and its offshoots. From before the war until the early thirties, he and his collaborator Clive Bell were the dominant art critics and publicists in England. Wealthy collectors such as Pierpont Morgan sought Fry's advice. He held, or was offered (and *refused*) the most prestigious positions in the art field. Against this figure Lewis directed the first charges of his post-war campaign. Fry is drawn upon in the role of a 'glow-worm' to see Picasso by, in the chapter of *The Caliph's Design* whose heading quotes his enthusiasm about 'the tiles in the South Kensington Museum Refreshment Room' (p. 178). In 'Roger Fry's role as Continental Mediator' (p. 197), printed in the first issue of *The Tyro*, he suffers Lewis's satire, which is devas-tating enough to seem to defeat its end, arousing sympathy for its victim.* On the same page on which this article appears, in 'The Children of the New Epoch', Lewis buries the past, which he saw as lying behind the large shadow of the war, and eloquently salutes the new forces 'delicately bursting forth everywhere', pressing on to realization of 'what is, after all, our destined life'.

* Such sympathy is likely to be dispelled by a study of the writings—and silences—of Fry and Bell of these years. Fry pointedly ignored the struggling English painters, and he seems to have made no objections to Bell's putting them down. A few examples of these attacks, often indirect and veiled, delivered with an infuriating smugness, from impregnable positions of power and prestige, are given in my book on the painting of Wyndham Lewis. To them, there was no effective answer. All one could do was to strike back, which Lewis, on occasion, did (*cf.* also *Letters*, pp. 116–17). W.M.

GUNS

Foreword to the Catalogue of Lewis's one-man show 'Guns', held at the Goupil Gallery, London, in February 1919.

The public, surprised at finding eyes and noses in this exhibition, will begin by the reflection that the artist has conceded Nature, and abandoned those vexing diagrams by which he puzzled and annoyed. The case is really not quite that. All that has happened is that in these things the artist has set himself a different task. A Tchekhov story, or the truth of a drawing by Rembrandt, is a highly respectable thing, and in the highest degree worth doing. I never associated myself to the jejune folly that would tell you one week that a Polynesian totem was the only formula by which the mind of Man—the Modern Man, Heaven help him!—might be expressed: the next, that only by some compromise between Ingres and a Chinaman the golden rule of self-expression might be found. My written work is hardly, after all, a monument of abstraction! 'Abstract art', expressionism, cubism, or what not is a fanatic, if you will, but a perfectly sincere insistence on the fundamentals of design or colour. The multitudinous formulae that present themselves to the artist and stimulate his curiosity or challenge his sense of adventure are investigated, combined, new formulae evolved. At the present day the Greco-Roman, Renaissance tradition, equally with the naturalism of the nineteenth century in France, or of the flat facilities that flourish by the Chinese sea, are not a fetish or a thing exclusively imbibed or believed. The Artist 'takes what he will', like the gentleman in the Purple Mask. As a logical development of much of the solidest art in this very various world there is nothing so devilish or mad in any of the experiments in art that prevailed in the years preceding the War.

That much said, and turning to this exhibition: there is very little technically abstruse in it; except in so far as it is always a source of astonishment to the public that an artist should not attempt to transcribe Nature literally, without comment, without philosophy, without vision.

I have attempted here only one thing: that is in a direct, ready formula to give an interpretation of what I took part in in France. I set out to do a series dealing with the Gunner's life from his arrival in the Depot to his life in the Line. Some episodes or groupings may, for

the physical interest I took in them, or in their arrangement, somewhat impair the scheme, looked at from the standpoint of the illustrator, and I have not yet got my series.

The War has, so far, been reflected in art with the greatest profusion. But the same can be said of life at any time; and we are not much the wiser. Whatever we may think about that, it is certain that the philosophy of the War, all the serious interpretation of it, has yet to be done. That could not, for a hundred reasons, be accomplished during the War. This is in no way meant to disparage the good work relating to the War, in painting, that has been done so far. But all the War journalism, in painting and writing, will cease with the punctuality and *netteté* of a pistol shot when the war-curtain goes down. It will then be the turn of those with experience of the subject, the inclination, the mood, to make the true record. Truth has no place in action.

This show, then, pretends nothing, in extent: I make only the claim for it in kind that it attempts to give a personal and immediate expression of a tragic event. Experimentation is waived: I have tried to do with the pencil and brush what story-tellers like Tchekhov or Stendhal did in their books.

It may be useful to consider War as subject-matter, its possibilities and appeals to the artist. Since war-art has been discussed as a result of the universal conditions of war prevailing and since artists, such as were not in the Army, have turned their subject-matter from the Academy rosebud into the khaki brave; or those in the outer fashion, from the cubed cockney into the cubed Tommy; ever since the art-critic, he also, has been forced to drag his eye and pen away from the Nymph and Pretty Lady and fix them on a muddy fight; what artist's name has been most frequently heard?

Uccello: that is the name we have most frequently heard. Now, in an automatic way people began to accept that name, and the picture that hangs in the National Gallery above that name, as typifying what the artist can do with War. Detaille, Meissonier were banal illustrators; Verestchagin was a war artist primarily; Uccello was the only great master, in a handy place, who could give us an example of war as subject-matter.

Uccello's battle-piece is a magnificent still life, a pageant of armours, cloths, etc., the trappings and wardrobe of War, but in the lines and spirit of it, as peaceable and bland as any tapestry representing a civic banquet could be. It does not borrow from the *fact* of War any emotion,

any disturbing or dislocating violence, terror or compassion—any of the psychology that is proper to the events of War. A Japanese warrior, with his ferocious mask, is more frigid than the classic masks of Mantegna's despairing women. Uccello's battle-piece is a perfectly placid pageantry. It was easier, no doubt, with so much obvious splendour at that period to retain this aloofness. But in any case, the principal thing is that this is a purely inhuman picture, in the sense that the artist's attitude was that of the god for whom blood and death mean no more than bird's plumage and the scintillations of steel.

Another great artist has given us a rich and magnificent work dealing with war from a very different angle. Goya's *Desastres de la Guerra*, a series of etchings done in his old age, is an alternately sneering, blazing, always furious satire directed against Fate, against the French, against every folly that culminates in this jagged horror. This war-art is as passionate as Uccello's is cold. Both are equally great as painting.

You know Van Gogh's scene in a prison yard? Then you know how he would treat war. You know Velasquez' *Surrender of Breda*? That is his war.

It is clear, then, that an artist of a certain type would approach any disturbance or calamity with a child-like and unruffled curiosity and proceed to arrange Nissen huts, shell-bursts, elephants, commanding officers, aeroplanes, in patterns, just as he would proceed with flowers in a vase, or more delectable and peaceful objects. Another comes at pictorial expression with one or other of the attendant genii of passion at his elbow, exciting him to make his work a 'work of action'; the Man of Action having his counterpart in the works of the mind.

Such general remarks may help in the reading of these pictures.

THE MEN WHO WILL PAINT HELL

Modern War as a Theme for the Artist

From the Daily Express, *No. 5,877, 10 Feb. 1919, p. 4. Printed with the following editorial note: '(Mr Wyndham Lewis is an artist without category. He declines to call himself an impressionist or a cubist. His exhibition "Guns", at the Goupil Gallery, is exciting much criticism.)' The first of the two exhibitions referred to in the first paragraph was the Canadian War Memorials Exhibition, 1919, and the second was held in 1920 at the Imperial War Museum.*

A new subject-matter has been found for art. That subject-matter is not war, which is as old as the chase or love; but modern war. We have had a series of exhibitions of war-art, drawings and paintings of soldiers, trench landscapes, pictures of the singular technical fauna of the air, battalion scenes and battery scenes; culminating in the present exhibition at the Royal Academy of war pictures for Canada. This is to be followed in a few months, I believe, by a similar Government exhibition of pictures destined to remain in this country in some public gallery. So there has been much discussion on the resources of this new subject for pictures and its appeal to artists.

As a theme for pictorial art, war differs from most others in that it is spasmodic and ephemeral. Today it is much more ephemeral than at any former period, but also much more intense. The French Impressionists of the last century took the life of the city for the subject of their pictures—café scenes, bars of music halls, a family at dinner, the eternal child-like awakening of a woman, or her equally eternal but less child-like going to bed, prayerless and bedizened, in some Paris room. British Royal Academicians portray principally episodes from the school history books and interminable stiff portraits. All the subjects persist, and are year in, year out, ready to the hand, either as studio property or daily life.

The eight-mile-wide belt of desert across France will be a green, methodic countryside in five years' time. The harsh dream that the soldier has dreamed—the barbaric nightmare—will be effaced by some sort of a cosy sun tinting the edges of decorous lives. At Austerlitz the trees waved pleasantly all through the carnage with Schilleresque

oscillations; the earth at Eylau could not have had many wounds to show. At a few miles' distance Salamis might have been mistaken for a stunt-regatta.

Ypres and Vimy, on the other hand, were deliberately invented scenes, daily improved on and worked at by up-to-date machines, to stage war. There is, or was, no trace in one of the valleys before Ypres except of this agency.

The artist will approach this territory and this life in one of two ways —either as the artist visiting a picturesque spot and selecting quaint bits and views of dilapidated survivals of a dead life—or as the artist who takes his subject-matter from the life around him.

Daumier would have painted soldiers with the same relish with which he painted women washing their clothes in the Seine, gatherings of rough people in the street, or what not. Degas, Delacroix, Van Gogh, are other names that suggest themselves. Delacroix would have painted the human subject of the war with his French, theatrical, fury—*furia francese*—Van Gogh with the delicate compassion with which he imbued everything that he touched. The Japanese formularized war into staring masks of hatred and the elegancies and energies of extravagant swordplay.

The wars of the Middle Ages partook of the pageantry of a Lord Mayor's Show—so that Uccello (whose painting in the National Gallery is rightly regarded, as art, as the greatest war painting accessible to the English public) could show you a scene of carnage with a super-calm pulse, and without the faintest indication that his fantasy had been troubled by the noises or horrors of battle. The armour, plumes, the decorative spears make up as suavely composed a picture as though the subject were a civic banquet. Nothing of the sombre strain, the hopeless monotony of war as we have it today, can be found in that placid and pleasant canvas.

It is clear that modern war, as a subject-matter, is accessible only to a certain type of creative artist. The man who painted Hell with such ability at Orvieto would have been the man to commission to make you a monument of the 'Over There' of the popular song.

HAROLD GILMAN

From Harold Gilman. An Appreciation, *by Wyndham Lewis and Louis F. Fergusson (London, 1919).*

Harold Gilman died in February of this year (1919). The following are the principal landmarks of his life. He was the second son of the Rev. John Gilman, Rector of Snargate with Snave, Kent. He was born at Road, Somerset, on 11 February 1876: educated at Abingdon, Rochester, and Tonbridge schools. In 1894 he went to Oxford, but ill-health compelled him to terminate his stay there before he could take his degree.

In 1895 he went to Odessa for a year. Returned to England in 1896, he started painting at the Hastings Art School. The following year he went to the Slade, remaining for three years or more. His masters were Professor Browne, Henry Tonks, Wilson Steer, and Russell.

In 1904 he went to Madrid, spending a year in Spain. A journey to America in 1905 and another in 1918 (excepting short holidays spent in Sweden and in Dieppe) were his only further deplacements. In 1918 it was in order to get the material for his painting of Quebec Harbour for the Canadian War Memorial at Ottawa. The last ten years of his life were spent principally in London.

If you are to seek for anything dramatic in his death, it is that his last picture (that of Halifax Harbour), on exhibition during his last illness, was in many ways the best he had done. Also, he was a painter who steadily improved, and at the time of his death was making an effort of self-expression that many abandon at a far earlier stage in the proceedings. In any appreciation of Gilman, this appears to be one of the two or three fundamental things about him: that whether you sympathized with his work or not, he never abated his standards, but pushed on in a logical progression towards his best. When you say he was an honest painter, it is as though you should say of another man, 'He is an honest man.' There was a parsonic honesty in his painting; a moral rectitude in his pursuit of pictorial truth, as he understood it. He showed indulgence for dishonourable painters—such as would have nothing to do with Sickert's trail of dabs and points, for instance; or later the enemies of Gogh—he even showed a happy humour in considering their misdemeanours. But there was a very frigid Anglican

core to his make-up as a painter that came into full and useful play in his functionings as President of a Group, an influential character in his circle.

His evolution as a painter can be stated fairly simply as follows: At the Slade he attempted to do the regulation charcoal drawing of the nude without conspicuous success. When he went to Madrid in 1904 he made numerous copies from Velasquez, and his first personal paintings were Whistler-like in tendency, and were attempts to carry out the tenets of the Spanish painter. His next stage was a freeing of himself from this model (rather unsuitable for his particular talent), with the enthusiastic connivance of Mr Walter Sickert; and companioning, as a painter, Spencer Gore. The next stage in the process was, in company with Charles Ginner, a rather rapid assimilation (much speeded up by his new friend) of the modes in Paris that immediately succeeded the Impressionists. Many of his paintings, up to the time of his death, were much of a kind with Vuillard and men of that school. In his more venturesome and more developed mood, he directed himself towards the figure of Van Gogh. If you went into his room, you would find Van Gogh's Letters on his table: you would see post cards of Van Gogh's paintings beside the favourites of his own hand. When he felt very pleased with a painting he had done latterly, he would hang it up in the neighbourhood of a photograph of a painting by Van Gogh.

After his break of what was more or less discipleship with Walter Sickert and his plunge into the Signac palette and a brighter scheme of things (with a certain amount of noise for such a quiet man), bitumen was anathema for him, and Sickert was bitumen. Sickert's obstinacy in not adopting the Signac palette he admitted was a source of great perplexity to him. He would look over in the direction of Sickert's studio, and a slight shudder would convulse him as he thought of the little brown worm of paint that was possibly, even at that moment, wriggling out onto the palette that held no golden chromes, emerald greens, vermilions, *only*, as it, of course, should do. Sickert's commerce with these condemned browns was as compromising as intercourse with a proscribed vagrant. He criticized with an impressive and rolling severity the slothfulness and sinfulness, the outward and visible sign of which was bitumen. You felt that he was exhorting you on the text, 'Cleanliness is next to godliness'; and that bituminous painting, *dirty* painting, was the mark of the devil. I do not mean by this that he exactly regarded Mr Sickert as a devil; but on several occasions it has been for me not

difficult to understand that he considered him as lax (pictorially lax), if not wholly immoral. Mr Sickert's paintings of Camden Town atrocities, in shuttered rooms, of Gilman himself, built up in, alas, impure spots, his picturesque houses in Dieppe, not so brightly coloured as Gilman would have wished, he shook his head over! But he always retained a great respect for the virtues of his first real master.

The Gilman tick was a thing prized by his friends next to the sternness of his painting. He was proud of a pompous drollery, which he flavoured with every resource of an abundantly nourished country rectory, as he was proud of his parsonic stock. He was proud of his reverberating pulpit voice: he was proud of the eccentricities of his figure. He was also proud of a certain fleeting resemblance, observed by the ribald, to George Robey, the priceless ape. But, above all, he was proud to be a man who could sometimes hang his pictures in the neighbourhood of a picture post card of the great modern master, Van Gogh. He would roll his eyes, and roll his voice, and shake his head in the very thick of his cultivated tick; and glory in being alive, in having a bald head, a humorous eighteenth-century eye, a new wife, a new baby, a new and quite unexpected enemy (for whom he was very sorry and over whom he sadly shook his head)—proud of everything that came within his ken. He had a great capacity for friendship, a poor and third-rate gift for hatred, every virtue of middle-class England, and, in fact, was one of the most amusing, genuine, equable, sensitive individuals I have met. And all his contemporaries agreed that he was a good painter.

As to his attitude to contemporary movements in art, or to any movement in art, that was not wicked, bituminous, or like Burne-Jones, he was almost equally cordial. He seemed to be shouting to almost any one he noticed painting a picture that he detected was not too bad, 'What a fine morning! Isn't painting nice! Don't you *love colour*? Yes, I thought you did! Thank God we are not "dirty" painters! You never use black, do you? Nor raw umber? I was sure you didn't! How like that bridge is to Van Gogh!'

As to a detailed account of his paintings, the reproductions in this book will show to any one knowing the movements in painting agitating these years, what Gilman was: and the exhibition being held this autumn (1919) will display sufficiently what a fine painter he was. If you mix the Signac palette; Van Gogh's strips and Sickert's spots; Charles Ginner's careful formularization of modern buildings, all their bricks painted in; a little Vuillard and a little Vlaminck; you get the material

of his talent. His sanguine and sensitive personality worked on that to individual ends.

I personally prefer amongst his paintings his last one of Halifax Harbour (one of the two or three best paintings in that large exhibition), his portrait of Mrs Mounter, and the drawings and studies directly kindred to that. I think, had he lived, he would have proceeded indefatigably and without haste on those lines: for an interminable time! I consider his early death a flat contradiction to every feeling that one had about his destiny. If it is true, as Whistler said of Titian, that he would still be painting as hard as ever if the plague had not carried him off at the age of ninety: it is equally true that Gilman's personality, as well as his friends, suffered a defeat in what was a paradoxical decease.

The artists that he has been chiefly connected with were the members of the original Camden Town Group, and the larger society that grew out of that, the London Group. Of these artists, those most closely connected with him in his work were Charles Ginner, Spencer Gore, Ratcliffe, and, in a rather less close way, Walter Sickert. The only other society at which he has exhibited is, I believe, the New English Art Club.

My own interests in painting lie in different channels to those navigated by Gilman. I admired much of his work, had a great relish and liking for him; but I am not so well equipped as some more closely associated with him in his work to give a specific account of it. But I hope that this personal sketch of him, and indication of the character and history of his talent, will serve, in the interim, to accompany the first photograph-collection of his paintings. I am sure that his work is of consequence, and that his memory will be attended to accordingly. Mr Charles Ginner's admirable article on him, which appeared in *Art and Letters*, is a first rough document of that nature. I hope soon that such stray articles or personal notes like these may be followed by a comprehensive book.

WHAT ART NOW?

The English Review, *April 1919*.

The war drove all the great pictures off the surface of the earth into the cellars of the museums. And it drove all the arts underground. They now come up: a little wan and blinking, some of them. What are they going to do now? we are asked. Have their houses been damaged and destroyed in the interim? If so, how are they going to rebuild them? Same architectures as before?

The general question as to what art we are going to have for the next decade, or, rather, if it will be different from what we had before the war, can be answered quite directly and certainly and for all the arts. The war has not changed our industrial society or the appearance of our world; nor has it made men desire different things, only possibly the same things harder still. Therefore, as you find the appearance of the world and the volition of men, so you will find art. An extreme political readjustment of our society in the near future even would not disturb these fundamentals of what art today must be, I should imagine.

The innovations in painting, pressed everywhere before the war, have by their violence and completeness exhausted the scope of progress on that point. That America may be considered as not only discovered, but crossed and cross-hatched from side to side, with the surveys and trekkings of its invaders. Expressionism, Cubism, Vorticism, all these movements now have to set about construction and development, and evolve a new world of art out of the continent their enterprise has acquired.

Or, rather, they have to do this if they plump for civilization. An abundant and solid art, producing here and there the veins of wit and beauty that compensate us for the steady stupidity of existence, can only occur in respect of the painters' or sculptors' art in a civilized centre.

Naturally, in their new country the innovators can still spend their life in the saddle if they want to; can trap, fight, buccaneer for yet many a day. Or they may bustle off after another world. In that way they would develop into world-discovering machines, their finds to be inhabited and enjoyed presumably by other people.

But the painter cannot be a man of action in the way the poet can.

He is anchored to his craftsman's destiny, his necessary virtuosity with all the paraphernalia of his trade. Then there is the laborious evolution of the technical basis of his work: the finding of his 'hand', of just what sort of a hand it is, and just what tools it needs: and then the organization of a vision that comes to him immature.

Nor need we (to return to our discoverers) visualize them as Anglo-Saxon colonists, but rather as a more intellectual type of pioneer. And, again, we can even drop the American image altogether. Their discovery has not been antipodean or beyond the setting sun; it is simply the world in which we all stand and live. So this America that has been unearthed is simply London, Paris of today. The Redskins that have to be beaten off and finally exterminated are simply the tribes of unabashed, barbarous, commercial artists infesting these spheres. But fire-water fortunately destroys quantities of them; and the rest we will hope will molest us less and less as time goes on.

But what you want to know—you who insist on regarding 'modern art' as a melodrama, in which Beauty is foully done to death by a villainous figure disguised as a Cube—you principally want to know when the pistol is next going off. What new technical surprises will you be expected to submit to?

This really rests entirely with the Italians. You always got your bloodiest bits from them, and always will. No one made such a ranting, gory job of the doing-in of Beauty as Marinetti. But all that remains in great uncertainty until the Futurist pamphlets begin to rain again this way.

Treating of the rest of the world: the cowboys with their sheepskin haunches, and their shirts of the hue of the Carmagnole, who *may* let off the stage gun, even two or three times, on our British boards, will be of the distant trapping or the rolling-stone order in these days to come. They will not necessarily be 'bad men', but they will probably be bad artists! The good ones did all the banging that was required some time ago. When you leap on to a new continent for the first time you are compelled to make a slight din to frighten away any savages that may be lurking in the neighbourhood. But a nice large new world really *has* been discovered. Let us get it into shape. (We have once more slipped back, when the cowboys came on, into our Columbian figure; but that will not cause us to forget that it is Oxford Street and the rue de la Chaussée d'Antin that we are talking about all the while.) I am afraid that all the proceedings of those artists vowed to the 'new art' will be

observed with the greatest astonishment for some time by the big
middle-class public. This public is, of course, never meant to under-
stand what is happening, or to enjoy the pleasures of a finer world. He
must be got to understand, however, that the baffling things of art are
probably quite in order, a portion of his world, only a luckier, more
rarefied and more sunlit portion. He usually, when he looks up at the
white peaks, shudders ostentatiously and says, 'Ugh! how *cold* all that
looks! Art should be *emotional*. It should be human—a cry of the heart!'
A sex-howl, a Burne-Jonesesque wallow of sentiment is what he means.
Well, he must not be taught, but policed, simply, this big public. The
public of the few thousands, on the other hand, must be carefully
instructed and made into a real and responsive chorus. It is on the
possibilities of rendering this smaller public *d'élite* more supple, more
interested, and much more learned in the matter of pictorial art, that
the healthy flourishing of painting in this country for the next twenty
years depends. It is a debile and rather morbid public; it requires
constant tonics and attention. The artist has many responsibilities in
these Islands!

At the time Van Gogh was a craze I knew an art student who cast
Rembrandt (in the shape of a monograph on that artist) into his latrine.
For Van Gogh himself, on the other hand, Rembrandt was almost a
religion. This should be driven into people's heads, this contrast. *No*
serious artist thinks or propagates the notion for his own use that any-
thing *better* can be done than such works as hang above Rembrandt's
name in Amsterdam or the Hermitage. The brainless little loafer who
has got into an art school because he was too lazy to go anywhere else
hears of this or that development in art. He hears that So-and-So
(capital S) 'is painting all black'. He rushes into the nearest café with
the news. And the next time he sees a picture in which there is a bright
carmine or orange he curls his lip and turns his back. Now, this is what
most people imagine to be the attitude of the man who 'paints all black'
as well. It is important for the public to realize that it usually is not.
Artists do not experiment to give old Breughel one in the eye, or to go
one better than Monsieur Tel et Tel, or to *improve* on this creation or
on that. The particular attitude of mind and of speech we have just
dealt with is confined to the unproductive café-haunting microbe, many
of whose attitudes and imbecilities are attributed to artists. For, as he
generally lets the hair at the back of his head grow long, and appears
in many ways untidy and unusual, he is just the public's idea of an

artist, and every small vulgarity that suggests itself to this shop-assistant allowed to stray is supposed by the unenlightened beholders to be the peculiar mentality that this occupation of picture painting engenders.

I hope that point has been enough cleared up, for it is an important one. It may finally be useful to consider, for the further illumination of it, what a painter's experiments imply.

The objects of a pathologist's experiments are to achieve some practical end: establish some law on which science can act. Once he has achieved this, he passes on to some other research. This law, again, is either right or wrong: it either cures people or kills them. The proof of its 'rightness' is immediate. And, like a piece of machinery, it can be *improved*. But you cannot *improve* a Corot, an Ingres, or a Gauguin.

A painter's extreme experimentation, occurring in our civilization, it would appear, every forty years or so, is a stepping aside from artistic production, almost, for the moment, into science. After a period of productivity which has burnt itself out and come to an end, he has to readjust and renew vision and virtuosity and develop the necessary material for a new term of creative work corresponding with the changed aspects and ideas of his time.

Cézanne's life-work is one solid block, of one material and of one character. He experimented heavily in the first instance to evolve this manner that fitted his vision. But a painter wants *one* vision, not the philanderer's seven hundred or more. The same applies to a movement or a school. It may have several facets, but to succeed it must have an exact and infectious character of its own.

So, because you have a revolution six years ago, you need not expect another next month. The revolution in painting of the few years preceding the war has thoroughly succeeded.

PREVALENT DESIGN

A series of four articles, which appeared in The Athenaeum *in November 1919–January 1920.*

I

Nature and the monster of design

Beardsley and Herbin, Gauguin and Modigliani, within what is more or less the same phase of European sensibility, provide remarkable enough differences of method and mood to make it difficult to point to any one prevailing idiosyncrasy, and to say that it is the day of that rather than of another. If, on the other hand, you look at any collection of Japanese prints, and then at a collection of pictures of the fifty years containing Gainsborough and Raeburn, you will recognize that you are in the presence of two separate worlds of design.

In the struggle today between the infinite number of modes that have been successively accumulated in the practice of modern painting, an older and more permanent struggle has been forgotten. I refer to the opposition between the methods of those painters who devoured Nature to feed a restless Monster of Design within them; and those who, on the other hand, offered their talents upon the altar of the Monster Nature; which talents, after absorption into the body of this mechanism, refused to be digested, and led a precarious and sometimes glorious existence in its depths.

But this older struggle, in a muffled and abstruse way, still persists at the present time. And many of the answers to the problems of painting that bristle round the student in 1919 are to be found by attending to the terms and conclusions of this deeper conflict. So in considering the modes that appear to be prevailing today, or in giving your reasons why you think that your particular favourite should prevail, the first thing is to dig under the hosts of sideshows that make of our horizons an aesthetic shambles, and unearth the old professional warfare of the Nature-man and the man of Fancy, or of wilful design.

In the Art Schools those students who cannot learn to draw the human form with that convincing power that they would wish, usually conclude that landscape must be their *forte*. Those again who find that, in

the early stages of art training, it is easier to do a satisfactory painting than a charcoal drawing, tend to the belief that they are 'painters'. In this way they side-step the glamours and ardours of 'draughtsmanship'.

In these Art School classifications, however, there is something more than questions of relative power in paint or charcoal, figure or fields, that makes the student decide for this line of work or that. And the Nature-man and his opposite too cannot be disposed of in terms of relative prowess. *You* may prefer the Monster Nature, as a monster, to the Monster of Design. But you cannot strike down the still more bestial painter of your antipathy with the slovenly dimensional dart. You cannot say, 'He is a bigger man; he *imagines*'; or 'So-and-so is the greater artist; he sticks close to the configuration of our street'.

Gauguin, if not as good a painter as Cézanne, fails *not* because he used a different method from his master; but because he did not succeed in it so strikingly as Cézanne in his.

The great obvious cleavage, then, between the design wrought on the body of Nature itself, and the design given to the forms of Nature after they have passed through a formularizing process within the artist's mind, must be evoked at once, and put in the foreground of your examination of Cubism, Expressionism, or any of the current movements in painting. Work done 'from Nature', and work done 'out of your head': those are the extreme rough figures of this conflict.

The particular decomposition and distortion of Cubism is a compromise, in one sense, within the dogmatic tradition of French nineteenth-century naturalism. It is the only way that a painter whose method is still intrinsically that of the French Impressionists of the eighties and who has an almost morbid bias for the 'common object', the 'street in which I live', can get design, a powerful and wilful shaping of the matter to be handled, without breaking definitely with the French naturalist side of his training. The violence, even—the extravagant character of the dive into pure abstraction, is the result of the naturalistic subject-matter of the French painters performing it. The more they strained to give the *immediate* truth of the copy of *La Presse*, the morning coffee-cup, the roof seen from the studio window, the *farthest*, finest, reality of those real and everyday objects, the farther, naturally, they got away from them in sober common-sense fact. For the utmost and acutest reality of those simple objects is an abstract reality; arrived at which, these objects participate in the existence of other objects less

and even more 'common'. They become the prey of moods and fancies that are more proper to the creating of a figure like Don Quixote or Macbeth than to the naturalistic rendering of a coffee-cup. For the *reality* of the coffee-cup and the copy of *La Presse* is the visual reality of common sense, as Manet would give it to you. The other 'reality' is something else.

When a great school of design is at the height of its activity, as was the case, for instance, with the paintings in the Ajanta caves, there would not be the same temptation, or necessity, even, to dislocate and decompose. Nature was thoroughly subjected and controlled by these artists. Permission did not have to be asked to arrange objects in this way or that. The objects were packed away within the artist's head, renewed and fed daily by observation: they were not dogmatically, irrelevantly, on a table before him, saying: 'You know your duty! Perform it!'

In the case of the category of painters most naturalistic in their method, design can hardly be more than the equivalent of a corset, a mode of doing the hair, or a fashionably narrow shoe. You feel that were the local and difficultly imposed pressure removed for a moment, the picture would fly back at once into the photographic proportions— masses and lines—of Nature. In the other category you feel that, did the design suddenly take life and have to adjust itself to the organic world, it would require at least a generation before these forms could mix with any but forms of their own kind, and assume the functions and duties of normal existence.

If you want a type of work up-to-date to illustrate these two methods, I indicate for the former the war-drawings of Eric Kennington: as a type of the latter William Roberts' picture of a gas attack at Ypres.

This old cleavage is due then to the method of work of the artist: this in its turn is the result of the complexion of his mind and talent, and somewhat of the pictorial habits of his time. A Japanese print may be as essentially 'true to Nature' as a close painting from the object by a French Impressionist. But it is not true to any given moment, or even quite any given place: the colours are not true (in the sense of red house and snowy mountain) to the accidents of the scene. For in this con- nection Cézanne's observation, that to alienate the colour of an object from that object also perverted its form and destroyed its integrity, applies only to the animal and vegetable world. It is manifestly of no importance whether the painter changes a house painted red into a

blue house, or chooses the moment when the mountain is white with snow, or purple, or green, in placing it behind that house.

If you are imitating the gradations and depths of the atmosphere and banishing local colour largely in the process, your re-handling and adjusting of the colours and forms in your picture must be of a much more restricted nature.

A strong and significant design, at all, implies such control of those colours and forms as cannot exist within the imitative method. You cannot control, order, and re-shape an object of which you are busy imitating either the form or the colour, or the play of light found on it at a particular moment.

This big general cleavage, then, is one even more of method than of outlook. Many painters, like the Japanese wood-cutters we have mentioned, used observation of nature for their eventually very methodic designs with the utmost closeness. On the other side of the chasm I effect, you would be wrong in thinking that I must refuse the term 'design' to the direct painting of Cézanne.

In my next article I will proceed with the application of the problems involved in this older cleavage to the conflict in painting today.

II

Painting of the soul

In my article in *The Athenaeum* for 21 November I indicated a connection between an old conflict and our actual one: the old one being the time-honoured dispute between the painter whose method is to work 'from nature', and him whose method, on the other hand, dispenses with direct work from nature, in the interest of a tyrannous talent for design, or the promptings of an arbitrary and exacting fancy. The reasonings for and against in this dispute could be used almost intact for the modern one. And if you made that transposition, in the process much light would be let into your mind on the subject of those questions of 'representation' and 'abstraction', tradition or a policy of adventure in painting.

But the first thing to establish clearly in your mind is what qualifies a painter for inclusion in one or other of these categories; what complexion of mind makes him find himself on one side or the other of this cleavage, or even in the alarming position of being straddled across the gulf.

You will notice to begin with that the fact of a painter's presenting you with a portrait of Mr Horatio Bottomley does not necessarily indicate him as being on the opposite shore to the man who traces Walpurgis scenes, ditches full of gnomes, cataracts of the Damned, or objects from which he is displaced by thousands of years or billions o miles. So putting aside for a moment the question of the innate respectability of imagining life on the farthest star, or in the most remote period of history, it is well to consider what constitutes remoteness, and in whose work it is most plainly discovered. And you will discriminate, as you go, between the man who has painted a scene that he can have had no possibility of observing 'from life', and the other who gives you a scene that organically, you conclude, could never have existed.

Gainsborough was a fashionable portrait-painter. He never painted anything or anybody that any Englishman of the day could not have seen and in his turn observed 'from the life'. And yet he was as much a fantastic as William Blake in his way. He did not see his sitters, or only saw them in a trance: a very mild, superficial trance, but nevertheless a palpable one. The fancies that hung round them, the flavour of their lives, their illusions about themselves, or about each other, all went to his head as they floated into his studio to be painted, like some enervating bergamot. He was doped with the graceful existence of all these pretty people, and that is how he worked. He saw nothing but pale blue clichés, and never a man or woman. Blake's Jehovah is a far realler person, or at least you can imagine him in the Tottenham Court Road more readily. You would take him for a Hampstead Nature crank, with his long hair, bare feet, and night-shirt. And the figure from the Covent Garden ball is at least not so real as the robust crank.

Or consider Rembrandt's imaginary scenes, and those 'from life'. His etchings of beggars, merchants, himself as a Polish cavalier, are used directly in his Bible illustrations. He does not trouble to alter the cut of the merchant's coat when that merchant has to play, in one of his etchings, the role of Judas Iscariot. The beggar is not modified when he becomes Lazarus. Blake, on the other hand, when he illustrates Job's very Jewish discomforts, or the burial of Moses, puts his people into night-shirts or strips them according to their occupation. But then if Blake had painted Hayley's portrait he would probably have painted him with horns and tusks. In short, he would have taken his world among his sitters, as Gainsborough abandoned himself to the unreal blandishments of his sitters' world. But the Bible was a reality to

Rembrandt's contemporaries and to Blake. And Blake's rather vague and night-shirted realities were nearer the fancy of a pretty fanciful pious man of his time than Rembrandt's crowd in the Hundred Guilder Print would be to the equivalent Dutchman.

Unless the whole of Rembrandt's work is on the fanciful side of the cleavage, none of it is. Whereas the other two artists I have cited are both there entirely. That is to say that, used in our particular contemporary sense, Rembrandt's scenes entitled 'The Return of the Prodigal' or 'Christ disputing with the Elders' are not 'illustration', whereas Blake's Job is. At that we will leave it for the moment.

But Rembrandt also is mesmerized by his world. It is the rich, rough and dingy miasmas of the world of commerce—Dutch seventeenth-century commerce—that drive his figures into a golden and rather subterranean world, coloured like a London fog. And certainly the common phrase 'he painted the souls of his sitters' has been applied more often to Rembrandt than to Gainsborough. Yet when you begin painting the illusions in the midst of which people live, show them constantly in a spot-light of blue or bright bronze, you have taken a considerable step away from the ideal practice of the Pure Visual. For we do not see souls with our eyes; and the function of the soul is, a good deal, to interfere with the senses. In a world where indisputably a wise man sees one tree and a fool another, the only question is what is the wise manner of seeing a tree. We may say that the wise man will see *more* in the tree, simply, than the fool. He will see more significance in it, and he will see more form in it, if he is a plastically developed wise man. But it is that *more* that evidently makes the different tree.

An illusion such as Gainsborough's transfigures also the form and colour of his subject-matter. The fact that he painted from his sitter does not affect the necessity to place him beside Blake or Moreau, Breughel or Gauguin. On the opposing cliff let us place a gigantic Cézanne Apple, coldly and closely seen, at the base of which crowd a variety of figures.

III

The man behind the eyes

I have grouped painters in two large camps, taking notice on the way of the anomalies that at once appear and would be liable to cause

confusion: the camp of the nature men and that of the men of design.

But I have indicated that the contradiction is not at an end when you say that one man paints only what he can, in his age, country and street, study at first hand with his eyes; and the other paints what, it is true, by implication derives from what he sees with his eyes, but is naturally a scene, an arrangement, that he could never have seen with his eyes. It is not only a question of the object seen or not seen. It is also, and even more, the way in which you see it: the significance you attribute to it, the mood in which you approach it.

In the case of the heroic 'Visual', Cézanne, the mind is presumed to have been cleared by some abstruse cleansing of the intellect, for the purpose of the great and single combat of the eyes. Or, to put it in another way, the eyes are supposed to have been vacuum-cleaned of every speck of matter not germane to their functioning of pure, direct, unmetamorphosed sight. The mind is masked behind them. It plays its searchlight on the objective world, and remains unseen. It is ostensibly an entirely impersonal vision.

When you have become aware of this vision fixed so inflexibly on the world of phenomena, it is, next, natural for you to ask: For what reason exactly are these brilliant pictures picked out of the blackness of nature by these enormously developed eyes? We see in a hard and frigid light masses of objects. It passes on, and we see a new picture: fresh groups of objects. It is a visually illuminating proceeding. But what is the purpose behind this scrupulous and searching eye?

All this has no purpose (the painter I supply you with will reply), but is done simply to gratify the man working the machine.

You have your answer at once on that point.

Pleasure, on the part of the man behind the eyes in working his machine around, and directing it upon the objects of his world: satisfaction in caressing with his eyes these objects, tasting their colours, examining their form.

But next, in the case of the heroic Pure Visual of the modern world we are considering, you will complain that, despite the power and directness of the light, there appears to be a squint somewhere in this searchlight: so that the little scenes cut out by it upon the night of nature are not as you would see them who do not squint, although possessing neither power nor directness.

Has the mind, then, intervened *visually*, you ask: although it may have refrained from all emotional obtrusion?

Yes, the attendant painter will reply: there is no doubt that what you describe as a squint is the result of the presence of the artist's mind at the source of vision.

So he is looking with his mind, to a certain extent?

The attendant painter admits that he is: that he must be. Emboldened by these admissions, you seriously lay siege to this pure fortress of vision. You say: The *character* of the intellect, is not that also an emotional variation? And incidentally, if *pleasure* is the goal, all impurities are permitted?

The attendant painter may make one of several replies. He may say that the intellect is unemotional: the *pure* intellect! To which you naturally reply with the usual objection, by thrusting the unfortunate mathematician forward and asking if *he* (you will hold him stiffly up) does not derive emotional satisfaction of the intensest sort—and so forth. As to your remark about pleasure, the painter's reply would perhaps be that all *purities* likewise were permissible. Or that this particular man's fun consisted in pretending to be pure (a pure visual).

Where you and the painter would eventually get to would be to a position something like this. The painter would have sculpted you a figure with searchlights fixed in its intellect, from which it planted areas of light on plates full of apples; and he would explain that the figure derived great *intellectual* satisfaction from this. You, on the other hand, at a disadvantage as regards pictorial training, and wanting to fix the searchlight, naturally, in the *emotional nature* of the artist (since all artists are *emotional*: that is what artist means), would be scribbling another figure on a piece of paper in which you set something you labelled emotional nature, and indicated with circles the proper position for the eyes!

You would probably admit to me or somebody else that the real meaning of *your* obstinacy, and why you were found disputing at all with your courteous attendant, was a natural sentimentality about the claim of the emotional nature to an honoured place in art; and a slight jealousy about, and in any case natural detachment from, the more specialized delights in which you and most people could not participate.

The painter, on the other hand, *brave garçon*, I am sure, would admit that he had been over-emphatic with the outsider to whom he had been attached. He would confess that the eyes were his professional hero, more sacred than any national one; and that he had romanced instinctively about the character of their deeds. But he would insist that to

diminish the girth of an apple or displace an eye, in a painting, in the spirit in which Cézanne did so, was a different thing to increasing the apple's girth to advertise the richness of a crop; or to displace the eye to give a look of malevolence or moodiness to the face.

But what, I should ask the painter, if the Cézanne, the visual, displacement *gives* a look of singular malevolence or ecstasy to the face? What if the distortion in the sculpture of Matisse gives the appearance of a decomposed imbecility, a diseased and stunted mess?

Surely this *result* of vision should be deliberate, where it often is not. The intellect, or the vision, and not the emotional nature, may decide, at the outset, on this character. (Although there is always equivalence between the intellect and its adjuncts.) But once the vision is made into a work of art, when that is done for the first time, its subsequent development should take into count this definite biological *result* of the vision.

IV

The bulldog eye's depredations

It requires as much skill and resource to keep design and significance in a picture on the Nature side of the cleavage as it does to keep vitality and objective truth on the side of Design. It is this effort on either side that produces perfect work.

When a painter chooses to portray an angel, the word 'imagination' is used to describe his talent. When, on the other hand, it is his breakfast table or his landlady that he paints, 'observation' is bestowed on him, if the result is approved. Most writers on painting do not possess enough 'imagination' themselves to see, in considering many Cubist or Expressionist pictures, that the breakfast table has become as fantastic as anything could be. It is still for them 'a breakfast table'. And with this label they will struggle with it, abuse the eccentricity of the artist, praise the significance of his planes, refuse him power, or deprecate his 'violence'; but *never* realize that it is, in fact, no longer a 'breakfast table'.

All the stock-in-trade of the Fanciful artist (Moreau, Blake, Beardsley, or decadently, in our day, Odell, for instance) is likewise as much the matter of Nature as the coffee-cups and the landlady. An abraxas or a centaur must be half-animal and half-man. The latter is usually composed of a portion of carthorse, and the upper part of a Poilu (selected

especially with a view to a massive effect). Blake's *Morning Stars Singing Together* are pretty English country girls or boys. You have seen faces very like theirs behind the counters of shops. As to their dress, it is like the costume adopted by students at the ever more numerous schools of choreography and physical culture. A gnome is simply a short (usually Mediterranean) type of man; a witch a very catty and very old woman, such as you can see anywhere. As to the Moreauesque landscape, again, or the grotto scenes of Leonardo, it is simply a question of scale. In small you see such a landscape (and it is not such a very elf-like task to enlarge it; just like enlarging a photograph, in fact) in any deposit of magnesia. Remember a few stalactite caves you have visited or photographs of such oddities, or the more romantic gorges of almost any mountain range, and you have your equivalent in nature for the most absurdly encrusted, cathedraled, bejewelled affair that has ever been painted.

The Cubist movement, or the movement of which Braque's paintings are the key, is a very intense reaction towards the Constructive and Inventive in painting, breaking out in the midst of the solid dogma of French Impressionism. The dogma was too young to be swept aside, and owing to the unusually rapid evolution of ideas the storm came sooner than it should to act logically on the minds that it attacked. In raging on the objects saturated with scientific nineteenth-century dogma, instead of overwhelming them, or sweeping the dogma away, it twisted the objects into unreal shapes, and contorted the dogmas themselves into the strangest-looking theories. With the Futurists, for instance, this intellectual tempest took all the appearance of the most ruinous cyclone. It threatened every monument of art, it lashed the waves of Canaletto's canals, and whistled through the hair of Renaissance statuary. And one of the modern Milanese tenets was: No nude figure for one hundred years! (You do not see the naked body habitually, so do not paint it!) But the Futurist then proceeded to paint the phenomena of the world around him in an idiom visually so abstruse that, little as our contemporaries have an opportunity of seeing the human form, it would yet appear as the most everyday object beside a painting by Boccioni.

Let us now, and finally, deal more specifically with Subject-matter, and its bearing on the questions that we are discussing. If your subject-matter is your breakfast table, then, whatever you do to it, your picture should still remain structurally true to—be in some intimate and direct

manner the pictorial equivalent of—that. The cups and coffee-pot, bread and plates, should not plastically usurp the character of the objects of a cobbler's shop, a scene in the Sierras, or a garden fête. In many cases in the pictures of Picasso, Gris, or Braque, this transformation has happened. A man with a mandoline becomes a group of buildings, and so forth.

Somewhere within the realistic practice of the Impressionists is the best method for rendering a breakfast table. There are undoubtedly a multitude of ways of doing it; but as regards extracting its objective pictorial truth from it, Cézanne or Renoir reached, it appears to me, the limits of that truth. The same thing applies to a portrait of a man sitting at that table.

On the other hand, you can proceed to paint a picture of all you know about that simple scene: the dribbling of the parotids, of the sub-maxillary and sub-lingual glands, the involuntary activities of the pancreas and central restlessness of the stomach; the conversion of the coffee and bread into absorbable matter, the villi and capillaries passing on the nutriment, with all the plant-like and imposing forms that our bodies contain; possibly introducing an interference on the part of a people of Pfeiffer bacilli with the process of digestion, their gradual ascendancy in the blood since their initial landing the night before. Or you can use the notions that illuminate this act of usual alimentation for the individual; a dark chagrin about the quality of the coffee, a glee at the heavy supply of fats. Or it may be that a consciousness of the active machinery of the animal seated at the table gives to your vision of him a grandeur resembling, in its effects, Gainsborough's consciousness of the delicate lives of his sitters, the high orthodoxy of their blood and habits.

But it will no longer be an enterprise of the senses, deriving directly and wholly from the sensual impression as commonly realized by other men. In the same way, only less obviously, if you always give far more weight and majesty to the tinklings of the mandolinist than his presence, occupation, and the character of his instrument warrant, you should escape from that mandolinist, forsake him for some very ponderous grandee of Spain or monstrously dignified Moor.

When the fancy is released and goes on its travels, it very soon leaves behind the coffee-cup and the studio window. The fancy is as proud of its talents as is the eye of its bulldog quality of ferocious grip and hold. And when the eye is lent to it for an adventurous spell, it chooses the

most deeply hidden and most distant game. It regards the eye as a prosaic monster; the eye fixing on it, in return, a glance of great distrust. But the eye is frequently used by the fancy in hunting more immediate game. This is perhaps the uncanniest combination of all.

What we have seen in European painting for the most part during the experimentation of the last ten years is a battle of wills between the eye and the fancy. The fancy, subjected to the legislation of the Impressionist movement, was forbidden to use the eye in the rounding up of any game except such as could be found within a radius of five miles of the painter's studio. But, on the other hand, it had the instincts of its time on its side, and was given carte blanche to do its worst *within* that area. The eye at its disposal (the bulldog of our simile) meanwhile, it must be remembered, had been trained by, and had acquired all the habits of, such exacting masters as Cézanne, Renoir or Manet. The confusion caused in the neighbourhood is not to be wondered at; nor that, at the end of this terrible period, everything should be *sens dessus sens dessous*.

The inventive faculty in painting (sometimes as fancy, sometimes in a more powerful imaginative form) has been revenging itself for the restrictions imposed on it by the absurd taboos of the 'scientific' age into which it had once more forced its way. It made havoc, even, of the domain of the eye. It has masqueraded as a 'pure visual' when it was nothing of the sort. It has in many cases used the properties of the dramas of the eye as magic carpets to transport us to its customary haunts.

A certain amount of 'abstract painting' has evolved from this confusion; similarly a certain amount of 'representative painting'. They really neither of them, *qua* 'abstract' or 'representative', have anything to do with it. Really 'abstract painting' is a province of the creative fancy. And there are very few paintings of your breakfast table, which do *not resemble* your breakfast table, that are not that as well. They are generally masquerading as an Impressionist's 'truth' or a pure visual truth.

THE CALIPH'S DESIGN

Architects! Where is your Vortex?

The book was published by Harriet Weaver's The Egoist, Ltd., *in 1919. Reprinting it in* Wyndham Lewis the Artist, *Lewis brought several of the references up to date and made minor changes in wording, similar to those referred to in the editorial comment to 'Vortices and Notes'. The later version is the one reproduced here. The following two paragraphs introduce the 1939 reprinting.*

I now come to *The Caliph's Design* and then, last of all, to the *Tyro* material. In both cases I was no longer a 'vorticist': I had not severed my connection with what was left of the other vorticists: I merely did not, after the War, wish to go on with that particular game, and the 'great London Vortex' consequently fell to pieces. Yet *The Caliph's Design*, written just after the War, was another *Blast*, and it continued the criticism of *Blast No. 1* and *Blast No. 2*.

The Caliph's Design was, I believe, one of the main sources of inspiration for the very modernist architect in Great Britain. So I did not shout 'Architects, where is your Vortex!' quite in vain. Yet as you read, 'The first great modern building that arose in this city would soon carry everything before it', you perforce will think to yourself that this revolutionary optimism has hardly been justified by events.

Preface

I have assembled round my parable a series of short articles and notes. These are all related to the idea which this parable embodies. The second half of this pamphlet deals with that section of modern painting which stands to our revolutionary epoch as a legitimate offspring of great promise, but which through certain weaknesses falls short of what such a relationship demands. These weaknesses in the painting in question seem to me a diagnosis of fatigue. Such shortcomings should be defined and isolated, lest they infect succeeding generations.

The spirit that pervades a large block—cube, if you like—of the art of painting today is an almost purely art-for-art's-sake dilettantism. Yet you find vigour and conviction: its exponents, Picasso, Matisse, Derain, Balla, for example, are very considerable artists, very sure of

E

themselves and of the claims of their great craft. So you get this con-
tradiction of what is really a very great vitality in the visual arts, and
at the same time a certain sceptical discouragement, a misuse of that
vitality. How far is this the result of the obtuseness and the difficulties
set up by the scratch-Public upon which painters have today to rely?
How far is it the result of a combination of the speculative agility of the
dealer and of a mere technical agility among artists?

Then the pleasant amateur (the vindictive failure of more settled
and splendid ages) sees his chance. He drops down into the arena from
among the audience, flourishing a red pocket handkerchief. By his
pranks—some pseudo-professional, skipping like any Espada; some an
impudent buffoonery—he adds to the general confusion. The little bull
laughs to see such sport; the crowds of degenerate and dogmatic
Toreros, popping with pedantic mirth, tumble in imitation of the new-
fangled clowns; the women hurl expressionist javelins torn from their
hats, and transfix the bottoms of the buffoons and the billycocks of the
banderilleros! The little bull, at first amused, as the Corrida ends,
dropping with boredom, goes quickly aside and falls asleep. A pale
urchin with side-whiskers and a hooked nose stands watching him with
a dull grin. Is not that a fairly accurate picture of the bloody spectacle
that we, Public and Performers, present?

It is evident that the Public is at fault. Why does it not insist on a
better type of Bull in the first place, a more substantial type of art, that
would be capable of driving all but the best performers from the arena?
If the public cannot think of a new type of Bull at the moment, and
is not willing to take a new brand of beast that we are rearing on trust,
let it at least put into the Circus some fine animal from Nineveh, or
rake the Nile valley for a compelling and petulant shape.

But the painter or sculptor, too, might give a hand, and the (I hide
my face! I am almost too ashamed for him to utter his name) the
Architect! Why does not the Architect (and every time I have to use
that word I shall feel like apologizing to you for mentioning such a poor,
forgotten, lamentable creature!)—why does not this strange absentee,
this shadow, this Ghost of the great Trinity, Sculpture, Painting, and
Architecture—for which I have substituted Design, from a feeling of
understandable diffidence—*why does he not cheer us up by building a
New Arena*? Constructing—around the new Bull that we are breeding,
our new very active Art—a brand new and most beautiful Arena?

That question, I know, will remain unanswered. It was tactless of

me to have asked it. But I have thought of a way out for the Architect. It has often been suggested of late that the Architect might become a department of the Engineering industry. But why should he take all his bric-à-brac over to that clean, fresh, erect institution across the road ? Rather let the Engineer and the Painter fix up a meeting and talk over the sadly-involved affairs of this decayed concern. Of all the scandals in the Art-World, the most discreditable by far is the pass to which Building has come. The Painter and the Engineer could buy out the Architect, go into partnership, and produce what would neither be a world of boxes on the one hand (as it would be if the Engineer controlled house construction—*vide* skyscrapers), nor of silly antique fakes on the other, as happens when the Architect has his sweet way. Let us divide up this ramshackle empire of Architecture. We could even dispense with a Caliph. There need not be any bloodshed. It is a not quite irrational world!

Now, of all painters who have ever breathed ponderously under a copper-coloured Vlaminck sky, the Cubist painters of Paris, the quantities of ponderous painters to be found cubing away in that city, are the best fitted for this role. It is they who should supersede, in a practical liaison with the Engineer, the virtually extinct architect.

The energy at present pent up (and much too congested) in the canvas painted in the studio and sold at the dealer's, and written up with a monotonous emphasis of horror or facetiousness in the Press, must be released. It must be used in the general life of the community. Thence, from the life outside, it will come back and enrich and invigorate the Studio.

When accepted at all, modern painting is accepted as a revolutionary oasis in the settled, dreary expanse of twentieth-century commercial art. It is recognized as a place where bright colours, exciting and funny forms, a little knot of extravagant people, are to be encountered, which it is amusing sometimes to visit. It was the same with the Impressionists. Whistler found himself beleaguered and interfered with in the same way: Gauguin and Van Gogh had the same experience.

Listlessness, dilettantism is the mark of studio art. *You must get Painting, Sculpture, and Design out of the studio and into life somehow or other*, if you are not going to see this new vitality desiccated in a pocket of inorganic experimentation. Then you must put the Architect, as he drags out his miserable if well-paid existence today, into the dustbin, *and close the lid.*

When in the course of this pamphlet I speak of the 'movement in painting', or Modern Painting, I refer to the sort of painting done by such diverse masters as Derain, Matisse, Picasso, Kandinsky, or Klee. These painters represent a single aesthetic current in the sense that they are none of them Impressionists, have all one synthetic intention or another, and are all roughly related in time and in enterprise. The complete non-representative character of Kandinsky's painting, or the weightiness and palpable logic of the Cézanne-evolved Cubist, belong really to the same impulse in art as do Derain or Matisse, who are neither Cubist nor Abstract. Klee's mixed phantasy is the same.

There are bound to be within this great general movement many experiments and enterprises attempting to attract all the rest in one direction or another. One of the most powerful of these and one that has held the stage for the last few years, is the Nature-morte development of a group of Cubist painters. Picasso, Braque, and Gris are three of the best known among them. Entertaining as some of these things are, I can see nothing of permanent interest deriving from them. Meantime, this exercise pursued over so long a period by these painters denotes, so it seems to me, a weak spot in the Abstract armour. Again, Picasso, great artist as he is, and much as I admire him, has an equivocal and unsatisfactory look. To an adverse analysis of this aspect of the general movement, I devote considerable space. But it is because I believe so much in the wider movement, and because the spirit of this *Nature-mortism*—also the David-Raphael eclectic classic wave—contradicts what I have written this pamphlet to propose, that I deal with it so thoroughly.

One other point in this preamble. I have no fault to find with Cézannism. Any faithful discipleship of that master is sure to be sound art. All the same, Cézanne is such a lonely figure, and he has such a weight of pups around him! No one man, even Cézanne, should have on his shoulders such a huge effort of initiation as was his. There should have been several men. Ungrateful as that sounds, one cannot but regard it as a misfortune that all the diversity of art and human talent of a generation should have depended upon this one old man, as has been the case since he was unearthed.

PART I

The Parable of The Caliph's Design

One day the Caliph rose gingerly and stealthily from his bed of gold and placed himself at a window of his palace. He then took a pen of turquoise, and for some hours traced hieroglyphs upon a piece of paper. They consisted of patches and of lines, and it was impossible to say what he was doing. Apparently exhausted by the effort, he sank back upon his bed of gold and slept heavily for ten hours. Waking up in the small hours of the morning, he summoned a messenger and despatched him in search of Mahmed and Hassan, respectively the most ingenious engineer and the most experienced architect in his dominions.

The Caliph was in fine fettle when they arrived. He pointed with a certain facetiousness to his design lying outspread on a table. Then he addressed them as follows: 'I am extremely dissatisfied with the shape of my city, so I have done a design of a new city, or rather of a typical street in a new city. It is a little vorticist bagatelle that I threw off while I was dressing this morning.' He negligently curled the tips of his beard. 'I want you to look at it and tell me what you think of my skill.'

Mahmed and Hassan bent over the design, and, noticing that their lord's eye was dancing, they indulged in a few hurried guffaws, scraping their feet and pushing and nudging each other.

The Caliph then observed, stroking down the sumptuous brocade of his new dressing-gown: 'Oh, Mahmed and Hassan, that is a very funny design. But it is my will that such a street should rise beneath the windows of my palace. Work shall start on it at ten o'clock tomorrow morning. It is your unpleasant duty to invent the forms and conditions that would make it possible to realize my design. You have till ten tomorrow morning in which to produce the requisite plans and instructions for such a work. Should you fail to do so your heads will fall as soon as I have been informed of your failure; between, that is, ten and eleven tomorrow. Goodnight, oh Mahmed and oh Hassan.'

Those two tremendously able men burst into a cold sweat. Their eyes protruded from their intelligent faces. They clicked their tongues, shrugged their shoulders, and shuffled out with gestures of despair. After a half-hour of complete paralysis of their brilliant faculties, they pulled themselves together. By ten o'clock the following morning a series of the most beautiful plans that had yet been made in Baghdad

(retaining with a scrupulous fidelity the masses and directions of the potentate's design) were ready for their master. And within a month a strange street transfigured the heart of that cultivated city.

The Bull Sounds

We are all agreed as to the lamentable nature of the form-content and colour-content around us. There is no one found to deny the hideous foolishness of our buildings, our statues, our interiors. The prevalent imbecility of Demos is a commonplace. But there agreement ends.

Divergence of opinion centres round the following points. Here is point one. Is it not preferable to have every manifestation of the vulgar and stupid constantly, in an appetizing, delicious form (something like the 'highness' of game), at the disposal of our superiority and wit?

What would Flaubert have done had France not bred Bouvards and Pécuchets with rabbit-like fecundity? Can nature ever be thanked enough for Sir Sampson Legend, Mantalini, Boswell's Johnson, Falstaff or any such types of Comedy, composed often of the nastiest excrement, the washiest imbecilities? No one would cut down these supplies of offal by so much as an ounce, which are the approved diet for so much that is good in art. No one would see folly or deformity, gluttony or cruelty, reduced by one single unit; or no one who recognizes the great benefits that have accrued, in the field of art, from their abundance in nature!

A less self-indulgent satirist, like Aristophanes, it is true, will attach a stink or some disgusting attribute to his absurd *bonhomme*, relying on the squeamishness of his audience: sending his characters about like skunks. But most authors are not so moral as to poison our pleasure with these gases.

Now a stupid form is for the painter the same food as a stupid man for a Gogol or for a Flaubert. So it is questionable whether without the stimulation of stupidity, or every beastly, ill-made, or tasteless object that abounds in life today, the artist would be as well off, as well *nourished*. Would he not be in the position of a satirist, like Flaubert, without a Bouvard, or of an artist like Boswell without his rich and very unusual dish? The irritation with the particular French folly that surrounded him, and that Flaubert's eyes devoured every day as regularly as he ate his breakfast; the consequent pessimism that became the favourite manure for his thoughts; we cannot see Flaubert without

that, any more than we can conceive of Rousseau the Douanier without his squab little bourgeois, and blank, paunchy little villa and silly little pony, in an ugly little cart.

The point rather lies in the *attitude* that was respectively that of Flaubert and that of the Douanier. Flaubert hated Bouvard: he considered the vulgarity and idiocy that he witnessed a very sad and improper thing. The Douanier, on the other hand, probably admired *his* Bouvards very much. It was with a naïvely respectful eye, it may be assumed, that he surveyed the bourgeois on Sunday, and noted his peculiarities like a child directly; without judging.

Shakespeare, it is true, must have relished the absurd or deformed more consciously. Dickens made a cult of it. But with Shakespeare it was against a vast background of other matter: as comic relief, or used in farces, and so labelled. It has never amounted to what has practically become, in our day, a *rejection* of anything as dull or useless *unless* it lend itself to our appetite for the comic or the 'queer'.

But Butler's, or Chesterton's, or Shaw's antithetic glitter, when used in journalism, may become the most wearisome thing. We long, confronted by such a monotony of inversion as we get in Mr G. K. Chesterton, for a plain 'dull' statement of fact. Similarly, there *could* be such a thing as too much ugliness, or foolishness. Since the beginning of time the imbecile has been the rule, the intelligent the exception. Yet if imbecility should become as it were the religion of the educated, its pursuit and enjoyment the main end of cultivated life—just as foxes, dogs, and horses monopolize the mind of the country gentleman—would not people begin to sigh for the old variety? The hero, the villain, the distressed maiden, the vamp and the 'comic-relief' would have their turn again. Should we not also, were we embedded in some bric-à-brac of stuffed birds and wax flowers, the languors of the 'aesthetic period' of the article I cite later in this pamphlet, look towards Karnak, a plain French provincial town, or almost anywhere, with eyes of longing provided there were no wax flowers or stuffed birds?

Surely all this sensibility of the 'queer', the 'amusing', the divinely ugly, the exquisitely vulgar, will date, and date very quickly.

There would today, in the 'modern' section of the art-world, be as great an outcry if some philistine proposed that the lovely embellishments of our streets, coloured signs, posters, beautiful police-stations and bewitching tiled Tube stations should be pulled down, as there would have been formerly—and is still by the 'beauty-loving public'—

when some 'picturesque old bit' or decaying cottage was removed.

With men trying their hardest to eliminate ugliness, injustice, or imbecility from the world, has there ever been any absence of these commodities for the delectation of the artist? Is there ever likely to be? It is true that the artist can gorge himself today probably as never before. But is that the best thing for his talent?

If twenty Christs charged abreast anywhere in the world, you would still get in a remarkably short time, and within a half-hour's walk of their super-calvary, some such monument as the First Pyramid, the result of such a block of egotism as had never been seen before, to demonstrate the futility of the humane corrective. But I do not believe you would ever get a pyramid builder without Christian hysteria.

Even in order to appreciate the 'banal' you must not have too much of it. And you must *pretend* that you do not like it, even if you are incapable of liking anything else. The reactionary Prussian theorists of war (*la bonne guerre*) of political tyranny, of 'functional' aristocracy, were less useful than the Pacifist, and less intelligent.

The approved arrangement seems to be this: you spend half your time destroying the cheap, the foolish, the repellent; the other half you spend destroying what is left over after your efforts! Such evidently being the way we are intended to live, there is no excuse for slackness in the performance of your unpleasant duty: that is, to desire equity, mansuetude, in human relations, to fight against violence, to work for formal beauty, for more intelligent significance in the ordering of our lives.

But to conclude. The great line, the creative line; the fine, the exultant mass; the gaiety that snaps and clacks like a well-braced instrument string; the sweep of great tragedy; the immense, the simple satisfaction of the completest art, you could not get if you succeeded in eliminating passion. Nor could you get it if you crowned imbecility, or made an idol of the weak. Whereas you can always get enough silliness, a sufficiency of obnoxious form, or of vulgar flavour to satisfy the most gargantuan appetite.

The Politician's Apathy

But what is this ugliness, this commonness and squalor, to which we have been referring? It is what meets the eye in any London street, in any railway, bus, teashop, restaurant or hotel in our capital city, or in the official art which is to be found annually displayed in Burlington

House. What influences go to the making of this repulsive form-content and colour-content of all the images that assail our eye—for which we may either offer up a prayer of thanks, or take no notice of, according to our temperament? What lassitude, or what ill-directed energy of mind, working through unnumbered channels, and multitudes of people, is responsible for the designs on match boxes, the ornamental metal-work on the lamp-posts, gates, knife-handles, sepulchral enclosures, serviette-rings; for most posters, menu-cards, the scenery in our musical spectacles, chapter-headings and tailpieces, brooches, bangles, emboss-ments on watches, clocks, cruets; pendants in Asprey's, in Dobson's, in Hancock's windows in Bond Street; in fact, every stitch and scrap of art-work that indefatigably spreads its blight all over a modern city, invading every nook, befouling the most attractive necks, waists, ears, and bosoms; defiling even the doormat—climbing up, even, and making absurd and vapid the chimney pot—which you would have thought was inaccessible and out-of-sight enough for Art not to reach—for the cheap modern thousand-headed devil of design not to find it out or think it worth while to spoil?

We are all perfectly agreed, are we not, that practically any house, railing, monument, thoroughfare, in this city should be instantly pulled down, were it not (and there's the rub) for the 'amusement' and stimulus that the painter may desire.

A complete reform (were it not for the needs of the painter who *must* have his bit of banality, bless his little heart!) of every notion or lack of notion on the significance of the appearance of the London scene should be instituted. A gusto, a consciousness should imbue the placing and the shaping of every brick. A central spectacle, such a street as Regent Street, should be worked out in the smallest detail. It should not grow like a weed, without any impulse but the drifting and accident of com-merce. A great thoroughfare like Regent Street develops and sluggishly gets upon its ill-articulated legs: blankly it looks at us with its silly face. —There exist Bouvards and Pécuchets in brick and stone. So there are Flauberts in paint and crayon.

Do politicians understand so little the influence of the Human Scene, or the effect of Nature, that they can be as indifferent as they are to the aspect of the capital of a wealthy and powerful community? Would not a more imaginative Cecil Rhodes have seen that the only way an Empire such as he imagined could impress itself upon the consciousness of a people would be to make the individual citizen aware of his privileges?

All ambitious nations have understood this. Whether in the weight of a rhetoric of buildings, in the subtler ways of beauty signifying the delights and rewards of success won by toil and adventure; in a thousand ways the imagination of the public would be captured and fixed. But beyond the obvious policy of not having a mean and slipshod surrounding for the capital of what sets out to be an 'Empire', simply for human life at all—*in order to increase gusto and belief in that life*—it is of the first importance that the senses should be directed into such channels, be appealed to in such ways, as to induce this state of mind of relish, of fullness, if not of exultation.

It is life about which, obviously, the legislator should be concerned: and full satisfaction of life is reached through the fancy and the senses. The latter must be stimulated and not depressed. But the streets of a modern English city are exceedingly depressing. They are so aimless, so painfully unplanned, that the mind and senses jog on their way like passengers in a slow train, with blinds down, in an overcrowded carriage.

This is worse, again, for the crowd than for the more fortunate few. The life of the crowd, of the Plain Man, is external: he can live only through others and outside himself. Then he, in a sense, *is* the houses, the railings, the statues, the churches, the roadhouses. His beauty and justification is in the superficial life of all that he *sees*. He dwindles, grows restless and sick, when not given the opportunities to live and enjoy in the simple, communal manner. He has just sense enough to know that he is living or not living: give him a rich type of life, a bit dashing perhaps, with clothes on his back that enhance his personality instead of killing it, with a glamour about it, and he is gladdened, if his stomach is not too empty. Give him processions and proper holidays; provide him with military display, if he lives under a military system. Yes, but there is something we were going to omit. He recognizes that the plaster objects stuck up in Oxford Street outside Selfridges for Peace Day are not a symbol of anything but commerce—in which he equally, though not so successfully, is engaged. There is nothing there to nourish his imagination. Similarly, it is not such a tremendous critical flight as you would imagine for him to connect in some subtle way in his mind these plaster statues with the more careful but even more effusively mean Albert Memorial, or any other monument that meets his eye. Yet these are the monuments that celebrate and advertise the society of which he is a unit. The putrescent dullness, that deadly and vacuous

stare with which he is confronted in those images—the symbols provided by his masters, who in their own persons are no more stimulating,
can hardly be expected to excite him either to buoyancy, obedience, or
anything but boredom.

So if there are a hundred good reasons why Painters should oppose
any modification of the appearance of our modern world, which in the
quaintness of its stupidity is as relishable as a Limburger cheese, there is
no reason at all, that I can see, why the politician should feel obliged to
protect it.

How the Fact of Style Obstructs

The parable of the Caliph's design describes the state of mind which
must be that of every true artist living in the midst of the blasphemous
stupidity, too much so even for mere animal health, by which we are
today surrounded. Alas! although, like the Caliph, a vorticist, I have
not the power of life and death over the Mahmeds and Hassans of this
city. Otherwise I should have no compunction in having every London
architect's head struck from his body at ten o'clock tomorrow morning,
unless he grappled with the problems of his art and endeavoured to
improve his understanding of it. I would flood those indolent offices,
where architects pursue their trade, with abstract designs. I am sure
the result would be to cram the modern scene with form and purpose,
where today, in so far as it is beholden to the architect, it has no
discernible significance of any sort.

There is no reason whatever why we should not have a number of
interesting architects. I can also see no reason why this pamphlet should
not bring them forth. I should be very proud of that. It is, I think, such
a modest optimism, that you will, I am sure, allow it. I should like to
see the entire city rebuilt upon a more conscious pattern. But this automatically would happen, should an architect of genius make his appearance: he would invent an architecture for our time and climate which
was at once a creative and fertilizing art-form. The first great modern
building that arose in this city would soon carry everything before it.
Hand in hand with the engineer by force of circumstances, his problems so exactly modern ones, this surprising building of our new
architect would provide a new form-content for our everyday vision.
All we want therefore is one single architect with brains. Him we will
regard when he arises, with unbounded optimism.

Now the question of the form-content of the everyday scene is obviously one that concerns every painter. Almost any authentic painter, sculptor, or designer will agree that Cheapside, Piccadilly, Russell Square, Marylebone Road, are thoroughly dull and discreditable masses of brick and mortar; that they are laid out according to no coherent plan; are fearfully vulgar in their detailed ornament; are in every way calling for instant demolishment. Similarly, he will agree that any large and expensive West End restaurant is the nastiest of sham palaces which ever vulgarized the eye of an unfortunate Demos.

But when you say to an artist that it is about time something was done to get rid of the whole graceless and stupid spectacle, he will *agree*, yes, but will quickly change the subject. Every law of common sense precludes any possibility of modification of this detestable sight, assailing all our eyes. He will either imagine that you are proposing some Utopia (as you are) or he will think that your notions hardly agree with the fashionable idea that all is for the best in the best of all possible worlds: that *whatever* reality accident (or your neighbour) flings at your head, your head should respond to in hollow acquiescence.

Of course there are good arguments that can be brought against you. I have made use of these arguments myself. We have just been adumbrating them in the section of this pamphlet entitled, 'The Bull Sounds'. But we will proceed to sift out with more thoroughness the Painter's argument; this time the argument of *any* painter.

Style, he will say, can transform anything whatever into gold. Take a convenient example. Suppose that Rembrandt had had a more interesting type of architecture before him, for subject-matter, in place of the homely mills by the side of the Dutch canals: would this better form-content have made one of his pen-drawings better drawings? To that there is only one answer 'No. It would not.'

But a windmill is a rough and simple contrivance, and there is a sad difference between the rough beauty and fitness of such objects stuck up centuries ago in Holland, and similar rough and simple objects built in the modern age in Great Britain. One would do better to imagine Rembrandt, working in the same way that he worked—doing similar drawings—in an industrial country like ours, in the twentieth century instead of the sixteenth.

Still you have to admit that as fine an artist as Rembrandt, by the magic use of the medium he chose, by his thick painterly line, by his tact of simplification and of elimination, would make a new thing of

whatever it was, however poor the original. Look at Van Gogh—though France, where he worked, was very different to industrial England. So in considering if it is worth while to change a single brick, even, or the most trifling ornament, however offensive, you would be obliged to admit that, as regards the production of pictures of great beauty, you would be no better off. The best half-dozen artists of any country, as regards the actual beauty and significance of their work, do not depend upon the objective world at all, for their stimulus to creation. Subject-matter you have to dismiss as unimportant.

As to all the thousands of artists, not amongst the most able or imaginative, but capable of something passably good, it is another story. *They* depend upon Nature, upon the objective world, from which their stimulus to work or their taste derives. Set a rather poor artist down on a camp stool out of doors, ask him to paint a picture of a street of houses in front of him. If the houses are of a good and significant build, he will be more likely to do a good and significant painting than if they are such clumsy, lineless, massless, things as we invariably find ourselves beset by today. If he has no invention or vision, the artist depends upon Nature. Nature must do at least half the work, then perhaps he will do the rest.

But the fallacy in the contention about *the good artist*, independent of subject-matter (for there is a fallacy) is this. Although he does not depend on Nature, he certainly depends upon *life*. He is subject to its conditions, and this surely re-acts upon his painting. If he is hungry, is disturbed in his work, or has to do some detestable type of commercial painting or designing to make a living, then this independence of external form and colour-content of his is clearly of little use to him.

Where the Painter would benefit

Upon this subject of *what we see*—of what our eyes are compelled to dwell upon, day in, day out, owing to the unsatisfactory way in which our cities are built and adorned—I have my views, as you see. I can perhaps help you to understand better what the problem is by stating it in the following terms.—Consider how I, or an artist like me, stands towards this problem. You see what my views are. What is the practical import of those views to me? It reduces itself to this: I have nothing materially to gain by your adopting this outlook. You are perplexed.

Painters are everywhere perplexed. I make you and them a present of this analysis of these perplexities.

I see, at all times, the shapes that you would see, were the applied arts and the art of building in better shape than at present is the case. I do not need to have a house built with significant forms, lines, or masses, and planted squarely before my eyes, to know that such significance exists, or to have my belief in its reality stimulated.

You, on the other hand, do require that. I am obviously here to be of use to you: I am at your disposal in this matter. But that is primarily your business and not mine. I can get on quite well, the artist always can, *without this material realization*. Theoretically, even, a creative painter or designer should be able to exist quite satisfactorily without paper, stone or paints, or without so much as lifting a finger to translate into forms and colours his creative impulse. It should be the same with the painter, the architect, or the sculptor as it is with the composer. (The Interpreter is really in the same category as the bricklayer, or at best a foreman of works.)

Still, I suffer somewhat all the same. This lack of readiness, or really of aptitude, on your part, to employ me usefully is none too good—and every true artist I know, painter or sculptor, is in the same box. Here is the trouble: it does not matter what objective Nature supplies. The inventive artist is his own purveyor. But the society of which he forms a part, can, by its backwardness, indolence, or obtuseness, cause him a great deal of inconvenience; affect his pocket adversely, cause him to waste an absurd amount of time.

In his final decrepitude—when he is old, and grey, and full of sleep— it would not be a waste of time for a painter or for a writer to lecture, or suchlike, upon the subject of his craft. Palsied and half-blind, that would be very proper. But the propaganda, explanatory pamphlets, and the rest, in which we, in this country, are obliged to indulge, is so much time out of our active life which would normally be spent as every artist wishes to spend his time, namely in producing pictures.

Yet were one's ideas of painting not formulated, and given out in the shape of a lecture, a pamphlet, or a critical essay, impossible conditions would result for an artist desirous of experimenting. Half his time at least, must be spent in these extraneous activities.

So when I say that I should like to see a completely transfigured world, it is not because I want to *look* at it. It would be a great mistake to suppose that. It is you who would look at it. It would be you who

would benefit by this exhilarating spectacle. *I* should merely benefit, I and other Painters like me, by no longer finding myself in the position of a freak—the queer wild men of cubes—the terrible *fauves* or wild beasts—or any other rubbish that the Yellow Press invents to amuse the nerves of its readers. Do you suppose that the art-man who reports on the present exhibition of French modernist pictures and describes the 'horror' of these canvases, really *thinks* that they are in any way hair-raising? Not a bit of it. He knows that for every extra thrill he makes an extra quid. Naturally it does not please me, or any other painter who paints pictures which appear extravagant, according to the pretty and facetious standard of this time, to be described as a wild man, or a 'man-eater' in paint. No pleasurable thrill accompanies these words when used about one's own very normal proceedings—rational transactions, since they appear to the painter the *only* rational transactions in the midst of the capers of the mild lunatic asylum it is our lot to inhabit.

The Public chosen

The public I should like for this pamphlet is a rather different one from that to which painters usually consider it worth while to address themselves. In the first place, any rank and file Royal Academy artist is fond of regarding himself as 'a craftsman'; as a specialist of the most dyed-in-the-wool, horribly professional order. He is the romantic guildsman of the Brush. The more furibundly ignoble his paintings, the farther he retires into the technical mysteries of his craft. Lay opinion consequently he scorns.

Then another pale exists, an even funnier one. Beyond that stand those multitudes who have not been taught a delightful faintness, a cheap catch in the voice, and the few dozen snobbish tricks of thought and hand coined in each decade for the lucky children of the rich. A board school master, an excise clerk, a douanier, for that matter, are usually approached if at all with every nuance of amused condescension that a stereotyped education can breed.

How sick such men must get with the wearisome and endless trifling that they have come to associate with the word Artist! I write in these notes for a socially wider, a not necessarily specialist, public. I write for the factory-hand, if by good luck this book should manage to reach him, as much as for the Cambridge aesthete or the Fashionplates of

Mayfair. The 'educated' are of course generally unteachable. Heaven forbid that I should aspire to educate the 'educated'!

Architecture

Architecture is the weakest of the arts, in so far as it is the most dependent upon the collective sensibility of its period. It is so involved, too, in utility, and so much a portion of public life, that it is far more helpless than painting and literature in the face of public indifference. Sculpture shares with it some of this helplessness. There are many good sculptors wasted today as thoroughly as anyone can be, through the absence of such conditions as are required to give them their chance of natural expression.

Had Gaudier Brzeska lived, he would be doing an odd door-knocker or two, an occasional paper-weight, or portrait bust, for a living, with all the limiting circumstances that personal vanity sets to the art of portraiture, whether in the flat or in the round. There only remains for the sculptor, as for the painter, the art exhibition, and the freak-selling or commercial selling of the dealer's shop. A man like Archipenko, for instance, quite capable of finer things, is reduced to stunt-sculpting of a dilettante sort, upon a small scale, and it may be assumed very ill-paid at that.

Have you ever met an Architect? I do not mean a prosperous *pasticheur*, who restores a house or runs one up, in Tudor, Italian, or any other style. I mean a creative architect, or a man with some new power in his craft, concerned with the aesthetic as well as the practical needs of the mass sensibility of his period? I never have, I may say at once. And what is more, should you wish to approach this neglected subject and learn more about it, you will find nothing but a dismal series of very stupid books, for your information and reference.

The best treatise I have come across is W. R. Lethaby's handbook, *An Introduction to the History and Theory of the Art of Building*. It appears to me to be an uncommonly sound book: if everybody were of Mr Lethaby's way of thinking we should soon find that the aspect of this lifeless scene had changed for the better. Furthermore this voice for the right and active vision comes from the unlikeliest quarter. For Mr Lethaby, I understand, is Chief Lecturer on Architecture in the South Kensington School.

But listen to this recognized authority of academic status:

'Modern armoured concrete is only a higher power of the Roman system of construction. If we could sweep away our fear that it is an inartistic material, and boldly build a railway station, a museum, or a cathedral, wide and simple, amply lighted, and call in our painters to finish the walls, we might be interested in building again almost at once. This building interest must be aroused.

'We cannot forget our historical knowledge, nor would we if we might. The important question is, Can it be organized and directed, or must we continue to be betrayed by it? The only agreement that seems possible is agreement on a scientific basis, on an endeavour after perfect structural efficiency. If we could agree on this we need not trouble about beauty, for that would take care of itself.

'Experience must be brought back once more as the centre of architecture, and architects must be trained as engineers are trained.

'The modern way of building must be flexible and vigorous, even smart and hard. We must give up designing the broken-down picturesque which is part of the ideal of make believe. The enemy is not science, but vulgarity, a pretence to beauty at second hand.'

What do you make of that? 'Must be . . . even smart and hard!' Does not Mr Lethaby, Professor of Architecture in the South Kensington Schools, speak to you in a tone seldom heard in the art-schools? What English Professor of painting would you find recommending his pupil to paint in a manner 'smart and hard'?

Such books as C. H. Caffin's contain nothing very useful. He refers to the Woolworth buildings in New York in the following way:

'Up to the present, the noblest example of this new movement is the Woolworth Building, which is not only the tallest of the tall buildings, but a monument of arresting and persuasive dignity. Such a building supplies an uplift to the spirit.' Etc.

The Woolworth Building, one of the tallest in New York, consisting of fifty-one storeys, is a piece of rudimentary ecclesiastical nonsense, twenty-five of its storeys being a spire. It is in every way less interesting than the less ambitious skyscrapers, which are at least enormously tall boxes, and by their scale 'uplift the spirit', that wishes to soar so high, far more than this Anglican monstrosity: which is not a church, however, and has not even that excuse for its stupid spire.

In this connection, we hear a great deal of claptrap talked about the skyscraper. The skyscraper, for the most part, is a tall box. So far it

has been nothing but that; except where, as in the Schiller Theatre Building in Chicago, or the famous Woolworth Building, some dreadful intervention of 'the beautiful' has converted it into an acre-high advertisement of the modern architect's fatuity.

It has been a fashion lately to admire the skyscraper in its purely engineering capacity, along with other forms of simple engineering. But a box is always a box, however high. And when you think of the things that could have been done by a liaison of the artist's fancy, once more, with all these works of engineering genius, you wonder that there is not one single example which one can quote of such a structure.

In the case of a dynamic shape like an aeroplane there is neither any reason nor any need for the collaboration of engineer and artist. All such machines, except for their colouring, or some surface design, to modify their shape, develop in accordance with a law of efficient evolution as absolute as that determining the shape of the tiger, the wasp, or the swallow. They are definitely, for the artist, in the category of animals. When we come to the static cell-structures in which we pass our lives there is far more latitude and opportunity for his inventiveness.

To begin with, let us by all means reduce everything to the box. Let us banish absolutely the stylistic architectural rubbish. But as to the shaping of the box or series of boxes let the artist be used.

For if you say that the surface design or ornaments which comprise the outer shell of the building is the same as the clothes on a man's back, there is still something to be said about the naked shape of the man or even about his skeleton. The nature of the nude body or of the skeleton will decide what the character of the clothes must be. So the artist should come into the picture long before he usually does, or give a new consciousness to the shaping of the skeleton of the Engineer. This should be invariable, not occasional: that is to say of course when the first painters or sculptors have come to be used for this purpose, instead of the horrible stock architect.

Remy de Gourmont expresses himself as follows on the subject of the decay of architecture in our time:

'Voilà le point capital de l'explication pourquoi on avait au moyen-âge le sens de l'architecture: on ignorait la nature. Incapables de jouir de la terre telle qu'elle est, des fleuves, des montagnes, de la mer, des arbres, ils étaient obligés, pour exciter leur sensibilité, de se créer, un monde factice, d'ériger des forêts de pierre.

'La nature s'ouvrit à l'homme parce que la France et le centre de

l'Europe furent sillonnés de routes, parce que les campagnes devinrent sûres et d'un commode accès.'

And he goes on to fancy that perhaps when nature has become too cheap, through its general accessibility, and men tire of it, that Art and Architecture will once more have their turn.

Since a narrow belt of land like the Nile Valley is more crowded with buildings, or their remains, than any other territory, and since the character of those buildings, the source of all subsequent constructions, was evidently determined by the nature of the landscape of Egypt, the hills, palms, and so forth, with which, further, the builders were at least as familiar as any men could be with nature, de Gourmont's theory would appear to be nonsense. It displays the listless and dull eye that a usually keen journalist can turn upon this Cinderella of a subject.

Child Art and the Naif

The Child and the Naif are two of the principal mainstays of dilettante criticism in this country—and practically all art-criticism in England is dilettante criticism, for art is an intellectual exercise, not a passion, for the English. This 'phenomenon' with all the sentimentality of which its exploitation clearly is susceptible, is one of the trump cards in the Amateur's game, and a fruitful source of confusion. It is one of the most obvious avenues by which the thoroughly undeserving can slip through into a position of artificial respect.

The Young Visiters is swelling into fabulous editions. Pamela Bianco, a child of nine, is fawned on by the hoary great. The Omega workshops have had an exhibition of children's drawings. The Naif is another doll-like dummy that the trader on sentiment pushes in front of him in stalking the public. The Naif is an elastic phenomenon: it is of earlier date, as regards its boom, than the child.

The Slade School produces regularly a certain number of professional naifs. They are frequently the most sophisticated individuals it is possible to meet. Beyond the fact that they wrestle with a slight incompetence, in addition to possessing a pretty feeling for the sentimentalities of rustic prints, they are no more naïve than Mr Horatio Bottomley. None are half as good at manufacturing naïvetés as are the French. Their graces and queernesses pall as swiftly as the tiresome mannerisms of a child, exploiting its childishness.

There are two types of Naif: the child-naif, and the primitive-naif. It is difficult to decide which is the more tiresome of the two.

The child-naif usually starts with a happy combination of an ingrained technical incompetence and of a feeling for the graces in the arts. Distressed that this feeling should be wasted owing to lack of power, he hits on the happy idea of bringing his lack of painter's prowess and his nice feeling for the arts together, and producing the very marketable commodity, Naïveté!

Or he may be a bit more definitely naïve than that. The woodenness of his figures or trees, his rickety line, may really have a pathetic charm for him. He genuinely pities his little wooden figures for being so wooden and silly-looking (a manner of pitying himself). He is sorry for himself through them. And this sensation grows upon him until it gets a hold; he goes on painting the little wooden figures. If he has been touched enough or, more likely, if his is a theatrical self-love, other people are touched: and the little wooden figures find a market.

The more literary pathos may be absent. That is another variety. The weak pathetic line, the meaningless forms, the unreal colour, are the object of a certain emotion: something that I can only describe as a technical pity, a professional pathos. The best is made of unfortunate limitation. This Naif may even become extremely bumptious in course of time, by the same process that produces the infantile swank of the deformed.

The Primitive-Naif may evolve rather in the same way as the Child-Naif, or he may not. It may be a refuge of incompetence. Or it may be a romantic mode, Teutonic in character. Then the Child-Naif and the Primitive-Naif sometimes come together in the same artist.

There is no such thing as the *born Primitive*. There is the *Primitive* in point of view of date, the product of a period. And there is the *Primitive voulu*, who is simply a pasticheur and stylist; invariably a sentimentalist, when not a rogue. When he is not specially an *Italian* or *Flemish Primitive*, but just a *Primitive* (whatever period he flits into *always* a Primitive), he is on the same errand and has the same physiognomy as the Period-taster, or any other form of dilettante or of pasticheur. The Primitive *voulu* acrobatically adapts himself to the mentality of a different stage of social development. The pasticheur, *en touriste*, visits different times and places merely, without so much readjustment of his mind as of his hand.

As to the Child proper. Of course the success of *The Young Visiters*

was partly due to its domestic appeal. Partly it was a sentimental curiosity. The distillation of Middle-class snobbery played its part as well.

Pamela Bianco, whose drawings are to be found in several fashionable periodicals, is like Daisy Ashford at least in one respect, namely: *she is not a child*. She may be nine years old, and *The Young Visiters* may have been written by a child of two. But they both have the sad relaxed quality of the average adult mind. They are as unfresh as that. Pamela Bianco's sensibility has naïvely devoured the Douanier's *Fête Nationale*. But that is the nearest she has come to naïveté. Otherwise she imitates Beardsley or Botticelli, or some fellow-child, with as sophisticated a competence as any South Kensington student. She is very exactly the aesthetic peer of the professional painter engaged in the same sweet make-believe.

The growth of the mind and of the body is so often not parallel, some people's 'mature' lives so long, others almost non-existent, that it is difficult to know where you are dealing with the art-product of the child, or, on the other hand, the child-like art of the adult.

Theoretically, a powerful nature should develop at once, disregarding the schedules of human growth and laws of probation. William Blake was a case in point: he took little notice of the dawdling ritual of intellectual expansion. But many individuals as adults have shown no precocity at all. Genius no doubt has its system of individual evolution appropriate to the character of the gift to be hatched out.

As regards the Naif—the real thing—Rousseau the Douanier is the only great Naif as far as I know. In his case Nature made on the one hand of his Douanier's calling a water-tight case against sophistication; then put something divinely graceful and simple—which we associate with 'childhood' and which that abstraction sometimes has—at his disposal for the term of his natural life.

Nothing seemingly could corrupt or diminish it; and it brought with it, like a very practical fairy, or like a sardine tin with its little key, an instrument with which to extract all the genius from within this Douanier of forty or fifty years old.

To return to the Child proper. The only case in which the drawing of a child is of value, is when it possesses the same outstripping or unusual quality that the work of a very few adult artists possess. Then what it does is not 'child-art'. That rare bird, the adult who is a true artist, may have accomplished nothing himself as a child: but the

drawing of the gifted child would seem perhaps to be his work at a more immature stage. It is not a question of Child or Adult then. It is a question simply of the *better being*. Both belong to an exceptional human type.

There is also a fresh and delicate charm of very young life that some children, not many, have the power of infusing into their drawings. And then there remains the melancholy fact that no infant's pictures could be duller than the average adult's. Consequently there is every bit as much justification for exhibiting any twenty children's scribbles as there is for exhibiting those of any twenty professional painting adults.

Machinery and Lions

The Italian Futurists had in their 'dynamic' *idée fixe* a great pull over the sentimental and sluggish eclecticism, the deadness and preciosity, of the artists working in Paris. But they accepted objective nature wholesale, or the objective world of mechanical industry.—Their paeans to machinery were stupid. It involved a mythical attitude towards a racing-car, or workshop where big guns (or Teddy-bears) are made—not a rational enthusiasm for the possibilities that lie in this new spectacle of machinery; of the technical uses to which it can be put in the arts. Machinery should be regarded as a new pictorial resource, as with a new mineral or oil, there to be exploited. A plant for the manufacture of the parts of a six-inch Mk 19 gun should be regarded apart from its function. Absorbed into the aesthetic consciousness, it would no longer *make* so much as a pop-gun.

Thenceforward its function would change. Through its agency emotions would be manufactured, related, it is true, to its primitive efficiency, shinyness, swiftness or slowness, elegance or power. But its meaning would be transformed. It is of exactly the same importance, and in exactly the same category, as a wave upon a screen by Korin, an Odalisque of Ingres, the beetle of a sculptor of the XVIII Dynasty.

Ingres lived among people consumed with a great appetite for the pseudo-classic: the Egyptian sculptor lived in the presence of a great veneration for the Beetle. Korin's contemporaries possessed a high susceptibility and sentiment for objects of the natural world. Korin's formal wave-lines is the same impulse as Balla's *Linee andamentali*. The Beetle and the Odalisque are both sleek and solid objects.

Ingres probably did not believe in the Odalisque as an Odalisque, although realizing the admirable uses to which an Odalisque could be put. The Egyptian probably found the beetle objectionable until transformed into stone. And there should be no obligation to behave like a religious fanatic about a sausage-machine or a locomotive. Other people can make parade of such mystical emotions—perhaps it is proper that they should: not the artist. If the world *would only build temples to machinery in the abstract* then everything would be perfect. The painter and sculptor would have plenty to do: they could, in complete peace, and suitably honoured, pursue their trade without further trouble. Else where is the sense in taking all the useful Gods and Goddesses away, and leaving the artist without any communal role at all, except that of an entertainer, or perhaps a business man?

Imagine Koyetzu, Signorelli, or the sculptor who carved the head of Akhenaton or of the wife of the Sheik-el-Beled, alive, painting and carving, today. They would have been in the profoundest sense the same artists. But just as a painter may use one medium one day and another the next; so far more than mere traces of the fact that they had seen with their eyes the machines that play such a great part in contemporary life would be found in their inventions. Just as the sculptors of Nineveh put the lions that were such immediate objects of their daily environment to good use in their reliefs, or the painters of the Sung period the birds and landscapes found by them in their wilful seclusion; so it was inevitable today that artists should get into their inventions (figures, landscapes, or abstractions) something of the lineaments and character of machinery. An artist could excel, no doubt, who never in his pictures revealed an acquaintance with anything more ferreous than a mushroom. But you would not be liable, I suppose, to pick a quarrel with the artists of Asshur because they used the lions at their doors?

The Artist's Luck

The best artists of the Sung period lived a secluded life, very luckily for them. It was considered incumbent upon them, in accordance with contemporary feeling, to inhabit the fairly distant country and live in intercourse with the objects of Nature. When this fashion passed, and a painter had to live within hailing distance of the court, the pictures produced showed an immediate decline in quality. That is *one* lesson.

The scenes in the Assyrian bas-reliefs from Nineveh were produced by an artist who led an unlucky kind of life. He was hurried about by the king in his *razzias* and hunts: no sooner had the party (a marauding or a hunting one) returned to the city than the harassed sculptors had to rush to their workrooms and produce by the next morning a complete series of bas-reliefs describing in flattering guise the exploits of their diabolical idiot of a master. For no sooner had he slept off the fatigue induced by the last of an incessant series of displacements, than he insisted upon seeing what he had looked like to his band of performing sculptors during the last week or two. Their heads probably fell like apples in an autumn wind; though there is seemingly no record of his ever having had sculptors enough to build up their skulls into a pyramid which is what he liked to do with heads, when there were enough of them. How these craftsmen succeeded in doing such good lions it is difficult to say. Perhaps the ones who did the good lions were left in a privileged peace sometimes. But on the whole, a sculptor fated to work for Asshur's deputy would no doubt have regarded the Sung hermit, his opposite number in China, as the luckiest old yellow crab that ever painted.

It has occurred to me that we might be worse off than we are. But I can see no reason why we should not be better off still: hence, partly, this pamphlet.

PART II

The Artist Older than the Fish

The artist goes back to the fish. The few centuries that separate him from the savage are a mere flea-bite to the distance his memory must stretch if it is to strike the fundamental slime of creation. And those are the conditions—the very first gusto of creation in this scale of life in which we are set—that he must reach, before he, in his turn, can create! The creation of a work of art is an act of the same description as the evolution of wings on the sides of a fish, the feathering of its fins; or the invention of a weapon within the body of a hymenopter to enable it to meet the terrible needs of its life. The ghostly and burning growths— the walking twigs and flying stones—the two anguished notes that are the voice of a being—the vapid twitter; the bellows of age-long insur-

rection and discontent—the complacent screech—all these may be considered as types of art, all equally perfect, but not all equally desirable.

The attitude of instructed people as regards 'the artist' has changed. It is mixed up with, and depends a good deal upon, the precision with which they apply this term. With the grotesque prostitution of the word Artist, and its loose and paltry meaning in this country, I will deal in a separate section. A German philosopher, living in the heyday of last century German music, propounded the theory of an *aesthetic* justification of the universe. Many people play with this notion, just as they play with Art; but we should have to disembarrass 'art' of a good deal of cheap adhesive matter, and cheap and pretty adhesive people, before it could appear a justification for anything at all; much less for such a gigantic and, from every point of view, dubious concern as the Universe!

The artist's function is to create—to make something; *not to make something pretty*, as dowagers, dreamers, and art-dealers here suppose. In any synthesis of the universe, the harsh, the hirsute, the enemies of the rose, must be built in for the purposes as much of a fine aesthetic, as of a fine logical structure. And having removed the sentimental gulf that often has, in the course of their chequered career, kept Sense and Beauty apart, we may at this stage of the proceedings even refer to their purposes as one.

Fabre describes the creative capabilities of certain beetles, realizable in their own bodies; beasts with a record capacity for turning their form and colour impulses into living flesh. These beetles can convert their faces into hideously carved and detestable masks, can grow out of their bodies menacing spikes, and throw up on top of their heads sinister head-dresses, overnight. Such changes in their personal appearance, destined to inspire terror in their adversaries, is possibly not a very profound or useful invention, but it is surely a considerable creative feat. Any art worth the name is, at the least, a feat of that order. The New Guinea barred and whitewashed masks are an obvious parallel. But any invention or phantasy in painting or carving is such. As to the wing mechanism that first lifted a creature off the ground, and set it spinning or floating through the air, you must call Shakespeare in to compete with it. Ma Yuan we can consider, roughly speaking, as the creator of the first tree; or substitute for him the best artist, who has painted the best tree, that you can call to mind.

The more sensible we grow about the world, the more sensible we grow about the artist. We are really more in sympathy with a bird or a fish today than we have been for a considerable period. And while people at large are being forced, by snobbery, into a less anthropomorphic mood, they find, with some awakening of respect, traces and odd indications of the artist's presence everywhere they go beyond their simian pale. The artist, we all agree, was the first scientist! His 'inhumanity' is so old that he looks with an understandable contempt upon that upstart growth of the Machine Age.

We have got out of our anthropomorphism, then, to this extent: that it is today as respectable to be a fish, as it was in the latter part of the last century to be a 'savage'. The Robert Louis Stevenson, George Borrow, 'back to Nature' Englishman (not an artist-type at all) is as dead as a door-nail. It is the artist-type, even, that has prevailed in the philosopher's mind, the latter's dogmatism correcting itself by a careful liaison with the spirit of the artist.

We no longer dream about earlier communities, since we know more about them, or long for some pristine animal fierceness, or abundant and unblemished health. We realize how every good thing dates; we grasp better the complexities of life's compensations. That does not mean that we are satisfied with today's conditions any more than we covet those of the Hereros or Hawaiian natives to a morbid degree. Generally speaking, an intelligent modern man does not place his paradise in the Prairie or in the heart of some wild Highland clan, although envying the great and simple assets that such plain conditions imply. He has caught a glimpse of something more subtle and to him more satisfying. He really at last has a vision of his own; it plunges him back to more refreshing energies and oblivions than the noisy and snarling claptrap of tribe and clan.

'The artist' formerly was identified with the savage or the schoolboy to a disobliging extent. This was in the main by thinkers impatient with the gushings and heroics of a type of rhyming or picture-painting crétin, or subman. Chelsea and Montmartre were romantic names. This disagreeable bohemian was as conservative as a woman, full of noisy protest at the draining and rebuilding of slums, which he would have 'saved' on account of their paintability and picturesqueness. Clearly this masquerader, this bechevelured nonentity loaded with rusty broadswords, Spanish knives, sombreros, oaths—the arch-priest of the romantic Bottle—was not an artist-type. Gauguin was not an

artist-type. He was a savage type addicted to painting. He was in reality very like his sunny friends in the Marquesas Islands. He was in as limited a way a savage as an American Negro. Such people are savages who go in for art for motives of vanity or of disguised sex. Theorists build their generalizations about the artist upon such human bric-à-brac. Gauguin appears like a vulgar tripper by the side of Cézanne.

The music of *Carmen*, the *Prince Igor* ballet, all the 'savage stuff' that always gets the audience, is where the artist is supposed to have his home. The truth is this: in the trek of the imagination, of however feeble powers, from any man's Present outwards in whatever direction, the first region struck is the Savage time—clash of cymbals, howl of clansmen, voluptuous belly-dance, Caucasian cartridge-pockets, casta-nettes, and vendettas. This is about as far as a respectable Public-school fancy takes you. It is like a scene from the more boring of the Russian ballets or a Victory Ball. There *all* the 'Chelsea artists' are to be found, every form of artist—far too many artists, in fact, and far too few straight savages. But the on occasion festive philosopher is a bit of an 'artist' of that sort himself. And it has been from such regions and hobnobbings that he has borne away his stereotyped convictions as to the nature of 'artists', and their abode in time. It is only since more adventurous men have pushed out beyond this sententious belt of savage life into less tawdry regions, that a new type of 'artist' has arisen, demanding a new classification. Incidentally he has disposed already of much of the prestige of the falsely labelled herds of submen.

The Physiognomy of our Time

Life, simply, however vivid and tangible, is too material to be anything but a mechanism, and the sea-gull is not far removed from the hydro-plane. Whether a stone flies and copulates, or remains respectably in its place, half hiding the violet from the eye, is little matter. It is just as remarkable to be so hard and big as to be so busy and passionate; though owing to our busyness and passion we have a shoppy interest in the hurrying insect that we do not display for the stone.

Life has begun, as language, for instance, begins, with a crowding and redundance which must be thinned out if the powerfullest instincts of life, even, are to triumph. Where everything is mutually destructive, and where immense multitudes of activities and modes of life have to be

scrapped, it is important not to linger in ecstasy over *everything*, simply because it *is*. Nor should we sentimentalize about Life where creation is still possible and urgent; where much life, although pretty, powerful or bewitching, interferes with and opposes the life of something still more bewitching and strong.

The genius of the executant in art, as much as the curiosity of the amateur, assume in their promiscuous tasting an equal perfection in everything that succeeds in living, happens to move as swiftly, or far more swiftly, for its size, than the swiftest motor-car; or to fly as infallibly as the most perfected plane we can imagine. And the impresario of the Futurists (with his Caruso tenor-instincts of inflation, of tiptoe tirade), involved himself, in his rant about *speed*, in the same position. He might, ten thousand years ago, have ranted about the lizard or the dragon-fly, with a deeper wonder at the necessities and triumphs their powers of displacement implied.

An act of creation in art is as far removed from the life of the fashionable chattering animal as is the amoeba from the monkey. Truth is as strange a bird as ever flew in a Chinese forest. What shall we do with it? Does it require a drab and fickle world to shine in? Can it thrive in anything but a rich and abundant setting? Shall it be allowed to become extinct, made war on by some ill-favoured reptile? Should it be caught and dispatched to the Zoo and fed by horrible Cockney brats upon stale buns? It is in any case difficult to admit the claims of the stuffed birds we have occasion to mention, to peck at and to refill themselves on the carcase of this more splendid creature.

We know that all intellectual effort indicates a desire to perfect and continue to create; to order, regulate, disinfect and stabilize our life. What I am proposing is activity, more deliberate and more intense, upon the material we know and upon our present very fallible stock. But that stock must be developed, not in the sense of the prize bullock, not simply fattened and made sleek with ideas proper to a ruminant species. It should become the soul of things in this universe; until as a bird a man would be a first-rate organism, and, even as a bullock, be stalled in a palace. Let us everywhere substitute ourselves for the animal world; replace the tiger and the cormorant with some invention of our mind, so that we can control this new Creation. The danger, as it would appear at present, and in our first flight of substitution and remounting, is evidently that we should become overpowered by our creation. Our society might become as mechanical as a tremendous insect.

When I assert that the aspect of life, the forms that surround us, *might*, perchance—without too great a sacrifice on the part of the painter, without too great a disturbance for our dear conservatisms and delicate obstructionisms—be modified, I start from Buddha rather than from Lipton, Vickers, or Fokker. But I start from Buddha with so much of passion and of Zeitgeist as he would have developed living in our midst today; familiar with and delighting in the pleasant inventions and local colour of our age—drinking Buchanan's Scotch whisky, smoking Navy Cut or Three Nuns; familiar with the smell of Harris tweeds, Euthymol, and the hot pestiferous Tube wind.

I do not recommend any abstraction of our mental structure. No more definite unclothing than to strip till we come to the energetic lines is desirable.

Supposing that we destroyed every vestige of animal and insect life upon this planet, and substituted machines of our invention, under immediate human control, for that mass of mechanisms that we had wiped out, what would be the guiding principle of these new species? The same as at present, the wild animal and insect forms? Would we domesticate the universe, and make it an immense hive working for our will; scavenging, honey-making, fetching and carrying for man? Or what?

It is not a bird-like act for a man to set himself coldly to solve the riddle of the bird and understand it; just as it is human to humanize it. So we do not wish to become a vulture or a swallow. We desire to enjoy our consciousness, but to enjoy it in all forms of life, and employ all modes and processes for our satisfaction. Having said *all* forms, we get back once more to the indiscriminate, mechanical and unprogressive world that we first considered. Only now we have substituted, in fancy, an approximate human invention for every form of animate existence. It is evidently not this hungry, frigid and devouring ethos of the scorpion, the wild cat or the eagle that we are disposed to perpetuate. However, every living form is a miraculous mechanism, and every sanguinary, vicious or twisted need produces in Nature's workshop a series of mechanical gadgets extremely suggestive and interesting for the engineer, and almost invariably beautiful or interesting for the artist.

The rant around machinery is really, at bottom, adulation for the universe of creatures, and especially the world of insects. So the froth of a Futurist at the mere sight of a warplane or a tank is the same as a

foaming ode to the dragon-fly or the sea-gull; not for any super-mechanical attribute of the fly or the bird, but simply because one is a flying insect and the other a bird. And this all-inclusiveness of the direction of our thought is the result, primarily, of the all-inclusiveness of our knowledge.

The Gothic stonemason, whose acquaintance with other forms of art than those he practised was no doubt nil, was better off than we are. Similarly, the Modern Man, the abstraction that we all go to make up, in absorbing the universe of beings into himself and his immediate life with his mechanical inventions, is equally in the position of the dilettante.

What is his synthesis going to be? So far it has been endless imitation; he has done nothing with his machinery but that. Will he arrive where there is no power or enjoyment of which other living things have been capable which he will not, in his turn, and by a huge mechanical effort, possess himself? If he is amused enough with his intellect to give that *carte blanche*, his individual existence as an ape-like animal will grow less and less important.

As already man's body in no way indicates the scope of his personal existence (as the bear's or the spider's indicates theirs) it cannot any more in pictorial art be used as his effective expression. But that is not to say that a plate of apples, a piece of cheese or a coal-scuttle can. (This choice of objects is with reference, of course, to the subject-matter of much current painting, which is *too* unheroic in its ingenious tastefulness.)

There is in the inorganic world an organism that is *his*: and which, as much as his partially superseded body, is in a position of mastery and of higher significance over the cheese, the coal-scuttle, or the plate of Provençal apples.

Fashion

Fashion is of the nature of an aperient. It is a patent stimulus of use only to the constipated and the sluggish: it is the specific for the second-rate, to correct the stagnations that are perpetually gathering where life is poor and inactive.

The Victorian age produced a morass of sugary comfort and amiableness, indulged men so much that they became guys of sentiment—or sentimental guys. Against this 'sentimentality' people of course reacted.

So the brutal tap was turned on. For fifty years it will be the thing to be brutal, 'unemotional'. Against the absurdities that this 'inhuman' fashion does inevitably breed, you will in due course need some powerful corrective.

Such are in fact our *fashions*, as we call them: a matter of the cold or the hot tap, simply. The majority of people, the Intellectuals, the Art World, are perpetually in some raw extreme. They are 'of their time' as a man is typically of his country—truculently Prussian or delightfully French. So there are some people who like cold in its place and hot in its place, or cold and hot *out* of their place; or the bath mixed to some exact nuance.

Actually how this phenomenon of *fashion*, in the art of painting, works out is that Van Gogh, Praxiteles, Giotto, the best stone carver of the VII Dynasty in Egypt, or the Hottentot of talent, are far more alike and nearer to each other than any well-defined type-man of the contiguous ages of Queen Victoria and George V, separated by no more than sixty years. It is at no time unnecessary to point out that what takes the glamour and starch out of the Chinese pigtail and the white hood of the Carmelite is when the pigtail proceeds from the scalp of Lao-Tse and the nun's coif surrounds the adorable features of Saint Theresa. East is East and West is West, and upon a Macaroni meeting a post-Georgian swell both would bristle with horror, and behave like cat and dog. But some men have the luck to possess a considerable release from these material attachments. They are blessed with a powerful hearing which enables them, like a woman in a restaurant, to overhear the conversations at all the neighbouring tables. They can gaze at a number of revolutions at once, and catch the static and unvarying eye of Aristotle, a few revolutions away, or the later and more heterodox orb of Christ.

PART III

French Realism

The French talent is not quite happy nor satisfactory in either its 'classic', its 'romantic', or its 'scientific' manifestations. As a great 'classic' or traditional artist you get an Ingres. About Ingres at present a considerable cult is in process of springing up: whether it is a dealer's

ramp or a piece of French (and Allied) sentiment it is difficult to say. Probably it is both. But in the teeth of any fashion it should be easy to discern that Ingres, with all his dreary theatrical costume pieces of the classical genre, is not as satisfactory an artist as Giotto, let us say, nor, for that matter, as Raphael. His malicious and meticulous portraits give him a permanent and peculiar place. But it is not the place, nor quite the kind of place, that is being prepared for him. To admire Racine or Corneille, similarly, is an amusing affectation in an Englishman, but those dramatists are trivial beside the Greeks. If it is true, for instance, that Racine should be praised for his psychological insight, I prefer to find psychological insight without going into such a barren region to look for it. As a Romantic, again, the Frenchman is a failure. Compared with the better equipped romantics of more romantic nations he falls a little short. Delacroix and Géricault are great romantics, but Burne-Jones, Böcklin, and Turner have them beat: or in the literary field, Victor Hugo has to hand it to Hoffmann, Dostoyevsky, or Scott.

When he becomes scientific in a reaction against Romance or Traditionalism, as in the case of the Impressionists, or Pointillistes, in painting, the Frenchman becomes *too* scientific. This is, of course, to be thoroughly carping: but that is what we are doing, so let us be thorough. The next thing you notice, having come to these disobliging conclusions, is that a variety of Frenchmen, Stendhal, Flaubert, Villon, Cézanne, Pascal, a big list, do not fit into the French national cadre. They have less local colour than the successes of the other European countries. Dostoyevsky, the most intoxicated of his worshippers must concede, has the blemish of being sometimes altogether too 'Russian' to be bearable; too epileptic and heavy-souled. Turner had too much of the national prettiness of the 'dreamy' Englishman. Even Goethe is much too German.

French Realism means, if it has a meaning, what these best Frenchmen had. They were almost more *real* than anything in the modern world. They have made France the true leader-country. But it is not what people generally mean, in this land or elsewhere, when they talk about the 'realism of the French'. Reality is the desideratum, not 'realism'; and to find that, you must watch for some happy blending of the vitality of 'romance', the coldness of 'science', and the moderation of the classic mind.

The Uses of Fashion

How are we to regard the European movement in the visual arts that has succeeded the Impressionist movement ? As the revenge of Raphael, a pilgrimage to Dahomey, a reawakening of austerity—as a barbarous or a civilized event ? Creative Line once more asserts itself; the rather formless naturalism of the Impressionist evolves into what once more are synthetic and constructed works. The tenets of catching the Moment on the hop; of snapshotting that Moment of Nature with the eye, and so forth, gave way before the onslaught of Invention, recuperated, and come out of its disgrace. Impressionism was really a period of decay, or one of humdrum activity. It was a scavenging the ground after the riots and too popular festivities of the Romantics.

But then your view of these movements will depend on what latitude you allow to human enterprise: how closely you examine the possibilities of any short individual life: and whether fanciful claims of Progress excite you or not.

Three or four main human types—about as many as there are large sub-divisions of the human race—Yellow, White, and Black—wrestle about with each other, rise, flourish and decay, then once more ascend. The only flaw in this parallel is that the Black race may die out, the Yellow predominate, or all races mingle in a resultant grey-yellow mixture. But the types of mind are likelier stubbornly to persist and maintain their struggle for mastery.

There are different kinds of Romantics, different sorts of Classics, and so forth. But in any movement you may be sure that one of these great warring sub-divisions is at the bottom of the disturbance. It may be composite. A movement at once Scientific and Classic is possible, for instance. And all individuals are so mixed in any case.

Cézanne, considering himself probably an Impressionist, as nominally he was (only with, he would tell himself, a way of his own of doing Impressionism) has turned out to be something like a pure classic mind. Derain, one of the two or three most conspicuous figures in French painting today, is almost a pure Romantic, in feeling, and capable of every sentimentality. This is natural in a man for so long a disciple of Gauguin, and the pasticheur of Rousseau the Douanier, as we find him in his ballet, 'La Boutique Fantasque'. Yet he has a deep classic strain. Picasso has dealt, in earlier periods of his work, in every sentimental and romantic flavour. Most men with energy and illusion

F

enough in them to do the finest work have something of the complete, composite character that I have in the preceding section attributed to the most representative Frenchmen.

But a perfectly balanced, divinely composite, *movement* is an impossibility. Anything so intelligent or so good as that is out of the question.

In the first place, that class of universal minds is such a small one, that the rare existence of such individuals is quite independent of movements. In the second place, were there numbers of such men co-existing their aggregate of work would not be a *movement*. It would be the reverse of that. Any movement of such an obvious sort as we are considering would bring them away from their centre. And for that they are disinclined.

So any movement is largely either a Romantic invasion, or Romantic reaction: a Classical or a Scientific one. It usually will have the character of these limiting sub-divisions. It is the swing of the pendulum from extreme to extreme: it is the superficial corrective and fashionable play of the general sea of men. So all men must wear black in one generation, green in the next, then white, then black again: for that uniformity is a law that cannot be contradicted. Fashion is the sort of useful substitute for conviction. At present it is the substitute for religion.

So you get the cry against tradition, the cry against emotion; or against superstition, or against science. Men's consciousness can grasp one of these ideas only at a time: they cannot work except under the spell of Fashion—that is, the particular conformity prescribed for their own particular generation.

The work of any artist under this spell of fashion, unable to function without this stimulus, and to see beyond this convention, dates very quickly and is seldom remembered after his death, except through some prank of the erudite, or some accident of history. But this slavery to fashion is a different thing from the acceptance of the data and atmosphere of a time. Rowlandson could evidently have existed, from the testimony of his work, in no other period than the eighteenth century. He *used* the spirit, the form-content, the dress, the impressionability of his time with an uncanny completeness. But had he been one dependent upon fashion he could have done nothing of the sort; for then he would have been far too afraid of what he handled, and far too obliged to it, to develop it in that bold and that *personal* way.

I would apply this analysis of the general character of 'movements' in order to present events in the art of painting.

To a good painter, with some good work to do in this world (if you will excuse this Carlylean way of putting it) the only point of the 'new movement' that he finds there when he comes on the scene (for there is *always* a new movement) is quite cynically recognized to be a movement that suits *him*. To look for anything more than the swing of the pendulum would be an absurdity. That *more* is supplied at the moment of every movement by the individual. And the painter who is at the same time an individual and the possessor of that 'more', is not likely to try and find in a movement what he has in himself. It is for the public to take 'movements' seriously—not for the artist.

Still, the individual, although ideally independent of the flux and reflux, is beholden to conditions and to the society in which he finds himself, for the possibility to deploy his gifts. So the 'movement' in art, like the attitude of the community to art, is not a thing to be superior about, though it is a thing to which you may be superior. And really it is the same type of man who advertises a sceptical aloofness as regards any activity directed to *improve* the conditions around us (*i.e.*, our own condition) who shows himself the most unimaginative and cringingly fashionable in respect of what he produces as an artist—the most assiduously up-to-date, the most afraid of opinion.

This movement in painting which was making such a stir in the civilized centres of Europe in 1914, just before the Great War hit us, really looked as though it were going to be the goods from the standpoint of its uses for the best talents. Opportunities, through the successful, even victorious, progress with which the campaign began, seemed to be indicated, for the full inventiveness of the human mind to get once more into painting. This was at least a refreshing prospect, after the Impressionist years, during which this full inventiveness could show itself in painting only in some ingenious disguise, or risk denunciation: or else pretend that it had really come to examine the gas meter, to grind colours, or to scrub the floor. All seemed for the best: very much for the best! But naturally the ragtag and bobtail of the 'movement' would not regard it in that severe light; for them it would be Le Mouvement, as who should say the Social Revolution, presided over by God Fashion, who is another form of the Goddess of Liberty.

So, has the worst happened? As far as Paris is concerned, has the revolution turned into a joke, as it is always liable to do in a Latin city? Or into some crafty bourgeois reaction?

Let us recapitulate the reasons that would induce an individual

painter to support this movement, engage in it, and use it as a medium—optimistically. The creative line, the massive structure, imagination untrammelled by any pedantry of form or of naturalist taboo; a more vigorous and permanent shaping of the work undertaken; these were the inducements and the prizes. The movement also developed a cult of experiment which allowed of any combinations and inventive phantasies. All the notions of the scientist as they came along could be employed without a foolish outcry. But this liberty and these opportunities also begot a necessity for moderation, or rather *concentration*, which would have been a vice in any age of repressive and academic tyranny. The painters have been thankful for this disembarrassing of the ground, for these splendid opportunities. They do not want to *lose* what has been won as a consequence of the infatuation for some effete mode, that there is no rhyme or reason to succumb to, apart from the megalomania of an individual artist, or the promptings of his business sense.

They do not in fine wish to be involved in the mere *acrobatics* of freedom. Freedom bristles with unexpected tyrannies. It would not have been easy for Cézanne, the laborious innovator and giver of this freedom, to do so; but any very able and at the same time resourceful artist could invent you a new mode every week-end without any difficulty. Some new stylistic twist can be thought up; some new adaptation of a scientific notion. Such a volatile and protean technique has its attractions. This is not, however, what is needed. If he can do nothing *else* than that, he must be allowed to go his way in peace, his chief praise a paean to his agility.

How we *need* and can *use* this freedom that we have is to invent a mode that will answer to the mass sensibility of our time with one voice, not with a hundred voices. We want to construct hardily and profoundly without a hard-dying autocratic convention to dog us and interfere with our proceedings. But we want *one* mode. For there *is* only one mode for any one time, and all the other modes are for other times. Except as objects of technical interest and indirect stimulus, they have nothing to do with us. And it is not on the sensibility of the amateur, which is always corrupt, weak, and at the mercy of any wind that blows, that the painter should wish to build. It is on the block sensibility, the profoundest foundations of his particular time.

What we really require are a few men who will *use* Fashion—Fashion understood as the ruler-principle in any age, the avenue through which alone that age can be approached. We desire that there should be a few

men to build something in Fashion's atmosphere which can best flourish there, and which is the right thing for that particular chronological climate.

Picasso and the men associated with him appear to have taken their liberty at once too seriously and not seriously enough. Picasso has turned painting into an affair of *modes*—we should not turn the blind eye to that fact. He has impregnated the art of painting with the spirit of the Rue de la Paix. He really has settled down to turn out a new brood of *latest models* every few months, which are imposed upon the world by the dealers and their journalistic satellites, just as a dress-fashion is. This, obviously for painting at large, is a bad thing. Picasso's output is something like brilliant journalism of the brush. But a highbrow fashion-expert, *obliged* to seek for an obvious novelty every season, or half-season, is an unsatisfactory sun for a system to have. A less inconstant source of energy would be preferable.—But, of course, all this is in all likelihood not Picasso's *fault*.

Cézanne

When that very useful process of reaction occurred in the art centres of Europe twenty years ago, the Impressionists came in for the customary heavy reversal of opinion. But the root theories of the Impressionists remained in the consciousness of the new men. Completely as they might imagine they had discarded Impressionism, Naturalism, and the rest of that movement, Impressionist compunctions and Impressionist fetishes could be found at every turn in the new painting.

There was nothing wrong with this. The Impressionists did much good work, their experience was a useful one to inherit. This would not be apparent to the rank and file of the new movement probably, but must have been to the leaders. And it was these leaders who cast round and went through their immediate heritage once more before finally discarding it. In turn the familiar faces of Degas, Manet, Renoir came up for inspection. Also Cézanne.

Cézanne came up rather crabbed and reluctant: a little aloof, and with something in his eye liable to awake distrust. And sure enough suspicion awoke—in fact, what the journalist would describe as a 'shrewd' suspicion grew up that this still second-class artist, as it had been thought—a rather incompetent, though well-meaning old fellow—had something very useful and new in him. He was probably more a portion of the new

sensibility, and possibly of more intrinsic importance altogether, it was decided, than any of his Impressionist contemporaries put together.

This suspicion grew into a furious conviction, that a very great artist had been unearthed. Cézanne became the most fashionable art figure in the world. So much so that it is impossible to write three lines about painting today without mentioning his name.

Matisse has not much to do with Cézanne. But the whole cubist movement comes out of him. Picasso is described by André Lhote as 'the Interpreter of Cézanne'. More apples have been painted during the last fifteen years than have been eaten by painters in as many centuries. But—for we must study the *buts*. It is a pity that this figure is so solitary. The only advantage is that at least there you have a condition favourable to homogeneity—to concentration of effort.

This one, very narrow, personality; enamoured of bulk, of simplicity, of constructive vision; sombre and plain as could be found surely *he* should be a boulder against diffusion—against the inroad of anything like a dilettante, undiscriminating sensibility.

But possibly the weakness inherent in this first condition, that of a *lonely source*, has left a loophole for the irresponsible, disintegrating passage of the eclectic. I do not feel that Cézanne would have agreed to Ingres, much less to David. But he would be asked today to agree to Everything—five minutes devoted to each item.

Cézanne remains the father and prime source of all contemporary inspiration in the art of painting. And it is the oddest of ironies that such a one-track intelligence as Cézanne should be responsible for such a chaotic fusillade of styles and stunts: that this great monogamist—this man of *one Muse* if ever there was one—should have ushered in a period of unexampled pictorial promiscuity, and universal philandering.

The General Tendency in Paris

In Paris there is a great profusion of 'advanced' work being done, in the art of Painting and Design, which can roughly be classified as follows (not necessarily chronological). Inevitably the degree in which a painting at present is considered 'modern' is decided simply by its relative 'abstractness'. This follows from the very physique, as it were, the startling properties of Abstraction. Whereas formerly it was a mere question as to whether you should paint a naked female refined to some

Greek type of the 'beautiful' animal, or on the other hand should choose her coarse, and give the Public a bit of the 'real stuff'—some lumpy Flemish frame squatting upon the edge of a dingy bathtub (the undraped Saskia, or Degas, or the facile Japanese realists); and whereas over periods of fifty years these opposing females were bandied about, and it took half a century for the 'Modern Art' of the time reluctantly to espouse one beauty, having laboriously divorced the last; *today* it has been found possible and expedient, within the trivial space of ten years, entirely to eliminate from the face of the earth the naked, clothed or other female—every vestige or tatter even of a human being at all, from the horizon of the purest, of the latest, art.

This is how the public views this matter. And the public, the ruffled, shaken, gasping but rather pleased, though not very helpful public, influences in its turn the Artist; and so back again.

Among the few hundred painters who form the façade of the temple of Fashion in Art, according to the above criterion of 'modernness' it is Kandinsky who is the most advanced artist in Europe. Matisse, I suppose, of the same elect *avant-garde*, is the most leisurely, or the least furibundly outstripping. His 'funniness' consists in distortion, of a simplicity akin to the facile images of French caricature, and a certain vivacity of tint, often, in his pictures, nothing more.

To proceed with these classifications Cézannism is by far the most widespread Paris mode. As Cézanne is at the bottom of 'Cubism', he has really effected, by the tremendous sincerity and certainty of his work, a revolution in painting, and has made new eyes for a crowd of men. In the recent French exhibition fifty per cent of the work was monotonously Cézannesque. In the best respected painter there, Modigliani, the heads of his sitters inclined to this side or that, because Mrs Cézanne, during the interminable sittings she must have undergone, drooped her head stoically and brutally in that fashion. She is, as it were, the leader of a chorus of (from the standpoint of the theatre queue) very plain and even preposterous females. Similarly, that the hands meet and are crossed in the lap is a trick or habit in the search for the compact and simple, that was Cézanne's occupation. Was there any lack of apples on tables? Did jugs abound? Were rigid napkins and tablecloths in evidence? Yes, they were ubiquitous in that exhibition, as in every other modern exhibition of the last eight years. Most of these things are a little more garishly coloured than were Cézanne's still-lifes, and side currents arrive in the midst of the bed of apples and crockery, from Vuillard,

from Matisse or from Van Gogh. But Cézanne is at the bottom of it, and will be for many a day.

The Futurists, and their French followers, have as the basis of their aesthetic the Impressionists generally. They are simply a rather abstruse and complex form of the 1880 French Impressionists. Their dogma is a brutal rhetorical Zolaism, on its creative side, saturated with the *voyou* respect and gush about Science—the romance of machinery engraven on their florid banner.

Matisse and Derain

Matisse at his best is certainly as good a painter as any working in Paris today. He possesses more vitality than Picasso; and he appears to have more stability—as a result possibly of that. Matisse has had far less influence than Picasso; he is in every way a different mentality. Derain, similarly, beyond influencing Picasso at a certain period, does not come within the scope of my immediate purpose.

Of the names of artists working in Paris well known to us here, most are those of foreigners, not Frenchmen. Matisse, Picasso, Gris, Modigliani are Belgian, Spanish, Italian. This is a new thing in France—that all its representative artists should be foreign. But outside of the large groups of artists working in Paris there are other European artists, some of equal note, and of equal importance in the history of this movement. Kandinsky among them, was, I believe, the first painter to make pictures of purely non-representative forms and colours. Kandinsky, with his Expressionism, is probably the most logical of the artists directing their attention to abstract experiment. He is not obsessed by *nature-mortes*; nor does one find in him the rather obvious obsession with common objects simply because they are common (which is a similarly limiting mode to the predilection for important and obviously significant objects). He differs from the Paris group in his interest for the disembodied world, and the importance he attaches to this new avenue of research and inspiration. Actually his pictures possess too much of the vagueness, of the effect of a drunken tracery, that spirit drawings have.

The painters working in England find no place in this pamphlet, but not because I do not esteem them. Nothing but a stupid parochial snobbism could make a half-dozen English names I can think of, seem

any less weighty than a half-dozen French (which as a fact are not French, as I have said). As to the Jewish painters, they are evidently of the same race and talent everywhere. And there are at least as many here as in Paris.

First, this is not a review of painting in Europe. Rather it plots the direction for painting to take today, if it is not to fizzle out in a fireworks of ingenious pseudo-scientific stunts, and a ringing of stylistic changes on this mode and on that.

The emotional impulse of the latest phases of the movement in Paris looks to me contradictory to the creative impulse in painting. And more clearly, it seems to preclude the development of any sensibility but that of an exasperated egotism. The eye becomes a little gluttonous instrument of enjoyment. Or it watches from the centre of its abstract brain-web for more flies and yet more flies. It would eventually become as mechanical and stupid as a spider, if it is not already that.

An effete and hysterical automatism certainly threatens every art. A sorrowful Eastern fatigue wedded to a diabolical energy for materialist responses; a showy and desiccated scepticism, wedded to a tearful sentimentality, as sweet and heavy as molasses. What is to be done about that? But that is a problem for another day.

Well, then, what I propose is that as much attention might be given—it would end by being as concrete—to the masses and entire form-content of life as has been given by the Nature-morte school to the objects upon a studio table. If architecture and every related—as we say, applied—art were drawn in—were woken up, then the same thing would be accomplished upon a big scale as is at present attempted upon a small scale. All the energies of art would not be centred and congested in a few exasperated spots of energy in a few individual minds. But the individual, even, would lose nothing as a consequence: the quality of his pictures would not suffer. And a nobility and cohesion would be attained that under present conditions it is difficult to visualize. Most people grasping at such a notion have stopped short at some fantastic Utopian picture.

But to enable you to arrive at a fair estimate of my conclusions, I must give you the analysis through which I come by them in detail. And I cannot avoid some investigation of the record, both technical and emotional, of Picasso. For Picasso is the recognized pictorial dictator of Paris. So the character and intellect of that one individual signifies a very great deal to all artists at the present time.

Picasso

Pablo Picasso is, to start with, one of the ablest living painters and draughtsmen; indeed it would be impossible to display more ability. In addition to this, he is extremely resourceful and inventive. The back of his talent is too broad to suffer from even an avalanche of criticism—it is the consciousness of this that makes it more easy for me to state plainly his case as I see it. For he is such a fine artist that criticism, except between painters, should be avoided. But this pamphlet *is* between painters more or less.

It is out of scholarship that this revolutionary intelligence came armed to the teeth with the heaviest academic artillery. Picasso was equipped for the great battle of wits that goes on in Paris with a thousand technical gadgets, of the most respected antiquity, which he often has put to the strangest uses. The exact analogue to this is the art of Ragtime or Jazz. Picasso stands now against the Parthenon in the same relation that a great jazz composer stands to Beethoven. Even Cézanne Picasso stands on his head. He takes Cézanne at his word: when Cézanne says (as he did) 'tout est sphérique et cylindrique', Picasso parodies this paradox.

With remarkable power Picasso has refertilized many extinct modes, and authenticated interesting new and specifically scientific notions. He has given El Greco a new lease of life on the Catalan hills in his painting of Spanish shepherds, oxherds and vagrants. He has revivified a great artist's line there, another's colour combinations here, and has played the most dexterous variations upon great classical themes. Since every great creative painter must at the same time have great executive ability —the more dexterity he can command the better—it is always difficult to decide where this hand-training does or should leave off, and where imaginative invention (apart from the delights and triumphs of execution) may or does begin.

Briefly, Picasso's periods are as follows. His earliest work contained a variety of experiments: women sitting in cafés in reds (the 'red period'); Daumier-like scenes, but more fragile and unpleasantly sentimentalized; then a painting of a poor family drooping by the side of a mournful bit of sea, their bones appearing through their clothes, their faces romantically haggard and hyper-delicate—a general air of Maeterlinck or some modern German 'poet-painter'. The best known has been widely reproduced. (Title: *Pauvres au bord de la Mer*.) Then came a period during which Derain's Gauguinism appealed to Picasso. El Greco was a still

more prolonged infatuation and source of study. Lastly Cézanne makes his appearance in his paintings; the portraits of Miss Stein and of Monsieur Sagot are of that time. And Cézanne and all the things to which Cézanne leads—was the great influence.

African carvings must next be mentioned in conjunction with the Marquesas Islands and André Derain. These solid and static models— African, Polynesian, Aix-en-Provence—drove out the Grecos, the Maeterlincks and the Puvises. Braque appears to have been the innovator in Cubism. The brown brand of mandoline, man's eye, and bottle, are his: lately, through Picasso's gayer agency, taking on brighter and purer colours. Futurism once more gave this Wandering Jew from not far from the Sierras a further marching order. Off his talent leapt into little gimcrack contrivances. *Natures-mortes*, in fact, stick out from the canvas; little pieces of *nature-morte* sculpture—nature as the artist sees her; the bottle, the mandoline and the copy of *La Presse* reappearing out of art transfigured (after passing at first through the artist's eye, spending a bit of time in the busy workshop of his brain, and so abiding for a year or so) into the flat world of the artist's canvas. After this series of hairbreadth adventures it is natural that this docile collection of objects should no longer remind the casual observer of any category of objects known to him.

In considering the future of painting, Picasso is the figure upon which you have to fix your attention. But it is the uncertain and mercurial quality of his genius that makes him *the symptomatic object* for your study and watchfulness. It is with some anxiety that the attention must be fixed upon this Jack-in-the-Box or *Spring-heeled Jack*. Everything comes out in the superb virtuoso perfectly defined. Every influence in his sensitive intelligence burns up and shows itself to good advantage. There is nothing, as I have said, with regard to technical achievement, that he cannot do. Picasso appears to me to have a similar genius to Charlie Chaplin's; that of a gnome-like child. His clock stopped at fifteen summers (and he has seen more winters than Charles, although Charles is not averse to a Dickens scene of the Poor Orphan in the Snow), with all the shallowness of a very apt, facile, and fanciful youngster and the miraculous skill you might expect in an exquisitely trained infant prodigy. As to what judgment you should arrive at, at the end of your critical survey, there the issue is quite clear. It will all depend upon whether this mercurial vitality, so adaptable as to be flesh-creeping, seems to you preferable to a vertical source of power, like the sour and

volcanic old *crétin*, Cézanne. It is which manner of life you most prize, or admire, really. I consider Pablo Picasso as a very serious and beautiful performer in oil-paint, Italian chalk, Antoine ink, pastel, wax, cardboard, glue—anything, in fact. But he appears to me to be definitely in the category of *executants*, like Paganini, or Pachmann, or Moiseivitch; whereas Cézanne is clearly a brother of Bach, and the Douanier was a cousin of Chardin.

That his more immediate and unwavering friends are dimly conscious of this fact is proved by a statement I have just read, in the current number of the *Athenæum*, by the French painter, M. André Lhote:

'Cézanne embodies, through the romanticism with which he was impregnated, the avenging voice of Greece and Raphael. He constitutes the first recall to classical order. It was necessary, in order that the lesson he gave us might be understood, that an *interpreter* should appear. This was Picasso.

'The young Spanish painter deciphered the multiple enigma, translated the mysterious language, spelt out, word by word, the stiff phrases. Picasso illuminates in the sunshine of his imagination the thousand facets of Cézanne's rich and restrained personality.'

What a performer on a pianoforte does in his concerts is to give you a selection of the works of a variety of musical composers. Now, apart from giving us very complete interpretations of Cézanne, Daumier, El Greco, Ingres, Puvis, as Picasso has done, there are other ways and far more convincing ones, in which a painter can betray the distinctively interpretative character of his gift.

What do all these 'periods' and very serious liaisons of Picasso imply? To dash uneasily from one personal revolutionary mode to another may be a diagnostic of the same highly sensitive but non-centralized talent as you would think that a playing first in the mode of El Greco and then of David would imply. An inconstancy in the scholarly vein might be matched by an inconstancy in the revolutionary. These are difficult things to decide, since painters are, through the nature of their art, at the same time composers and executants.

What has happened in this volatile and many-phased career of Picasso's? Has he got bored with a thing the moment it was within his grasp? (And he certainly has arrived on occasion at the possessive stage.) If it is boredom, associated with so much power, one is compelled to wonder whether this power does not derive from a source infected with automatism. He does not perhaps *believe* in what he has made. Is

that it ? And yet he is tirelessly compelled to go on consummating these images, immediately to be discarded.

But when we consider, one by one, with a detailed scrutiny, the best types of work of his various periods, we must admit that Picasso had certain reason in abandoning them. However good a pastiche of El Greco may be, it is not worth prolonging indefinitely such an exercise. The same applies to his Daumieresque period. Splendid such paintings as the *Miss Stein* and *Monsieur Sagot* undoubtedly are. Still they are Cézanne. And although many artists, among his dilettante admirers or his lesser brethren, would give their heads to produce such almost first-hand Cézannes, once you *can* do this as easily as Picasso, it can hardly seem worth while to continue to do it.

Very likely, at the present moment, his Ingres or David paintings will induce the same sensations of boredom in him (I can imagine David inducing *very* dismal feelings in an interpreter), and will have a similar fate. All that remains to be considered are the less easily deciphered works of his more abstract periods. I think his effort of initiation, and obstinacy in that brand of work, showed a different temper. But these innovatory abstractions, again, are open to question. They reduce themselves to three principal phases. The first, or Cubist phase—really a dogmatic and savage development of Cézanne's idiosyncrasy (example: *Dame jouant de la mandoline*)—is in a way the most satisfactory. But I am not convinced that Cézanne gains anything by what is so violent an interpretation of his vision. On the other hand, the *Lady with the Mandoline* appears to me as interesting as a typical Cézanne portrait, and it is a powerful and inventive variation on Cézanne.

About the next step—fourth-dimensional preoccupations and new syntheses added to the earlier ones (*Dame assise*) and the first Braque-like contrivances: these probably are more important as grammatical experiments than as works of an artistic consummation. But the whole character of these things: the noble structural and ascetic quality, the feeling that the artist was doing something at last worth while, and worthy of his superb painter's gift—this makes them a more serious contribution to painting than anything else done by him so far. All the admiration that you feel for the really great artist in Picasso finds its most substantial footing in the extraordinary series of works beginning with the paintings of the time of the Miss Stein portrait, and finishing somewhere in the beginning of his Braque period.

I have been analysing this work according to the highest standards of artistic excellence. In the light of his more recent work, with which I entirely disagree (and for the purpose of combating the tendencies that must inevitably result from its influence), I have underlined Picasso's shortcomings. They could only result in the mechanical eclecticism that I describe in the next section of this pamphlet (The Studio Game).

PART IV

Foreword

Two things have conspired to exalt indifference on the part of the painter to the life around him, to the forms that life takes, into a virtue. For a specialized visual interest in the débris on your table, or the mandoline you have just bought—in copying the colours from your garret-studio—is *not* the creative interest required for art. It is a parasitic interest. Your interest in the forms around you should be one liable to transfigure and constantly renew them: that would be the creative approach. To use the grand masses of surrounding life, in fact, as the painter uses the objects on his table. He does not approach those objects as though he were a photographer. He arranges, simplifies, and changes them for his picture. So it should be with the larger form-content of general and public life.

Braque and Picasso have *changed*, indeed, the form-content before them. Witness their little *nature-morte* concoctions. But it has only been the débris of their rooms. Had they devoted as much of their attention to changing our common life—in every way not only the bigger, but the more vital and vivid, game—they would have been finer and more useful figures. They would have been less precious, but not less good, artists.

Two things, then, have made this indifference displayed by most artists to their form-content come to be regarded as a virtue. One is the general scepticism and discouragement, the natural result of the conditions of our time. Intellectual exhaustion is the order of the day; and the work most likely to find acceptance with men in their present mood is that work that most vigorously and plainly announces the general bankruptcy and their own perdition. For the need of expression is, in a sense, never more acute than when people are imperturbably convinced

of its futility. So the most alive become the most life-like waxworks of the dead.

The painter stands in this year in Europe like an actor without a stage. Russia is a chaos; whether a good one or a bad one remains to be seen. Writing in Paris has fallen among the lowest talents. Painting is plunged into a tired orgy of colour-matching. A tesseract broods over Cézanne's apples. A fatuous and clownish mandoline has been brought from Spain; an illusive guitarist twangs formal airs amid the débris. Germany has been stunned and changed; for the better, pious hope says. But for the present art is not likely to revive there.

A number of the younger painters are embarked upon an enterprise that involves considerable sacrifices and discomforts, an immense amount of application, and an eager belief. This effort has to contend with the scepticism of a shallow, tired and uncertain time. There is no great communal or personal force in the Western World of today, unless some new political hegemony supply it, for art to build on and to which to relate itself.

It is of importance, therefore, to a variety of painters, who have to put their lives into this adventure, that it should not be—through the mistakes, the cupidity, or the scepticism of their leaders, or one mischance or another—brought to wreck.

This part of my pamphlet deals with a path which should have a *Danger* board every ten yards; or rather two paths. For the Braque *nature-morte* phase, and the David-Ingres phase, in which painters in Paris are at present indulging, is the same sort of thing, different as the results (a small abstract *nature-morte*, and a large painting *à la* David) may appear.

Our Aesthetes and Plank-Art

There are two attitudes towards the material world which are especially significant for the artist: whichever of these manifests itself in him, designates him as belonging to one side of a definite creative pale. These attitudes can be approximated to the roles of the sexes, and contain, no doubt, all the paradoxes of the great arbitrary sexual divisions of the race.

An artist can Interpret, or he can Create. There is for him, according to his temperament and kind, the alternative of the Receptive attitude, or of the Active and Creative one. One artist you see sitting ecstatic on his chair and gazing at a lily, at a portion of the wall-paper, stained and

attractive, on the wall of his delightfully fortuitous room. He is enraptured by all the witty accidents that life, any life, brings to him. He sits before these phenomena in ecstatic contemplation, deliciously moved to an exquisite approval of the very happy juxtaposition of just that section of greenish wall-paper, and his beautiful shabby brown trousers hanging from a nail beneath it. He notices in a gush of rapture that the white plate on the table intercepting the lower portion of the trousers cuts them in a white, determined, and well-meaning way. He purrs for some time (he is, Mr Clive Bell will tell you, in a state of sensitive agitation of an indescribable nature). And then he paints his picture.

About everything he sees he will gush, in a timorous lisp. He is enraptured at the quality of the clumsy country print found on the lodging-house wall; at the beauty of cheap china ornaments; a stupid chair, obviously made for a stupid person; a staring, mean, pretentious little seaside villa. When with anybody, he will titter or blink or faintly giggle when his attention is drawn to such a queerly seductive object.

I am, you will perceive, drawing a picture of the English variety of art-man. The most frequently used epithet will be 'jolly' for the beautiful; and its pursuit invariably will be described as 'fun'. So we have before us, all said and done, a very playful fellow indeed, who quite enters into the spirit of this 'amusing' life, and who is as true a 'sportsman' as any red-coated squire; only, for the pursuit of 'jolly' little objects like stuffed birds, apples, or plates, areas of decayed wall-paper, and the form of game that he wishes rather smirkingly and naughtily to devour, he must be as cunning, languid, and untidy as his distinguished brother-sportsman is alert, hearty, and coloured like a letter-box. For stalking a stuffed bird you have, in the first place, to be a little bit dead yourself.

I have been portraying to the best of my ability the heir to the aesthete of the Wilde period: the sort of man who is in the direct *ligne* of Burne-Jones, Morris, and Kate Greenaway. And he is a very good example of how to *receive* rather than to *give*.

Now all the colour-matching, match-box making, dressmaking, chair-painting game, carried on in a spirit of distinguished amateurish gallantry and refinement at the Omega workshops, before that institution became extinct, was really *precisely the same thing*, only conducted with less vigour and intelligence, as the burst of abstract *nature-mortism* which has marked the last phase of the Cubist, or Braquish, movement in

Paris. These assemblings of bits of newspaper, cloth, paint, buttons, tin, and other débris, stuck on to a plank, are more 'amusing' than were the rather jaded and amateur tastefulness of the Omega workshops. But as regards the Nature-mortists and Fitzroy tinkerers and tasters, one or other have recognized the affinity. Both equally are the opposite pole to the reality and intensity of creative art.

The Bawdy Critic

Under a series of promptings from Picasso, then, painting in Paris has been engineered into a certain position, that appears to me to bear far too striking a family likeness (in its spirit if not in its workmanship) to the sensibility of our English Amateur not to arouse the deepest misgivings. In this analysis of what I see as a deep weakness, and a scholarly, receptive and tasteful trend, rather than a creative one, I must provide chapter and verse, and devote some space to what are otherwise thoroughly unimportant people. The important thing is obviously the painting in Paris— not the type of English dilettante mind to which I relate it. But if I can make you see this striking community of temperament, you will know better where you are when you find yourself in front of an arrangement of bits of newspaper, cloth, cheese parings, bird's feathers and tin. You might not otherwise arrive at the heart of this mystery at once. For the law that assembled these objects together will appear, and indeed is, more daring and abstruse than the more nerveless and slovenly colour-matching and cushion-making to which I relate it.

Again, it is really only what happens in a picture which is not organized to attract the objects that it depicts. Whether you stick a bit of wall-paper and a patch of trouser-leg side by side on a piece of wood, or use these objects in a picture painted on a piece of canvas, it is much the same. The only thing that can be said of these particular experiments is that they demonstrate an exasperated interest in media, and the shop-side of painting, and a certain mental liveliness. But there the life stops.

A desire to accept and enjoy; to accept what is already in the world, rather than to put something new there: to be in a state of permanent *pamoison* about everything; the odder the thing, the *queerer* that you should find yourself fainting and ecstatic about it—the *funnier*, you see? It is in the possession of this spirit, at bottom, that these two sets of otherwise so dissimilar people betray their relationship.

A composer of music does not, in his best moments, fling himself into a luxurious ecstasy at a musical performance. The painter, similarly, does not derive from his own paintings, or other people's, aesthetical ecstasies or anything nice like that. He derives from the production of his own paintings, or should do so, a hundred times more pleasure than any hysterical amateur is likely to experience in front of *any* work of art. As a matter of fact, in most cases, it is out of *himself*, not from the picture, or the art object, that the amateur gets his satisfaction. Hence the tone in which some of them chant in the newspapers of their experiences. 'Connoisseurs in pleasure—of whom I count myself one—know that nothing is more intensely delightful than the aesthetic thrill', etc., croons one.

Unsatisfied sex may account for much: you wonder if it is really a picture, after all, and not a woman or something else that is wanted, for the purposes of such a luxurious thrill. Is not most emotional interest in Music or Pictures, unaccompanied by the practice of the art enjoyed, sex? In fact, the painter or the musician are the only people for whom it is *not* sex. These bawdy connoisseurs should really be kept out of the galleries. I can see a fine Renoir, some day, being mutilated: or an Augustus John being raped!

'We Fell in Love with the Beautiful Tiles in the South Kensington Museum Refreshment Room'

If we intend thoroughly to pursue our Pablo into the deplorable corner into which his agile genius has led him, and others at his heels, we cannot do better than marry him, in our minds, for the moment, to the erudite form of Mr Roger Fry. And if I devote a little space to the latter gentleman, it is only to use him as a glow-worm by which we can the better investigate Pablo's peculiar plight.

I will give you a passage from an article of Mr Fry's which appeared in the *Athenæum* of 11 July of this year (1919):

'Objects of the most despised periods, or objects saturated for the ordinary man with the most vulgar and repulsive associations, may be grist to his (the artist's) mill. And so it happened that while the man of culture and the connoisseur firmly believed that art ended with the brothers Adam, Mr Walter Sickert *was already getting hold of stuffed birds and wax flowers just for his own queer game of tones and colours.* And now the collector and the art-dealer will be knocking at Mr Sickert's

door to buy the treasures at twenty times the price the artist paid for them. *Perhaps there are already young artists who are getting excited about the tiles in the refreshment room at South Kensington,* and when the social legend has gathered round the names of Sir Arthur Sullivan and Connie Gilchrist, will inspire in the cultured a deep admiration for the "aesthetic" period.'

Mr Sickert you find embedded in the midst of this useful passage. He is a living and genuine painter; and is in that galère, therefore, you can take it, fortuitously and through no fault of their own. Notice, first, the stuffed birds got hold of by Mr Fry's artist 'for his queer game of tones and colours'. Mr Fry's artist's 'queer game' is the same as Picasso's or Braque's ingenious sport. Then we have a luxurious picture of 'the collector and the art-dealer' knocking at the artist's door, and asking to buy his 'treasures' (more luxury)—the stuffed birds that have been used in his 'queer game'—for *Twenty Times the Price* paid for them. Next we have a little vignette of the young students of the South Kensington School eating buns and milk in the Museum Refreshment room, and oozing infatuated lispings about the tiles they find there; and going back with naughty, defiant minds to their academic lessons, their dear little heads full of the beautiful tiles they have seen while at lunch. 'WE FELL IN LOVE with the beautiful tiles in the South Kensington Refreshment room', to parody the famous advertisement. We think of the sugary poster-couple on the walls of the Tube, who utter their melancholy joke and lure you to the saloons of the Hornsey Furnishing Company; and we know that Mr Fry's picture is as sentimental a one as that—the student 'getting excited'—the gush, the buns, *the tiles.*

The last sentence of the passage I cite prophesies that 'the cultured will at some future date conceive a deep admiration for the aesthetic period'. After the tiles of South Kensington Museum, the faded delights of the aesthetic period! Mr Fry chooses the aesthetic period as the subject of his prophetic vision because of a natural predilection that he no doubt has for it, because he is a little bit in advance of his time in this respect. Already he experiences the thrill of such an admiration.

But you are to understand first that there is no mode of the human mind, no 'period', no object of any sort or description, that will not have its turn, and be enthused about either by the art-student, or the 'cultured'. Secondly, that this is very much as it should be, and that this universal tasting and appreciation is all for the best; quite the most suitable way of envisaging the art of painting, sculpture and design.

It was no doubt, in the first place, a very naughty piece of fun for this scholarly and fastidious art-critic, with a name in Europe for his taste, his deep knowledge of Italian pictures, to find himself exclaiming in rapture over some object as *trivial* as most of the objects he had up till then dealt in had been *rare*. He naturally might get a kick out of that.

Theoretically this honey-bee had no predilections. All flowers are the same. But an especially *conscious* plant on which he should chance to alight would recognize from his method of settling, the character of his *tâtonnements*, that he had not alighted for the purpose of extracting honey at all. Such a critic, at the same time a dilettante, is not curious about the *object* that his mind approaches, but is entirely engrossed with *himself*, and his own sensations. It is amusing to flit from petal to petal; the grace with which you alight is amusing; it is amusing that people should suppose that you are engaged in such a beautiful business as gathering honey; to bask in a slightly intoxicating pollen-thickened atmosphere is delicious. But the fun is *only to pretend* to be a bee. To be a *real* bee would be a frightful bore.

The eclecticism, then, as regards modes and periods of art, finds its natural development in an eclecticism as regards *objects*. 'A man's head is no more and no less important than a pumpkin', from the article already quoted. 'Objects of the most despised periods may be grist to his (the artist's) mill.' Should art connoisseurs and dilettantes all turn painters, the sort of art movement they would like to find themselves in the midst of (we are supposing them fashionably-minded, as many are) would be such a giant amateurism and carnival of the eclectic sensibility as we are in for, if the dealers' riot in Paris succeeds, and if the votaries of *nature-mortism* and the champions of the eclectic sensibility here, are to be believed.

We see exhibitions of French painting written about in the tone of an intellectual tourist—as though they constituted an entirely new thing in the way of pornographic side-shows, to which the English tripper is immediately led on his arrival in Paris. The 'aesthetic thrill' obtained at these shows is described in an eager and salacious key, and with many a chuckle. The truth is that for the amateur turned critic, or the amateur painter, these modern painters' experiments still remain imbued, as they do, for the public, with a great deal of naughtiness. The English philandering flapper-sensibility transpires in every sentence.—There we have then our indigenous aesthete spreadeagled for our leisurely observation.

I will now give you a few lines of an interview with Picasso, which appeared in the *Weekly Dispatch* of 1 June of this year:

'Picasso was enchanted with our metropolis (London). He waxed excited over our colourful motor-omnibuses.

'And Picasso had a thrill of joy on discovering a pavement artist. "This good man knelt down and drew in coloured chalks on the stone. I assure you, they are admirable."'

The motor buses are the same as the tiles in the Refreshment Room. The pavement artist is the eternal Naif or the Gifted Child. When will the Naif, the Pavement Artist and the Child resume their places, *quâ* Child or Naif simply: the very good Naif, like the very good child, as rare as anything else very good, alone remaining in our foregrounds?

And it is easy to see how Picasso, wonderful artist as he is—the great professional—has encouraged this hope of a thoroughly detestable state of amateurish philandering—naughtiness, scepticism, and sham. Here and in Paris Cézannism is being side-tracked into a pretty studio-game. Certainly no painter who does not want to be turned into a tasting-machine should allow his delight in technical acrobatics to run away with him. He should turn a deaf ear to the twanging of the deliciously cracked guitar.

The Vengeance of Raphael

David is the order of the day. David, the stiffest, the dreariest pseudo-classic that ever stepped, has been seized upon (as a savage tribe might take one of their idols by the heels and drag him out), and has been told in frenzied and theatrical accents that *he must avenge himself*! And, being probably a rather peppery and sanguine little Frenchman, revenge himself he will, if he is not stopped! Or, rather, M. Lhote, his self-appointed executioner, will do the job for him. Picasso, alleged to be doing portraits in the manner of Ingres, is the cloaked and consenting, the sinisterly Spanish figure in the background of this 'classical' razzia. 'Raphael shall be avenged!' shrieks M. Lhote. I have heard from people who have seen this artist in Paris in the last month or so that he is very excited. The Madonna-like face of the Florentine master inspires him to very great fury: a fury of Mariolatry, a determination to make short work of those who have played ducks and drakes with their inheritance of Greek and Roman beauty.

The parrot-like echo of all this turmoil turns up punctually in our Press. I saw this week in a current art article the first tinkle of the eulogistic thunder that is shortly to burst, everything indicates, around the Parthenon Frieze in the British Museum. Nasir Pal's square Semitic shoulders may get a pat or two in passing. But it will be in the Greek Gallery where all the fun of the fair will rage. These draped idealities have already been described as *distorted*, to bring them into line!

Ingres, David, Raphael! Poussin and Claude! Easter Island carvings, El Greco, Byzantium! But there is a vast field yet to cover: the friezes from Nineveh, the heart of Sung, Koyetzu and Sotetzu, the Ajanta caves, Peru, Benin; and the Polar regions have their unhappy dolls, their harpoon handles, and the Midnight Sun for some future ballet!

This is leaving out of count *the tiles in the South Kensington refreshment room* and the 'aesthetic period', and a million other things. What incredible distances the art-parasite travels! How he does see the world!

Is Western Europe too uncertain of tomorrow, the collapse of religion too dislocating, Great Wars too untimely, for us to have an art that is any more than locally or individually constructive? I am convinced that the sooner the general European destiny of painting gets out of the hands of the dealers' ring in Paris the better for it. Also the hysterical second-rate Frenchman, with his morbid hankering after his mother-tradition—the eternal Greco-Roman—should be discouraged. And if Picasso, with all his native Catalan freshness and *sans-gêne*, succumbs to the classical influences of the French capital, he should be momentarily disowned.

General Nature and the Specialized Sense

When it was necessary in this country and elsewhere to undertake a rapid education of a public of some sort, exaggeration—that was unavoidable—had to be indulged in. The position had to be posed *too logically* for reality, or too altogether exact. Also everything in the innovation that contradicted the tenets of the prevalent and tired sensibility had to be thrown into a crude salience.

But today this necessity no longer exists.

Yet writers supporting, more or less, the great European movement in painting still repeat the lesson as it was given them. The statement, for instance, that a man's head is no more and no less important than a pumpkin, indicates a considerable truth: it depends in what connection,

only, it is advanced, and how, of course, applied. The ideal *pure visual* obviously has no preoccupations but formal and colour ones. But when you say that Cézanne, an heroic *visual pure*, in his portrait of the two men playing cards was emotionally moved only by the form and colour, you are omitting a great sub-conscious travail of the emotion which fashioned, along with the pure painter's sense, what he did; dyeing, with a sombreness and rough vitality, everything. There is no painter's sense, admittedly, so 'unbiological' that it can be independent of this extra-sensual activity of the painter's nature. His disposition, his temper, his stubbornness, or his natural gaiety are all there in his specialized sense. Given the undoubted and fundamental rightness of this sense, it is an open question how far the emotional non-specialized activity of the mind should be stimulated, and how explicit its participation should be in a painter's work.

The important thing is that the individual should be born a painter. Once he is that, it appears to me that the latitude he may consider his is almost without limit. Such powerful specialized senses as he must have are not likely to be overridden by anything. He would laugh at you if you came along with your 'head and pumpkin' dogmatizing.

To sum up: On the subject of eclecticism, if there were no painters and therefore no art, the dilettante would have nothing to be eclectic about. Secondly, no great painter has ever been eclectic, or very fickle, in the matter of his work. His subject-matter has tended to be constant. His manner he could change no more easily than his *name*. And if the complexity and scepticism of their time drives artists into the role of the dilettante, or interpretive performer merely, that is unlucky for them, that is all one can say.

GROUP X

Foreword to the catalogue of the 'Group X' exhibition, which took place at Heal's Mansard Gallery in March 1920. Members of the Group, besides Lewis, were the painters Jessie Dismorr, Frederick Etchells, Charles Ginner, C. J. Hamilton, E. McKnight Kauffer, William Turnbull, Edward Wadsworth, and the sculptor Frank Dobson.

The members of this group have agreed to exhibit together twice annually, firstly for motives of convenience, and with no theory or dogma that would be liable to limit the development of any member. Each member sails his own boat, and may lift his sails to any wind that may seem to him to promise a prosperous cruise.

On the other hand, the ten original members have not come together so much by accident that they do not share certain fundamental notions in common.

Clearly, should one brace his jib-boom, and pull up his top-gallant-sail, and steer a course that was undoubtedly going to bring him to port cheek by jowl with such scurvy and abject craft as bear the euphonious names of 'Jack' or 'Collier', he would be expected, and indeed in any case would, remain in that golden and vulgar port until the Crack of Doom, as far as his present companions are concerned.

Group X, on the other hand, is not in the nature of a piratic community. They are a band of peaceful traders—naturally armed to the teeth, and bristling with every device to defend the legitimate and honourable trafficking that is the result of their enterprising toil.

That much established, it still remains evident that the founding of this small community is not entirely fortuitous.

When you speak of the unfettered development of the individual, you do not mean such development as has just been indicated, terminating in the gilded, sluggish port. And it is probable that the merchandise marked X will be known for a certain quality rather than another. X will not, and is not meant to, signify *anything* that can be made.

It is unnecessary to review in detail the existing organizations for the exhibition of pictures in England. But the artists collaborating in this Group hold roughly the following opinions on the subject of two of the largest of them.

The large official *Exhibition at Burlington House* appears to them to be beyond redemption. It is a large and stagnant mass of indescribable beastliness, that no effort can reform short of the immediate extinction of every man, woman and child at present connected with it.

Of the 'outside' and so-called independent Societies, the *New English Art Club* is a large and costive society. It is choked with the successive batches of Slade talent, and is an obviously enervating and retrograde institution. Like any society that has existed so long, practically un-purged year after year, it has grown a constipated mass of art-school dogmas whose function is to nurse the young through its connection with the largest (independent, also) art-school in the country, the Slade School. But the Slade is enormously prolific. As an art-school, it is prone to producing geniuses very much of a pattern. The result is that the New English Art Club might be said to suffer intestinally from over-feeding on this particular delicacy—namely, 'Genius'. This Victorian monstrosity, the favourite food of the N.E.A.C., will eventually be the death of it.

As to the *London Group*, several members of Group X have expressed their sentiments with regard to the utility of that now rather swollen institution (destined perhaps to become a New English Art Club up to date) by lately retiring from it.

Of the 'certain fundamental notions' that this small collection of artists have been said to hold in common, the following may be taken as those that principally give them the solidarity necessary for them to thus go aside from the greater exhibiting bodies and form an independent Group.

They believe that the experiments undertaken all over Europe during the last ten years should be utilized directly and developed, and not be lightly abandoned or the effort allowed to relax. For there are many people today who talk glibly of the 'victory' of the Cubist, Vorticist or Expressionist movements, and in the next breath of now putting the armour off and becoming anything that pays best, repairing wherever, after the stress of a few years, the softest time is to be secured.

A group was formed some months ago, naming itself six and ten, or something like that, which has used, to recommend itself, arguments on these lines: '*We* are the latest thing, if that is what you are looking for. We have gone right back to the Pre-Raphaelites—that is so English, too, you know, as well as being *le dernier cri*. The Cubists were useful (not to us, of course, but to Art in general—vaguely—somehow); but

that battle is over, that war is over! Let us, therefore, as occurs in the case of all wars, forget at once all about it, and also what it was supposed to be for. It was really, as we have very astutely seen (and tell you in confidence) for Pre-Raphaelitism all the time! And we are such a "spiritual" lot of chaps too'!

Why Pre-Raphaelitism (for which Dante Rossetti was a good deal responsible) should be particularly English it is difficult to see. Rowlandson, Fielding, are English enough—more English than any phase of Victorian Romanticism. The age of Elizabeth furnishes examples of art that are surely as 'national' as it is desirable to be: perfectly interpenetrated with Western European culture, and yet using that culture independently with a freedom considered barbarous by the French.

I give this instance of the manœuvres of one of the many associations of younger artists resolved to step into one well-trodden path or another, and call it new, and at the same time abuse the living movements still developing on the Continent of Europe, in order to indicate at the same time one of the tendencies with which Group X is in conflict. If you should wish to relate the artists of Group X to something English, Rowlandson would be the figure they would indicate rather than Madox Brown, as a model Islander. Also they would refer you to a time in English history when England formed part of Europe, participating intellectually in the life of France, Spain and Italy, rather than to a time when England took on a clammy cloak of provincial narrowness, as occurred in the Victorian period.

Nothing more than these general indications of policy need be said in explanation of the founding of this small group.

TYROS AND PORTRAITS

The introduction to the catalogue for an exhibition of paintings and drawings by Wyndham Lewis, held at the Leicester Galleries, London, in April 1921.

I have narrowed this exhibition to two phases of work. One is of work done directly in contact with nature, or with full information of the natural accidental form. The other phase is one which I have just entered, that of a series of pictures coming under the head of satire; grotesque scenes of a selected family or race of beings that will serve to synthetise the main comic ideas that attack me at the moment. What I mean by the term Tyro is explained in a further note.*

Unnecessary as it would appear to point out that these Tyros are not meant to be beautiful, that they are, of course, forbidding and harsh, there will, no doubt, be found people who will make this discovery with an exclamation of reproach. Swift did not develop in his satires the comeliness of Keats, nor did Hogarth aim at grace. But people, especially in this country, where satire is a little foreign, never fail to impeach the artist when he is supposed to be betraying his supreme mistress, Beauty, and running after what must appear the strangest gods.

Most of the drawings are drawings from nature. It is important for an experimental artist and for experimental artists generally, to demonstrate that these activities are not the consequence of incompetence, as the enemies of those experiments so frequently assure the public. I do not know if all these drawings will be productive of that conviction, but some of them may.

There are no abstract designs in this exhibition, and I have included no compositions or purely inventive work except my new vintage of Tyros, wishing to concentrate attention on this phase of work.

I will add one general indication of direction. There are several hostile camps within the ranks of the great modern movement which has succeeded the Impressionist movement. The best organized camp in this country looks on several matters of moment to a painter today very differently from myself. The principal point of dispute is, I think,

* Tyro—An elementary person; an elemental, in short. Usually known in journalism as the Veriest Tyro. [All the Tyros we introduce to you are the Veriest Tyros.] (L.)

the question of subject-matter in a picture; the legitimacy of consciously conveying information to the onlooker other than that of the direct plastic message. Is the human aloofness and various other qualities, of which even the very tissue and shape of the plastic organization is composed, in, say, a Chinese temple carving, to be regarded as compromising?

My standpoint is that it is only a graceful dilettantism that desires to convert painting into a parlour game, a very intellectual dressmaker's hobby, or a wayward and slightly hysterical chess. Again, abstraction, or plastic music, is justified and at its best when its divorce from natural form or environment is complete, as in Kandinsky's expressionism, or in the experiments of the 1914 Vorticists, rather than when its basis is still the French Impressionist dogma of the intimate scene. Prototypes of the people who affirm and flourish this new taboo of 'pure art', which is not even *pure*, will, in twenty years' time be reacting obediently against it. Twenty years ago, 'art for art's sake' was the slogan of the ancestor of this type of individual. Our present great general movement must be an emancipation towards complete human expression; but it is always liable in England to degenerate into a cultivated and snobbish game.

My Tyros may help to frighten away this local bogey.

NOTE ON TYROS

This exhibition contains the pictures of several very powerful Tyros.

These immense novices brandish their appetites in their faces, lay bare their teeth in a valedictory, inviting, or merely substantial laugh. A laugh, like a sneeze, exposes the nature of the individual with an unexpectedness that is perhaps a little unreal. This sunny commotion in the face, at the gate of the organism, brings to the surface all the burrowing and interior broods which the individual may harbour. Understanding this so well, people hatch all their villainies in this seductive glow. Some of these Tyros are trying to furnish you with a moment of almost Mediterranean sultriness, in order, in this region of engaging warmth, to obtain some advantage over you.

But most of them are, by the skill of the artist, seen basking, themselves, in the sunshine of their own abominable nature.

These partly religious explosions of laughing Elementals are at once satires, pictures and stories. The action of a Tyro is necessarily very

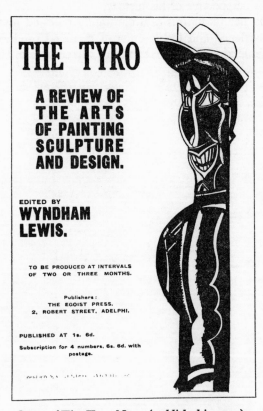

Cover of The Tyro No. 1 (*published in* 1921).
*It shows the 'Cept', a Tyro whose clash with
the 'Megaloplinth' was announced in the
second issue of the magazine.*

restricted; about that of a puppet worked with deft fingers, with a screaming voice underneath. There is none of the pathos of Pagliacci in the story of the Tyro. It is the child in him that has risen in his laugh, and you get a perspective of his history.

Every child has its figures of a constantly renewed mythology. The intelligent, hardened and fertile crust of mankind produces a maturer fruit of the same kind. It has been rather barren of late. Here are a few large seeds.

THE COMING ACADEMY

Printed in the Sunday Express (*No. 121, 24 April 1921, p. 3*) *with the following editorial note:* 'A satirical prophecy by the brilliant young "rebel", who will not be represented there.'

I have been asked to prognosticate as to the character of the next Royal Academy show.

What sort of a competition is this, Mr Editor? I shall no doubt lose on technical points, as I am not very exactly informed, not often visiting Burlington House. But as to the aggregate art value of the Royal Academy, *that* I can describe to admiration.

One thing at least we can be sure of: that the next Royal Academy show will be indistinguishable from the last, as the last was indistinguishable from the one before that. It is too easy, but I will sketch it, without, however mentioning any names. (You have no doubt guessed that names of exhibitors at Burlington House is not my strong point.)

Well, then, I enter the next exhibition (or the next after that, if you prefer), and I am confused to find a man confronting me on the nearest wall who was once the adjutant of a training unit in which I passed some pleasant summer months. He has, however, suffered some kind of change. It is largely a change into new heavily varnished paint: but also he has climbed since we met, it is evident: he has experienced so much satisfaction at his promotion that he has obviously spent his blood-money or bonus on having himself painted, brass-hatted and correctly ribboned.

There he sits like a waxwork, or a stuffed image in a booth—'on the line' all right—in this sort of Happy Hampstead of our artless bourgeoisie. And readers of the *Morning Post* swarm round him, frowning knowingly at him, and he frowns knowingly at them. It is an apotheosis that everybody present appreciates. I pass on and am conscious of a considerable quantity of Guineveres, of passionate Castillian dancers, their mannish hats raking their right eye, their left hand glued to their equivocal hip, the rose of Carmen stuck in their locks (saturated with linseed oil and turpentine). There is also a sprinkling of nudes—discreet, compared with similar wares at the Salon, rather flashy, fleshy photographs if compared with the allurement of a Kirchner or the charm of an Etty.

But I am conscious of large brown oily and florid horses constantly recurring. 'The famous horse painter, X,' I say to myself, pleased at knowing a name. There is always a 'famous horse painter', ever since Rosa Bonheur invented that particular luxury.

The portrait of the year! I am in front of the picture of pictures! I learn this by the dense crowd I meet, the whispering voices. It is an atmosphere such as a Madonna might provoke. But it is not a Madonna.

It is a painting of a stoutish lady, lavishly advertising her worthless taste in her attitude, the assembly of objects with which she is surrounded (or it would be more correct to say the worthlessness of the taste of her time, the vulgarity, the lack of measure, the lack of any canon of taste or decorum). Her three girl-children second her wonderfully in this revelatory sociological effort, giving you besides a thrilling glimpse into the future. The painter (some ever staler and staler, emptier and emptier post-Sargent) is the merest servant, a deft and self-effacing one, of this uncouth display.

And all this, gentlemen, is to see, translated into terms of pictorial art, the worst insipidities of our degenerate stage, the dreary foolishness of the novel of the month, that is sold at twopence one year later on the dusty bookstalls, or the cheap and sugary music concocted for the palate of the servant girl. It has no more to do with Rowlandson, Hogarth, Turner, Constable, Alexander Cozens, than the other things I have mentioned have to do with Fielding, Goldsmith, Dickens, Congreve, or Purcell.

And yet this official State-endowed affair, it is claimed, is the guardian of tradition! What tradition, in heaven's name, may we ask?

THE OBJECTS OF THIS PAPER

Lewis's introduction to the first issue of the magazine The Tyro, *which he edited. One other issue appeared, in 1922.* The Tyro *printed poems, essays and fiction by various writers, including T. S. Eliot and Herbert Read, and reproductions of works by experimental painters and sculptors.*

To be a rallying spot for those painters, or persons interested in painting, in this country, for whom 'painting' signifies not a lucrative or senti-mental calling, but a constant and perpetually renewed effort: requiring as exacting and intelligent application as any science, with as great an aim. The only papers at present existing purely for painters are, in a more or less veiled way (usually veiled in a little splashing of bright colour and little more), tributaries of the official painting of Burlington House. There is actually at the moment no paper in this country wholly devoted to the interests of the great European movement in painting and design, the most significant art phenomenon in Europe today.

The number of painters experimenting in England in the European sense are very few. The reason for that, and the remedy for what appears to us that backwardness, will be 'explored', as the newspapers say. Again, this paper will especially address itself to those living in England who do not consider that the letter of any fashion (whether coming to us with the intelligent prestige of France, or the flamboyance of modern Italy) should be subscribed to by English or American painters. A painter living in a milieu like Paris has a great advantage, it is obvious, over one working (especially in his commencements) in England. But it would be absurd not to see that the very authority and prestige of the Gallic milieu, that so flutters and transports our friend Mr Bell, for example, also imposes its faults on those working in Paris, in the very middle of the charm. *The Tyro* will keep at a distance on the one hand this subjection to the accidental of the great European centre of art, and on the other hand the aesthetic chauvinism that distorts, and threatens constantly with retrogression, so much of the otherwise most promising painting in England today.

A paper run entirely by painters and writers, the appearance of *The Tyro* will be spasmodic: that is, it will come out when sufficient

G

material has accumulated to make up a new number; or when something of urgent interest hastens it into renewed and pointed utterance.

One further point. The Editor of this paper is a painter. In addition to that you will see him starting a serial story in this number. During the Renaissance in Italy this duplication of activities was common enough, and no one was surprised to see a man chiselling words and stone alternately. If, as many are believing, we are at present on the threshold of a Renaissance of Art as much greater than the Italian Renaissance as the Great War of 1914–18 was physically bigger than preceding ones (substitute however intensity and significance for scale), then this spectacle may become so common that the aloofness of the Editor of this paper from musical composition would, retrospectively, be more surprising than his books of stories and essays. In the same way kindred phenomena, in letters, science or music, to the painting of such pictures as this paper is started to support and discuss, will be welcomed and sought for in its pages.

THE CHILDREN OF THE NEW EPOCH

From The Tyro No. 1

We are at the beginning of a new epoch, fresh to it, the first babes of a new, and certainly a better, day. The advocates of the order that we supersede are still in a great majority. The obsequies of the dead period will be protracted, and wastefully expensive. But it is nevertheless nailed down, cold, but with none of the calm and dignity of death. The post-mortem has shown it to be suffering from every conceivable malady.

No time has ever been more carefully demarcated from the one it succeeds than the time we have entered on has been by the Great War of 1914–18. It is built solidly behind us. All the conflicts and changes of the last ten years, intellectual and other, are terribly symbolized by it. To us, in its immense meaningless shadow, it appears like a mountain range that has suddenly risen as a barrier, which should be interpreted as an indication of our path. There is no passage back across that to the lands of yesterday. Those for whom that yesterday means anything, whose interests and credentials are on the other side of that barrier, exhort us dully or frantically to scale that obstacle (largely built by their blunders and egotisms) and return to the Past. On the other hand, those *whose interests lie all ahead*, whose credentials are in the future, move in this abrupt shadow with satisfaction, forward, and away from the sealed and obstructed past.

So we, then, are the creatures of a new state of human life, as different from nineteenth-century England, say, as the Renaissance was from the Middle Ages. We are, however, weak in numbers as yet, and to some extent, uncertain and untried. What steps are being taken for our welfare, how are we provided for? Are the next few generations going to produce a rickety crop of Newcomers, or is the new epoch to have a robust and hygienic start-off?

A phenomenon we meet, and are bound to meet for some time, is the existence of a sort of No Man's Land atmosphere. The dead never rise up, and men will not return to the Past, whatever else they may do. But as yet there is Nothing, or rather the corpse of the past age, and the sprinkling of children of the new. There is no mature authority, outside

of creative and active individual men, to support the new and delicate forces bursting forth everywhere today.

So we have sometimes to entrench ourselves; but we do it with rage: and it is our desire to press constantly on to realization of what is, after all, our destined life.

ROGER FRY'S ROLE AS CONTINENTAL MEDIATOR

From The Tyro No. 1

It appears to me that for Englishmen today the continuity has been blurred or broken between them and the greatest intellectual traditions of England's past. Just as it is often said that a Stuttgart audience, or an audience of Steppe peasants, understands a performance of Shakespeare better than any modern English audience could; so I think that a Frenchman, on the whole, is nearer to the greatest traditions of England, today, than Englishmen, on the whole, are.

In the second place, surely we must admit that craftsmanship in France is second nature: is not a thing that people make a fuss about, as they do here if such an anomaly is noticed, but a thing that every French painter, of whatever order, possesses as a certain inheritance.

Let us add to this the undeniable fact that conditions for 'independent' painting in Paris are far better than here—that they are in fact better almost everywhere in Europe.

When an Englishman today says 'English' to describe some virtue of the intellect or sensibility, he invariably means Victorian English, which should be regarded by the Briton with his national interests at heart with as much horror as Yellow English. The English virtues, of the intellect or sensibility, developed by Rowlandson, Hogarth and their contemporaries, and earlier at their flood-tide in the reign of Elizabeth, are those with which Englishmen could naturally link up, if they wished to; but they have to fight their way through the Victorian crusts first of all. All that *sensiblerie*, pathos of Dickens, personality-mania, and so forth has alienated us from that time, as it has also, intellectually, from Europe, which has been more conservative and guarded its past better.

All this set forth, I can express my conviction that the best chance for English art is not to stand on its dignity, be stupidly competitive and land-conscious, but to regard itself as thoroughly involved, for better or for worse, with the main intellectual life of Europe; and join its effort, simply and without humbug, to that of France, Germany, or Italy, but especially France and Paris. Is it afraid of losing its 'English' identity? If such identity could be lost in that way, it is not worth keeping.

Now, one of the difficulties of the situation in England for an experimental painter is the unfortunate wars that divide the small 'extreme'

section of the painting community. Since probably all 'moderns' or extremists appear very similar to one another, just as the member of an animal species appears without identity to an untrained human eye; so they cannot understand how discrimination, extreme difference of opinion, can divide, jeopardizing their interests, what has the appearance of being a small and homogeneous crowd.

In reality, this minority is a small world by itself (although it is a puzzle to me, frequently, to see why some people in it ever came there). And, at least as artists, everyone outside this world is genuinely regarded as not existing. An exhibitor at the Royal Academy, an artist who produces magazine covers or the usual poster, is literally, for me, not an artist in any sense at all. The tradition in which he works, the taste and understanding of the large democratic public for which he provides, is so beneath contempt, if you compare it with the milieu experienced by the painter living in Sung China, ancient Egypt, or what not, that he has not begun to be, or ever dreamed of being, an artist. This is so exact, as I see it, that if an artist today should produce a painting that were a more or less successful attempt to recapture the spirit of the great Chinese, Egyptian, Rajput painters, applying their great method, however, to the subject-matter of our day, he would be, or frequently is, regarded as a vulgar, harsh, revolutionary.

This being more or less the attitude of a genuine experimental painter today, it will be clear how it is that he comes to neglect the popular, modern industrialized world, and exist only as a unit in that world of effort directed, in Science and Art, to the development of a new consciousness (which is largely synonymous with rescuing the old) with all the experiments and readjustments that that involves. And that world has its wars. I, of that world, am a pronounced pacifist, a sort of Quaker. But I find that it is very difficult, sometimes, to keep the peace. Many of my neighbours are not so pacific as I am.

One of the anomalies in the more experimental section of English painting, is that a small group of people which is of almost purely eminent Victorian origin, saturated with William Morris's prettiness and fervour, 'Art for Art's sake', late Victorianism, the direct descendants of Victorian England—I refer to the Bloomsbury painters—are those who are apt to act most as mediators between people working here and the Continent, especially Paris. And Paris gets most of its notions on the subject of English painting through this medium.

Mr Roger Fry, the publicist and painter, is their honoured leader;

Mr Duncan Grant their darling star-performer. Mr Clive Bell, second in command, grows almost *too* articulate with emotion whenever he refers to either of these figures.

I propose, in the next issue of this paper, to consider more fully the inconvenience of possessing an eminently Victorian group of advocates and go-betweens in our relations with Paris.

There are also a few personal objections to Mr Fry. He is, I think, a true artist, and much the most important of his Bloomsbury painting colleagues. I am sure that he has the devoutest regard for painting. But he has the distaste for reality of the scholar, and some of the spoilt-child qualities of the Rich Man. He feels, and naturally enough, that, in such a small world as he has chosen, he should have very much his own way. He loves too well to unearth some tiny personality and call him 'genius' for a while: some personality that is quiet and obedient, and that does not interfere with his dream. He has lived so much, again, with pictures whose authors are dead, that he does not really like the idea of such people living at all. All good artists should be dead, we imagine him feeling, or at least, if that cannot be, they must be French, Russian or Dutch. Pictures are so beautiful! Should he meet Giotto in the flesh!—but that is too sinister an event to contemplate. Then again (and I don't like saying it, because it is after all an artist, a sensitive and real being, that I am talking about) his paintings fall so short of his knowledge and intention. And as, like some others, he has his human vanities and caprices, he also *must*, with so much knowledge and desire, resent too much the accident of Power in another artist, which frequently means so little.

Some complex of all these things—his too protracted scholarly habits, his slight overbearingness, the unreality of the Victorian milieu and traditions that are his—account for a great deal that has been unsatisfactory, biassed and capricious in the use he has made of his European reputation, his position of worldly advantage and opportunities for furthering the modern European movement here that he so fervently advocated.

ESSAY ON THE OBJECTIVE OF PLASTIC ART IN OUR TIME

Art subject to laws of life (*from* The Tyro No. 2)

From what, in my preamble addressed to the public, I have said as to the tremendous ultimate effect that art has on all our lives, it might seem that I was claiming for such painting as I advocate merely a usefulness, regarding it as, in the usual sense, a means to an end. When I claimed that a man painting in his studio a plate of apples could influence, by the way he treated those apples—the aesthetic principle involved in his vision—the art of the architect, commercial designer and so forth, that might seem to be evading affirmation of the absolute value of the painting productive of such far-reaching effects.

To begin with, I hold that there is never an *end*; everything of which our life is composed, pictures and books as much as anything else, is a means only, in the sense that the work of art exists in the body of the movement of life. It may be a strong factor of progress and direction, but we cannot say that it is the end or reason of things, for it is so much implicated with them; and when we are speaking of art we suddenly find that we are talking of life all the time. The end that we set ourselves, again, and that we are able to imagine but not to possess, is so relative, that we are operating in a purely conventional system of our own. A picture, in the interminable series of pictures, is in the same position, in one way, as is a scientific theory. Let us take a concrete example of that. Professor Sir W. H. Bragg (to name, I think, the best authority) suggests today that we may have to return to the corpuscular theory of light, abandoning the wave theory that has passed as the likeliest for so long, and which superseded Newton's theory of a bombardment of particles. But it would not be the *same* corpuscular theory that would then be arrived at, but one that had passed through the ether waves, so to speak. It is quite possible that the wave theory may come in for another lease of life, with the constant arrival of new factors of knowledge, beyond the revised Newtonian view of the matter, if such once more prevails.

Is there a culmination to that series, and whither do these speculations tend? Whatever the answer may be to that, art is in the same position as science, in one sense: that is it has the same experimental character, and exhibits the same spectacle of constant evolution. To see this

evolution at work life-size, we will take the painting of our own times. The French impressionist picture of the last century provided a new experience in the historic chain. This success was taken over by the school that succeeded the impressionist, other elements were introduced, and again a new thing was the result. This 'newness' in both cases possessed the merit of being what the painter of the preceding school would have evolved had he been given a double term of life. It did not mean the death of a good thing, but its fecundation. The inexhaustible material of life, as it comes along, suggests constantly a readjustment and revision of what is there when it arrives. The new thing in art, is not *better* than the thing that preceded it, except at the turn of the tide in a period of great poorness and decadence, when a dissolution and death is occurring. It *may* be better, though never better than the best already recorded or existing. It may be worse. But it is a growth out of its immediate predecessor, and is marching in time, also, with the life with which it is environed. A form of it becomes extinct, perhaps, in one race, and is taken up in another.

The way in which science differs, at first sight, from art, is that the progress of scientific knowledge seems a positive and illimitable progression; in the sense that we know more today about the phenomenon of electricity, for example, or of disease, or the structure of the world, than men are recorded ever to have known. There is a reason to believe that we shall soon be still better informed. In painting, on the other hand, a masterpiece of Sung or of the best sculpture of Dynastic Egypt is, as art, impossible to improve on, and very little has been produced in our time that could bear comparison with it.

But art is a valuation: in its relation to science it is somewhat in the position philosophy has so far occupied. Science presents men with more and more perfected instruments, and the means of material ascendancy: these appliances are used, and the use of them reacts on the user, and on his estimate of the meaning and possibilities of life. These estimates and beliefs are chalked up, and more or less critically signalled, in the works of the artist, and assessed sometimes by the philosopher. So science, in a sense, is criticized by art at the same time as is man.

The popular current belittlement of the function of what, since Socrates, has been called philosophy, tends, as is always the case, to become vindictive; to thrust too harshly some hero of the moment into the empty throne. But no doubt philosophy must become something else to survive, though the character of mind that has made a man up

to the present a philosopher will still operate. The pseudo-scientific element in philosophy, with the growth of exact specialized science, has brought it to its present pass. That unbridled emotional element found in it, that has discredited most speculation in retrospect, is proper to art, where it can be usefully organized and controlled. All that side of the philosopher has its legitimate outlet there. And the man of science, so long as he remains ideally that, is a servant and not a master. He is the perfect self-effacing highly technical valet of our immediate life. The philosopher as such shows every sign of disintegrating into something like (1) the artist, (2) the man of science, and (3) the psychologist. The artist gets a good share, it is certain, of the booty attending this demise.

At the moment of this break-up it is perhaps natural that art and science should both be momentarily swollen with the riches of this neighbouring province suffering partition. The disinherited spirit of the philosopher finds asylum in these related activities. The philosopher, that hybrid of the religious teacher, man of science and artist, was always, certainly, a more artificial and vulnerable figure than his neighbours. And yet neither the artist nor the man of science can take his place.

When, however, the definitely intellectual character of art today is complained of, and artists are accused of theorizing too much on the subject of their books and pictures, one cannot do better than quote David Hume where, in the process of relating morals to the aesthetic sense, he writes: 'But in many orders of beauty, particularly those of the finer arts, it is requisite to employ much reasoning, in order to feel the proper sentiment; and a false relish may frequently be corrected by argument and reflection. There are just grounds to conclude that moral beauty partakes much of this latter species, and demands the assistance of our intellectual faculties, in order to give it a suitable influence on the human mind.'

The finer the art, the more extended the role the intellectual faculties Hume speaks of are called upon to play.

The concatenation and growth of scientific theories (to return to our earlier argument) may be like the growth of a tree, which from the start is destined for a certain height, volume and longevity. The human mind, evolving its theorizing chain, may have such a circumscribed and restricted destiny. It certainly is as irretrievably rooted in its soil, and on any at present ascertainable base it cannot balance itself more than a certain height in its atmosphere. If you take this restricted point of view

(and all human life is lived in some such assumption) art then will always be its ultimate necessity; it is what the philosopher comes to out of the discomforture of his system; what, for the man in the street, cannot with impunity be divorced from the attitudes and very form of his religious belief; and it is the ideal check on the mechanical encroachments of science.

Art and games

The game of cricket or billiards is an ingenious test of our relative, but indeed quite clumsy and laughable, prowess. These games depend for their motive on the physical difficulties that our circumscribed extension and capacities entail. It is out of the discrepancy between *absolute* equilibrium, power, and so on, of which our mind is conscious, and the pitiable reality, that the stuff of these games is made. Art is cut out of a similar substance.

The charm of a game consists partly in our inordinate satisfaction with ourselves when we succeed in some trivial physical manœuvre. Such satisfaction would be impossible without the existence of the humorous philosophy of sport. This British invention has produced what is called the 'sporting' attitude. Fundamentally that is nothing but a humorous (an artistic or a philosophic) acknowledgment of our grotesque and prodigious limitation. Why we are able to embrace this philosophy without abjectness, is evidently on account of the great discrepancy that our consciousness of this situation predicates between what we can perfectly well imagine and what, in the limited time, conditions and space at our disposal, we can accomplish. The man, as 'sportsman', says, to all intents and purposes, when he is administering the sporting spirit: 'Steady, steady! Easy, e-a-s-y! It'll all be the same a hundred years hence. Don't fling yourself on that ball as though it were a chocolate-ice in the tropics, or a loaf of bread let loose on a famine. It's only a little leather balloon. It's only a game you're playing. We all know you're a very wonderful player, my friend, but don't murder that man, or commit suicide: it's only a game.' Or if he is being 'a sport' at the moment, himself, his gesture of restraint or abnegation will declare: 'This is not *real* life. We're only exercising our bodies, laughing at ourselves a little, for the funny little machines that we are; being deliberately children.'

The Englishman is justly proud of this invention. His attitude, and his games, are a great practical contribution to human life: though they are also peculiarly his own, and it is doubtful if his formula can be satisfactorily used by anyone else. The *revers de la médaille* I will not go into here; though it evidently consists in the fact that, in the aggregate, the Englishman has not a 'reality' good enough to place against his 'game': or rather he has it, but omits to use it. His achievement is an analytic and practical one; a slowing down, a sedative pill for too harsh vitality. In Taine's description of the English, he refers to the abnormal checks required for so much egotism as he found among them. Turn the coin round, and back to back with the philosophic athlete you will find nothing more than—Queen Victoria (whose name I hesitated to mention, on account of the lèse Strachey it entails). The national aggregate sports, on its currency, the athlete: but it has not, as it should have, Shakespeare or Newton on the other side.

According to my view, all intellectual endeavour is in the same contingent category as a game of cricket or billiards. It is remarkable what can be done with the mind, and the doing it is stimulating: just as it is surprising, or so it is felt to be, that we should be able to leap so high and as far as we do, run 100 yards under 10 seconds, defend our wicket for so many overs, and so forth. But, although the mind possesses immensely more scope and resource, and its exercise is vastly more complex and exciting, it ultimately is marking time as much as the body, it has the movements of marching forward, but does not march, but is energetically drumming one spot all the while. Its method is built up, like that of a game, on the same reservations; and even like the appetite for the game, is mixed with a sense of the weak and the ridiculous.

The art impulse reposes upon a conviction that the state of limitation of the human being is more desirable than the state of the automaton; or a feeling of the gain and significance residing in this human fallibility for us. To feel that our consciousness is bound up with this non-mechanical phenomen of life; that, although helpless in face of the material world, we are in some way superior to and independent of it; and that our mechanical imperfection is the symbol of that. In art we are in a sense playing at being what we designate as matter. We are entering the forms of the mighty phenomena around us, and seeing how near we can get to being a river or a star, without actually *becoming* that. Or we are placing ourselves somewhere behind the contradictions of matter and mind, where an identity (such as the school of American

realists, William James, for example, has fancied) may more primitively exist.

Our modern 'impersonality' and 'coldness' is in this sense a constant playing with the fire; with solar fire, perhaps, and the chill of interstellar space—where the art impulse of the astronomer comes in, for instance.

But an astronomer, confronted with a whole drove of universes, is by no means abashed. They are his game merely, and he knows it. He regards the stars as the cattle of his mind, and space as his meadow. He must do, even to the simplest observation; or else he would not be so jolly even as he is.

Some adjustment, then, between the approach of a conscious being to that mechanical perfection, and the fact of his mechanical incompetence (since mechanical perfection will not tally with the human thing) is the situation that produces art. The game consists in seeing how near you can get, without the sudden extinction and neutralization that awaits you as matter, or as the machine. In our bodies we have got already so near to extinction! And with these portions of mountain and star, in which we remain with such hardihood and even insolence—playing fast and loose daily with our bacillus-ridden, terribly exposed *pied-à-terre*—we are in a daily aesthetic relation. The delight in physical danger, another ingredient of our games, the major motive of the switchback, of mountain climbing and so forth, is the more extreme form of our flirtation with extinction, or matter, if you like. All the thrill that we obtain from an exercise of the sense of humour is based on this phenomenon.

In a great deal of art you find its motive in the assertion of the beauty and significance of the human as opposed to the mechanical; a virtuoso display of its opposite. But this virtuosity, in its precision even in being imprecise, is not so removed from a mechanical perfection as would at first sight appear.

There is a passage in Dostoyevsky's 'Letters from the Underworld' quoted by Lavrin, that has a bearing on this point. I will quote it before leaving this part of my argument. 'If ever a formula is discovered which shall exactly express our wills and whims, make it clear what they are governed by, what means of diffusion they possess: a formula mathematical in its precision, then man will have ceased even to exist. Who would care to exercise his will-power according to a table of logarithms? A man would become, in such circumstances, not a human being, but an organ-handle or something of the sort.'

Standards in art

The difficulty of standards in art is very great. But it is not more difficult in art than in anything else; science alone, with its standards of weight, can, in its dealing with dead matter, pretend to a certain finality. No one controverts the velocity of light, established for us by Roemer, though its constancy may be questioned: little facts like the distance of the Earth from Saturn remain quiet and unchallenged. Once these things have been *measured*, there is an end to the matter. The science consists solely in inventing the most satisfactory means of effecting these measurements.

Metaphysics, on the other hand, is in a chronic state of flux and chaos; so much so that today the metaphysician seems to have been driven off the field. As I have said already, I think he will reappear in some rather different form; and he will reappear all the better for his holiday among the hospitable arts and sciences. (For he *must* be somewhere: and I do not believe that he has become a stockbroker, in disgust, or a commission agent.) Kant, in his Prolegomena, writes of his science of metaphysics: 'In this domain there is as yet no standard weight and measure to distinguish sound knowledge from shallow talk.' And, again, 'It seems almost ridiculous, while every other science is certainly advancing, that in this, which pretends to be wisdom incarnate, we should constantly move round the same spot, without gaining a single step. And so its followers have melted away: we do not find men confident of their ability to shine in other sciences venturing their reputations here.' At least a standard in art is not more difficult to fix than it is in this constantly discomforted sister science.

What has happened to philosophy has also, to some degree, happened to the fine arts. The incessant disputes between schools, the impossibility in which the public finds itself of establishing an interest (whether commercial or snobbish) anywhere, has ended by exhausting its patience, and it falls back on Rolls-Royces and whiskies and sodas with a vicious and defiant glance at the artist. 'I hate books', 'I hate pictures', or 'I hate music', is a remark not infrequently heard on the lips of people who formerly would have derived some satisfaction from supporting the arts. They have backed too many 'duds': they know that there is nothing they can encourage or identify themselves with that will not involve them almost in abuse, that will not be violently attacked. It will be almost as though they had done the beastly thing themselves! Such pictures,

music or books as would *not* involve them in this, are too stupid and clearly insignificant to waste time about. So, desiring a quiet life, they fight shy of the arts altogether.

And yet, because this produces a vacuum, which as true children of nature they abhor, in their existence as social beings, and makes their life shrink to a valueless and less excusable affair, all this leaves them a little ashamed and worried. All science can give them, and to it they repeatedly turn, in the shape of values, is a scepticism of which they have enough and to spare, and accumulations of animal luxury, which they feel, in its naked effrontery, should in some way be clothed with values, and the intellectual disguises in which their selfishness has always formerly been wrapped.

This question of standards is forever the ultimate difficulty where art is concerned. When the social life on which art depends becomes especially diseased and directionless, it appears with more insistence than ever, forced out of the contradictions beneath. This is because the picture, statue or book is in effect a living and active thing, evolving with other living things, and suffering their checks and distresses.

You can have a perfect snowball: what you expect of it is that it be made of snow and nothing but snow. That is all you mean by 'perfect' in this case. All snow is the same, and so you get easily enough your perfect snowball.

But the book or the picture again not only is living but gives an account of life. The work of art is produced by means of an instrument not originally shaped for performing these literary or other feats, and one that has to be employed concurrently at a variety of blunting tasks— it may be, even, making a living in a bank, or livery stable. The mind, hybrid as it is, with no end and no beginning, with no nice boundary at which it could be said: 'Up to this mark you can depend on a perfect result, and all that arises you are competent to deal with': from this mind nothing can be awaited but such productions as may cause us to say: 'That is the work of a good specimen of human intelligence': just as you say 'a handsome woman', 'a fine cat', or in French, 'un beau nègre'. Calderon de la Barca, Voltaire or Plotinus are good human specimens. There is nothing 'perfect' about their plays, novels or treatises. They are good in relation to the ineptitude around them. Strengthen this ineptitude, isolate it, into a potion of some body, and you get one of these striking men. But you must not mix it *too* strongly, or vitalize it too much: for he who sees God, dies. Gather into one personality all

the traces and virtues of the three men I have taken, and you would have no further need of any one of the three, theoretically. But then a synthesis of their prowesses would be less stimulating for us than one really lively specimen of such a distinguished triad. Amalgamated, they would be a pale shadow of their separate selves. Perfection, therefore, from this standpoint, appears as a platonic ideal, and is a thing with which we have not very much to do on our present road. With perfect snowballs or lightning conductors, we have some commerce; but not with 'perfect' works of art or human beings. The next point is this: could you disintegrate Voltaire or Plotinus still further; and would you get a still further improvement? I should rather say that Voltaire, etc., were the exact degree of disintegration from some all-inclusive intelligence needed to arrive at what we are adapted to comprehend. And that any further disintegration results in the dispersion of mediocrity, of little Voltaires: and anything more universal must progressively cancel itself.

If you conclude from this that I am treading the road to the platonic heaven, my particular road is deliberately chosen for the immanent satisfactions that may be found by the way. You may know Schopenhauer's eloquent and resounding words, where, in his forcible fashion, he is speaking of what art accomplishes. 'It therefore pauses at this particular thing: the course of time stops: the relations vanish for it: only the essential, the idea, is its object.'

That might be a splendid description of what the great work of plastic art achieves. It 'pauses at this *particular thing*', whether that thing be an olive-tree that Van Gogh saw; a burgher of Rembrandt or Miss Stein. 'The course of time stops.' A sort of immortality descends upon these objects. It is an immortality, which, in the case of the painting, they have to pay for with death, or at least with its coldness and immobility.

Those words are, however, part of a passage in the World as Will and Idea that it may be useful to quote fully:

'While science, following the unresting and inconstant stream of the fourfold forms of reason and consequent, with each end attained sees further, and can never reach a final goal nor attain full satisfaction, any more than by running we can reach the place where the clouds touch the horizon; art, on the contrary, is everywhere at its goal. For it plucks the object of its contemplation out of the stream of the world's course, and has it isolated before it.'

We might contrast this with a Bergsonian impressionism, which would urge you to leave the object in its vital *milieu*. Again, the 'presence

of mind' in the midst of the empirical reality which Schopenhauer cites as the characteristic of genius, this coldness is a self-isolation, in any case; for he who opens his eyes wide enough will always find himself alone. Where the isolation occurs, of subject or object, outside or inside the vortex, is the same thing. The impressionist doctrine, with its interpenetrations, its tragic literalness, its wavy contours, its fashionable fuss, points always to one end: the state in which life itself supersedes art: which, as Schopenhauer points out, would be excellent if people knew how to use their eyes. But if they did it would no longer be 'life' as we commonly mean it.

To continue the above passage, omitting several lines: 'This last method of considering things (that of experience and science) may be compared to a line infinitely extended in a horizontal direction and the former to a vertical line which cuts it at any point. The method of viewing things which proceeds in accordance with the principle of sufficient reason is the rational method, and it alone is valid and of use in practical life and in science. The method which looks away from the content of this principle is the method of genius, which is only valid and of use in art. The first is the method of Aristotle; the second is, on the whole, that of Plato.'

The act of creation, of which a book or picture is one form, is always an act of the human will, like poisoning your business rival, or setting your cap at somebody; the complete existence and exercise of this will entails much human imperfection, which will be incorporated in the book or picture, giving it the nervousness of its contours, and the rich odours, the sanguine or pallid appearance, which recommends it to us.

In art there are no laws, as there are in science. There is the general law to sharpen your taste and your intelligence in every way that you can. John Constable, in writing of an exhibition, said: 'Turner's light, whether it emanates from sun or moon, is always exquisite. Collins' skies and shores are true. His horizons are always pretty.' That is about as far as any painter gets, except Leonardo or a very few, in analysis of what he understands so well but about which, on the side of direct concrete appraisement, there is so little to be said beyond affixing a rough epithet.

All that we can definitely say—and we know that, surely, as much as we know anything—is that Bach's music is better than Paul Rubens or that the Sixtine chapel is better art than the Nurse Cavell monument, with relation to any end that we can conceive. Only a few people are able

to discriminate, it is true, between these respective works of art. A freak might be found who would derive identically the same intellectual satisfaction from gazing at the Nurse Cavell monument that Picasso would from gazing at Michelangelo's paintings in Rome. And for this freak there would be no difference between them. But if that were so, it would be Michelangelo that he would be looking at, in reality, or what is Michelangelo for us. And in any case he would be mad.

Every time has its appointed end, and its means are proportioned to it. Beauty occurs in the way that is met in motor-car construction or the human body. No more in pictures than in anything else can it be isolated from some organic principle. It is a portion of the Means, nothing else.

A third method, between subject and object

The function of the artist being to show you the world, only a realler one than you would see, unaided, the delicate point in his task is to keep as near to you as possible, at the same time getting as far away as our faculties will stretch. The motive of this contradictory manœuvre is as follows. He has, before he can show you reality, to dissociate himself from the objective world entirely, and to approach it as a stranger or (which is the same thing) a child. He, ideally, must not take any of the acquired practical information of daily life with him, to the point from which his observations are to be made. Any of the fever of combat (where he is at his task) would impair the equilibrium of his instrument.

When anyone says, however, a 'realler' world, not only an intenser and more compact statement of it than the usual working of our senses provides, is meant, but also a different world.

For what the artist's public also has to be brought to do is to see its world, and the people in it, as a *stranger* would. There have been so far principally two methods of achieving this. One is to display a *strange* world to the spectator, and yet one that has so many analogies to his that, as he looks, startled into attention by an impressive novelty, he sees his own reality through this veil, as it were, momentarily in truer colours. The other method is the less objective one of luring the spectator to the point from which, inevitably, the world will appear as the artist sees it, and the spectator from that point of vantage paints the picture for himself, but with the artist's colours and his eyes. The first of these methods can be described very roughly as the impersonal and objective

method, and the second the personal and subjective one. The latter method (contrary to what is sometimes supposed) seems to be more assured of a positive result: for a lesser effort of intelligence is required on the part of the public. It is the method that usually characterizes the art of an undeveloped society. The former, in which everyone partici- pates more fully, is proper to a 'civilized' time. The civilized man again is less willing or less able to abandon his personality sufficiently. He is (each member of the thronging audience) a little artist himself. He will not be meddled with: he must be addressed and moved, if at all, in the capacity of critic. He is not adventurous enough to go far field. It is a case of the mountain going away from Mahomet where Mahomet will not budge himself, if it is desired that the mountain should not be so near to the spectator.

The artist, unless of a very lucky or privileged description, can only exist, even, by pretending to be one of the audience. Nothing less democratic than that will be tolerated.

By this description of what we call a 'civilized' public you may gather that I am not very enthusiastic about it. In that you will be right: but it is not because I contrast it nostalgically with its opposite. A sort of undisciplined raw democracy of the intellect is what 'civilized' describes in our time. It is the revolt of the not naturally very wise or sensitive against any intellectual rule or order (parodying or marching in sympathy with political revolution).

What I consider that a certain amount of contemporary art presages, is the development of a new method—a third, if you like—that should not, if it comes, resemble the religious tyranny of the subjective method, and would escape from the half sophistication that the other method begets or for which, partly, it is designed. This point I will develop later, however; showing more fully, I hope, what I find unsatisfactory in the opposing methods, how the reconcilement might be effected: and how I see in some work of today an indication of the approach of a time when it may be used.

The sense of the future

Bergson's view that the permanence of the work of art, or its continued interest for us, depends on its uniqueness, on the fact that such and such a thing will *never happen again*, would make everything in life a work of art. This uniqueness is a portion of everything, and need not be invoked

for the definition of art. In fact, the other factors of the work of art of an opposite and general description are those that distinguish it from the rest of life, cancelling as far as possible its uniqueness. Indeed, as I have shown, it would seem that successful expression occurs exactly at the point where, should this uniqueness be diminished any further, it would lose in force as human expression. Even one of the only standards of measurement we have is the distance to which a personality can penetrate into the general or the abstract, without losing its force and reality for us.

The object, in Schopenhauer's words: 'Plucked out of the stream,' also is only plucked so far as will still enable it to breathe and live. Or rather—to dispense with the metaphor—the 'plucking' consists just in *abstracting* it. When it has been abstracted it is not quite what it was when in the stream. It is always a *different* thing, as we have said, when conveyed to us as an object of contemplation. And yet, it is that particular thing, still, that it was in the stream. For the distance it has traversed in the process of abstraction is insignificant if compared with the distances involved were it to reach an ultimate abstraction.

The question of uniqueness is bound up with that of the 'present time' for the 'present' is the essence of the unique, or of *our* unique. I will deal with this later on in the present essay, only considering for the moment our relation to the *future*, which must be considered at this point.

If it is true that all the past is in us, that it is this past, in terms of the present, that the artist shows you when he excites you most;—where, we must ask, in all this, does the future come in? Tragedy drags to the surface your wild monsters, gives them a few hours' frolic, and they are then driven back quietly to their dens. There is another sort of artist (of which the Italian Futurist, now deceased, is an excellent specimen) who should really be called a Presentist. He is closely related to the pure Impressionist. He pretends to live, and really succeeds sometimes, a sort of spiritual hand-to-mouth existence. He has tried with frenzy to identify himself with matter—with the whizzing, shrieking body, the smooth rolling machine, the leaping gun. And his life is such an eternal present as is matter's: only, being a machine, he wears out: but with his death nothing comes to an end, or is supposed to come to an end, but the matter of which his dynamic present is composed.

There are, however, some men who seem to contain the future as others contain the past. These are, in the profoundest sense, also our men of action, if you admire that term: for, as the hosts of the unlived

thing, they are the impersonification of action. I think that every poet, painter or philosopher worth the name has in his composition a large proportion of *future* as well as of past. The more he has, the more prophetic intuition, and the more his energy appears to arrive from another direction to that of the majority of men (namely, the past), the better poet, painter or philosopher he will be.

A space must be cleared, all said and done, round the hurly-burly of the present. No man can reflect or create, in the intellectual sense, while he is acting—fighting, playing tennis, or making love. *The present man in all of us is the machine.* The farther away from the present, though not too far, the more free. So the choice must be between the past and the future. Every man has to choose, or rather the choice is early made for each of us.

We all know people, and not necessarily old people, who live in the past. The past that they survey is only a prolonged present, stretching back as far as their mind's eye can reach. We know a great many more, the majority, of machine-like, restless and hard individuals, who positively rattle with a small, hollow, shaken ego; or, less objectionably, throb and purr with the present vibration of a plodding and complacent mechanism.

The man of the future, the man who is in league with time, is as engrossed *away* from the actual as the first man is in his dear past. There is not such a sad light over the future: it is not infected with so many old murders, and stale sweetheartings, and therefore the man accustomed to its landscapes is of a more cheerful disposition than his neighbour the other way.

I must leave this attractive figure, however, and once more hurry on, hoping to deal with him more fully before this essay is completed.

I will offer an exhortation, however, on this theme before departing from it.

You handle with curiosity and reverence a fragment belonging to some civilization developed three millenniums ago. Why cannot you treat the future with as much respect? Even if the Future is such a distant one that the thing you hold in your hand, or the picture you look at has something of the mutilation and imperfection that the fragment coming to you from the past also has, is not the case a similar one? May it not actually possess as well the 'charm' you allow to your antiquarian sense? I think we should begin to regard ourselves all more in this light—as drawing near to a remote future, rather than receding from

an historic past. The time has perhaps arrived to do that! Have not a few of us been preparing?

The future possesses its history as well as the past, indeed. All living art is the history of the future. The greatest artists, men of science and political thinkers, come to us from the future—from the opposite direction to the past.

The function of the eye

The practical and, as we say, 'prosaic' character of the function of our visual sense does not enable us to experience through it normally a full emotional impression. We cannot dream with our eyes open. Association is too strong for us. We are all, in a sense even, so thoroughly hidden from each other because we *see* each other. It is more difficult to exercise our imagination when the eye is operating. (The ear, being blind, is in that respect better off.) The practical and very necessary belittlement accomplished for us by the eye at the same time invalidates its claim to priority as the king organ where imaginative expression is concerned, although in every other sense it is so supreme. Even the eye cannot have the apple and eat it too; or be the apple of the mind's eye, and Nature's as well. The eye has to pay, emotionally, for its practical empire over our lives.

In dreams, however, the eye is in every way supreme. Our dreams are so muffled (or are such dreams only a painter's?) that they are nearly as silent as the Kinema. There the mind, by arranging things as it requires them for its own delight or horror, can get the full emotional shock, the purely visionary quality that early in life becomes dissociated from our exercise of the visual sense.

In what does this 'emotional' quality, the stripping of things and people by the eye of their more significant and complete emotional vesture, consist? Simply in an incessant analysis of the objects presented to us for the practical purposes of our lives. We are given by the eye *too much*: a surfeit of information and 'hard fact', that does not, taken literally, tally with our completer values for the objects in question. To make up, from the picture presented to us by the eye, a synthesis of a person or a thing, we must modify the order for which the eye is responsible, and eliminate much of the physical chaos that only serves to separate us from the imaginative truth we are seeking.

The eye, in itself, is a stupid organ, or shall we say a stolid one. It is robust to a fault, where the ear is, if anything, hypersensitive. Everything received through the eye from the outside world has to be 'treated' before it can be presented to the imagination with a chance of moving it. The law of this 'treatment' is, first, a process of *generalization*. An intense particularization may, however, on the principle of extremes meeting, have the same effect. But, broadly, it is by a *generalization* of the subject-matter that you arrive at the rendering likely to be accepted by the imagination. I am using the word 'imagination' to stand for that function of the mind that assesses and enjoys the purely useful work performed by the other faculties; the artist-principle in the mind, in short.

In traditional psychology the distinction between imagination and memory is said to be that with the former the sensations are arbitrarily re-ordered; whereas 'memory' is the term we apply to a fainter picture of something already experienced, but the sensations occurring in the same order, in the order of nature. Dreams are an example of sensations evolved, with great complexity, in a new order, and with new emotional stresses and juxtapositions. The work of the dramatist or novelist is in this category, and that of most painters whose work is remembered. But the work of art does the re-ordering in the interests of the intellect as well as of the emotions.

It is by studying the nature of this process of organization in art, taking several concrete examples, that I shall begin the search for the laws that govern this form of invention.

THE CREDENTIALS OF THE PAINTER

The English Review. *Part I appeared in January and Part II in April 1922.*

I

That the painter is a different sort of artist from any other, and a different sort of animal from any other artist must be recognized, and the ways in which he must necessarily differ should be thought about, before his claim can be fixed for us. Just as each individual artist stands for a certain mode of life and sensation, so each species of artist is related to a certain type of man. Each type of intellectual or of art activity possesses, in a sense, its own local and proper philosophy: and a world of different men and women would be engendered from the emotional and mental material of each of the several great clans of artists—painter, man of letters, musician—if all the rest of the world were wiped out, and only that clan or guild remained.

The painter in his fullest development appears to me to approach more to a generalized human type than the musician does. He is not so definite a specialist. Although to excel he must be as profound a technical specialist as the musician, yet, because of the very material in which he works, the colder, more practical, and less emotionalized material of the visible world, he is more of that world. He can whistle or hum an air while he works, whereas the musician begins working the moment he hums or whistles. He will therefore be less of a differentiated type than the musician. He will have something of the musician in him and something of the man of letters. And yet there will be something peculiar to him and to no other man, artist or otherwise.

In this article I am starting to examine the credentials of the painter. From that more general survey I wish to proceed to a consideration of the different modes of expression within the narrow frontiers of the graphic and plastic arts: with the ultimate object of providing such painters and sculptors (cubist, expressionist, vorticist) who are most in need of it with material towards such a document as is still constantly required of them whenever they appear in public, and present their works for the edification of a baffled world.

The painter of the 'Abstract' picture, regarded today as the votary of a mode that is likely to be superseded by other modes, will I think

establish a form of painting which will have to have its place, side by side with other forms of pictorial expression on which it will heroically react, but with which it will not interfere. The same man might practise several modes of painting side by side: just as classification of figure or landscape painter is a stupid and superstitious one when it implies a disability in a neighbouring mode. It may quite well seem as simple, some centuries hence, for a critic to name this form of painting as one of the established branches of pictorial art, as it was for Aristotle in his *Poetic* to divide painters into such sharp and simple categories as this: 'Polygnotus showed us types better than average men, Pauson worse, and Dionysius just the same.'

How satisfactory it would be if one could write: 'A paints people as we see them. B does not use natural objects in his pictures at all. C lies halfway between the two.' There would be a fourth who did all three.

To begin at the beginning, or the end, if you like, let us take two types of contemporary work, and glance at their credentials. I will choose an average of the yearly flood of 'portraits', on the one hand, things that can be approached in the easy mood in which a good photograph can be approached: or the painting that you can identify with some facile mode of the romantic fancy of the crowd of the time. An example of the latter, for our day, is the painting of a dark woman with a rose in her hair, sitting rakishly on the edge of a table, in a black Spanish hat, with a mantilla, smoking a cigarette. Both the portrait and the woman sitting rakishly on the table find their *raison d'être* diminished in the ratio in which they depart from the regions of quite local mental coarseness and confusion of any popular *milieu*. The usual type of the Academy Line picture, providing the *trompe-l'œil* is skilfully executed, is the static and more or less flattering mirror of the portrait, in which the civilized man has gazed for a great many generations. Apart from his feeling that some glasses are more flattering than others, the portrait will play its part in the life of the civilized man as long as the mirror will. The reality that is reflected in some portraits (but not I am afraid those painted very recently) is so fresh and delicate, as in the case of the great familiar portraits of the Renaissance, that it is, while you gaze at these reflections, like living yourself, in a peculiar immortality. And with the most matter-of-fact renderings, so long as they are efficient, it is one of the only, and one of the most immediate, means that men possess to defeat time. A portrait evidently ceases to be a portrait when it has that transporting effect that makes you feel, not that you are sharing a

moment of life removed by centuries from your own lifetime, but also that you are participating in a heightened life, the living of which only is an event as solitary and fixed as the thing at which you are gazing.

The pseudo-Spanish Carmen-like creature of a crowded afternoon at Burlington House is in a much lower category of usefulness than the apoplectic General with all his ribbons, tabs, and braid, whom she jostles (with true Andalusian insolence, as the thrilled spectator will feel) on the commercially important Line. For the portrait *must* be fairly like the General, or he would not pay for it. It has *so* much guarantee of truth. Whereas the Carmen-like figure (coal-black eyes, cigarette, effrontery) is a stage property. She is an exploitable figment of the crowd's mind. When they are looking at her they are gazing into their poor heads instead of out of them. The artist's wife, or the model, has to be imbued with an audacity and brilliance probably foreign to her. Somewhere between the reality (the model) and the figment (Carmen) the painter will lose the little bit of truth that might, in a painting from nature, have redeemed his work.

The fundamental claim of the painter or sculptor, his fundamental and trump credential, is evidently this: that he alone gives you the visual fact of our existence. All attachment to reality by means of the sense of sight is his province or preserve. His art is in a sense the directest and is certainly the most 'intellectual', when it is an art at all. The word-picture of the writer is a hybrid of the ear and eye. He appeals to both senses. In his imagery he leaves you the emotional latitude almost of the musician. He says 'the dog bayed', and as you read it a ghost of a deep sound causes a faint vibration in your throat (you 'bay'), and a vague hound appears with bloodshot eye and distended neck in the murk of your consciousness. The painter paints you a dog baying: it is a new and direct experience. More precise and masterful, it is less fluid and partakes less of the emotional physical nature of any movement. The dog never bays, although it shows you the gesture of baying. Although evidently existing in our atmosphere, one of the attributes of such existence is wanting.

The 'Happy melodist unwearièd, Forever piping songs forever new', of Keats, is only so happy because his pipe is soundless and because he has sacrificed the whole of his existence for the frigid moment of a sort of immortality. There is not one immortality, evidently, but several types, and this one is the painter's; a sort of death and silence in the middle of life. This death-like rigidity of the painting or statue, when a living being

is represented, this silence and repose, is one of the assets of the painter or sculptor. If pictures made a noise, like the statue of Jupiter Ammon or the figures at the approaches to Samuel Butler's Erewhon, the unique character of the destiny of plastic art would be impaired.

No one has ever wept at the sight of a painting in the way they sometimes weep when they listen to music. You could not by showing people a picture of a battle cause their hearts to beat and their limbs to move, eyes to water, and stomachs to turn round, as it is fairly easy to do by beating on a drum, and blowing into a fife. The respective physical effects of music and painting must always be insisted on in any attempt to arrive at a definite idea of the destiny of either of these arts. The coldest musician, even one who, like Schönberg, appears to be writing a sort of musical prose, cannot help interfering with your body, and cannot leave you so cold as a great painter can. As you listen to music you find yourself dashing, gliding, or perambulating about: you are hurried hither and thither, however rhythmically; your legs, your larynx, your heart are interfered with as much as is the membrane of your ear. Whereas looking at Botticelli's 'Birth of Venus' would cause you as little disturbance of that sort as looking at a kettle or the Bank of England.

Were it in the nature of things for a rhythm apprehended visually to have the same direct physical appeal as one conveyed by way of the ear, it would be much easier to explain to a person quite unversed in pictorial art how it is possible for a painter to derive such satisfaction from the abstract proportions and shapes, merely, of a pictorial composition, apart from its human reference. I have arrived here at the question of abstract pictorial composition. The credentials of the painter engaged in such work are the least obviously convincing of all. It may be as well to state, in passing, that his human justification is very much that of the musician, only without, on the one hand, the musician's uncanny physical appeal, or, on the other, the representative painter's part in our direct physical experience. To this I propose to return, however, in my final article, confining myself at present to such painting or sculpture as is more or less an imitative image of the world as we see it with our eyes, with more or less of the limiting complexities of nature.

But it will also be seen that there is a much closer relationship between what are regarded as the painters of the Right and those of the Left wing, or between the most 'representative' and the most 'abstract' painter, than is generally supposed.

A great many people are repelled by this coldness of the picture. They

cannot 'live' the painting as they can music. Too definite an image is imposed on them. Of all the arts painting and sculpture are the most independent and exterior to their public, and the public will readily feel for them something analogous to its feeling for the 'intellectual'— 'so aloof, unemotional, etc.'

Heine, in an account of the Romantic School, describes the nature of the opposition to Goethe in Germany. Heine endorses, with his usual flowery verve, Goethe's critics. He writes:

'Goethe's adherents looked on Art as an independent world in itself, a sort of *primum mobile*, which moves and governs all the shifting ways of men, their religion and their morality....

'No, God does not manifest Himself in all things alike, as Wolfgang Goethe thought, an opinion which made of him an indifferentist occupied with dilettantism, anatomy, the theory of colours, the physiology of plants, the observation of clouds, instead of the highest human interests....

'Goethe sang the history of emancipation in some of its chief crises, but only as an artist. With his antipathy to Christian enthusiasm, which was his special aversion, his inability or unwillingness to understand the philosophic enthusiasm of our times, and his dread of ruffling his placid self-composure, he regarded enthusiasm generally from the historical point of view, as an objective datum, as so much material to work upon. Thus spirit turned to matter under his hands and was moulded into shapes of beauty. Thus he became the great artist in our literature... Goethe's masterpieces adorn our beloved fatherland as fair statues adorn a garden, but they are, after all, statues. One can fall in love with them, but they are barren: Goethe's poems do not beget deeds, as do Schiller's... I was walking through the lower rooms of the Louvre and looking at the antique statues of the gods. There they stood with their blank gaze, and in their marble smile a secret melancholy, a troubled memory, it may be, of Egypt, the land of the dead whence they sprang...

'They seemed waiting for the word to give them life again, and break the spell of the ice-bound immobility. Strange, these Greek antiques reminded me of Goethe's poems, which are as perfect, as glorious, as calm, and seem likewise to pine and grieve that their icy coldness cuts them off from the stir and warmth of modern life, that they cannot weep or laugh with us, that they are not human beings, but hybrids of divinity and stone....'

I have quoted such a substantial piece of this indictment of Heine's because I find it particularly useful for my purpose in these essays. Goethe, as an artist, was the sort of artist a painter is. I want at the outset to get an image of him, the sort of existence he managed to live in the modern world, the spirit he so superbly represents, fixed in the mind of my reader. At the same time an image of the Painter will have taken shape, possessing, if one literally relates it to Heine's account of Goethe, this contradiction: that the painter participates more in life itself in one way than any other artist; but in another sense he is the most removed from it.

II

In my first article I insisted on the dyer's hand analogy, showing the painter working in a medium so physically different from that of the musician, and with preoccupations so opposed, in every way, to the other categories of art, that he will also remain a very individual species. In these articles it is not my object to discuss aesthetics in general. It is not the credentials of the artist I am writing about, but those of the painter. Yet a part of his credentials are also those of his genus. Therefore something has to be said on the larger justification of Art at all, and how it stands in relation to other activities.

First, then, the great difficulty in writing about a painting or piece of sculpture is that if your appreciation of it is a literary or philosophic one, the reality of the thing is apt to escape you; and if your interest is a technical one only (or as well) the specialist appreciation that results will be of interest to painters and not to the general student or the public.

In painting, as in the other arts, there are no laws. There is nothing clear-cut, demonstrable, and intellectually satisfying, such as you get in, for example, a Law of Motion of Newton, or the Kinetic Theory of Gases. Science, in argument, always has the advantage of an art where the man in the street is concerned. The contemporary public venerates science as much as it can anything. Even science it takes very much as a matter of course. All the same, a man who can tell it some FACT about a stress—how many tons of a given matter you can raise in the air without danger of collapse, and the probable term of a given structure's resistance to shock: or one who can supply it with an infallible chemical datum for a marketable glaze or what-not, is the specialist whose devotion to an abstract study he understands. And it is indeed satisfactory to be

able to give, with mechanical accuracy, the conditions of success for an experiment or a process of general moment.

The Chinese and Japanese, it is true, had their laws in painting: for example, the Japanese rejection of shadow in a painting. They held that the shadow of an object was of no significance, and should be ignored. But such a statement is a BY-LAW rather than a law. It may be necessary for seventeenth-century Japanese, just as today Survage paints, where men are concerned, nothing *but* their shadows. For his particular picture, the Survage combination, this is a law. But these parochial regulations and arbitrary little rules appear the flimsiest caprice when compared with some grand physical law of universal application.

Yet, less mechanical than the general law, the law of the individual, that intimate order and code by which he lives, with all its supple appearance of caprice and organic liveliness, should excite our admiration just as much.

Archimedes, with his lever, again, would rout Bach's pedal in an importance-competition, always, if only on the score of permanence. The lever is like another and more powerful hand bestowed for ever on men, whereas Bach is a wind in the ear, merely, it would be said. Yet Bach's music splendidly summarizes a great human type: the lever moves the body, of whatever dimensions ('Give me somewhere to stand, and I will move the world!'), but a Bach fugue moves something that possesses no physical dimension, but which is even more important to us than matter and its mass. Supposing the platform Archimedes called for were forthcoming, and he proceeded to jerk the world about: apart from the alarm he would cause in millions of breasts, the value of his action would be relative to the value of what was found on or in the earth at the time. In that way you arrive immediately at the question of value on which the general credential of the artist is based, and which it is impossible to resolve, whether it be in a dispute with regard to two works of art, each of which has its supporters, or between a work of art and some object of great general utility.

Where David Hume, speaking of moral beauty, concludes that for its appreciation the participation of the intelligence is required, he writes: 'But in many orders of beauty, particularly those of the finer arts, it is requisite to employ much reasoning, in order to feel the proper sentiment; and a false relish may frequently be corrected by argument and reflection.'

Argument and reflection are certainly very necessary, much as people

dislike them, where the finer, or better the finest, art, in any kind, is concerned. But, in the interests of this dialectic, no laws can be adduced of universal application. The work of art, in the end, has to impose itself on men like a living individual. Instead of appealing to their intelligence only, supplying them with a mechanical formula of universal efficacy, it must appeal to their whole make-up, or to their taste. The taste is a sort of higher, more complex intelligence. Every faculty serves it, and is found represented in its composition. Very few people possess this personal arbiter, or synthesis of the *ego*. The system of mutually contradictory compartments obtains usually: a man passes from one room to another. In one he performs actions that would be found repugnant to the self that he has left in the last, and *vice versa*. It is taste alone that can make him a dependable and ordered being. Here we can usefully allow ourselves to be reminded of the figure brought forward in the last article to typify the painter: Goethe. This art of understanding with the *entire* man, not some specialized section of him, which I say is required for art, might naturally bring Goethe to your mind once more, since he has been so lately mentioned—he who stands so much for development in all directions. And, once more, it is to this ideal of a certain inclusiveness that the painter appears to respond, much as Goethe does, and to possess as his birthright a similar healthy coldness.

Philosophers have from time to time decorated the imposing architectures of their systems with aesthetics as a building is embellished with wall-painting. ('Aesthetic' also has often been used with another significance than that we are giving it here, and in which sense it is more generally used.) But you get the feeling from listening to the metaphysician, while he discourses of art, that you would not pay much heed to what he thought of an individual work of art. You would know that Hegel's taste in painting would probably be Böcklin: and his conclusions on the subject of aesthetics, if you were a painter, would suffer in your estimation in consequence. 'He builds a good system of thought,' you might say, 'he may be as good as Wren—but he is not a very good man of letters, my friend X tells me, and I don't expect he knows a good painting from a bad one.'

Even a discursive philosophic essayist like Santayana pens art ingenuously and at once in the category of the Will as opposed to the Idea, and goes to look for it with a sense of holiday abandon, in the pleasure-quarter of the town.

Pleasure, in some form, is certainly the object of most art. But is it

not also the object of any other activity higher than pure bread-winning ? To make the majority of men feel comfortable and keep them quiet, the notion of the dignity of toil, in the sense of mechanical labour, was long ago invented. To unrivet the perception from the need, to disentangle art from the practical artifice of life, is the artist's constant task in his work. His task is, however, supposed to be as purely delightful as it in reality is delightful and arduous. His life, his work, is seen as one long holiday. He, the play-boy, the pleasure-man, dreams the day away while the stern surgeon stands in the operating theatre cutting off legs, or whipping out appendixes and the earnest chemist bends over his balances weighing and weighing and weighing, all in the end either for the comfort or enrichment of men. The artist, in contrast to this, can only show as a result of his day's activity some picture, music, or writing that, if men became supermen, or were provided with infinite leisure and opportunity to develop their intelligence, they could appreciate, and regard as the symbol of their elect existence. For art, in the deepest sense, is surely nothing but this. If so, what else is it?

The gesture of dragging art down to the level of a possible general humanity, empirically decided on, or of 'educating up to art' an un-numbered public, is equally absurd. Art always has been, and within limits must remain, the monopoly of the intelligent few. The mass will go to the performance of Shakespeare, the national picture collection, or buy the *Tale of a Tub*, but will understand nothing. Art is either an improvement of the head, of the summit of a society, or it is popular art, which, given primitive conditions, can be admirable, but will not satisfy the civilized man.

Taste, as I have described it above, is what would occur in the sphere of morals if David Hume's 'argument and reflection' became a habit, something that accompanied a man into whatever compartment of his existence he might be passing at the moment. In art it is the standard of value; its development is more and more in the company of 'argument and reflection'.

The usual thing that you hear advanced today to defeat the instinct and conviction of the artist is this: 'If the Prime Minister and Mr Bottomley get sensations from looking at a painting by Louis Wain, whereas they feel nothing but boredom when confronted with a Signorelli, then the former is the better picture while they are looking at it. There is no such thing as one picture being *better* absolutely than another. It is only better for *somebody*,' etc.

This attitude, a scepticism or dislike of the good emboldened by some unconscious leaning on the ideas released by relativity and other theories of our time, gives us the measure, also, of our chaotic life. For it implicitly repudiates also a scale of value for the individual, the spectator. It makes a clean sweep in which the hydrocephalous idiot, Machiavelli, and Mr Churchill find themselves of exactly equal authority. It pushes forward the claim, likewise, that you can be a vulgar sawney and a great artist too; just as you can be an ignoble and illiterate rogue and a 'great statesman' at the same time. In the case of the *artist* it definitely claims that that will be a confirmation of your fineness in your special work; with the politician this conjunction of qualities is tacitly agreed to be propitious. The possession of a general culture would be regarded with suspicion, and would not be tolerated, in an English statesman today. If he possessed such a thing he would have to keep it dark.

If we cannot get, at the top, a human world, then art, and everything that we have so far identified with the word civilization, must perish. If our values become the values of stones or matter generally, we perish, too. So long as you do not envisage the immediate likelihood of this, you have to deal with art, which, as tragedy or comedy, speech or adornment, is bound up with our human life.

If, however, without identifying ourselves with matter entirely, we yet evolved into a total material asceticism, how would it be with art then? One is bound to admit that art has so far been dependent on religion, a luxurious life, or superstitious fancy for its existence. But for any life that we could evolve into, short of identification with matter, or the other extreme of dissociation from it, there would be an art, or 'expression'. It is a half-way house, the speech, life, and adornment of a half-way house. Or it is a coin that is used on a frontier, but in neither of the adjoining countries, perhaps. As we know nothing about these or any other countries, it is impossible for us to say. Art is a coin, if you like, that has no aesthetic value, only an historic one. But it must be composed of a certain metal, and it must ring true. To recognize this ring you depend entirely on your ear. Your eyes, and even your teeth, can also be brought into play. And you can speculate on the character of the stranger who is tendering you the coin. These, taken together, make up your 'taste'.

H

PART III

The Trough between the Wars

INTRODUCTION

Lewis's optimism and vision of a new epoch, expressed in *The Tyro* of 1921, did not survive long into the twenties. The 'Tyro' figures, the grinning and villainous comic puppets after which the review was named, do not reappear in the second issue. They are replaced by the satirical characters of *The Apes of God*, instalments of which began to reach T. S. Eliot, for publication in *The Criterion*, early in 1924. The book satirizes the wealthy Bohemia of London, in their nursery games of playing at being geniuses, artists and critics. 'The Dithyrambic Spectator' (p. 235), a year later expands this view of what Lewis saw as the invasion of the stage by the audience, leading to the dithyrambic collective dance, to art as magic or religion. To this spectacle he opposes the more aloof perfection of Greek sculpture and drama or of the statues of Pharaohs and Buddhas.

Spending much time in the Reading Room of the British Museum, occasionally attending, by way of field work, a Diaghilev ballet or Mayfair soirée, Lewis pursued his analysis. There was a number of books, of which *Time and Western Man*, published in 1927, is the most spectacular in scope. The book locates the sources of the spiritual lassitude of Europe. It finds them in the disintegration, in philosophy, of the material, spatial world of common sense, and its replacement with the dark and feverish confusion of 'mental' truth. This development Lewis saw as issuing out of the cults of time and flux, expressed most notably in Bergson's philosophy and Spengler's 'world-as-history'. One-third of the book is a sustained and dramatic critical foray showing how this time-dominated world view is reflected in such diverse manifestations as the popularizations of science by Alexander, Whitehead and others, and the works of art by such practitioners as Pound, Gertrude Stein, Proust and Joyce.

As in the case of Baudelaire, Lewis's writings on art cannot be neatly separated from those on literature. Even a political book such as *The Art of Being Ruled* is basically an investigation of the conditions, intellectual and political, in which painting as much as literature or philosophy will flourish or die. To represent this wider preoccupation, this collection includes a key passage from *Time and Western Man*'s chapter 'Pure Poetry and Pure Magic' as well as the essay 'The Values of the Doctrine behind "Subjective" Art'.

The concluding essay of the twenties, 'A World Art and Tradition', shows Lewis approving the Continental surrealist painters, surprisingly, because in *The Enemy No. 3*, published a month earlier, he had devastated their literary counterparts, who were then associated with the Paris magazine *transition*. But, as he recognized, the painters had little to do with the writers. And so the pictures by Lewis which illustrate the essay show the influence of the works of the early de Chirico, which were the inspiration for such painters as Ernst and Tanguy also.

English painting in the twenties could show some artists of quality, of whom Paul Nash is characteristic. But there was little by way of radical experimental work. In 'A World Art and Tradition', Lewis suggests that 'the fragments I amuse myself with in the intervals of my literary work are, I suppose, among the only specimens of such painting done in England today.'

The situation changed in the thirties, when a number of British painters and sculptors, for the most part too young to have been witnesses to Vorticism, began to work in Continental abstract and surrealist modes. Lewis, fifty years old in 1932, decided he must make a return to painting. He began to work on a number of canvases, for an exhibition which would be his first major one since 1921.

There was little contact between Lewis and the groupings such as 'Axis' or 'Unit I', which arose around him. For one, these directions represented nothing new to the veteran of *Blast*. Then, the completion of his projected series of paintings, which had to be supported by writing, to allow him to live and pay doctor and hospital bills, took all his energy. The exhibition, finally shown at the Leicester Galleries in 1937, contained most of the oil paintings on which his reputation as a painter rests. Most of them showed invented figurative forms in stage-like or hieratic arrangements, ranging from beach scenes to dream visions or creation fantasies. The show was of an extraordinary variety and accomplishment, certainly one of the important shows in London of the between-the-wars period. Yet, by the end of its first week, only one painting had been sold.

In this depressing failure to sell his pictures, Lewis was in the same position as the other moderns working in London, where the public interest in English contemporary art had reached what was probably an all-time low. At the end of the decade, 'modern art' in England, finding itself with hardly an audience and nowhere to go, went backward. The

directions to which most of the painters turned, impressionism or a romanticism inspired by the nineteenth-century followers of Blake, did not augur well for a modern art of the forties.

An account of the reasons for the low state of painting in the late thirties, and a suggested remedy, were provided by Lewis in 1939. In *Wyndham Lewis the Artist*, he argues that the twentieth-century revolution, one of whose advocates he had been, had failed. The cause was the decline of professionalism and the rise of Dada and Surrealism, which had reduced art, in the eye of the public, to nothing more than a joke. Lewis saw the only possibility for painting's revival in a return to nature—or rather 'supernature'.

With hindsight, one may disagree with the advice Lewis gave to his fellow painters. Certainly he did not foresee, as he did not live to witness, the 'mass market' for contemporary art. What he proposed was, for him, simply the only way, and it became the direction in which, in a series of delicate drawings of the forties, he continued to work. As *Wyndham Lewis the Artist*'s reprinting of *Blast* and *The Tyro* suggests, the 'supernature' of Lewis's 1939 book was nothing but what he had aimed at all along, an art consisting of 'nature transformed by all her latent geometrics into something outside "the real"—outside the temporal order —altogether', but an art which was, at the same time, 'tied to nature and with its roots in the sensuous reality'.

ART CHRONICLE

Lewis contributed two 'Art chronicles' to The Criterion, *whose editor was T. S. Eliot. Both appeared in 1924, one in the July and the other in the October issue. We reprint, from the second, Lewis's review of* Living Art, *a portfolio of reproductions printed for* The Dial *by Ganymed Press, Berlin, in 1923.*

. . . Paul Signac's *View of La Rochelle* is a pretty effect; there is a fishing-boat in the centre, and there are two towers, placed, I suppose, at the extremity of some waterway, making it like a gate. The tissue of this picture is a beggar's rags, and conveys in its *sans gêne* the romantic side of nineteenth-century science. The ragged (and it is true not in detail very sensitive) reflections of the fishing-boat, towers, and clouds make a very agreeable picture; though not, I think, as agreeable as an old print would be of the same scene. The pretentious tinsel of its sunlight would be no equivalent for the 'classical' untidiness you would obtain in the print.

The *Rue à Nesles*, by Maurice de Vlaminck, is a very brilliant affair indeed. It is particularly well suited for reproduction, with its glare of white, sepia, and orange. Its appearance is that of a world as seen by the head-lights of a motor-car; if you imagine the head-lights provided with sphincter muscles, and connected with a qualified seat of aesthetic sensibility, registering its detached inhuman impressions on a brilliant disc, for the information of the god in the car, side by side with the time and speed-recording instruments. It is butterfly-shaped in its composition. Most of the pictures recorded by the car in the way indicated above would be of that description, of course. That is to say, that the Norman village depicted descends from the four corners of the picture and meets at its vanishing point, more or less, in the centre. It is what could be termed in composition a species of *radiata* that all the more lifeless forms of composition tend to be; though never mechanically centripetal, of course, but elegantly lopsided. The visualization of a motor-car is suggested not only by the *glare* of the painting, by the way it is hung on to the spectator's eye, stretched down to a vanishing centre, but even by a certain turning movement, as though revolving on parallel axes. The *Rue à Nesles* is, in short, a

street seen by a fairly sensitive, very powerful, motor-car, at five o'clock on a March evening; seen, of course, in a flash or a wink. It is the gulf (which its inhabitants—who are invisible—would name a street) into which, with a screaming bark, the car is about to plunge.

Among the drawings there is a fine line-drawing by Dunoyer de Segonzac of a stream and trees. The faggots or bundles of sticks (that is, the bushes or trees on the shallow banks, divaricating from a knot of scratches at the point at which they respectively come in contact with the ground) come perhaps from the Musée Cézanne, where so many other things come from; but Segonzac is always an interesting draughts-man.

The Matisse—*La Dame aux Capucines*—suggests to me—and whenever I see anything by Matisse I am forced to the same conclusion—that the contemporary world of art has in the case of Matisse gone very far wrong in according him the great place that it has. The reasons for that, seeing the dimensions of the mistake, would require an analysis that I cannot offer here. They can, however, be very roughly indicated.

The summary and superficial *chic* of his work makes it, I think, the natural idea of the dilettante. Most of his well-known paintings have been posters, to begin with, scrawled and distempered thinly on a uniform ground. They have been specifically *caricatures* in the sense that they resemble—allowing for their difference of scale—a quantity of very entertaining and dexterous little drawings that you can see any day of the week in a French comic paper. In a deviation from the normal—of which *caricature* is an example—it is not possibly so easy, but it is as natural, to distort or rearrange in the direction of a *heightening* of effect, as of a *lowering*. It is unnecessary to say that all the art we have up to the present agreed to admire has tended rather to the former deviation than to the latter. Of course, it is not a simple matter to agree on this question of direction; and the sculpture of Matisse—which invariably shows you some pathological distortion or variety of imbecility—could be defended against the superior assault of, say, the head of Colleoni at Venice on the ground that the latter is that of an *energumene*, demented in its martial energy. I must content myself here with saying that: (1) The people in the work of Matisse are arbitrarily distorted to satisfy a human predilection of the painter, rather than to satisfy the magnetic behests of neighbouring objects; (2) the predilection seems to me to be a mean, ridiculous, and empty one; (3) the effect has been to degrade the human accompaniment of his pots, furniture, and screens not only in significance,

H 2

but also in beauty; (4) and that even from the coarse, summary treat-
ment—showing an apt, but thin and slovenly, intelligence—this result
could be anticipated.

Matisse is best at a very circumscribed, thin, gay, and pretty, cleverly
arranged effect; and many small canvases of his, for what they set out
to be, are good enough. They especially have the merit of providing a
fairly palatable, 'sketchy' article for the amateur who feels the absence
in his life of intellectual excitement, but does not want *too much*. And
(as remarked above) they also meet the dilettante painter half-way—
providing him with a common ground of 'work'—half-way between
the playful immaturity of his daubing and dabbing, and the forbidden
regions of great achievement. This, in an age when the spectators have
revolted, and insist on participating in the performance and refuse to
take an interest in anything that cannot be easily imitated—has taken
Matisse a long way too. . . .

La Dame aux Capucines is a good specimen of his work. The two
human figures are unstrung streams of paint rather *sarcoid* than *living*,
like distended toffee-sticks rather than anything else. It is a well-arranged,
tasteful decoration, the colouring of which is certainly no better than
you usually get in any Japanese print of however degenerate and coarse
a type. Indeed, the harshness and crudity of some of the late bad prints
are usually much more pleasantly irritant than the merely sweet, 'taste-
ful', and pleasant colouring of Matisse. . . .

THE DITHYRAMBIC SPECTATOR

An essay on the origins and survival of art

The essay appeared in The Calendar of Modern Letters, *April 1925. It was reprinted in* The Diabolical Principle and the Dithyrambic Spectator. *The essay opens with an Introduction, which is a pessimistic analysis of the future of the fine arts. These arts Lewis sees as no longer associated with the needs of life, and beaten by the machine 'in every contest involving a practical issue'. They will survive, he argues, as the privileged pastime of the wealthy and a sop to the idea of 'civilization', 'not any longer as an object of serious devotion'.*

The concluding four paragraphs of the Introduction are given below. The last of these hints at the essay's argument. In Part I, Lewis explores the idea, suggested by Dr Elliot Smith's book The Evolution of the Dragon, *that the great works of Egyptian art developed from earlier functions of a supremely vitalist character. In Part II, another account of the origin of the arts is explored, that of Jane Harrison, in* Ancient Art and Ritual. *Miss Harrison's view that 'art and ritual have in emotion toward life a common root' is also vitalist. But, in Lewis's neat juxtaposition, it is seen to be the intellectual justification for the state of the arts delineated in the Introduction.*

We reprint from Part I the passages dealing specifically with the fine arts, and from Part II an excerpt which introduces the concept of the 'dithyrambic spectator'.

. . . But already in proportion as the technical standard declines, the performers (except for a very few privileged Stars) are more often than not recruited directly from the audience. They return to the audience when their summary performances are terminated. The community of the stage and of the auditorium is becoming absolute.

But it is hardly any longer correct to refer to this audience as composed of critics. The critic is, on the one hand, enough of an amateur performer to take a part; and, on the other, enough of a passive and voluptuous spectator to get a thrill of sorts. Always, at all events, he is too much of both to be unbiased.

At the end of this essay the fusion of audience and stage-personnel

will be seen to bear a strong resemblance to the triumph of the ἐθελονταί, as described by Aristotle: or, in that contemporary school of anthropology and folk-lore that has given a new lease of life to classical research originating with the work of Sir James Frazer, as traced by the late Miss Harrison in her popular book, *Ancient Art and Ritual*. The *critic*-stage—the point at present reached in the Western evolution of authentic expression—is half way between the spectator and the full effective crowd-performer.

The first part of this essay will expound briefly a recent and brilliant account of the origin of the Fine Arts, an account with a bias directed to show the supremely vital character of their earliest functions. And from that I will pass to a very different account of their origin, also with a bias—but this time an unintelligent, doctrinaire, and political bias—in favour of vitalist explanation; namely, that contained in Miss Harrison's little book.

PART I

That Art started on its long career—or rather that it first started being a substantial factor in human life—as a sort of Elixir, or Life-giver, is what Dr Elliot Smith's book, *The Evolution of the Dragon*, sets out to show. That it was hand-in-hand not only with magic, but with the doctor and anatomist, that Art made its debut; that the site of its first serious efforts was Egypt; and that it began as a purveyor of immortality, he affirms. ('The sculptor who carved the portrait-statues for the Egyptian's tomb was called *sa'nkh*, "he who causes to live", and the word "to fashion" (*ms*) a statue is to all appearance identical with (*ns*) "to give birth".') It was hand-in-hand with the Great Mother or with Aphrodite, surrounded by the vulvas of cowrie shells, and assisted by mandrake roots—in the same workshop as the embalmer and primitive physician—that the Artist began his terrestrial career.

'In delving into the remotely distant history of our species we cannot fail to be impressed with the persistence with which, throughout the whole of his career, man (of the species *sapiens*) has been seeking for an elixir of life, to give added "vitality" to the dead (whose existence was not consciously regarded as ended), to prolong the days of active life to the living, to restore youth, and to protect his own life from all

assaults, not merely of time, but also of circumstance.'

The great imaginative interest of this book of Dr Elliot Smith cannot be denied. It shows the statue evolving out of the corpse. It emphasizes how closely the sculptor's and painter's art was imitational and vitalist, in its earliest destiny.

Mummification is picked out as the great fecundating fact of egyptian life, from which (so says Dr Elliot Smith) world-civilization has ensued.

In *The Evolution of the Dragon* he sets out to trace the effects throughout the world, wherever the egyptian influence penetrated, of this peculiar concrete necromancy, as Diodorus calls it. The past became as important as the future, and these strangely preserved inanimate figures from a distant reality carried in themselves a host of questions. They were a living portrait gallery almost, a waxwork, not an art. The mummy symbolized, in fact, the extremely vitalist character of the egyptian view of art's functions.

I suppose that Dr Elliot Smith's identification of the birth of culture with mummification—or of the birth of the Great Mother with the cowrie shell—would be called a *theory*. But in the sort of historical research in which he is engaged the word *theory* should not be given the same meaning as in a more exact research. Such an identification should probably be regarded as a genial expedient for the effective launching of a more imaginatively fused information. It is with him a habit almost; and an extremely attractive and unusual one, an almost necessary simplification. You see isolated for you at the beginning of time the EMBALMER, bending over a CORPSE. And from the very simple conjunction of these two figures, representing the function of PRESERVATION and CONTINUITY, you see the whole world, from Ireland to Peru, bursting into cultural bloom. . . .

You only have to walk into a museum gallery devoted to egyptian art to recognize at once that you are walking into a sort of churchyard or very curious sort of undertaker's shop. Thoth, in massive trutination, is weighing life against death. And, sure enough, the form life takes on this occasion is that of *art*. Indeed, in dynastic Egypt, *art* comes nearer to being *life* than at any other recorded period: and apparently for the reason that it was *death*.

But plastic or graphic art necessarily flourishes in the mortuary. The *living death* that is represented by egyptian culture is the very atmosphere for the sculptor and painter to thrive in. A vivid materialistic life (such

as the egyptian population, no doubt, lived, but which was not allowed
to migrate, without hushing itself, into the tombs and temples), wherever
lived, produces, at its best, some coloured easy popular homologue of
the Japanese Print. At its worst, it produces the feeble gibberish of the
contemporary railway bookstall, the designs and stories of the popular
magazines. Great art is, for the hurried and unexacting standards of this
quick unconscious life, a useless instrument. Such life itself resembles a
railway station, or railway carriage, the things of which it is specifically
composed made for its hurried uses, left on the seat when the train is
left, and swept up as rubbish at the terminus.

But the premium or fine paid by great Pharaohs for leases in the other
world is put aside in this world for the upkeep of vast imitation establish-
ments peopled by imitation immortals: in other words, for building,
sculpting, and recording on a giant scale worthy of eternity. The
egyptian sepulchre and temple is, actually, a building already in another
life. And it is replete with all the massive state of an ambitious, and
almost endless, continuity.

Into the egyptian *living death*, again, a good deal of the *rigor mortis*
has passed. And that suits art admirably. It asks nothing better than a
corpse, and it thrives upon bones. Did not Cézanne bellow at his sitter
when he fell off the chair, 'You're *moving*! Les pommes, ça ne bouge
pas!' He preferred apples, in short, not because he otherwise discrimin-
ated between men and apples, but because men moved, whereas apples
did not.

But there was an even further stroke of luck for the egyptian crafts-
man. That was that the corpse or the corpse-statue had to be a par-
ticularly *lively* one. This, of course, might go too far: as can be gathered
from the account of the naturalism that this life-obsession engendered.
Especially was that the case with regard to the eye. That *sparkling eye*
threatened the whole structure of egyptian art, and probably contributed
to its ultimate downfall.

The sculptor, always preoccupied with the *life-like* and nothing else,
arrived at last at startlingly natural images in stone or wood of the
grandees he was commissioned to immortalize. With paint he improved
still further his facsimile. But still there was something lacking, apart
from the movement of life, that even he could not give. The EYE was the
last thing to resist his ingenuity. But at last he had that shining, coloured
and marvellously alive as well. His statue, although so still, now scintil-
lated and lived.

This triumph of the imitative art was not regarded by the Egyptian as a *tour de force* however—not one of art, or rather not *for* art. The sculptor (he thought) *had made the statue live*. Death's psychic evulsion was reversed, the soul had been put back by this craftsman, into the dead. It was a 'living image'. The eyes themselves were regarded as one of the chief sources of the vitality which had been conferred upon the statue.

According to the most fanatical canons of art, and according also to many quite temperate canons, these statues are not the best produced in Egypt. These sparkling eyes, had the Egyptians possessed the mechanical equipment, with the centuries of positive research behind them that we have, would soon have *moved*. Thereby, from the artist's point of view, they would have come into competition with apples, the advantage remaining heavily upon the side of the fruit. But luckily the liaison between art and science had not then been effected. There was a lacuna in human ingenuity on the hither side of which, like an island nation, art prospered.

The information brilliantly presented by Dr Elliot Smith about all this ferment of creative intelligence around the corpses of egyptian magnates, is of the greatest importance for the understanding not only of egyptian art, but of art altogether. The more you reflect upon this information, the more you are convinced how very much to be preferred a dead magnate is to a live one. 'There's a great deal to be said for being dead' (or for the incessant contemplation of death) on the part of a person sitting for his or her portrait. . . .

But what assured for this egyptian portraiture (equally it appears a child of life and death) conditions particularly favourable to artistic expression, was in the nature of the *truth* required. It had its chance of perfection because it was working for *the other world*.

Those artists could be said, indeed, to be living as much in one world as in the other. People's small vanities do not transgress death very readily, although their mortal needs were supposed by the Egyptians to accompany them. Under such circumstances they do not want so much to be *beautiful*, as to be *like themselves*—terribly and truly like. And so long as they think that such things as the earlier dynastic sculpture are *like* them, the artist is at the zenith of his opportunity. (As they become more knowing or civilized and mechanical, the art *pari passu* becomes less good.) The art of the perruquier or the dressmaker, though it has its place, has given way in egyptian art to the great creative instincts of

our kind. To be true rather than false was the function of the egyptian artist.

Any account of the origins of art given us by Dr Elliot Smith necessarily confines us, to begin with, to the banks of the Nile; for there and nowhere else, says he, all civilization saw the light. Whether this necessary restriction has given, or not, a particular twist to his version of the birth of art, which we have just surveyed, it remains a very interesting one. And whatever the ultimate fate of his theory of egyptian cultural priority, there is nothing *behind* Egypt that has been so far discovered that can be said to interfere with its claim to origination. When we are examining a work of egyptian art, it is even an assumption that we cannot entirely dispense with that here we may be confronted with the first tremendous human effort—which perhaps we may have been dissipating ever since, and which is unlikely to be repeated. In touch in an organized way with a supernatural world of whose potentialities we can form no conception, the art of Egypt is as rare and irreplaceable a thing as would be some communication dropped upon our earth from another planet.

For Dr Elliot Smith, then, the practice of plastic art (which is one of the most peculiar activities of human beings) developed body to body with the corpses of pharaonic grandees. It was thus a superhuman effort of *imitation*. Because it was all carried out not in the interests of this life, and its vanities, but for the Other-world, it was able to be *true*. This facsimile truth, imposed upon a certain naïf hieratic gaucherie, is all there is to it.

In the first place, had the art of Egypt been nothing but that—and a great deal of it, especially later work, is not much more—we should not have heard so much about it. This *corps-à-corps* imitation of the human form, its translation into a stone or wood facsimile, leaves out of count the great wealth of abstract design, with all its peculiar and untranslatable severity of imagery, which is equally a feature of egyptian art. Enamelled plates, perfume spoons, vases, amulets, stools, borders and facings of all sorts, every form of applied art, show an almost inhuman wedding of what is a sort of geometric power with a particular aesthetic principle. Then the beauty of the Canopic jars, which are amongst the earliest inventions of egyptian art (examples dating to the Old Kingdom, we are told), cannot be put down to the practical requirements of evisceration. The wall and ceiling decorations of the mastabas are the

reverse of *imitation*. They are as mathematical, intricate, and in contradiction to the disorder of the natural world as musical composition or geometry. If you add to this the superb architectural remains, and the records that we have of their secular building activities, you arrive at a mass of creative work in the midst of which the exact portrait study of the deceased becomes unimportant as *art*. It is no more important to the study of the origin of this instinct than is the singular means taken in the case of the statue of the Pharaoh Mycerinus to ensure its perduration by rooting it in the virgin rock.

But this does not interfere with an acceptance of the theory of how all this extraordinary harvest of intellectual achievement was made possible by the early business association of the sculptor and the embalmer. It does however reduce this theory of the origin of art in Egypt to a practical question, having no bearing upon the essential function of art. It may be regarded simply as an account of the social conditions or accidents that are likely to enable an artist to do his art. It is not an account of the inner process whereby a person becomes an artist, or what art *is*.

If there were a man in London who was prepared to pay two thousand pounds to have a large music room and hall, say—or a billiard room, bathroom, and hall—decorated (instead of buying a super-car), and *if* such a man had some taste, of a rather severe and unusual nature, then I should be able to indicate to this man where he could find an artist who could be entrusted with the execution of this commission. Such a patron does not exist, of course. But Egypt bred such patrons like flies, under the shadow of the Other-world, and with the help of the theory of the immortality of the soul. That does not tell you anything about *art*, all the same, only about the opportunities that bring it to flower. Indeed, the specific examples of egyptian art that are the closest to this origin in a practical requirement, are the least interesting pieces in the history of that art.

PART II

Dr Elliot Smith's is an exhilarating and adventurous treatise. I will arbitrarily associate with it, here, a book of a very different order—in the hope that, from a consideration of the two together, I shall be able to bring something to light, and for the evulgation of which such historic backgrounds as they provide are necessary. This second book is Miss Harrison's *Ancient Art and Ritual* (Home University Library).

If Dr Elliot Smith is attracted, by reason of his professional experience, to the physiological antecedents of art, Miss Harrison is temperamentally attracted by the May-pole festivities of the village green—those of Merry England, and still merrier Greece. Whereas the truth of which Dr Elliot Smith makes us so handsome a present has the authentic stamp of the hospital upon it, with the professional appeal of that type of reality, Miss Harrison is principally indebted to Sir James Frazer for her very interesting evidence, and the anthropological *pugging*, if not the plan, of her theory. In *Ancient Art and Ritual* she is, of course, directly concerned with the philosophy of art. And the material is presented in an attractive and lucid form.

Miss Harrison's theory of the origin of art reduces itself to this. She asserts that (1) the transition of art out of some earlier activity can be studied better in greek art than elsewhere: that (2) of the two most important forms of art in Greece, the *drama* and *sculpture*, the *drama* came out of the ritual and magical practices of the people, or the particular practices associated with the cult of Dionysos; and that the *statue* is— well, what all statues of gods are, a representation of a deity, which in its turn is the ideal presentment in mud, wood, or stone of a May-King, or Jack-in-the-Green—Dionysos or Apollo.

'The stages, it would seem [she says], are: actual life with its motor reactions, the ritual copy of life with its faded reactions; the image of the god projected by the rite; and, last, the copy of that image, the work of art. We see now why in the history of all ages and every place art is what is called the "handmaid of religion". She is not really the "handmaid" at all. She springs straight out of the rite, and her first outward leap is the image of the god. Primitive art in Greece, in Egypt, in Assyria, represents either rites, processions, sacrifices, magical ceremonies, embodied prayers, or else it represents the images of the gods who spring from those rites. . . .'

Today we have started the return journey *back* to ritual, Miss Harrison tells us—back to the community-singing, the mass-dancing, back to the excited crowd. In her *finale* ACTION is uppermost once more— 'Thanks be to God.'

'For those of us who are not artists or original thinkers the life of the imagination, and even of the emotions, has been perhaps too long lived at second hand, received from the artist ready-made and felt. Today, owing largely to the progress of science, and a host of other causes social

and economic, life grows daily fuller and freer, and every manifestation of life is regarded with a new reverence. With this fresh outpouring of the spirit, this fuller consciousness of life, there comes a need for first-hand emotion and expression.... Art in these latter days goes back as it were on her own steps, recrossing the ritual bridge back to life.'

So at the last, having watched with some pain and perplexity the differentiation into artist, spectator, and so forth . . . we are privileged to observe the tide setting back again to those 'deeper, vaguer, more emotional regions'. Once more the 'amateurs' (ἐθέλοντaί) come crowding back. Once more we live *collectively*. All men once more are *actors*.

Now this fusion, or uprising of the audience and return of Everyman into the arena or choral acting-place, is, true enough, occurring universally. But it is not a *return to life*, as a return to a true primitive belief would be. There is a third stage, therefore, with which Miss Harrison does not deal, and of which apparently she is not aware.

Greek humanism is, for Miss Harrison, 'characteristically a group limitation'. 'We moderns are in love with the background. Our art is a landscape art.' Our art is 'the art of a stage, without actors; a scene which is all background, all suggestion. It is an art given us by sheer recoil from science, which has dwarfed actual human life almost to imaginative extinction.' It is science, according to Miss Harrison, that has 'given us back a world-soul'. It is also, she says, science that has given us an art of backgrounds, in which the human individual disappears. It is science that is *the great democratizing force*, in short, of the modern world. Science stands for the theory of *collective* life, art for the doctrine of *individual* life. Science is for the *dromenon*, art for the *drama*. Science is for the dithyrambic dance: art is for the aloof perfection of the Attic stage.

If it is asked of what *use* art is, the answer must be that it has been put to innumerable uses. When not interfered with, it can make a sort of paradise of the world (which, it is unnecessary to say, whenever such a thing has occurred, can no more have been noticed by those privileged to dwell in the midst of it than the abstract beauty of 'nature' is experienced, probably, by primitive men).

But the great traditional use of art as a *catharsis* is still its best credential. With religion, magic, or primitive 'mystery', usually the crowd has those 'backgrounds' just referred to thrown open to it: or there is always a tendency to 'fusion' and ecstasy. 'The back is knocked out' of the stage.

With art men are shown these 'backgrounds' too. Great art is cut out
of the same wild material. But it is as spectators that they survey these
terrible truths, with the atmosphere of the distances which art main-
tains, and the *measure* of its trance, to soften them. That is the form,
no doubt, in which a community less demented than most, and capable
of receiving their purges with fortitude and relative calm, would always
receive them.

But art ceases to be art, or great art at least, when beneath its seductive
exterior these ultimate realities are not found. And it is the most perish-
able of specifics. Great discipline is required to prefer to watch a game
perfectly played, rather than kick a ball about clumsily yourself, if you
have that option.

Very rapidly the banks of spectators turn into a great assembly of
'amateurs' ($\dot{\epsilon}\theta\epsilon\lambda o\nu\tau\alpha\acute{\iota}$) once more. Then it is that the phase left out by
Miss Harrison occurs: that namely in which a collective 'play' is engaged
in, in which no 'real' or 'practical' issues are involved.

But this is the *transition*. In this phase left out by Miss Harrison we
have, no doubt, the *bridge*, 'back to primitive life', of which she speaks.
It is nothing but a bridge, of course, since people cannot 'play', and
fiddle about, for long. The full blind collective ecstasy is not far off
when this translation of the *spectators* into *amateurs* has been effected.

The transition *referred to is the magazine, founded in Paris in 1927
by Eugene Jolas, and edited by himself and Elliot Paul. In* The
Diabolical Principle (*1929*), *an attack on the politicization of art,
Lewis had made an example of* transition *and its constant contributor,
Gertrude Stein. In a 1931 reprinting of* The Diabolical Principle
and The Dithyrambic Spectator, *from which our text is taken,
Lewis prefaced the latter essay with the following 'Note':*

The intimate connection between these two essays, *The Diabolical
Principle* and *The Dithyrambic Spectator*, is evident in the last paragraph
of the latter. The *bridge*—the mode of the *transition*—'back to primitive
life'—that provides the explanation for that feverish and ramshackle
pontoon which was the *transition* of Paul, Stein and Jolas. As to the
'dithyramb'—all, with the transitionist, is dithyramb! It is the ecstasy
of destruction.

PURE POETRY AND PURE MAGIC

From Chapter IV of 'An Analysis of the Philosophy of Time', the second part of Time and Western Man.

Earlier, Lewis discusses Henri Bremond, author of La Poésie Pure *(Paris, 1926), whom he uses as a stand-in for Bergson. He brings in Professor A. N. Whitehead, the mathematician and philosopher, whose imbuing of* matter *with* spirit *he had attacked in earlier chapters of* Time and Western Man. *In the present chapter, the two men are made to perform an entertaining and brilliantly conceived* contredance. *Both are seen as exploiters of the artistic consciousness and the methods of the artist. Brémond is a 'religionist' masquerading as an artist or critic of art or a philosopher. Professor Whitehead addresses his attention to art in the interest of scientific theory.*

I will state very briefly my own belief as to the true character of artistic creation. The production of a work of art is, I believe, strictly the work of a visionary. Indeed, this seems so evident that it scarcely needs pointing out. Shakespeare, writing his *King Lear*, was evidently in some sort of a trance; for the production of such a work of art an entranced condition seems as essential as it was for Blake when he conversed with the Man who Built the Pyramids. To create *King Lear*, or to believe that you have held communion with some historic personage—those are much the same thing. The traditional romantic epithet for the poet—and as M. Brémond says, all creators are equally poets—namely, 'dreamer' (which subsequently became a term of belittlement or contempt on the lips of the romanticist for positive knowledge or the science-snob), accurately describes all creative artists; though, of course, it need not apply, indeed could hardly do so, to the great number of practitioners of art who do not possess the essential qualifications of the artist.

If you say that creative art is a spell, a talisman, an incantation—that it is *magic*, in short, there, too, I believe you would be correctly describing it. That the artist uses and manipulates a supernatural power seems very likely.

The poet or philosopher in the non-religious greek states occupied, we are told, much the same position as the priest or witch-doctor or

magician in a more religious or superstitious community. It was for that reason that a poet or philosopher was held responsible for his slightest or most casual utterance in the way that he was. He was recognized as the custodian of the spiritual consciousness of the race. The productions of art assumed somewhat the role of sacred books.

It is the appreciation of this *magical* quality in artistic expression—a recognition that the artist is tapping the supernatural sources and potentialities of our existence—that composes a good deal the attitude towards him and his creation that so often comes to light, and at some periods in a manner so unfavourable for his function. The artist is definitely, for the fanatical religionist, fabricating graven images, or tampering, in a secular manner, with sacred powers. The sort of material that Pirandello makes such a liberal use of in his plays, reduces itself to an expression of this consciousness: namely, the sort that realizes that Don Quixote or the Widow Wadman is as *real*, to put it no higher than that, as most people ostensibly alive and walking the earth today.

So the only dispute I am concerned to engage in with such critics as M. Brémond is such as is suggested by the question: All that being admitted as fact, where do you propose that that should lead us?

For me art is the civilized *substitute* for magic; as philosophy is what, on a higher or more complex plane, takes the place of religion. *By means of art*, I believe Professor Whitehead and M. Brémond wish to lead us down and back to the plane of magic, or of mystical, specifically religious, experience. And though the artist is certainly not devoid of religious emotion, it is exercised personally, as it were; and he is in temper the opposite of the religionist. The man-of-science is another sort of transformed magician. He, too, is opposite in temper to the religionist. The truly scientific mind—which Professor Whitehead, it is evident, does not possess, any more than he possesses, it is plain, the artistic—is as 'detached', as we say, as is the artist-mind.

From this point of view the true man-of-science and the artist are much more in the same boat than is generally understood. The sort of time that would produce a great flowering of art would be apt to produce similar ferments in science. But the mixing of them up à la Whitehead can only have one motive: to retransform both of them into the primitive magician from which they both equally spring, or rather to retransform their chosen material into simple magic.

This, I am afraid, is a very imperfect statement, and requires, I am

quite aware, considerable amplification. It is, however, all I can give for the moment. If I attempted a more detailed statement in this place, every further step would involve us in further elucidations, and I should risk extending this part of my argument at the expense of what I have to say elsewhere, and which at the moment is of more importance.

THE VALUES OF THE DOCTRINE
BEHIND 'SUBJECTIVE' ART

From The Criterion, *July 1927. This essay was also incorporated into Lewis's* Paleface: the Philosophy of the Melting Pot.

The object of this article is to set in relief the automatic processes by which the artist or the writer (a novelist or a poet) obtains his formularies: to show how the formulas for his progress are issued to him, how he gets them by post, and then applies them. According to present arrangements, in his dealings with nature he is almost always apriorist, we suggest. Further, he tends to lose his power of observation (which, through reliance upon external nature, in the classical ages gave him freedom) altogether. Yet *observation* must be the only guarantee of his usefulness, as much as of his independence. So he takes his nature, in practice, from theoretic fields, and resigns himself to see only what conforms to his syllabus of patterns. He deals with the raw life, thinks he sees arabesques in it, but in fact the arabesques that he sees more often than not emanate from his theoretic borrowing, he has put them there. It is a nature-for-technical-purposes of which he is conscious. Scarcely any longer can he be said to control or be even in touch with the raw at all, that is the same as saying he is not in touch with nature: he rather dredges and excavates things that are not objects of direct perception, with a science he has borrowed; or, upon the surface, observes only according to a system of opinion which hides from him any but a highly selective reality.

The mere fact—with the artist or interpreter of nature—that his material is living, exposes him to the temptation of a drowsy enthusiasm for paradox, since 'life' is paradox (sprinkled over a process of digestive sloth), and all men live, actually, upon the amusement of surprise. 'What man is this that arrives? A beautiful, a wonderful, stranger!' they say: and all strangers are wonderful or beautiful. 'What will the day bring forth? There will be some pleasant novelty, at least of that we can be certain!—a novelty with whose appearance we have had nothing to do.' 'Life' is *not*—knowing: it is the surprise packet: so, essentially unselective, if nature can be so arranged as to yield him as it were a system of surprises, the artist will scarcely take the trouble to look behind them, to detect the principle of their occurrence, or to reflect that for 'surprises', for the direct life of nature, they are a little over-

dramatic and particularly pat. So he automatically applies the accepted formula to nature; the corresponding accident manifests itself, like a djinn, always with an imposing clatter (since it is a highly selective 'accident' that understands its part): and the artist is perfectly satisfied that nature has spoken. He does not see at all that 'nature' is no longer there.

You are merely describing, you may say, the famous 'subjective' character of this time, in your own way and a little paradoxically. If I could surprise anybody into examining with a purged and renewed sense what is taken so much for granted, namely our 'subjectivity'— though who or what is the subject of Subject?—I should have justified any method whatever. But I am anxious to capture the attention of the reader in a way to which he is less accustomed, a less paradoxical way.

In Western countries the eighteenth-century man and the Puritan man are perhaps the most marked types that survive, disguised of course in all sorts of manners, and differently combined. We have learnt to live upon a diet of pure 'fun', we are sensationalist to the marrow. Ours is a kind of Wembley-life of raree-shows, of switchbacks and watershoots. We observe the gleeful eye of Mr Bertrand Russell as he appears suspended for a moment above some formal logical precipice. Or there is Mr Roger Fry in the company of his friend Mr Bell, sustaining delightedly shock after shock from the handles of some electric machine, or in other words from the unceremonious vigour of some painting which, charged with a strange zeal, outrages in turn all the traditional principles of his English training and his essential respectability. Then there are the roundabouts for the Peter Pan chorus, swings for exhibitionists, mantic grottoes and the lecture-tents of the gymnosophists. Oh it is a wild life that we live in the near West, between one apocalypse and another! And the far West is much the same, we are told. In a word, we have lost our sense of reality. So we return to the central problem of our 'subjectivity', which is what we have in the place of our lost sense, and which is the name by which our condition goes.

Elsewhere I have described this in its great lines as the transition from a *public* to a *private* way of thinking and feeling. The great industrial machine has removed from the individual life all responsibility. For an individual business adventurer to succeed as he could in the first days of industrial expansion, will tomorrow be impossible. It is evidently in these conditions that you must look for the solid ground of our 'subjective' fashions. The obvious historic analogy is to be found in the Greek

political decadence. Stoic and other philosophies set out to provide the individual with a complete substitute for the great public and civic ideal of the happiest days of Greek freedom: with their thought we feel ourselves quite at home. I will take the account of these circumstances to be found in an essay of Edward Caird.

'Even in the time of Aristotle a great change was passing over the public life of Greece, by which all its ethical traditions were discredited.... By the victories of Philip and Alexander the city-states of Greece were reduced to the rank of subordinate municipalities in a great military empire; and, under the dynasties founded by Alexander's generals, they became the plaything and the prize of a conflict between greater powers, which they could not substantially influence ... we may fairly say that it was at this period that the division between public and private life, which is so familiar to us but was so unfamiliar to the Greeks, was first decisively established as a fact. A private non-political life became now, not the exception, but the rule; not the abnormal choice of a few recalcitrant spirits, like Diogenes or Aristippus, but the inevitable lot of the great mass of mankind. The individual, no longer finding his happiness or misery closely associated with that of a community ... was thrown back upon his own resources.... What Rome did was practically to pulverize the old societies, reducing them to a collection of individuals, and then to hold them together by an external organization, military and legal ... its effect (that of roman power) was rather to level and disintegrate than to draw men together.'

There is not much resemblance, outwardly, between the pulverization by one central power, such as that of Rome, and the pulverization of our social and intellectual life that is being affected by general industrial conditions all over the world. But there is, in the nature of things, the same oppressive removal of all personal outlet (of sufficient significance to satisfy a full-blooded business or political ambition) in a great public life of individual enterprise: and, in the West, at the same time, through the agency of Science, all our standards of existence have been discredited. Many people protest against such an interpretation of what has happened to us in Europe and America: they do not see that it has happened, they say that at most 'there may be a danger of' it: yet every detail of the life of any individual you choose to take, in almost any career, testifies to its correctness.

As to what is at the bottom of this immense and radical translation from a free public life, on the one hand, to a powerless, unsatisfying,

circumscribed private life on the other, with that we are not here especially occupied. But the answer lies entirely, on the physical side, with the spectacular growth of Science, and its child, Industry. The East is in process of being revolutionized, however, in the same manner as the West. Let me quote Mr Russell: 'The kind of difference that Newton has made to the world is more easily appreciated where a Newtonian civilization is brought into sharp contrast with a pre-scientific culture, as for example, in modern China. The ferment in that country is the inevitable outcome of the arrival of Newton upon its shores. ... If Newton had never lived, the civilization of China would have remained undisturbed, and I suggest that we ourselves should be little different from what we were in the middle of the eighteenth century' (*Radio Times*, *8 April*). If you substitute Science for Newton (for if Newton 'had never lived' somebody else would) that explains our condition. We have been thrown back wholesale from the external, the public, world, by the successive waves of the 'Newtonian' innovation, and been driven down into our primitive private mental caves, of the Unconscious and the primitive. We are the cave-men of the new mental wilderness. That is the description, and the history, of our particular 'subjectivity'.

In the arts of formal expression, a 'dark night of the soul' is settling down. A kind of mental language is in process of invention, flouting and over-riding the larynx and the tongue. Yet an art that is 'subjective' and can look to no common factors of knowledge or feeling, and lean on no tradition, is exposed to the necessity, first of all, of instructing itself far more profoundly as to the origins of its impulses and the nature and history of the formulas with which it works; or else it is committed to becoming a zealous parrot of dubious and short-lived systems reaching it from the unknown. In the latter case in effect what it does is to bestow authority upon a hypothetic something or someone it has never seen, and would be at a loss to describe (since in the 'subjective' there is no common and visible nature), and progressively to surrender its faculty of observation, and so sever itself from the external field of immediate truth or belief—for the only meaning of 'nature' is a nature possessed in common. And that is what now has happened to many artists: they pretend to be their own authority, but they are not even that.

It would not be easy to exaggerate the naiveté with which the average artist or writer today, deprived of all central authority, body of knowledge, tradition, or commonly accepted system of nature, accepts what he receives in place of those things. He is usually as innocent of any

saving scepticism, even of the most elementary sort, where his sub-
jectively-possessed machinery is concerned, as the most secluded and
dullest peasant abashed with metropolitan novelties; only, unlike the
peasant, he has no saving shrewdness even: and this is all the more
peculiar (and therefore not generally noticed, or if recognized, not easily
credited) because he is physically in the very centre of things, and so, it
would be supposed, superlatively 'knowing', and predisposed to doubt.

Listen attentively to any conversation at a café or a tea-table, or any
place where students or artists collect and exchange ideas, or listen to
one rising—or equally a risen—writer or artist talking to another—from
this there are very few people that you will have to except: it is astonish-
ing how, in all the heated dogmatical arguments, you will never find
them calling in question the very basis upon which the 'movement' they
are advocating rests. They are never so 'radical' as that. Not that the
direction they are taking may not be the right one, but they have not
the least consciousness, if so, why it is right, or of the many alternatives
open to them. The authority of fashion is absolute in such cases: what-
ever has by some means introduced itself and gained a wide crowd-
acceptance for say two years and a half, is, itself, unassailable. Its
application, only, presents alternatives. The world of fashion for them
is as solid and unquestionable as that large stone against which Johnson
hit his foot, to confute the Bishop of Cloyne. For them the time-world
has become an absolute, as it has for the philosopher in the background,
feeding them with a hollow assurance.

But this suggestionability, directed to other objects, is shown every-
where by the crowd. The confusion would be more intense than it is,
even, if every small practitioner of art or letters started examining, in a
dissatisfied and critical spirit, everything, whatever you might at this
point object. And, if that is the case, why attempt to sow distrust of
the very ground on which they stand, among a herd of happy and ignor-
ant technicians 'entranced', not with 'mind', but with 'subjectivity'?
Was not the man-of-science of thirty years ago, in undisturbed posses-
sion of all his assumptions as regards the 'reality' he handled so effec-
tively, happier and brighter and so perhaps more useful, than his more
sceptical successor today?

This argument would carry more weight, if the opinions to which it
referred were not so fanatically held. It is very difficult to generalize like
that: sometimes it is a good thing to interfere with a somnambulist and
of course sometimes not. You have to use your judgment. The kind of

screen that is being built up between the reality and us, the 'dark night of the soul' into which each individual is relapsing, the intellectual shoddiness of so much of the thought responsible for the artist's reality, or 'nature', today, all these things seem to point to the desirability for a new, and if necessary shattering, criticism of 'modernity', as it stands at present. Having got so far, again, we must sustain our revolutionary impulse. It is an unenterprising thought indeed that would accept *all* that the 'Newtonian' civilization of science has thrust upon our unhappy world, simply because it once had been different from something else, and promised 'progress', though no advantage so far has been seen to ensue from its propagation for any of us, except that the last vestiges of a few superb civilizations are being stamped out, and a million sheeps-heads, in London, can sit and listen to the distant bellowing of Mussolini; or in situations so widely separated as Wigan and Brighton, listen simultaneously to the bellowing of Dame Clara Butt. It is too much to ask us to accept these privileges as substitutes for the art of Sung or the philosophy of Greece.—It is as a result of such considerations as these that a new revolution is already on foot, making its appearance first under the aspect of a violent reaction, at last to bring a steady and grow-ing mass of criticism to bear upon those innovations that Mr Russell would term 'Newtonian', and question their right to land upon the shores of China, and do there what they are said to be doing.

In the arts of formal expression this new impulse has already made its appearance. But the deep eclipse of extreme ignorance in which most technical giants repose, makes the pointing of the new day, in those places, very slow and uncertain.—Really the average of our artists and writers could be regarded under the figure of nymphs, who all are ravished periodically by a pantheon of unknown gods, who appear to them first in one form then in another. These are evidently deities who speak in a scientific canting and abstract dialect, mainly, in the moment of the supreme embrace, to these hot and bothered, rapt, intelligences: and all the rather hybrid creations that ensue lisp in the accents of science as well. But is it *one* god, assuming many different forms, or is it a plurality of disconnected celestial adventurers? That is a disputed point: but I incline to the belief that one god only is responsible for these various escapades. That is immaterial, however, for if it is not one, then it is a colony of beings very much resembling one another.

So then, before discussing at all the pros and cons of the 'subjective' fashion, it is necessary to recognize that it is not to the concrete material

of art that we must go for our argument: that is riddled with contra-
dictory assumptions. Most dogmatically 'subjective', telling-from-the-
inside, fashionable method—whatever else it may be and whether 'well-
found' or not—is ultimately discovered to be bad philosophy—that is
to say it takes its orders from second-rate philosophic dogma. Can art
that is a reflection of bad philosophy be good art? I should say that you
could make good art out of almost anything, whether good or bad from
the standpoint of right reason. But under these circumstances there is,
it follows, no objection to the source being a rational one: for reason
never did any harm to art, even if it never did it any good. And in other
respects we are all highly interested in the success of reason.

But if, politically and socially, men are today fated to a 'subjective'
role, and driven inside their private, mental caves, how can art be any-
thing but 'subjective', too? Is externality of any sort possible, for us?
Are we not of necessity confined to a mental world of the subconscious,
in which we naturally sink back to a more primitive level; and hence
our 'primitivism', too? *Our* lives cannot be described in terms of
action—externally that is—because we never truly *act*. We have no
common world into which we project ourselves and recognize what we
see there as symbols of our fullest powers. To those questions we now
in due course would be led: but what in this article I have tried to show
is that first of all much more attention should be given to the intellectual
principles that are behind the work of art: that to sustain the pretensions
of a considerable innovation a work must be surer than it usually is
today of its formal parentage: that nothing that is unsatisfactory in the
result should be passed over, but should be asked to account for itself
in the abstract terms that are behind its phenomenal face. And I have
suggested that many subjective fashions, not plastically or formally very
satisfactory, would become completely discredited if it were clearly
explained upon what flimsy theories they are in fact built: what bad
philosophy, in short, has almost everywhere been responsible for the
bad art.

A WORLD ART AND TRADITION

Drawing and Design, February 1929. The article includes reproductions of three drawings characteristic of this period of Lewis's career: semi-abstract figure compositions of the type represented by Creation Myth (*Tate Gallery, London*), *and* Manhattan (*reproduced in* Rude Assignment).

Accompanying the two or three pictures this paper is reproducing, is this short note to serve as comment. Since I last wrote about painting (*Tyro* 1922), there has been nothing very much to report; everywhere 'abstract' painting has vanished from the scene as far as England is concerned except in the practice of individuals: extremes of Expressionism, or of any description of experiment, are rare. Turning to the other extremity, however—the extreme of Salon or Royal Academy Chocolate-box—that too, though it holds its own better than its opposite, is in a languishing condition. The frank Chocolate-box is almost as dead as the 'abstract' picture.

These two facts are not quite independent of each other. The Chocolate-box now has a brain: this brain enables it to peer out upon the world and recognize that to be a plain unvarnished Chocolate-box is stupid. So it pretends to be something else, less objectionably commercial—and in doing so naturally marks a significant step in advance in general commercialization. The Expressionist picture, on the other hand, tends to close in, in the direction of the Chocolate-box: it, too, finds it commercially too stupid to be an 'abstract' affair, and times are hard. These two centripetal movements tend to result in one neat, intelligent, highbrow average, marketable and yet intellectually more respectable than the juicy Salonizing of the past. The militant heroics are over and customers are put at their ease: commerce all along the line wins in this manœuvre. But the economic principle is dangerous for artistic expression, though they are not incompatible altogether. It is probably not a bad thing that the inventor should be isolated— that is the most cheerful view to take, and it is the view generally adopted.

But as all aristocratic instincts, as they become forbidden elsewhere, in a militant democracy, it seems take refuge in Art (even in Moscow an actor who would fancy himself in a coronet can put, legitimately, a

realistic zest into playing the part of a noble of the Court of Ivan—and, as we know, Western Bohemianism has received into its gossipy bosom all the living fashion-plates, the most exclusive), then perhaps in art there *should* be a reactionary barricade against the worst squalors of commerce. In any event, it is the only place where you will get it—in fiction not in practice, or in art not in life: Art is indicated as the 'last ditch', and the appropriate place to be non-commercial. Figuratively, the intelligence put into the blurb or into the book-jacket cover, or in a more general way all advertisement, cannot but be stolen from what it advertises, in some way more or less patent. And who can believe it is unexceptionable that of the twenty thousand students in art schools in England at this moment, nineteen thousand should be destined to design nothing but smart advertisements for arc-lamps, stomach-belts, jumpers, brilliants, the Smoke with the Ivory Tip, fire-extinguishers, cosmetics, butter-scotch, false teeth, soap, beautifully curved house-drains, men supreme through Pelman, etc?

The Democracy that dooms its artists to such a grotesque handicap is in serious danger itself, who can doubt. It is very important how society treats its artists; it looks decidedly black for our democracies from that point of view; for the only use that can be found for artists at present is to design clothes and add stupid flourishes to mass-production utensils. Nothing that is kept more than a week or two, or nothing that matters if it is broken, is given them to justify their existence.

So as to the disposition of the Parties in Painting, it is roughly this: there is a great mass of well-mixed art in the Centre, there is a Right and Left wing more sparsely feathered every day. In London there is no Left at all—there is nothing but the graduated Centre and a heavy Chocolate-box fringe upon the Right horizon. In Moscow, on the other hand, there is only a Left (but very much too political—again a form of advertisement) with a sort of Centre. In Paris, Berlin, New York and so on, there is a fairly influential Left, in painting and plastic art, but in numbers it is apt to shrink, except, I think, in New York.

My own view is that it is only this Left (still to employ the political term) that is of any creative value at all in painting, though an experi-mental artist may be a very bad one. My reasons for that it is not necessary to give here. What I can say, however, is that the alternative is the kind of ugly and untidy kitchen-garden that is a London Group exhibition, for example (excepting perhaps a dozen painters, notably the Nash couple, and of course Sickert). In the wake of Cézanne,

Bonnard, and the French Impressionists and Post-Impressionists, everything turns out as a formless and cheerless weed or vegetable, for some reason. The puritanism of Cézanne is somewhat responsible, no doubt. The exhibitions that I have in mind have all that kitchen-garden look. They are not the bright parterres of the Dutch, nor the stately dreams of the Italian Renaissance, nor the parks of the Eighteenth-Century School: a squalid and neglected allotment or crowded communal food-plot is the nearest they get to order or beauty.

Over this kitchen-garden landscape in England hovers the benevolent, cheaply-fanatical form of Mr Roger Fry, about whom I will say no more, except that I can never understand why he is tolerated in his position of authority in the London Group by the more active members of that society.

The function of an artist of the Left, at present, is to secure the equilibrium of the jelly-like Centre, I think—by his presence rather than his technical influence however. (The Centre has already incorporated as much as it dare of his extremism: another cubic inch and its bread and butter would be threatened.) I am only using the term Left to indicate any ambitious experimentalism in Painting: and I must in a moment make clear what I have meant by 'experimental' and 'abstract'. As to the question whether the tornado of Cubism, Futurism, Expressionism, Vorticism, has left art better than it found it, that can only be answered in the affirmative. It has forbidden a quantity of stupidities and has filtered a little backbone into almost everything (except for certain quite irreclaimable regions). Perhaps beyond the great upheavals to which our present society is distinctly liable (religious or political) it might be called upon to express more completely than so far it has been able to do, in the midst of our degenerate commercialism, what it is suited to express. Meantime, there it is still in such effective energetic knots as that formed by the association of Ernst, Milhaud, Tanguy, etc., or in Russia or Germany, as groups and as individuals (such as Klee), like an official *échantillon* of what our civilization *might* become if it wanted to. That civilization can always say to itself—'There is my model, in full working order: there is architecture, there is every form of design, indications of novel art-forms, only waiting to burst harshly into bloom: *if I wanted to* I could take all that up and quit my kitchen-garden tomorrow or the asafoetida of my hot-house: it only rests with me. Not that I ever shall: still it is jolly to reflect that I could if I had a mind to.'

I

The few dozen artists meanwhile who continue in those directions have become like Aztecs or Atlantans, representatives of a submerged civilization. It is perfectly astounding the dreams that they represent: there is a complete world, with its aqueducts, its drains, its courts, private dwellings, personal ornaments, almost its religion with its theurgic implements, which have never existed. And this world, it must always be recalled, may be the actual world of the future. That, of course, does not make it any more important, but it gives it an indirect reality—it brings it into the sphere of practical politics as it were—far too much, it must be confessed, on occasion.

There are a number of individuals, and some are among the most important artists of the day, who live, at least to their own complete satisfaction, in the light of that glimpse of a novel world. The rest, the majority, without changing their own habits very much, 'hint blue'— squeeze a drop here and a drop there, of the novel concoction: and so a sickly reflection of *the light that never was* of the 'extremist' plastic imagination spreads over everything. This phenomenon has a parallel in the 'pink' revolutionary principles of our Western society.

The fragments I amuse myself with in the intervals of my literary work are, I suppose, among the only specimens of such painting done in England today. The plates you will see are three chosen at random. Such things seem I should say to the casual commercial eye of the same order as the first Chinese or Japanese work seen in Europe; as first and foremost a curiosity. If I might venture an opinion on a point of commercial interest solely, I should say that the best of this sort of work would be worth considering; for if people ceased to do such pictures altogether, they are very curious, and at any moment a craze for them might develop, like postage-stamps or anything else: and if such painting continues, then the best of it will always have the value of a strange prestige, and attract, as well, the fanatic.

I will venture upon a mildly prophetic hint. Is it not probable that the puritanism that is in the ascendancy everywhere will eventually suppress all other manifestations of art as too carnal? (May there not be a sort of speak-easy in the future, where millionaire debauchees will meet at the dead of night and, sitting in a circle draw a nude model—a kind of Messe Noire effect?) Under such circumstances 'abstract' art might become the official style and then these early specimens, which you can acquire today if not for a song, at least at a reasonable price, would be colossally valuable.

I have myself no economic interest in painting, I am able to speak with complete detachment of the chances of such collecting.

In conclusion, you may ask how it is that I assume such a stark cleavage between what we are compelled loosely to term 'experimental' or 'expressionist' or 'abstract' painting, and what is not. But it seems to me that that cleavage is the reflection of a break in continuity of a chronological, or historical, order of the first magnitude. This chasm has been hastily bridged in a variety of ways, and is camouflaged by most existing governments. But the fact remains that, so recently that most people have not realized it, the Earth has become *one* place, instead of a romantic tribal patchwork of places. 'Tradition' on this side of that division could no longer mean, for anyone a little instructed, the Greco-Roman tradition. A world-art became necessary, if there was to be art at all. Until there is politically one world (as physically and scientifically there is one world) however, the organization of a world-art presents extreme difficulties. Especially with pictorial and plastic art, the 'transition' (which takes the form in the West, furthermore, of a romantic, opportunist, *historical*, retrogression) offers hopeless obstacles to any expansion on the grand scale.

It is as a primitive form of a world-art, then, that this sort of work should be envisaged: its set-back is simply the result of the retrogressive movements (political in inspiration) to which I have referred. It may quite well stop altogether long before the political omnibus, lumbering furibondly forward, catches it up: and of course, as that political omnibus is after all our human nature, it may never catch it up at all. But at least what one can say with confidence is that the romantic plunge backward of this 'transitional' Juggernaut is a sham and all it produces by way of self-expression must be a sham as well. What has fact on its side is still this strange synthesis of cultures and times (which we named Vorticism in England) and which is the first projection of a world-art, and also I think the clearest trail promising us delivery from the mechanical impasse.

THE KASBAHS OF THE ATLAS

The Architectural Review, *January 1933. Lewis had visited Africa in 1931. The trip resulted in a series of essays in* Everyman *and a book,* Filibusters in Barbary (*London and New York, 1932*).

The great Kasbahs of the Atlas are a formidable explosion of Berber power; as far as we know (in this land without records, monumental or otherwise) its greatest. Most likely they will be its last. At grips with the great Kasbahs we shall find out all there is to be known of the essential Berbery, or Barbary. They are barbarous, if you like; but outside of China they are the greatest expression extant of the human being at this stage of the cycle of Earth-life.

All these great castles are in the High Atlas, in the Anti-Atlas, or in the mountains or plains of the South, or Sous. But the finest by far are in the High Atlas. And the workmen who are employed to build them all belong to one tribe, the Aït Ya Ya, living in a valley upon the Saharan slopes of those mountains, which wall in the desert on the north-west.

The oldest of the existing Kasbahs of the Great Lords of the Atlas, dates, I believe, from, at the most, eighty years ago. By far the greater number, however, are much more recent than that. As to the 'Lords of the Atlas' themselves, they are also of very recent creation. They are self-created. Of the present reigning families of the High Atlas, namely the Glaoui, the Goundafi and the M'Touggi—only the M'Touggi dates from more than a century ago.

These enormous structures, called *Kasbah* (meaning fortress), must resemble the Pelasgian fortresses encountered by the first Greeks to invade Hellas. They are truly *cyclopean* in appearance, in spite of the fact that very little stone is employed in their construction. When in ruin, they remain as gigantic blocks, not of granite, but of mud. They have, all of them, the air of belonging to the civilization which had its headquarters in Crete and are of a truly grand and massive beauty. Often of very great architectural resource, most elaborately grouped, towers behind towers, their structural repertoire is suggestive of a civilization of the first order, in the background, rather than of a rustic tradition, however elaborate; they are, many of them, upon the boldest and vastest scale.

Who are the Kasbah builders ? is one of the first questions that presents itself to the European artist. Well, it seems that they are certainly not gentlemen with brass plates upon the doors of their professional premises. They are nomads, of a rather special order—they must take cases of tools about with them on their donkeys, and today most probably picture-postcards or dog-eared snapshots in their pockets, of the best castles they have built, and perhaps tattered testimonials in their berber wallets or handsome vanity bags. They are simply berber workmen who wander about offering to build castles for anyone who requires such a luxury, or if the client only wants a little mosque, or a fairly strong little fortified residence, suitable for a modest marabout, without much following, why, then *that*! The trades of architect and of master-mason are essentially nomadic, and these two trades are identical, and no doubt nomadic plumbers move along with them too—though *Carver and Plumber* may be a trade designation and these functions devolve upon one and the same person, for all I know.

'*Le décor berbère a bien pour qualité propre la grandeur*', say Terrasse and Hainaut; and certainly nothing could be more unlike the structur-less confections of the hispano-mauresque than the type of these Kasbahs of the dictators of the High Atlas. It would, I suppose today, be generally conceded that hispano-mauresque—that is to say the architectural tradition responsible for the Alhambra (though not for the fountain of lions, which was a rebel gesture on the part of one of the last Moorish Kings of Granada, restless under the barren rigours of the coranic compulsions, which stamped out organic form, and put a *Verbot* upon life altogether, and for which, of course, the body of a lion in stone would be a trespass)—most people would even be eager to concede that this hispano-arabian pastry was the reverse of a great art-form. We have at present (how thankful we should be for this small mercy) the *monumental* appetite! And hispano-mauresque is the opposite of monumental: it is a feeble and unenterprising architecture; the dull shell is provided, and then the interior-decorator and the birthday-cake carver is let loose on it, and these minor personages are relied upon to drench it in ornament, and make it look as if it were a great swell after all, and a match for the most impressive monuments of any civilization whatever.

Luckily, here at least, all fashionable thought is with us: it is almost, if not quite, fashionably correct to prefer the monumental beauty of the Berber Kasbah, to the tiresome surface elaborations of the arab-born hispano-mauresque. I took full advantage of this fact not to stop and

write a chapter on the city of Fez in my book *Filibusters in Barbary*: and
I am able to inform you without danger of incurring your contempt,
I know, that while in Fez I visited *no* Merdersas—or any Merdersas
anywhere else. A mosque is for me a stork's nest, nothing more. As such
it serves its purpose. I confess that I am unable to understand why such
an intelligent 'author' as Mr Richard Hughes should import a mock
mosque into Wales, as I understand that he has, along with some friends,
and why it should amuse him to dress up as an Arab and, I suppose, go
and shout from the top of it.

But if the berber tradition is an ancient one, how did it withstand the
assaults of arab taste? In the first place no doubt the absence of the
written word (except for *tifinar* there has never been in Berbery any-
thing but the spoken language) has been the most powerful factor of
any in mummifying a tradition that may be coeval with Knossos, or
the early history of the Nile Valley. But the Kasbah art is also a part,
essentially, of the scene in which it occurs. The walls of the Kasbah
are made of the surrounding earth. When the Kasbah is a red Kasbah,
the valley in which it stands is a red valley. With its tower of mud-
concrete it is a puissant organization, and it owes its organization so
much to the earth in which it is set that it has the air almost of some
colossal vegetation, sprouting in this element of rock or mud. Its summits
are spiked like a cactus: its flanks are marked and patched as if it were
a rectilinear stump of a cyclopean cane, or a people of such stumps,
webbed to each other by big pitted and spongy battlements: or some-
times the roofed towers, with their flat mud hats, blunt-edged, and with
the thick blurred shadows of their eaves, appear like groups of some
toad-red fungus.

Battered into impressive vertical planes, with its portholes or pencil-
like slits high up, the earth of the mountain does not become rock, it
becomes pocked and scarred. It is only battered into an imperfect
concrete. By nature it is horizontal. It can only become a cliff—an
elegant fragment of cliff—with difficulty. Its surface, where water has
splashed upon its declivities, is soon mottled like the face of a tawny
cheese.

Near the tops of these feudal pinnacles of mud a system of rather
Mexican ornament occurs. These are the rectilinear abstractions of the
Berber rug, sometimes with discs, expanding stars, or framed diamonds.
Often in an open space there are noughts and crosses, or else figures
reminiscent of the *tifinar* alphabet.

But no one could rush into these mountains and settle there, quarry out of the earth stiff ramparts of *pisé*, and produce great plastic fortress-prisons, lettered with coarse hieroglyphs, that so astonishingly belong to the Atlas as these Kasbahs do. They are the wild fruit of these particular short scorched plains or volcanic gorges; as they descend towards the Sahara from the central crater of Sirwa, the Kasbahs become more and more magnificent. The Ksar of Ouarzazat is probably the culmination of this great out-cropping of the life—of man and of nature—of the High Atlas.

The Kasbah is as much a work of nature as a hive or ant-city, in one sense then. Only a people like the Berber, who know nothing of anything but nature, always in the company of the sun, the rocks, the desert, could have produced them exactly as they are; they are so fine, in the first place, because of this great air of having been done unconsciously—as the animal, or as the human genius, functions. But also they could not have been produced without the existence of some very splendid tradition of building. In the past, in a world no doubt less primitive than this, these great habits of building had their beginning.

The first architectural oddity to strike the observer is the strange appearance—that is like a trick of perspective—of all these towers drawing together as they rise into the air. This in fact is the case: the flanking towers are tapered from the base up. In some cases, in the course of an ascent of, say, forty or fifty feet they may lose as much as a quarter of their girth. This obliquity of the Egyptian pylon, recalling immediately the ancient temples of the valley of the Nile, is probably a first clue to the ancestry of these buildings. The diminishing silhouette of the pylon (only two or three times as high)—in place of the sharply-projecting cavetto of the former, if the tower is high, there is a combed and martial crest—is found again everywhere in the heart of the Atlas.

In various places upon the rocks of the Saharan Atlas, or that eastern part of it which has been accessible to the European, designs of animals are seen. Near Figuig, for instance, there are two rock carvings of a ram, with the solar disc between its horns flanked with the uraeus.

In Karnak, Gautier tells us, and in the temples of Upper Egypt, it is impossible to see the criocephalic Ammon-Ra, represented so often in the wall paintings, without immediately being struck with the analogy between Ammon-Ra and the Ram of the Atlas. 'It is exactly the same profile of the same head,' he tells us, 'bearing the same disk, similarly

flanked—the solar disk, in short. A necklace adds still further to the resemblance.'

And *Ammon* is the god of the Saharan oases. So it is natural enough that his image should be found at Figuig, the gate of the Sahara. Ammon is not a very old god. The cult of Ammon-Ra dates from the eighteenth dynasty (that is to say, roughly 1,500 years before Christ). So we are well inside the temporal frontiers assigned by history to the Berber races.

Nowhere else in the world, as far as I know, is there any monumental building of this order, with a façade of dual towers, tapering in the manner of the Egyptian pylon, and producing exactly this effect, except the Kasbah of the Atlas. And in spite of the Libyan Desert and the Sahara, the Atlas is, after all, the next-door neighbour of the Nile, in the same way almost as it is the neighbour of the Niger. Between the Eastern and Western Soudan and the Atlas there is nothing but the desert routes—a dream a few days long upon the back of a camel.

The resemblance has also been insisted upon between the Berber Kasbah-art and the Soudanese *Tatta* or Mosque architecture, of Timbuctoo, for instance. But I think this applies much more to the *nouala*. That is obviously the same thing as the Congo hut. Or it applies of course, to the architecture of Tiznit, the desert city to the south of Agadir, built where the steppes of the Rio de Oro begin. Tiznit and Timbuctoo are in many respects interchangeable. The principal mosque of Tiznit, bristling with spikes like a hedgehog, the Bordj el Rhemis ramparts, could take their place among the spiked sugar-loaf effects of Timbuctoo without anyone remarking their intrusion, I should think.

The *Kasbah* itself is, in principle, a simple structure of four gigantic walls of mud concrete, at right angles to each other. Inside the quadrangle so contained harbours the house of the chief, his stables, stores, barracks and so forth. At each corner (or only at two of the corners) are the pylon-like towers. That is how the Kasbah *starts*. When the local cantonal President first starts upon his career of *Amghar* it may be more or less that. But this fortified quadrangle No. 1 has built up against it a quadrangle No. 2, probably larger, or perhaps smaller, upon a higher or lower level than itself. Just as a Berber workman shuns a perfect symmetry on all occasions, and no two sides of a porch or two towers are exactly alike, so he would never dream, if asked to add a second towered quadrangle to the first, of making a facsimile of No. 1. There are no *facsimiles* in his repertoire. Besides, when a super-Kasbah, of towered

quadrangle upon towered quadrangle, begins piling itself up, the particular purpose of each fresh monumental accretion has to be taken into account. The Sheik, or Caid, has increased in power; he has an extra two dozen women, say; guests are more numerous and frequent; a hundred more black slaves are used in farm work; his armed guards have increased in numbers. The new buildings take the form implied by these new needs. But there is, of course, no end to the variety of circumstance dictating the growth, embellishment, or strengthening of the fortress. If it is to become a super-Kasbah, it rapidly becomes a kind of town, of the order of Animiter. It is the first stages of Babylon. Turkish-bath architecture is imported into it (as also, in fact, too, Turkish-baths).

That, according to the standards of a classic art, or the most perfectly adjusted and organized civilization, this method is unsatisfactory, is true enough. But this is a *barbaric* creation, admittedly, of the same kind as a Shakespearean play: its canons are romantic ones, or those of expediency, realized in the midst of a social chaos.

I 2

WHAT IT FEELS LIKE TO BE AN ENEMY

This article appeared in the Daily Herald, *30 May 1932. Ten days earlier an article had appeared, by M. Maurice Dekobra, called 'The Art of Making Enemies', illustrated with pictures of Wyndham Lewis, Miss Edith Sitwell and J. McNeill Whistler.*

If a man gives himself a bad name he may not be hanged but he lives a dog's life ever afterwards.

He calls himself 'Enemy', for instance. Why not? As good men—or almost as good—as the present writer have made war upon society all the days of their life.

Wasn't it Dickens who attacked the factory system; and Dante—the dago who's always mentioned with our boy from Stratford, Sweet Will —popped a whole social system into a hotter place than I should like to mention here—but it's the place you are told to go to when a fellow's impatient, and which Trollope refers to as H-ll.

Well, he sticks a feather in his cap and calls himself *Enemy*, as I was saying, and subsequent to that he will be a lucky guy if he doesn't find himself lumped with a low-down lot of the type of Texas Guinan, Al Capone, Jack Diamond, Pancho Villa (the rebel general of Mexico)— and such company as I was made to keep (photographically) upon this page in the 'Daily Herald' ten days ago.

Still, a guy has to stick to his guns—especially if he's a 'two-gun man', and I'm a three—so I'd better swallow all these insults and without more ado give you a peep behind the scenes.

What worries an 'Enemy' most? Well, I should put first on the list *the poor quality* of his enemies. The breed leaves much to be desired, it must be at once conceded.

Personally, I spend far too much of my time disguising some mongrel society hack as a thoroughbred, or defending the inmates of my circus against cowardly attacks and a rain of cruelly contemptuous remarks as I trot them out from the ill-natured public.

But that is really the *only* thing that worries a first-class Enemy.

What does it feel like to be an 'Enemy'? Much the same as a Friend— a very *intimate* friend, who has forgotten why or how he ever came to begin the relationship.

'Yes, but how does it feel—under the skin, you know—to be an

"Enemy"?' When? In the morning? I'm no good myself by about five p.m. I'm at my best before nine a.m.

I often ring up an enemy at seven or eight a.m. to have a row. I'd never take on a tenth-rater even after seven in the evening. But this is not generally known, and they think I'm most dangerous when in reality I'm just the reverse and feeling just off-duty.

The telephone is an important weapon in the armoury of an 'Enemy', a sort of deadly air-pistol. I don't know what I should do without the telephone.

After breakfast, for instance (a little raw meat, a couple of blood-oranges, a stick of ginger, and a shot of Vodka—to make one see Red) I make a habit of springing up from the breakfast-table and going over in a rush to the telephone book. This I open quite at chance, and ring up the first number upon which my eye has lighted. When I am put through, I violently abuse for five minutes the man, or woman of course (there is no romantic nonsense about the sex of people with an Enemy worth his salt), who answers the call. This gets you into the proper mood for the day.

You then throw on a stately Stetson, at the angle that intimidates, thrust a cigar between your teeth, and swagger out into the street, eyeing all and sundry as if they were trespassing on the pavement.

You cruise round the West End of London on the look out for an Enemy, and when you meet one pour in a few broadsides of 'vitriol' or of 'invective' (you have, of course, provided yourself with bandoliers full of both) and pass on.

Perhaps you grapple and then board an East-bound bus (to get yourself back to the centre of the battlefield); if from its top you catch sight of an enemy, you lean out and give him a potted piece of your mind as you sweep past.

Of course, you have to work sometimes, so you return to your home—it is a small concrete villa in a northern suburb, with *chevaux de frise* along the front of the garden (where a hedge would be if you were a man of peace) and a bomb-proof door. (I know that since Sir William Rothenstein has described me as 'a tank', and that has taken on, I am supposed to be locked up in a sort of garage at night—but that is not the case.)

You look up and down the street, and pass hurriedly inside. That is as far as I am able to take you. No 'Enemy' should ever *work*, nor would have to in a properly organized society. . . .

ART IN A MACHINE AGE

The Bookman, *July 1934*. *Abstract of an address delivered at Oxford University. Portions of it appear in various sections of Lewis's* Men Without Art (1934).

As the subject of this paper is the destiny of the *arts*—of their flourishing or the reverse in an industrial community—it may be as well at the outset to determine what we are to understand by *art*. I do not mean of course to supply a new definition of the arts, but at least to consider a little what the arts are and what they are not. This is all the more necessary since several influential literary critics have canvassed of late the question of the procuring of *salvation* by means of the arts. The art of poetry especially has been singled out as the likeliest art to accommodate us in that respect. And I will say at once how exceptionally meaningless this singular proposal strikes me as being. *Salvation by Shelley*, for instance, or same by Alexander Pope, is as a notion not much less nonsensical than salvation by Henry James or by Trollope would be—or salvation by Nicholas Poussin or by James McNeill Whistler. It is indeed so profoundly absurd, that it is difficult to believe that such a proposal has been advanced as anything more than a recondite joke—a joke of course at the expense of and against the arts, on the part of a malicious professor who has perhaps come to dislike, a little too heartily, what (in this instance) he so pretentiously professes.

So it is to a defence of the poor arts, somewhat—which are made fools of, poor things, by some of those who profess to teach them—that I must direct myself at the start.

It is not easy to establish the frontier at which an *art* begins and at which *life* leaves off. And this is of course largely on account of the fact that life does *not* leave off when art begins; and that art, on its side, does not disappear altogether even in the very midst of life and of ACTION. There is a good deal of rough art (to take a very dynamic example) in a bayonet-thrust or in a sword-thrust, for instance; some even in driving a car or aeroplane; there is *art* in sailing a ship, there is *art* in catching a seal, there is *art* in all the various steps that lead up to the birth of a baby; and there should be some tincture of art in death. (To come roaring into the world no man can help; but in the course of life he should have collected enough of the Graces—'always the Graces!'

—to go out of it with decorum and if possible with a decorative phrase.)

On the other hand, there is a great deal of life—indeed a distillation of the most concentrated essence of life—in a verse of Donne's, of Blake's, of Bishop King's, of Robert Browning's. The doings of all the Othellos, Timons and Coriolanuses, upon all the stages, have been as productive of concrete, of protoplasmic results—have been as *eventful*—as most 'real' doings elsewhere in the world of *fact*—not fiction. 'All the world's a stage' tritely remarked our national poet—but perhaps an aesthetic theory of a kind may be masked in that celebrated truism. He may even have been toying—who can say—with some *pseudoist* notion—*à la* Richards or *à la* Eliot—of makebelieve, only the other way round.

There is nothing mysterious about the fine arts, about literature and the rest of the arts, I take it. There is nothing up the artist's sleeve, I hope. Art is as transparent and straightforward a proceeding as is animal life itself. Singing, dancing, acting and building are all indulged in by animals of one kind and another. The pretentions of art, I take it, do not point to anything beyond the thresholds of life, or aspire to transcend the well-defined limits of man's animal status.

An animal, in every respect upon the same footing as a rat or an antelope, I imagine you will agree—man, except for what the Behaviourist terms his word-habit—except for what many men have regarded as his mystical destiny and his national function—man is *that* and no more —an animal upon the same footing as the chimpanzee and the stork.

So really *the word*—in contrast to the sound or image—is the thing, from whichever side you approach him, most proper and peculiar to man (*the word*, and laughter perhaps). That for all practical purposes we are merely *talking* monkeys—rats, elephants, bullocks or geese—is obvious. It is a most peculiar situation, regarded 'objectively' as we say. But it is only a peculiar situation, not at all owing to the fact that it is strange that splendid people like ourselves should at the same time be 'animals': not that—but because it is a little odd that mere 'animals' like ourselves should be enabled, by means of our 'word-habits'—to know that we are 'animals' and be compelled—or indeed *be able*—to go on being animals and behaving as such, and yet perfectly realize what we are.

William James selected the dawning of the consciousness of this 'peculiar situation' as constituting the first step upon the path of philosophy: 'One need only shut oneself in a closet and begin to think of the fact of one's being there, of one's queer bodily shape in the darkness

(a thing to make children scream at, as Stevenson says)... to have the wonder steal over the detail as much as over the general fact of being.' (W. James, *Problems of Philosophy*.)

But what sort of *art* (if indeed you can imagine such a thing as art existing at all under other circumstances)—what description of art would you expect a flock of geese, a warren of rabbits or a herd of oxen to practise, if suddenly they were enabled to *talk*—to look before and after, and in fact do all the things that men do? Well, I imagine the answer must be: 'Much the sort of art that men have always produced.' Pictures, in pigment or in words, of each other, or songs expressive of the pleasure or pain experienced in response to all the agreeable and disagreeable sensations that accompany this mortal career. What else could *we* possibly do under the circumstances, or any other animal so placed, and seeing that we are very naturally extremely interested in, and intensely surprised at each other?

So our arts in a general way fall into two categories. In the first case they are expressions of our great admiration of each other—admiration when we reflect how much *more* 'hideous' we *might* have been—for all our teeth, claws, digestive-tract and the rest of it; and at the really remarkable self-possession, industry, moderation, modesty and sanity that a handful of us display to the astonishment and disgust of the remainder; and in the second case, our arts are the expression of the keen appreciation we have of the particular foolishness or futility that, as animals, willy-nilly we fall into. Most great literary artists have been engaged in working the *latter* and perhaps more fruitful of these two alternative mines of artistic expressiveness. The names at random of Cervantes, Rabelais, Sterne, Swift, Dante, Molière, Shakespeare will I think carry out this view of the matter. For contemporary instances you have not far to look. A bird-woman plaster-mask of Picasso or, following Picasso in a weightier substance, a pin-headed giantess of Mr Henry Moore, with a little crease in the stone to show the position of the face, but with great fruity bulges for her dugs, or in the literary field (though we are all literary today, it might be said, on the same principle as Sir John Simon's 'We are all socialists today'), you have Mr Joyce's Leopold Bloom or Cissy Caffrey, or Mr Eliot's Klipstein and Krumpacker—Mrs Porter and Mr Sweeney. But I need not insist. In any of the arts the beauty doctor's wares are at a discount.

As to the former alternative, of those two categories into which I asserted that all the art that has ever been produced might be said to fall

—namely the category of *admiration*, the province of the pure beauty doctor—you have to go a long way back for that. And you only meet it once, in full and authentic flower. It is in fact mainly the preserve of the Greeks, and only of the Apollonian Greek (as he was called by a German sage) at that; as opposed to the Thracian and 'dynamical' Hellene who, with the Silenus-headed Socrates, was a practitioner of the opposite order.

But what has this got to do with an Industrial Age, you may commence to inquire? A very great deal, I should say; but you must allow me to approach the problem of the Industrial Age in my own manner, and make quite sure—in a rough way of course—what art is and what art is not—first of all. For my *only* interest in the Industrial Age is the part that art may play in it. *Without* art, you might as well ask me to give my opinion upon an anthill or a colony of bees. For I hope that so far I have not conveyed the impression—although it is true that *salvation by art* does not appeal to me as a very sensible notion—that I have a low opinion of the arts.

Regarded then as great herds of performing animals (the Behaviourist's view)—as small, mischievous, physically insignificant and, mentally, extremely prone to endless imitation—very susceptible to hypnosis, as individuals and in the aggregate—regarded from that standpoint, our tricks—and our literature, our 'fine arts', are only a part of our repertoire of tricks—not necessarily our *finest* tricks even—is indeed too unimportant a matter to detain us for so much as the twinkling of an eye. If you do not accept the presence of a mystical destiny, or if you do not make good a metaphysical human claim to something not comprised in the so-called materialist dialectic, if you banish the idea of value altogether, then indeed you must never trouble so much as to waste a thought upon art, whose values are nothing if not contingent. They stand or fall with other values than their own. There can be no art-for-art's-sake—at all events as I see the matter.

A good dinner, accompanied by as good a bottle of wine as you can secure, a good game of bridge, a pleasant spin in the fresh air, in as satisfactory a petrol-wagon as you can afford—a nice digestive round of golf—a flirtation speeded up by the rhythmical movements prompted by a nigger-drum (purging you of the secretions of sex)—a nice Crime Club volume (which purges you pleasantly of the secretions proper to us in our capacity of 'killers' and hunting-dogs)—our lynchings, arsenic-administering, throat cutting and policemanesque proclivities

all rolled into one—all these things are far more important than any-
thing that can be described as *art*—'art', that is, in any highbrow sense,
to employ the clownish American jargon, to supply the requisite gutter
picture of what we wish to describe—the noblest exercises of the per-
forming animal, Man.

What should be said, then, it seems to me, first and last, about *the arts*
(whether those of the eye, ear, lungs, hand or foot), is that they are
a pure game—a *game* in its different forms, directly arising out of our
functions of sight, hearing and so forth—out of our functions as trained
social animals—as 'political animals' of course, and as rational animals.
This would class art at once—to call it a game—if it were not that life
itself—the whole of 'the peculiar situation' in which we find ourselves—
should also be considered purely as a game—a game in the sense that no
value can attach to it *for itself*, but only in so far as it is well-played or
ill-played. Art in this respect is in the same class as ritual, as civilized
behaviour and all ceremonial observances—such for that matter as
those in which it has its roots historically: it is a symbolic discipline.

It is at this point that we make contact with the free-lance moralist—
that strangely instinctive fellow, who is the fortunate possessor of an
ethical judgment, which enables him to decide between right and wrong;
or of an 'inner check', which gives him a great range of ethical under-
standing. For having referred to *good* play and *bad* play, it is easy to see
that we have inadvertently got within range of that gentleman.

With his humanist metre-stick our moralist-at-large would (assenting
very grudgingly to the above definition—for game is a word that suggests
something altogether too trivial and lighthearted to him) approach these
judgments of 'good' and 'bad' play. 'Very well', he would perhaps
exclaim; 'have it that way if you must. Call *a good* action a good piece
of playing, if you like. But the good in the good piece of acting is *my*
province, anyway.' And it is of course just there that one is compelled
to discourage the egregious moralist-at-large very firmly indeed—as
firmly *in one's own way* as the theologian finds it necessary to do in his.
For this moralist's idea of a good play—to narrow down for the moment
this well-played 'game' in question to a theatrical performance—would
always be a play of a vulgar edification, which showed the audience some
unsightly ethical principle at work, triumphing in the teeth of rather
redoubtable odds; just as the pure and unadulterated politician's idea
of a 'good' play would be a play throwing into prominence a party-
principle—*his* party's in fact.

In a word, the irresponsible moralist's, or the fanatical, the un-adulterated politician's, *good*, or his *bad* likewise, is not universal enough, but is too deeply embued respectively with the pragmatical, utilitarian values of the mere animal, Man, or the values of the vote-catching and power-giving philosophy of the parish pump.

Having indicated, however roughly, the view of *art* that is implicit in anything I shall say in the course of this paper, I will turn to the Industrial Age, the effect of which upon the arts it is our intention to examine.

'Industrial Life', as opposed to Agricultural Life, is just the urban life of the Machine Age. And it must, I suppose, be visualized in terms of the cities of the future rather than those of the present. We have to think, in order to realize what 'Industrial Life' is ideally to stand for, of a super-Manhattan, or surrender ourselves to the mechanical dream of the most fanatical anti-land, pro-proletarian Marxist in existence.

But really, in order to arrive at any valid conclusions about 'the effect of the Industrial Age upon Art', you would have to enter very much more deeply into the purely political aspects of the question than I have either the time or competence to do. For the answer to the question: 'What is to happen to art as the Industrial Age advances and organizes itself ever more closely', is to be found much more in politics than elsewhere. It is far more a political problem than a mechanical problem.

Will the ruling class of the future be an economist-oligarchy, such as the ultimate world-triumph of communism would realize, or will there be some other form of leadership? It is in the answer to such questions as these that is to be sought what *will* happen to the arts as we have inherited them—not what *might* or *should* happen; though we should certainly never cease to agitate for what we believe *should* happen, against what *might* happen, and even against what *must*.

I am prepared to hear somebody say that, in his 'materialist dialectic', the *politics* merely follow in the wake of the *facts*; or that the *theory* breeds out of the *practice* or out of the *facts* which precede either idea or ideology; the practice being blind until it gets its eye, so to speak. (As Professor John Macmurray puts it: 'Ideas are the eyes of actions.') But if anybody should say that, it would sound to me either mistaken, or else implying a creed so stupid and volitionless as not to merit any serious attention, except in so far as it was capable, if only because of its very limitations, of recommending itself to a majority of men. But as a

matter of fact, as everyone knows, and indeed as the Marxist pragmatism expressly states, it is not in the realm of notions but of actions that we must look for the meaning of Marxism.

There is however something to be got, in the way of enlightenment, from Marxist theory. And I will now quote an interesting passage from Professor John Macmurray's recently published book, namely *The Philosophy of Communism*. Where he is explaining how Karl Marx found himself unable to subscribe to the Hegelian dogma identifying the 'idea' with the 'reality', the following remarks occur: 'If we think that the life of the mind is *higher* or *nobler* or more important than the life of practical activity, we must go on to admit, in principle, that the idea is more important, or more significant, than the thing.' And he then proceeds to say: 'In the aesthetic field there is a parallel to this. The artist who lives for his art, or the aesthete who prizes the work of art above the ordinary products of life, is committed in principle to the view that the image is more significant than the thing of which it is the image, and so to the "reality of the image".'

Food and shelter are necessities of life, and there are very many people who imperfectly possess both these fundamental necessities. And there is the further monstrous paradox today of *Want in the Midst of Plenty*. And if you have to choose between spending a pound upon a starving man or upon a work of art, you of course must spend it on the former. But these *facts* have nothing to do with *the value* we attach respectively to 'the work of art' and to 'the ordinary products of life' (as specified in Professor Macmurray's argument). Without entering into further discussion about the passage I have just quoted, it will be sufficient to say that Professor Macmurray is evidently getting up a sort of little class-war of his own between the picture and the person portrayed in the picture, between the marble bust and its original of flesh and blood. That is what he is doing in the passage I have quoted. Without again stopping to demonstrate what a profitless contest that is, that he has imagined, I will only remark that the Marxist doctrinaire is apt, exactly like the art-for-art's-sake doctrinaire ('the aesthete'), but from the opposite quarter, to promote the separation of, or the belief in the distinction between, *life* and *art*. And in the above passage Professor John Macmurray may be observed busying himself to that end.

I would say that Professor Macmurray (and the general run of Marxists would do the same) attaches too much importance *per se* both to the arts of life and to life itself—or, I should rather say, both to *life*

divested of the values that *the arts of life* bestow upon it, and to *the arts of life* without the values that *life* bestows upon them.

If the task of framing the new society, now in the melting-pot, devolved upon the Western European pure and simple (though not always quite so simple as he looks), he would create a human life *outside* the machine, I believe. And then the arts, more or less as we know them today, or as they were known to the Chinese and Japanese, the Egyptians and the Greeks, would be cultivated as before. If, on the other hand, the Western European has little or no influence upon this future, then it might (although not necessarily so) be otherwise. But what is quite certain, I think, is this: that if art, along with the mind of man, goes to live in the heart of the Machine—goes, as it were, to live over the shop—then the arts will ultimately cease to exist as we have known them up to now, or perhaps at last in any form whatever. By the substitution of a quantitative for a qualitative norm, the very meaning of art indeed must become lost. Even today, by a very superficial study of the operation of the corporative business mind in the 'book-world', as it is called, such a future may be gauged in advance, in the early stages of the general intellectual paralysis.

In the course of these discussions of yours, which are just starting, you will undoubtedly hear much regarding the various features of Machine Age life which militate against and indeed contradict the artistic impulse. I have not specifically noted any of these tendencies, as first of all I took it for granted that you were familiar with these arguments; and in the second place, and more important, I have wished to insist not upon the crushingly unfavourable conditions—which without undue pessimism may be anticipated—not upon the conditions, but upon the need to forestall them and to deal with them; at all events, upon the possibility that, whatever adverse conditions for the arts may be announced, and even contemporaneously illustrated, things may not work out quite in the way that the most enthusiastic pessimists antici-pate. . . .

PLAIN HOME-BUILDER:
WHERE IS YOUR VORTICIST?

From The Architectural Review, *November 1934.*

For the past twenty or twenty-five years in the Anglo-Saxon countries outraged protests have arisen at every fresh manifestation of 'advanced' art, whether in sculpture, painting, architecture, or the applied arts—and, to a lesser extent, regarding 'modernism' in novels, plays, and verse. On the side of those engaged in these outrageous activities many attempts have been made at conversion: but the Anglo-Saxon public (this applies more to England than to America) has remained obdurate, and has refused even to adopt a tolerant attitude, much less to be converted.

A small number of 'highbrow' men and women meanwhile—a very small number—have supported these 'extreme' expressions of cubist, surréaliste expressionist art. A handful of modernist villas have been run up; a few big factories have gone cubist. Women's dress has been affected more than most things, but Victorian modes have always routed the 'robot' fashion, whenever it came to a stand-up fight. One shop in a hundred has acquired a chromium-plated modernist façade, but only in the very large cities. Yet one swallower of the new forms of expression does not make a summer—for the artist! And for one who was a swallower there have been a thousand who were non-swallowers—who with teeth set have violently rejected the medicine. For a *bitter pill* it is—why deny it?—this art of the most 'modern' schools. In this country architects like Etchells, Holden, Connell and Ward, Tecton, Emberton, Tait, Wells Coates, Chermayeff, McGrath, Fry; painters and sculptors like Henry Moore, Epstein, Kauffer, and the Nashes are in the nature of paregoric or codliver oil to the over-sweet Anglo-Saxon palate; about that there is no question.

Those modernist suites of furniture—even 'attractive' up to a point—are undeniably ultra-puritan in conception; far too bare and cheerless to the average eye. An 'ideal home' furnished with these uncompromisingly severe bookcases, rugs, steel chairs and aluminium beds, angular armchairs and so forth, would be *ideal* only for the very few. And one of Mr Henry Moore's pinhead Titanesses—highly prolific of foetus-like stone babies, certainly, but otherwise very remote from routine humanity

—would scarcely be found by poor little Mr Omnes to add anything to the gaiety of his interior. Nor would a cornfield by Mr Nash even help matters, suspended upon an empty wall, above a nest of gloomy boxes full of Mr Gollancz's harshly-coloured books (as they would appear in the eyes of the average book reader).

What is all this about, the puzzled man-in-the-street has asked, over and over again, ever since in the far fourteens of Nineteen Hundred, with the war about to break, the Vorticist assailed his senses with images of, to him, a revolting ugliness ? It is because I do not think that the Plain Gallery-goer (to give the 'Plain Reader' a brother!) or the Plain Home-builder (to give him another brother) choosing an architectural box to live in and choosing 'antique' furnishings on the one hand, or modernistic furnishings on the other, with which to *line* his nest—it is because this still puzzled person has not yet received quite the fairest answer possible, that I am addressing myself to the task of lifting the veil for him a little higher; and in a way that, I believe, has not up to the present been attempted.

If I seem to fetch from rather far my explanations I can only reply that they do lie very much off the beaten track. You have to go into the fastnesses of esoteric politics and into the most tortuous labyrinths of the religionist-at-bay, to discover the impulse that outwardly manifests itself in Mr Kauffer's Tube Posters, or the posters of his school; in the architectural plans of Mr Wells Coates; in Mr Eliot's crossword puzzles in the place of poems (as it seems to the uninitiated); in Mr Epstein's *Underground* Building statuary; or Mr Henry Moore's or Mr Lambert's plastic experiments. With this warning, namely, that the road to understanding of the 'inhumanity', the 'abstractness', the 'ugliness', of extreme contemporary art, is not (as indeed might be anticipated) an easy one or a path of roses for the humble Home-builder or Gallery-goer in search of englightenment, I will proceed.

I am myself, of course, one of the chief offenders in the matter of all this horrible 'inhuman' modernity. It was I who was the arch-vorticist: and so recently as last week I perpetrated a picture which, when it is exhibited, however much the art critics (a fine body of men!) applaud it, will not perhaps please *you*. I say all this to make it clear at the start that you are getting this from the horse's mouth—or from between the dragon's teeth if you like that better!

It may be as well to explain one feature of Vorticism which has a great deal of bearing upon what is being discussed here. I refer to the

fact that Vorticism (the characteristic movement with which all these modes of extreme modernism began in England) was, in a sense, *a substitute of architecture for painting*. It was not only that the Vorticist was peculiarly preoccupied with the pictorial architectonics at the bottom of picture-making—the logical skeleton of the sensuous pictorial idea. It was more than that. 'Vorticism' was a movement initiated by a group of painters, but it was aimed essentially at an *architectural* reform. (I was almost about to say, *rather than* a pictorial reform!) My pamphlet entitled *Architects, where is your Vortex?* (written a couple of years after the war) demonstrates this fact sufficiently plainly even in its title. And what I, as a vorticist, was saying to the architect was: 'Produce *a shell* more in conformity with the age in which we live! If you do not do so, it will be in vain for us to produce pictures of a new and contemporary nature.'

But the pictures produced by myself, and other painters of similar aims, and which have been produced continuously since that time, were often rather exercises in architectural theory—rather pictorial *spells*, as it were, cast by us, designed to attract the architectural shell that was wanting—than anything else. We were compelled at the outset—since the architect had lagged behind, and the shells, the appropriate *walls*, were wanting—to go over into the field of pure architecture more than otherwise would have been necessary, or indeed desirable. And, in the early stages of this movement, we undoubtedly did sacrifice ourselves as painters to this necessity to reform *de fond en comble* the world in which a picture must exist—for its existence is obviously contingent on, and conditioned by, what the architect produces. In the heat of this pioneer action we were even inclined to forget *the picture* altogether in favour of *the frame*, if you understand me. We were so busy thinking about the sort of linear and spatial world in which the picture would have its being and thinking about it in such a concrete way, that we sometimes took the picture a little for granted. It became merely a picture X—a positional abstraction, as it were.

But what has happened, in the sequel? Well, the appropriate shells—the buildings—have been, in a small way it is true, forthcoming. But they, too, have forgotten the picture! Or rather, it has turned out that the architect (having *got* his Vortex at last) has conceived it usually in such a manner as potentially to *exclude* the picture altogether from his dogmatic vorticist or cubist walls.

Almost all the photographs you see of 'ideal homes'—in the advertise-

ment pages of periodicals, or in periodicals, or articles, devoted to the furnishing of a 'modernistic home'—are *pictureless*, or nearly so. One picture, or two, at the most, relieve the aggressive severity of these advertised dwelling rooms. And for this we (Vorticists and others) are somewhat to blame.

But to say that we are *altogether* to blame would not be true. For there are other factors, of immense importance, behind these puritanic landscapes of domestic bliss, and over-mathematicized architectures, and it is those that, in this article, I have particularly proposed to canvas.

So at last, after a false start, as it were, just now—let us get under weigh, and let us start at the beginning, upon the primeval religious and economic foundations of everything, whether it be the Katoubia at Marakech, a short story of Tolstoy's, or Mah Jong or Ping Pong.

I have said in a book, dealing with these subjects, that some people suffer fools gladly: and I boldly asserted that I was one of those people that did so—that for me the fool was welcome—that to the 'little children' of whom the Kingdom of Heaven is composed should be added the Fool, for he has a similar claim upon us as have the evangelist bambinos; and in any case, here on earth, is not the Fool, as it were, the inert reservoir upon which genius draws? His opaque and lustreless eyes, his heavy features, large animal jowl, shallow brow like that of the Roman gladiator—*that* is our fundamental humanity. Upon that dull folly everything that we erect must be built. But it is the reverse of a quicksand. It is a rugged conglomerate, a thoroughly conservative mass —stable, if deadly stupid.

Such sensations as these are the sensations at the back of much of the architecture, painting and sculpture, and applied arts, and books as well, which have given rise—and still continue to do so—to such bitter controversy. It is because we have in a sense accepted the Fool, even proceeded to the worship of the Fool, that the Fool is so scandalized and angry with what we do!

For the Plain Home-builder to understand why his home—if it is to be 'ideal'—should, by all rights, be *very* bare and *very* unsensuous, he must be directed, to start with, to the study of the religious attitudes peculiar to his time. (It is best, I think, to take the religious first, as the political would be liable to confuse him.) When I say 'religious', I mean the particular brand of intellectualism which flourishes at the moment as a parasite upon the fundamental religious emotions.

During the latter decades of the nineteenth century, professional

religionists were locked in a death-embrace, or so it seemed, with Natural Science. Charles Darwin, conspicuously, had dealt a knock-out blow to the dogma of the Fall—or so it seemed: for humanity learnt from him that it had 'descended' from a lower form of life—not 'fallen' from a higher. To the 'forthright' Northern children of the Reformation these 'facts' of Darwin's appeared pretty difficult to reconcile with the Old Testament myth of the Creation (borrowed from Babylon, that conspicuously impure State), with which they had been familiar from childhood. (And when they learnt, from Sir James Frazer and others, that Judaism had taken over Adam and Eve, lock, stock and barrel, from other religions, that did not help matters, of course.)

To telescope into a few words these tremendous events, the Christian religion did not disappear, as many thought it might. Eventually it was recognized that there *were*, after all, more things in Heaven and Earth than were mentioned in the philosophy of Darwin and Huxley. The 'stubborn facts' of Natural Science were 'found out' and seen not to be so 'stubborn' as all that, and there were anyway *other* stubborn facts with which Science showed itself incompetent to deal. And after these homeric struggles the professional religionist came up smiling, if I may be allowed to put it in that familiar way—but smiling a little wryly. And, further, a good deal of the *scientific* attitudes had been absorbed in this desperate *corps-à-corps* by the badly-shaken Pillars of the Church—for it had been necessary to engage Science with its own weapons, and the weapons were retained after the worst of the encounter was over.

This not triumphant, but relatively satisfactory, emergence of the religious mind from the dark period of Evolutionary eclipse, is put on record, with great brilliance, by the late Lord Balfour in his famous book, *The Foundations of Belief*.

The Plain Gallery-goer, or the Plain Home-builder (who beyond question has been asking himself with growing impatience what on earth, or in heaven, religious controversy has to do with chromium-plated easy-chairs or cubist bungalows) cannot be expected to wish to follow the late Lord Balfour in his eloquent exposé of 'the emotional adequacy', or, rather, 'inadequacy', of the ends prescribed by the Naturalistic Ethics. So he may be willing to take my word for it, when I point out that those Naturalistic Ethics were fairly closely related to the Naturalistic Aesthetics. And it was the recognition of the in-adequacy of the Naturalistic Aesthetic that was primarily responsible for the downfall of the bourgeois art of the nineteenth century (the

stronghold of which, in Great Britain was—and still is!—the Royal Academy).

But the Naturalistic Ethic, and its 'beautiful' sentient creation, got pretty badly knocked about by Natural Science, as was indicated by Balfour. The *ascetic* values of the mystical religious mind fared better, and, as I have said, *emerged*—not intact, but not at all destroyed. Nineteenth Century Science, however, left its mark upon all that was, as it were, *physical*. Religion has had its 'come back', but in its grimmer, contemplative, aspects, with its vows of poverty in evidence, to an impoverished world. It has come back because Man has fallen upon hard times and is in very great distress. It has come back attuned to an apocalyptic situation, armed with the despairs of the earliest Fathers of the Church.

In an often-quoted passage, Lord Balfour asks what man turns out to be after all, from the point of view of Science—according to anything that Science *by itself* is able to teach us. And it transpires—he has no difficulty in showing that—that Man is after all not the final cause of the universe: 'His very existence is an accident, his story a brief and transitory episode in the life of one of the meanest of the planets. Of the combination of causes which first converted a dead organic compound into the living progenitors of humanity, Science, indeed, as yet knows nothing. It is enough that from such beginnings, famine, disease, and mutual slaughter, fit nurses of the future lords of creation, have gradually evolved, after infinite travail, a race with conscience enough to feel that it is vile, and intelligence enough to know that it is insignificant.'

This passage is so extremely well known that I dare say even the Plain Home-builder I am especially addressing will be familiar with it. It registers, with its bland declamation, a very low temperature indeed (as the few lines I have just quoted will have shown, I think).

Now Lord Balfour, having rubbed in, to the full extent of his mournful eloquence, the meaning of what Science teaches—namely the insignificance, the worthlessness, the absurdity, of Man and all his works, asks his readers whether this may not perhaps be utilized to turn the attitude of this miserable half-animal (this twin of the 'miserable sinner') to 'what is Abiding and what is Eternal'. And Man, in the mood engendered by this depressing revelation of his unimportance, nay futility—is in no mood, it may be imagined, to give an emphatic No. That this depressing and degrading picture may be—*has* been and some will think *should* be —utilized in the field of art as well as in the field of religion, is what I am

seeking to demonstrate here. And I am among those who, with certain reservations, believe that it *should* be.

The absence of sensuous appeal—the *purism*, or to give it its ethical equivalent, the puritanism—of the great contemporary movements in architecture, house-furnishing, sculpture, painting and design, proceeds ultimately from the same source as—and proceeds hand-in-hand with—the new evangelism, which is to be seen as much within the frontiers of the Roman Catholic communion, as in other—and more traditionally 'puritanizing'—folds.

The recrudescence of asceticism, if we can call it that—perhaps it would be better to say the *popularization* of the ascetic principle: the *re-dehumanization* of a religion, which was in origin anti-human (in the sense that to be anti-family, with Saint Augustine, may be described as to be anti-human) and which has oscillated between that and an accommodation to the all-too-human principle: all this can be matched in the political field. Indeed the identity of temper in every department of life is today remarkable. The more closely organized human life becomes, the more perfect this identity will be.

So, although I began with religion, I could equally well have begun with politics. In both 'advanced' religious and 'advanced' political theory there is the same cold-shouldering of the 'bourgeois' moral values—notably of the humanitarian values. The *value of human life*— to take only that one value, as typical of the rest—the stocks of *that* value have never stood lower than they do today. We find the world rushing headlong towards further, and yet more disastrous and diabolical, wars.

But the traditional guardians—religious and political—of the humanitarian values do not seem to turn a hair at the thought of bigger and better bombs, laden with poison, for the destruction of 'alien' cities. (I merely refer to this to make good my point—not in censure, I need not say; that would be quite out of place in such an article as this.)

If you wished to link up still further this network of dehumanist principles, you could not do better than turn to the controversy of five or six years ago regarding *Humanism* in America. Actually a number of pseudo-religionists and political extremists were collected together by somebody or other, and unleashed at the throat of that benign and highly gifted figure, the late Professor Babbitt of Harvard, the principal representative of so-called 'Humanism' in America. While agreeing with much of the criticism (for Babbitt did lay himself open to the jibe that he was a *genteel* embodiment of Bostonian America, and his

'inner check' was an ideal target) I could not help wondering at the time just *why* this benevolent old gentleman should have aroused such evident animosity. However, that is neither here nor there. What I wish to stress is that the anti-humanist can very easily become, if he is not that already, the anti-human. How the notorious *inhuman* characteristics of so much contemporary art and thought might have something to do with mass attacks upon *humanism*, is not very difficult to see. And that non-human principle—so characteristic of the art of Asia, in contrast to that of Europe—promises a finer standard of art, whatever else you may think about it, upon purely human grounds.

I will proceed now to the final unravelment of the modernistic mysteries. First, Man, with a capital M, was not the centre of the universe for a Chinese or Japanese artist, in the way that he has been that, mostly, for the European. A fish, bird, tiger, fly, or frog entered his pictorial universe upon an equal footing with the human biped, at whom he looked, true artist that he was, as if he himself had been a stork rather than a fellow-man. This was an *inhumanity*, according to Hellenic standards. Or take an obvious case from everyday life: the surgeon, although he may be a very human person, is committed to a hard-boiled attitude once he enters his hospital: in the interests of humanity, even, he must be 'inhuman'—efficiency demands it. But any man of science is compelled to make himself into a depersonalized machine. All that is obvious enough; but what is less so, although equally true, is that the artist, as much as the scientist, must exclude as far as possible the specifically human from the organization of his intellect. In his way, it is incumbent upon him to be just as cold-blooded as the efficient surgeon or duellist: his eye must be as detached, his hand as firm as theirs.

A time of great poverty—of 'want in the midst of plenty'—such as ours, is economically disastrous for the artist. And as to the Communist State, that does not, on the face of it, sound a very promising place for the artist, either. But on the other hand the 'Bourgeois' society, so bitterly celebrated by Flaubert, is not ideal for the artist either. Inflated prices for 'old masters', side-by-side with 'chocolate box' standards— or magazine-cover standards: that is what you arrive at in any Banker's Olympus.

The artist may, of his natural bent, be as gloomy as the poets Crabbe or Webster; but even so he is probably better off in an age when a certain cheerfulness prevails, a certain over-plus of vitality rather than in such a grim and artificial bankrupted society as ours, with its

atmosphere of the last and gloomiest plate in a very, very wicked *Rake's Progress*—where each month seems the last before the lights will go out upon civilization for ever. And unless, surrendering to the prevalent despair, he ceases to be an artist, he will not thank the religionist, either, for popping into the Waste Land of the post-war, rubbing his hands with professional glee over this spectacle of desolation—of dying industry, languishing art, and general paralysis of will and intellect.

Having admitted all this, we come to the paradox of this same artist applauding many of the features peculiar to this frugal and denuded— 'nudist' and needy—scene, and having indeed been in part responsible for them (as was the Vorticist, as I have said). Whatever the reason may be (and whatever may happen in the sequel) the art of painting, to take only that, has not been so much alive for a couple of centuries, at least, as it is today. All of the *non-human* influences I have been discussing operate in favour of its being of a high standard of excellence—if not commercially prosperous, which is another matter. The disappearance of spare cash from the pocket of the Public may certainly in the end lead to the extinction of the fine arts; but, in the meanwhile, the *severity* of the intellectual ideal has helped them immensely.

So, as to those modernist interiors (such as you see advertised in the luxury-magazine)—those interiors obviously designed for a particularly puritanic athlete of robotic tastes, with an itch for the rigours of the anchorite, and a sentimental passion for *metal* as opposed to *wood*, and a super-Victorian conviction that cleanliness is next to godliness. What are we to say regarding them?

Well, first of all, it is far better to have *nothing* on the walls than vulgar and trivial things; and it must always be remembered that the average athlete—or tennis-girl turned wife, or golfing-motorist become home-builder—possesses no taste at all, and should if possible be restrained from buying those coloured prints of comic Bonzos he naturally favours and putting them up on his walls. For him a perfectly *blank* wall is the only decent solution. He is what 'bourgeois' civilization has made him. He should put himself humbly in the hands of a competent modernist designer, and cubist-bungalow architect, and allow them *to ration* him, very strictly indeed, in the matter of everything barring strict necessities —tables, chairs, lamps and bookshelves for the detritus of his 'mystery' literature, and to be the trash-boxes for his Crime-Club sequences.

But to say that *that* 'ideal home', of that spoilt child of the Machine-age, is in fact ideal, or is at all final, would indeed be absurd, and

criminally discouraging. He is not an ultimate flower exactly—he is not the end of a progress! On the contrary, he is an embryo, as it were, a foetus, of what should be—let us square our shoulders, and say *shall* be —it will do no harm. That his bungalow reception-room should be as bare as a cave is right and proper, because he is in fact a *cave-man*. But he is a cave-man who has no art—but only a cave. The marvellous art of the Altamira Caves would be as appropriate in *his* cave as in those at Altamira, or any others, if he had reached that stage of cultivation; but he has not. He is too primitive as yet, so there are no cave-paintings. He had evacuated all the bric-à-brac he was born with. He has not yet had time to furnish intellectually, at all, his cubist cavern. It is as yet the Plain Home-builder's spartan nest—that is the idea. He is *proletariat* too—the newest of the new poor; the first swallow of the Anglo-Saxon Bolshevy that is to be. But that is just a skeleton of a much richer existence, we must at least hope. And in the meanwhile, there is nothing whatever to prevent you from putting as many pictures up—upon these immaculate, sinisterly puritanic, walls—as you have the taste to choose and the money to buy. You must not take these spotless polar models of the 'ideal' interior too seriously. They are a doll's-house for a sports-girl robot, yes. But they have a great deal in their favour. And it is up to you to make them habitable—even disorderly.

You should not be afraid of *desecrating* these spotless and puritanic planes and prudish cubes; and it is up to you, after all, to refuse to be made into a sedate athletic doll—into an exhibit, like a show-piece for a lecturer, or in an interview with 'the perfect proletarian, in the newest frugal, least domestic, prize-puritan-parlour'. Modern furniture, the best of it, is exceedingly nice and much better suited to the requirements of all of us than the old—to put it at its lowest, for its lines are often of great interest apart from that, and visually suggestive of much that no Plain Home-builder need worry his head about; and likewise the little cubist-bungalow. And you can with advantage hang *any* picture on the most modernist wall—or any number of pictures too—from a Medici reproduction of Uccello's Battle—a Raphael, or a Rowlandson—to an 'abstract' design by Mr Wyndham Lewis, the writer of this article. There is no occasion to allow pictures to be abolished—it is no use learning about modern architecture and furniture if you do not learn about modern pictures too; unless you wish to exist as the least imaginative of cave-men or cave-women, as, of course, the average must do. But I have not been addressing myself to an *average* Plain Home-builder.

POWER-FEELING AND MACHINE-AGE ART

From Time and Tide, *October 1934. In the earlier article referred to in the first sentence, Lewis had criticized a tendency to leave all but a minimum of pictures out of interiors of modern design—interiors 'designed for a sort of bastard half-class of half-proletarianized nobodies' who could perhaps tolerate one picture, but no more.*

In my last article I discussed the 'Boy stood on the burning deck' situation of the *one* picture that was left upon the wall of the Ideal Modern Home, in the midst of the cold conflagration produced by 'Machine-mindedness' in domestic design—machine-minding-minded-ness, or 'machine-consciousness', preached, megaphone in hand, by Signor Marinetti twenty years ago, and which the Russian Communist Magnetogorsk borrowed lock, stock and barrel from Marinetti after the war, and which they (very slowly) returned to us, like a dreamy and dilatory boomerang, a few years ago. Posing as a great novelty here in England (even, in the art of poetry, confusedly founding a school of iron tulips, and moonbeams of steel, playing round rows of dogmati-cally brave-new-worldish pylons) on a wave of pro-Russian sentiment it came, flood-lit with Red light. (Needless to say, I am not criticizing Communism as a political creed here, but merely the 'dope' that accompanies it—dope of a 'progressive', brave-new-world, order.)

That I am a brave-new-worldite myself, I freely confess; but the first stage of Italian Fascism (namely, Marinetti's 'futurism') I opposed at the time (as the files of newspapers of that period will bear witness): that interpretation of the 'new' seemed to me a shallow and sensational one, which could lead nowhere, except to a degrading vulgarization, and to a religion of force and 'action' at all costs. And I see no reason to change my attitude when an in every respect identical machine-worship reaches these shores from a country even less industrialized than was pre-war Italy, namely Russia.

Because it is essential—or so it is thought by the Marxists—to convert at top speed an agricultural community of slow-witted Slav ex-helots into an up-and-coming industrial hive, upon the American model there is no reason why the inhabitants of England, who have been machine-minded for a hundred years, should go to school again and start at the bottom of the class, as it were—intoning the Marxist A.B.C. of machine-

mindedness as if they had never seen a driving-belt or a piston before
in their lives! Such, at all events, is my argument. And hence my some-
what sardonic attitude to stream-lined armchairs. And as to chromium-
plated cowslips, and cast-iron 'kestrels', *Render unto Nature the things
that are Nature's and unto Man the things that are man's*, I should be
inclined to remark. If you must have kestrels, let them not be cast-iron
ones; if tulips, why not nature's variety?

The world has been held up for twenty years by War, Post-war, and
then by Slump, and now the forces of brave-new-worldishness are
organizing themselves once more, I am glad to say. I am glad to say,
because no change could be too radical to my mind, as applied to the
physical anachronisms that beset us. This may at first sight appear to
smack of the Chronologic Philosophy, but I have always insisted that
the best manner to keep Time in his place is to take Time by the forelock
—not to allow Time to drive you along like a flock of sheep with a pack
of ideologies barking at your heels. This is especially the case when
Time is equipped with machines, for dragooning its herds, of such
unexampled potency. A machine-gun is in another dimension to a
flintlock.

The journalist and the half-artist are again compacting to turn *art*
into *action*—to give the statue crimson cheeks, to make it move its eyes
and hips, and eventually to have it speak. That is what is afoot, the
living statue—which comes upon the scene hand-in-hand with the
robot-man—the herd machine-minders mingling, without recognition
of a difference, with the herd of Hoffman puppets. Or at least the life-
like statue may stand as the symbol of what is under way, with the same
implications today as in the classical ages.

It is of some importance to put a spoke in this crude Wheel—this
child's hoop of steel—before it acquires too blind a momentum, of
fashionable herd-magnetism—whether deriving from Magnetogorsk or
elsewhere. I have had a good deal of experience in this sort of salutary
sabotage. I can, without boasting, say, I believe, that, knowing the
Wheel upside down (or, shall we say, from A to Z, since it is a child's
alphabet of a Wheel!) I can insert the necessary spokes as well as most
people. Let this stand as an advertisement of my intention to do so.

Every fresh crop of scientific inventions, or mechanical improvements
in industrial technique, has produced its crop of madmen and of cranks,
since the early days of the steam engine, the mechanical piano and
musical box, or first cameras—people intoxicated with the novelty of a

new toy, or with the unexpected power, amounting to veritable magic, conferred upon them thereby without any effort of their own, from one minute to the next. That this technical 'advance' (perpetual advertisement as it has been for the ideologies of Progress, with the full stature of its vulgar capital letter) has been in no way equated with an intellectual or spiritual advance is by now, luckily, the merest commonplace. Everyone recognizes—everyone who does not absolutely belong to the underworld of irredeemable imbeciles—that the possession of a radio set (invented by somebody else) is nothing to be proud of, and is in some ways rather a handicap than an asset as a civilizing instrument.

But what has stood out more than anything else in this kermesse of machine-production, as the determining factor as far as the delight displayed is concerned, may be summed up in the one word *power*. To borrow the wings, the habits, of the swift or swallow—to rush along the surface of the earth with the speed of a cockroach or a rat (however snail-like this progress may be if compared with the velocity of light)— such things have gone to the head of mankind naturally enough, since, in the average, men's heads are passably weak.

It was inventions of this order—the musket, pistol, and breechloader, not to mention the fire-water—which enabled the European to overrun the globe a few centuries ago. And what good has it done to him or anyone else? That should be a startling enough advertisement of the vanity of regarding the machine, used as the instrument of the ordinary, undisciplined, power-instincts of Man, in the romantic manner of Marinetti or of Magnetogorsk. For in most of the places where the White Man went with his little gun, his polo-ponies and gangster-films, he has destroyed something finer than himself. And he is just preparing to wipe *himself* out with his aerial bombs—of truly divine destructiveness, we are informed by the expert.

But if there is one thing—in spite of Spengler—that does *not* produce art, it is the sentiment of *power*. Art has nothing to do with punching-power or blasting-power, or with crude speed—with the images of brutal force, or of colossal scale (witness Egypt in decay, with its immense, dull statuary). And the most gigantic power-station is controlling a power against which the power that is resident in art cannot be measured, for they have nothing in common. So much, hastily stated, for the power-sensation, and the intellectualist advertisement associated with the machine.

Now, first of all, as to machines, and machine-power, as a subject-

matter of art. Should the picture upon Mr Modern's spotless wall represent, or suggest, a machine, because this is a 'machine-age'? Should the book of verse upon Mr Modern's table sing of pylons and pistons, *because* there are pylons and pistons to be caught sight of occasionally outside? That is the question.

If you say *Yes*, then you are merely conforming to the discredited tenets of the French Impressionists of eighty years ago, who insisted that the artist should slavishly represent what was under his nose, because it was there—even though it would be far better that something else were there instead! At that time it was the *Bar at the Folies Bergères*, today it is the American Bar; then Degas's thoroughbreds, today Amy Mollison's aeroplane.

But if, on the other hand, you say *No* too firmly, you are implying that the artist should not make use (even casually and as a matter-of-course, as did the Chinese and Japanese) of the spectacle of the contemporary world; in which today there are, beyond question, tanks, in place of Boadicea's chariot.

Nature sees to it that our intestinal machinery is kept out of sight, where our anatomy is concerned. Perhaps it would be better to keep *all* machinery, pure and simple, out of sight as far as possible. *Possibly* that would be better. At all events, do not let us entirely neglect that point of view; although it would be absurd to overlook the beauties of precision, which have been so stressed with our increased mastery over nature.

That power and that precision are the two qualities that are apt to inform all art having its origin in an emotional attitude to the machine, may, I think, be affirmed. That, in the abstract, *power* is not a sensation conducive to artistic creation has already been pointed out. It remains for us to consider *precision*.

Wherever precision takes the form of *slickness*—or of machine-finish—it can safely be asserted that it is in some way contradictory to the principles that have always governed the productions of the artistic consciousness. That an absence of symmetry, or the absence of the, as it were, *ruled* straight line, have usually, though not always, characterized the art of all peoples, is undeniable. On the other hand, that very great precision, and often hardness and sharpness of limiting edge, and a geometric accuracy of design, has characterized a great deal of art, from that of the Greek Vase to that of the Solomon Island canoe, is equally certain.

But in a general way, whether in architecture, painting, sculpture, or

K

furniture design, the influence of the Machine—of the Machine-age—
has been suggestive of those sensations of *power* (more proper to a
captain of industry than to an artist): and more often than not a sort of
crude *precision* has characterized these productions.

Further, the much-advertised 'simplicity' of the average 'modernist'
design is different to the simplicity belonging to a great period of art—
that elaborate simplicity, grand by reason of the elimination of all
unessentials from a concentrated core of existence, a simplicity that is
rich with a compacted significance—not merely (as with so much
machine-age art) a bare board, or a crude whitewashed wall, or a com-
mon or garden *box*.

That Europe has achieved, in terms of *power*, great triumphs of art
in the past is, as Spengler has claimed, true enough. But it has resulted
in European art being a series of lonely peaks—the Michelangelos,
Beethovens and so on. And even there, for some of us, the power is
often a kind of obstacle to enjoyment. With Goethe, we are inclined to
put our fingers in our ears and rush out when the orchestra crashes too
insistently—'as though the house were tumbling about our ears', as
Goethe expressed it.

That *power* is identified with the Machine—the ever-more-powerful
machine—in the elaborations of national, or of class, passions, is
obvious enough. Where all social education is proceeded with in terms
of war and incessant friction, as is the case with Communist Russia,
the image of Magnetogorsk is broadcast like that of a league-high
Moloch. Always it is power that is stressed, in connection with the
Machine, by the propagandist-dictators. And when machine-minded-
ness (under such promptings) comes into a Western art today (whether
poetry, painting, architecture or music), it comes informed with the
sensationalism of power (as with sensations of the activity of battle),
whether those who submit to such influences are aware of it or not.

How this machine-mindedness or the power-sensation inherent in it,
when it enters 'the home' in the form of 'modernist' furniture is apt to
work out, is in a tension and over-energizing of everything. Regarded
as a reaction against the dingy period-room, this is extremely welcome,
certainly. But as *power* sensations and a crude *precision* are at the bottom
of the new internal scene, thus brought into being, it is little wonder
that *art* has no place in it.

BEGINNINGS

Reprinted from Beginnings (*London: Thomas Nelson and Sons Ltd., 1935*), *a collection of essays by fourteen novelists and short-story writers describing how they began as writers. Edited by L. A. G. Strong.*

Beginning with pen and brush, the penman and the painter are apt to clash; but in my own case this did not occur, when at a very early age these two personalities first came on the scene. Indeed, they made their appearance arm-in-arm, as though they had always cohabited and neither could quite conceive of life without the complementary presence of the other. Indeed, at first, until the fact was pointed out to me, I swear I did not notice that there were *two* familiars there instead of one!

I speak here, of course, as a writer. And I can affirm, I think, that I was so *naturally* a painter that, when I first took up my training, the penman went his own way undisturbed—*bousculant*, certainly, from time to time, and on occasion, the artist in oils and ink (and vice versa, for the penman would sometimes find himself for months together prevented from plying his trade, but that did him no harm—he was all the better for the rest); but on the whole the *homme plume* existed upon perfectly amicable terms with the other occupant of this mortal establishment.

No doubt that was partly a question of equilibrium. When a painter is also a writer, whether good or ill should ensue, artistically, upon this double birth—this twinship in the fashion of Siam of the literary and the plastic executant—depends upon how these partners are mutually balanced. With me, I am inclined to claim, the equilibrium was practically perfect. My best picture, I believe, is as well done as my best book.

Constant association with a person of another but kindred craft could hardly fail to be profitable to both the craftsmen concerned: unless one, it should be found, were overpowered by the other. Given this equality, it must be to the good. Had, for instance, Robert Louis Stevenson lived in intimate association with Paul Gauguin—to select two men of very similar genius, and each pulling about the same weight in their respective worlds—the alliance would have been a great success, I should say; although, in the case of that particular pair, rather harmoniously negative perhaps. Their beach-combing and lotus-eating would have precluded, it is possible, even that minimum of mild friction—of healthy stir and

pother—that is requisite to keep the waters of life sweet. With them things would have been *too* absolutely Pacific!

The most notorious instances of duplicated talent, for painting and writing, that is, are, for the Englishman, William Blake and Dante Gabriel Rossetti. Blake's especial hero, Michelangelo, was another. It may be worth while to make a few remarks as to how these tandem talents functioned, and how, as a rule, one is liable to affect the other.

What we principally notice in each of these artists is that in the two mediums employed by them, literature and painting, their genius is equally powerful. And what can be laid down as an invariable law is that this double life, to be successful, has in truth to be thoroughgoingly *double*—one mode must not merge in, or encroach upon, the other. This is extremely important to understand.

Blake, as a poet, is far more powerful than Rossetti as a poet; and the best of his pictures is far more powerful than anything done by Rossetti. But neither of them was really successful in his dual role, because their two selves were upon too intimate terms with one another. In the Rossettian Woman—as celebrated in the Miss Siddall pencil-drawings —resides, no doubt, Rossetti's most enduring claim to celebrity. They are a higher expression of the beautiful intelligence of this extraordinary man than are the sonnets he committed to the grave, when the original of the delicate drawings died, in a somewhat sinister manner. He should have sacrificed all the drawings, too, still in his possession, to have been consistent. He drew better than he wrote, as it turned out; but there is, in fact, the same quality and degree of excellence in the sonnets and the pencil-drawings. (The paintings are altogether inferior.) In the two arts to which they respectively belong the pictures and the poems are upon a similar plane of achievement—far beneath the *Songs of Innocence*, or Blake's drawing of *The Morning Stars Singing Together*.

It is impossible to imagine—and this is what I am trying to enforce in order to throw some light, I hope, into what is an obscure corner, for most critics, of the natural history of genius—it is quite impossible to imagine Rossetti the painter (responsible, as he was, for the series of pencil pieces of the anaemic English Rose—who broke his beautiful Italian heart when she sank into death like a languid and unhappy alien dream) being also responsible, in the art of literature, for the poem commencing:

> *Tiger, tiger, burning bright*
> *In the forests of the night.*

There was nothing of such sinewy substance as that in his nature: you cannot be one man in one art and another in another, though you must certainly be the painter when you are painting, and the word-man (or *homme plume*) when you are writing. And it held good for one art as much as for the other that this romantic and sensuous dreamer had had imposed upon him not only a certain compass, but also a certain type of self-expression. Whether perfectly or imperfectly expressed (and in painting it was very imperfect), his genius directed him to not only a similar eminence, but also to a particular climate and region. And that is the rule.

In a word, there is no such thing as a great poet who, if he gave up some time to producing pictures, would not produce pictures with *some* quality in them that only a great poet could be possessed of—however murkily it might shine forth through an imperfect technical equipment. W. B. Yeats, who began life as a painter, would, had he persevered, have produced *something* with a vague but authentic likeness to his finest poems; J. M. W. Turner's poems were in reality a criticism of his paintings; Mr Joyce's *Chamber Music* or *Pomes Penyeach* should give the critic a foothold from which to survey to advantage the panorama of *Ulysses*; D. H. Lawrence's pictures (as exhibited in the Warren Gallery) were quite competent enough to betray many secrets of the writer of *The Woman Who Rode Away* or *The Plumed Serpent*; and the pen-sketches of Charles Baudelaire were of a deliberate, vigorous, and imposing quality, which could leave no doubt in any one's mind that had he devoted more time to pictorial art he would have excelled in it as he did in literature, and upon similar lines—though, naturally, the result might not have been so fortunate. There is the Man, and then there is the Moment. With the *Fleurs du Mal* goes an immortality that paintings corresponding to them, done at that time, might not have brought him. The habits of the literary life may have suited him better, again. There are many things in the world besides this or that talent or predisposition. There is a time to paint a picture, and there is a time to compose an epic in prose.

But I have forgotten Michelangelo. Well, there again you have a poet of the first rank; not in output to be compared, certainly, with the immensely industrious painter and sculptor—the poetic output is nothing; but conveying the same reflection of a high imagination. There are people to be found, even—in spite of the marvellous abundance and facility of his creations in the plastic arts, and the reverse in

the literary—who prefer Michelangelo the poet. On the other hand, although the poems prove him to have been the intellectual peer of Dante, the poems alone would not have given him in literature the place possessed by Michelangelo Buonarroti in the art of painting.

From all this it will emerge, I hope, that most such questions as: 'Which art do you prefer—painting or writing?' addressed to a writer who is at the same time a painter, or contrariwise; or all such remarks as 'So-and-so is a *better* this than he is a that' (advanced in connection with a dual personality in the arts) is somewhat superficial. The only question that is sensible and not entirely beside the point is: *Which have you done the most of?* or *To which have you devoted most time and energy?* But this is usually obvious, anyway: so those questions, too, are unnecessary.

If you have regarded this preamble as needlessly dilatory, where I am supposed to have set out to inform you 'How I began to write', you have, I can assure you, not allow sufficiently for the especial difficulties in which a writer who never has had a half-finished canvas far away from the desk at which he wrote—who possesses a twin brother in another art—must find himself if interrogated as to 'how he began'.

For he began, at least that was the case with me, in a painting academy. He wrote his first short story (if the writer in question is the author of *The Apes of God*) while he was painting the subject of it with hog-hair brushes, in petrol quick-drying medium, if I remember rightly; and the short story was shorter than the painting, I believe I should be correct in saying, in the matter of the time that it took to write. The short story referred to here is one of those to be found in *The Wild Body*.

Technically, then, the short story, as we call it, was the first literary form with which I became familiar; and I think I may say that the dramatic necessities of this form of art were immediately apparent to me—namely, that *action* is of its essence. And acquainted as I was with both French peasants and English villagers, I chose the former deliberately, because I have always considered that my turn of mind is better suited by the spectacle of people to whom the fundamentals of life are still accessible. Also, I like a wild and simple country, with a somewhat inhospitable skeleton of rock. And if I have not gone to seek these conditions in such parts of these islands as may be found to provide them, it is largely on account of the incessant deluges of water that fall from the Britannic firmament, or because of the detestable Scotch

mists that continually conceal everything, and which cause one to become a walking sponge. This is partly owing to an innate dislike for rain, and partly it is, beyond any question, due to the professional reactions of the painter to a climate where he is continually checkmated by poor visibility or by a downright night-by-day. But I very much enjoy the sun as such—apart from any complex reasons for avoiding as far as possible the rain. When I go to a film like *The Men of Aran*, I shudder at what I see: I recognize that the dry intervals in which it was possible to shoot the film must have been very few and far between; and this pall of rain (into which I have passed many times, on board incoming liners, both from Africa and from America) which stands over England fills me with a hideous melancholy. Rain and no snow! The absence of snow is, if anything, worse than the presence of the rain! Coronation Gulf or the Bay of Whales can be contemplated with pleasure, at least by me. But Aran or the Hebrides! However, I will expatiate upon this no longer. Why my short stories must occur in other parts of Europe, then, or perhaps in the sub-tropical belts, is climatic mainly. I would rather have written *On an African Farm* than *Wuthering Heights*, because in order to write the latter one would have to exist for many years in a perpetual drizzle. To write the former one would at least have to live in uninterrupted sunshine for a considerable length of time.

It was the sun, a Breton instead of a British, that brought forth my first short story—*The Ankou* I believe it was: the Death-god of Plouilliou. I was painting a blind Armorican beggar. The 'short story' was the crystallization *of what I had to keep out of my consciousness while painting*. Otherwise the painting would have been a bad painting. That is how I began to write in earnest. A lot of discarded matter collected there, as I was painting or drawing, in the back of my mind—in the back of my consciousness. As I squeezed out *everything* that smacked of literature from my vision of the beggar, it collected at the back of my mind. It imposed itself upon me as a complementary creation. That is what I meant by saying, to start with, that I was so *naturally* a painter that the two arts, with me, have co-existed in peculiar harmony. There has been no mixing of the *genres*. The waste product of every painting, when it is a painter's painting, makes the most highly selective and ideal material for the pure writer.

Tarr was my first published book. It is a novel. It was first published during the war; and I wrote it during the first year of the war, while I

was ill for six months, off and on, and preparing for the worst. It was a rather ridiculous illness. It hung about for some time, but was not serious. When the last coccus took itself off, I knew I should then become a soldier in the natural course of things (I had no conscience with which to 'object'), and already my late companions of peace-time were dying like flies. I naturally assumed that it was quite on the cards that I should take the same road as they and rejoin them in quite a short while now in a better world—it was at least not unlikely. It was very much with this in mind that I took up my pen one day to write my first novel— perhaps my *only* novel, I said to myself. I wished to leave behind me a little specimen of my hand, that was the idea—upon the big scale, in a great literary form, to show the world—should I in my turn succumb— what a writer it had lost! A romantic consideration! But the war, as it descended upon us, made romantics of us all, I think, if we were not romantics already. I had, however, in the back of my head a great accumulation of that matchless literary material, that waste product I have mentioned (flung back in his toil by the uncompromising painter). It did not take long to spin my plot. And there I lay, writing of Huns and Hunesses, without at all understanding the political symbolism of my action, while the Hun was hammering at the door, encamped almost at Calais.

I thought of no great paragon of style when first I dipped my pen in the ink and put *Knackfuss* for *Montparnasse* (thus germanizing Paris): I was in far too great a hurry to do that. There was no time to consult the great masters of manners. Such manner as I possessed was my own. I entered writing with a careless tread. Nay, I bolted into literary composition—there was some arrogance perhaps in my invasion of the literary field. There were the circumstances; but if the tailor had not been impatiently in attendance to measure me for my British Warm, so to speak—if I had had a world of time in which to turn round and pick a pilot—it would have been just the same.

ART AND PATRONAGE

Reprinted from The B.B.C. Annual. *London, British Broadcasting Corporation, 1935.*

. . . The problem of *patronage* is at present of great moment to every kind of artist. How should it be otherwise, seeing that every great traditional institution has its back against the wall, fighting tooth and nail for survival, itself; so is far too harassed, too poor, too uncertain of the future, to lend an ear to the necessities of the scribbler, the singer of songs, or of the house-decorator (why *decorate*, when the roof may be tumbling about its ears in a fortnight?): and as to the Individual, he has his back against the wall, too, poor devil (or relatively poor devil), with the tax-collector's fingers on his windpipe. These are elementary truths that, in any consideration of *patronage*, must be thoroughly mastered at the outset.

That many people, under these circumstances (politicians, sociologists, economists), have meditated a *world without art*, and with considerable complacency, be it said—even with a vindictive chuckle or two (for at all times the artist has enjoyed a degree of privilege and popular romantic esteem which has not endeared him to the man of shekels, as jealous as is the legislator, or would-be legislator) all this is undeniable. The Artist, whether writer, plastic artist, or musician—that man who is by way of being 'a law unto himself', that man who is 'without dogma' or who 'is his own dogma', as George Moore described it—this privileged creature has been regarded very much askance as much by the salvationist politicians of Russia, as by the by-no-means 'art-loving' paladins of our own Bankers' Olympus.

The artist, in his more politically troublesome forms, that of novelist, essayist, or playwright, for instance, is the typical 'intellectual', as thundered against by the masters of the new revolutionary societies (mostly 'intellectuals' themselves!) for his 'irresponsibility'—even, as often as not, sentencing him to be shot out of hand, just to *show* him, and all his kind. And the artist fares no better, except that shooting is dispensed with, at the hands of the new-rich money-masters of the old democratic societies of the West, who have not the same incentives to be 'cultivated' as had their predecessors: they have not been at any pains to disguise the fact that commercial values are the only ones that

mean a great deal to them; and that to all these intangible, non-commercial, non-quantitative values, resident in everything that can be labelled 'art', they are sublimely indifferent. It is thus that the tennis-player, the sob-stuff film-star, the beauty-queen, the dirt-track rider, the money juggler or stunt-flyer (along with the exponent of the 'perfect murder', and the gunman, the armed sheikh of the gutter) now occupy the position formerly reserved for the Wagners and Beethovens, Goethes and Carlyles, Dickenses and Tolstois. These were literally the saints of pre-war Europe, still as much Roman and pagan as anything else: Stratford-on-Avon was 'the most celebrated birthplace of the Western World' (I quote Mr Shaw). But neither the materialism of post-war democracy, nor the 'dialectical' materialism of the Marxist dictatorship, cares overmuch for this particular type of 'great man'—in that matter as in some others, they agree. It is a sort of 'greatness', an order of prestige, which is apt to interfere with the smooth working of materialist dogma, whether of the Kremlin or of Wall Street. . . .

But we must assume, for argument's sake, that the present rapidly evolving societies will, although starving or shooting (according to taste) all their artists on principle, yet leave a few, here and there, who may pretend at least to carry on the traditions of the greatest art; and who may serve, at all events, to keep up the commercial values, if only by contrast, of the 'old masters' (whose works are regarded as in some ways a safer investment than precious stones, and if there were no *living* artists these objects might somehow, in some queer way, lose caste and so depreciate). . . .

But this, as a matter of fact, is a fairly safe assumption: for the artistic impulse is a very fundamental, semi-magical, thing, of deep organic importance in the life of man: and although the Money Man—who is detested by every true artist, and who heartily loathes the artist in return, if, for no other reason, because the latter, with his highbrow airs, makes him feel small—although this man of shekels would have as little compunction as the political gunman in shooting all the men of art within reach out of hand, people in general possess an uneasy conscience where art is concerned. Their instinct tells them that it makes life less hideous, that without it routine existence would become so unlovely, so stripped and black and snarling, that the very appetite for life would cease to operate, and the 'gaiety of nations' so utterly disappear that all incentive even to *act* (to fly, to make money, to kick footballs, to shave in the morning, to make love) would vanish; their instinct tells

them this, so art, in some attenuated and rudimentary form, will be preserved—in spite of milord L.S.D., and his salvationist excellency Ghenghis Khan *à la mode de Marx.*

Having allowed this assumption, then, the position of a disreputable and distasteful axiom, we may proceed to consider how the life of the remnant of a once noble race, of mighty craftsmen, may (like the last survivors of the Redskins) be organized in State reservations, or else be supported (in the manner of the London Hospitals) upon voluntary contributions; and attempt to assess the value of these respective forms of patronage.

If you were to inquire of the artist—were you so eccentric, so courteous, as to do that—which sort of patronage he would prefer, that of the State, that of a great Corporation, or that of an individual person, nine artists out of ten would answer 'Give me a rich little stockbroker every time!' Richard Wagner would certainly have replied 'Give me a mad king of Bavaria!' in preference to, say, the Prussian State, or a syndic of Württemberg tradesmen. Michelangelo would have plumped for even the most cantankerous Pope, as against a committee of constipated bureaucrats, or against institutional patronage.

The reason for this preference for an individual is obvious enough. The individual, however odious, is one thing—is simple: whereas the state, or the corporation, is many things, and this complexity, masquerading as a unity, is suspect, especially to such a man as the artist.

Yet, of course, how corporate patronage works out depends upon the individuals involved—sometimes upon one individual, if influential enough: and it could be and occasionally has been an ideal arrangement; and needless to say the opulent stockbroker or the cantankerous Pope could well be dispensed with by the artist; indeed, the artist would be overjoyed to see the last of them, if he were sure that he would not be exchanging them for an abstract mass of stockbrokers and other categories of patron, amongst whom he would have primarily to reckon with the lowest of most common denominators.

But *any* patronage is better than one deriving from the politicians, that is fundamental. And corporate patronage will be better or worse according to the personal detachment from the art, on the one hand, and from political faction, on the other, of the officials involved. Broadcasting, for instance, if it came under so-called 'business' control— namely, the big business interests in Films, Books, Theatres and the rest—would become a vast vehicle of Advertisement merely—one huge

and particularly corrupt Blurb. It is sincerely to be hoped that that may not happen.

In the remainder of the essay, Lewis deals with the problem as it appears 'today'. He states that the individual patron can be left out of count (the rich never buy a contemporary work of art). Of the possible forms of corporate patronage he feels that represented by the B.B.C. to be 'the best in the worst of all possible worlds for the artist'.

FOREWORD TO CATALOGUE

Foreword to the Catalogue of the Exhibition of Paintings and Drawings by Wyndham Lewis, held at the Leicester Galleries, London, in December 1937.

Three or four years ago I painted the first of these pictures and they are in some sort a series, from the *Stations of the Dead* to *Inferno*—the latter is still wet.

It is considered by some people that the artist's business is to please, first, last, and all the time. Others believe that it is the function of the artist to translate experience, pleasant and unpleasant, into formal terms. In the latter case, as what we experience in life is not all pleasant, and the most terrible experience, even, is often the most compelling, the result is a tragic picture, as often as not. Bearing this in mind, one of the main questions to which this exhibition will give rise, in the mind of the general public, is answered. The art of tragedy is as much the business of the painter as it is the business of the dramatist. And many of these pictures belong to the tragic art.

As to the manner of conveying the tragic, and the tragi-comic, impression. The canvas entitled *Inferno* will be plain sailing, I assume. In this composition (an inverted T, a vertical red panel, and a horizontal grey panel), a world of shapes locked in eternal conflict is superimposed upon a world of shapes, prone in the relaxations of an uneasy sensuality which is also eternal.

On the other hand, the *Departure of a Princess from Chaos* is the outcome of a dream. I dreamed that a Princess, whose particularly graceful person is often present in the pages of our newspapers, was moving through a misty scene, apparently about to depart from it, and with her were three figures, one of which was releasing a pigeon. This dream, with differences, was repeated, and it was so vivid that, having it in my mind's eye as plainly as if it were present to me, I painted it.

As to the resemblance of the figure in the canvas to the princess in question—whose face you all know well, and whose beauty must have impressed itself on you as much as it has on me (though not with the same results)—the likeness is not material, and I have seen nothing but press-pictures of my dream 'model'.

Lastly there is a portrait of Miss Margaret Ann Bowes-Lyon, and there I had in the flesh a very beautiful, smiling girl before me. I hope I have not wronged those looks too much. However that may be, I would issue a challenge to *Messieurs* of the Royal Academy to do it better, if it is ever their good fortune to attempt it.

SUPER-NATURE VERSUS SUPER-REAL

This essay and 'The Skeleton in the Cupboard Speaks', which follows, form the introduction to Wyndham Lewis the Artist. *The book reprints* The Caliph's Design, *most of Lewis's writings on art from* Blast *and* The Tyro, *and his letters to* The Times *dealing with the rejection of his portrait of T. S. Eliot by the Royal Academy in 1938. Lewis's concept of 'super-nature' is defined in the pages that follow. 'Super-realism' is the translation of* surréalisme *much used in the thirties.*

I

Here is a considerable body of criticism dealing with the visual arts, and it is imbued with one consistent purpose, since it is the work of a practitioner of an art, not of a detached and eclectic theorist. All of the Notes and essays collected in this book are therefore dogmatic. Further, they advertise a bias in favour of the new and the untried, in painting, sculpture, architecture, and design.

I will start this Introduction by defining the nature and the limits of that bias. These Notes and 'vortices' set out from the conviction that it is not so good a thing, at the present day, to paint a picture in the manner of Tiepolo, or of Velasquez, or of Manet, as in some new or different manner, more appropriate to the beliefs and conditions obtaining in the twentieth century. Yet nowhere will you discover a disposition to assert that the work of Tiepolo, or of Velasquez, or of Manet is *inferior* to what would be done if the contemporary artist had a free hand and were encouraged to evolve a new style of painting.

Although dogmatic, therefore—as becomes an artist, who stands upon what he does; who argues back, as a matter of course, from what he himself chooses to do, with all his intellect and his sensuous nature thrown into the scales of pro and contra, this school or that—these critical utterances are not what might be described as chronologically parochial. I am happy to be able to claim for them this immunity from intolerance. I have no fondness for the merely fashionable, or for absolutism that has not its roots in some creative necessity.

I was not a little flattered to encounter, in a book published the other day (*Modern Painting*, by Charles Marriot), a quotation from my *Blast*

days, approving my clairvoyance at that period and 'moderation'. Painting, I had said, would after a time withdraw, would 'flow back into more natural forms from the barriers of the Abstract'. For even when most furiously engaged, blasting-tools in hand, upon that granite frontier of the universe of 'pure form', I never pretended that such purist exercises were for all men, or for any man for more than a certain period. That was, as it were, a conventional limit. A *direction* was imposed by going to the end of the road, where the form of the artist becomes indistinguishable from that of the geometrician. My designs were no more arbitrary or absolutist than that.

Of course, as to what 'the beliefs and conditions obtaining' at this moment, or at any moment, *are*, no two men could be found to give the same answer. Some would say, even now, that Dr Freud was the most typical 'modern' man; some that Dr Rosenberg (the Nazi ideologue) was he. Some would point to such a figure as we have in Father d'Arcy, say, asserting that nothing was so modern as the New Catholic.

But at least there are certain fundamental ways in which this age, or this century, differs from the age of Pericles, or of Louis XIV, or even of Napoleon III. In some form this difference should be taken count of —that is all one can perhaps reasonably affirm: though in 1914–25 I obviously went very much farther than that. I envisaged an absolute revolution in the principles that govern the visual arts, in response to a fundamentally altered world. And at that time—however fallaciously— it did seem as if the visual arts were about to enter upon a period of drastic revaluation.

Such a revaluation—such a revolution in values—would run counter to all nationalist thinking, especially nationalist thinking of the type with which we are familiar today. And, at a moment when even the most extreme internationalism is seen to be merging back into nationalism again, what has to be reckoned with more than anything else is this movement of return to what is anchored in the soil, and sunk deep in the past, and away from all that is merely contemporary or *abstract*. As it was what has been called 'abstract art' that I, more than any other Englishman, was identified with, nationalism, and what it implies in the visual arts, must be my theme for a moment.

For my part I was not unalive to the limitations imposed upon artistic expression by climate, by national tradition, by the cultural environment of the individual artist. The 'vorticist' manifestos, which were composed by me, demonstrated that. (*Cf.* 'Bless England', etc., *Blast*

No. 1.) Yet such thoroughgoing revolution in the visual arts as I advocated could not recommend itself, that is obvious, to the nationalist or the traditionalist.

The Machine Age has made nonsense of nationalism, or so it appears to me, by destroying all the landmarks upon which national sentiment nourishes itself. In shearing off the pigtail of the Chinese—by restricting the use of the turban, the tarboosh, and the topper—by abolishing the national costumes of the European peasantry—by substituting bourgeois-capitalist architecture for the organic architecture of the feudal state, or of the small urban oligarchies—in a word, by standardizing life throughout the world, the technique of industry has imposed inter-nationalism upon us, whether we desire it or not.

All nationalism, of necessity, tends to be artificial and unreal, with the nations themselves no longer psychologically watertight, nor their distinguishing marks intact. Even the most robust of it is tainted with the gas-lit artifice and false sentiment of *Cavalcade*, and is of the same family as the Lord Mayor's Coach and the druidic togas of the Eisteddfod.

Politics have so great a bearing upon art—and especially the politics of nationalism, upon the extremes of artistic expression—that I must continue for a moment to be politically controversial.

It is difficult to see why the extremes of artistic expression, upon some ideal plane, should not be contained within the frontiers of a nationalist consciousness. But in practice these two things appear to be to each other as oil is to water. Nationalism, perhaps because it is today self-conscious, is invariably antiquarian. And a steel-and-glass writing table cannot cohabit with an escritoire or a grandfather-clock.

But are we justified in ascribing a superior reality to what has for some decades been regarded as 'the new'? May not the grandfather-clock and the escritoire live again, and enjoy a second term of existence? And in no country so much as in England is the 'dead hand' the *real* hand, and more powerful than any hand of mere flesh and blood.

On the European continent, in the nationalist states, from Gibraltar to the frontiers of the Soviet, the 'dead hand' has been galvanized into tremendous life: it wields a very up-to-date and startlingly real machinery. Can we deny *reality* to such an imposing manifestation?—It looks to us a little unreal—as if a gang of energetic ghosts had laid hold of a power-station, or manned a battleship. But is it our eyesight that is playing us tricks?

I do not think so. But because of political necessity a thing which is in itself, and in the larger perspective, unreal, may, for a stated time, acquire a reality of sorts. So much must be conceded. Even if persisted in—and no one can say how long certain modes of feeling prevailing in many countries today will be persisted in—it might supersede, with its arbitrary reality, what would seem the more natural time-order of the Real.

Upon the longevity of those modes of feeling it is perhaps idle to speculate. The present violent return to the sentiment of nationhood—in opposition to the natural evolution (as it seems) towards a commonwealth of nations—may persist for so many years, and take such roots, as to deflect, or attract to itself, the main course of history. It appears to me improbable; but stranger things have happened. The *esprit de corps* of the Byzantine sporting factions (in the course of whose pitched battles thousands died) was a far stranger thing than even the campaign of the Chaco, where the irrational ferocity of national pride reached its climax of absurdity—seeing that both sides spoke the same tongue and were identical in racial origin.

The vorticist, cubist, and expressionist movements—to return to them —which aimed at a renewal of our artistic sensibility, and to provide it with a novel alphabet of shapes and colours with which to express itself, presupposed a new human ethos, which undoubtedly must have superseded, in some measure, modes of feeling of a merely national order.

That these movements have not succeeded is plain enough: for now let us come to today—the early months of the year 1939—and endeavour to arrive at some not too prejudiced idea of what is happening—of what is *the actual*, if it is not the *real*.

What has *already happened*—that can be said at once—is that modern art, of the highly experimental sort advocated in these essays and manifestos, is at an end. It is all over except for the shouting—of the rearguard, as they fly, but who, true to best traditions of contemporary journalism, affect to be *advancing*, what while they hurry off the stricken field.

In the form of Expressionism all that smells of the 'modern' in art has been booted out of Germany, and the door been bolted against it. In Italy its only manifestation was 'Futurism', which lived but three years. It was buried in 1914. Giorgio de Chirico has taken to chocolate-

boxes—upon which a symbolical charger, more and more fatigued, languidly prances. (It was the Horse, actually, that killed Chirico, it is said.) He was the solitary important Italian.

As to Paris, there it is the *crépuscule*. The picture-market has collapsed (and the French book-market is down fifty per cent, as reported year ending 1938): all the graceful *petits maîtres*, a great store of which France always possesses, have crept out of their holes, as the Catalan sun sets—in human blood, alas! As Barcelona falls, and the phalangist standard is unfurled there, we can all see that that is the end of a chapter—of painting, among other things. There will be no more Catalan painters, to act as hormones to the old Paris *cocotte*.

Under the shadow of Politics, the great movement in the arts celebrated in these pages, bankrupt or refugee, is expiring. 'But *surrealism*—that is a very advanced movement, is it not?' you may demur. 'That is still with us.' Yes, but that is anti-movement. That is merely the road *back* (via 'advanced' subject-matter) to the portals of Burlington House and Mr Russell Flint. (The late Mr Glyn Philpot, R.A., actually went half-way to meet it, hat in hand.)

No: surrealism is not the last of a *new* movement, but the whimsical and grimacing reinstatement of the old—and of the bad-old at that, the 'academic'. This perhaps should be qualified; read *continental-academic* for academic. Most of it leads straight back to *The Islands of the Dead*—of which mausoleum Dr Freud has become the curator, demonstrating upon the cadaver, in his dank magician's cave, the functioning of the libido.

Let me, however, give more definition to the word 'modern'. Admittedly, it is a silly word. It fatally conjures up such clichés as 'Miss Modern' or 'a modern girl'. In religion it stands for dilution of dogma. Politically it signifies an understanding of the out-of-dateness of the Capitalist System, and a desire to expedite its demise. In its popular sense, 'modern' is used to convey a liberal outlook in all things—not much more than that.

As applied to pictures, music, and books, a rupture of tradition is indicated; a tendency to do something *new* is expressed. New? Well, surprising, and, in England, 'shocking'. But it is all a little vague, of course, because people think or feel vaguely about everything.

The Germans are relatively logical. Why *they* do not like pictures or books to be 'modern' is for what at first sight appears a sound sociological reason—because they identify all very modern movements in the arts

with Karl Marx, and his theories of armed proletarian revolt against the Capitalist System.

But this has always seemed a little shallow to me; because, in the first place, the Germans themselves are just as much a threat to the Capitalist System as are the most orthodox Marxists—if indeed not rather more so; secondly, because nothing could be less proletarian than Picasso, who is the high-priest of 'modernism' in painting; and, more generally, all these manifestations, whether in the visual arts or in literature, have had much more to do with scientific thought than with political thought (as far as the latter can be dissociated from the former).

We have learnt only this year, from the pen of Miss Gertrude Stein, that Picasso is a Jew. The Germans and others assert that all 'modernism', or extreme liberalism, is Jewish, and therefore an alien and inappropriate mode of expression for the European. But though Picasso is Jewish, James Joyce is—I was about to say, the *opposite*! Again, though the Dadas were for the most part Jewish, Auden is a Nordic Blond.

As to extremist painting, Cézanne, much more than Picasso, is at the bottom of that. He is the chief culprit in the pictorial revolution. And Cézanne was not a Jew, but a Provençal Frenchman—nor was 'Vincent', nor was Rodin (a great subverter in his day—and he was the forerunner of Mr Epstein, not the other way round).

James McNeill Whistler is another famous artist who did not conform to the *racial* theory of the origin of revolution—Whistler, who for many years was regarded, by the Anglo-Saxon part of the Germanic World, as a menace to all civilized society, because he painted those peculiarly gentle and beautiful pictures, the *Miss Alexander* in the Tate, and the *Portrait of Thomas Carlyle* in Glasgow.

Neither the Germans nor the Anglo-Saxons like the visual arts very much, and usually they drag in God and the Devil, in order to put their aversion upon an unassailable theological footing, insisting that they stand for God and the artist for Satan. I suspect that both really regard painting as 'unclean' and a bit 'dago'. And certainly painting does seem to be a dago art. It would appear to belong to those countries where the sun is strong. A visual art is clearly at a disadvantage in a London fog or a Scotch mist.

However, let us sum up. If it is the *crépuscule* in Paris, it is the night here. It would be idle for me to pretend that what you are about to read—the essays for which I have written this Introduction—represents a doctrine

belonging to a movement that is alive. It is so palpably dead that it would be impossible, even if I wished to do so, to proceed very far with that deception.

On the other hand, while there is any art at all for us to talk about—and in the sequel I shall not disguise my belief that in a very few years there may be no art whatever to discuss—the influence of this movement that has failed will be considerable. Brief as was its reign, its works will stand there behind us to obstruct too abject a return to past successes. It is a snag in the path of those who would sneak back to Impressionism. Some of its vigour will remain, and inform the phases of the great withdrawal that is everywhere taking place, and at least prevent the retreat from degenerating into a rout.

I am quite certain therefore that these critical *obiter dicta* can be perused with advantage by any artist or theorist, whether he was ever drawn towards such disciplines himself or not.

I must say that all this panorama of defeat does not distress me over much. I survey this stricken field—strewn with cubes and cones, with fearsome masks with billiard balls for eyes, venomous futurist hat-pins, and bashed-in Catalan guitars—with considerable equanimity.

People flung themselves into those movements for different reasons. Some hurled themselves in as a dog does, when his master is about to move house, into the chaos of objects surrounding the packing-cases. Being no lover of impermanence and disorder, that was not my motive. The promise of an intenser discipline, and less impermanent equivalents for our personal experience, was what attracted me. The cortex, massive and sharply outlined, not the liquefaction within, I have always regarded as the proper province of the artist.

Then I was not an 'extremist' because I was technically incapable of being anything else. I am a master in the painting of tradition. And it suits me just as well to paint close to Nature, as to paint for the megalo-politan glass and concrete of a Brave New World. In Rome I paint as the Romans do. Luckily I am able to do it at least as well as the Romans.

II

It is far better not to delude ourselves as to the position of the arts; of all the arts, though especially of the visual arts. The issue is much wider than the fate, merely, of a 'new sensibility', and the discouragement or not of its exponents.

Much more it is a question of the imminent extinction of any sensibility whatever. The issue is not less considerable than that. It is a case of *Men Without Art* indeed (to make use of the expressive title of one of my books). In a generation or two our society may have arrived at that nadir, with all that such a condition entails.

It may be that then no adult art will remain. There will be the scribbling of children—abruptly terminated by the onset of puberty—over whose productions parents would bend moist-eyed. There would be, it is true, what remained of the primitive races. But the Eskimos, Black Boys, and all other 'primitives', are dying out: there would be no savages left to carve a totem-pole or embellish a canoe. So even they would not be there to help us to illustrate this lost sensibility: only the kiddies.

Adult art—the adult art of civilized man—may thus become a memory of the unenlightened ages. National Galleries may close, and all the Raphaels and the Rembrandts be transferred to the ethnological sections of the Museums. These pictures in oils would be preserved as records of an extinct pre-logical activity.—In that case their value would diminish, or practically disappear: and that of course is the reason why the picture-dealer still stages exhibitions by *living* artists (in spite of the fact that no pictures by living artists any longer sell, except for figures so small as to make it uneconomic to accord them wall-space). I can imagine no other reason. The 'Old Master' must be prevented from slipping over entirely into the class of things dead and done with, curiosities of historical value only.

This world without art—except for the scribbling of children—upon the imminence of which I have just been speculating, is no phantasy of mine. It is an extremely plausible solution of what we observe on all hands today. It is not in the same class as the prognostications of the man of science, foreshadowing a time when mankind will have shrunk to dwarf-stature, marrying at five years old and dying at ten. On the contrary, it is the only logical issue to much contemporary theorizing upon the functions of the arts.

If you will allow me I will suspend the course of my main statement for a moment to make good this assertion. And I will go to the books of my old friend Mr Read for the evidence I require.

What is required, is it not, is evidence that the typical theorist of 'advanced' visual art points to the Child as the *perfect artist*—or something like that? And as obviously children are better at being children

than adults are—however hard the latter may try—*in the end* the adults will give up the unequal contest.

Then, it is not unreasonable to assume, only the scribbling Child will remain. The little savage of ten or eleven will do his caveman stuff: he might even have his own religion and medicine men, once it was generally recognized that this savage and irrational phase through which man is compelled to pass possesses not only its appropriate aesthetic, but also its appropriate theological, oddities. The adult would look on: no 'art' for him, nor any 'religion' either. Even females aged nine or ten of this new organized savagery (of 'tender years', as idiomatized by the Victorian) might weave quite delightful fabrics—typically geometric—which adult women would acquire and incorporate in their summer beach-fashions. Children might even be segregated, to make this infant-culture more effective. They might even attack their elders in their war-canoes—though the adult world, with a few well-placed machine-guns, would experience no difficulty in repelling them.

Mr Herbert Read has an unenviable knack of providing, at a week's notice, almost any movement, or sub-movement, in the visual arts, with a neatly-cut party-suit—with which it can appear, appropriately caparisoned, at the cocktail-party thrown by the capitalist who has made its birth possible, in celebration of the happy event. No poet laureate, with his ode for every court occasion, could enjoy a more unfailing inspiration than Mr Read; prefaces and inaugural addresses follow each other in bewildering succession, and with a robust disregard for the slight inconsistencies attendant upon such invariable readiness to oblige.

Under these circumstances, to correlate Mr Read's many utterances is not unlike attempting to establish a common factor of eclectic inspiration in the rapid succession of 'models' emanating from some ultra-fashionable Parisian dressmaker. The *Read Model* for January 1939 is probably quite different, superficially, from that of October 1938, the last with which I am acquainted.

Yet there is something that is essentially *Read*. This man has a core to him, which is not unlike that to be found at the centre of his young colleague, Mr Day Lewis, whom he resembles in his emotional make-up, as in his obviously official destiny. And that central impulse leads him to the sensational and sentimental quarter of the philosophic compass. Naturally enough, he finds in the Italian philosopher Vico the intellectual authority that he requires.

Now for my quotation, which will be my sufficient evidence, not for

the prognostications I have ventured upon above, but for my inclusion of Mr Read in the ranks of those who are actively promoting such a utopia of the immature, and busy making the world safe for the Child. It is from *Art Now*; from a subsection headed *Vico and the rise of the genetic concept of art*. It happens to be poetry about which Mr Read is speaking. But of course these remarks apply to painting even more than to poetry, since for every adult we find doing an infantile poem, we find ten doing a child-art picture.

'Vico identifies poetry with the primitive phase in the history of man: poetry is the first form of history, it is the metaphysics of man whilst he is still living in a direct sensuous relation to his environment, before he has learned to form universals and to reflect. Imagination is clearly differentiated from intellect, and all forms of poetic activity are shown to depend on the imagination; in civilized epochs poetry can only be written by those who have the capacity to suspend the operation of the intellect, to put the mind in fetters and to return to the unreflecting mode of thought characteristic of the childhood of the race.'

Mr Read then proceeds to 'throw out the prediction that we are going to hear a great deal more about Vico in the immediate future', and that, in short, 'his theories are going to play a predominant part in the development of modern criticism'.

'Art no longer conceived as a rational ideal ... but conceived as a stage in the ideal history of mankind'—that is the conception of art which finds expression upon the walls of our present-day Nursery—a nursery of *rich* children, naturally; for the proletariat, though suitably childlike, do not possess nurseries.

If Mr Read can 'throw out a prediction', why should not I throw out one too? In an essay in the *Criterion*, in 1924, entitled *The Apes of God*, I foreshadowed a state of affairs which has now come to pass—so I have this advantage over Mr Read, that a prediction of mine has already been confirmed by events.

My present prediction is this: that 'modern criticism', as that is understood by Mr Read, will continue to find arguments, month after month, and year after year, for the Nursery where our capitalist children play at being artists, but that before very long this 'criticism' will only be read by themselves: that all 'art-criticism' will first diminish in volume, and then entirely disappear from the Press (except for an annual outburst on the occasion of the R.A. exhibition); and that then the small private nurseries (or highbrow picture-galleries) will be shut

up, and Herbert's occupation will be gone! I am sorry, for I like the beggar. But when prophet meets prophet, well, each has to 'throw out' what is travailing within. And, say I, without fear of the issue, let the best augur win.

III

These childish backwaters of Anglo-Saxon culture—which are in the main clumsy glosses upon the French, from which most that is non-academic in England derives—are not cheerful places to go sightseeing in, especially just now. London reflects not only the culture but the disintegration of its continental original; upon a small amateur screen, but with a reasonable fidelity.

The forces of what in politics would be called 'reaction' are everywhere in the ascendant, in England as much as elsewhere. The crescendo of the struggle for political power; the struggle for mere subsistence in a world of 'want in the midst of plenty'; the universal decline in the intellectual standards of the capitalist class; the impoverishment of the middle class, the paralysis of the energies of the aristocrats, the peasantry, and the proletariat—all this has relegated the arts to a position of nonentity. 'Intellectual' has become a term of contempt (as if the only worthy use of the intellect were in money-spinning or in the power-game of the politician): as much among us as in the 'dictator' states is this the case.

All ruling factions are at one in a tacit—or stridently advertised—resolve to discourage irresponsible intellectual attainment, in the un-moneyed and the destitute-of-power. The Bourgeoisie—either *la haute Bourgeoisie* enthroned in the democratic states, or the little Bourgeoisie enthroned in the dictator-countries—are of one mind when it comes to the 'uppishness' of what used to be termed, in the bad old days of Liberalism, *genius*. There are two things: there is Money, and there is Power. Outside of that there is nothing. And both Money and Power are recognized as possessing the right to exploit, without return, all that is creative, or to crush it when it suits their book.

In this section of my Introduction I confine myself to the London scene, or, rather, continue my unveiling of that, begun in the last chapter. It is there that I propose to show the working out of those detestable principles. The backgrounds of that English scene are of course Europe, and its deadly schisms. What we see is in part made up

of the political blight reaching us from the continent, in part the intellectual blight which is an inalienable feature of all Anglo-Saxon society, as much in the 'capital of empire' as in any drab colonial hamlet. These intellectual shortcomings are not improved by the decay of taste and good sense in Europe.

The jealousy of the 'lower animals' for the 'higher animals' would be a standing difficulty for the staff of any Zoological Garden, if the animal world had acquired our habits of introspection and of speech. But as indications of how this principle operates—that of exalting the Big Battalions and banishing from the public view all that offends the monied or the power-inflated 'Great', by reason of its insolent and uncomfortable intelligence—I will select two instances from among many: both express, in their different ways, the triumph of what Arnold called 'the Philistine' in England.

1. My first illustration is a homely one. It is the Honours List.—For what qualities is a man marked down for honour by the State? You do not have to examine the Honours List very closely to discover that, in a majority of cases, it is for demonstrating his capacity as a money-spinner—for before you can distribute money, in a good cause or the reverse, you must first *make* it. In no case is it the *creative* faculty that is singled out for these coveted awards. You will find in these lists the names of people who purchase and exploit the inventions of others, not of the inventors: of people who publish books, not of those who write them: of the middleman who corners the distribution of milk, not of the farmer who has the care of the cows which produce it.

There is no artist I hope who is so fatuous and so lost to all self-respect as to desire the sword and knee-breeches of a modern 'knight', and it might be represented as a subtle compliment, that such vulgarities are not even suggested to us. But I hardly think that that interpretation is correct; the less flattering one is the more likely, namely that it never crosses the mind of those concerned that there is anything except buying cheap and selling dear (whether it be soap, milk, oil, toilet-paper or tobacco) that deserves notice.

2. My second illustration is a matter of more specialist observation.—The other day I picked up an English newspaper and occupying half of its available space for the reviewing of books I was confronted with a large photograph of a portrait of Lord Castlereagh—or of Lord Aberdeen or Lord Melbourne, I forget which, but that is all one.

This 'new biography' was 'hailed', in the best flunkey-accent of inflated deference, in a two column puff. The author had no name that I can remember: *he* did not come into it of course. It was Lord Castlereagh—or Lord Aberdeen or Lord Melbourne—that did it. There is no hack who picks Charles II, or Lord John Russell, or Lord Randolph Churchill, or Lord Rosebery—there are plenty to choose from—and does a 'life', who does not receive more space than Tolstoi would with *War and Peace* (which today would be lumped with six other 'novels', and receive ten lines of comment; it might be 'hailed' as a masterpiece, but so would the other five).

We all know what 'great statesmen' really are like today: we hear them on the radio, we see a million close-ups of them. It is impossible for us to preserve our glittering illusions. But we have every reason to infer that dressed in a periwig and with lace ruffles they would be no different, except for an occasional man of parts like Pitt. Yet all dead politicians are 'great', and many living ones too, to the flunkey who sits in the editorial chair. And such 'great statesmen' as Lord Baldwin would in the editorial mind eclipse a hundred Gibbons or Faradays. This vulgarity is extremely symptomatic. And it grows in volume and intensity, the more tenuous the reality upon which it reposes becomes. Such things belong to that *sham-antique* system, in the clutch of whose 'dead hand' we gasp for breath.

Alongside the above significant pieces of mass-observation, place another—concerned likewise with the editorial mind, and the policy of the great newspapers.

Reviews of books—reports of concerts and other musical news—still occupy considerable space in the Press. The Theatre is well reported too. That is because capital-interests of some magnitude are involved.— But the visual arts are in a different category. The art of the dead encroaches daily upon the space that was once devoted to the art of the living.

We have given up the living as hopeless—or rather the capitalist system seems to have said—'How could art coexist with *us*? There *can* be no good living artists, in such a time as *ours*!'

Reports of auctions (with prices fetched) of Old Masters: reports of charity exhibitions (with totals obtained for this or that fund): reports of shows by school children (as Educational news): of painting by post-office workers or candlestick makers (Labour item—or 'human interest'): exhibitions of pictures or sculpture by members of the Royal Family or

by titled persons ('Court and Society' of course)—all these take the
place, more every day, of critical articles about picture-shows by pro-
fessional artists.

I am not suggesting that a sorter at a post-office, or a Duchess, or an
impoverished clubman, is incapable of painting a good picture. All I
am asserting is that the *best* results are obtained by the career of a painter
being open to everybody. And today it is not.

But *professional*—there is a word that today can hardly any longer
be used. All the whole-time artists, or artists *de métier*, are in fact
rentiers. Some are small rentiers, some very large rentiers: but all are
rentiers.*

Practically all picture-exhibitions therefore are in the *amateur* category,
as much as is the annual tennis tournament at Wimbledon. Further-
more, the number of works that sell in them (outside of purchases by
friends or relatives) is negligible.

As to the Royal Academy, ninety per cent of the annual exhibits are
by people of amateur status too—who do not live by their work: they
are the work of retired sea-captains, wives of prosperous surgeons,
society women, 'stinks' masters at Public Schools, bird-fanciers, stock-
brokers. It is a large yearly bazaar of well to do people, who meet and
show each other 'what they have done', with a sprinkling of 'pro-
fessionals' to make it look a real and serious affair.

For many years the Royal Academy has been as extinct economically
as it is artistically. Last year the total of sales was reported in the Press
after it had been open some weeks: the number of exhibitors among
whom this total was distributed, also was mentioned. At the time I
worked it out, basing my arithmetic upon these data: if you had a
picture accepted, it seemed you stood a one-sixteenth chance of selling
it, for a sum averaging £37. Once a year you had a one-sixteenth chance
of making £37! Supposing you were a 'professional' artist, and this
exhibition was the great annual event for you, that would not be a very
rosy prospect, to say the least of it. You would not stand even a one-
sixteenth chance of paying your studio rent. Studio rents in London
start at about £150 per annum; though a good studio at that rent is not
easy to find, most studios being occupied by musicians, bridge-clubs,
dancing academies—scarcely ever by artists: since, as I have just pointed

* There are, outside official or state-subsidized artists, a dozen genuine
artists *de métier* in England at this moment perhaps: John, Spencer, Nash,
Bone, to name four.

out, there are practically no professional painters left, and the amateur paints his picture in the drawing-room or tool-shed.

But if all this is true of the big official picture parade in Piccadilly, it is also true of the little affairs outside, in the highbrow backwaters of the West End. And just how *little* these affairs are the public would be astonished to learn: little not only in the talent displayed—for except for two or three big 'professionals' of talent (big *mercenaries*, as we might call them, like Chirico, Picasso, Dali, or Max Ernst) called in, at a *solde*, to lend weight to the enterprise, the rest are obviously very small fry—but *little* as to the amount of good honest cash that is expended by some excitable little backer, who soon gets tired of even that modest munificence.

When one reflects what is squandered upon some dud theatrical venture, which closes down after ten days run, the outlay involved in launching a painting 'movement' is seen to be negligible. Three or four brand-new 'movements' a year could be floated for what it costs to finance one fairly ambitious West End theatrical flop.

For map out the sort of budget this entails: you are a capitalist (male or female) and are contemplating a 'movement' in the painting line, suppose. The 'cast' is insignificant. There are the two or three big names, of the foreign *mercenaries*. A one-man show of the recent works of one of these is a nice thing to have. But it is an extravagance—you can dispense with it. You do not need to retain the two or three big 'pros'. You merely borrow a few canvases from a Paris dealer. That, I suppose, entails no more than the transport costs.

Distance diminishes the horror that the little ones feel for the big ones: and you would probably hate so much your local 'strong men' that you would sooner have no 'movement' at all than call upon *them* to assist. But there is Mr Paul Nash—he is a really good local man. And he is a good 'mixer'. You would get him in to bulk out the thin amateur broth.

When you have received the canvases of the big stiffs, sent over from the Paris headquarters, you mix them well in with the local junk, and you start off with a bang: with a sizable 'mixed' show. The local half-dozen movementeers (all except Mr Nash, who is a 'pro') have some money—they are not destitute, some may be rich; they are *friends*. Now and then you purchase the smallest of their pictures you can find. You may get off with the purchase of three or four—say fifty pounds the lot. What else is there, outside the rental and fitments, light and heat? Two or

three women (one half-time) and a boy-of-all-work at fifteen bob a week. Stationery expenses next: a box of red tabs to stick on canvases 'sold'. Prospectuses, posters, an inch advert now and then in a big Daily. A few inexpensive frames (modern pictures are *cheap to frame*, thank God).

It is not necessary to work this out to the last drawing-pin. You can see that for nine or twelve months it does not involve a great outlay. You *sell* nothing of course, except one or two canvases of the big 'pros': for no one's fool enough to buy anything else, and scarcely any one ever visits the gallery, except for the opening cocktail-party. But there is really no more economical way of amusing yourself; and for a month or two it must be good fun.—The last few months must drag.

But let us go into the question of the Painting Pro a little more deeply yet. I feel convinced that in that rapidly disappearing figure is to be found the key to any serious inquiry as to the prospects of English painting in the future.

The 'Gentlemen and Players' business would not be so bad if *gentleness* were not synonymous with *cash*, and if money were not the criterion of *fitness to paint*. If none but members of the family of the Reigning House, or of the territorial nobility, were allowed to paint, or draw, or sculpt, that would simplify matters. Everyone would be able to grasp the issue—everyone would be indignant. The depressed 'pro' could compose a letter of protest to the newspapers, with certain chances of redress.

But *money* and its privileges are so much more ticklish things to cope with than 'Norman blood'. There, you are treading upon consecrated ground. And just as it is natural that the fair offspring of a commission agent, or a pawnbroker, with a nice overhand service and a flair for attractive tennis-panties, should be protected against the unfair competition of the 'pro' (some brawny minx in an ill-cut canvas skirt) so it is exceedingly difficult to make people understand why the son of a railway porter or of a miner, should have the same facilities for painting a picture (*surely* an occupation more appropriate to the son of a prosperous cotton-spinner or chain-store executive) as his betters. In an Anglo-Saxon country it is uphill work explaining. Napoleon did not call us a nation of shopkeepers for nothing.

Things have gone so far that this discussion is perhaps academic. When the *Apes of God* was written, yes; there was still time for the public to act. But with a war twice the size of the last one hanging over our

heads, I doubt if a pulse can be stirred, upon such an issue as an *art*. But one never knows.

English 'pros' in painting are exceedingly scarce, as I have said. (I am not counting pavement-artists.) They are almost as rare as the hansom-cab, or the Mauritius penny-red '47.

A certain number of men technically of amateur status are in fact 'pros'—that is to say they enjoy the privileges of the 'amateur', and dispute his miserable pickings with the 'pro'. But in England it is a pitiable thing to be a pure 'pro', in painting as much as in cricket or tennis. I did not *start* as a 'pro'. I went to the Eton of art-schools, the Slade. I had a good 'allowance', as it was called in the pre-war, which enabled me afterwards to continue my studies in Holland, France, Germany and Spain. I began in the amateur class, or I should not be as well off even as I am, now that I have dropped into the pro-letariat.

No one in Great Britain, starting from scratch, stands the proverbial Chinaman's chance.—'What porridge had John Keats ?' But you know what happened to *him*—'snuffed out by an article', telling him to get out of the poetry-racket and go back to his job behind the counter of the chemist's shop.

Ninety-seven per cent of picture-painting in England today (by painters who have no means) is an affair of charity. It is a not very munificent reward for social services. The *picture* never comes into it. People may even forget, when they have 'bought' it, to hang it up on the wall—especially as they probably dislike it.

If I may be forgiven such an extreme lapse into the vulgar and the personal, I should say that I am one of the half-dozen painters in England whose pictures are bought not because the people who purchase them like *me*, but because they have a fancy for the picture.

That is not so conceited as it sounds, for it might be better for me if they liked me a little more and my pictures a little less. People are prepared to pay more for a disarming personality than they are for a rather alarming picture. I do not blame them at all. They have come to look upon pictures as a fly does upon a fly-paper—nasty sticky things where you are lucky if you get away with the loss of a couple of tenners—not nice things that you are lucky to possess for so little as a thousand odd, as in Whistler's day.

My main handicap as a 'pro' in England has been that I am in the heavyweight class. That has been my main difficulty. Being a great big

heavyweight stresses the *professionalism*, you see. It makes it much more uncomfortable for the 'pro' concerned. Even now I am always afraid that I shall be accused of *bullying* whenever I paint a canvas over 30″ × 20″. And indeed at the time of one of my exhibitions I *was* denounced as a bully, because, it was said, I was not being 'fair' to the flyweight who was holding an exhibition in the next room.

Heavyweight is not my word. In an interesting article the other day Mr Newton very sensibly suggested this classification of painters, into heavyweights, featherweights, and so on. He adjured people not to expect from the heavyweight what was only to be had from the flyweight —I beg your pardon, it was the other way round, but only because it was one of the more thoughtful of our critics. And ah how often I have wished that some such principle could inform the responses of the public —who of course in England look upon a heavyweight as in some way not quite nice—just as heavy-hitting by a professional cricketer is really scarcely 'cricket'—and for whom *all* power is slightly obscene.

Though I am able to be personal about myself, no one may be explicit about other people (unless they are too poor to hit back). I should otherwise be able to supply you with statistics showing that what I have been saying is in the main an understatement. Things are *worse* than I have said—more silly than I have said; more so than it would be possible to convey in words. I have been white-washing things, for fear of depressing you too much.

There are painters, with 'European reputations', who depend for their livelihood upon the bounty and goodwill of one or two *richissime* collectors, who like what those big 'pros' do for some semi-porno-graphic, or pathologic, reason—nothing, at all events, to do with *la belle peinture*. They like having frescoes of half-dissected male torsos in their bathrooms, perhaps: or a pictorial *frisson* or two upon the walls of the room in which they eat. It is much the same story as that of Lawrence, for instance, who never had more than a modest sale for his books until he wrote *Lady Chatterley's Lover*.

Such, at all events, is the state of affairs in our great profession— where the private collector has practically disappeared (only the freak collector is left, or the rich and jealous amateur) and state-patronage is not yet born—except for such an institution as the Chantrey Bequest, which is the preserve of the Royal Academy.

A student when he leaves the Royal College of Art—the largest art-school in England, or I daresay in the world—has not one chance in

ten thousand, if that, of becoming a painter. He becomes either (1) an art master, or (2) a commercial-artist—entering a sort of factory, where he works at a small salary, and becomes a slave to the requirements of the advertiser. Anyone who does not do that is a *rentier*. Such are the plain facts of the case: and an extremist 'art-critic' like Mr Herbert Read is acquiring an agreeable reputation by writing about something that does not exist, except for a handful of monied dilettantes, amusing themselves by being childish in public.

IV

I will have seemed to have been saying, to some readers, perhaps, that the art of painting is at an end, that those who write about that art as 'critics' are amusing themselves at the public expense, and that hence this book of mine is a cynical evolution in the void, performed by an out-of-work abstractist, designed apparently to annoy a handful of wealthy nobodies, and to fill up an idle hour.

Things are not quite so bad as that. Nor did I intend to convey that impression—though I see that I may have done so, in glancing over what I have just written. This impression I will endeavour to dispel.

It used to be said of Austria—before its absorption by Germany—that things were *always desperate* there, but *never serious*. It is the same with us, in the painting-racket. The art of painting is bankrupt but beautiful; moribund but high-spirited: artists, though they paint less and less, as the price of gas and electricity goes up, and the price of frozen meat climbs, run into debt to a society that hates pictures, and they settle their debts with images everyone agrees are worthless. Pictures are like dud cheques, but dud cheques that have attained a kind of disreputable currency of their own. Drawn for a thousand pounds, they change hands at one or two per cent of their ostensible value.

Austria, however, could provide us with a yet more striking parallel. For what could be more like the present status of the Fine Arts than the great capital city of the Hapsburg Empire, Vienna, become the metropolis of a German province of seven million people; all the splendid palaces, theatres, museums, hotels still there, but nothing now but a head without a body? How strikingly that recalls the present condition of the Fine Arts—the visual arts, in a world that has ceased to use its eyes, and so the 'visual' ceases to concern it.

No, I never said that painting had quite ended—though I agree that

L

I said that it might. Unless something is done to preserve it, and to keep alive the few artists who are able to do it—life may flicker out. Our grandchildren may lisp: 'What *were* artists mama? Why aren't there any now?'

I did say, certainly, that it could not survive as a mere sport of the rich, like tennis or like ski-ing, nor can it. I said that since it is no longer possible to proceed to any far-reaching experimental reforms except in a hole and corner way, it would be better frankly to go back to the natural function of painting, and, in a word, *imitate*.

Imitation is its Aristotelean definition. Hogarth's *Shrimp Girl*, or Goya's *Maja Desnuda*, are quite respectable acts of creation. By way of imitation, they create. They are good enough things to do. So get in the Shrimp Girl, say I, or disrobe the lovely 'maja', and proceed to create by way of imitation.

If I favour this return to nature, it is because I am a painter, not a critic, impresario, or politician. I do not repine at finding myself amongst such relatively orthodox images. And I am persuaded that that is the road to take—the only road open to the painter today—if painting is to be salvaged. It has been scuttled by the clowns of 'super-realism'— which was a sort of revenge of the second-rate. In order to come back, it must become popular.

The painter has a long score to settle with those journalist parasites who have exploited his *métier* for their own anti-artist ends.

To paint a shrimp girl as Hogarth did is at the least good painting. What is *bad* is to pretend; is to make-believe that you are creating new forms when you are only dishing up old ones, but disguising them in surface novelties. These novelties are not even formal or technical novelties, but *frissons* imported from the clinic of the psychologist.

The *surréel* is work done for a few dozen people at the outside. The smaller the theatre becomes, the more fuggy and subjective the work.

What has been really deadly for painting has been what was first 'Dada', and then all that irresponsible journalism of the 'super-real' that came out of Dada. As painting slumped, that fungus waxed and flourished.

I am ready to believe that such things take in Mr Read. (One of the few illusions I have left is a belief in the sincerity of Mr Read.) But all that *bad* advertisement—it was so obviously the kind of advertisement that painting did not want—that was the *coup de grâce*, to any but the possessor of a substantial pocketbook.

Dispassionately considered, things must have worked out that way, seeing that the public, especially here in England, are distrustful of art in any case. These exhibitions where the public paid its bob or its five francs to go and sneer or laugh was the point at which the goose that lays the golden eggs finally stopped doing so.

Potatoes, their earthen buttocks rouged, their 'eyes' pencilled with mascara, joined to each other with umbilical cords of crimsoned flex: a bisected topper, with a fringe of pubic hair gushing upon its inner rim, standing upon a sawed-off water-main: a few large pebbles under a glass clock-case; these never very funny mock-exhibits were the un-doing of the artist. No pictures *could* sell after a year or two of that, at least nothing off the beaten track.

This was the excuse that the British public, at all events, had been waiting for—to take *nothing* seriously, of all this 'modern stuff'. It compromised for ever all serious invention—except for a few best-sellers like Braque.

Such freak exhibitions may be excellent nihilist politics—or they may be excellent fun for some small capitalist who is prepared to rent a gallery. They might even have a freakish educational value, for a class of children. But, as things were, they made it impossible for anyone there-after to dispose of a picture that was not blamelessly orthodox. The un-orthodox became associated fatally in the public mind with the clownish. It was felt that the 'modern artist' had admitted that what he did was a practical joke. For everyone mistook this for the work of artists: there was no one to tell the public that it was only a 'rag' organized by a band of political journalists.

I am anxious to make my position quite clear. The super-real was not an outbreak of high spirits. (Mr Breton has announced in fact that *suicide* is the logical outcome of his theories, though it is a pity that his suicide did not *precede* these self-exhibitions, rather than the other way round): nor was it anything really to do with painting, and no good painters participated, until Dali stepped into the breach.

A dozen people, Paris 'intellectuals', who earned a comfortable living as civil servants in ministries, or in advertising offices (which is what the 'Dadaists' were) spent their spare time in concocting politico-aesthetic manifestos and promoting exhibitions of 'more-than-real objects'.

For twenty years or more before this the patience of the public had been sorely tried. It did not know that a new age had made its appear-ance—it thought, as it always does, that it was still living in the age of

the French Impressionists. Van Gogh had been more than it could stomach; and Picasso had strained its credulity to the breaking point.— Then had come the War: a gigantic pause, when it got something it really *did* understand—shrapnel and poison gas. And, as I have indicated at the beginning of this essay, that wrote *finis* to any hope—for I daresay a century—of attending to the art-needs of the new-born epoch. Such dreams had definitely to be laid aside.

It was *then* that Dada got busy. The raree-shows labelled 'super-real' (in which the public were solemnly shown a lot of uproariously assorted junk) the final effort of Dada, was like an answer to their prayer to be quit of all this 'modern' nonsense. As if the poor public had not enough to worry about as it was!

They had at last become convinced that all along—and by *everybody*, who had ever 'cubed' or 'vorticised'—they were having their legs pulled. Here was the proof at last. The result was that people stopped buying pictures altogether, or bothering about 'art' at all.

As things peter out on the Continent, they come over here on tour: that is the rule. And during the last few years this intellectual circus has moved to London. In Mr Read it has had an ideal spokesman. Without wishing to say anything unkind, Mr Read is such a *solemn-looking* fellow that he was ideally suited, even physically, to preside at this macabre harlequinade. The public only had to look at the sad and earnest mien of the lugubrious promoter, to appreciate still more the pictorial jokes so decorously chaperoned by him.

It might be supposed that the 'academic' artist would have benefited by this final break between the public and the 'advanced' school of painting. That has not however been the case.

The Royal Academy, as I have said, or rather its small professional personnel, only just keeps its head above water. There can be no change in that, and the reason is obvious, to anyone at all acquainted with the market for those utterly discredited commercial wares.

The provincial galleries are plastered with Royal Academy pictures, acquired during the last seventy years, upon which millions of pounds were expended. When these pictures come into a sale-room, or pictures by the same hand, they are knocked down for less than the price of the frame.

If you were a hard-headed city elder what would your attitude be to the purchase of fresh oil paintings? When the curator of the municipal gallery approached you and suggested the purchase of a picture from

the walls of Burlington House, you would gaze round the walls at the array of proved duds that you and your predecessors had acquired. You would undoubtedly shake your head. Why throw good money after bad? —If, on the other hand, the curator was an ambitious man, and had the temerity to suggest the purchase of an 'ultra-modern' canvas, you would burst out laughing.

What often happens in the latter case, however, is that the reaction of the city worthy is not so jovial, we are told. Instead of giving way to uncontrollable laughter, he squints suspiciously at the young and ambitious curator, and gives it as his opinion, at the next committee meeting he attends, that they have a 'bolshie' in their midst. Should the tactless young curator persist in his solicitations, in favour of the new and untried, he is liable to lose his job. Should he have a wife and family, this may be a very serious matter for him. As a result, few modern pictures—of an 'extremist', or even semi-extremist, variety—are bought for provincial museums.

One great provincial city is reputed to have a sum, which has attained the proportions of thirteen thousand pounds, lying idle. It represents bequest funds for the purchase of contemporary English pictures. For some years it has been untouched. The city elders just cannot make up their minds what to buy. Wherever they look, they see nothing but pictures that, by all sale-room precedent, are not worth the canvas they are painted on. The years pass, and the sceptical burghers refuse to allow the money to be squandered upon productions experience has taught them to be worthless.

When yearly the local magnate comes to peruse the notices which appear in the great London newspapers of the Royal Academy Exhibition, there is not much comfort there. That pillar of respectability, *The Times*, whose politeness would have in any case to be heavily discounted, is not even *polite*.

But that is the provinces: in London things are different, you might surmise. The answer there can be short and to the point. There is one gallery in London that buys and exhibits contemporary pictures, namely the Tate Gallery. And the Tate has five hundred pounds annually to spend for the purchase of pictures and sculpture. That for an Empire on which the sun never sets is not a great deal. Tens of thousands of pounds can be spent upon an 'old master'. But, all told, there is five hundred pounds allocated annually for the support of the art of the living—for pictures, sculpture, and design.

I have said enough, I think, to explain the causes of the rot, which cannot be altogether accounted for by the impoverishment of our society, the suspension of all normal political progress, and the uncertain outlook caused by crisis and by artificial want. That accounts for the absence of that *surplus* of vigour and well-being which would make artistic initiative possible all along the line (we cannot help to build a new world, or anything of that sort, in conditions of such impermanence). But it does not account for the complete severance of all relations between public and artist, and the extinction of all interest in the visual arts, even among educated men and women.

There is only one solution that I can see. I have indicated it already. The more influential artists (the R.A.'s do not count—I do not mean them) must repudiate the journalist, and the self-advertising clown, and return, even noisily, to nature, if so inclined, to romantic nature, without looking back—at once. Otherwise a handful of artists—we are only a handful—will remain in penniless impotence, while—with deep sincerity—Mr Read and others write book after book about what is being done in this wonderful new world that is not there.

It would be a much less exciting world for the theorist; and there would be much less advertisement to be got out of it for the various eccentric parasites who batten upon the past prestige of the visual arts. But it would be better for us who want to paint pictures.

As it is, the situation is replete with absurdity. It is like a quite empty luxury hotel, occupied by a skeleton staff, in which an elaborate Menu was most ingeniously drawn up every evening (by a professor of cooking) for guests that were not there. A cocktail party in the lounge every now and then would scarcely justify its continued existence.—That such a fantastic establishment should be liquidated without delay is obvious.

V

England is a country with a fine tradition of its own in painting. We are better painters than the Germans, for instance: we have a lighter touch. And as one would expect, a number of men and women of talent, born under the Union Jack, are living today, and are as able and ready to paint a good picture as they are to wield a bayonet (or deftly insert a swab) should Britain require it of them.

A few of these able-bodied painters of marked talent succeed in painting pictures somehow or other—do not ask me how. And once

whoever-it-is manages to get a picture painted, by hook or by crook, there are always plenty of dealers willing to hang it up on their walls, since, as I have remarked, it helps to sell their Old Masters and French Impressionists for large sums of money.

If you visit the Galleries, as of course you should, you will be able to verify this statement. These contemporary pictures (as you will see, if you will repress all antiquarian snobbery) are just as well worth buying, some of them, as the pictures of the dead. Lack of talent is not our difficulty.

Such painting as there is—such as is able, by means of subsidies or charities, to lift its head above the level of the deadly flood that has submerged most intelligent activities—displays one of three main tendencies, which I will briefly describe.

First, there is what is left of the old revolutionary art of 'abstract', or semi-abstract, experiment. A sculptor, Mr Moore, is the most notable of these stalwarts. His latest Arp-like families of stones with big holes in them are excellent.

There are two painters (pros) Mr Sutherland and Mr Nicholson. The former starts with a romantic Scottish mountain landscape, which he ingeniously transforms into something like a still-life of Braque. When you consider the great difference between a mountain and a mandolin this is, in itself, no mean feat.

The second and third classes of artist are of a *back-to-nature* sort. And the two wings of the *back-to-nature* front converge upon the small island of abstractists (of say three pros, and three half-pros). The left wing is labelled *surrealist*. Let me deal with that first. It is not unmanageably large, and not so difficult to handle.

Super-realism (or surrealism) has crossed the Channel at last, thank God. It is in effect a sly return to old forms of painting, and not the most desirable at that. That is why I have put it under the heading back-to-nature. It can be described as sly, because it slips back to the plane of the *trompe l'œil* clothed in a highly sensational subject-matter. The subconscious is ransacked to provide the super-realist with an alibi to paint like a Pompier.

What is meant by *subject-matter* (if you happen to require this information) is as follows. Supposing that Frith had painted pictures of crowds of nude men and women, in a green light, with gold-hunters instead of eyes, and serpents instead of hair; with strips of flesh hanging loose here and there, exposing the muscles and blood-vessels; the

painting would have been in all respects the same—neither better nor worse than his *Derby Day*—but the subject, being so extremely different, and so very sensational, it would have looked quite a different picture. Only painters would not have been taken in.

Superrealism is like that. Meissonier and Böcklin are the avowed masters of Dali: and Magritte (the next-best-known painter of that school) follows Dali very closely, with less skill however, or regard for workmanship.

The English professional representatives of that school are two in number—I said it was not an over-populated school: Mr Paul Nash and Mr Armstrong.

Both are adherents of two years' standing, one having come to it out of Cotman ('abstracted' into a tube-poster), the other out of the temples of the Pharaohs. These two painters have not the power of their Catalan master, whom they follow very closely, but both are excellent artists.

That two swallows do not make a summer it is unnecessary to stress. But they have a very active mouthpiece in Mr Read: and if anybody could make a summer out of a couple of swallows—or bricks without straw—that man is Mr Read.

Now I come to the third category, and it includes all the other good painters in England, from Mr Matthew Smith (a half-pro, I believe) to Mr Pitchforth (an art-master, I am informed). This is the class of my predilection; I have explained why.

Here (in however frenchified a form, as often occurs) we are back with nature again. As it is the little touch of nature that will make artist and public kin once more, it is that that I support. There are probably a dozen good pros (or half-pros) doing this. A hundred pure amateurs (or as good as) really make things look as if the art of painting were in full swing, once you reach these naturalist levels.

I need not go through these dozen painters, one by one: and among them are one or two who belong to that tiny band of artists, to be counted upon the fingers of one hand almost, whose pictures are bought not as a favour, or out of charity, or for old-school-tie motives, but because people who are complete strangers to the artists who do them like them and desire to acquire them. Mr Stanley Spencer, a naturalist with a strongly Flemish fancy, is one of these.

Although I do not need to dwell upon the work of these painters individually, I should like to make a few general remarks. There appear to me to be two prerequisites to the rescue of painting from its present

tragic eclipse. The first is the unconditional surrender, in face of *force-majeure*, of the minuscule colony of 'abstractists': also the discovery of some effective deterrent, to prevent Mr Read from falling in love with a new 'movement' every six months, and entirely to no purpose (except to satisfy the vanity of half a dozen people out of forty million) and so disturbing the extremely jumpy, convalescent, British public—which has to be nursed back to health with every possible precaution.

That is the first thing—and you may object that it is unheroic and un-British. But those I am sure are the only terms upon which painting can be started up again, as anything but a sport of the rich, or decoy-duck for the sale of Old Masters. Faced with the alternative of *no painting* or the *Shrimp Girl* of Hogarth (to use her again) there is no painter who would not plump for the latter. And there are some who would be glad today if they had never left her, to run after geometrical will-o'-the-wisps.

The second prerequisite is something *positive* in the manner of this 'return-to-nature'. It must not have the look of a jaded return to an exhausted goldmine. It must have the air of a new gold-rush, or nothing. I will however explain myself.

Compare, if you like, the problem in question to an analogous one in politics. When a politician has to 'ginger up the Democracies', the difficulty he encounters is the absence of a rallying-cry. He is at a dis-advantage compared with the professional agitator, of either Left or Right. 'Democracy', with which we are all so familiar, has no kick left as a watchword, or not enough to inflame the imagination to the requisite degree.

As an artist, I should be sorry to regard this as more than a super-ficial parallel. Nevertheless, our palate has been demoralized with strong sauces: and 'nature' *tout court* is a little wanting in publicity-value.

If the painter is to return to nature, he should perhaps pause to reflect before taking his plunge, how diabolically interesting nature *is*. He should acquire an understanding of how unnecessary it is to strip off a man's skin, or to give him three eyes, or arms, instead of two, to make him an object of amazing interest. Even, it is a poverty of imagination that prompts anybody to require that of the artist.

Having thoroughly prepared himself by this moment of rapt contem-plation, he can then precipitate himself upon this mystery we call 'nature' (as if it were quite *natural* that 'nature' should be what she is) with some prospects of taking the public with him.

L 2

All I would say of what has happened so far in the return-to-nature movement of some painters, is that they have not gone *directly* enough, and so have missed an opportunity. When I said I advocated a return to nature, I meant *really* to nature—not to Degas, to Tissot, to Delacroix, or to Meissonier. That is a very different thing, and not so likely to awaken the interest of an intelligent public.

That anyone with nature there *should* want to go back to Degas might require explaining, even. The *Cavalcade* spirit that has possessed itself of England is however the sufficient answer. To go back to a former *mode* of life and its expression, rather than to life itself, is typical of this exhausted time. Even nature has to be approached historically, and at second-hand.

VI

That I never deserted the concrete for the abstract—that I not only continued my interrogation of nature, but based my geometries upon that—I have already pointed out. And for the plates to accompany the text of this book I have gone to work in which I am seen deep in the imitation of nature, rather than exploring those independent abstractions that suggest themselves, as a result of any observation of nature that is at all profound.

Today I am a *super-naturalist*—so I might call myself: and I wished the reader of these *Notes and Vortices* to see what could be done by burying Euclid deep in the living flesh—that of Mr Eliot or of Mr Pound—rather than, at this time of day, displaying the astral geometries of those gentlemen. I am, as an examination of the plates will reveal, never unconscious of those underlying conceptual truths that are inherent in all appearances. But I leave them now where I find them, instead of isolating them in conceptual arabesques.

Much modernist painting unquestionably is the work of inferior artists, who were unable to do the 'straight' stuff, and disguised their limitations in a pretentious technical mumbo-jumbo. Of course *all* painters who ever experimented have been accused by their academic opponents of belonging to that class.

One always has to ask oneself, in looking at a picture in which imitation is abandoned, and elaborate distortions, for whatever reason, are indulged in, whether the painter in question is merely being evasive and mysterious because he would cut a poor figure if he challenged nature

more openly—setting his forms and colours against hers, so that they could be readily checked by any trained eye. In a subtler way, even with a persistent *landscapist*, it is legitimate to enquire what sort of a job he would make of it if he matched himself against one of the great figure painters—a Bellini, or even a Cézanne. This is a relevant question, I think, even in the presence of such landscapes as those of Turner, or of Claude. The appropriate answer would tell you something about Turner, or about Claude, that you would otherwise have missed. In the last analysis, who would paint a tree when he could paint a man?

I hope, however, that by my selection of the pictures in this book, I shall have proved that these charges brought against the revolutionary artist are not always well-founded.

I have used the expression 'super-naturalist', and like all such expressions, it has as much or as little meaning as you like to put into it. People are fond of tags. If I was looking for one for myself, that would be as good as any.

The super-realist (or *surrealist*) is, as I have pointed out, a naturalist pure and simple. He will copy an object in a slovenly or photographic fashion: it is essential to him that the object should be as *real* as possible, in the sense of a camera-study in a newspaper. And the stupider and more matter-of-fact the pictorial statement the better.

It is of the first importance to him, even, that nature should not be altered, or 'interpreted', in any way. That is of course why Meissonier or Frith are regarded as better models by the super-realist than Velasquez or Renoir. There would be much too much beastly *art* about an object as seen by either of the latter. It is not 'nature seen through a temperament', but *nature* plain and unvarnished that is required. *For it is not an aesthetic emotion but a real emotion—like that experienced in the presence of a street-accident—that is required.*

Such, at least, is the *surrealist* ideal. Matter-of-fact nature—really, the photograph. Even real watches are stuck on to the pictures by Dali, lest his painted version of them should not be *real* enough. All the interest is in the queerness of the reality chosen; or in the odd juxtapositions of objects, or wholesale suppression of same. It is a psychological, rather than a pictorial, interest that is at work.

The *super-naturalist* would be aiming—in my case is aiming—at the opposite to the *super-realist*. The emphasis would be upon *nature*, not upon *the real*. With the super-naturalist it is from within nature that the change is effected, not from without. The 'real', in the photographic

sense, would never make its appearance at all. Art, as he understands it, involves a banishing of that kind of reality. The spectator is offered sensations, as if on the switchback at a fair, among the scenes of nature, by the super-realist. The sensations provided for him by the super-naturalist would be of a quite different order. Nature would be *pre-digested* for him. He would not be required to participate in any way in the real. Super-nature is not super-real. It is nature transformed by all her latent geometries into something outside 'the real'—outside the temporal order—altogether.

Most artists are agreed that Salvator Dali is an admirable painter. With that judgment I am in accord. But if I were asked what I thought about super-realists, or *surrealists*, in general, I should be inclined to say that super-realism, as a method, served to disguise dullness, and bad painting, as much as ever Cubism did.

That should not be the case: for the naturalism which is the basis of super-realism ought to betray at once the dullard hiding his dullness or the incompetent concealing his lack of skill. But for my part I have found it quite possible to be momentarily deceived. That was not perhaps so much a lack of acuteness on my part, as a readiness to pass a pleasurable moment at this pictorial Maskelyne and Devant.

I have often found in going into a gallery, where there were surrealist pictures, that I have greatly enjoyed some jumbled scene, invented according to a surrealist receipt, with its witty incongruities and pictorial euphuisms. But once I have got used to it—as used to it as I am to Piccadilly Circus, which takes about five minutes—and the novelty has worn off, I am then left face to face with something that I find tawdry and second-rate. I feel a little humiliated that I should have been taken in. How easy I am to please—I say to myself—if all you have to do is to place an ill-painted iron-bedstead on top of an ill-painted alpine peak, amid obvious snow-white snow, to secure my approval!

Another experience of mine that is perhaps worth recording is that when some painter whose work I have not greatly enjoyed, but found a little crude and hard, suddenly goes 'super-realist', I find I like him better. The more confused, the more haywire he becomes, the more able am I to enjoy what he does. On such occasions as these it is my habit to ask myself whether what I see is *really* better, or if it only seems so to me.

It is plausible to suppose that, released from the hard necessity of impressing the onlooker by his mastery of natural form, a not very first-

rate painter should actually produce something of more intrinsic significance. Then, just as the onlooker likes novelty, so does the artist. The combined stimulation (1) of not having to worry about *facts*, and of (2) being amused by the topsy-turvydom indulged in, may result in a picture intrinsically better than otherwise he could do.

But, of course, just as the onlooker very rapidly grows used to some ingenious incongruity, and experiences a deception when able to examine soberly the stuff of which this trick-effect was made, so the painter himself cannot be amused for long over what was at first a pleasurable surprise.

He knows, far better than we do, the value, taken in isolation, of these ill-assorted objects. They are, after all, the same old units of the same old stock-in-trade, painted—in detail—in the same old way. He understands the advantage obtained by the jettisoning of logic, of sequence, of àpropos. He cannot take in *himself* for long. Consequently we can discount very largely, I think, the stimulation administered to the artist by the mere jumbling, reversing, and telescoping of the eternal world of sense.

It is quite a different matter where, by the methods of elimination, or of simplification, the objects of nature are themselves transformed into something like themselves, yet differing, in reality, as much as chalk from cheese. This was the great achievement of the art of the Orient, especially the Chinese. And the movement of which Vorticism was a part was, as understood by me, a first step towards a reform in the European vision. It was a discipline preliminary to a complete abandonment of the naturalism we inherit from the Greeks.

That discipline *I* have undergone. The *Notes and Vortices* you are about to read are a record of that experience. The few examples of the *super-natural* (I regret that it has not been possible to include many more) which you will find reproduced in this book, will help to demonstrate the purpose of those disciplines.

THE SKELETON IN THE CUPBOARD SPEAKS

A

'He blasts best who blasts last' refuted

These *Notes and Vortices* are reprinted from *Blast No. 1* and *Blast No. 2*, which appeared in 1914 and 1915 respectively; and from *The Tyro No 2* which appeared in 1924.

The readers of a book in great part so technical as this will be artists, or people concerned with the fine arts; so I do not have to go into the circumstances that gave rise to *Blast*; though why such a storm broke when it did in Great Britain (rather than ten, fifteen, or twenty years later which is the more usual procedure) I will make plain.

The following pamphlets, articles, and manifestos were written, of course, in defence of the experiments in painting in which the 'vorticist group' were engaged. The 'vorticist group' were a band of young painters led by myself, and established in 1914, to make England a land safe for a pictorial hero to live in. It did not succeed—as was sufficiently indicated in *Super-nature versus Super-real*. England continues to be a place highly unsafe for a pictorial hero to live in.

You have only to reflect what an immense weight of opposition is, in Great Britain, at once mobilized against any innovation, to see how necessary such a defensive verbal barrage must be.

Almost, I have become a professional writer in the process of defending my paintings. Mr Shaw's 'Prefaces' tell the same story; Whistler's admirable pamphleteering was a phenomenon of the same kind.

'Vorticism' was, in 1914, decidedly over the odds. Nothing had prepared the British public for such unadulterated extremism: Mr Fry, with 'Post Impressionism', had taken its breath away a few years earlier, and left it—not disagreeably—gasping: but 'Vorticism' was beyond a joke. It was in the nature of a foul blow, and a deep note of indignation was sounded, among the usual cat-calls, in the daily and weekly press.

Inevitably the painter indulging in such practices was obliged to spend at least half his time scribbling manifestos, or otherwise supplying explanations for every line he drew, or brush-stroke he delivered. This wasted a great deal of valuable time.

The 'vorticists' enjoyed a life of a year or two, no more. They were

snuffed out by the Great War. Some were wiped out by it in every sense.

The War came a few months after the publication of *Blast No. 1*. I, who had been the principal exponent of 'vorticism', attempted to keep the vorticist flag flying for a short while, then became a soldier: Gaudier Brzeska was killed in action within 6 months of the outbreak of war— that was a very great loss to the art of sculpture; Hulme, the philosopher-journalist of 'abstraction' in 1914, was killed in action in 1917, only a few hundred yards away from my own gun—his battery was within sight of ours, a few hundred yards to the right, in the soggy coastal plain behind Nieuport in Flanders. The sergeant of my gun was killed and most of my gun-crew made casualties, during the same prolonged bombardment, which was the German answer to our preparations to attack.

Among these Notes you will find the following passage: 'if out of the campaign in Flanders any material, like the spears in Uccello's *Battle* in the National Gallery, force themselves upon the artist's imagination, he will use it. The huge German siege guns, for instance, are a stimulus to vision of power.' Great guns are just as magnificent as are unwieldy spears of armoured cavaliers. The guns were at all events my choice. I was not associated myself with a more imposing object than a six-inch howitzer; but I made what I could out of that. (My picture of a battery in action is in the Ottawa war-museum.) Gaudier carved out of the butt of a German rifle a vorticist image.—We all of us went over into the War, and lost our 'Vortex' in it. When we came back into art out of life—desperate life—again, we had no appetite for art-politics. At least I had not.

I had tried the 'group' game, in the art-racket: I had found it more trouble than it was worth. And in *The Caliph's Design*, which comes after these *Notes and Vortices*, it was not as part of a rather bogus battalion, but as *a single spy*, that I was speaking.

It is always said that London follows the Continent, and especially Paris, after an interval of a decade or two. The 'Nineties' movement in England, for instance, was the Seventies in Paris, reproduced upon our miniature island stage, in a romantic and self-conscious form. Verlaine was an Oscar Wilde—was advertising the particular vice—even went to jail, and recorded the fact in tragic verse—long before late-victorian England was electrified by the Queensberry trial, or before the *Ballad of Reading Gaol* saw the light, and touched with romance the English Prison System.

Really all that happened in England in 1914 (the pictorial disturbance of which *Blast* was the organ and rallying point) ought not to have happened then. It ought, by all the rules, to have happened about 1920 or 1930. And of course, it *is* really happening now—in due course and at its appointed time—just as if 1914 had never been at all. The great *massif* of the War barring off 1914 from 1918, makes this much easier, of course.

For a thing to have happened in England *at the same time* as in France was unheard of. And some of the participants in those irregular events felt that they were being a little hustled. At the time, I think I may add, several of my artist-companions—although, being young, eager enough to be up and doing—were a shade resentful. They were not entirely unconscious of the fact that they were being asked to do a thing *twenty years before it was supposed to be done*. Even, they were relentlessly invited to do a *new* thing—not merely imitate Picasso and the other chief exponents of Cézanne revolution: invited to attempt something *untried*, if you please—instead of, after a suitable decade or two, proceeding to an effortless mimicry in retrospect.

All this complicated matters a little bit for me (for I was the prime mover: I was the person—I say it without any vain-glory—who was solely responsible). Certainly since that time it has resulted in my assuming a little the position of a skeleton in the cupboard—a cupboard that, needless to say, had to remain *locked*.

I have, however, been extremely accommodating, I will say that for myself. Up there in my cupboard, I have kept remarkably quiet: I have been content to forget, and have never objected to other people conveniently forgetting, that there once upon a time was a big pink *Blast* that coloured the London sky: and now that I am beginning to throw myself about a little bit, I do so in as correct a way as my confined position allows.

That I had to expect a certain amount of odium to attach to me because of this tactless speeding-up of the British Workman was obvious: this or that painter persuaded by me to ignore the regulation British time-lag, would have much preferred to wait until 1924 or 1934 to do what I persuaded him to undertake in 1914. But how much more tiresome was it not for my old friend Mr Read the critic, who would far rather have had nothing happen in 1914, so that when, by 1930 or thereabouts 'abstraction' was ripe for discovery upon these shores, he could have

weighed in without all these echoes of premature bombardment in his rear. 'Abstraction' *should* not have been practised here—and above all, been *written about*—fifteen years before its time. Ignore it as you might, this fact has been a skeleton at Mr Read's little feast of reason.

Again, had I merely painted, instead of engaging in a verbal 'blast'— or had I been in Paris, instead of returning to London to do it, it would not have mattered: that is of course the point. But to choose London to do it in was not quite playing the game. Certain Gentlemen were doomed thereby to anticlimax. The British timetable had been brutally dislocated. The comfortable belief that *He blasts best who blasts last* had been fatally undermined.

Now that Mr Paul Nash is at last sowing his wild oats, I feel that I may break my long silence. I feel that we *must* be approaching the end of that particular chapter in the history of modern art. It was the spectacle of Mr Nash as a matter of fact that gave me confidence to speak my mind once more, and as it were officially close this epoch.

As far as Mr Read is concerned, there my mind is quite at ease. Once he learns from Paris that there is no young painter left who would be seen dead within a mile of a cube, a holed-stone by Arp, or a demented foetus from the cabinet of Dr Freud,* Mr Read will not allow the grass to grow under his feet, of that I am quite sure. I am perfectly easy in my mind about *him*. He will evolve from one day to the next a gentle salvationist technique to deal with a rather thin and frivolous Chardin, or a rather puerile shadow of Le Nain.

I have a sort of qualm about Mr Moore. He is an artist whose work I relish. He is a genuine hard case—a sufferer from that famous British time-lag. He ought to pack up, and come out of the land of plastic shorthand (a certainly delightful shorthand but to which only a dozen people are privy) and make his peace with Nature. The odds are too great: the Brave New World was a mirage—a snare and a delusion. He could steal back and make a hole in a flat stone from time to time, or rig up a little buttoned rock with trelliswork of taught twine.—It is my hope that he will be so alarmed at the spectacle of Mr Paul Nash sowing his wild oats that he will pull out one of these days in a sudden panic.

Well, I am sorry it was necessary to go back to the *super-real* and all

* A dealer who had gone prospecting in Paris the other day informed me that in a large collection of 'the under-forties' he could not find a single non-naturalist picture.

that, and to the last rose of the 'abstract' summer, and launch a second minor polemic before getting down to the text of my reprinted articles. But what I wanted to say was that even where remarkable talent is displayed, or minor variations introduced to freshen up the old stew, there is nothing being done in 1939 in England that was not done by us—Gaudier, Mr Wadsworth, and myself—in 1914. That is a fact there is no getting round, I am sorry to say. We see every month or so things announced as 'new' that we have all seen before, many times over: which is merely silly. Considering all the circumstances of the time, these stale 'sensations', staged for an audience that is not there, is in the nature of an obstruction on the line. It holds back the reunion of the Public and the Artist, which is so greatly to be desired, and is so long overdue.

I regret that it is my melancholy task to announce the end of all that, and that it has devolved upon me, of all men, officially to close this bankrupt exhibition, of what are now nothing but freaks—repudiated by the Zeitgeist, let down by the very force that instigated their creation. But there it is.—And is Nature, then, so contemptible? The answer is thundered at us from the roof of the Sistine Chapel: or whispered to us by the feathery pale perfection of the trees in Corot's landscapes.

B

Explanatory Notes regarding Notes and Vortices

That a new effort, both critical and creative, will be demanded of everybody engaged in the back-to-nature movement, is obvious. Nature, you will see me saying in the course of these Notes, of the year 1914, is a convalescent home, a retreat, for those deficient in vigour or intellect. And indeed that is the case, if nature is allowed to do all the work; or if some formula is embraced which enables the artist to pass off photography as creation.

'Nature is just as sterile a tyrant as Tradition', you will hear me say. And so it is. Naturalism can be just as dead as academicism. That is why *super-nature*, as a tag, might serve to remind the new naturalist that nature alone is not enough.

The problem of the artist does not change, and time is only a factor in his problem. The very severe and extreme disciplines that such a movement as Vorticism imposed did not alter the fundamental questions

that had to be asked and answered. And the sort of thing discussed in these *Notes and Vortices*, or in *The Caliph's Design*—for instance (1) the non-identity of life and art; (2) the certain 'deadness' and lack of inventive imagination that is inclined to dog the French School; (3) the place of literary imagination in pictorial art; (4) the role of subject-matter in the art of the painter; (5) how far nationality must influence the painter; (6) what is the value and meaning of 'originality'; (7) whether the Machine Age is incompatible with the visual arts—all these and many more considerations belong to the permanent material of critical investigation. I propose to run over, in advance, all the pieces reprinted here, selecting such passages as I find suggestive for discussion. The reader, if he prefers to do so, may proceed immediately to the text, returning to this commentary afterwards.

It must be remembered, to begin with, that the author of these *Notes and Vortices* is a dual personality. He is (1) a Revolutionary; and (2) a Traditionalist. He is those two things in that order, and not in equal parts. His traditionalism is impregnated with the spirit of his revolutionary alter ego. And so it comes about that *his* mother-nature is a super-natural nature. He cannot paint a dead nature (a *nature-morte*) if he tries: for that would be merely a *pattern*—which is not worth while, as he sees it.

The way in which Vorticism was supposed to differ from all other 'isms' will transpire once you come to the vorticist text. I say *was* 'supposed to', for it had only just been born when it met its untimely end in 1914; and it had scarcely had time to give effect, in canvas after canvas, and carving after carving, to its principles. It was a program, rather than an accomplished fact; but in such works as had begun to spring forth fully armed from the iron brains of a handful of adherents, it showed itself more resolute in its exclusion of the past than the Paris School, less concerned with the glittering jazzed-up spectacle of the megalopolis than the Italians, and much more distinct from architecture than the Dutch (such as Mondrian).

The fundamental injunction, in all the explanatory matter you will be reading, is *to invent*. That was, of course, the pure revolutionary impulse—for only the revolutionary says *invent*. There must be no echo at all of a former age, or of a former manner. Even *all* manner must be dispensed with if it suggest an earlier manner. No manner at all would be better than 'the grand manner': though there was every reason, it was implied, to go out and seek the formidable, and the grand, in the

new subjects made available by the more inhuman Context of the contemporary world.

The Cubists come under fire because they imitated nature—taking the things upon their breakfast tables as a basis for their designs, rather than inventing forms they could not see: however distorted this 'photography' might be, these 'natures mortes' were still treated as *photography* by the vorticist. If, on the other hand, the Cubists departed from what was under their eyes, they went back to the academic foundations of their vision, and reproduced (in however paradoxical a form) an El Greco, a Buonarroti.

The extreme revolutionary position then was taken up prematurely, in Great Britain, in 1914. Everything must be *new*, in the Vortex, from top to bottom. Mr Wyndham Lewis, the vorticist of 1914–15, was a 'sea-green incorruptible'. That is the first thing he understood. He thought the time had come to shatter the visible world to bits, and build it nearer to the heart's desire: and he really was persuaded that this *absolute* transformation was imminent. He was, in fact, a little like the Christians of the first century who believed firmly that the end of the world was at hand.

What in fact happened was, as we know, the 'Great War'. At first this happy vorticist did not in the least understand what was occurring. The War looked to him like an episode at first—rather proving his contentions than otherwise. He did not fully recognize the significance of that disaster until he found himself in the mud of Passchendaele, and dimly discerned that he was present at a great military defeat, and that the community to which he belonged would never be the same again: and that all *surplus* vigour was being bled away and stamped out.

'Vorticism' accepted the machine-world: that is the point to stress. It sought out machine-forms. The pictures of the Vorticists were a sort of *machines*. This, of course, serves to define Vorticism as the opposite of an 'escapist' doctrine. It was cheerfully and dogmatically external.

The philosophy of 'escape' from the sordid and mechanical—which he describes as 'an inevitable tendency of the modern spirit'—Mr Herbert Read has stated as follows:

'The more mechanical the world becomes (not only the visible world, but the actual process of living) the less spiritual satisfaction there is to be found in the appearances of this world. The inner world of the imagination becomes more and more significant, as if to compensate for the brutality and flatness of everyday life.'

In the case of Vorticism—and this is what I wish to stress—the 'inner world of the imagination' was not an asylum from the brutality of mechanical life. On the contrary it identified itself with that brutality, in a stoical embrace, though of course without propagandist fuss.

It did not sentimentalize machines, as did the Italians (the pictorial fascists who preceded the political fascists): it took them as a matter of course: just as we take trees, hills, rivers, coal deposits, oil-wells, rubber-trees, as a matter of course. It was a stoic creed: it was not an *uplift*.

Also Vorticism, unlike its contemporary rivals, was visual, not functional. That is to say, it did not identify the artist with the machine. The artist *observed* the machine, from the outside. But he did not observe the machine *impressionistically*: he did not attempt to represent it in violent movement. For to represent a machine in violent movement is to arrive at a blur, or a kaleidoscope. And a blur was as abhorrent to a vorticist as a vacuum is to nature.

A machine in violent motion ceases to look like a machine. It looks, perhaps, like a rose, or like a sponge. For in violent enough displacement the hardest thing takes on the appearance of the softest. A statue cut out of basalt would become more fluid than flesh, if whirled round sufficiently swiftly. So the very spirit of the machine is lost—the hard, the cold, the mechanical and the static. And it was those attributes for which Vorticism had a particular partiality. You will find, in the course of these notes and essays, the engravings of Mantegna mentioned more than once. In Mantegna you get a mechanical ideal expressed with great beauty and with consummate power. That is why vorticist literature (which is of course mainly my handiwork) returns so often to the name of the great Renaissance engraver.

I do not need you to tell me that all these distinctions between one school and another—schools that now are defunct—may seem otiose. I have enough experience of teaching to understand that. Vorticists, Constructivists, Futurists, Cubists—all are much of a muchness to the outside observer, or even to the artist who is out of sympathy with such heresies.

I have said that Vorticism was 'cheerfully and dogmatically external'. The external world did not appear to Vorticist No. I, at least, as too horrible to contemplate.

To return to that great authority on all things 'abstract', Mr Herbert Read's explanation of modern 'abstractness', of 'geometric art', is that it was and is an *escape*, as I have just remarked.

'Is (our outer world of today) not rather a world from which the sensitive soul, be he painter or poet, will flee to some spiritual refuge, some sense of stability? And is he not likely, in that tendency, to desert the perceptual basis of the empirical art of the immediately preceding epoch, in favour of a fixed conceptual basis?'

To *conceptual* form, in place of *perceptual* form, Vorticism did certainly adhere. But it was not a clinging to a lifebelt, or to a spar, or something satisfactory and solid, in the midst of a raging perceptual flux: or not more than *all* attachment to the conceptual is part of the technique of living, which involves imposing laws upon the perceptual chaos.

I am not sneering at Mr Read's expression 'sensitive soul' if I say that the vorticist made rather a point of being tough, so that he might be in harmony with his material. As you will see when you arrive at *The Caliph's Design*, that 'sensitivity' that was such a striking feature of the aesthete known as 'the Bloomsbury' was greatly deplored at the headquarters of the Great London Vortex; indeed it was incessantly ridiculed by Vorticist No. I—even after he ceased to be a 'vorticist' and became the solitary 'enemy'.

Now this was not entirely a 'tough guy' attitude, either. It was *deliberately* tonic. There were no schoolboy heroics, of the emotional Hemingway order about it. It was just the sternness and severity of mind that is appropriate to the man who does the stuff (in contrast to the amateur who stands rapt in front of it once it is done and stuck up to be looked at); especially when that stuff is a harsh, reverberative, and indeed rather terrible material. It was the actor's attitude to his tragic *décors* and property stilettos: it was, yes, *professional*.

Mr Herbert Read will have it that this century proved so much more repulsive and horrible than the last that in its first decade and a half, artists 'flew' to 'abstraction', away from the sensuous, as if to a *steel*, rather than an ivory, tower. That would not be my way of putting it. The Renaissance in Italy, the age of Vasari, was turbulent, harsh, and to a 'sensitive soul' would have seemed highly disagreeable. But its artists did not 'fly' to geometric expression. And China was a welter of war and famine, when its artists were placidly pot-making and screen-painting, more naturalist, or super-naturalist, every day.

In the next few pages of this essay, Lewis set himself 'to advertise, in advance, a few of the points upon which the central argument of Notes and Vortices turns'. In this book, each of these passages has been placed at the head of the section to which it refers. The following paragraphs are the final ones of 'The Skeleton in the Cupboard Speaks'.

In conclusion I would like, at the risk of appearing a little *nationalist,* to deprecate the artistic ascendancy of Paris in the Anglo-Saxon world. If English painters—and American, too—are to go back to nature, to English nature and American nature, they need bother very little about Paris.

Paris has its function; but it is that of an art-school, nothing more. A *finishing school,* let us call it. I myself am Paris-finished. Rowlandson, the most English of artists, was Paris-trained. Indeed Rowlandson could not have been so superbly English if he had not learnt how to do it in Paris: but he could not have done it at all if he had not forgotten all Frenchiness, and kept his eyes fixed upon the English scene.

All that the French have to teach us is *technical* matters. In receiving at their hands a technical instruction, we should at all times be careful not to absorb along with that a spirit that is not our affair. The Anglo-Saxons cannot dispense with the *technical* instruction, unfortunately; they are defective, like the Germans, in visual sensibility, in any case. They are much better poets than they are painters; and France is the handiest country in which to correct native shortcomings. But the French School has its shortcomings too, of another order.

Paris is a much more delightful city to live in than any in the Germanic or Scandinavian countries: and the political enervation of the Spaniards, their national poverty, made Paris the intellectual metropolis for them as well. What has been called the 'Cézannean revolution' was conducted by immigrant Catalans, Braque being the only outstanding Frenchman in that upheaval.

The limitations of the French genius should not be less carefully noted and weighed than that sensitive accomplishment that has made of Paris the Mecca of the painter. It is not in order to belittle Paris painting, which is fine and sure, if it is shallow too often, that I am writing this, but to reassure all those timid provincials, whether British or American, who suffer from an inferiority-complex regarding 'the latest' from the Rue La Boétie. What is best in Paris is Spanish, Belgian, or Russian:

and *nothing* except technical dexterity and a sensitive approach to the visual world is to be found there that cannot be found elsewhere.

The French School, on the whole, has been at all times, surprisingly *unheroic*. I am the last person to wish to deal in nationalist claptrap: but how can one avoid the conclusion that Chardin, say, is the typical Frenchman, Michelangelo the typical Italian? I have an active distaste for such unsatisfactory counters as 'French' and 'Italian'. But if I open a book of photographs illustrating the art of Italy, and then one illustrating the art of France, compare them I must—just as I am obliged to compare a very tall man standing by the side of one of modest stature.

When I think of Italy, in connection with the art of painting, I think of the terrific images of superhuman power associated with the names of the great Italian masters. But French painting conjures up nothing of that sort—there are no Leonardos, Giottos, Signorellis there. The impression one brought away from the *Chefs-d'œuvre de l'art français* at the Paris Exhibition was of a patient and exquisite observation of nature; sometimes more urbane than the Dutch, but quite as remote from the heroical as were the latter.

To 'cultivate one's garden' is a very fine thing to do—if you do it with such consummate grace as the French. But there *are* such things as the Circumnavigation of the Globe, the ascent of Everest, the discovery of the North Pole, stratosphere flights, hunger-strikes 'unto death', the investigation of disease, with all its labours and dangers. And the Sistine Ceiling is in that latter category; in the *heroic*.

Heaven forfend that I should be thought to assert that such adventures are *better* than the modest effort entailed in planting a gooseberry bush, or pushing the mowing-machine over the lawn. No: I am a good enough democrat to recognize that 'small' and 'big' are terms it is better not to use, where that can be avoided. Yet, unimportant as scale is from a certain standpoint, how can we disregard it in considering—let alone *assessing*—artistic achievement? The Sistine Ceiling is in a *different* category, at least, to what is most typical of the French School, just as the scenery of the Himalayas is *different* from (not better than) Box Hill.

In the light of their artistic output the Italians appear to us as a nation of heavyweights (to revert to Mr Newton's classification): the French as a nation of lightweights. The British are in the 'cruiser' class: but ideologically, inclined to aspire to the Flyweight title.

It is quite ridiculous talking about nationality in the arts—it would be like introducing the sex-war into art criticism. But there is reason

to suppose that Cézanne was in fact Cezanni. Must we say—*Hence his severity*? attributing to his Italian origin that rather sombre power, which used Impressionism to make a quite new and more imposing revolution—with the aid of a superbly gifted Catalan Jew?

All this is, however, going much farther than is necessary. To stick to this century, the *école de Paris* has not been a French School at all. About what is truly and typically French in painting there is a smallness, a neatness, a prettiness—something like the delightful, airy tinkle of a French music-hall air. This is not a thing to be shunned: but also it need not be an object of obsequious imitation.—A good deal of the criticism you are about to encounter, and some that you have already met with in the course of these preliminaries, is related to the above merely geographical facts. I have demonstrated that to the economic interpretation of art I am by no means blind. Now I have shown that I am alive, as well, to the geographic factor.

PICASSO

The Kenyon Review, *Spring 1940*.

Fifty years hence the 'art-expert' of the day may quite probably class Pablo Picasso with Gauguin. Among other things, Picasso is a great exotic. But he is, of course, as a sort of Gauguin, a very *sedentary* Gauguin. The latter betook himself to a Pacific island and *pastiched* the primitive art he found there. Picasso has imported the Pacific and Africa to Montparnasse.

Today we are remarkably equipped for armchair exoticism. Great quantities of superb photographs of all the primitive cultures imaginable arrive by every mail. Picasso has been able to stop in his Paris Studio and the Marquesas Islands, the Sandwich, Solomon, and Andaman Islands—Easter Island—have been brought to him.

Fifty or sixty islands and archipelagos have been ransacked by the snake-like, darting eye of this omnivorous little expert. Each has been given a twist, as happened with the author of *Noa Noa*, suggested by the European mind, or dictated by the taste of the period.

Picasso is a great expert. He has the mind, too, of a collector, one of great resource and enterprise. Imagine a collector of such technical *expertise* that he was tempted to fake and parody, upon the lines of whatever new ethnographic oddity was brought to him. We can see, in our mind's eye, this great amateur, with agents in every jungle; with side by side a museum and a workshop. He maintains a large workshop where he has 'gone native' technically, as others do in their personal life. But since this collector of genius we have imagined is not without conceit, regarding his power to copy or to caricature whatever is brought to him, his fakes become more and more insolently stylistic. He introduces the *chapeau melon* and the modes of the Rue de la Paix into the middle of a savage Pacific formula. He comes to regard himself as a cultural alembic, through which all these innocent manners of seeing must pass, and be transfigured into some witty, distorted reflection of the original, arranged for that eclectic symposium which is the brain-trust installed at the centre of a great modern metropolis. And is not Paris, that centre of centres, the cultural hub of the world? Picasso is the *enfant terrible* of the Paris brain-trust.

Under this figure of the whimsical, immensely endowed collector, it

is possible to visualize Pablo Picasso and to understand his mind: a collector who began in a small way, quiet and unenterprising—with late Renoirs, or milder Lautrecs; who next went in for El Greco extensively (after a fit of particularly sentimental Blues): and at last he falls for Cézanne. (Cézanne is the great influence: that, and the arts of primitive man.)

But if Picasso is parasitic, in this sense, he is at the same time original. His originality is of a technical order. The task of imitation, the search for the correct material—the very mistakes, or slips of the hand—suggest variations, paradoxical variations, upon the original.

This figure of the uncannily gifted collector makes too many demands, perhaps, upon the fancy of the reader. It would be easier, or more exact, to use, for purposes of analogy, the instrumentalist: the interpretative executant musician, as opposed to the creator, or original composer. There are many executants of such resource that they can turn upside down some masterpiece, and almost make a new one in the process. And were Picasso a musician, he would be able to play a dozen instruments, and be as adept with a kettledrum as with a harp. But he would not be a Bach or a Beethoven.

These observations may sound slighting, but they are not intended to be that. Picasso plays such a very great part in our art (and deservedly so) that it is of importance to understand him. And there is nothing to be gained by flattery. That one has to write at such length, and with such careful attention, is flattery enough. It is possible to admire Picasso, to marvel at his great agility, but to admire other artists more. And I believe there are other models whose superior merits should be stressed, especially at the present time. For it is no longer a question of defending Picasso against the censure or abuse of the ignorant. Picasso's reputation is quite safe. It is, in fact, a question of saving art itself.

In sitting down to write this article I decided to think aloud about Picasso—to say just what I thought, rather than to write only what it might seem expedient to write. Picasso has become too much an obsession. 'There are five and sixty ways of constructing tribal lays—and every single one of them is right.' Picasso is only *one* way. That, for the sake of the young generation, if nothing else, should be repeatedly emphasized. If I offend a few sentimentalists or interested parties, well (if I may risk such a remark), those gentry are of less consequence than are the painters, or the genuine students of painting. Perhaps we have been inclined to consider the art-dealer, the fashionable 'socialite'

and—oh yes—the 'art-expert', too much, and for far too long a time.

The bad painter is of course the worst enemy of painting (always excepting the 'art-expert', and his ally the 'socialite'). But it is painters and only painters who, in the end, are the *valuers* of painting.

There would be no two-hundred-thousand dollar Rembrandts and Michelangelos today without the recognition and consent of the painters, generation after generation; and for musical valuations we depend ultimately upon the musician—as much as all that we know of Newton or Einstein we know thanks to the physicist and the mathematician. So if here I am treating the painter respectfully, mere workman though he be—rather than regarding him as an excuse for the art-expert, or a sort of freak entertainer for the fashionable socialite—if I am doing this, it is not so absurd as at first sight it might seem.

Cézanne (a man of the creative type) was fanatically attached to time and place. In that he conformed to the Impressionist dogma, of the immediate scene. Cézanne would have loathed Picasso. His dislike would have been expressed with a terrific unambiguity. We know what he thought of Gauguin. When some young painter mentioned Gauguin (a new figure upon the horizon at that time) Cézanne flew into a rage and in the richest provençal—his r's rolling a tempestuous tattoo—he shouted at his guest: 'Ne me *parrrle* pas de ce *Monsieur Gauguin*—avec ses images chinoises! J'avais un peu de sensibilité! Il me l'a prise et l'a porrrté chez les Nègres!'

Cézanne would have regarded Picasso as an obnoxious pseudo-Hottentot, crossed with a crooked necromancer. 'Tout est sphérique et cylindrique' was the famous dictum of the Seer of Aix, pondered so deeply by Picasso. But Cézanne did not mean that nature should be reduced to drab and pedantic geometries. He did not want to *paint* cones, and spheres, and cylinders. He detected their shadows, merely, at the bottom of the well.

The fact that Picasso came from Barcelona, however, would, for a nineteenth-century Frenchman, have settled the matter. Of a Catalan, what could you expect? And as more and more Catalans sprang up, and contorted themselves into stranger and stranger shapes, the sceptical nineteenth-century Gaul would have shrugged his shoulders and decided that Nature was in one of her absurder moods, and all this was a pleasantry, which must be taken in good part. Even today in Paris the

surrealist Salvador Dali is considered as an Anglo-Saxon *engouement*. Just as certain brands of Champagne are labelled *Goût Américain,* so the *horribleries* of the surrealist circus are marked off as *Goût Anglo-Américain* by the majority of Frenchmen.

These preliminary remarks must not be taken as a summary of my sensations regarding Picasso, only as a first step to understanding, covering one aspect of this mercurial personality. That there is much more in Picasso than that is obvious. He is not all *art nègre*. He has done more than out-Gauguin Gauguin, though that he is an interpreter rather than a creator—a great critic and 'taster', rather than a man who wants to make something new—holds good whichever way you approach him. (For the *new* is not merely the *different:* that is a vulgar confusion.)

If, however, you removed from Picasso's immense eclectic output all that did not in some sort come under the head of primitivist, what would the residue amount to? Of course you could not so isolate what was not Negro sculpture, or Polynesian ritualist mask: all his modes are so mixed up with one another. But what could be isolated would be of diminishing account. All that he did before he fell for Cézanne, for instance, would not secure him a very high rank as a painter.

Let us say this. The 'Pre-Raphaelite' (the English 'primitive' of a century ago) had one way of being primitive. He thought only in Greco-Roman terms. Picasso is just as *merely* pre-Hellenic or extra-European, as the English Pre-Raphaelite was pre-Renaissance, pre-Raphael, if we put aside his flirtation with the Fourth Dimension.

To write about Picasso in the United States at this moment is admittedly a ticklish business. He is such a brilliant, amusing, and irrepressible spirit. And he is having an apotheosis (his *last* apotheosis—for there is no other place for him to go to, to have an apotheosis in, after America): and it is an ungrateful task to obtrude, plump in the middle of an apotheosis, the seeming irrelevancies of commonsense! To draw near, as the clouds are opening to receive the elect, and to advance a few detached observations about this remarkable phenomenon, is to invite indignation.

As an artist of course I approach these goings-on as an *observer*, rather than as a fellow-reveller. The fact is, alas, that far from being intoxicated, I am bored. Bored—but nicely, amusingly, bored. I would far rather be bored by Picasso than I would be interested or amused by a less lively person. I would rather be bored by Picasso than by Bouguereau, or by Gauguin, or even by David. I *like* being bored by Picasso. But I get

tired of being bored at all, that is the trouble. Over-familiarity with the unfamiliar is the most boring kind of familiarity, I suppose.

'Mon dieu! Comme ça se dégonflera vite!' Degas exclaimed, at a Bouguereau exhibition. And the *more* you inflate, the more, when the time comes, the pneumatic phenomenon subsides with a nasty hiss.

But let me at once remark how anything that may be advanced regarding Picasso is not an invitation to paint like Bouguereau—or like Simon Elwes or Brockhurst or their American academic equivalents. That is not the true contrasting opposite.

The alternative that presents itself in modern painting is much more complicated than that. The alternative is not between something very strange on the other hand, and just vulgar pictorial photography on the other. By far the greatest part of the best art in the world is in no way sensational or strange.

The Roman populace demanded *sensation*: they wanted to see the entrails of gladiators. Men were crucified, or otherwise massacred, upon the Roman stage. We too demand *sensation*. But sensation is not *art*. The Greeks even held that it was art's opposite. And the Greeks were much finer artists than the Romans.

If to speak with great freedom about Picasso as about any other phenomenon that presented itself were interpreted as an invitation to paint *en pompier*, then it would be better to remain silent. Why so many people do keep to themselves what they know is probably because they fear to throw open, by so doing, the floodgates of the commonplace. Meanwhile art—the arts of painting, sculpture, and design—languishes. And it is because it languishes, and will eventually die out, unless something is done about it (and only art-dealers, socialites, and art-experts be left to bear witness that art once *was*) that it is necessary to be explicit. Several of us must blaze a trail through the jungle of journalistic clap-trap. The great civilized bases of our human sensibility must be reached, in a violent, or anyhow rapid return to nature. For *those* bases plainly are more central, for us, as civilized men, than that more distant animal basis towards which we have been impelled by recent influences. The arid labyrinth in which we have moved for so long shows every sign, however, of the penetration of the light of day. Whether we want it or not, we shall soon be back in the visual world, which is the best world for all the visual artists. There is no European painter under forty who is abstracting or negro-arting any more, a fact which speaks for itself.

In this connection, it will be profitable to examine one aspect of such a programme as Picasso's: namely, is it, as often we hear it described, a *revolutionary* programme? And if so, in what way is it revolutionary?

First of all, it should be plain to everybody that in a revolutionary society—in a socialist, or a communist, society—such a phenomenon as Pablo Picasso could not come into existence: or if already it existed, it could not flourish. Picasso, regarded as a social phenomenon (and the same applies to surrealism) provides the barbaric—the 'revolutionary' —thrill to the wealthy 'socialite' of a capitalist society. He would have no meaning for, and evoke no response in, the newly conscious masses of a revolutionary society. I am not registering this against him, perhaps I should remark. I am merely establishing the facts.

Corbusier, the famous 'revolutionary' architect, has remarked upon the rapidity with which a revolutionary society like the Russian or the German tires of 'revolutionary' art, and turns its back on it. It was only in the very old societies, such as the English, that the 'new' architecture could hope to find a home. If it did not find one there, then it could shut up shop. America, Corbusier asserted, was quite hopeless. It was too new!

As a *destructive* force, of course—as a 'decadent' principle, to promote decay—Picasso, and his fellow Catalan Dali, have some meaning. And who would care to assert that our society, as it stands at present, is something that we should religiously conserve? Who would shed a tear if, rotted from within, it were swept away?

But that decadent principle, that social dissolvent, is not art. It is politics. If Picasso ought really to be regarded politically—as a rat, or as a termite—and not as an artist (in the same sense as Raphael, or Dürer, or Ingres) at all—if that is the case, then it may be very bad politics for me to be analysing him as now I am doing, though it might be very good art.

But the corruption has gone so far that the social aspect of the matter surely can be left to look after itself. Our society is so visibly dropping to pieces beneath our eyes, that destructive agents have lost their point. We, as artists (however revolutionary we may be), can look after *ourselves* for a change. We can turn away from politics, and back to the preservation of this great human function—artistic expression. For, whatever we may think of contemporary society, *that* is worth preserving: it would be a pity if the artistic faculty became atrophied: if we came to live in a world of Men Without Art. So we can leave politics out of the picture

for the moment—whether we are parlour pinks, or true-blue Republicans or what not—and give our undivided attention to art and its more specialist problems.

Having disposed of Picasso's 'revolutionary' claim, and having discounted his further usefulness as a reagent of social disintegration (if such he be or ever were) we may turn our attention exclusively to Picasso the Artist. And at the recent exhibition at the Museum of Modern Art anybody who wanted to, or was in any way competent to do so, could make up his mind, as never before, what he really thought about Pablo Picasso. There was the whole of his work—or excellent specimens of all his periods—laid out for inspection: beautifully hung, catalogued, and footnoted. A perfectly fool-proof display.

If anyone ever had 'periods', that artist is Picasso. He is nothing *but* periods. He is a 'periodic' artist to such a degree that every six months, during one vast period of forty years, has been a period. And to master these eighty-odd periods must be, for the poor 'art-expert', a truly exhausting task.

I may say at once that the two sorts of work—or periods—that I like best in Picasso are the so-called 'Roman' period, and then the period covering the concoction of the big *Guernica* painting.

The set piece of the Exhibition at the Museum of Modern Art—the big 'Guernica'—is not a success, it seems to me. It is a big, highly intellectual poster, uninteresting in colour, and having no relation to the political event that was supposed to have provoked it. When Goya drafted into a set of wonderful plates (*Los desastres de la Guerra*) his accumulated sensations of disgust and anger at the devastation of Spain by the French armies, he produced something that was not coldly cut out of cardboard, but had flesh and blood, and struck the thing aimed at as effectively as a physical missile. The inalterable 'intellectuality'—the frigidity, the desiccation—of Picasso is demonstrated more forcibly by this largest of his canvasses than anything else could have done.

Of course, the very concreteness of this topical historical subject may have interfered with his abstract *élan*. He did not, in the case of *Guernica*, emerge, and show himself above the surface in recognizable shapes, as be did in *The Race* (catalogue No 167) or *La Vie* (nude couple, confronted by woman holding child). But whenever he *has* shown himself, in human form, the result has been disappointing.

It is no use going to Picasso for a world of living creatures of the force

of Daumier's or the spiritual intensity of Blake's. You will find nothing but a troupe of anaemic aesthetes, followed at a considerable interval by another troupe, of dropsical imbeciles, dull-eyed and listless, dressed up in dirty Attic draperies.

Why, when Picasso is not engaged in painting grotesqueries or semi-abstract compositions, and goes back into nature, should the creatures of his preference be of that order? That *why* is of some importance. For 'why not?' would be an insufficient answer. In *The Race*—the coloured plate that served as cover to the illustrated catalogue of the Museum of Modern Art, and which many readers will, I expect, have at hand—one sees a couple of foully bloated females, masquerading in Greek costume, disporting themselves upon a beach. Why, so young, are they so unbelievably gross—thick-set and flaccid? What females of what time or breed suffered from this fatty deterioration? Why are their hands and feet so disgustingly adipose (as likewise those of their sisters in other canvasses of the 'Roman period', such as *Two Seated Women*—'one of the most imposing', says the catalogue, 'of Picasso's compositions of colossal nudes').

I have a theory regarding the rationale of these empty, pneumatic giantesses, with enormous lifeless eyes, and dropsy-thickened extremities. But without going into that it will suffice to say that plastically, or pictorially, they have no especial justification. The explanation usually given that these flabby expanses, anchored to the floor with great swollen feet, contrive to persuade the spectator that he is looking at something *very heavy*, is insufficient. For mass could be conveyed better by other methods.

This question of *why* a departure from the human norm is thus and thus, is of the utmost importance for the critic. People are usually afraid to put such a question for fear that they may be betraying a lack of understanding. Or they are easily satisfied with some glib jargon. Yet in fact most of the departures from the human or organic norm in recent art are quite arbitrary and not in conformity with any law that can be rationally stated.

An artist should, of course, be able to explain, if he wants to, the reason for placing three eyes instead of two in a row—or four instead of three; or why he paints a foot twice the size it would be in a normal person. He should be able to explain that just as readily as an architect could tell you why he made a door only four feet high (if he did) or twenty feet, on the other hand: or why his floors were all slightly running

M

down hill, instead of being, as are all other floors, as level as a spirit-gauge would make them.

Were the architect to say: 'Just to be *different*', that would be a sort of explanation. But that is not the explanation in the present case. The giantesses of the 'Roman period' for instance are very orthodoxly naturalistic. Some human purpose is involved in their pathologic departures from the norm.

In spite of these strictures, I prefer Picasso's 'Roman period' canvasses to any other, except for the quite recent horse-and-bull drawings (those done as a creative warming-up for the fiasco of the *Guernica*). A little of the ample splendours of the Vatican Raphaels seems to have filtered —as if through sweaty layers of flannel drapery—into these bloated dolls. They insult fineness—they insult 'the graces'. They are not even strong. But they exist in their own right, in a sort of barren boredom, of 'too, too, solid flesh', steeped in a stupid emptiness, peculiar to them, and not without original grandeur.

The *Guernica* studies—great numbers of them were done—are in a different class altogether. I like them best of all. They are grotesqueries of great nervous inventiveness. If on the other hand you want to compare Picasso with Goya (where the former is *above the surface*, as it were, and not occulted in the field of abstraction) take his etching—'Probably Picasso's most important print', says the catalogue—called *Minotauromachy*. This highly crowded, ill-organized improvisation literally could not have been produced by the master responsible for the *Caprichos*.

Had this plate been signed by any name but that of Picasso, one would not look at it twice if one came across it in an exhibition: this confused, feeble, profusely decorated, romantic *carpet*. It is like a Victorian bizarrerie, in feeling; in its execution so far below what one expects of Picasso that when first I saw it I did not believe it was his.

I have indicated what I like best in this plethora of 'periods'. What for my own personal count I like least is what is described as the 'blue period'. (It is these blue pictures that were the most popular in the exhibition at the Museum of Modern Art, because people came to them with a sigh of relief, and perceived with delight that they were not only 'like nature', but, into the bargain, sentimental and emotionally saccharine. They were the great success of the exhibition.)

Where the 'blue period' begins and ends I am not quite clear, but the sort of picture I refer to—and they are generally coloured a maudlin blue—shows us a theatrically emaciated race of bogus beggars, or

stylistically starved '*pauvres*'. That Picasso felt nothing personally about Guernica is amply demonstrated by the canvas in which culminated his efforts to *think* about it—since he was unable to *feel* anything about it. But that he never experienced a touch of authentic sympathy for the poor and outcast (such as one invariably encounters in the pages of the great Russian novelists) is proved, if that were necessary, in the blue light of this most unfortunate of his *explicit periods*, as they might be termed. The *explicit periods* would of course be where the type of picture allowed of human judgment; where an assemblage of normally integrated natural forms invited comparison with other famous artists, of the pre-abstract ages.

The music of *Pélléas et Mélisande* is here distilled into a human form somewhat approximating the 'Pauvre Pêcheur' of Puvis de Chavannes. But de Chavannes is almost direct and robustly unaesthetic compared with these creatures of counterfeit sentiment, oozing with a spurious melancholy. Burne-Jones—along with Puvis de Chavannes the nearest analogy to this 'blue' world in question—Burne-Jones is well-nigh *tough* besides these 'women with folded arms', or beggars by the sad sea-waves (which was not among the 'Blues' to be seen at the Museum of Modern Art, as far as I remember, but is one of the most typical of these canvasses).

You will see from these last remarks that there *are* things in Picasso by which I am not agreeably bored, but disagreeably bored. This is, however, confined to the canvasses of the blue period. All the other periods I enjoy, in one degree or another.

It may surprise the reader of this article that one can speak with such absence of enthusiasm of much of Picasso's work, and yet on the whole enjoy his pyrotechnic displays. Both the enjoyment and the lack of enthusiasm are nevertheless quite genuine. Compared with any bad pictures—and ninety per cent of all pictures painted are dull, vulgar, or incompetent—his pictorial displays are an enjoyable event.

Of the two sides of his work, the one representing nature fairly traditionally, the other not doing so, I suppose on the whole that I prefer the latter. Did he only represent nature, had he never done anything else, I should not be very interested in Picasso. The account I have just given of two of his representative periods (the 'Blue' and the 'Roman') will explain why a purely 'representative' Picasso would not be my pidgin exactly.

In a *negative* way, again, Picasso, Léger, etc., have much to be said for them. They make a distinct and stimulating shape, vigorously out-lined, upon the wall of an apartment. In Mr Sweeney's flat in New York, for instance, from which everything is banished, or practically every-thing, to house them, this is seen to good advantage. It is only when you look into these things that their shortcomings are at once obvious. They are seen to be a decorative branch of architecture, more than anything else. The decorative elements have been abolished everywhere from floor to ceiling; instead of being dispersed all over the walls and furnish-ings, they are rather preciously concentrated in these small areas, bounded by the four sides of the picture frames. Yet even within that area set aside for fun, the fun is Mohammedanly severe.

As we gaze at these privileged architectural microcosms, we see that there is nothing *inside* them, after all—perhaps, we think, because we have nothing to put there, except ornate bric-à-brac, therefore our artists have not either. We are a little coarse and empty, and so are they!

In a brief general survey of the sort of things Picasso does, it only remains to consider the more 'abstract' patches in his lifework. Today, as much as when first I wrote about it (at a period when I was occupied in those experiments myself) it seems to me that Picasso is very im-perfectly 'abstract', or not abstract at all; merely making amusing patterns out of what is half purely naturalist material, half four-dimensional playfulness.

In 1913–14 there were three 'abstract' movements in Europe—authentic attempts to escape from all human reference in the visual field, that of form and colour. One was the movement in Holland with which the name of Mondrian is internationally associated; one the 'vorticist' movement in England, I being the inspirer of that, and the most thoroughgoing practitioner: and there was a third in Russia. Picasso has seldom attempted anything so radical. In general he has contented himself with taking Cézanne's formula 'tout est sphérique et cylindrique' to its logical conclusion, and inventing 'four-dimensional' arabesques, upon a theme strictly naturalist.

What I have done in these few pages of comment upon the Picasso exhibition at the Museum of Modern Art, is to isolate the naturalist from the non-naturalist side of Picasso's painting—to discuss the one as if the other did not exist. It was my intention, having isolated these two parts of his work, to defeat them one at a time—though I have not of course the space to deal with either side of his work in such detail as

would be necessary to convince the educated layman. Such a detailed analysis I hope to provide in another place, a little later on.

The generalship outlined here is, I am sure, extremely sound, and the method is to be recommended, for anybody anxious to master the complexities of this protean Jack-in-the-box among painters; a painter who deserves our admiration and attention, certainly, but who should not be allowed to develop into a stultifying obsession, as he threatens to do in the United States.

I should perhaps in conclusion explain that I am a partisan—I am not the 'impartial critic', or anything of that sort. In Europe I am leading a 'back to nature' crusade (which the war has interrupted, but after the war will be resumed). And although I cannot go into the circumstances that motivate this demonstration, it may be of interest to give some passages from my advance statement, which has a great bearing upon all the questions provoked by such a thing as a retrospective Picasso exhibition.

I am dealing, as will be seen below, with the problem of turning away from the unfamiliar to the familiar. A street in Timbuctoo is always so much more interesting, superficially, than a street in one's home city. This is only *one* problem, but its solution is imposed upon us at the outset, in any such undertaking as a 'return to nature' on the grand scale. But here are the passages in question.

> *Lewis proceeds to quote five paragraphs from part (v) of* Supernature versus Super-real, *beginning with 'The second prerequisite . . .*

Upon that I may close my review of this great massing of Picassos in New York. As I have already remarked, Picasso's reputation as a painter of genius is perfectly safe. But the whole of Art, and the healthy continuance of this great human activity, is more important than the fame of any one man. And Picasso's is altogether too totalitarian a temperament: what he has done, taken in isolation, does not quite justify the space he occupies upon our horizons. He is such a great, luxuriant, voracious, plant: and he is a little too much of the liana—the prolific, tropical creeper—rather than the solid giant of the forest—to which description Daumier, or Cézanne, or Goya answers, but he does not.

AFTER ABSTRACT ART

From The New Republic. *New York, 8 July 1940. The earlier article, referred to in the opening sentence, had been published in the 1 April issue.*

In an article printed recently in The New Republic I announced the death of 'abstract art'. I implied that the final liquidation of all of these anti-natural movements, in the visual arts, is imminent. At this prospect I was frankly elated. Our 'abstract' adventure (I recapitulate) revealed one great objection to high-hatting nature. On the one hand a certain polar emptiness; on the other an, in the long run, equally disconcerting tropical redundance, a romantic excess, is what happens in a visual art when the objective datum of the visual field is abandoned.

So much for the technical obstacles. Quite as noteworthy are the psychological complications—'Difficult painting', like caviar, is a thing of which there cannot be very much: and its consumption, again like that great delicacy, is confined to the plutocratic crust of our society. For an artist, to be 'difficult' is either to die or to go to live with Croesus and his satellites in a glittering dreamland. And the contemporary Croesus is, alas, a consummate savage.

Now snobbery *re* the 'difficult painter' is indicative of a barbarous *lack* of interest in art: just the same as too exotic dishes suggest enfeeblement of the taste as much as of the appetite. Snobbery does not originate in the studio, but in the salon, of course. The painter can hardly be a snob. All painting—Corot, Chardin or Giotto; Rouault, Rembrandt or Blake—delights him. So it is not in him that the appetite is wanting: although in some societies the painter may be the only man who regards a painting otherwise than as an exhibit, a possession or a counter in a game. Art that is too gamey reveals the presence of an undesirable order of patron, as much as human flesh appearing on a menu would justly be regarded as an outrage by the 'Club des Cent' (not to mention anything so suspect and Anglo-Saxon as the Food and Wine Society). And some of the most fashionable painting today has been hung too long.

Seeing how exclusively pictorial art has become an expensive condiment, valued by its barbarous user in proportion to its kick, no wonder 'difficult' painting has been compromised, and the whole of painting

been shot to pieces economically. From the moment Croesus—ably abetted by the millionaire picture-dealers and fashionable experts—cast his gorgon-eye upon a blank blue canvas, with two pink spots at its centre and a scarlet triangle up in one corner—gazed at it bleakly and found it *good*, the doom of all that was not *blank* was sealed.

Then came the Child, with its fascinating scribbles, and the adult that sat at the feet of the Child, and then the inmate of the asylum, with *his* fascinating distortions; and we were all set for a number of decades, if not forever. But politics, seemingly, are coming to our rescue. Such an unlikely instrument as the New Deal, even, has played its part.

Freedom for the painter is what this new dispensation spells—nothing less than freedom; for better or for worse, of course. Freed of the snobbish obligation to excel in oddity, as if they were running a freak-show, all but a decimal percentage of professional painters will breathe freely once more. The dangers inherent in this freedom are obvious. Those in a decimal minority, in a free community, are not always the least endowed. You do not need to tell me that. But before you shudder at the thought of those dangers, you have to inspect very conscientiously the condition of art, as we find it today, and ask yourself what is likely to happen—or *not* to happen—if that state of affairs endures.

All that our abstract experiment of twenty years ago did for painting, it seems, was to substitute sensationalism for the cultivation of the senses, and to clap down upon the practice of painting a snobbery of the most withering description. The hatred for art in all its forms which is such a characteristic of that well-groomed barbarian, the 'socialite', and his strange new prompter, the 'art-expert', has found in these snob-values the satisfaction of its animus. So we have arrived at the stagnation which we see today.

In this freedom-for-the-painter slogan there is a paradox. For it was in the name of freedom that as abstractionists, or cubists, or what not, we set out to explore beyond nature. Yet the constraint and unfreedom that have provoked what is now happening are very much of a reality. Nature—the nature of Holbein, of Ingres, in distinction to that of the photographer—is not respectable. And such conventions are found cramping by most artists.

That this freedom that is now being won for painters will be used to paint simpering photographs of an obnoxious sweetness, and scenes of an enervating domestic bliss—the kitten playing with the ball of wool,

and the child nestling in its mother's lap—is certain. That is what complicates the process, and freezes the hoorah upon our lips.

Here we arrive at the question—since it evidently has become a question everywhere—of what to do next in art, so as to restore painting to its old position of creative mastery: so that it should cease to be a plaything—a joke—of the rich. For several decades it has had the status of a dwarf at the court of a king of Castille. It is surely time it ceased to waddle and grimace at the heels of some scented playboy, or playgirl, and remembered some of the things it had done, better worth doing than that, since it first came on the scene, in Greece and China.

The Federal Artists' Project is now an old, and I am afraid stale, story. It must, I suppose, be allowed, too, that you cannot *stick art onto life*: life itself, and the shells in which life is lived, have to be altered first. Nevertheless, Mr Roosevelt has done more for the art of painting than any other public man alive, in any country in the world.

His gesture is so entirely unique that it cannot be enough, or long enough, applauded. Why should we complain that the statesman gives too little heed to art, if, when at last the rule is broken, as in the case of Mr Roosevelt, and a great deal of youthful talent is unearthed, you put yourself on your guard, mobilize all your critical faculties, as if an unworthy attempt had been made to make you an intellectual sucker?

'Post-office art' is, a great deal of it, far better than gallery art. I would much rather go to the Twenty-third Street Post Office in New York City than to most picture exhibitions. Although it is an unnecessarily hideous hall, and the colour scheme not of a kind to induce people to linger (and one can see that, in a post office, that had to be guarded against), I never go there to buy a stamp but what I admire some new dexterity or piece of invention on the part of the artist.

As to the type of art, these Federal Artists' Project murals naturally reflect the tendencies of the last few decades. But in a 'new deal' for the artist the technical problem is of far less importance than the psychological, or if you like the political. When the state steps in, and throws the doors of its post offices open to the artist, what it is doing more than anything else—and this is generally overlooked, or insufficiently stressed—is taking the destinies of the art of painting out of the hands of the 'socialite', the dealer and the expert. That is the thing of capital importance.

The kind of art, as I have remarked, is unimportant. To imitate what is under our eyes; to develop those imitations into generalized (*super-*

natural—but not *super-real*) realities; and beyond that, and in a more general way, to care for, and to influence people to observe, the visual amenities, and to banish as far as possible from the visual field all that is degrading or stupid, all that is of trivial or slovenly design and texture: these are great human functions, surely, that people neglect to their cost.

PART IV

The Forties and After

INTRODUCTION

Lewis was nearly sixty when he began his extended stay in the New World, thirty years after the youthful Pound and Eliot had vacated it for the Old. By the time he reached the Western Hemisphere, another war had broken out in Europe. He had long dreaded the coming of this war and warned of its consequences. But he derived new hope from the vitality of the American 'melting pot'. Whereas in 1940 he said he would not shed a tear if, rotted from within, our society were swept away, by 1946—in 'Towards an Earth Culture'—he was noting with approval that the world was in transition toward a cosmic unity of some kind. The stage was set for the emergence of the cosmic art he had envisaged in the 1929 essay 'World Art and Tradition'.

During his North American stay, Lewis published little on art. He gave lectures about it, however, and the text of one of these, dealing with Georges Rouault, is included in this section. After the war, in the thirty or so art reviews he wrote for *The Listener*, he concentrated on contemporary British artists and commented on nearly all the important ones. Occasional discussions of impressionism or earlier painting give evidence of the freshness of his approach to the older masters. Their presence, in our alphabetical order, leads to Gerard David incongruously rubbing shoulders with Jacob Epstein, or Vuillard with Julian Trevelyan, just as they might have been encountered by Lewis on a morning's tour 'Round the Galleries'.

The Listener had shown imagination in picking their man. With his mastery of the brief, incisive statement, Lewis could fix the essence of a painter's work in a paragraph. There must have been a good deal of alarm at his enthusiastic appraisement of painters then barely recognized and unfashionable. But most of the artists he favoured are now well established and sought after. Mainly, these were painters who worked with imagination and freedom in terms of natural forms—such men as Craxton, Bacon, Ayrton, Colquhoun, Herman, Minton and Richards. Even total abstraction, against this background of the painting of Life, was welcomed again, in the works of Hepworth and Pasmore among others.

But most of the painters he regarded so highly were even now having difficulty selling their work. 'Art lies bleeding at least as much today as before the war', he wrote in 1950. A book, *The Demon of Progress in the*

Arts (1954), sought to explain how cliques, fashion and the forces of politics were combining to produce this situation, to threaten art as the inventory of truth. 'There is something peculiarly diabolic about all the concentration of selective energy, all the beauty of the mind embalmed in some great carving, deformed in the name of art, "abstracted" into nothing to satisfy some collective vanity.'

Lewis last wrote on art at the time of the 'Wyndham Lewis and Vorticism' exhibition, really a Wyndham Lewis retrospective, which the Arts Council arranged in 1956. The notion he expressed on that occasion of 'a large design of something like a Jabberwock outraging an eagle' (p. 458), which he would do if he could see, is comforting evidence that even when blind and old he had not lost his satirist's vision, which could accommodate the low and the lofty in the same picture.

RELIGIOUS EXPRESSION IN CONTEMPORARY ART

Rouault and Original Sin

Reproduced from a typewritten manuscript for a lecture given by Lewis in January 1943 at Assumption College, Windsor, Canada. The occasion is described in a recent article by J. Stanley Murphy, C.S.B., then as now Registrar of the College which is today merged in the new University of Windsor. The framework was the 'Christian Culture' series of lectures, founded by Father Murphy. The series was open to the public, and it was attended by an audience drawn from Windsor and across the U.S. border from Detroit.

The climate in which Rouault had to be defended as a religious painter is given by the rejection, in 1942, by the Municipal Gallery of Dublin, of an important Rouault 'primarily due to Catholic hostility towards its treatment of the subject-matter', as Lewis was informed.

Where religious expression, in art, ends, and the profane begins, would be hard to decide. *The Marriage of the Virgin* by Raphael, in the Brera Gallery at Milan, beautiful and splendid as it is withal, has not any of the religious spirit in it. The lovely head of the Virgin by Luini—Leonardo's pupil—is another matter: and the fact that it is selected for mass-reproduction in Catholic countries is suggestive. But of course we go to the Gothic, not to the Renaissance, masters, or to the Primitives for an expression of the religious mind.

The painting of El Greco has influenced contemporary art more than that of any other Old Master; a great deal of it comes under the head of religious painting, and it seems even to be, at first sight, 'religious painting' *par excellence*. By reason not only of its subject-matter, but of its unearthly lighting effects, and its avoidance of all that is trivial or belonging to the daily round, as well as its, as it were, religious seclusion, in a region of moonlit rocks, it would seem ideally to qualify for that.

If you look a little closer, however, this elegant mysticism of El Greco's seems greater as painting than it is as religious painting.

Its mysticism is not so much that of a mystic as of an ascetic virtuoso. El Greco is an inspired exploiter of the mystical, for pictorial ends. It would be scarcely possible for a bona fide mystic to be so finished a craftsman. We have the evidence of William Blake and other great mystical artists.

The possession of technical mastery of the shapes of the external world seems to dilute with nature the spirit of the visionary: but we may go further than that, and assert that even the desire for such a technical mastery signalizes a less fervid visionary impulse. Then again, subject-matter does not make religion, or its expression: and with El Greco these austerities have a stagey look, at last. There is another thing—a most revealing detail in this connection. If you examine the facial types in the pictures of the great Toledo master, you discover that the women's faces are strangely trite and matter-of-fact: solemnly pretty, without dignity, expressionless and commonplace. His Madonna is a *mademoiselle de magasin*.

It is with surprise that you make this discovery. For the execution is so perfect—El Greco is so supremely able to set down on canvas what-ever he wishes to—to give immediate concrete shape to whatever he has imagined—that you know that what you see set down is exactly what his mind's eye saw. And all the *human* side of this imagery, in his great compositions, is, in contrast to his portraits, devoid of emotion and sometimes trivial (allowance made for the Byzantine elongation of the features which for us endows it with an exotic cachet).

So the human beings who float and posture in his spiritual world of opalescent and blue-bathed rocks are a conventional and insipid statuary elongated as in a convex mirror. Compare them with the carvings at Chartres—or the profound mystical vision which burst through the muscle-bound dummies of Blake—and you will see at once how the one is conventional, the other an authentic emotional expression.

In the twentieth century religious experience has found very intense, but very paradoxical expression, in the work of Georges Rouault. There are no elegant ecstasies—there is no avoidance of the things of everyday life: on the contrary, far from dwelling in a mystical ivory-tower, as does El Greco, Rouault is up to his neck in the mire of human life. His favourite illumination is not a 'mystical' blue, but the angry reds of Dante. And as to the subject-matter of his pictures, it is anything but edifying. Yet it is, I believe, a mystical expression of the highest order. And although as craftsmanship it is exceedingly accomplished, it has the uncouthness, too, and the unnatural strangeness, that is to be looked for in the mystic.

Perhaps I should say that my remarks with regard to El Greco were not a 'playing down' of so mystical-looking an artist or describing over-critically his ethereal graces, for the purpose of my subsequent advocacy

of Rouault. It was my object merely to make use of what is I believe a fairly accurate summary of the metaphysical claims of El Greco (and if we compare him with Raphael, his is a very spiritual art) in order to establish a rough criterion of what constitutes the religious in art and what does not. The fact is that, especially to a North American audience, Rouault does demand a good deal of explaining. And the art of Georges Rouault is the main subject of this paper, being to my mind what in contemporary art most truly illustrates the religious impulse, at its maximum of creative power.

I have no theology, so I cannot speak of that. But for me the religious painter *par excellence* of our time is as I have said Georges Rouault. He is French and he works in Paris: he is a modern of the moderns, in the sense that his works excite to immediate rage all that is *pompier*. He is so ferociously 'modern'—to employ again that horrid vocable—that to speak of him as a great exponent of religious art is an equal paradox to claiming for him pre-eminence as a painter.

The work of Rouault may be bad theology—though I doubt that. It is such good painting that I feel it must be good theology. I feel very sure in any case that it is more impregnated with religion than is the work of any other contemporary: infinitely more so, for instance, than was the sculpture of Eric Gill, who may be best known through his work for the Catholic cathedral at Westminster.

It is no discovery of mine that Rouault is a great religious painter. In spite of the fact that people who are outraged by the originality of his work deny that it is, or could be, *religious*, many other people, far better qualified than I am to decide in such a matter as this—like Jacques Maritain and his wife, who are not at all dismayed by these fearful images—regard him as I do.

Even, Rouault has been called the painter of original sin. That seems to me a most apt description of him. If you went back through history of art to find an analogy for him, you would have to go all the way to the Middle Ages before you reached anything so unaffectedly strange, anything so equipped with faith and so obsessed with sin. But to quote again, from the descriptions that have been invented for him, he has been referred to as 'the monk of modern art'. It was his friend Suarez called him that, and he did at one time contemplate the monastic life. It would have been a famous monastery, that contained such an inmate as Rouault! The phrase, at all events, 'the monk of modern art' is

picturesquely suggestive. It points to what should be looked for in this strange painter, in whom mysticism and realism contend for mastery.

At least, this attribution to Georges Rouault of the most authentic religious impulses, is not personal to me: indeed it would even be *self-evident*, that one was, with Rouault, in the presence of a master of religious art (and since his subject-matter is often that of the great Gothic craftsmen, the cathedral builders and missal-makers) were it not for one thing: namely his *modernism*. Were it not for the (to the average eye) repellent character of his imagery, no such preparation as this would be necessary—for a 'monk of painting' or any other kind of monk appears to many a solecism, walking down a twentieth-century street: and to come upon a 'monk' so amazingly *at home* as is Rouault in the twentieth-century atmosphere, and so painfully familiar with a humanity replete with twentieth-century materialism, is highly confusing.

Even his great friend Léon Bloy was confused: this is what that noisy writer said about some illustrations which Rouault had done for *La Femme Pauvre*, one of Bloy's best-known books. I quote from an article by Raïssa Maritain:

'At no price will I have anything to do with these illustrations. Here was a matter of painting the most tragic possible beings: two bourgeois, male and female, *complete*, just as they are: ingenuous, peace-loving, merciful and wise to the point of making the horses of the constellations foam at the mouth with fear.—*Instead*, he painted two assassins from the suburban slums.'

That is his great friend speaking. So no wonder many people have misunderstood these pictures of his: seeing that the human masks he depicts have no trace of what is ingenuous, pacific, merciful or wise. The faces you see in his pictures have none of those disarming qualities. On the contrary, they are dark and merciless—packed with cruelty and craft. For they are in fact a portrait gallery of the sort of people who make life intolerable for their gentler, or at all events less professionally predatory, fellows: portraits of people whose destiny it seems to be, to pry upon and oppress the ingenuous and tragic multitude. And from these vulpine masks of sumptuously clothed despots—in sultry scarlets and smouldering gold—there is no *relief*: Rouault does not show one of the faces, by way of contrast, of their more inoffensive and less alarming subjects. The arrogant wickedness of the ruler does not, in his *personae*, alternate with the submissive pathos, the humbler patience, of the enslaved; or, perhaps, the gentle and confiding graces of those who have

been too obtuse to know they are enslaved, frolicking in the yard of their prison, which they mistake for a pleasure-resort. He gives us nothing but one side of the picture, the tough side.

When we *are* shown a figure which is not a positive human scourge—a self-confessed despot or palpable slave-driver—the poor wretch we are then shown (who has not made the grade, so to speak, and won nefarious authority) this child of poverty and servitude is so disfigured with toil and suffering that he is, in his humbler way, just as alarming as his master. He is vulpine too (as we see him—or is it *her*—straddled in the plate called *Clown and Acrobat,* if you ever come across any of these things). In his puny way he is as accomplished an egoist as the power-blinded madman who rules him. His heart has been blackened and calloused as well as his hands.

Rouault is so obsessed with the wickedness of the great ones of this earth—the Herods, the Caesars, the 'Leaders' who mislead, the 'Protectors' who do not protect—that he seems incapable of imagining anyone being happy or graceful or kind: how *could* they be?—for they ought, if they are not, to be forever conscious of the sinister prison and slaughter-house in which they live and have their being. 'Man is a wolf to man' is the title of one of the designs for *Miserere et Guerre.* How can man be otherwise than degraded and blasted to the bone and to the bottom of the soul by the awfulness of his servitude to evil?—And how could a 'painter of original sin' look at things otherwise than that?

Of course, there *is* social criticism here: but one can nowhere detect a positive political impulse. I was about to say these pictures are too *mature* for that. Perhaps a better work would be *sincere.*

For a political impulse, in such a tragic context, would imply some measure of easy optimism—or at least the appearance of it. Politics, in such a connection presupposing as it does, confidence, in the efficacy of political reform, presupposes likewise the inherent goodness and intelligence, rather than the inherent badness and stupidity, of human nature. To be sincere, it must think that if only a *change* were effected, then the unjust man will be despatched, and the just man step into his place—remaining as just and uncorrupted as when he was a private citizen—and mankind live happily ever afterwards—or if not quite that, at least the worst evils of the social system be substantially remedied by political action and political action only, materialist principles quite equal to the task.

But for Rouault, Evil is too inveterate and pervasive to admit of such a hope—reform would have to come from another direction. The 'painter of original sin' he remains to the end: and evidences of grace are feeble and intermittent.

His mind has its being 'en una noche oscura'. A procession of crooked magistrates, preposterous businessmen, hideous prostitutes, squalidly evil social small-fry, clowns and emperors posture and grimace for us. They stare at us stonily out of his little canvases, with a pompous imbecility: or leer sideways at us from the corner of a bloodshot eye, in hostile disdain.

There has been nothing since monastic times quite so uncompromising, so opaquely dark. And perhaps why so many people today have turned to such images of life as these, rather than to more delectable ones, is because our present world has gradually become so unbelievably bleak, charged as it is with a hundred unresolved and brooding storms, crowding behind the particular hurricane of the moment.

War, with luck, can solve many things: but there seems so very much that resists solution, or should we say shows no signs of becoming molten even in the furnace of global conflict.—So what is sombre in artistic expression, in pictures or books, finds a ready echo in the conditions of the times. For I do not think I should subscribe to the explanation of Rouault's melancholy, often to be met with, in appreciations of his life-work; namely that his mind is of so sombre a cast because he was born during the Paris Commune in 1871—that his mother was flung out of bed by the concussion when a shell hit the next house and so the creator of *Miserere et Guerre* was born: OR (another line of argument) that because his parents moved to North Africa (to Algiers) in his boyhood, so unspeakably isolated did he find himself there, that his pictures surpassed all others in gloom ever afterwards.

But such an unceremonious manner of entering the world would be just as likely to produce rather a jolly chap (he'd feel that at least the world he had got into was *lively*, if full of ups and downs): and as to loneliness and isolation, I am sure that an artist who lives in Valley City North Dakota, or Saskatoon, has even more cause for complaint—yet artists from such places as a rule bristle with vitality and are very jolly indeed, and don't seem to realize that they are in a far worse place than Algiers—I mean for an artist.

These methods of accounting for genius are too mechanical I fear.

Neither a reactionary shell nor the souks of Algeria produced *Miserere et Guerre*.

As to the dark time we live in, and this causing us to register a sympathetic reaction to the dark travail of such a mind as that of Rouault, that is another matter. For although I do not believe the period produces the outlook, in the case of the artist, necessarily, yet it may cause him to find favour with his contemporaries. Among the many sorts of artists coexisting—grave and gay, forcible and insinuating—we tend to select the one who corresponds to our mood, on the same principle that we pick a phonograph record out of our collections. Rouault is the record for 'black Friday', so to say.

I will however dilate for a moment (it will be to digress) upon this time and its violence. There are some of us (and I am one of those) who have the temerity to believe that out of this universal destruction great benefits can be expected, provided everything goes as it should, and must.

The President of the United States observed, in his address to the new Congress, that it would be 'sacrilegious' were *nothing* to come of it—Yes, everything *must* in short go as it should: and I found my private hope upon the sheer numbers of those who are bound to echo that imperative —to feel as the president does—and see to it that it *does* go as we think it ought.

Having said that, I am of course free to admit that the general complexion of the mundane landscape is, in these forties of the twentieth century, uncommonly dark and uninviting. So much suffering, whichever way we turn our eyes, darkens—whatever the outcome—all our spirits.

When you consider what the nineteenth century was, and what the twentieth century is and will yet be, it is plain that the western nations are in the act of waking from a deep and rather over-blissful sleep. The American and the Englishman both dreamed a dream that lasted about a century.

I do not know which was the sounder sleeper, but I suspect that it was the Englishman, for he had not even a Civil War to break the spell: and on his right little tight little island, swarming with vigilant and deferential police constables, the conditions were even more propitious for the isolationist trance than in the New World,—where, after all, the detonations of the gangster's pistol, and the bracing atmosphere of machine politics, would always serve as a reminder of realities.

Still America dreamt quite a lot: it was 'the land of opportunity'—new virgin territory to be overrun, and in some sort looted. It was remote from other nations, safe behind its oceans. This fact induced in the American great buoyancy and optimism.—Above all, the notion of 'Progress' became a tenet religiously held.

Well, that epoch, we know, is ended. As to England, the nineteenth century—'The English Century', as it has been named—witnessed the British Empire being painlessly, or almost painlessly, acquired, saw the mercantile class supersede the landed society, saw the great British middleclass build itself up into what was in effect a Middleclass Millennium.—The Pax Britannica endured until 1914, when it was broken by the Prussians. Then *that* dream of sleepy peace and plenty ended (as the American dream ended in 1929). There was, for the English, the *levée en masse*: there was Heartbreak House. The bursting of the American Bubble in '29 altered the character of the American people.

But in examining *ideas* that came to birth and dominated that era, it is the idea of *Progress*—and everything that goes with it—that occupies the first and dominant place, both in England and on the North American continent: the belief of the well-fed and well-to-do man, that, in the first place, everybody is considerate, and very anxious to please, without an unkind thought in their hearts bless them, *good* bodies that they are! —that Nature having been at length tamed and the rougher side of human nature smoothed out to a sleek and comfortable finish, humanitarian principles happily supreme—that *now* at last we were out of the wood, or rather out of the jungle, and a new and enlightened age had begun. When we reflect what a shock was involved in waking out of a dream of *that* order and of that intensity—for it had all the convincing authenticity of the external world of sense—we see at once that the world is not necessarily quite so dark as it must appear just now by contrast. It is merely dark in comparison with the nineteenth century which was a slightly unreal interlude. Industrial technique, and all the revolutionary changes it engendered overnight, caused men to delude themselves as man had never done before. Now he rubs his eyes and sits up.

The *change* however, that is now upon us, is going to be (is already) according to any standards, tough and unnerving. That same 'technology' is responsible for that, as it makes bombs as well as bath-tubs.

Industrial technique will go on turning out its mechanical marvels every week-end, when 'peace' sets in. But the plain man is arriving at the point at which he is far less sure than formerly that these *conjuring*

tricks, and quick-change effects, have anything to do with *progress*.

That is the great and revolutionary event: that is the capital difference between today and yesterday. It is the thing that is altering the outlook of everybody more than any other single thing.

Remove, abruptly, the notion of *Progress*, from beneath the Modern World where it has been for so long solidly based, at the very centre of popular belief. What will happen then? Something terrific, that is to say when the full effect has registered. It will leave a vacuum so great that it will alter the thinking of everybody: it will be in the class of Darwin or the internal combustion engine.

Mr Henry Miller, the New York born author of the *Tropic of Cancer*, returned to the States in 1940 after an absence of ten years in Europe. His unceremonious manner of referring to his native-land is 'air-conditioned vacuum'. This was in 1940. I judge that he had remarked and understood that novel vacuum of which I have been speaking. From Washington Square to Columbus Circle he noted I suppose a great *absence* of something that formerly was there—a spiritual, or ideologic, something: a blank where before there was a belief.

But there was that *gouffre*, you recall—that chasm—which Pascal forever saw at his feet. Well it is a void like that.—Only Pascal's was not *air-conditioned*.

However, there is the situation: in some degree, in all the western lands, it is *le vide*, felt to be everywhere: and every year that passes men become more conscious of it; are more terrified by it—for very naturally, it alarms. And there are fearful aspects of these great changes that are taking place, as we are all but too well aware: Russia and China are great tragedies, although they will be victorious powers: a melodramatic glare is over everything.

Now, I will resume my discussion of how religious expression is found, more boldly creative, less tame, more free, than for a long time past, in the field of contemporary art, and will take up again the problem of that 'monk of modern art', where I left him for the purpose of this brief analysis of the tragic coloration of our world.

Such are the conditions of the time, for which the art of Georges Rouault has proved to have so deep an appeal.—He comes with something as it seems from very far away—for this devout Christian, apprenticed as a boy to a glazier, and painting still as if he were at work upon a stained-glass window (the *leading* of which is represented by the thick black lines which characterize his handiwork)—done for a chapel five

hundred years away, instead of producing an easel-picture for a smart Paris picture dealer—this strange master is anything but 'modern' in the ordinary sense.

He is having a great influence among the young. He is one of those who have been called to fill that vacuum: that pit—that bottomless bomb-crater—left by the exorcism of the notion of Progress, among other things, in our society.

That there is very little of the archaeologist about Rouault is however a fact of importance—for if he were merely archaic he would not have interested his contemporaries. He arrives from very far away, certainly, but he speaks in the idiom of the twentieth century, even to the point of employing the slang, the cant phrases, of the moment. His great effectiveness lies in this. To be at once old and new is a difficult acrobatic feat, but Rouault has accomplished it.—I am reminded of an occasion when the poet, T. S. Eliot, and myself were spending a vacation on the Loire and we had gone over one morning to visit a famous French monastery. We went up to the porter's lodge and enquired if visitors were admitted, and at what hour.—The porter told us the hours, and suggested that we fill in the time by visiting the church, a short way up the street.

'Ah you should see that!' he boomed. 'It is very fine.—It is *very old— c'est très ancien !*' Then detecting, as he thought, an expression of disappointment in our faces, he added hurriedly—'*C'est très moderne !*'

'It is very modern'—or alternatively, 'It is very old!' that is a comprehensive formula. Really Rouault is like that church. You *can* say about him—if you are in the same predicament that the porter believed himself to be in—'*il est très ancien ! il est très moderne !*'

His mind I suppose might be found too *modern* for the taste of some: but its archaism is objectionable to nobody.—All one can say about Rouault and his treatment of humanity, is that he *suffers*—he is *not amused*—by what he sees: and by what he believes to be the reasons for what he sees. For Rouault each of us is a *datum*, something fixed and preordained: a fearful symbol in some dark and possibly perverse theological equation. For the philosopher on the other hand, to turn to that other type of mind, we are indeed *horrible*; but *why* we are that, is the first step, merely, in a fascinating philosophical inquiry.

As William James suggests, however, in a passage of great penetration, we can do worse than begin with this strange box of tricks that is *our-selves* in the construction of what is to be our 'system'.

It will be obvious to any member of the audience, I take it, by this

time, how much beside the point it would be when confronted with one of Rouault's images, to object that 'there is no *beauty* in it'. *Of course* there is no beauty! That is the whole point of it!

Beauty of a certain sort—the delight of technical mastery and so 'beauty', if you please, to the eye of the specialist—there *is*. But that does not enter into the controversy: for *technical mastery* can occur equally in the rendering of *pleasing* images, or of *displeasing* images. Raphael can be as technically exciting as Rops or as Dali. And in Rouault's pictures of pairs of fearfully animalized puppets, or in Picasso's sculpture, where there are billiard-balls for eyes, and potatoes for noses, the *subject-matter is of the first importance*. The subject-matter is anything but accidental (or as it were *incidental* to some technical achievement). It is a great mistake to suppose that it is. It is *ugly* on purpose. All these figures of Rouaults are *meant to be* villainous. For it is villainy upon which he has his eye fixed, to the exclusion almost of everything else. And if his friend Bloy is surprised and disgusted at encountering the scowl of an assassin where he expected to find something else, that is Bloy's fault, not Rouault's.—*Since all men kill the thing they love*, are they not all assassins, Rouault might have argued: for he did not believe in Bloy's pair of bourgeois turtledoves, and that is all there is to it.

That Rouault is a one-track mind, again, goes without saying. He is almost like some inspired parrot, as he goes on repeating the same thing over and over again. With the repetitive hypnotism of a slogan, he goes on showing us one set of things—almost the same things again and again. And they are all evil. But he does not do this as a result of any appetite for the diabolic—at least that is plain enough. What is evil has imposed itself upon him against his will, so greatly does he abhor it. *That* is perhaps his tragedy, rather than the accident of an exploding shell which precipitated his birth, or any other physical accident.

The culture of the French, the Latin culture, is very different from our own: that is perhaps a matter that should not be neglected. The Anglosaxon mind—so breezily practical and animal, so little inclined as a rule to the mystical, so shy of art and all that is 'queer'—will always find it difficult to fathom these harsh and 'pessimistic' images, that come to it from Latin and of course Catholic lands.

Yet, if we import these images among us, or allow them to be imported, as is happening today—for New York is filling up with Rouaults fast, and there is even a house in Buffalo that is packed with them—then

it is our business to try and understand them: and not merely to reject them as *Unamerican* (as they certainly are) or as *Unenglish*. And I do not believe that perhaps the best method would be to approach them as if they were a by-product of some savage medieval rite—indulged in by Dagos, Wops, and others (whose inferiority is perhaps most clearly demonstrated by their extraordinary aptitude for *Art*—especially for *visual* art; for visual art, the most *Dago* of *all* the arts!).

Humility is generally recognized as being an emotion not found in great abundance in the human species because I suppose it conflicts with the instincts of self-preservation: and a religious discipline that promotes it, or attempts to do so, labours for the good of all. But race plays its part in such things as this: and Rouault possesses a beautiful humility and most genuine modesty, which is met with less infrequently in the old races than the younger ones.

French painting is seldom detected putting on airs—putting on dog. How *natural* it is, like good manners; and self-effacing. The *violence* of Rouault has a quite different origin to most of the other violences in the pictorial expression met with in Paris, that great cosmopolis.

The humility which is natural to Rouault is a factor of great importance, for an understanding of what he does. It accounts for his identifying himself with the 'humble'—with those who suffer—rather than with those who are placed over them, and who so often forget the responsibility which is theirs, as a consequence of their station, or the wealth that society allows them to accumulate.

Since Rouault has been selected by me to demonstrate on—in consideration of the fact that he is one of the latest scandals on the cultural scene over here, and easily accessible in such places as the Modern Museum in New York—and since Rouault is *par excellence* a product of Latin mysticism as much as the sculptors who carved the gargoyles, to embellish medieval cathedrals, let me dwell for a moment upon this aspect of the matter, the fact of the difference of the religious, as well as cultural, backgrounds of *this medieval modernity*. (For of course, most of the things that are today surprising you by their *newness*, or by their *strangeness*, derive from the Past. They are novelties, of the same order as the dinosaur, if that could be brought back to life.)

I have no intention of trespassing into the field of religious controversy. But although most people here belong, I expect, like myself, to another communion (are not Roman Catholics) yet we are all, I am sure, prepared to *give the Devil his due*, and to admit that the Catholic mind

has certain advantages over ours. It is far more *mature*, to start with, as one would expect from the adherents of 'the Old Religion' (as it used to be called in England). In some respects it is less frivolous: it does not *cry for the moon*, as we do. Nor does it prate of 'Men like Gods'. It does not desire to be so 'beautiful' itself—for it *believes* that it has evidence of so perfect a Beauty that all it could pretend to in that direction would be *peu de chose* and not worth bothering about. In a word, that mind is more *humble* than ours.

Writing once upon a time about the God of *Emergent Evolution*, or of the mystical experiences of William James (or what is really the God of Comte namely '*Humanity*') I pronounced myself as follows: 'Looked at from the simplest human level, as a semi-religious faith, the *Time-cult* seems far less effective, when properly understood, than those cults which posit a Perfection already existing, eternally there, of which we are humble shadows. It would be a very irrational conceit which, if it were given the choice, would decide for the '*emergent*' TIME-GOD, it seems to me, in place, for instance, of the God of the Roman faith. With the latter you have an achieved, co-existent supremacy of perfection, impending over all your life—not part of you, in any imperfect physical sense, and touching you at moments with its inspiration.'

As you will gather from the passage I have just quoted—where I am for the Thomist God as against the pantheistic God of the Evolutionists—I am disposed to particular sympathy for the Catholic habit of thought. And that metaphysical school of painting that has sprung up in Paris, with a coloration like a poem by Donne (it certainly is not all Catholic, but it has been *nursed* in a Catholic and Latin soil), the works of that school of metaphysical painters I would always support, whatever direction I might take myself.

The Majority, I suppose, still desire Raphael more or less; but *not enough* to insist on getting it. And the grimacing monster, on the other hand, is only given the glad eye by a *very few*—not enough to make the world entirely safe for the monstrosity, or to enable the *monster* entirely to supersede the Madonna. If it is no age for a Raphael—if it is a time when the darkest, most grimacing monster can come out into the open and be greeted as a normal denizen of our world—it is not yet a homogeneous age at all.

Then there will always be people whose equanimity is impaired by a visit to the baboon-house at the Zoological Gardens: and there will always be people who resent such humanely unattractive images as those

presented us by Rouault. For they fail to comprehend the masquerade.
They prefer to look upon Evil *masked* if they must, not unmasked.

One does perhaps require, let us concede, a certain taste for the
macabre, as well as a robust humility. But there it is—you are not bound,
when you go to the Zoo, to look at the anthropoids, the serpents or the
hyenas. You can spend *all* your time with the humming birds and the
Flamingos. There is nothing to stop you. And who would be prepared to
say that you were wrong?

For the great mistake that everyone is liable to make in talking about
this type of art—especially those who, for whatever motive, are inter-
ested in advertising it, and, of course, those who succumb to mere
ballyhoo—the great mistake is to assert—or to suggest—that it is the
only sort of art. That of course it is not. It is an extremist expression.

But there *are* epochs. For every time and place there is a dominant
cultural strain. Only fools or saints go against that. And for the dark
times in which we live the *Dark Night of the Soul* of Catholic mysticism
is very *à propos*. That is how it comes about that a throwback, like
Rouault, to medieval pessimism and dogmatic disgust with his kind,
has a measure of popularity: how such a mind as his comes to find itself
in the same camp as the destructive materialist, or the (equally pessi-
mistic) idealists.

We all feel today, I suppose, that things have to get worse before they
can get better. If we are not actually entering upon a so-called 'Dark
Age' we are in the first years of a *dark spell*, at least. So it is little wonder
that we demand something fairly bitter in our imaginative art. We are
out of sympathy with beautiful things.—And with those with any pre-
tension to be *intellectual* that is especially the case.

TOWARDS AN EARTH CULTURE

The Eclectic Culture of the Transition

From The Pavilion, A Contemporary Collection of British Art and Architecture. *Edited by Myfanwy Evans, 1946.*

Great confusion prevails in the arts—those under consideration here being the arts of painting, sculpture, and design. No unity, either of purpose or technique, is apparent, such as obtained in former epochs, so that it is easy to recognize a work as belonging to such and such a country and period. In some ways this confusion follows very closely the pattern of the social confusion of the present day; too closely, one might say. There is no one conceptual centre of our life but a score of centres, no religion or ideology imposes upon it an organic pattern; all the patterns are too small and local.

First, ours is a society in sluggish transition: there is everything in it from the earl, still 'belted' and still called 'my lord', to the ex-taxicab driver raised to Cabinet rank; from the monocled Blimp of the Carlton Club to the communist; from the adherent of free enterprise to the totalitarian doctrinaire of iron control. People live on dividends earned for them by the ill-paid labour of many men—we are ruled by people vowed to abolish such social malpractices (which is rather like watching a spellbound constable staring disapprovingly at a burglar loading his swag into a stolen automobile, but making no move to stop him). So, politically, figures out of different eras and economic systems exist side by side; there is little wonder, therefore, that in art there is a jumble of everything, too. That situation alone would account for a good deal of puzzling contradictions.

An even more powerful agency of intellectual confusion, however, than the antinomies of the social scene outlined above, can be shown to exist. I refer to that more comprehensive revolution brought about by those great twentieth-century techniques, of flying, radio, cinematography, rotary photogravure, and so forth, unifying the nations in spite of themselves. We should all give thanks for, and in any way we can promote, this union.

A visitor to London galleries, seeing the Picassos brought here by the British Council, seeing Jack Yeats vying with Matthew Smith in

dashing density of pigment, with cliffs of paint making all contour superfluous; seeing Graham Sutherland or Mr Bacon cheek by jowl with the late Mr Wilson Steer (who has now been canonized as one of the greatest painters of all time, not just, as we had thought, a tardy English impressionist, with a tendency to imitate Constable), and a score of other contradictory sights, would undoubtedly receive an impression of inconsequence and chaos. Eliminate the violence of the more radical craftsmen, there is still no common goal, no common style.

But what of it! This confusion is a healthy sign, as I shall explain shortly. It shows that the national barriers have been broken down—there is no cultural nationalism any longer (to illustrate which let me instance the fact that Moore, Piper, Sutherland and Smith are among the most popular modern painters as far away as in the American Middle West, where many people, I found, possessed one or more of the Penguin Modern Painters series). Actually we are beginning to have a genuine international, or cosmic, culture; even though, alas, no world-state is yet in sight. And as the political barriers around nations are no more an obstacle to ideas, so the time-barriers have largely disappeared. With the wonderful deluge of colour-plates and photographs—especially that finer work pioneered by the Germans and French—T'ang is as near to us as, if not nearer than, the neo-classicism of David, or even the Impressionism of Monet.

The confusion turns out to be, in the main, then, merely a general eclecticism, characteristic of this period, on the one hand; on the other, and as that regards the social scene—naturally reflected in the arts—it is merely that one set of people are moving out (as the result of an expulsion order, actually) and another moving in. But that is being done in a pleasant and leisurely way, *both* being momentarily there under the same roof, all mixed up together like one rather seedy-looking family; the retreating Chippendale mingled with pieces of the incoming proletarian parlour-suite: the pictures of the newcomers going up on the walls before those of the former tenants have been taken down. So Mr Sutherland's (new tenant's) admirable goal-posts crowned with barbed-wire are to be found frame-to-frame with a pastiche of Constable by Steer (old tenant's).

Finally, let me repeat and particularly stress the new eclecticism is a most happy event (in its wider human portent). For a painting by a British, or American, artist in which the roof of a house reminiscent of the Willow Pattern shelters a figure reminiscent of Altdorfer, dressed in

garments which strongly recall those of the Pueblo Indians, with a background that might be a Klee imitated by a Japanese—*this* would be a sign as solemn, as replete with promise, as the arrival of the dove at the Ark. Such things mean that the racial and national prison-walls are crumbling; that the cosmic society of the future is already in being, in however rudimentary a form—and if as yet established in the cultural dimension only, since upon the 'real-political' plane there is no footing for it yet.

The artistic confusion follows if anything *too* closely, I said just now, the social turmoil. I meant of course that the artist's concern was primarily with art. But there is nothing self-evident about that statement, and I have not very great confidence in its truth. For instance politics has come to occupy the place, to some extent, formerly occupied by religion, and it is easy to see how brooding on social justice might induce in the artist a romantic violence which will come out when he passes over, with his brush, into the dreamland of the Unconscious. There are pictures which are as truly the instruments of Belief as an altar-piece or psalter. Contrariwise, if hardboiled and averse to change, an artist may be prone to select the most placid subjects: he may go after scenes of a nostalgic peace, existing only for rich tourists, with their pocketbooks bulging with money they had stolen from the workers. These two types would account at least for two very marked classes of painting, the coexistence of which is in itself a source of popular bafflement. All the confusion we see is not due to the replacement of one social system slowly by another; but for a discussion of the question of the artist's responsibility or the reverse it affords a basis comparable to that of religion.

The 'pure artist' is, I fear, the bunk, though I daresay the more a man was born to be that only, the less apt he would be as a religious, or as a political, instrument; since, like the man of science, he is wayward and speculative. Everybody, however, is necessarily politically-minded, as once they were religious-minded: and the artist as a rule is highly influenceable. In these circumstances, unless he is endowed with a very remarkable intellect, a most unusual occurrence, there is no particular harm in that. Religion, or creative politics, would gain something and art be very little the loser. But admittedly it is a difficult subject.

How much latitude should be granted to artistic expression is indeed quite extraordinarily difficult to decide. Simply from the standpoint of

art, artists are at their best, probably, when most free or irresponsible. It is the comparative value of art itself, as you can see, that is at this point the question.

That detachment and intellectual incorruptibility of the great man of science should belong also to the artist. Such is the view of the artist. In the one case scientific truth, and in the other the magic of language (either of words or the direct language of imagery or the musician's aural medium) is the first consideration. Had Charles Darwin when he began investigating the descent of man been influenced by the thought of what effect his researches might have upon the moral laws by which the life of that creature is governed, in whose 'backgrounds' he was so interested (not to mention Christian compunctions concerning what would happen to the doctrine of the Fall and so on) he might have compromised with biologic truth and not given Adam a tail. Had Rutherford been deterred from bombarding his atom by scruples as to the diabolical power he might be putting at the disposal of irresponsible governments (no more fitted than schoolboys to possess such knowledge) nuclear energy would have remained locked up in nature, for the time being. Both these discoveries have been productive, and are yet to be, of far more harm than good; indeed there is a fair chance that one of them will wipe us out altogether.

I should I suppose, ultimately, support complete freedom for science and for art, whatever might come of it. But then I am an artist. Just as no scientist, that enquiring man, would agree to putting his inquisitive impulse in leading strings, so no artist would chain up his impulses to a great Authority, if he had his way. These modes of self-expression become dear as life itself. This particular problem has been admirably stated if not solved by Mr Herbert Read (*Art and Society*). He sets out to demonstrate that art is an autonomous activity of the highest importance. Especially is he concerned to show that although art has been regarded as 'the handmaid of religion', as being deeply influenced by, if not submerged in, it, in fact it has always led a free life of its own. Even when serving religion it is not identical with it. It is a leader, in other words, not a follower. Everything must be risked for, everything sacrificed to, this 'vitality', or this intuitive knowledge, superior to the deliverance of reason. Man's rational self is a poor thing in comparison with *that*.

An oil-painting may not be able to do what Dr Freud, or Nietzsche, or Dostoyevsky, or Karl Marx can do, any more than a flower can sing, or

a song-bird write a poem; but art is of transcendent value. Such is Mr Read's thesis. It is perhaps a pity that having rescued art, as it were, from Buddhism and then from Christianity, Mr Read should seem afterwards to be handing it over to a more contemporary cult.

Such ultimate problems as freedom are of great intricacy, and this work of Mr Read's is all too short—little more than a handbook. The liberators—like Freud—are preferable, whatever harm they incidentally do, to the restrainers—the religionists or political zealots. The first can be responsible for an explosion of silliness, nothing more; too much Freud may occasion that. With the other comes the gibbet and the stake, Gestapo and gaschamber. Although you might say to yourself—while turning over in your mind those conditions for which Mr Read so reasonably and, unlike many of his fellows, so unemotionally argues— you might think as you read that, given a great religion, or even a creative political doctrine, promising great happiness to men, the best thing art can do is to identify itself with that: faithfully serve it, rather than go its own sweet way, supplying as it were rival intuitions claiming at least equal privileges.

When I learnt that Picasso had become a communist I felt, I remember, that there was something straightforward and dignified about that. So many people fool around with communism—get all they can out of it, gain intellectual approval and prestige without committing themselves. About Picasso there was nothing of the little Pink however; there was an obvious logic in this violent man—who has described his own work as 'the sum of all destructions'—taking the step he did. But it seems to follow, does it not, that if a Picasso enters with his talent a militant institution, more possessive than catholicism, then there is no good reason why less gifted people should be jealous of their artistic independence and careful of the prerogative of their less illustrious ego ? In the past, too, one remembers very great artists sinking upon their knees at the foot of their own painted crosses—who certainly would not have supposed that their pipe-line to the Freudian Unconscious would be capable of tapping a truth superior to that of the Christian revelation.

But, as I started by saying, this is a most difficult subject. Having, as you peruse so interesting a book as that of Mr Read, made some such qualification as the above, and decided not to underwrite his conclusions (especially as, in one sense, he seems to be giving away his argument) nevertheless you will keep an open place in your mind for this and cognate doctrines.

N

Although there is no unity of style or purpose in contemporary art, that does not matter. It could not be otherwise. In so far as you or I may have fixed ideas as to the kind of society that would be the best for the world, or for such and such a region, we will think certainly there should be unity at least in that respect. But there is a more comprehensive dynamism involved: in cultural, as in racial and national matters, it loosens everything from its ancestral hold and plucks it away, into the common melting-pot. I would consider it a favourable sign if the confusion increased rather than diminished.

We are in transition from being a number of locked-in, parochial, national communities, to a cosmic social unity of some kind (this not precluding more wars of a nationalist complexion, most unfortunately, since while there are sovereign states there must be wars). Manners of expressing ourselves in the past have had the stamp of locality and race very strongly on them, in the arts as in everything else. But a 'regionalist', or a nationalist, today, anywhere, is the *last* of his species. There will be no more Sean O'Caseys, and it is only because Ireland is a hundred years behind England that he exists at all. (He is a nice thing to have certainly, but today sad and unreal.) The painter is the most internationalist of all artists, his sign language being universal. In consequence he is of great importance now, since it is only his mind he has to universalize, not his language.

Examples of universalizing artists, in the past, are not of great use as illustrations because their tendency was sentimental or romantic. Yet it is worth mentioning Whistler, who got himself a Japanese eye, or Gauguin who acquired the visual habits of Tahiti. More to the point is Picasso, who has gobbled up the primitive tribal art of the African and Polynesian and a few others besides. In this way artists should continue the eclectic process, for it is of great social value. Whether it is Whistler's Butterfly which transgresses national and racial frontiers, starting in Japan winds up in Cheyne Walk, or Picasso's Manitou (that is Algonquin but it makes no difference) exerts its malefic powers in the Quartier Montparnasse: all this is what is needed. The old days were bonnie, we know, but all the scents and colours have faded from that. So, however nostalgically inclined, is it not best to turn to a new universal unity rather than to refurbish a little local one? I write this for British ears.

There is a kind of chronologic nationalism, too. Looked at properly, *fashion* is that. It is confining. In those arts where things can be quickly

TOWARDS AN EARTH CULTURE

turned out, fashion has always been more prevalent than in the more monumental ones. But men have freely moved up and down in time and refused to be screwed down. In painting and sculpture they have for whole periods removed themselves into other times and thought as Greeks and Romans. In architecture, in fact, they seldom stop in their own time. If they build a church, for that they always move back to the Middle Ages; a Town Hall would be regarded as all wrong if it looked contemporary. Roman cornices and Tudor timbers are ubiquitous in the Machine Age (and why factory executives do not sometimes wear tights or togas I have never understood; our clothes are about the only invariably contemporary thing about us).

A man anchoring himself, however, to a particular tribal valley and cultivating a geographical and tribal emotion, would be a matter of far greater offence than should he refuse to be chronologically promiscuous. The first is, in what Mr Byrnes would call 'the atomic age', an act of sabotage against the international idea (the promotion of which is essential to our survival). The second may even be a virtue. It does not militate against the eclectic, and you can be 'classic' without taking to the peplum like Racine or Lord Leighton.

That the motley scene presented by the contemporary art-world is a source of annoyance and bewilderment to the average member of the public is unfortunately true. 'Mad letters' in the papers, both press and radio controversies, remove him further every day from the normal enjoyment of art. This is disastrous to the artist, it goes without saying. Often a man is driven off a quiet little picture which he is about to acquire by the uproar caused by partisans and pundits collected rapturously about some large violent canvas. It may be that the little picture is as good as a Chardin and the big violent one not worth much more than a commercial poster. The Chardin goes unsold. Or the big violent canvas may, in its violent way, be very good; but people are frightened away from it more by the outraged bellows of other members of the public than by its dramatic power, its distorted forms, and loud strong passionate colour. So it is as difficult for an artist at times to be violently dramatic as it is to be restrained in expression, or to deal in understatement, if so inclined. A false value is imported into everything by the pundit and the bagman.

Those who seek to provide themselves with a guide to the contemporary maze of art usually receive that guidance from people with an

uncommonly big axe to grind, either a business, a political, or a crankily-emotional interest. The obsession of the average man about 'beauty' is a major obstacle, and indeed since we have taken to deep-sea diving some of the monsters we bring to the surface from the depths of the Unconscious are certainly not prepossessing. So everyone writes letters to *The Times* about it as they would about any other monstrous or exceptional birth.

I should in one sense be a bad guide, because I enjoy everything that is good in its kind; and partisanship is necessary with many people. They like their guide to be *emporté*—otherwise they feel no enjoyment. Upon the English scene I like what I have facetiously, but by no means slightingly, called Sutherland's goal-posts; I like Victor Pasmore's *Flower Barrow*, John Piper's de Segonzac-like *Curfew Tower*, or Irish de Brocquy's *Clothesline*, as I do interiors often seen here by Matisse with a bowl of bold flowers and a boldly spotted curtain. Only the linoleum school leaves me cold. I have never met anyone with so little taste as to dislike Henry Moore—so that is easy. But I even like—(I perceive I was about to utter a libel. But I hardly ever hear anyone say a good word about this unnamed one though they admit his gifts).

This catholicity is very rare, and scarcely respectable. It is seldom met with among pundits or journalists, though sometimes artists have it. The former are hot partisans. They will make a Church of anything—an old sail with bird-droppings on it or the pelvis of a musk-ox.

In Picasso we have a standing example of catholicity *in practice*. His is—or was—an example of the workman's wholesome attitude. For ten years (starting about 1917) he led a Jekyll and Hyde life. One day he would paint a classical picture; he was *School of Ingres* to start with—he would examine an Ingres drawing beneath a magnifying glass, and then forge an Ingres with consummate skill. But next day he would paint a strident abstract pattern, with an eye in the middle of the nose—the usual thing. Then next day back to the classic graces—the pure line, the melting delicacy of exquisite transitions, the noble carriage, le bel air, the large tranquil eye. Then once more, the following morning, the barbaric pattern, the planes screeching and jarring, the mouth eaten by syphilis, the ear in the middle of the cheek. It is obvious that he enjoyed both equally, or he would not have done them on alternate days for so long. He enjoyed as much limning the features of that empty face beloved of Classic Man as he did interpreting the repulsive power of Machine Age Man. Then his classic products began, as if in mockery,

to have larger and larger hands and feet, their eyes grew more bovine and lustreless. Then the whole thing stopped. Perhaps his wonderful vitality may have flagged, otherwise I do not see why one of these two modes dropped out; for the one that he now carries on with alone has altered very little for a long time.

Here should be, anyway, an adequate alibi for one prone to catholicity of taste. There is no occasion to apologize for deriving great enjoyment from both a fine Degas drawing and a painting by Miró. These are not religions, but schools, and such enjoyment is not an act of faith. During the Italian Renaissance classical antiquity was a fanatically adhered to fashion; but today we remember Pico della Mirandola for keeping his head and preferring to do homage to the genius of every age rather than to shut himself in with the genius of one.

There is one thing upon which I feel I ought to insist. In so far as this is an age or period, and not merely the chaos of an interregnum, Picasso was alone contemporary during his ten years of double life to which I have alluded, or when he was engaged upon his satirico-abstract compositions, or his Dahomey, Kaffir, Solomon Island pastiches.

It is a commonplace of criticism today that a harsh and distorted mode of expression in painting, writing, or music, is the only one that testifies to a sense of the present; whereas work provocative of a happy mood, that is pleasing to the eye, the work of a strictly rational spirit, does not. It is probably 'escapist' or 'Ivory Tower'; and work that betrays no trace of anguish, strain, or horror is wanting in timeliness or sensitive awareness, or is just bad politics. Myself, I incline to adhere to the view that Dali's most Freudian escapades, the grimaces—swollen snouts with eyes stuck in them like elongated sores, epileptic dentures, distorted jawbones—of Picasso, are the accurate aesthetic measure of this age. There is no classic art today (except, most paradoxically, Picasso's), but if there were it would probably be more disturbing than what there is, just as we should be disturbed if suddenly lapped by soft Lydian airs at a place of mass execution, or if moving about the ruins of Hiroshima our ears were abruptly assailed by a jaunty Souza march. There *is* a time and a place for everything.

The Renaissance was a resurgence of Pagan values, after a thousand years of mystical disciplines. The rediscovery of antiquity at that time is comparable to our own intensive popularization of all the cultures of the earth, great and small—from the most simple and primitive to the

most elaborate and highly civilized, from the dark world of the Medicine Man to that softly-lit and delicately appointed one of the Mandarin. Such popularization was made possible as I remarked above by improved techniques in photogravure and colour-photography, and the researches of historians, ethnologists, the enthusiasm of collectors, and with an emancipatory bias in the field of the philosophy of art. In the influence upon our cultural life of this tidal-wave of information about alien cultures there is an obvious similarity with that of Renaissance Man. But there the resemblance ends, our tasks quite different ones.

The humanistic culture of antiquity, which began to be unearthed in the thirteenth century in Italy, was that 'healthy and worldly' Pagan one which had been displaced by a great religion. Religions are, in the nature of things, never gay, lighthearted, or sunlit. This one was of a particularly sombre cast. Its appeal was to the masses. In its earliest stages it represented the end of all things as imminent. With a doctrine steeped in the deepest tragedy throughout, from its cosmogony of the Fall to the terrible melodrama of the public execution of a gentle and saintly god, it cast a shadow of grief and guilt over all the Christian nations. So the thousand years of Faith was an austere period, one of endless mourning for a dead Messiah. Since of course it is very difficult to be a Christian, men amused themselves by crusades and mass persecutions, much as we do now. The Renaissance, coming after this, was (although politically violent) abounding in vitality and the healthy sport of living such as sparrows and peacocks enjoy. The vitalist values predominated again, in contrast to the transcendental ones. Men thought of *happiness* once more, without a pricking of conscience—they went out of mourning: and such a philosophy as that of Jeremy Bentham was one of the last great manifestations of humanist vitalism, prior to the onset of the mechanical age. Even Bentham's aversion to the cleric was the logical attitude for such a teacher to adopt, for *happiness* is not a Christian watch-word. Happiness is only, in the Christian metaphysic, for the Other World.

Nothing could be more unlike the spirit of the Cinquecento than that of the twentieth century. Even it is significant that whereas the nineteenth century harked back to the Italian Renaissance (for which it was the great Act I of the modern age, when science freed itself from the alleged obscurantism of the cleric, and civil liberty was evolved in the new urban democracies) in this century the Renaissance is not a period much favoured, or often mentioned even. There is none of the sunlit animality of Cellini's world, or the scholarly cynicism of those days

when the Popes attended performances of Plautus, when the Madonna became a pagan idol, serene and dimpled. We are back into a sad time again, of transcendental values, although, paradoxically, there is no great all-pervading religion. Only politics.

Many minds, it is true, have turned to the Old Religion, as to a sanctuary. Newman was the first great figure to give the lead in England to this movement; there have been many Newmans since those days. But Christianity is divided into a number of sects; although influential, it certainly is not responsible for the darkened atmosphere, the flitting across our crepuscular scene of fakirs, for the ethical passion. That derives, in part, from another direction.

A religion of Man—the Law of Nature, erected into a metaphysic—as it is a regenerative force, is naturally uninterested in the joy and glitter of life. It is anti-humanist, critical of all the values, in decay, it found there when it came, and it has captured the soul of all this generation. It is not only a Party: it is a new ferment present in all parties. It has been compared to institutional Christianity, but is a puritanic force. In art it does not so much eschew the image as scorn the natural, all those things at least that belong to the easy comfortable vision of the bourgeois ethos. It is as it were the ethical end of the great revolution imposed on us by scientific techniques. In the arts an influence largely indirect, some of the violence, some of the prevalence of tragic motives derive from it. One well-known continental art movement is explicitly its offspring with Freud as co-father.

But not only social life, and plans dynamically to purge it, but all human life is involved. As at present existing man may be inadequate to carry on; the crisis arising from the fact that at last his simian inventiveness has outrun his moral and intellectual powers altogether. Nuclear energy, the latest of his discoveries, is so terrible a challenge to those feeble powers that no one could guess what is about to happen.

However, in conclusion, although you might, like myself, incline always to unity, there will be none until all the fragments of the present world-eruption have been dissolved and a new, this time universal, pattern has emerged. Already glimpses of this future integration may be obtained. We have to live in a chaos. Let us wear our motley to the best advantage, and let us pride ourselves on the number of different patches we display, the more the better.

The works of mine reproduced here are not examples of the eclecticism I advocate in this article. They are a fairly homogeneous group

of recent paintings and drawings, the work of a few years (brought abruptly to an end by the war) of concentrated effort to a particular end.

But I should perhaps add, before concluding, that just as eclecticism as a policy would find its justification in a new synthesis, so, in the case of the individual artist, his personality will all the time be creating a personal synthesis. Even with so mercurial and promiscuous a virtuoso as Picasso, one is never in doubt as to whose hand it is, whether he is being Pompeian for the moment, or despoiling a Zulu kraal of its aesthetic contents. Nor is the great expansion of our sensibility a dispersion, nor is to universalize to thin out. It is, for a time, to thicken. Picasso, who is the champion swallower of cultures, absorbed, at the height of his capacity, on an average two or three a year. When all the cultures have been digested, we shall become a new cultural creature: an Earth Man.

ROUND THE GALLERIES

A selection from Lewis's reviews in The Listener *of shows in London galleries between 1946 and 1951.*

MICHAEL AYRTON (9 June 1949)

When interested by the work of one of 'the young', I like if possible to check up on personality and physique. For I know that this poor devil has to pass through two or three more wars, a revolution, and a number of depressions. Most, I feel, will fall by the wayside—their talents will die, if they don't. But about Michael Ayrton I entertain no anxiety: his stamina is unmistakable, since it is of a piece with the air of stability possessed by his work. At the Redfern Gallery, where he is holding an exhibition, is the classic serenity he so much prizes—even to a touch of coldness. Where the women are symbolically distressed, or distracted, by the first signs of a great storm, it is but in a rhythmic trance of distraction. With Michael Ayrton, unlike the other 'young', we have emphasis on subject-matter. It was in Italy he found this specific material, and found himself too, I believe. He may be the bridge by means of which the British 'young' move over into a more literary world again. Michael Ayrton is one of the two or three young artists destined to shape the future of British art.

FRANCIS BACON (12 May 1949)

The Hanover Gallery is soon to hold an exhibition of the work of Francis Bacon, among the most original of the young. One piece is already at the Gallery. . . . Bacon's picture, as usual, is in lamp-black monochrome, the zinc white of the monster's eyes glistening in the cold crumbling grey of the face. Bacon is a Grand Guignol artist: the mouths in his heads are unpleasant places, evil passions make a glittering white mess of the lips. There are, after all, more things in heaven and earth than shiny horses or juicy satins. There are the *fleurs du mal* for instance.

(17 November 1949)

Of the younger painters none actually paints so beautifully as Francis Bacon. I have seen painting of his that reminded me of Velasquez and like that master he is fond of blacks. Liquid whitish accents are delicately dropped upon the sable ground, like blobs of mucus—or else there is the

cold white glitter of an eyeball, or of an eye distended with despairing insult behind a shouting mouth, distended also to hurl insults. Otherwise it is a baleful regard from the mask of a decayed clubman or business executive—so decayed that usually part of the head is rotting away into space. But black is his pictorial element. These faces come out of the blackness to glare or to shout. I must not attempt to describe these amazing pictures—the shouting creatures in glass cases, these dissolving ganglia the size of a small fist in which one can always discern the shouting mouth, the wild distended eye. In the *Nude*, in front of not the least ominous of curtains, about to enter, the artist is seen at his best. Bacon is one of the most powerful artists in Europe today and he is perfectly in tune with his time Not like his namesake 'the brightest, wisest of mankind', he is, on the other hand, one of the darkest and most possessed.

DAVID BOMBERG (10 March 1949)

In the Arcade Gallery, Bond Street, the 'Borough Group' exhibit, David Bomberg is the leading spirit. What happened to Bomberg after 1920? Was he one of the lost generation that really got lost? Or has he an aversion to exhibition? He ought to be one of the half-dozen most prominent artists in England. When I got there, the gallery had no one in it: it was nothing but a chaos of pictures only half on the walls. Anything with which that fine artist, Bomberg, has to do you cannot afford to neglect.

EDWARD BURRA (9 June 1949)

I share Burra's emotions regarding war: when I see the purple bottoms of his military ruffians in athletic action against other stout though fiendish fellows, I recognize a brother. In the present show I find there is too much that looks like a large, not very sensitively coloured, magazine illustration. *Zoot Suits* for instance. He is at his best in *Project for Don Juan*. If I might venture the suggestion, he should avoid the familiar. He is not at home in it, and is led into banality. And no show of Burra's is complete for me without the bulging husky leathery shapes I associate with him.

ALEXANDER CALDER (18 January 1951)

Has the Machine Age a jester? Have machines a sense of humour: is a Diesel Engine conscious of being ridiculous, as is that far more extra-

ordinary machine, Man? Our digestive system is a super-machine for
the transformation of porridge, bacon and eggs, lamb cutlets and goose-
berry fool, into energy. This, in our more reflective moments, appears
to us funny. Does a helicopter or a combine harvester ever realize itself,
and does it laugh? These are the kind of questions elicited by the
mechanical sculpture of Mr Alexander Calder, some specimens of which
are now showing at the Lefevre Gallery.

Calder is an American: he is probably America's best living artist,
and he is an engineer. For a great skyscraping land, machine-made,
worshipper of technic, this is as it should be. Or so one would say
though there is the complicating factor that these contraptions do not
effect anything. They are mechanical futilities. They come from the
workshop of a facetious, idly ingenious, machine-minded man. Whether
these toys would amuse an engineer as much as they do me I am not
sure. Calder, for all I know, may have been a failure as an engineer.
My knowledge of machines is too slight, perhaps, to appreciate his
'mobiles'. It is easy to understand how a machine which has taken to
thinking, like Man, should develop hysteria in contemplating itself, and
have a laughing fit about its hearing holes, its smelling and breathing
holes, its intestinal barrel on legs. But whether the machines man
creates do, as extensions of his mind, in a sense share in such reactions
I am not competent to decide. I can only speak with confidence of a
locomotive (not the stream-lined latest model, but the traditional
puff-puff). That *knows* that it is absurd. There is no doubt about
that.

In addition to his sculpture, Calder has produced a profusion of
barbaric ornaments, some of them reminiscent of Gothic or Viking art.
As a straight craftsman, a steelsmith as we might say (for steel or tin,
not gold or silver, are the metals of his preference), he is tremendously
expressive.

Mr James Johnson Sweeney, who provides a foreword for the cata-
logue, has on the balcony of his handsome penthouse in Manhattan a
large 'mobile'. This clatters about when it blows. For its existence it has
no other visible purpose. But in his bedroom I noticed a large spray of
tinfoil, which was graceful as well as amusing. So there are two kinds of
work which have made Calder the best-known artist of the New World.
Only the so-called 'sculpture' is at the Lefevre.

As Mr Sweeney says, Calder possesses 'a very youthful heart'. His
social peculiarities are legendary and they also, with a juvenile directness,

tend to ignore inhibiting rules of social behaviour. Mr Sweeney recalls how once after dinner Calder went to sleep on the floor at his wife's feet. The host and hostess conversed over his prostrate body, but as it became late Mr Sweeney went to bed, leaving his wife to mount guard over the guest. About two o'clock Mr Sweeney wakened; astonished to find that his wife was not there he hastened to the living-room. There he found her knitting away, Calder still stretched out at the feet. When Calder came to London in the thirties people conversing with him were surprised and abashed to notice that quite suddenly he had fallen into a deep sleep. Whenever bored he slept.

The group of 'mobiles' collected in the present case are of a very different character to Mr Sweeney's rather dull and noisy machine. The Lefevre Gallery is full of a soft tinkling suggestive of an Indian temple: the air is full of the movement of large and small, black, red and yellow metallic leaves. They are the airiest things imaginable. If they touch your head or leg they gently recoil. In assembling them, I was told at the gallery, once you have found the point of balance your work is done. The system of objects begins floating around. I suppose that the Gallery is more like a tank of mesmerized, slowly groping fish than anything else. How the public is going to be got into it I do not know.

These huge toys are a mechanical triumph, obviously. Their beauty is kinetic, not visual. It is their hypnotic movement, their positions in the air, not the things themselves, which delight us.

MASSIMO CAMPIGLI (9 June 1949)

Massimo Campigli is one of Italy's most celebrated painters: and a comprehensive exhibition of his work is to be seen at the St George's Gallery, Grosvenor Street. Campigli inhabits a world in which is neither man nor mannish thing: only the effete joys of very gentle, moon-faced women. The latter have long noses and small mouths pursed at a sweet shrewd angle. You will know at once where they come from, namely from Pompeii that was destroyed. The Italian returns as naturally to the Rome of antiquity as Piper and Rex Whistler do to the age of Jane Austen or of Samuel Pepys. A *very* innocent eye, however, has to be adopted for the fresco art of Pompeii. If Campigli is as monotonous as Marie Laurencin he is a highly interesting artist, and incidentally a fine draughtsman, as revealed by his drawings and lithographs at this gallery.

GIORGIO DE CHIRICO (12 May 1949)

Giorgio de Chirico provides the great sensation of the month: and there is far more to the drama of his recantation than just a man's violent severance from his past and flouting of his fame. Imagine, for instance, on the political plane, Mr Molotov recanting. What would he become? A democrat, a social-democrat, an anarchist—or nothing? In England there is at present a retreat from the extremes: some artists go back to Cotman or to Palmer and live in their time; others to some great French Impressionist—or to Wilson Steer! So the big question of the moment is this: If you throw over all that the twentieth-century revolution in the arts has stood for (among other things the repudiation of the materialistic chaos of 'impressionism', and the re-establishment of formal values) *where are you going to*? Are you going *back*? Is that the only way you can think of going?

The London Gallery, 23 Brook Street, offers us a few examples of the earlier Chirico: a little canvas, for instance, on which is glued a Petit Beurre biscuit. Date 1915: title *Death of a Spirit*. Presumably the 'spirit' referred to is the human spirit. Near it hangs a still earlier canvas, *Melancolia*—the usual white statuary of Greek antiquity introduced into a vast drab emptiness, symbolizing the machine-age scene. For nostalgia for the past was *always* a feature of this Italian's creative impulse.

Next, to Suffolk Street: there, in the Summer Exhibition of the R.B.A., a room has been set aside for the work of the *newer* Chirico—who loathes the Petit Beurre, and spurns the 'super-real'. Some evil genius, he believes, led him to stick biscuits on to his canvases. To the consternation of his hosts (if I may judge from a conversation with one of them) he displays a sleekly-painted female nude outstretched before a stage-ocean. It is easy to understand how both Academicians and Royal British Artists must feel about this 'academic' performance. In the main decadent Impressionists themselves, how they must bristle with the dogmatic pugnacities of the eighteen-eighties at the sight of his many fanciful feudal fripperies, of the 'Combattimento sotto un Castello' type: how deeply they must feel themselves compromised at finding themselves in danger of being taken for the time-mates of Delacroix or of Chassériau.

So Chirico may change his style but not his uneasy destiny. The nude self-portrait of this silver-haired, angry old painter—as ever superbly painted—is eloquent. May he yet, fine workman that he is, shake off the

spell of the past: which first led him into a high metaphysical region, and now has betrayed him into platitude.

ALAN CLUTTON-BROCK (19 January 1950)

Really the best way of assessing the merit of Alan Clutton-Brock's pictures, at the Marlborough Gallery, 18 Old Bond Street, is to say that they display the stark opposite of 'vitality' which however does not at all mean absence of life. Just as a canvas of Pasmore's (whose work some of these things recall) is not looking for power, any more than Henry James was trying to be a big barbaric passionate writer, like Zola, so the last thing that this particular painter wants to do is to knock you down. Hemingway once described (as another illustration of what I mean) how one of those from whom he learned his trade in Paris counselled him to turn the gas down lower—this figuratively of course—lower and lower yet, until it was almost extinct. But Clutton-Brock might almost have been listening to some such stylistic advice when he produced a most admirable painting called *Elevenses* of a woman and child sitting at a table. The faces are seen in that ultimate moment before the gas fades out altogether! Opposite this is a highly successful flower piece. The pigment is always pure and light, faded biscuits are favoured, discreet greens, no colour that confers too rich a body. There are commonplaces: but a number of the pictures here are of a most fastidious perfection. The critic today, moving from show to show, has somehow to accommodate chaos, which I hope I have done.

ROBERT COLQUHOUN (13 February 1947)

Robert Colquhoun is generally recognized as one of the best—perhaps the best—of the young artists. That opinion I cordially endorse. Perhaps I should have said Colquhoun and MacBryde, for they work together, their work is almost identical, and they can be regarded almost as one artistic organism. Usually we say 'Colquhoun' when we speak of it. The latest monotypes of Colquhoun are very fine. The influence of Rouault is apparent. They are flat black, white and grey slabs of people: or heads set on elongated slabs, which may be aprons or whatever else very simple women wear. The fact that they are all women dispenses the artist from indicating nether limbs, and assists him in achieving a maximum simplicity of statement.

With this simplification of statement *below* the face, the face should probably conform—as is the case with Rouault—to two or three marked

Proof sheet of article from *The Listener*, including section on Alan Clutton-Brock and showing revision in Wyndham Lewis's hand.

jargon, and it impresses. Minton does not employ such adventitious aids. Nor is Minton a violent painter. I could mention several who are more like a prize-fight than he is. This is because nature is not violent and he is a naturalist. His is the classical attitude, he is not self-assertive. He may exploit—it is open to all good naturalists to do that —the violencies and oddities of nature: but never in such a way as to suggest that the calmness of nature, the norm which the snobs call 'dull', is not equally the object of his cult.

Yet going from Minton's show to the Howard Bliss Collection, on view at the Leicester Galleries, is almost like leaving a prize-fight at Madison Square Gardens and passing into the remoter parts of Central Park on a foggy autumn night. This is a large collection and there is a small percentage of exceptions; Matthew Smith's 'Roses and Pears', Adler's 'Composition—Nude', or Craxton's 'Boy on a Blue Chair', might be cited. But these are departures from a *permeating* dimness.

Here is a collector possessed of a most extraordinary prediction—for the thin brown dim amorphous world, in fact, of Ivon Hitchens, the major influence obviously in the making of this collection. I venture to think that this is a kind of pictorial-world to which a musician would b: attracted: and of course this is a *sensation*, not a criticism. Very rapidly Mr. Bliss made an enormous collection of relatively inexpensive, for preference *weightless* but invariably tasteful, things. At first one does not notice the few 'strong' things—though of course there are no Colquhouns and other 'strong' artists are in their milder moods: and probably William Scott with his eggs and frying pans is the collector having a little quiet fun with himself.

There is a most interesting Foreword by Mr. Bliss. A 'lyrical affinity' with Gainsborough Mr. Bliss sees as the prerequisite, in a picture, for admission to his collection—for joining his other ' problem children ' as he calls them (though as Gainsborough is hardly a ' problem child ', it must be Hitchens, rather, that he has in mind). The psycho-

rancid vegetation, tropically gigantic. Such pictures are not seen at their best *all around one*, in a small room. A little concentration on individual pictures will soon reveal how excellent is the workmanship. The ' Villa Solaia ' is admirably composed: and what tremendous vitality there is in the ' Tomarova '. *Vitality* is what Garman's pictures essentially possess, these heavy coarse green forms, these large pale faces in which the universal green is reflected. The huge plants are suggestive of daring tapestries, as are even the colours, with their selective monotony. The aforesaid vitality, however (although that is not all), assures this artist of a high place among his contemporaries.

Really the best way of assessing the merit of Alan Clutton-Brock's pictures, at the Marlborough Gallery, 18 Old Bond Street, is to say that they display the stark opposite of ' vitality ' which however does not at all mean absence of life. Just as a canvas of Pasmore's (whose work some of these things recall) is not looking for power, any more than Henry James was trying to be a big barbaric passionate writer, so the last thing Mr. Clutton-Brock wants to do is to knock you down. Hemingway once described (as another illustration of what I mean) how one of those from whom he learned his trade in Paris counselled him to turn the gas down lower and lower—this figuratively of course—lower and lower yet, until it was almost extinct. Mr. Clutton-Brock might almost have been listening to some such stylistic advice when he produced a most admirable painting called ' Elevenses ' of a woman and child sitting at a table. The faces are seen in that ultimate moment before the gas fades out altogether! Opposite this is a highly successful flower piece. The pigment is always pure and light, faded, Homely favoured, discreet green, no colour that confers too rich a body. This artist has lapsed: but a number of the pictures here are of a most fastidious perfection.

Handwritten marginal annotations (in Wyndham Lewis's hand): But · like Zola, · That this particular painter · B'scuits · moving from show to show, · —The critic today has somehow or other to accommodate chaos, which I hope I have done · pervasive · (H) · Constableon

types. Colquhoun uses a kind of Assyrian head which seems to qualify as one of these. But in the case of the Irish peasants the face becomes more varied, and even anecdotal. It is unlikely, however, that Colquhoun will continue for sixty years doing the same thing, as Rouault has: so it is unnecessary to work out details of that sort, as otherwise would be the case.

(23 October 1947)

Someone sets out to paint a picture of a male dancer. His will first projects an oil-painted figure upon the mental screen within—the picture I am talking about is one done 'out of the head'. It is an oil-painting already: the painter not only does it 'out of his head', he does it *in* his head—or there is where it begins. This image finds its way on to the canvas, there being modified by the *real* medium.

When confronted with a living sitter, this process is reversed. The original image appears *outside* first: namely, the sitter. This natural object, transmitted within, has to be relieved of nature's *trop-plein*, and reduced if possible to an orderly and logical shape. These remarks are by way of preface to what I have to say about Robert Colquhoun, who paints people from memory only, or produces them 'out of his head': and who, among other things, has painted a picture of a male dancer, which you will see in the illustration accompanying this article. A memory of other pictures of dancers, as well as of a living performer, has contributed to this 'out of the head' conception.

The exhibition at the Lefevre gallery is not the first one-man show Colquhoun has held, of course—there were two in 1944 and 1945—but it is much the largest. I will here reaffirm my high opinion of the possibilities of this young artist. It is unusual to find *la condition humaine* attacked, as a subject, by artists in any field in England today. There is a grave dug behind all his canvases of a certain kind: his elderly women, covered with such summary garments as their poverty and the austerity of this artist's mind allows, are poised above it, already they have the waxen pallor of a corpse. Livelier ladies, such as the earth-faced one with a fierce and famished cat shooting over her shoulder, is thrusting out a nerveless hand in one of the purposeless gestures invariable with this existentialist humanity of his. None of his female figures are troubled with bloodstreams any more than phantoms. Two 'students' sit at a table—they are ghosts: they 'study' no doubt the Nothingness from which they precariously emerge. The heavy one (perhaps a

male) is dogmatic in outline. The other student has an aggressive silhouette.

The new histrionic element, of dancers, conjurors and other performers, is lavishly coloured in bright reds and yellows, which demarcates it very sharply from all the grey women. There are some pictures belonging to the new colourful variety however which are not of theatrical subjects. A sad sullen moronic squat little picture which should be entitled *La Nausée* (No. 23) is one of the most existentialist in the show, and is overcharged with rich deep colour, without relief or relenting. For what it is intended to do it is one of the most successful of these twenty-six pictures. For a change this is a young woman I think: it bursts like an over-ripe plum with the brooding melancholy of its youth. Youth is almost represented as if it were the bubonic plague! This attitude is of course not a novelty, since for forty years, in Rouault, Picasso, and scores of other artists the same aloofness from, or disgust for, the enticing human envelope has been encountered.

Then there are the studies of Irish women. These belong with the aged Scottish women, but they are relatively naturalistic: national idiosyncrasies and grimaces are carefully noted. I should be very sorry however to see him abandon Scotland for Ireland altogether. He is more gloomily inspired in his own country. An epic drabness in the colouring can there be depended upon, the ghastly light of predestination which falls upon the locked-up countenances of his grim female pairs could not be found in the softer airs of the island of the saints.

But I must turn to the problem for which I was preparing in the first paragraph of my article. In this formative period there are some things Colquhoun has to do, or they will never get done. Now in every case these pictures, if not painted 'out of his head', are from recollections of people seen for a moment only. The danger of this, unless one possesses a startlingly accurate memory like Toulouse, is that the image grows thin or conventional. The image comes from inside and all things that come from there lack body. William Blake had his mind full of lay-figures, but he succeeded in transfiguring them, so great was his mystical excitement. The geometrical abstractist, again, does not have to worry. But Colquhoun remains supremely concerned with people's faces and bodies. Nature should be used more often by him, I would say: not to put it into his pictures, or to make them more naturalistic, but in order to enrich, with memories of carefully studied form, the pictorial intelli-

gence within, which is responsible for the pictures we do 'out of our head'.

AUSTIN COOPER (14 October 1948)

Mr Austin Cooper has a number of pictures which are like nothing I have ever seen. He provided me with sensations, too, of an order I have never experienced before. His is an abstract universe, but violently alive. His backgrounds as a poster-ace provide him with a great experience of natural form. This attempts to break through, but fails. There is no vestige of our logic, yet for another artist it is unquestionably a *speech*— a wild tongue. I do not desire to repeat the sensation: I would be as unwilling to have one under the same roof with me as a bit of radium. Regarding them is to be addressed by someone in another dimension. It is a less pleasant parallel to hearing the authentic voice of one defunct.

JOHN CRAXTON (14 July 1949)

Mr John Craxton belongs to the youthful *avant-garde*—for I have to use this term: at the London Gallery, 23 Brook Street, he is to be seen in force, with several big canvases. The smaller his pictures are the better; and when small, very good. He does not deviate idiosyncratically from many exponents of this type of montonously bright painting—as Vaughan does so markedly depart, for instance, so that the moment you see one of his works you recognize it as a Vaughan. Craxton is like a prettily tinted cocktail, that is good but does not kick quite hard enough. He is very young and will probably become more taut and individual.

GERARD DAVID (20 October 1949)

Taking these Galleries in geographical sequence, we arrive at Wildenstein's, selected by the Arts Council for an exhibition of Gerard David. Mr Friedländer's introductory note in the catalogue is not calculated to send up our temperature: 'In the history of art David represents the end, the tuneful knell of the fifteenth century in an ageing city (Bruges).' Was this the best trumpeter they could find? What a dismal blast he gives forth! But, indeed, David is so obviously the last tired wave, which has not even the strength to break but melts away with a gentle sigh, that his resurrection in the first place was distinctly unkind, and it was

typical of the Arts Council to have spent money so badly needed at home in bringing David over here.

JACOB EPSTEIN (13 February 1947)

It is impossible to speak of the new Epstein exhibition at the Leicester Galleries without referring to the recent refusal by the Tate to accept his winged Lucifer. If there is a building in London that would be the better for a little fire and brimstone it is the Tate Gallery. Nothing short of this diabolical human bird will ever take the chill from those marble halls. Is there no means of persuading the Tate committee to reconsider its decision?

For me, personally, a visit to a new collection of work by this great vitalist sculptor, where, among other things, there are heads of the poet Ronald Duncan, of Winston Churchill, and of Pandit Nehru, modelled as only Epstein is able to, brings something else to my mind. When in this country there is a monumental portraitist of so rare a kind, why was not the Roosevelt memorial statue entrusted to him?

Nothing, of course, can be done about this—except to note that once again it has been demonstrated that statues of eminent men destined for our public parks and squares, must conform to some ineluctable law of mediocrity. But those standards ought not surely to be allowed to invade the interior of those of our public buildings set aside for the display of works of art. Of new pieces by Epstein I like best a fragment of a larger composition, which he projects, to commemorate the struggles of the coloured peoples to attain a true, and not a sham, emancipation. There are chains upon the arms of the male figure. My only criticism is that the chains are too light. They should be ten times as heavy. . . .

(23 March 1950)

In Epstein's stone carving of *Lazarus* at the Leicester Galleries he has produced perhaps the most impressive of his series of giant carvings. These works, in which the subject-matter, the story, is so important, are what we are accustomed to call 'literary' today. They are literary in the sense in which the King of Judah (Chartres), Rodin's *Burghers*, or Michelangelo's *Dying Slave* or *Pietà*, are literary. Epstein in his *Lazarus* is, I believe, celebrating the great power of our blessed Lord, who *can*, today as much as then, call men back from the dead. But at the least this face rolled back upon a shoulder, the rest of the body still numb, as it

stands tied up for the last sleep, is a feat of the creative imagination. In this fine show there are a number of small masterpieces, like the gold-bronze head of Ann Lucia Freud.

HENRY FUSELI (16 February 1950)

The Henry Fuseli Exhibition is at the Arts Council's New Burlington Gallery. The Briton loves a good stiff climb. I can guarantee him a climb in this case that will bring out all that is grittiest in him. Fuseli was a super-illustrator, a rip-roaring romantic with a classical training, and he comes to us recommended by Blake as the only real person in England at that time. Eight years' academic training in Rome had made a busi-nesslike artist of him, where Blake remained an amateur of genius. To be clear as to Fuseli's limitations, think of Hogarth's *Shrimp Girl*: but *Mad Kate* shows him a painter of high order. For composition he possessed a genius—*The Women of Hastings* is a striking example. His power as a draughtsman is not exceptional. A study of Plates One and Eight in the catalogue will make this clear. An insensitive line, in both cases, limits the shadow above the nostril. A lack of any fine observation of form in the features should be noted—or anywhere else in the draw-ing. Yet the floating eyelid in Plate One is amusing, and in both designs the composition is superb.

THEODORE GARMAN (19 January 1950)

At the Redfern Gallery Theodore Garman, an important newcomer, is to be seen. On entering the gallery you are overwhelmed by a rancid vegetation, tropically gigantic. Such pictures are not seen at their best *all around one*, in a small room. A little concentration on individual pictures will soon reveal how excellent is the workmanship. The *Villa Solaia* is admirably composed: and what tremendous vitality there is in the *Tomarova*. *Vitality* is what Garman's pictures essentially possess, these heavy coarse green forms, these large pale faces in which the universal green is reflected. The huge plants are suggestive of daring tapestries, as are even the colours, with their selective monotony. The aforesaid vitality, however (although that is not all), assures this artist of a high place among his contemporaries.

CYRIL HAMERSMA (16 February 1950)

Cyril Hamersma is a barber in a hospital. When he is not shaving the patients and the doctors he paints pictures of tremendous expressiveness

—but of so austerely abstract a power that it is perhaps absurd to hope that he may be freed from this drudgery. His first one-man show at the London Gallery, 23 Brook Street, is an event. I was surprised to learn that the red storm in chaos I had seen and admired in the window was really a pair of brown shoes: and was also duly astonished to learn that the large glowing object upstairs (more like a rough tinselled cylinder in an African sun) was a cigarette. The Ecole de Paris is to blame for such confusions. First there has been the smartalecking of the dealers and pundits, of course; and then the habits of the painters themselves, in using a still-life or a bonhomme to arrive at something of so different a nature as an abstract composition. But to conclude: this elemental energy of Hamersma's, if scientifically harnessed, might be used to light and heat the hospital or several hospitals. A great deal of unwanted artistic genius will in the end perhaps be technologically exploited, like a mountain torrent or a split atom. But shaving and haircutting!

MARK GERTLER (14 July 1949)

As to what takes one so far afield as the Whitechapel Art Gallery, that, on this occasion, is a very melancholy errand. A memorial exhibition of Mark Gertler's work has been assembled there: and I cannot at all agree with the catalogue that it is most fitting it should be held in White-chapel—room should have been found for him in some centrally situated gallery. The evidence of one of this country's crimes against art is to be found in the most convincing form in this exhibition: and that perhaps is why it is at Aldgate East, where few people will see it. As the most overwhelmingly incriminating items I would select *Mr Gilbert Cannan at his Mill*, a wonderfully successful picture, and the *Roundabout* (1914 and 1918 respectively). Oh, but those are early pictures, you will object. Unfortunately for that objection there is *The Spanish Fan*. The date of this is 1938, the year before he killed himself; gassed himself, quite simply because no one would buy his pictures, and he had no money.

Have you noticed in latter-day England how artists show great promise, often, and then 'go off'—or actually go to pieces? It is not the rule elsewhere that artists get worse as they get older. Why that pheno-menon only is met with here is easily explained. Their power does not prematurely wane any more than Rembrandt's or Titian's, or Cézanne's or Daumier's, or Poussin's. No, what happens.... But you know how sweet a tooth our public has, how unwilling it is to give its attention to

anything a little severe, how it exerts its slothful, sentimental pressure from the first moment a fine artist reveals himself. Flowers, and still-lifes with jolly little ornaments soon begin to appear in an English artist's work. It is all he can sell. Some in the end do no more good work at all. Gertler *did*—it is that that causes one to be particularly indignant.

BARBARA HEPWORTH (17 October 1946)

These two artists [Hepworth and Moore] weigh in at a very different figure: [Miss Hepworth] is limited in comparison, but what she does she does admirably. It is rather like the work of a maker of musical instruments. If anyone would know how to make a beautiful belly to a mandolin or a lute it is she. If she were a potter, she would be a potter of distinction and resource. But she comes at a time—as does Mr Moore—when artists are working in a vacuum. No one wants anything especially beautiful in the way of a musical instrument; no one really *wants* anything new at all. They prefer imitations of old models, in furniture or ceramics or anything else. So Miss Hepworth begins creating arabesques in the void. The possession of one of these 'involutes', 'convolutes', or 'conoids' would improve the scene in any living room or study. The one reproduced on the previous page, looking like a titanic shell which had been converted into a musical instrument, would be a very nice thing to have. The string, by the way, of which she makes frequent use, is not a novelty. The rather questionable device was first employed, I think, by Calder. We learn from Miss Hepworth's interview with herself in the current number of *The Studio* that 'ovoid shapes as a basis for sculpture' has always been her idea. The oval form of the human head, or the body of a bird, are the ellipsoidal objects she especially mentions. There is also the egg itself, however, which is a sufficient prototype of these objects. Where Brancusi used the egg to make a human head with, the egg involves itself, with her, hatching out an ovoid extension of itself in space. A majority of these shapes have the appearance of the shell of something that has been emptied of its contents; its inside lining usually being whitish. If there is, for me, a fault in Miss Hepworth's work, it is to be found in its resemblance to commercial objects, turned out with an industrial sleekness and slickness.

But this is all I have to say as *criticism*. For the rest, this is a laboratory of aesthetics, where formal possibilities are investigated. And many people prefer aesthetics at this stage. In most cases I do myself.

<div align="center">(16 February 1950)</div>

At the Lefevre Gallery is a large and important exhibition of sculpture and drawings by Barbara Hepworth. For some reason all the drawings are naturalistic, the greater part of the sculpture very abstract. Furthermore, the drawings are described as 'Studies for Sculpture'. But for what kind of sculpture? Not that on view. The surgeons operating would make a very fine painting. This extraordinary woman would be in her element handling the white masked abstractions of the operating theatre. She should attempt a large-scale monochrome in a dry medium. Meanwhile she is showing some of those things which are practically translations into the monumental medium, stone or wood, of certain ideas of Picasso, in which she and Moore overlap. Then there are some fine grotesques, for instance *The Cosdon Head* in blue marble. One thing the abstract-primitive fashion has done is to give opportunities to the gothic imagination and to produce a wonderful crop of grotesques.

<div align="center">JOSEF HERMAN (20 October 1949)</div>

It involves an elaborate journey to see Josef Herman's pictures of miners, but it is worth it: they are at the Geffrye Museum in Shoreditch. Herman lives at Ystradgynlais, a Welsh mining village. There is no 'nobility of toil' stuff in what he does. The miner's life, as he sees it, is hideous and dark—so dark, in fact, that some of his canvases are little short of pitch-black. It is always possible to discern, however, a miner or two in slow motion—painfully slow owing to the opaque medium in which they live: either entombed in the black earth, or (as in 'Evening at Ystradgynlais') relaxing in the hideous black-red glow of the furnace-effects produced by the setting sun. He may also be seen engaged in musical relaxation: puffing out powerful hymns to the miner's black God: or milking a black cow. So go to 'Ystradgynlais in Shoreditch'.

<div align="center">IVON HITCHENS (10 March 1949)</div>

This is an artist for whom I have not greatly cared. Now I change my mind. As he emerges from his feathery jabs of paint—from capricious and accidental hedging round of Nothing, as it seemed to me—into more explicit scenes, I become his admirer.

(9 November 1950)

When an artist has evolved a manner so intensely personal that a picture of his can be recognized a half-a-mile away, and has for a number of years remained pretty stationary, it is most unusual for him to break the spell and open up on us with a new line. Yet this is what has happened at the Leicester Galleries where Ivon Hitchens has broken out of his brown web and revealed to our astonished gaze a large recumbent nude female. What is one to say, except to congratulate him on this comely girl, and wait to see what is going to happen next?

AUGUSTUS JOHN (13 May 1948)

The most distinguished Royal Academician exhibits not in the R.A. but where (to go no farther) he has more elbow-room, namely in the Leicester Galleries. Augustus John has got together this one-man show with more than usual care. A good proportion of its thirty-six paintings, with a wall full of drawings, are of recent date. These are not the least interesting—as witness the portrait head and shoulders of Dylan Thomas, a diminutive masterpiece: or the equally fine (big scale) 'Canadian Girl'.

Of the earlier portraits, we have Henry, most romantic of John's sons, in one canvas as an Arab, and then neither as Arab, nor seminarian, but just his handsome self. The Governor Fuller portrait is here too. One can see exactly the kind of man upon whose decision the lives of Sacco and Vanzetti hung: which proves, once again, what a superb portraitist John is. The Governor gives the spectator a cool, stolid, quiet, quizzical look, which is made slightly funny by a large white daisy (or marguerite). He seems to know that it is up there, as it were sticking to the back of his head. Of course it is part of the background. But he looks so *knowing* and self-conscious, that he draws the eye to the flower, which is so big and white.

The *pièce de résistance* is as fine an example of Augustus John's large-scale decorative work as I have ever seen, including the cartoon in the Institute at Detroit. In his youth John acquired, with fanatical concentration, great mastery over the visual techniques, great power as it were for power's sake—as another man furiously amasses wealth. But subsequently the consciousness of this technical plenitude often has urged him towards something physically commensurate. Such a great groping

is to be seen in this exhibition, in a very large composition, with figures, 'The Little Concert' (a cartoon in grisaille). It is to that I was referring above when I said that if anything John had surpassed himself. Some large public building should be found to house it.

A critic would have to be inordinately fond of paradox to speak of John as a 'classicist'. His legend leads away into the wilds of romanticism. He is a model of 'Faustian Man'. That is the superficial view: but I believe it needs correcting. In fact, of the two departments into which Nietzsche divided the creative spirit, the work of Augustus John is Olympian. In his 'Little Concert', for instance, reigns an Augustan peace. Not a trace of the frantic, the Dionysian, disturbs the immortal crooning of the aged vagrant plucking perfunctorily at a guitar, nor the plump and vacant nymphs darkly observed by the dames of the steeple-hatted Welsh variety. These are stylistic creatures of a world forever sheltered from the intrusions of passion.

(17 November 1949)

Returning to the Lefevre and this time it is drawings, not paintings, to be considered, a group of Augustus John drawings contains at least two superb specimens. John has always been olympianly remote, a psychological factor which I think the critic should remember. Time obsesses us. But for John I am sure Mantegna is as contemporary as Matisse. The 'Head of an Old Gypsy' is traditional drawing of the very highest order, it would do credit to any of the greatest masters of the Renaissance. It is also psychologically as humanistic as work of that time. To continue with drawings, William Roberts at the Leicester Gallery has a great display (twenty-eight altogether): for those who can appreciate fine drawing a memorable collection. These things are very different from the work of John, and it may be instructive to compare 'Ironing Board' by Roberts with John's 'Gipsy'. For Roberts man is a machine, for John he is a spirit.

FERNAND LÉGER (2 March 1950)

The Arts Council shows us Fernand Léger close on the heels of Fuseli. The Tate Gallery contributes two large rooms, and Mr Douglas Cooper has written the foreword to the catalogue, and nineteen drawings and about half-a-dozen canvases from his collection are present on the walls. Léger is a hero of twentieth-century art; in a sense he belongs to history

as much as does Fuseli. Certainly he still paints as well as ever, but it is the same picture that he paints; an over-life-size female figure in cold monochrome, the face a parody of the classic mask—this figure appearing in association with highly mechanized stock decorative properties, most typically coloured red white and blue, just like flag-colours—no subtleties—or perhaps some metal flowers and leaves will be used. This female figure has a half-dozen identical twin sisters. Sometimes they all appear together, as diving girls for instance, a dense monochromatic ganglia, or else, less involved with one another, as in 'Composition with Parrots', a splendid performance. When we think of Léger, we see in the mind's eye within narrow limits some such picture as that, just as Braque's name evokes something like a peasant patchwork quilt, of the kind the French-Canadian 'habitant' contrives, only of great elaboration. Léger's subject-matter is human—if this coarse abstraction of a pseudo-classical female can be called that. Lastly, working in a city full of rug-designers, his things suggest neither rugs nor patch-quilts. Also on the credit side, no good taste is anywhere discernible.

Let me say at once, after this cold-blooded inventory, that Léger appears to me a great muralist (if you will forgive the word). These are powerful designs that we see at the Tate, and if they would be most appropriate in a cocktail bar or public baths, do not let us be snobbish about baths and bars. . . .

The present exhibition invites us to define Léger's position in twentieth-century art. His limitations are aggressive, he makes a merit of them; and time, for him, is the only reality. From 1940 to 1945 he was in the U.S. One of his lectures there was described to me by a fan. It seems he mentioned in rapid succession a number of famous artists—Manet, Courbet, Gauguin, Bonnard, Degas: after each name he shouted fiercely '*A la gare!*' Literally, of course, 'to the railway station', its idiomatic significance is more lurid. On the physical plane it was once '*A la lanterne!*' for everyone in palace or *hôtel*: where reputations not persons are involved, it is '*A la gare!*' for all in the contemporary pantheon.

It is difficult for a true Frenchman not to be an '*à-la-gariste*', as it might be called. If much of it is noise, it is apt either to imply, or lead to, subjective frenzy. The French disdain of all that is not French is a familiar feature of '*à-la-garisme*'. The collective mind, of course, is subject to constant change—and its changes, under the direction of the Zeitgeist, have the value of absolutes. Yet as Mr T. S. Eliot has very well

said, this change is 'a development which abandons nothing en route, which does not superannuate either Shakespeare or Homer or the rock drawing of the Magdalenian draughtsmen'. But it superannuates, while the change is occurring, all values immediately antecedent to itself. There is, however, a massive animal confidence that goes with an exclusive belief in actuality: and that Léger possesses. And we may from this point proceed to what most contributes to Léger's marked identity among painters of the Paris School. I refer to his attitude to the Machine. The Italian Futurists, it is true, were Machine Age enthusiasts long before him, but among French painters he, more than anyone, has advocated the introduction of machine-values into the work of art. His approach to pictorial composition is that of the engineer to a precision job.

In a book just published, *Fernand Léger et le Nouvel Espace*,* you may read how, in World War I, Léger 'became the first painter to interpret our industrial civilization'. As I have said, actually he was not at all the first, but we learn how the gleaming machinery that hurled shells at the enemy was a revelation to him. 'I was dazzled by the breech of a 75-millimetre gun which was standing uncovered in the sunlight: the magic of light on white metal.... Once I had got my teeth into that sort of reality I never let go of objects again.' Signal boxes, lottery urns, and tugboats were other objects, seen then, which he was never going to take his teeth out of. So the standardized woman who is the central object of his later pictures may find herself (in a 'new' red white and blue space) between a railway signal box and a lottery urn. Léger abandoned, as he observes, in favour of these excitingly concrete objects, 'the abstractions' of pre-war—tricolor trees and dirtily-coloured cubistic compositions. But his role of 'interpreter of industrial civilization' ended about 1924, though everything remains mechanized, including the stock woman with tubular limbs and body, and flowers or clouds. In Mr Cooper's Léger book which I have mentioned the text is in French and English, the photography is extraordinarily fine. Being the work of a man who is a considerable Léger collector, it is a partisan statement—Léger is to be preferred, it is implied, to Braque, Picasso, Gris, etc. He sees that his hero is 'vulgar' and 'coarse'. But that we may regard as an asset. And indeed Léger's should in the last analysis, be regarded as a *popular* genius, paradoxically expressing itself in a high-brow idiom. Under other circumstances he would have produced

* By Douglas Cooper, Lund Humphries, 1949.

magnificent posters. Mr Cooper's assertion that the art of the French hoardings owes much to Léger sounds likely enough.

JOHN MINTON (19 January 1950)

The Lefevre Gallery was my first call, John Minton was the attraction. This show is the result of a visit to Spain, a country most congenial to his vision. Had there been two or three more of them, this show might have been called just 'Matadors' (or 'Killers', to translate the word). These 'Killers' are the traditional dandies of the world of sport. The Spanish paradox has attracted yet another painter. The principal of 'The Two Bullfighters', very tall and slender, is halted impassively, limply holding the folds of his cape like a bundle of sticks, bored, immaculate, heroically the opposite of 'dynamic'. This, with its elegantly composed vertical blades of colour, is an achievement. The picture by the window, of a single matador, is superb in colour: all of the Valencia and Alicante drawings are very fine: though there is a watercolour landscape of his at the Leicester Galleries which is packed to bursting with formal beauty.

In philosophy a pretentious jargon has often impressed, so in painting there is a jargon, and it impresses. Minton does not employ such adventitious aids. Nor is Minton a violent painter. I could mention several who are more like a prize-fighter than he is. This is because nature is not violent and he is a naturalist. His is the classical attitude, he is not self-assertive. He may exploit—it is open to all good naturalists to do that—the violences and oddities of nature: but never in such a way as to suggest that the calmness of nature, the norm which the snobs call 'dull', is not equally the object of his cult.

CLAUDE MONET (9 November 1950)

The doctrinaires of the photographic 'real', the French Impressionists, were to my mind inferior to those who came before them and those who came after them. But a man of great talent often transcends his own bad doctrine: or so I reflected as I found myself in the presence of the Claude Monets at Gimpel Fils. There are certainly several large and imposing specimens of the kind of Monets which are star pieces in collections. But there is also a kind of Monet I have not noticed before: several canvases which contain no features, hardly any objective content at all—reminiscent in this respect of a very late Turner, when his eyesight only per-

mitted him to see the shadow of things. There are two very exquisite, very luminous, Monets in this Gimpel exhibition tending to this same featureless ideal.

HENRY MOORE (17 October 1946)

In his new exhibition at the Leicester Galleries Mr Henry Moore is showing two large pieces of sculpture, seven small and less important pieces, and a number of drawings. In one of the two large pieces (destined for the grounds at Dartington Hall) and in many of the drawings, there is renewed evidence of Mr Moore's tendency to return to a pre-Picassoan phase of his work, and so to a less romantic impulse. The figure for Dartington Hall is one of his finest. A female figure, as always: for what might be described as this artist's type is a small-headed, weighty, female figure—accompanied sometimes, though not in this instance, by a stone—or a wooden—baby.

This woman of his lives in a primitive world—which his pre-war drawings represented with great power, a kind of druidic wilderness. With a puritanic energy—which is not affection—she will clutch this satellite body, or stone baby, to her body. In the company of other women she is bleak and aloof. Such is the natural subject-matter of Moore.

But there are trios and pairs of these women now, as revealed by his drawings: mollified by the medium, perhaps—the chalks, and inks, and washes—they, without becoming urbane, show us they can inhabit rooms, even with very primitive curtains at the window: and one we actually find installed upon a very exquisitely drawn, and not un-upholstered, sofa. Whether it is Penelope surprising the Suitors, or some massive trio seated upon a cube, biscuit tin, or some vaguer elemental form, they are now, although they never speak to each other, social beings.

Some of the groups in the Shelter drawings were most beautiful, after an hellenic fashion: and some of the drawings in this exhibition recall antiquity—the barbarous overtures to the stream-lined perfection. The root of what we term the classic is, in literature, the *muthos* as laid down by Aristotle, and, in the fine arts, design. Design is second nature to Moore: in that his is a classic mind: especially as a repose of sorts dwells in all these ponderous figures, and something of the decorum of the greatest art.

(14 October 1948)

At Roland, Browse and Delbanco, next door, there is a collection of Mr Henry Moore's drawings, 1928–1948. A sculptor is always in danger of becoming something like a public monument—a landmark, its significance no longer recognized. Of international fame, Mr Moore is passing into the august company of John and Epstein, where people are but too apt to take plastic feats for granted.

Here, it is true, is nothing which I do not feel I have seen many times before (though some were done this year). But also there is nothing I would not willingly see as many times again: whether shelter drawings, pages of serried notes, or classico-picassoan giantesses, voluminous but lashed around with hoops of white bodycolour. It might be regretted that a retrospective selection of Mr Moore's designs was not weightier and more comprehensive. But there are so many things to delight his admirers that this show will be greatly appreciated.

(9 November 1950)

At Roland Browse and Delbanco's, is something of surprising excellence. It is a small head in stone (of 1928 I think) which is, if I am right, Henry Moore at his very best. The third dimension is the naturalistic dimension. But Moore overcomes the limitations of the round with great resource. Most of the other sculpture there shows how important it is to know how to circumvent the natural platitude of the dimension of life.

VICTOR PASMORE (17 November 1949)

In violent contrast to this [exhibition of paintings by Francis Bacon] is Victor Pasmore, for whom everything tends to the White as with Bacon it does to the Black. He has a most exciting show of quite abstract pictures at the Redfern Gallery. It is as tense as a game of chess—but there are no howls when you lose. It is not an affair of life and death: death is not of the *parti* any more than it is 'In the Garden' with Bonnard. This exhibition is *exciting* to the artist—its excitements are not those of life in the raw, as with Bacon. Description of course is hopeless. What in a picture we call 'composition' is abstracted from the rest and of course it is not all geometries. First structure is developed, as it were the skeleton of pictorial organisms. Then this purely compositional creation

takes on features of its own. Admittedly such abstractions are as abstruse as the work of 'difficult' writers. It demonstrates what a very serious artist Pasmore is that he should go aside and, in the teeth of an economic blizzard, devote himself to this unpopular type of work.

CERI RICHARDS (14 October 1948)

Mr Ceri Richards' exhibition at the Redfern Gallery, Cork Street, reveals an artist of very exceptional vitality. My introduction to his work was in a mixed show. I came upon a picture which was like a live fish in the midst of a collection of dead ones. Or it was like a hundred little fish of brilliant hue, in violent movement, in the midst of a number of big, slate-grey, piscine corpses: and no Paris influence discernible. There is plenty of evidence of it at the Redfern. But his 'Versions' of a 'Rape of the Sabine Women'—except for the superb 'Version 3', where perhaps Matisse collaborated—is *Parisrein*. Of the younger painters I would place him beside Colquhoun—both figure painters. Colquhoun's figures are always hieratically transfixed—erect in stiff Scottish solemnity. Richards' are like quicksilver. I would suggest for immediate purchase by national institutions one of the 'Rape' Versions. His 'Pianist' pictures are delightful performances. In No. 16 the player has a Picasso face but legs of her own. The 'Costermonger' studies are more purely decorative, but quite admirable.

WILLIAM ROTHENSTEIN (18 May, 1950)

The Rothenstein memorial exhibition at the Tate is a historical event even more than an artistic one. In the history of English art Will Rothenstein should be ranked with Ruskin. He wrote no *Stones of Venice*, it is true: on the other hand, and what is much rarer in England, he would never have mistaken Whistler for a cockney nor missed out on his 'Nocturnes'. Let me begin with the actual exhibits, and speak of Rothenstein's invisible assets later. There are three main sorts of picture here. (1) The early work with a Whistlerian palette but a non-Whistlerian subject-matter. The 'Coster Girls' is a good example. Two Forainesque Cockney girls stand before a Whistler backcloth. (2) There is the series of 'interiors'. I have heard it said that these blazed the trail for McEvoy, Orpen, etc.—or perhaps it should be said revived the Pre-Raphaelite interior for their benefit. (3) Lastly there are the farm-buildings,

quarries, and, I suppose, most of his famous drawings of famous men.

In these selections from a lifetime of hard work one notes with admiration the uncompromising severity—the reason, of course, for the coldness of the public during his life. The severity is to be seen, perhaps, rather in what he *would not do* than in what he *did*, though in all conscience his farm-buildings are bare, yellow and dry enough to satisfy a Saharan nomad. There is nothing to recall the desert, certainly, in the immaculate interiors where an Edwardian *bourgeoise* plays with her child. Yet even there it is as puritanically free of the extraneous as a hospital and as clinically clean. The human values inherent in a Vuillard interior are absent. His mind was at its roots a little arid. But a devouring interest in people is superadded in the case of his portraits, which is why it is there we see him at his best, or so I believe. In Augustus John's amusing tribute, written for the catalogue, most justly the word *heroic* is employed. (Rothenstein's) 'standards were high and difficult enough, God knows ... even his failures were heroic'. Of course Rothenstein was a hero: and a typically English hero too. His was the Dunkirk spirit. He knew that the artist in England has his being upon a precarious beachhead in Philistia. He stood his ground with heroism, gradually filling a barn with his unsold canvases. 'I have a very fine and complete collection of my own pictures,' he told me. It was most fortunate that he was rich. Often his temper, on the other hand, was so optimistic that one would have said he regarded himself, in spite of all the frustrations, ideally an inmate of the City of God, rather than engaged in a bitter rearguard action. Such optimism is not inconsistent with the Dunkirk spirit. The English appetite for Dunkirks may be traced to 'Bible-religion', with its history of a small people often in a tight corner. In such natures the bitterness actually appears to feed the optimism, too. From his Paris training Rothenstein derived the same advantages as those possessed by Sickert or Whistler. Fresh from Paris, for instance, he could not fail to notice how little the English are attracted by drawing, an art so greatly prized by the French. And more than anybody it was Rothenstein who compelled people here for a while (for they have relapsed) to recognize the technical beauties of this sometimes rather shoppy form of artistic expression. He was a born teacher, an eager mentor. To have his brains picked was what most delighted him. His were public, not private, brains. And he was one of the last people in England able to distinguish between what is authentic, and what is not, in the field of art.

WILLIAM SCOTT (14 October 1948)

The 'Recent Paintings of William Scott' at the Leicester Galleries are likewise very much worth a visit. He is a newcomer. What he has to offer is an original idea of colour; a very personal, flat, empty design, as if cut out in cardboard; interesting form. His statement is always so strict, parsimonious, and dogmatically severe, that it looks even emptier than it is. He brings us his mackerel and his marigolds as a child, just able to walk, solemnly brings objects—it would, like Mr Scott, bring a frying-pan, a birdcage, or a colander—and deposits them as an offering before the attentive adult. I have only one complaint. The surface quality is such as anyone would produce who took up a brush with paint on it, and filled up any given area of these canvases.

STANLEY SPENCER (18 May 1950)

This is a good opportunity to discuss Spencer in general. His work could come from no country except Britain. No harm in that: but it is by no means the best work done here. That Spencer is not the Royal Academician's cup of tea must also be said. The type of woman predominating in a Spencer picture has something to do with it. She is at times aggressively corpulent, her flat and homely face is drained of all intelligence, she lollops about matter-of-factly in her grave, or leans over the headstone to chat. What is more, Spencer's Resurrections invariably occur in the lower-middle-class section of the cemetery. It would be difficult to imagine anything more calculated to lower the tone of a high-class Exhibition like the R.A. than the presence on the walls of a few dozen of these women. It is obvious that they could not be introduced into the same gallery as the Bishops and Lady Mayoresses.

Now what would make Spencer unpopular with a Royal Academician would not disqualify him, of course, with an artist. Yet he is not the artist's cup of tea either. Here I hesitate, remembering that many people, even Sir William Rothenstein, have thought very highly of Spencer's work. The reader should remember this too. But the typical contemporary painter finds it impossible to think so highly of this work, and his reasons may I think be fairly summarized as follows. I may say they are the reasons I myself would give. Spencer, it is felt, is careless of paint. His painting is the negation of quality. It is quantitative. He is endlessly repetitive. One feels he could turn out a thousand figures as easily as a hundred, it would take him ten times as long that is all. All

O

would wear jumpers (even his angels wear jumpers), all would have the Cookham face and the light mouse-coloured bobbed hair. In his multi-figured compositions the detail (the jumper, etc.) is a convention poor in form, illustrational. The colour is drab. Think of a 'Resurrection' 7×22 feet by Rouault. Of course his could not be like that; but the *Gemeinheit* need not be so virulent. There is still his 'quaintness' to be considered. It is English art-studentish: it is the diluted 'primitivism' of the school 'Sketch Club'. His naivety is painful, like the oppressive archness of a self-conscious little girl. For all this I respect Spencer. Were he to paint the figures in his compositions as carefully as his excellent self-portrait at Tooth's all would be well. He inhabits a different world from the potboiler. He has a visionary gift, after all.

JULIAN TREVELYAN (23 March 1950)

Of the many new pictures I have seen in the March exhibitions the ones that have interested me most are those of Julian Trevelyan, at Gimpels, 50 South Molton Street. Such paintings as 'Taormina' and 'The Gold-fish Tank' are an act of violent imagination, an uncovering of what nature's photographic veil conceals, and what without some violence does not emerge. Such pictures as these probably never could have existed except in succession to 'abstract art'—which latter is itself the most sterile thing imaginable, but when *reincarnated* in this fashion develops an almost matchless truth to nature, in the deepest sense. Abstraction, let me add, is great fun for a short while, but no one but an idiot—or a Dutchman, like Mondrian—would pass his life in that vacuum, any more than he would voluntarily live in an iron lung. Finally, Trevelyan's small portrait of David Gascoyne is charged with an extra-ordinary nervous life.

EDOUARD VUILLARD (17 June 1948)

At the Wildenstein Galleries, New Bond Street, the exhibition of the work of Edouard Vuillard (1869–1940) is a great artistic event, the first exhibition of this artist's work that has been seen in England. Revolu-tions of great violence in the fine arts began to occur about the time his reputation normally would have taken on more substantial proportions, especially internationally. As it was, something like eclipse attended him: the Cubist steamroller flattened out his *petit bourgeois* 'intimacies'. Everybody knew of him, but for thirty years he was a background figure, while fresh waves of revolutionaries charged into the limelight one after

the other. It is probable that without this *contretemps* he might have put forth more solid blossoms.

The present writer was not aware that he still lived until he died: yet as late as the nineteen-thirties he was painting superb pictures, and the nineteen-twenties was probably his best period. But now the lid is to be removed—for the Museum of Modern Art has put on a major show of Bonnard's work also. We should be hearing a good deal more of the *intimistes*, as they were called, in the immediate future. It is as it should be that Bonnard comes into the foreground in New York, Vuillard in London. The former was a dashing fellow as compared with his quietistic, monosyllabic friend, all prudence and integrity: who, if you go to Wildenstein's, you will find is diabolically sensitive, as pattern-making an animal as any Indian, as a draughtsman a peer of one of his two cherished models, namely Degas: whereas his colour is of astonishing subtlety, beauty and range. How with all these intense and captivating endowments he can have remained so placid appeared to have puzzled one, at least, of his intimates.

The 'Seated Woman in Interior' from the Tate, which decorated *The Listener*'s cover last week, is the only intrusion of youth in a collection given up to old age or its ante-chambers. Vuillard is fond of middle age, but still more of what succeeds it. Rembrandt far preferred sitters to have passed their eightieth year, and Vuillard, who singled him out for particular admiration, was much the same. He did not really paint his friends until they were conditioned, as it were, by time. And so we have the truly magnificent 'Portrait of Roussel in his Studio', to be seen in this show. Roussel is a small seated figure at the bottom of a dark, shadowy and precipitous cave—he is boxed in (enthroned) with a cluster of deep blue shafts. He inclines himself sideways towards us, with his uniformly lined mask like a Chinese sage. He is cut off at the waist, we only see the trunk: pathetically overwhelmed in his gigantic burrow.

Quite near to this is a 'Portrait of Bonnard'. That is very different. Bonnard is on his feet and taut, difficult, it would seem, to subdue to the correct degree of quiescence. Both these spendid portraits are dated 1925. 'Madame Kapferer', who, as the largest figure painting present, has the place of honour, is evidently blind, or nearly so, and her hands are held before her above the lap in devotional habit. It is, however, too high in key and too distinct in treatment, for dramatic effectiveness. The other side of Madame Kapferer is 'The Roussel Family'. It does

not disprove what was written above, as to Vuillard omitting to paint his friends when they were young: for this is a *genre* picture. The old mother in the centre—her face identical in colour with the wall behind it, the only sign of life a dull scarcely visible light in her eyes as she watches the baby without a face—is No. 1 figure in this fine canvas.

Vuillard is the last great impressionist. But were he a true impressionist you would not have encountered in this article the expressions of delighted recognition you have read. Since one of the essentials of Impressionism was *plein air* (and he was only interested in interiors) and another essential was the analysis of light, and the achieving of a maximum luminosity (and he lived only discreet tonalities), he was not impressionist without large qualification obviously. Then he carefully composes his pictures: they are not just jabbed in and left—*impressions*. Yet he himself, at the last, felt, we are told, dissatisfied. In looking back he considered they were 'sketches' only: and he set out to produce something complete—that would not be merely a 'sketch' or impression. And it is because of the 'sketch' factor that he remains an impressionist.

His desire for the perfect, the 'finished' rather than the sketch is reminiscent of Cézanne, whom in other ways he recalls. Nearly all his friends—Denis, Roussel, Vallotton—leaned to the classical side, or like Denis were confirmed classicists. This played its part in regulating, at least, his Impressionism: one influence and another assisted at the emergence, at all events, of a dish that could only have been cooked in Paris, at a certain period, of which I must admit to being very *friand*. But alas, when he 'finishes', the spell is dissolved: all that remains is a full-blooded coloured photograph (*cf.* 'Dr Viau in his Dental Surgery').

Not many steps up the street, at the Lefevre Gallery, is a Renoir show: not pretending, happily, to compete with the neighbouring sensational exhibition. Although containing nothing important, it deserves a visit. 'Les Pêches' is an iridescent pyramid which, without the signature, would be attributed to a later hand, an example, we assume, of the outrageous versatility of his early years: and as if to confirm this assumption, hung near it is a picture of academic type, as polished and slippery as ice. 'Nu à la méridienne' is a typical small nude of customary pale salmonish pink with blue eyes. When in 1881 Renoir visited Italy violent disillusion with Impressionism resulted. It was his draughtsmanship, he felt, that was most in need of attention: and he practised assiduously. Looking at the shining, hot-coloured, but compact body, then up to the formless countenance, and at the vapourish gluey stuffs

in which the body of this 'Nu' is nested, one recalls Renoir's self-criticism: especially so after coming from Wildenstein's.

EDWARD WADSWORTH (30 June 1949)

The artist who has just died was a notable one. Here, first of all, are the data the occasion demands. Edward Wadsworth, A.R.A., was born 29 October 1889, at Cleckheaton, Yorkshire. His mother was Scottish: it was at Fettes that he received his non-technical education. At Munich (1906) via industrial draughtsmanship his art-training was begun. After that came Bradford, and finally the Slade School of Art, London (1910–12). He first exhibited as a 'vorticist' a year or so after leaving the Slade. His 'vorticist' period and his connection with me terminated with the dissolving of 'X Group' immediately after World War I. The Associateship of the Royal Academy came late, in 1943.

Wadsworth belonged to a wealthy factory-owning family, of the great wool-city of Bradford. He was yet another example of how an artist— much more in our commercialized age than formerly—should possess the wherewithal to acquire his expressive equipment at leisure, without the necessity of exposing his talent to the blunting and vulgarization incident to commercial work. You have to have a hideous amount of character to survive without that adventitious aid. And even with the startling quantity of character involved, there would have been no Cézanne minus a papa, nor a Van Gogh minus a brother. The *rentier* background is stressed here by way of stimulus to the State—which in destroying the *rentier* must understand it is removing the artist's papa, and should be prepared to become a Papa (or Big Brother) itself.

I should be sorry to perform on my old comrade, for obituary purposes, that post-mortem operation consisting in a hasty extraction from the remains of a potted abstract: declaring, 'There, that is what he was, that is what is worth preserving.' To Time alone, and many busy hands of various kinds of men, should be left that task. I am only *one* kind of man, and can only record my impression. His place in twentieth-century English art is, I am sure, quite secure.

Like Paul Nash, he was not a figure painter. He was a painter of scenes and objects: a crowded port, or a Black Country waste strip, with a few shrivelled trees, between two factory-masses: otherwise, a ball of waxed nautical twine associated with a sextant or a marlinespike.

About 1920 I remember Wadsworth taking me in his car on a tour of some of Yorkshire's cities. In due course we arrived on the hill above

Halifax. He stopped the car and we gazed down into its blackened labyrinth. I could see he was proud of it. 'It's like Hell, isn't it?' he said enthusiastically. (To forestall correspondence, it did not seem to *me* like Hell. But perhaps I am more particular.) A series of small scenes of the black industrial savagery outside Birmingham, perhaps they were wood-cuts, was Wadsworth at his best, to my thinking. For he had machinery in his blood, and he depicted a machine with as much loving care as another man would lavish upon a cow or a bunch of grapes. But if he had a passion for machines, the nautical, rather oddly, disputed with the mechanical for the first place in his mind. Service with the Marine Reserve in World War I left him with a rolling gait, a becoming tan, and an unrivalled collection of salty limericks. At one time he rented a studio at a south-coast port in order to hunt nautical subjects and be near other old salts. Then his father died and he became very rich. His eventual absorption by the Royal Academy was on the way for a decade or so. Although regrettable, it did not soften his hardness, but it did brighten his pictures, so that anything he did in the end looked rather like a lurid geometrical flower. But at length he did definitely turn to flowers themselves, towards the end abstracting again, but with a bunch of flowers as his starting-point.

It seems a far cry from a casting-shop to a chrysanthemum (except that with him the latter would be of metal); and the true Wadsworth is to be found among the blast-furnaces, where no flower grows, or such is my belief. All that I can say, in conclusion, is that Wadsworth was an important artist: that as much as Old Crome was a genius of agricultural England, Wadsworth was a genius of industrial England (deflected, so I think, into nautical channels): that he had a power of generalization and design uncommon in England—had he been French he would have been something like Léger, and been better understood by what we call 'the logical French mind' than he ever will be here; but that the passage of time can only make his best work more, not less, respected.

FROM 'THE LISTENER'

A selection from Lewis's articles in The Listener *between 1946 and 1951*

A NEGRO ARTIST (7 December 1950)

I do not wish to be guilty of what is called overpraising (as if an artist could be overpraised), but I consider Denis Williams a young man of very remarkable talent. He paints pictures the size of a pantechnicon with as little effort as the blackbird sings. But these huge canvases are not the apparently care-free vocalism of a bird, they are heavy with human import. The canvases are big because there is such a volume, such a weight, of emotion there, requiring a big receptacle into which to pour itself. And even so there is congestion. The small gallery, Gimpel Fils, looks to me as if it might burst at any moment, for these pictures do not stop growing when Williams lays down his brush. They are like a jungle, their vitality is boundless. His is a devouring impulse to create: not to create with the implacable concentration of some artists, but just to go on pouring himself out, upon canvas after canvas. And he paints finely, he is not merely fecund. In spite of the fact that Denis Williams speaks with an unmistakable Welsh accent, he is a Negro. But because of the empire-building propensities of the Briton of yesterday he is British, for he comes from British Guiana. Georgetown, the capital city, is where he lives. It is anything but the jungle: there are splendid boulevards, lined with blood-red trees, a fine hotel (for Sahibs only), a busy port. The Negroes are tennis and cricket playing Negroes; Milton, and the other national poet Shakespeare, is what they are brought up on, but especially Milton. Williams' feelings about Milton are as emphatic as were, until recently, those of Mr T. S. Eliot. He was a highly-salaried post-office clerk working in handsome offices. Consequently, the jungle is not a feature of his daily life. But the jungle is there in the background, behind the rice and sugar plantations outside the city. And it obsesses the pictures he paints, existing like an atmosphere about the symbolic figures, which stand entranced in a hot yellow vegetation. It is perhaps atavistic. But whatever the reason may be, these are jungle pictures: only, in this art of Social Symbolism, the jungle stands for our existence on this earth. . . .

The lot of the Negro, and related to that the lot of the underdog

everywhere, is, with Williams, an ever-present tragedy. The word 'Korea' is for him a violent irritant. The smaller 'Plantation' pictures, as much as the large ones, are Moralities. At this point I must mention a theoretical complication. Williams is an existentialist, or has been greatly influenced by the teaching of Sartre. 'Anxiety' is a word that often recurs in his conversation: the Kierkegaardian 'Angst' receives a new interpretation entangled with contemporary politics. 'Horror' is another word obsessively frequent. It is what Anxiety merges in when stimulated by such symbolic names as 'Korea' or 'MacArthur'.

In this set of paintings, with the monotony of a tom-tom, practically only one colour is used: namely yellow. His highly successful use of this colour tells one something about the colour. Its effectiveness in sustaining precisely the reaction he requires of us is remarkable. It is wearying, in the way intended. Lastly I find I have not mentioned the fact that Denis Williams is a very fine draughtsman, as, being a figure-painter, he is bound to be. People do not become figure-painters if their draughtsmanship is defective.

I have spoken only of his Social Symbolism, of work which is naturalistic, as it must be to present his symbolic message with maximum effect. But there are other paintings in this exhibition, of a kind he was doing three years ago. Less naturalistic, the moralities, the illustration of social ideas, are absent. The evocation, in magical terms of the forest, is one I would especially note: there is considerable abstraction, however. For myself, I prefer this more detached phase of his work. I am not proposing to mingle criticism with my eulogy of this brilliant newcomer. The figures of his symbolic moralities are excellent, whatever value one may attach to the philosophy or politics inspiring them. Neither of these is to my liking, but good philosophies do not make good paintings, and a bad philosophy an artist may find excessively stimulating. There are many weighty arguments in favour of enlisting the visual art in the service of a cause, or more generally of humanity. Some people will prefer the work he does coloured by social and metaphysical theory. All I have to do here is to acclaim these pictures, full of power and of vitality. No one interested in what is being done in London today should fail to see them.

CANADIAN NATURE AND ITS PAINTERS
(29 August 1946)

The Canadian consciousness must always, to a peculiar degree, be implicated with nature, seeing that Canada is first and foremost an agricultural and raw material nation, and, still more important, is everywhere on the frontiers of the wilderness.

The development of the cultural life of Canada will necessarily be conditioned—or so it seems to me—by these facts, however much present-day anti-regionalism there may seek to ignore them. On the other hand its situation on the North American continent also deeply involves it in the Machine Age. The neighbourhood of Chicago and of Detroit is a formidable fact. The culture of this northernmost of the nations of the western hemisphere might develop, consequently, a dual personality. The pull of nature, however, will probably exceed that of the attraction exercised by the blast-furnace and power-house. Further, the Anglo-Saxon genius has always displayed great affinity with primitive nature. The French Canadian would, after his Latin fashion, continue no doubt to take more interest in man than in primitive nature. The latter is really, in practice if not in theory, and in spite of Rousseau and his school, almost an English monopoly.

An Ossianic pantheism pervades the literature and the life of the Briton: a passionate inclination for the virginity of nature and for the most unruly moods of the elements. Evidences of this can be traced as much in the fondness of Shakespeare for thunder and lightning, as in the appetite of a twentieth-century boy scout for getting lost on quite mild little mountains and practising woodcraft in the home-spinney.

These are the things however that have spelled Empire: that 'violent trading' of the English, as a Frenchman has called it, which eventuated in the North American continent speaking the English tongue: resulted in Hudson Bay, Ellesmere Land, Prince Patrick Island, and other cosy little spots, bearing Anglo-Saxon names, rather than Spanish, French, German, Italian, or Dutch. Such reflections are appropriate in approaching the question of what kind of culture may be produced by the population settled in such close neighbourhood to so overpowering and top-heavy a mass of primitiveness as is to be found in Canada, north of the narrow settled belt—from the Bush up to the muskeg and beyond to the icepack.

The question in fact is whether all this unassimilable mass of 'nature'

will in the end be left severely alone (just as we seldom turn our eyes
up towards interstellar space, and have long ago lost interest in the
moon, except for crooning purposes): or whether this proximity of the
wilds will continue to influence the descendants of the contemporary
Canadian. Surely the latter. That I think is the answer; just as certainly
as a people who inhabit a sea coast are conditioned by the neighbouring
ocean and its rude habits—the works of their bards being full of splash-
ing and tossing, of shipwreck and of ships inopportunely becalmed.

Now it seems to me that for a person with these tastes, and with these
traditions, Canada, artistically, offers extraordinary opportunities, and
that these have on the whole been surprisingly neglected. One would
have expected for instance Canada to have produced one outstanding
poet, inspired by the scene and by the history that is there as native as
the folk-song 'Alouette'. This has not occurred.

But pictorially, in a sense, it has. And the Phaidon Press publication,
*Canadian Painters,** in its massed photographs, gives one an excellent
idea of this flowering—though the effect is perhaps cartographical
rather than horticultural. This painting is, in fact, the blazing of a trail
and a rough charting—a sometimes crude advertisement of a rich
aesthetic vein—rather than a finished achievement of authentic beauty.

In 1920 a movement announced itself in Upper Canada (that is
English Canada) under the name of 'The Group of Seven'. This
Phaidon volume really celebrates the work of that group. A further
volume is announced dealing with work reflecting contemporary
European and American influences: for Canada on the whole, it could
be said, is busy decanadianizing itself, and firmly shutting the door
upon the doctrinal 'regionalism' represented by the seven pioneers of
post-war No. 1.

The key man in this Canadian regionalist school is Alec Jackson,
because without him it is doubtful if it would ever have existed. Tom
Thomson, generally regarded as the star-member of the school, died,
in mysterious circumstances, up in one of his Northland lakes, in
1917. He was a commercial designer—as all of them were at one time
or another, except Harris. In 1913–14 Thomson, then a week-end artist
of no particular distinction, became acquainted with Jackson, not long
returned from Paris, and a spark was struck. They shared a studio, and
by the end of 1914 this contact had transformed Thomson into a remark-
able colourist, equipped to get on to his canvas some of the cold vivacious

* *Canadian Painters*. Edited by D. W. Buchanan (London, 1945).

beauty of the spring woods in the Algonquin country. For the rest, his ten years of commercial designing at Grip Limited supplied the formal accessories and the organizing habit.

It would be idle to pretend that the oils, large and very small (mostly the latter), produced by Thomson during a mere three years—1914 to 1917—which is all that is of interest, would set the Thames or the Seine on fire, because they would not. Most gallantly this little group (for the rigours of the social climate were so formidable that only the toughest could survive) pioneered: when the hostility of the press and public held them up, they retreated into commercial design, but always to emerge again as—for the time and place—militant and iconoclastic. Their work was rude: they chopped out their paintings as if they had been chopping wood. They adopted, often, the brutal methods of the bill-board artist to put their country across big and harsh and plain: with all its emptiness and savagery—its trees that crawl along the surface of the frozen earth because they cannot stand erect in the Arctic wind, its shack-hamlets submerged in snow, its Northern Lights, and all the other things you do not meet with anywhere else. Sometimes they painted a beautiful or an original picture. Most of the time they were blazing the way for others: opening up the Canadian scene— for I am sure Jackson did not expect his school to end with the 'Seven'.

The members of this group are dispersed, have 'gone west', have disappeared or died. Only Jackson is left. He had much to do with starting it all: now he stands there alone in Toronto before his easel, in the Studio-building in the Ravine, painting doggedly, the 'grand old man' of Canadian painting.

Canada will always be so infinitely bigger physically than the small nation that lives in it, even if its population is doubled, that this monstrous, empty habitat must continue to dominate it psychologically, and so culturally, as I started by saying. The Northland, as they call it, the 'forty miles of white water', the 'beaver ponds', the virgin beauty of Mississuaga, these are what cause us to give Thomson a hearing for his crude song. It is not generally realized how at a relatively short distance north of the cities strung out across Canada in a wavering line the 'bush', the wilderness, begins, with its multitudes of lakes and streams. But Jackson went much farther afield even than Thomson: to Great Bear Lake and to the Polar Sea, and brought back grisly records of what he had seen.

With Alex Jackson I will bring this article to a close, for he interests me the most. He is himself like a bit of nature—and I have explained how it is the nature we see in them, however imperfectly, that gives them their real significance—and the rock is always more important than the man. And with Jackson let me associate Gagnon, as the French and English are conjoined in their native Quebec.

French Canada had in Clarence Gagnon, who died in 1942, a sort of national painter. These two artists are very different, though superficially their canvases have a kind of family look. Both come from the province of Quebec; in the pictures of both there is a lot of snow. There the similarity ends. Whereas Gagnon painted very attractively (mostly in his studio in Paris) an exotic world of brightly-clad peasant-puppets, in their snow-bound hamlet, Jackson paints the same little Quebec hamlet for preference deserted, battened down, all but submerged in the white pest of the Canadian winter. Gagnon's is an innocuous snow, almost as if it were a stylistic device of nature (a very good-natured nature!). But Jackson's is like a white lava to smother and blot out. It is not even white! Often it is a depressing spectral grey, or acidly greenish: not at all like the sparkling blue-and-white of the icing merchants (among whom it would be unfair to count Gagnon).

The village is not where Jackson is most at home. He has painted some excellent villages: but where there are few signs of man is where he really likes to be. Where there is just Jackson and Nature. 'Nature' for Jackson does not mean what it did for Turner, a colossal and sumptuous pipe-dream akin to the Kubla Khan of Coleridge, nor what it was to Van Gogh, a barbaric tapestry, at the heart of which was man and his suffering—his human rhythms branching out, the tormented nervous system of nature responding to man's emotions. In Jackson's case it is nature-the-enemy as known to the explorer.

Yes, it is an affair of Jackson-against-nature and vice-versa. Jackson being what is called a 'fighter' likes this situation. His painting seasons are as it were *campaigning seasons*, rather than the breathless rendezvous of a 'nature-lover' with the object of his cult. It is impossible to associate the notion of pleasure with these grim excursions, or at least nothing sensuous. If anything there is too little that is sensuous; he handles nature roughly. Few have tried to paint the snow. These snowscapes of his fill one wth the fascinating ennui of a chapter of the log of a polar-explorer: one of those grand monotonous books where one wonders how many more hundreds of pages must be traversed or trudged through

(on seal-meat and pemmican) before one reaches that extraordinary over-rated abstraction the Pole.

There is gaiety sometimes in Jackson, but it is rationed. His vision is as austere as his subject-matter, which is precisely the hard puritanic land in which he always has lived: with no frills, with all its dismal solitary grandeur and bleak beauty, its bad side deliberately selected rather than its chilly relentings. This is a matter of temperament: Jackson is no man to go gathering nuts in May. He has no wish to be seduced every Spring when the sap rises—neither he nor nature are often shown in these compromising moods. There is something of Ahab in him; the long white contours of the Laurentian Mountains in mid-winter are his elusive leviathan.

THE BROTHERHOOD

22 April 1948. Review of an exhibition called 'The Pre-Raphaelites', *held 8 April–12 May 1948 at the Whitechapel Art Gallery in the East End of London.*

The Pre-Raphaelites produce a gay effect, like a bonnet-shop (for their subject-matter, compared with their pseudo-models, the Primitives, is trivial). Even Holman Hunt's large Scapegoat is on the gay side. No tragedy is visible, to the naked eye—just an overlarge, somehow disagreeably bright, picture of a goat. But Hunt was the only confirmed painter of religious subjects in the movement. And he was (1) an inferior painter, the least talented of any: (2) no advertisement, it is to be feared, on the religious side, for either the refinement or seriousness of his countrymen. I am thinking of *The Light of the World*.

As to Burne-Jones, so dazzlingly successful a pioneer of surrealism, he, again, failed completely in his religious subjects. For instance *The Star of Bethlehem* (not part of this exhibition) has even to be apologized for as a picture. Whereas I would far rather possess one of his Perseus series than a Botticelli. That series—or rather the full-size studies—is alone worth visiting Whitechapel to see. In *The Escape of Perseus from the Immortal Sisters* there are none of the tawdry poetic accessories impairing some of his work, only the faces and limbs, moving to the rhythms imposed by imperious immortality, in a dream where all is sadly predestined, even escape from predestination. The scaffolding is still visible near the half-finished foot of a Sister where the canvas has been squared.

It would be pleasant to hang four or five of the Perseus studies in the same gallery with an equal number of pictures by Delvaux. Salvador Dali has expressed much admiration for this latecomer among the Pre-Raphaelites, and it is easy to see why.

Burne-Jones did not steal the show for me in Whitechapel, but whereas the rest of the Brotherhood disappointed me in a way for which I was unprepared, with him I found myself duly entranced, as much as I am by M. Delvaux or by the music of 'Pelléas et Mélisande'.

Pre-Raphaelite pictures generally are cheerful in colour because Primitives used pure bright pigment. Then nothing must be left out either—for the Masters left nothing out. No hair on the back of the sitter's hand, no leaf on the tree, no brick in the wall of the house, must be omitted. At the same time, laws of perspective and anatomy remained surprisingly intact: nor was the drawing in any sense primitive. The drawing in the portrait of Ruskin (46), *The Blind Girl* (48), *The Last of England* (4), or *Mother and Child* (117) is as orthodox and modern as in a portrait by John or Sargent. Nor did they employ colours brilliant and unmixed. As 'Primitives', in short, the Pre-Raphaelites were not serious. Madox Brown's *Work* actually is less primitive (though in the same way) than Stanley Spencer.

My disappointment was due to an impression, in which more seriousness was attributed to this school than they in fact reveal, upon a second and more critical encounter. Nothing of course of the marvellous ordering of nature of Samuel Palmer was to be looked for in an imitative naturalism such as theirs. It was not that. But it was all so pretty. Only the masterly solidity of Madox Brown relieved the prettiness (but with his inane composition called *Work*).

The method of depicting objects one by one (the portrait of a leaf, or of a pebble) of the master craftsmen called 'primitive', was, for the Pre-Raphaelite, the *external* model. But he took no interest, apparently, in the *internal* model: so the Pre-Raphaelite Movement proved, in the end, a rebellious, picturesque, but shallow interlude in Victorian philistinism.

The student of course will visit this show: and, as I observed, the general public should not fail to make the journey to Aldgate East if only to see the studies for the Perseus series. I am sure that Burne-Jones ultimately will be valued more than any of these painters. At least there was something he had an overmastering desire to paint, and he possessed to a remarkable degree the necessary powers.

THE COURTAULD MEMORIAL EXHIBITION
Published 10 June 1948.

The Courtauld Memorial Exhibition at the Tate Gallery is naturally enough a parade of masterpieces—records of a great collector's triumphs. The number of important, even famous, pictures is surprising. All are of the French Nineteenth-Century School, technically from Corot to Picasso, though these artists are represented by token works only.

Cézanne's *Card Players* is the trump card, the ace, of the middle gallery. With what sublime absence of enthusiasm they address themselves to this sad pastime! One would expect the acquisition of specimens of his cubist progeny to follow from the possession of major Cézannes—for there is also his *Man Smoking a Pipe*, a picture full of cubistic suggestions. Again, as far as Rouault is concerned, there is only one very small water-colour: but there is the regulation Modigliani—a large red nude, almost a mass-produced article. In the company of all these intently studied masterpieces it looks like what it is—not more than a journeyman cartoonist's outline drawing for *Pêle-Mêle* or something, hurriedly filled in with an opaque red flesh pigment.

If the School of Cézanne is not there, Cézanne himself is represented by a superb little group of canvases. The *Oakleaves and Apples* is the most classically beautiful still-life he ever painted, I believe. But to return to the first gallery into which the visitor passes, and to the enormous picture which will be the first thing he will see as he enters. Its name is *Une Baignade*: it is by Seurat.

Une Baignade was painted while Seurat was still in his (relatively) dark and earthen stage, before he had purified his palette, but that is not important. What a picture! Nothing could bring to life this dull monotonous expanse. The cylindrical tailored dummies of *La Grande Jatte* or, in the present exhibition, *Woman Powdering Herself* (who was the artist's mistress, we are told in the catalogue—a Mlle Knoblock—presumably in an attempt to stimulate interest) are empty pretexts for the trying-out of optical notions, and attempts at a new form of pictorial illusionism. In fact, had his figures remained as photographic in quality as in *Une Baignade*, we should with this method have been presented with a novel example of the 'trompe l'œil'. As it is, no one can mistake the *Woman Powdering Herself* for a *real* woman.

In one respect this exhibition may be of use to the student. Where

the authentic break with the past occurred should be clear. Corot or Delacroix was not where it came. *Le déjeuner sur l'herbe*, composed after a group by Raphael, does obviously not belong with the hideous neo-impressionism of Seurat: but nor does it with the impressionism of Monet. It is with surprise that one realizes how few actual *impressionists* there are. It was with them the break came; the disintegration of form, the identification of art with nature, via science. Technically it was the analysis of light, and result of the *plein-air* doctrine, that divided Monet from Rousseau, say, and the Barbizon School. But these two innovations precipitated a transformation of outlook. The group-life of French Impressionism lasted little more than fifteen years. Three names, no more, and the work they stand for—Monet, Pissarro, Sisley—*are* Impressionism.

If Manet was a man of the museums, so was Cézanne whom he so despised. 'I should like to do something solid and durable', were Cézanne's words, 'like the art of the museums.' But a complete impressionist could only feel embarrassment or boredom in a museum. Degas, who continuously exhibited with this group from the first, whatever it called itself, strenuously objected during the period when it made use of the term 'Impressionist'. His doctrinally linear canvases could certainly not be described as 'impressions', in the way that the sketchy and spotty *plein-air* work of many of his friends could. That some picture of his in the Salon once secured for him most warm recognition from Puvis de Chavannes is easy to understand bearing in mind his frieze of brown-skinned boys called *Spartan Games*.

THE CHANTREY COLLECTION
Published 13 January 1949

A little over fifty years of cold war, between champions of good art and bad art respectively—that is of non-commercial art and of that done primarily with a view to financial reward—has reached the showdown stage at the Royal Academy, where at present the entire collection of Chantrey Bequest pictures and sculpture is being exhibited. The fifty-odd years here referred to lie between 1897 (when the Tate Gallery came into being) and today: and the showdown is between the Tate, which regards as anything but assets the Chantrey pictures and sculpture, and the Royal Academy, whose taste—or absence of taste—those works represent.

It was a Treasury arrangement that the Gallery built by the Tate, and run by the state, should be Chantrey's dream-come-true: a big official palace to receive his big gift. So the R.A.s picked pictures from the walls of the R.A., sent them to the Tate, the Trustees of which shot them promptly down into the cellar.

'MODERNISMUS' AND A MELLOW MONK

Almost from the start, in 1897, however, this Treasury arrangement was recognized to have been a mistake. For after all, there were in 1897 plenty of people whose idea of a good picture was completely different from that of the Council of the Royal Academy. Not only would this apply to inveterate professional opponents of the Academy like Whistler. Everybody at all interested in the Paris schools of that time—in Seurat and Signac, for instance, Toulouse Lautrec, perhaps Gauguin or Van Gogh—would think exactly the same about the Royal Academy as I do: or as Mr Epstein or Mr Henry Moore or Mr Piper do, or Mr Michael Ayrton or Mr William Gaunt. Actually, Mr Gaunt has provided us with the best possible parallel with which to convey the ineligibility of the earlier Chantrey pictures. The Tate started life with eighty-three of them—'not a classic basis on which to build. It was as if a library of the best books began with a nucleus of popular novels.' That was just the kind of thing it was. The present Director of the Tate describes in an excellent small handbook how grim were the prognostications for the future of British art in the first years of this institution—destined apparently to be 'a national Valhalla for shaggy cattle and rollicking monks'. But on such archaic vulgarities the more recent juicy slicknesses —the *Modernismus* of sixty years ago (Scandinavian and German) clumsily Anglicized, and mixed a little with this or that—the all-pervasive dirty and untidy backwash from nineteenth-century Impressionism— these later modes are no improvement. I prefer a mellow monk, a *ham* pirate, or rugged glimpses of Victorian beefsteaks horned, hairy, and on the hoof.

The words of a summary prepared for the press by the Tate is anything but an overstatement: 'Throughout this period (1897–1948) the selection of these works, in which the Tate has never exercised any decisive influence, has been the subject of continuous unfavourable comment'. A select committee of the House of Lords, even, in 1904, under the chairmanship of Lord Crewe, reported adversely upon the quality of the Chantrey purchases by the R.A. The Massey Report in

1946 recommended a device by means of which the Chantrey fund might pass into the control of the Tate. Criticism has come literally from all quarters. And, frankly, it would have been better to leave the Tate completely empty, rather than hang any of the Chantrey pictures of unmixed Academy cookery.

It is an insult to the artistic genius of England—a libel on the race of Hogarth and Cotman and Blake—to offer these things—either those of 1897, or those of 1948—as 'works of the highest merit ... that can be obtained ... in Great Britain'. (The words of the testator, defining the objects of his ill-starred Bequest.) I write immediately after a visit to Burlington House—not shocked but ashamed. From Dicksee to Devas it is another world of expression altogether, from that of those great English artists who are the natural models for any 'national collection'.

As a result of considerable agitation, the Royal Academy, in 1922, agreed to the institution of a Recommending Committee of five (three Royal Academicians and two representatives of the Tate Trustees). This committee was to recommend to the R.A. Council what works it should purchase under the Chantrey Bequest. But the R.A. Council retained its right to veto these recommendations.

Since the two Tate members were outvoted by the three R.A. members, with the R.A. veto threat always present at their deliberations, the result necessarily was an unsatisfactory compromise. The three R.A. members were restrained from acquiring really full-blooded atrocities. On the other hand, when they were brought to consent to the purchase of work by a good artist, it would only be on condition that it was the feeblest or tamest example.

There emerges from this twenty-six-year-long tussle, on the asset side, a handful of twentieth-century works, of some merit, for the nation, plus a batch of Alfred Stevens' drawings. I would name Gilman's *The Artist's Mother*, and Pryde's *The Doctor*. It appears that even L. Pissarro had to be *pushed* in (though a wan second-cousin of Impressionism is what we mostly see at an Academy exhibition): and even Augustus John—himself an R.A., of a sleeping-partner order, but still an R.A.—would not have made the grade, with his head of Yeats, unless pressure had been exercised from the two outsiders in the Recommending Committee. Similarly Walter Greaves' *Hammersmith Bridge* or *The Green Dress* were victories of 'the good Party'. Yet out of any ten things bought with Chantrey money nine have been reverses for the Tate, and the *one* that we mark up to the civilized side has usually

been nothing to get excited about—a success to be a little ashamed of, in fact.

The Alfred Stevens' cartoons and drawings must apparently be reckoned a triumph. How beautiful a confirmation of the fact that the Academy does not even possess the solid merit of a body standing for the Tradition—that it is not even *academic*!—merely a collection of businessmen. And the same curious fact is brought out in the difficulty experienced in effecting the acceptance of a Holman Hunt. And it appears they were much too go-ahead to want to have anything to do with the last good picture painted by Sir John Everett Millais.

BURLINGTON HOUSE TÊTE-À-TATE

There is a list published, and easily obtainable, recording, year-by-year, the Chantrey purchases. This is instructive, and sometimes amusing. The first year of the Recommending Committee, 1922, was a bumper year for art. It was then—in the first-flush of the Tate's admission into partnership—that all the Stevenses were bought. Epstein, Greaves, Innes, are also of that year.

Evidently by 1923 the honeymoon was over: it is the Potboiling Principle's year. In 1924 there are nine names, only one worth while, William Rothenstein. (If I am correct that is a subject with three children, however, in which that severe and excellent artist was trying his hand at an 'Academy picture'.) In 1929 the morale of the Tate members seems to have touched zero. That year they had a *Verde di prato* 'Sea Lion' unloaded on them, as well as stone and bronze. In 1930 they had not recovered. In 1931, however, they rallied and scored two Greaveses. But, after all, Greaves is an old master, and dead people do not worry the R.A. anything like so much as live ones.

Despite a quickening of the pace during the war, it has been, all told, a compromise productive of so little, this Committee, that it would have been better to have declined to go into it. And that holds for all future offers. Nothing but frustration can ensue. The Bequest is that of an academician (Sir Francis Chantrey was a rich R.A.) to the Royal Academy.

To alienate that yearly money from the R.A. and its standards is, I should think, legally an impossible task. Meanwhile the existence of this by no means prodigious sum (today worth perhaps £800) stands in the way of adequate support from the state. Would it not be the best thing for the Academy to keep this collection of ghastly junk itself? Surely

the galleries on the right as you go through the turnstile in Burlington House could be reserved for the works of the Chantrey Bequest? The spring exhibition of the R.A. would be a trifle smaller—but still would be all-too-large.

BREAD AND BALLYHOO (8 September 1949)

The position of the painter in Great Britain has at all times been uncomfortable: today it has so greatly deteriorated, economically, that in a few years there will be no art except 'commercial art', and no painter except the 'week-end painter'. Even the 'potboiler' output has steeply declined, its market melting away—*vide* R.A. sales. This situation is known to a large number of people, and it is surprising how silent everyone is about it. Certainly there is a big new racket, if I may use so flippant an expression, prone to suppress, in the interests of Optimism, such information. But silence is not in the interest of painters, except for a very few. The optimism in question is not the confidence resulting from health, but rather the high spirits of well-paid grave-diggers.

With living costs more than doubled, with the impoverishment of everybody except the manual worker, the artist's case would only have to be stated—with the irrefutable data of studio-rent, cost of materials and frames, food, heating and lighting, dealers' $33\frac{1}{3}$ per cent commission, and it would immediately be recognized that, unless subsidized or protected, *that* particular 'cultural' activity is at an end.

There is a great deal going on of a character to obscure such hard facts, and, to some extent, it is intended that it should. The public's ears are filled with the ballyhoo of the great feats of our officials, who—to cheer you up after what I have just said about the painter—are flourishing as never before. For every painter who puts away his brushes and palette in despair and goes into commercial art or—still worse—potboils, at least three officials are signed on to 'feed art to the people', to watch over our 'art treasures', or to show the foreigner how cultured we are. No less than 157,452 people visited the Tate to see Van Gogh's pictures. I would not question the value of moving pictures about—they ought perhaps always to be on the wing. But the fact remains that Van Gogh's travelling expenses, as things are, come out of the pockets of *living* painters. Nor can any conceivable good be done to *living* art, whatever it may or may not do to the public, by those huge spectacles of grandly-dressed Emperors, Infantas, or Princesses, and Peter-Paul's gigantic charcuterie, like the Vienna pictures. Indeed, it operates in the

reverse sense. People go sightseeing to these lavishly advertised 'cultural' displays instead of visiting the small Picture Galleries of the West End, which show work in progress here and today.

THE REACTION OF THE ARTIST

It would be a pleasant change to see these same sightseers re-routed, to see them swarm into the dealers' shops: the salesmanship of the London dealers would be put to the test; the public would certainly acquire a far more intimate knowledge of art by conversing with the dealers, arguing with them about what they had for sale, than it does where the big loan collections are staged. Canvases of the so-called 'gilt-edged' class have a chilling effect, they are remote and economically august, like the Crown Jewels. No one can look *with pleasure* at a picture worth forty thousand pounds. The way for people to learn about pictures would be to go where they are being painted—why not take parties to private studios, by arrangement with the artist?—or to the place where newly painted pictures are hung up for sale.

If this policy would be liable to bring officials or even Councillors in contact with other than hand-picked yes-men artists that would be too bad. I see the difficulty: some of these fellows are very uncouth, and quite certainly desperately hard-up. But as far as the principle of 'feeding art to the people' goes, which is what is supposed to matter, it would be a more creative experience for the uncultured millions. *The painting of Today for the public of Today!* There is another principle, the advantages of which are many and impressive. Before canvases depicting Infantas and Doges the general public can only have at the best *historical* sensations, which is not what an Art Gallery is for.

The reaction of the artist to the sudden popularity of art as 'Culture', as a thing to make a noise with, as if it were a large and hollow object, devoid of life, is understandable. It is as an artist I am speaking here: and the painter's viewpoint is so exceedingly rarely heard that it must, I am aware, sound a little strange at first.

The artist's reaction—and it is not only *mine* but that of all artists not in some manner privately protected (and the latter are usually not those with most vitality, since vitality offends) this reaction will probably seem not only impolite but unjust. If it is to be heard at all, however, it is best that it should be heard undiluted. The official art-boom policy, then, is looked upon by the artist as merely a noisy and immensely expensive Façade: a pretence of ardent activity in the interest of the arts,

but which in fact resembles an elaborate screen arranged to conceal a dying man, to spare others the shock of witnessing this demise. Those imposing institutions, the Arts Council or the British Council, by their mere existence serve to conceal from the public the neglect of contemporary art. It would be far better, from the artist's standpoint, if they were not there. Things could scarcely be worse: and without these make-believes it might become plain to the public how desperate things are.

CAN WE AFFORD A RENAISSANCE?

When and why the building of this cultural Façade began we know. Lord Lloyd, actually, was the pioneer. That initiative 'to assuage the conscience of the age'—to show how art blooms in the midst of bloodshed—was sooner or later taken up on all hands. The action of the Pilgrim Trust developed into what is now the English equivalent of a *Ministère des Beaux Arts*, namely the Arts Council (the chairman of the Arts Panel presumably the de facto *Ministre*). The great national collections, boroughs, even counties (*e.g.* Leicestershire) joined in. Now the Festival of Britain looms in the distance.

By 1945 such a Façade had been run up, suggestive of a 'cultural awakening'—like a Renaissance façade in a Hollywood set—that, echoing the slogans of the official propaganda, the public must have said to itself 'there has *never* been such an interest in the arts!' But there is of course no renaissance or rebirth. You cannot have a renaissance of the *living* arts without patrons, or patronage. Artists unfortunately cannot live on hot air. But the State has killed the geese that laid the golden eggs (or is in process of discouraging them financially with such efficiency that most as patrons are already dead), but it has not itself become a giant Goose, occupying the economic vacuum. If it believes it has done that, with its Councils, it is deceived, or has been deceived.

From the official attitude the natural deduction would be that visual art in England today, though of course its existence had to be recognized, is not deserving of much attention. This estimate is violently unfair. Actually England is so well-endowed with artists of first-rate quality at the moment that, given the opportunity (*i.e.* the official economic support) it could in fact *be* what it is merely officially *advertised* to be. The ballyhoo could be transformed into reality. There is an unusual wealth of young talent, at last up-to-dately equipped, not harking back to French Impressionism, or to pre-Impressionist romanticism. But there can only be *promise*, in the absence of substantial support. All that

Nash, myself and others—to put it that way—worked to create in England is *here*. From my standpoint, the country is bursting with good painters. I feel, and for the first time, at home. But the capital needed to exploit this creative outburst is spent in other ways.

What is the total outlay, annually, of H.M. Treasury for the purchase of work by living English artists? It is in fact so small that it would not do much more than keep a half-dozen artists, were they the sole beneficiaries. Three grants are involved, namely that to the Tate and those to the Arts Council and the British Council. The sum which the latter institutions elect to spend is modest but not very clearly defined. £2,000 *may* be spent by the Arts Council, but only if there are 'enough interesting pictures' available. The British Council would not agree it spent anything like that yearly: but both are fairly regular purchasers in picture exhibitions. I would guess that between them they spend £2,000 or £3,000 yearly. The Tate's £2,000 grant has to cover foreign and British works for over a century.

The State is not necessarily mean, but, one supposes, ignorant. The responsibility lies elsewhere. A phoney list could very easily be drawn up purporting to show that an extremely large sum is spent every year for the purchase of contemporary works of art—by the provincial cities, societies, the Chantrey Bequest, the Transport Board, and indomitable collectors. Such an inventory would be highly misleading. Our society is being socialized at top speed, and the main buyer of good pictures has always been the middle class, most deeply affected.

The subject is so intricate—there are so many official alibis to be dealt with, the multiplicity of conflicting values where pictures are concerned is such a source of confusion—that all that can be done in an article is to stimulate attention. We have, however, one piece of first-rate evidence, of the utmost concreteness. I refer to the 'Income and Expenditure' pages in the *Third Annual Report of the Arts Council* (1946–7). They are not very explicit, but the following facts stand out. The sum finally at the disposal of the Council that year was roughly £450,000. As I have said, of this a maximum of £2,000 is ear-marked for the work of living artists. But Covent Garden pulled down over £90,000. Music, all told, received £212,000—theatrical companies £56,000 odd. But the essential—the stupefying—figures are 450, and 2.

The Council's Art Department has much less money to spend than the Drama, but it spends it practically all on exhibitions, lectures, and salaries. There are no lectures listed in the above Report on 'How to

act' or 'How to play the oboe'. Drama is treated as creative art, Opera
and Ballet the same. The visual arts, however, are treated as a branch of
education. The artist, the *producer*, is sacrificed to some idea of *con-sumption*: he is smothered beneath a mountain of 'cultural' advertise-
ment. The cultural publicity man, the educationist, and the 'amateur'
have supplanted the artist: the painter is being talked and explained,
Art is being boosted, off the face of the earth.

THE HOWARD BLISS COLLECTION (19 January 1950)

Going from Minton's show to the Howard Bliss Collection, on view at
the Leicester Galleries, is almost like leaving a prize-fight at Madison
Square Garden and passing into the remoter parts of Central Park on a
foggy autumn night. This is a large collection and there is a small
percentage of exceptions: Matthew Smith's *Roses and Pears*, Adler's
Composition—Nude, or Craxton's *Boy on a Blue Chair*, might be cited.
But these are departures from a pervasive dimness.

Here is a collector possessed of a most extraordinary predilection—for
the thin brown dim amorphous world, in fact, of Ivon Hitchens, the major
influence obviously in the making of this collection. I venture to think
that this is a kind of pictorial world to which a musician would be
attracted: and of course this is a constatation, not a criticism. Very rapidly
Mr Bliss made an enormous collection of relatively inexpensive, for
preference *weightless*, but invariably tasteful, things. At first one does
not notice the few 'strong' things—though of course there are no
Colquhouns, and other 'strong' artists are in their milder moods: and
probably William Scott with his eggs and frying pans is the collector
having a little quiet fun with himself.

There is a most interesting foreword by Mr Bliss. A 'lyrical affinity'
with Gainsborough Mr Bliss sees as the prerequisite, in a picture, for
admission to his collection—for joining his other 'problem children' as
he calls them (though as Gainsborough is hardly a 'problem child', it
must be Hitchens, rather, that he has in mind). The psychological ex-
clusiveness of his taste is better conveyed further on. To be enabled to
exist 'without change of mood' (his words) among objects which stimulate
that mood, was apparently our collector's aim. This fixing of a mood—at
least so deliberately—is surely a novelty in the West, and Mr Howard
Bliss evidently attributes to pictures a much more active function than
other *amateurs*—even if for him it is a somewhat negative action that is
sought.

THE BALLYHOO OF NEWNESS (23 March 1950)

The New Burlington Galleries are in Old Burlington Street. And the Institute of Contemporary Art presents 'new trends in contemporary paintings and sculpture' which in fact are old trends in painting and sculpture: so the 'New' Gallery in the 'Old' Street is symbolic. In the slip prepared for the press the claim to be showing something *new* is reiterated. The ballyhoo of newness again, is as old as the hills: and there is nothing novel here except that every individual is a little different from any other individual. These remarks, provoked by the tone of the promoters of this very average modern picture show, does not mean that Bacon's pictures are any less fine than when they were seen a few months ago at the Hanover; or that Craxton's big picture, or still better his *Bathers near the Hotel* is not very excellent, and the sculpture highly expressive. (Actually, if we are to put a premium on newness, the 'collateral descendant of Francis Bacon' is the only relatively young artist so far qualifying.) The French artists have been picked on account of (1) their relative youth, and (2) their abstractness. They are much less interesting than the English—if only because (in the end) a section of a brown check dressing-gown is less interesting than a man in a brown check dressing-gown: and ten brown or blue and green check dressing-gown sections mixed up into a solid brown check mass is not more interesting than one section. Yet a lot of painters and pundits seem to think it is.

CONTEMPORARY ART SOCIETY (6 April 1950)

Supporters of the Contemporary Art Society have staged an exhibition of more than 300 paintings, sculptures and drawings at the Tate Gallery: not works purchased by the Society, but selected from the private collections of members. Why should they have decided to make this *demonstration*, as their Chairman describes it? Ah, that is what makes the exhibition so interesting. Is it (1) the swan song of private collecting? Or (2) will it succeed in reinvigorating private support of the arts? There is another aspect of it: (3) is this a phase in the close co-ordination of private and state patronage—seeing that practically all those on the art committee set up by the state (in its 'Arts Council') including the Art Director, are also members of the Contemporary Art Society?

In an introductory note in the catalogue the Chairman of the executive committee, Sir Colin Anderson, disclaims any intention on the part

of the Society to aim at a representative show of contemporary art. Yet
it does in fact illustrate most adequately what kind of work has interested
the intelligent minority most during the past forty years. 'The kind of
contemporary work which is actually being enjoyed in the home' the
Society's spokesman particularizes. For of course one of the main
prejudices to be overcome is that 'modern' work proves disturbing in
the home, that it cannot be *lived with*. Those disinterestedly concerned
with the improvement and development of taste in England recognize
this as a primary difficulty: which is why we find *the home* stressed—as
the natural place even for a serious picture—in this statement of aims in
the catalogue. For the rest, it is as a recruiting campaign that we are
officially invited to regard this exhibition. 'New blood' is what is asked
for. There is some new blood in this Society already, and it is a great
improvement on the old.

Before turning to the vastly important questions, discussion of which
this exhibition imposes, I would like to say what a fine collection it is.
It is of a sober excellence, extremism is markedly absent. Also, there is
a significant absence of large canvases, such as you would see in any
French exhibition. The only really large canvas is Augustus John's
Dorelia. John's work, or that part of it which posterity, I think, will value
most, is dominated by the figure of Dorelia. Could the decorative black
fence be spirited away from this masterpiece its power would be en-
hanced. A great number of Moore's and Piper's things are here—the
former's cracked figures and the latter's cracked walls. (The psychology
of the crack is deserving of study.) Piper of course is a vetustic specialist.
His old cliffs and aged buildings provide the surfaces and advance the
mood he prefers. Dufy himself could not handle watercolour and wash
with more deftness and bravura than he. None of Moore's splendid
carved or modelled *Mother and Child* pieces are here, those stone-age
idylls where he is most himself. Two of Victor Pasmore's atmospheric
transparencies, one with bird and moon, are outstanding exhibits.
Evening Star has all the perfectionist exquisiteness of the best Whistler.
The vigour of this artist is demonstrated by the fact that, having achieved
a quite new sort of perfection for him—as in *Evening Star*—he plunged
abruptly into abstraction: abandoning all his wonderful lyricism to go
pioneering with a pack of cards. Then Sutherland's *Descent from the
Cross* is a memorable sketch, in which the nest of brilliant thorns loading
the head is a fine invention, the fresh, almost gay, spring colours are the
first elemental intimations of the Resurrection. Lastly, Frances Hodgkins,

New Zealand's greatest artist, seems to have the colour values of a slightly saponaceous aquarium tank: and her forms are apt to be flattish, as if subjected to the pressure of a heavier element than air. There are eleven of her exhibits. Then Gilman, more and more, attains a long delayed posthumous recognition. Forty years ago is of course when this well-merited interest should have been accorded him.

I have space only briefly to indicate the situation implicit in this 'demonstration' at the Tate. In England without promotion and protection visual art cannot exist, except of course for the potboiler. This was a fact recognized very clearly by Ruskin, and later by Fry, who, in its early years, dominated, if he had not been responsible for, the Contemporary Art Society. So the very existence of this Society would seem to involve the axiom *All serious painting in Great Britain can only exist privately, or semi-privately.* The organization of charity is not what is proposed but what is the next thing to it. The public-spirited rich are urged to purchase what is otherwise practically unsaleable in this country.

Let me say at once that the above axiom is to my mind unchallengeable, so long as an only partially collectivized economy exists. An enlightened public of minute size (whether organized as a Club or Society or not) will certainly have to carry the artist on its back—or a select few artists. They must be severely restricted in number. Should some of these artists carried on the back of the make-believe 'public' get chosen because they are light-weights or fly-weights, what more natural?

This carefully planned collectivized patronage plays the part of a stage-army. It supplies the illusion of an 'art-world' in England. In the past—forty years ago when the Contemporary Art Society was founded —art was so sick that artificial respiration was necessary. Today, and I get tired of saying this, the situation is *not* better. How could it be? But the activities of the above stage-army, with which the museums, the state, and even the dealers, co-operate, put up a terrifically life-like show. With this and the masses of pictures of all nations, times, and schools always on view, the public, the *real* public, could not do otherwise than believe that art is booming. Between the wars, gazing in from the outside, into this sheltered little so-called 'art-world', with its carefully regulated economic climate, in which like a small herd of gazelles Britain's team of 'modern' artists subsisted—to the outsider it was unimpressive, to say no more. Since the end of the war the wind of the outside has been permitted to penetrate and to freshen up the enervating

atmosphere. The presence in this exhibition of several Colquhouns is a
sign. But to conclude. We must accept it in England that the artist has
become the inmate of a very small private world. The drawbacks of this
are obvious. They are those of a large family unit. Favouritism is an
unavoidable curse of family life, all competing for the love of Papa and
of the Uncles. Then the art itself is liable to suffer, both because of
interference on the part of the Guardians, and through a sense of futility
consequent upon living so artificial a life. Every step should be taken to
counteract these tendencies. Since the state has come on the scene,
although at present it is identical with the private set-up, it should in
the end be possible to depersonalize the mechanism of patronage.

But at this time my analysis can be taken no further. Everyone should
see this momentous show. It is I believe a last attempt to save the
Exchequer from having to carry on its back an 'art-world' which is a
major casualty of the industrial age—an atlantean task for which it has
little appetite. Were it obliged to assume it, it might drop the whole
'art-world' into the Thames, after carrying it for a year or two.

CRITICISM OR PROPAGANDA ? (13 July 1950)

In approaching the Italian Exhibition at the Tate, the main feature of
this article, I should like to make a few observations about what is called
'art criticism', but which today is so often not criticism but propaganda
in the case of those who write exclusively of the *avant-garde*. By this term
is meant those who believe that the naturalism we find in gothic,
renaissance, baroque, romanticism, impressionism and post-impression-
ism is to be transcended. The naturalistic giantesses of Picasso or Léger's
big doll as much as the abstract symbols of Kandinsky belong to the
era that is succeeding the graeco-roman, for Picasso's giantesses are
big fat insults to the classical. In England, with critics who cannot shake
off a taste for nature in the raw and probably secretly prefer Munnings
to Mondrian, lip-service to any aberration however violent is never
withheld. The streamlined *avant-gardist* criticism usually is sincere but
looks equally artificial. There is a danger of criticism finally disappearing
altogether, of analysis being disallowed; of propaganda—and official
plaudits—superseding criticism entirely.

Since it is 1950, in other words, do not let us always be behaving as
though it were 1910. At a time when state officials and gallery directors
describe as a 'reactionary' anyone preferring the art of the Crete of
antiquity or Renaissance Tuscany to that sponsored by Marinetti or

Apollinaire, surely it is no longer necessary for any person of goodwill to limit himself to propaganda, as if the 'moderns' were still in the catacombs. So now for the 'Modern Italian Art' at the Tate: and it will be as a critic, not as a propagandist of the 'modern', that I shall write. To insure the great impulse to find for our twentieth-century consciousness a visual equivalent, it should not be encouraged to remain merely a series of 'rebellious' gestures. A brick thrown through a plate-glass window, or derisive scribbles upon a convenient wall—which frankly is all that Miró's illustrations for Dada are—is not what the innovators should be doing today. . . .

CHILDREN'S ART (21 September 1950)

By far the most interesting of current exhibitions is 'Children's Art 1950', at the Royal Institute Galleries, Piccadilly. One hundred and fifty thousand people visited this extraordinary innovation, for which the *Sunday Pictorial* is responsible, last year. It is just as crowded at present. It must be given first place because it contains much more art of high quality than is to be seen anywhere else—though no exhibitor is over sixteen, and some are only five. Then the issues raised by this new annual event—significantly situated opposite the Royal Academy— would alone require one to feature it. It is not far also from the dealers' galleries where 'avant-garde' shows are held, an even more suggestive circumstance: for much of the work displayed there is deliberately infantile. This does not only apply to Klee's or Miró's pastiches of Child-art but to a general predilection for 'the Innocent Eye'. Picasso, so Mr Herbert Read alleged in his opening address, on visiting a Child-art exhibition, described how he had striven to identify himself with the child-artist. 'At that age', Picasso said, 'I could draw like Raphael. It took me years to learn to draw like these children.' So it is obvious how momentous this development is: the authentic Child has stepped on to the stage, up till now the playground of adults. But what makes this a really serious matter is that because of a novel educational technique, he presents himself equipped with all the latest adult devices. It is not the untrained child in this case, with its customary pot-hooks and mannikins—though this plain unvarnished child finds a place here too. It is a miniature Miró or Dufy, coached by some zealot of the new educational technique, some Matisse and Miró-minded adult. Surely the little dog should laugh to see such sport and Chagall's Cow jump over the moon. So far only the Royal Academy has reacted, in the form of utterances at

an R.A. banquet by Eton's headmaster, pooh-poohing (I gather) 'Child geniuses'. But the 'avant-garde' in the little Galleries may ultimately have more cause for concern than the Worshipful Company of Potboilers across the road.

There are expressive regions to which the Child is unable to attain, however he may be coached—Raphael if you like, though there are works more inaccessible to Childhood than his. Will the adult artist at length be obliged to abandon the delights of Childhood—just as the artist forsook naturalism confronted by the camera? Such a question may be premature, but it is not irrelevant.

It is its tendentious character which makes this show of such unusual interest—the shadow of the adult behind the Child. There are 30,000 entrants, we learn, and only 300 are accepted and hung. Those chosen are sent in by a school possessing a teacher inspired by Mr Herbert Read or from some family where intellectual influences are present and active. An injunction of Mr Read's is, like a sacred text, hung conspicuously on the wall in the main gallery. The golden rule for the teacher is to be a *collaborator*, not a mentor, is what it says, though I forget the words. Nothing new about that: but it draws our attention to how much adult collaboration is discernible throughout this exhibition. And why not? Child art is generally dull. But this show proves that the Bonnard-Rouault-Matisse-Dufy-taught children (and some are already adolescent) are anything but dull, and often brilliantly effective. The Innocent Eye has been disciplined, the virgin vision harnessed. Mr Read is to be complimented on what is largely the result of his teaching. Soon oil paints will be at the disposal of all talented children, some will take the abstract road: there will be maestros of fifteen and sixteen; after two or three years of Trilbyesque precocity to lose their virtuosity. Writing in the catalogue Mr Philip James of the Arts Council is candid. 'This exhibition is more a tribute to teachers . . . than a showing-off ground for children who are only being their natural selves.' There is little evidence of the 'natural self' among these highly selective exhibits. Mr James shares with me, I see, a dislike for 'the superficial freedom to splash about'. He adds that 'There is a high degree of self-discipline' here. One might almost say that there has been a conspiracy on the part of a few advocates of visual revolution to mobilize the Kindergarten against reaction. Three hundred compositions by carefully picked schoolchildren are produced, and the promoters cry: 'The Children are with us—they are natural visual revolutionaries! The Bauhaus reveals

itself in the nursery! The artistic revolution is justified by your children!'
What takes away a little from this impression is the nature of the prize-
winning picture, *Harvesters*, a typically sentimental rustic idyll inspired
by Palmer. This is possibly a deliberate backsliding on the part of the
committee.

THE CAMDEN TOWN GROUP (9 November 1950)

A show which is certain to attract a good deal of attention this month is
'Paintings by Some Members of the Camden Town Group', at the
Lefevre Gallery. Sir William Rothenstein once sagely observed (he
was referring to what he regarded as the phenomenon of Sickert's great
reputation), 'In England if you only live long enough you become a
great painter.' This used to be true, I think. However that may be, if a
man has been dead, or if a group has been extinct, for two or three
decades, he or it appears suddenly to acquire value to dealer or bio-
grapher.

And some excessively dull dogs and dull groups do in this way get
fished up. As to the Camden Town Group of forty years ago, though not
interested I was there. There was nothing in England then but Impres-
sionism, slightly stimulated here and there by reflections of Vuillard or
Bonnard—not of Van Gogh or of Gauguin, as Mr Maurice de Sausmarez
says in the catalogue. As I have referred to this introductory note, let
me also observe that it was with surprise I read: 'Apart from an agree-
ment about the needs for an association of painters that would give
equal opportunity for exhibiting to artists of various tendencies whose
views were in conflict with established societies, it is difficult to find any
common factor among the members of the group.' What surprised me
here was to find a distressing family likeness overlooked and petty differ-
ences singled out. A pervading dinginess, drabness, and marked lack
of interest in form, is what one is aware of as one gazes around one—not
the fact that there are of course some who, given the power, would have
liked to be one thing, some another. That is how this collection of artists
appeared to me at the time: past sensations are revived, no more. An
honourable exception is Gilman. His portrait of Sylvia Gosse might
find itself among Vuillards without disgracing itself. He discarded the
muddy palette of most of those around him, and in his deep parsonic
voice rejoiced in primary colours.

As a nation, the English are naturalists. Impressionism is a kind of
painting suited to their temperament. In 1911 there was the Camden

Town Group: then about thirty years later I entered a small Gallery off Piccadilly and really believed myself at first among French Impressionist pictures. There sure enough was a Degas, there a Monet. But upon inquiry I discovered that this was merely a new demonstration of British loyalty to French Impressionism and of British desire that that movement should not like others pass into history but be kept alive continually by new adherents—something like the flame that is perpetually rekindled in the Arc de Triomphe. This was the Euston Road Group. I feel sure that three or four decades hence another recrudescence of Impressionist ardour will occur in England until finally, perhaps, it will be claimed as 'British'. Let me say at once that if a Camden Town team were matched against a Euston Road team it would be a pretty near thing. Of course, if there were half a dozen good Sickerts and good Gilmans they would win. But with the team on show at the Lefevre it would be a walk-over for the Euston Roaders.

THE 1949 RETROSPECTIVE EXHIBITION

Lewis's Introduction for the Catalogue of the Exhibition, held at the
Redfern Gallery 5-28 May 1949

This assemblage of paintings and drawings contains a few specimens of quite 'abstract' work; much of abstracting tendency; and much work which is naturalistic. The presence of work so different in kind, in what is largely a retrospective show, is not to be explained chronologically. In the days of 'vorticism', I was at pains to put it on record that because I was 'abstracting' that did not mean I would abstain from work from nature. The first of these modes of expression did not appear to me to preclude in any way the second. To illustrate this last week I executed a 'semi-abstract' work and I was also completing two portraits which hang in this exhibition, in which Mr T. S. Eliot and Mr Julian Symons can be seen exactly as they are in the flesh, their respective physiques in no way tampered with.

The only way in which chronology applies is as follows. In the year or two prior to World War I, I attempted totally to eliminate from my work all reference to nature. This is not the place to expound my motives: it is enough to say that you will not find any work of mine later in date so 'abstract' as that.

At that early period I reproached, even, the Paris school; of '*nature-mortists*', as I called them, for their inability to free themselves from the habit of naturalism. It was their practice to begin by painting a straight still-life, or figure (as *morte* as was the '*nature-morte*'), and then subject it to abstractions and distortions. For the work to be anchored in this way in a naturalistic subject-matter seemed ridiculous. There *is* an abstract world of forms and colours: there is a visual language as abstract as a musical score. If you are going to be *abstract*, I argued, why worry about a lot of matchboxes, bottles of beer, plates of apples, and picturesque guitars? Why not turn your back upon familiar objects altogether—since by the time you had finished your picture they had, in any case, almost disappeared?

Although I found the abstract too empty for my taste, and saw no reason, on reflection, why I should dehumanize my vision, I still believe that, in art, the abstract is either (1) something to be *used*, merely in a

P

humanly significant context, or is (2) a new language altogether, of form and of colour, not of this world.

Since that first period, then, I have made use of abstractionist modes, employed stark simplifications, and availed myself of stylistic habits which remained with me, to achieve some unusual effect, or to serve me in some expressionist excursion. It is legitimate to avail ourselves of the abstract tongue in this way, in order to heighten or to flavour the concrete —provided there is no pretence of being truly abstract—or no phoney scientific pretence. I may add it is most happily employed in conjuring up the unfamiliar, rather than in conferring an unfamiliar appearance upon the familiar.

Another thing I might mention is this. Very few twentieth-century artists—to my way of thinking too few—have painted people, except indirectly, in symbols and masks. Kokoschka, Modigliani (though the latter is stylistic caricature), there are a few: but the African or Polynesian mask has almost banished from the walls of our galleries the *individual*.

As to the 'long conspiracy of silence' to which Mr Ayrton, with the generosity and courage of youth, alludes: that no book exists with reproductions of my work (where there are so many such books), that the considerable body of work, collected through the enterprise of this gallery, here seen for the first time, should have remained unknown for so long, are the kind of things which I find are apt to provoke the impartial observer, or of course friend, to comment. Let us say (not to indulge in truths that would lead straight to suits for libel) that the 'conspiracy' dates from 1913—it has been, as Mr Ayrton says, long: from the time in fact that I hustled the cultural Britannia, stepping up that cautious pace with which she prefers to advance. Apart from anything else, for *that* one is never forgiven.

THE 1956 RETROSPECTIVE
AT THE TATE GALLERY

Introduction to the Catalogue of Wyndham Lewis and Vorticism,
an exhibition held at the Tate Gallery in July–August 1956

The period enclosed by this Exhibition is some time towards the end of the first decade of this century, down to five or six years ago, when I became blind. I first exhibited, I believe, in the Carfax Gallery, a small gallery belonging to Robert Ross, situated in St James', between Jermyn Street and King Street. A large oil of two French fishermen was the principal work I showed there. My last picture, before blindness, was the large portrait of T. S. Eliot, now in Magdalene College, Cambridge. Already, while painting this last, I had to stand close to the sitter, and there was a strict limit to what I could do. In the following autumn I learned what I was suffering from, namely a tumour pressing upon what is known as the optic chiasma. It continued to press, and soon I could neither read nor write, much less paint pictures.

I have been unable to trace any work of this first, Carfax, period, though I believe there will be a drawing in ink, a relic of that time.

The next period I will mention is that culminating in the magazine *Blast*, which appeared just before World War One. This enormous puce-coloured periodical (as it was intended to be, though in fact there were only two issues) was the verbal expression of a movement in visual art whose vivacious span, 1913 and 1914, was wedged in between the outbreak of war and its initial impulse in the autumn of 1912. The large oil, *Revolution*, possessed by Mrs Stross, is all that can be found to represent this period.

About the Group, directed by myself, and called 'Vorticist', a great deal has been written by what we now call Art Historians. Some of the Art History relating to Vorticism which I have read has been un-recognizable.

Vorticism, in fact, was what I, personally, did, and said, at a certain period. This may be expanded into a certain theory regarding visual art; and (much less theoretically) a view of what was excellent in literary art. The *Enemy of the Stars*, and the first version of the novel *Tarr*

exemplified the latter of these two intellectual novelties with which, however, we are not concerned here.

As regards Visual Vorticism, it was dogmatically anti-real. It was my ultimate aim to exclude from painting the everyday visual real altogether. The idea was to build up a visual language as abstract as music. The colour green would not be confined, or related, to what was green in nature—such as grass, leaves, etc.; in the matter of form, a shape represented by fish remained a form independent of the animal, and could be made use of in a universe in which there were no fish.

Another thing to remember is that I considered the world of machinery as real to us, or more so, as nature's forms, such as trees, leaves, and so forth, and that machine-forms had an equal right to exist in our canvases. I found colleagues who came from the industrial North, like Wadsworth, more ready to accept my views in this respect.

Vorticism, then, was a composite of these and other ideas. In general I repudiated this teaching after the experiences of World War One. Persons today who have become advocates of abstract art, and who have written about Vorticism, are apt to write differently about it from the more objective 'historian'.

Were I going to relate what it was decided me to abandon this road, from 1920 onwards, I should involve myself in an attack upon the Abstract in Visual Art, and I am not going to do that. If people wish to know what my view is on the Abstract, and other modes somewhat similar in purpose, I recommend them to buy my not-very-expensive book, *The Demon of Progress in the Arts*, in which, expounded in the most elaborate way, are my reasons for objecting to these fashions.

Let me make a few general remarks on painting. When I came out of my vorticist period, just before the beginning of the twenties, I set myself to perfect my drawing by practising tirelessly in work from models. This is a work I should have done much earlier. I knew that, but I went to school, as it were, in order to build a solid foundation. One of my first experiments was to create a toothy tribe which I called Tyros. My dentistry was not naturalistic, that was sacrificed for the creation of a type. I produced a few good grinners, but it was, I fear, an empty exercise. I fled from these horrible grins to the repose that lay in un-alloyed naturalism.

I had at all times the desire to project a race of visually logical beings; and this I believe I attained in the constructions named *Tank in the Clinic* and *The Mud Clinic*. Such pictures as *The Stations of the Dead*

and even the *Surrender of Barcelona* are an extension of this intention. Whether as a banshee, a strutting soldier, or the invalid inhabitant of a Mud Clinic, my creatures of that kind served a visual purpose. They were not created as we create characters in a book, but with some purely visual end in view. If I had given them a name it would probably have been monads.

In my portraits what is lacking is numbers. I wish I had done fifty MacLeods and Spenders. However, it will show you what a grand visual legacy a man can be responsible for if he submits himself to a proper training at the start, and is not driven about by Wars and otherwise interfered with.

Finally, I am sure that, in one form or another, Nature supplies us with all we need. There are people who imitate the primitive Greeks, others the Negroes or the Chinese, which is merely because they are too snobbish to remain with nature. What a loss it would have been if Rembrandt had imagined himself an Etruscan, or a Primitive Man. My merit, whether great or small, in the portrait of MacLeod, resides in the long legs of a Scot, the fondness for books of a mature man, and the stone and steel colours of the tweeds.

THE VORTICISTS

Vogue, *London, September 1956*

When a man is young he is usually a revolutionary of some kind, so here I am speaking of my revolution.

I had been trained (ostensibly) as a draughtsman and painter, and, on my own account, had written verse and stories, and formed the habit of writing. So there I was, at the beginning of my career, (a) ostensibly, a painter, but (b) privately almost a writer.

I first became known to the society in which I was a painter in a very revolutionary frame of mind, by an immensely pink, very thick, and awfully large magazine, with the name of *Blast*.

Blast by its name explained itself. Inside it announced itself as on fire with a new philosophy called Vorticism. This inflammatory doctrine affected equally the images which issued from its visual inspiration, and likewise the rather less evident literary sources of its ebullience.

Nowadays one is often asked, 'What is Vorticism?' And in this article my most immediate business is to answer that question. Let me do that without circumlocution.

The 'Great London Vortex', as it was vociferously described at the time, was one of those catch-words invented (not by me). It described a movement springing in the brain of one man (in the present instance, mine)—for I was the 'Great London Vortex'.

The origin of the term 'Vorticism' was the idea of a mass of excited thinking, engrossed in a whirling centre. We all know, without applying to the dictionary, what is meant by a vortex. It is a violent central activity attracting everything to itself, absorbing all that is around it into a violent whirling—a violent central engulfing. An ingenious critic noticed that my position was offensively central, that I was at once calm and whirling, that I was at once magnetic and incandescent, and he drew his own conclusions. He remarked my wild and whirling words. They laid it down that the painter should sever his connections with nature, and should cease to behave as a copyist. He should invent shapes of his own, and assemble them—'compose' them—in full independence, just as the musician does his sounds.

But although this is the meaning as far as the dictionary will take us, the term Vorticism represented more than a whirling hole in the water.

It meant, I assume, the ideas of a time concentrated by an individual energy into a doctrine. But by 'a time' one must mean something more limited, geographically, than the whole of Europe. It can only mean us here in the western corner, with our immediate influences.

As you see, I am attempting to retain for this idea as close a frame as possible. But I am describing something, it must always be remembered, of very limited duration. A great war came down on top of it, and, in a sense, isolated it. And I, personally, stepped out of it.

Having circumscribed in this way the doctrine I am describing, let me say that Vorticism was an intellectual eruption, productive of a closely-packed, brightly-coloured alphabet of objects with a logic of its own. The doctrine which is implicit in this eruption is to be looked for in the shapes for which it was responsible.

But at this point one is obliged to confess that the actual number of these shapes is small. In the white heat of the 'Vorticist' eruption one was not granted enough time to expand oneself, and produce a sizeable amount of canvases and the like. The best way to realize the essence of this doctrine would be to assemble the works produced since that time which are touched with the authentic fire. I can think of dozens of drawings which would not be the original things they are if it had not been for their 'Vorticist' ancestry. Even an oil portrait like the *Hedwig* (a picture sent by me to the Tate exhibition), coming as it does quite near to another convention, is nevertheless, in its massive design, a creature of the Vortex.

Had I been teaching Vorticism at the time I was practising it, in the shadow of the First World War, one of my main doctrines would have run as follows. I would have insisted upon the creation of a language absolutely distinct from what was handed us by nature—such as stones and trees, and men and women, or all the other visual entities of our everyday world. I should have said that the musician does not require these things, and why should we? I should have recommended the construction of an alphabet of as abstract as possible a kind.

I should not have been alone in Europe in advocating this procedure. But I should have been one of the first, and part of a European development of this kind. I wish to distinguish this from the geometric abstractions which have occurred since that time.

What I should have put in place of trees and stones, and men and women, would have been invented shapes, with no direct connection with nature. What I objected to in the contemporary innovations at

that time was the fact that in all cases they were distortions of nature. The cubing which produced the works of the Cubists was a flattening and chopping out of planes in a face, or in objects upon a table. They were Naturalists, after all.

In my class I should have had upon a table objects numbered, or marked by letters, and have excluded those resembling, say, a bottle, or a hand, or an animal, or a flower.

Had I been able to start a workshop, like the Omega workshops, I should have had classes developing the above themes, and encouraged the shaping, in clay or in wood, of objects conforming to those theories. In other words, a world of not-stones, not-trees, not-dogs, not-men, not-bottles, not-houses, etc.

I should not have insisted upon this world of negation, but I should have used that as a means of teaching repudiation of nature. Then I would have posed an interesting person in front of a drawing class, and asked them to give versions of this model which were as different as possible.

I started by saying that, as a very young man, I was rebellious. And it has been suggested that I should consider the usefulness or otherwise of rebellion. I could not imagine my own life beginning otherwise than as it did. I am all in favour of a young man behaving rudely to everyone in sight. This may not be good for the young man, but it's good for everyone else.

But, aside from these general observations, England was in an unusually somnolent condition. Fifty or sixty years before, English Society had received a shock from the Pre-Raphaelite Brotherhood. This owed its impulse to a movement of young Germans in Rome. It awoke a great deal of talent. That had been the last contradictory impulse. All painters ended by entering the Royal Academy, which was the official, indeed Royal place for Art to occur in, as its name describes it. But Royalty in England had never been attracted by painting—since, that is, Charles the First, and he was summarily dismissed by the British because of his alien tendencies.

Well, a loud unseemly cry of 'Blast' broke in upon this lethargy, and was followed, some years later, by an announcement that I was 'The Enemy'. I made it quite clear what my position was. Wars have made it impossible to get on with anything for very long, but I am glad that I got in, at the very beginning, a resounding oath.

I have referred to only one Vorticist, namely myself. But there is a

tendency to speak as though Vorticism were a doctrine adopted by a considerable company. I am afraid that this is an illusion. I say this regretfully, because in the past I expended a good deal of energy in order to create the impression that a multitude existed where there was in fact not much more than a very vigorous One.

It was essential that people should believe that there was a kind of army beneath the banner of the Vortex. In fact there were only a couple of women and one or two not very reliable men. But let me, for those who still may wish 'historically' to write of 'The Vorticists', supply the names of those who might consent to be described in this way. First, Helen Saunders and Jessica Dismorr (only the former is alive), both very gifted women, would be willing to go down to history in my company. Now as to men. Edward Wadsworth was the painter most closely associated with my Vorticist activities. He came from the North, and the landscapes of the Industrial World especially attracted him. Such names as Etchells, Hamilton and Roberts are mentioned in association with me—though how much they would agree to this I do not know—and the sculptor Gaudier-Brzeska may be counted in.

It must be remembered that we were sandwiched in, in the year or two before the guns of the First World War began cannonading.

Hogarth's *Shrimp-Girl* shows what splendid painting can be done in England. But since that eighteenth-century explosion there have been only the Pre-Raphaelites, and so it must be admitted that painting is not our forte. But passing hurriedly from such dismal considerations, let us look brightly toward several centuries in which such paintings as the *Shrimp-Girl* may occur with greater frequency. If we could only get started—dodging in and out between colossal wars—we really might get something done. It is worth aiming at this, I am sure. But we would have to start always with a divine discontent, as there are here in Great Britain several notorious pitfalls for the painter, the first being, of course, that enormous trap in the centre of our principal thoroughfare, Burlington House.

I believe it must be from the class to which Hogarth's masterpiece belonged that our most painterly material will come. Some of our best inspiration in the literary line has come from Jabberwocky, and that suggests rich visual possibilities in the future. Fantasy of that type is the Briton's long suit. I am sure that the most promising procedure would be to consider what we are best at in our great literary field, and undoubtedly, in our Visual Art: that is where our best successes would be

found. If we went to the other side of the Looking Glass, like Lewis Carroll, we should find images of the most exciting kind. Led by the Shrimp-Girl we should direct ourselves between the Mad Hatter and the Red Queen, and there we should be at home. I am merely charting a course for the Ancient Mariner, and showing where he best can steer himself.

The question is not how a thing is done, but the thing that is done. However, unless the thing is beautifully painted, it never comes to life. I have never seen the original of the *Shrimp-Girl*, but several colour plates of it. I am blind, but, if I could see, I would do a large design of something like a Jabberwock outraging an eagle.

L'ARLESIENNE

This piece, typed on a sheet of paper, was among the papers Lewis left.

'*L'Arlésienne.*'

What does this Van Gogh say?

It says that we grow old.—Here is this human being, who has been a young girl, dressed herself up to attract; attracted; mated; experienced all that mating is.—Now she sits huddled up, with a face like a fish: with eyes moist with a melancholy emotion, staring into the terrible mystery in front her.

Is she devout? Probably, at that time. With however all the instinctive reservations of the sensual average.

A blank yellow glare behind her is symbolic of the feverish emptiness upon which her meditations are unrolled.—Or it is the cruel honey in which this human fish is embalmed.

NOTES

p.26 LADY MOND. Wife of the industrialist and Liberal M.P. Sir Alfred Mond, later Baron Melchett (1868–1930), who had been persuaded by Violet Hunt to buy *The English Review* after it encountered financial difficulties late in 1909. Lewis's first published writings had appeared in the review earlier that year.

p.31 ARBUTHNOT. Malcolm Arbuthnot, the Bond Street photographer.
H. SANDERS. *Blast*'s spelling for Helen Saunders.

p.33 SEX AND CHARACTER. *Geschlecht und Charakter*, by Otto Weininger (1880–1903), created a sensation when it was published in Vienna in 1903 and was quickly translated into several languages. Weininger is 'blasted' in *Blast No. 1*.
L'ILE DES PINGOUINS. The novel by Anatole France. This sentence is omitted in *Wyndham Lewis the Artist*.

p.35 HOFFMAN ROMANCE. E. T. A. Hoffman (1776–1822), novelist of the Romantic movement in Germany, was popular in Britain and France in the nineteenth century.
HIS MONA LISA ELOPED FROM THE LOUVRE LIKE ANY WOMAN. Leonardo's Mona Lisa was stolen from the Louvre in 1911.

p.36 (TO D'ALEMBERT). J. J. Rousseau, *Lettre à d'Alembert contre les spectacles* (1758). Jean le Rond d'Alembert, the mathematician and philosopher, had condemned the prejudice against the stage in the *Encyclopédie*.
SWINBURNE BEING RETIRED DEFINITELY INTO PUTNEY. The poet Algernon Charles Swinburne was taken in 1879, at the request of his mother, to live in this respectable suburb for the purpose of recovering from the effects of alcohol.

p.37 ART KNOWN AS BELGIAN. 'Belgian' was used as a term of contempt by Baudelaire, who spent several of the last years of his life in Brussels.

p.38 WITH PICASSO'S REVOLUTION. *Wyndham Lewis the Artist* has 'With the present revolution'.
TOO AMATEURISH A CARPENTER. *Wyndham Lewis the Artist* adds '(in his collages)'.
BECHSTEIN HALL. Opened in 1901 by sons of the founder of the Bechstein pianoforte firm, this concert hall on Wigmore Street, London, is now known as the Wigmore Hall.

p.40 H. WADSWORTH. Despite the initial as originally printed in *Blast*, this seems another reference to Edward Wadsworth.

p.42. H. A. GILES. Herbert Alan Giles (1845–1935), author, translator and editor of a number of works dealing with Chinese culture and literature. PERSONAL TRICKS AND CEREMONIES . . . ARE CASUAL EXAMPLES OF THE SAME SENSES' ACTIVITY. *Wyndham Lewis the Artist* continues 'activity, which select and arrange the impressions they receive, in order to compose a picture'.

p.44 THE ONE COMPACT HUMAN FORM IS HIS TOM-TOM. *Wyndham Lewis the Artist* has: 'His pictorial Tom-tom.'

p.46 KANDINSKY AT HIS BEST IS MUCH MORE ORIGINAL AND BITTER. *Wyndham Lewis the Artist* reads: 'Some other painters have been much more original and bitter.'

p.48 BUILDING OF A CITY. Now known as 'The City Rises', the picture is in the Museum of Modern Art, New York.

p.51 A.B.C. SHOP. 'All A.B.C. Tea-shops (without exception)' were 'blessed' in *Blast* No. 2. With initials standing for The Aereated Bread Co., they constitute a chain of inexpensive restaurants and were popular with *The New Age* circle as well as the *Blast* group at this time.

p.53 OUR VORTEX IS WHITE AND ABSTRACT WITH ITS RED-HOT SWIFT-NESS. *Wyndham Lewis the Artist* omits this and the preceding two lines.

p.54 FREDERICK SPENCER GORE. The artist was born 26 May 1878 at Epsom, Surrey. A memorial exhibition was held in 1916 at the Carfax Gallery. Gore was given an Arts Council exhibition in 1955.

p.60 CONCENTRATED. A wartime term for 'enemy aliens' placed in concentration camps.

p.64 IN THE FIRST SHOW THE FUTURISTS HELD IN LONDON. The exhibition opened at the Sackville Galleries in March 1912.

p.66 MR FRY'S CURTAIN AND PINCUSHION FACTORY IN FITZROY SQUARE. Lewis's reference is to The Omega Workshops, Ltd., founded by Roger Fry in 1913 at 33 Fitzroy Square, London.

p.67 'THE MONICO' OF SEVERINI. Severini's 'Pan Pan at the Monico', a café scene, had been a much-discussed picture at the Futurist exhibition, which could be seen in most European capitals in 1912.

p.76 THE 'DECORATIVE' ARTIST (AS EXAMPLES, THE SORT OF SPIRIT THAT ANIMATES JUGEND, RHYTHM, MR ROGER FRY'S LITTLE BELATED MORRIS MOVEMENT).
Jugend. The Munich magazine which popularized *Art Nouveau* in Germany. Hence the German name *Jugendstil* for this style. Fry's movement was the Omega Workshops. William Morris (1834–96), the

pioneer of arts and crafts, working with furniture, wall paper, stained glass, carpets, etc.

p.77 MR BRANGWYN, MR NICHOLSON AND SIR EDWARD POYNTER. Three representational painters of the time. Poynter was a president of the Royal Academy.

BRANGWYNESQUE BUBBLES ON THE SURFACE OF THE ABSTRACT. A note following this essay promised some further sections for the next number of *Blast*. No further number appeared and the essay was not continued.

p.78 THE BEHAVIOUR OR APPEARANCE OF THE YOUNG VIENNESE. *Wyndham Lewis the Artist* replaces 'Viennese' by 'composer'.

p.80 MISS SIDDALL LANGUISHED BEHIND THE COUNTER IN THE HABERDASHER'S. Elizabeth Eleanor Siddall, the London shop girl whose beauty prompted members of the Pre-Raphaelite group to adopt her as a model. She later married Dante Gabriel Rossetti.

p.82 THE INK WAS STILL UNDRIED ON SMITHERS' CATALOGUES. Leonard Smithers, publisher of Beardsley, Dowson and Wilde. His catalogues of rare books, several of them lavishly illustrated (four with designs by Aubrey Beardsley), appeared in 1895–8.

p.85 THE LONDON GROUP. The paintings by Wadsworth and Roberts are lost. Roberts's drawing *Dancers* is reproduced in *Blast No. 1. Rock Drill* refers to the plaster model of the bronze at the Tate Gallery. At the London Group show, the figure was exhibited mounted on an actual rock drill. The reference to 'Junkerism' is to a review, 'Junkerism in Art: The London Group at the Goupil Gallery', which appeared in *The Times*, 10 March 1915.

p.87 I ADMIRE MANY QUALITIES IN MR GILMAN'S AND MR GINNER'S PAINTINGS. Harold Gilman (1876–1919), painter greatly influenced by Van Gogh, was the first president of the London Group. Cf. p. 109. Charles Ginner (1878–1952) painted in Paris during the first decade of the century. He was influenced by Van Gogh also and developed a 'Neo-Realism' which insisted on painting from nature only.

CAMDEN TOWN GROUP. The group was formed in 1911 by painters who used to meet at the studio of Walter Sickert. Lewis was one of the original members but his experimental tendencies set him apart from the rest. The group held three exhibitions and in 1913–14 merged into the London Group.

p.88 THE DEVELOPED IMPRESSIONISM OF THE SACKVILLE GALLERIES. The reference is to the large Futurist exhibition of 1912 (*cf.* p. 22).

MR NEVINSON . . . IN AN OPEN LETTER. Nevinson's letter does not appear in *Blast*.

p.90 THE SCANDAL OF THE DAY, WAS THE NEW ENGLISH ART CLUB. The New English Art Club was founded in 1886 by Philip Wilson Steer and other, mostly Paris-trained painters. For a discussion of its later role see, e.g., Sir John Rothenstein's essay 'Harold Gilman' in *Modern English Painters*, Vol. 1.

SCHOOL-BOY LIKE INDIVIDUAL BY THE NAME OF TONKS. Henry Tonks (1862–1937) was, wrote Lewis in *Rude Assignment* (p. 111), 'the guiding spirit and policy-maker' during his student days at the Slade School of Art. Tonks joined the staff of the Slade School as a teacher of drawing in the 1890s and quickly became the most influential personality at the School, as recorded in a number of memoirs and anecdotes. In 1917 he became head of the Slade. He called Post-Impressionism 'a contamination', according to Paul Nash, in *Outline* (London, 1959), p. 93.

p.91 HE WAS AESTHETICALLY OVER-INDULGENT IN HIS FURY OF SCHOLASTIC PRECOCITY. For Augustus John's reaction to this article, see *Letters*, p. 70.

THERE IS NO REFERENCE TO MR ROTHENSTEIN HERE. William Rothenstein, the painter and art teacher, knighted in 1931.

AN ARTIST CALLED, I THINK, PRIDE. James Pryde (1866–1941), British painter and partner with Nicholson in poster designing.

PART TWO : World War I and the early twenties

p.105 AN EXAMPLE OF WAR AS SUBJECT MATTER. The picture by Paolo Uccello is *The Battle of San Romano*.

p.109 HALIFAX HARBOUR. 'Halifax Harbour after the Explosion', 1918. The National Gallery of Canada, Ottawa.

p.111 EXHIBITION BEING HELD THIS AUTUMN. Memorial exhibition, at the Leicester Galleries.

p.112 PORTRAIT OF MRS MOUNTER. *Cf.* 'Mrs Mounter at the Breakfast Table', 1917. The Walker Art Gallery, Liverpool. Reproduced in John Rothenstein, *Modern English Painters*.

p.121 THE FACT OF A PAINTER'S PRESENTING YOU WITH A PORTRAIT OF MR HORATIO BOTTOMLEY. Bottomley was a journalist, financier and Liberal M.P. prominent in First World War recruiting efforts in Britain. He was sentenced in 1922 to seven years' penal servitude for fraud involving Victory Bonds.

IF BLAKE HAD PAINTED HAYLEY'S PORTRAIT. William Hayley (1745–1820), English writer and poet. Author of *Life of Cowper* and other books which William Blake illustrated.

p.144 AN INTRODUCTION TO THE HISTORY AND THEORY OF THE ART OF BUILDING, by W. R. Lethaby, first published in 1912.

p.145 SUCH BOOKS AS C. H. CAFFIN'S CONTAIN NOTHING VERY USEFUL. C. H. Caffin (1854–1918), Anglo-American art critic whose writings appeared in such periodicals as *Harper's Weekly*. His books include *American Masters of Sculpture* (1913) and *How to Study Architecture* (1929).

p.149 THE YOUNG VISITERS, a novel by Daisy Ashford, British child author, published in 1919. It was written when its author was nine years old. PAMELA BIANCO. British child artist who exhibited at the Leicester Galleries, London, in 1919 at the age of twelve. Out of this exhibition grew *Flora*, a book of drawings by Pamela, with illustrative poems by Walter de la Mare.

p.154 THE ROBERT LOUIS STEVENSON, GEORGE BORROW, 'BACK TO NATURE' ENGLISHMAN. George Henry Borrow (1803–81), whose books, including *The Romany Rye*, are autobiographically-inspired accounts of Gypsy life. 'SNOBBISH BORROVIANS, running after Gipsy Kings and Espadas' were 'blasted' in *Blast No. 1*.

p.155 FALSELY LABELLED HERDS OF SUBMEN. The 1919 edition has: 'a manifestly different and falsely labelled species'.

p.161 LA BOUTIQUE FANTASQUE. Derain executed the sets, costumes and curtains for Diaghilev's ballet *La Boutique fantasque*, first performed in London in May 1919. His designs were published by J. Miles and Co., London. See Denys Sutton, *Derain* (London, 1959), p. 140.

p.176 KATE GREENAWAY (1846–1901), British illustrator and water colourist, especially known for her pictures of child life. She influenced the design of children's clothing and illustrations for children's books.

p.177 FITZROY TINKERERS. The reference is once more to Roger Fry's Omega Workshops. *Cf.* p. 66 and note.

p.178 WE FELL IN LOVE WITH THE BEAUTIFUL TILES. The restaurant room at the Victoria and Albert Museum, South Kensington, London, was designed in the Pre-Raphaelite style, with tiles a prominent feature. It is no longer in use as a restaurant. And Gornsey Furnishing is no longer listed in the London telephone book.

p.181 WEEKLY DISPATCH. A London publication now defunct.

p.185 A GROUP . . . NAMING ITSELF SIX AND TEN, OR SOMETHING LIKE THAT. One may assume Lewis knew well the group was called the *Seven and Five Society*. It was founded in 1920. Ivon Hitchens was one of the early members, but the group did not come into its own until the later twenties.

p.194 YOU WILL SEE HIM STARTING A SERIAL STORY IN THIS NUMBER. 'Will Eccles', revised and completed as 'You Broke my Dream', in *The Wild Body*.

p.198 THE BLOOMSBURY PAINTERS included Duncan Grant, Clive Bell's wife Vanessa Bell, and Fry.

p.200 IN MY PREAMBLE ADDRESSED TO THE PUBLIC. *The Tyro No. 2* (1922) contains a 'Preamble to the Usual Public', not reprinted here. SIR W. H. BRAGG. Sir William Henry Bragg (1863–1942) who worked in the fields of radioactivity and quantum physics.

p.204 IN TAINE'S DESCRIPTION OF THE ENGLISH. Hippolyte Taine (1828–93). See *Taine's Notes on England* (London, 1957). LÈSE STRACHEY. Lytton Strachey's *Eminent Victorians* had appeared in 1918 and his *Queen Victoria* in 1921.

p.206 VELOCITY OF LIGHT, ESTABLISHED FOR US BY ROEMER. Olaus Roemer, Danish astronomer (1644–1710), determined the velocity of light from observations of the moons of Jupiter.

p.209 THAT BACH'S MUSIC IS BETTER THAN PAUL RUBENS. *Wyndham Lewis the Artist* reads: 'that Bach's music is better than that of Irving Berlin.'

p.210 THE NURSE CAVELL MONUMENT. This statue by Sir George Frampton of Edith Cavell, shot by the Germans in 1915, was unveiled in 1920 at a site near Trafalgar Square, London.

p.214 AS THE KINEMA. *Wyndham Lewis the Artist* reads: 'as the silent film.'

p.215 I SHALL BEGIN THE SEARCH FOR THE LAWS THAT GOVERN THIS FORM OF INVENTION. A note attached to this essay in *The Tyro* promised that it would be continued and that the complete essay would appear, amplified, as a book. The complete version never appeared.

p.222 DAVID HUME. For an earlier use of this quotation, see p. 202.

p.224 LOUIS WAIN, a book illustrator known for his drawings of cats, combining prettiness with the influence of what turned out to be schizophrenia.

PART THREE: The trough between the wars

p.233 HEAD OF COLLEONI. The fifteenth-century bronze equestrian statue of the condottiere Bartolommeo Colleoni by Andrea Verrocchio.

p.236 ANCIENT ART AND RITUAL, by Jane Harrison. New York, 1913; London, 1927. THE EVOLUTION OF THE DRAGON, by Grafton Elliot Smith, Manchester, 1919.

p.239 EGYPTIAN PORTRAITURE. During the period of his life when this essay was written, Lewis avoided capitalization of national designations when the latter were used as adjectives. This practice was meant to indicate the lack of importance he attached to national entities in general (see pp. ix–x of *The Enemy No. 2*).

p.249 ELSEWHERE I HAVE DESCRIBED. *Cf.* pp. 155–62 of Lewis's *The Art of Being Ruled* (London, 1926).

p.250 TO BE FOUND IN AN ESSAY OF EDWARD CAIRD. Edward Caird, *The Evolution of Theology in the Greek Philosophers* (Glasgow, 1904), Vol. II, pp. 44–7.

p.253 THE BELLOWING OF DAME CLARA BUTT. Dame Clara Butt (1873–1936), British contralto singer. She specialized in ballads and oratorios.

p.261 TERRASSE AND HAINAUT. Two French authorities on Berber art.

p.262 RICHARD HUGHES (b. 1900), the British novelist and traveller.

p.263 IN KARNAK, GAUTIER TELLS US. Émile Félix Gautier, author of *Le Sahara* (Paris, 1928).

p.269 WITH SOME PSEUDOIST NOTION—À LA RICHARDS OR À LA ELIOT. In his entertaining chapter on T. S. Eliot in *Men Without Art*, Lewis discusses what he calls the theory of *pseudo-belief* held by Eliot and I. A. Richards.

p.270 W. JAMES, *PROBLEMS OF PHILOSOPHY*. William James, *Some Problems of Philosophy*, 1911.

SIR JOHN SIMON'S 'WE ARE ALL SOCIALISTS TODAY'. Sir John (later Viscount) Simon, 1873–1954, the British Foreign Secretary.

p.273 AS PROFESSOR JOHN MACMURRAY PUTS IT. John Macmurray (b. 1891), British philosopher, at that time Grote Professor of the Philosophy of Mind and Logic, University of London, in his *The Philosophy of Communism* (London, 1933).

p.279 I HAVE SAID IN A BOOK. *Men Without Art*, p. 212.

p.280 THE FOUNDATIONS OF BELIEF, by Arthur James Balfour, Earl of Balfour, 1848–1930 (London, 1895).

p.289 MOLLISON'S AEROPLANE. Amy Johnson Mollison (1903–1941), the celebrated woman pilot.

p.301 'STATIONS OF THE DEAD', Aberdeen Corporation Art Gallery.
'INFERNO', National Gallery of Victoria, Melbourne, Australia.
'DEPARTURE OF A PRINCESS'. This picture was painted over by Lewis: the reference is to Princess Marina who, in 1934, had married the Duke of Kent. She died in 1968. The pictures so far mentioned are reproduced in Charles Handley-Read, *The Art of Wyndham Lewis*.

p.302 MARGARET ANN BOWES-LYON. The portrait of Miss Bowes-Lyon was destroyed in World War II.

p.303 MODERN PAINTING. *Modern Movements in Painting*, by Charles Marriott, New York, 1921.

p.305 CAVALCADE. Noel Coward's historical play, first produced in 1931.

p.307 BUT SURREALISM. The International Surrealist Exhibition, held in London in 1936, had been attended by more than 20,000 people.
MR RUSSELL FLINT. Sir William Russell Flint (b. 1880), like Glyn Philpot, had become a member of the Royal Academy.

p.310 MY OLD FRIEND MR READ. Lewis and Sir Herbert Read had known each other since the first world war. The kind of criticism that follows was resented sufficiently by Sir Herbert to make him conclude his obituary of Lewis with the statement that, during their association, he 'had always the uneasy feeling that any day I might be shot in the back' (*New Statesman and Nation*, 16 March 1957).

p.311 MR DAY LEWIS. Cecil Day-Lewis, who became British Poet Laureate in 1968, was a leading left-wing poet in the thirties.

p.312 ART NOW, by Herbert Read (London, 1933).

p.320 MR NEWTON. Eric Newton (1893–1965), the art critic.

p.327 THERE ARE TWO PAINTERS (PROS), MR SUTHERLAND AND MR NICHOLSON. Among others working in abstract modes were Ivon Hitchens, whom Lewis came to admire in 1950, Ceri Richards, whose work he first reports seeing in 1949, and Barbara Hepworth.

p.328 MR PAUL NASH AND MR ARMSTRONG. John Armstrong (b. 1893) had moved towards surrealism after a period productive of more classical compositions. On Paul Nash see p. 337 and note. Others showing surrealist pictures in the decade were Richards, Sutherland, Edward Burra and Roland Penrose.
COTMAN. John Sell Cotman (1782–1842), British painter whose watercolours are classics of landscape.
I HAVE EXPLAINED WHY. Lewis does not mention the Euston Road School here. It was founded in reaction against both abstraction and surrealism. For a later encounter between Lewis and the group, see p. 448. As will be seen, Lewis's super-nature had nothing to do with the French Impressionism which, to his mind, this group stood for.

p.330 TISSOT. James Tissot (1836–1902), French-born painter of fashionable Victorian society.
THAT OF MR ELIOT OR OF MR POUND. The Eliot portrait is now at the Municipal Art Gallery, Durban, South Africa, and that of Pound at the Tate Gallery. The Eliot picture was reproduced in *Wyndham Lewis the Artist*, together with *Inferno* (Melbourne), *The Surrender of Barcelona* (Tate Gallery), *From the Sea to the Mountains* (British

Council collection), *Sleeping Dog* and *Spartan Portrait*, all from the thirties; and three portraits and two *Enemy* covers from the twenties.

p.332 THIS PICTORIAL MASKELYNE AND DEVANT. John Nevile Maskelyne (1839–1917) and David Devant (1868–1941), British conjurers. Partners in the theatre of magic founded by Maskelyne in London, their names became synonymous with conjuring.

p.334 MR FRY WITH 'POST IMPRESSIONISM', HAD TAKEN ITS BREATH AWAY. Roger Fry organized the exhibition 'Manet and the Post-Impressionists' at the Grafton Galleries, London, 1910, and the 'Second Post-Impressionist Exhibition', at the same gallery, in 1912.

p.335 AMONG THESE NOTES. *Cf.* foreword to the catalogue of the exhibition 'Guns', 1919, p. 104.

MY PICTURE . . . IS IN THE OTTAWA WAR MUSEUM. *A Canadian Gun Pit*, National Gallery of Canada, Ottawa.

p.337 NOW THAT MR PAUL NASH IS AT LAST SOWING HIS WILD OATS. Before beginning to paint in the surrealist manner, Nash had been best known for his Cubist-influenced dramatic World War I landscapes.

p.352 EXHIBITION AT THE MUSEUM OF MODERN ART. 'Picasso—Forty Years of his Art', The Museum of Modern Art, New York. Catalogue, edited by Alfred H. Barr, Jr., 1939.

p.353 'THE RACE', 1922 . . . 'TWO SEATED WOMEN', 1920. Chrysler Collection.

p.354 MINOTAUROMACHY. 1935. Lent by Henry P. McIlhenny.

p.355 PÉLLÉAS ET MÉLISANDE. Opera adapted by Claude Debussy from Maeterlinck's play and first produced in 1902.

IN MR SWEENEY'S FLAT. James Johnson Sweeney (b. 1900), lately director of the Museum of Fine Arts, Houston, Texas.

p.360 FEDERAL ARTISTS' PROJECT. Also known as the Federal Arts Project, this was inaugurated in 1933 by President Franklin Roosevelt's administration.

PART FOUR : The forties and after

p.367 REPRODUCED FROM A TYPEWRITTEN MANUSCRIPT. The MS. was put at our disposal by Mrs Lewis. A number of typing errors were corrected by reference to a handwritten manuscript (in Lewis's own hand), of which the typescript is a later, somewhat re-arranged version. The handwritten manuscript is at the Rare Book Department, Cornell University. Reproduced by permission of the Library Board of the Cornell University Library.

UNIVERSITY OF WINDSOR. 'Wyndham Lewis at Windsor.' *Canadian Literature*, Winter 1968 (a special Lewis issue).

CATHOLIC HOSTILITY TOWARDS ITS TREATMENT OF THE SUB-JECT-MATTER. According to James Johnson Sweeney, in a letter to Lewis of that year (*Letters*, p. 341). Lewis replied that the incident did not surprise him.

p.370 LÉON BLOY. His work attracts Lewis's critical attention in *Rude Assignment*, pp. 31–2.

p.382 The WILLOW PATTERN was a design in pseudo-Chinese style for English pottery and porcelain.

p.384 ART AND SOCIETY, by Herbert Read (London, 1936).

p.387 MR BYRNES. James Byrnes, American Secretary of State 1945–7, and subsequently Governor of South Carolina.

p.391 THE WORKS OF MINE REPRODUCED HERE. The article reproduced several works of the thirties: *The Surrender of Barcelona* (Tate Gallery), *Inca with Birds* (Arts Council), *Tank in a Clinic* (Priv. Coll.), three drawings: *Female Nude, Fann MacCuil, the great Irish giant, waiting for Far Rua*, and a composition of witches or ghosts and a human figure, later called *Heroic*.

p.393 ROUND THE GALLERIES. These notes have not been burdened with documentation of every one of the numerous pictures mentioned. Where the precise identity or date, or a reproduction of a picture, seemed difficult to find as well as important to Lewis's argument, the information has been given. Where several points are annotated, these are separated by a dash. Where more than one review is given to the same artist, notes on them are separated by a double asterisk**. '*Ill.*' indicates that the review was accompanied by a reproduction of the picture named.
MICHAEL AYRTON. *Ill.* 'Portrait of William Walton' (1948). Lewis wrote two other pieces on Ayrton: 'A Note on Michael Ayrton', *Nine* No. 4 (1950); and the Foreword to the artist's collection of essays, entitled *Golden Sections* (London, 1957).
FRANCIS BACON. The picture, 'as usual . . . in lamp-black mono-chrome', was one of the artist's portraits of 'a man with no top to his head'.** The November exhibition was held at the Hanover Gallery. *Ill.* 'Study for Nude' (1949), later called, at Bacon's request, 'Study from the Human Body'.

p.394 DAVID BOMBERG. Lewis had known Bomberg's work up to the early twenties, when the artist began to spend much time abroad and gave up his interest in Cubist and abstract modes of painting. Bomberg's last major exhibition had been in 1936. The next was to be a Memorial Exhibition, arranged by the Arts Council, in 1958.—The Borough

Group, formed in 1947, consisted of Bomberg and a number of his students at the Borough Polytechnic.

EDWARD BURRA. Leicester Galleries. Burra painted two watercolours entitled 'Project for Don Juan' and had also done work for a ballet called 'Don Juan', produced at Covent Garden, London.

p.396 MASSIMO CAMPIGLI. *Ill.* 'Girls with a Bird'.—For another comment by Lewis on Marie Laurencin, see *Self Condemned*, p. 50.

p.397 GIORGIO DE CHIRICO. De Chirico in the twenties abandoned his modernist tendencies for a return to classicism. The results have been generally considered deplorable.—The early paintings mentioned are widely reproduced. Later works are reproduced in the monographs by Isabella Far (Rome, 1953) and Lo Duca (*Arte Moderna Italiana*, No. 10, Milan, 1936). *Cf. Letters*, pp. 421–2.

p.398 ALAN CLUTTON-BROCK. Besides being a painter, Clutton-Brock (b. 1904) has been art critic of *The Times* (London), and was Slade Professor of Fine Art at the University of Cambridge, 1955–8.

ROBERT COLQUHOUN. The exhibitions were held at the Lefevre Gallery. The review of the second is illustrated by a reproduction of 'The Dancer'.—Robert MacBryde, like Colquhoun, studied at the Glasgow School of Art. Both were associates in London, professionally, stylistically and in common assertion of their Scottish heritage. For further impressions of the pair, see the 'Envoi' chapter of Lewis's *Rotting Hill*.

p.402 AUSTIN COOPER. London Gallery. The artist had worked as a poster designer until 1934, when he began to paint. This was his first one-man show.

GERARD DAVID. 'Gerard David and his Followers.' Introduction by M. J. Friedländer.

p.403 JACOB EPSTEIN. The Winged Lucifer was also rejected by the Fitzwilliam Museum, Cambridge, and by the Victoria and Albert Museum, London. It is now in the Birmingham City Museum and Art Gallery.—The Roosevelt memorial statue in Grosvenor Square is by Sir William Reid Dick and was unveiled in 1948.—The 'new piece' admired by Lewis was one of several small maquettes for monumental works, shown at the exhibition.** The 1950 review is accompanied by a detail from 'Lazarus' (New College, Oxford).—Anna Freud is the sculptor's grand-daughter, and daughter of the painter Lucian Freud.

p.404 HENRY FUSELI. Pls. I and VIII in the catalogue are of 'Head of a Woman with Neckband' and 'Girl at a Table', both Kunsthaus, Zurich.—'Mad Kate' (Das verrückte Käthchen) and 'Girl at a Table' (Mädchen am Tisch) are reproduced in *Johan Heinrich Füssli* by A.

Federmann, Zurich, 1927; 'The Women of Hastings' in *Atlantis*, February 1941.

p.405 MARK GERTLER. The three paintings mentioned in the review are reproduced in *Mark Gertler: Selected Letters*, ed. Noel Carrington, London, 1965.

p.406 BARBARA HEPWORTH. The opening sentence compares the artist and Henry Moore. The article was entitled 'Moore and Hepworth', and the paragraphs here quoted follow those on Moore.—Miss Hepworth's 'interview with herself' is entitled 'Approach to Sculpture', an answer to a questionnaire, in *The Studio*, London, October 1946.** 'The surgeons operating' is a reference to a number of pictures of scenes in operating theatres, drawn by the artist in 1947–9.

p.407 IVON HITCHENS. The March 1949 show was held at the Leicester Galleries.

AUGUSTUS JOHN. The 1948 review is illustrated by 'Portrait of Governor Fuller'.—The cartoon at the Detroit Institute of Arts is 'The Mumpers'.—For some suggestions Lewis made to John, of subjects for pictures, see *Letters*, p. 481.

p.409 FERNAND LÉGER. *Ill.* 'Divers'. The exhibition was arranged by the Arts Council and the Association Française d'Action Artistique, at the Tate Gallery, following one of Fuseli (*cf.* p. 404).—The Eliot reference is from Selected Essays (London, 1951), p. 16.

p.413 HENRY MOORE. *Ill.* (1946 review) 'Memorial figure' (1945–6), Dartington Hall, Devon.** The 'small head in stone' is reproduced as 'Head of a Child' in the review and as 'Head and Shoulders' (1929) in *Henry Moore, Sculptor: an Appreciation*, by Herbert Read (London, 1934).

p.415 WILLIAM ROTHENSTEIN. *Ill.* 'Coster Girls' (1894), Graves Art Gallery, Sheffield.—In 1938, Lewis had reviewed Sir William Rothenstein's exhibition 'Fifty Years of Painting' at the Leicester Galleries. The review, written for *London Mercury*, remained unpublished (see *Letters*, pp. 259–61). We would have liked to include it but, for reasons of space, had to limit ourselves to published material, with the exception of the Rouault lecture (p. 367) and 'L'Arlésienne' (p. 459).

p.417 STANLEY SPENCER. Several pictures in the 'Resurrection' series are at the Tate Gallery and the Southampton Art Gallery.

p.418 ÉDOUARD VUILLARD. *Ill.* 'Portrait of Madame Kapferer' (1918). 'Dr Viau in his Dental Surgery' (1937) was not part of the exhibition.

p.421 EDWARD WARDSWORTH. *Ill.* 'Cape of Good Hope' (from *Blast No. 1*), and 'Port de Mer', a characteristic nautical subject of the twenties.— *The Black Country* is the title of Wadsworth's 1920 exhibition of

wood-cuts and drawings of industrial landscapes, also collected in a book of that name, published by the Ovid Press in 1920.—'Old Crome' is John Crome (1768–1821), the great English landscape painter.

p.423 A NEGRO ARTIST. Denis Williams. *Ill.* 'Human World'. Another painting by this artist, 'Figure', had been reproduced in Lewis's 14 July 1949 article. Williams later taught in Africa and has published two novels, *Other Leopards* (London, 1963) and *The Third Temptation* (London, 1968). For Lewis's efforts to help Williams, see *Letters*, pp. 500–1, 527–8.

p.425 CANADIAN NATURE AND ITS PAINTERS. *Canadian Painters*, ed. D. W. Buchanan (London, 1945).

p.429 THE BROTHERHOOD. Review of the Centenary Exhibition of Pre-Raphaelite Art at the Whitechapel Gallery, April–May 1948. *Ill.* 'Mother and Child' by F. G. Stephens.—'Portrait of Ruskin' and 'The Blind Girl' are by Sir John Everett Millais; 'The Last of England' and 'Work', by Ford Madox Brown.—Most of the paintings referred to in the review are reproduced in *Pre-Raphaelite Painters*, by Robin Ironside (London and New York, 1948).

p.431 THE COURTAULD MEMORIAL EXHIBITION was held at the Tate Gallery, May–August 1948, as a tribute and memorial to the collector Samuel Courtauld (1876–1947), who had made over much of his collection of paintings to a trust for the benefit of London University. At his death, he bequeathed further paintings to the same trust. Notable for its Impressionist and Post-Impressionist paintings, the collection forms an important part of the Courtauld Institute of Art at the University. See *The Courtauld Collection: a Catalogue and Introduction*, by Douglas Cooper (London, 1954).—*Pêle-mêle*, the Paris humorous weekly, published 1916–30.—Degas' picture is 'Young Spartans Exercising' (1860), National Gallery, London.

p.432 THE CHANTREY COLLECTION. The Collection results from a bequest for continuing purchases, made by the sculptor, Sir Francis Legatt Chantrey (1781–1841). Until 1949, the Royal Academy's influence upon the selection of pictures for purchase was decisive, with the results described by Lewis.

p.436 BREAD AND BALLYHOO. The van Gogh show took place in 1947–8. —'Vienna pictures' refers to the exhibition 'Art Treasures from Vienna' held at the Tate Gallery in 1949.—Lord Lloyd, the chairman of the British Council, 1937–41.—The Pilgrim Trust, founded in 1930, supported the wartime Council for the Encouragement of Music and the Arts, which was taken over by the government and in 1945 became the Arts Council.—The Festival of Britain was held at London in 1951.

p.441 THE BALLYHOO OF NEWNESS. The Institute of Contemporary Art which, at its founding in 1947, was called by its president, Sir Herbert Read, 'an adult play-centre', was a favourite target of the author of *The Apes of God* (see, e.g., *The Demon of Progress in the Arts*).

CONTEMPORARY ART SOCIETY. *Ill*. 'Portrait in Albion' by Robert Colquhoun. The CAS was founded in 1910 by Roger Fry and others—partly to oppose the misguided use of the Chantrey Bequest funds. The Society buys works of living artists for public galleries.

p.444 CRITICISM OR PROPAGANDA ? *Ill*. 'The Disquieting Muses' (1917), by Giorgio de Chirico.

p.445 CHILDREN'S ART. The annual event is now sponsored by the *Pictorial's* successor paper, the *Sunday Mirror*. It is still held at the Royal Institute Galleries, on the opposite side of Piccadilly from the Royal Academy's Burlington House headquarters.

p.447 THE CAMDEN TOWN GROUP. For an earlier view of the Group, see 'History of the Largest Independent Society in England', p. 90. The portrait of Sylvia Gosse by Gilman is in the Southampton Art Gallery, which says it knows of no published reproduction.

p.449 THE 1949 RETROSPECTIVE EXHIBITION. The 1949 ELIOT portrait now hangs at Magdalene College, Cambridge. The portrait of JULIAN SYMONS, poet and critic (b. 1912), is in his possession.

p.450 APT TO PROVOKE . . . TO COMMENT. Michael Ayrton had written in his foreword to the exhibition catalogue that the 'conspiracy' had been 'undertaken by such personages as find themselves compelled by their own inadequacy, so to attempt to discomfort him, and they may have hastily been led to suppose at one time, that he had been discredited and forgotten'.

p.451 THE 1956 RETROSPECTIVE AT THE TATE GALLERY. 'Revolution' (*ca*. 1915), Tate Gallery; 'Tank in the Clinic' (*ca*. 1936), Priv. coll., New York; 'The Mud Clinic' (1937), Beaverbrook Art Gallery, Fredericton, Canada; 'The Stations of the Dead' (1933–7), Aberdeen Corporation Art Gallery; 'The Surrender of Barcelona' (1936), Tate Gallery; 'Portrait of John MacLeod', Coll. John Cullis, Esq.; a 'Portrait of Stephen Spender', City Art Gallery, Stoke-on-Trent.

p.454 THE VORTICISTS. 'Hedwig' is a portrait dating from the late thirties and now in a private collection. It might be considered to be in the naturalistic tradition. But it is dominated by the swirls and bunchings of the sitter's coat, which have an abstract quality.

SELECT BIBLIOGRAPHY

Wyndham Lewis wrote nearly fifty books. Listed here are those among them of special relevance to this volume.

Enemy of the Stars. First published in *Blast* (No. 1, 1914) and, in revised form, by Desmond Harmsworth, London, 1932.

Tarr. First published in Britain by The Egoist Ltd, and in the United States by Alfred A. Knopf, New York, both 1918. Reprinted in its revised (1928) form by Methuen & Co. Ltd, London, 1951, and as a Jupiter paperback by Calder & Boyars, London, 1968.

The Caliph's Design. London, The Egoist Ltd, 1919.

Time and Western Man. London, Chatto & Windus, 1927; New York, Harcourt Brace, 1928. Reprinted in the U.S. as a paperback by Beacon Press, Boston, 1957.

The Wild Body. London, Chatto & Windus, 1927; New York, Harcourt, Brace, 1928.

Paleface: the Philosophy of the Melting Pot. London, Chatto & Windus, 1929.

The Apes of God. London, The Arthur Press, 1930; New York, Robert M. McBride, 1932. Reprinted 1965 as a Penguin Modern Classic paperback, also available in the United States.

The Diabolical Principle and the Dithyrambic Spectator. London, Chatto & Windus, 1931.

Men Without Art. London, Cassell & Co. Ltd, 1934; New York, Russell & Russell Inc., 1964.

Blasting and Bombardiering. London, Eyre & Spottiswoode, 1937. New edition with extra material published by Calder & Boyars and University of California Press, 1967. Especially the chapter 'Tomorrow an Artless Society'.

Wyndham Lewis the Artist, from 'Blast' to Burlington House. London, Laidlaw & Laidlaw, 1939.

Rude Assignment, a Narrative of My Career Up-to-Date. London, Hutchinson & Co. Ltd, 1950.

Rotting Hill. London, Methuen & Co. Ltd, 1951; Chicago, Henry Regnery Co., 1952. Especially useful for its story 'My Disciple'.

The Writer and the Absolute. London, Methuen & Co. Ltd, 1952.

The Demon of Progress in the Arts. London, Methuen & Co. Ltd, 1954; Chicago, Henry Regnery Co., 1955.

PERIODICALS EDITED BY WYNDHAM LEWIS

Blast. Review of the Great English Vortex. London, John Lane, the Bodley Head; No. 1, 20 June 1914; No. 2, July 1915.

The Tyro, a Review of the Arts of Painting, Sculpture and Design. London, The Egoist Press; No. 1, 1921; No. 2, 1922.

The Enemy, a Review of Art and Literature. London, The Arthur Press; Nos. 1 and 2, 1927; No. 3, 1929.

COLLECTIONS AND MONOGRAPHS

Handley-Read, Charles (ed.), *The Art of Wyndham Lewis.* London, Faber & Faber, 1951. A monograph on Lewis's pictorial art with an essay by Eric Newton.

Michel, Walter, *Wyndham Lewis: Paintings and Drawings.* London, Thames & Hudson, 1970; Los Angeles, University of California Press, 1970; Toronto, McClelland and Stewart, 1970. With a *catalogue raisonné*, and an essay by Hugh Kenner.

Rose, W. K. (ed.), *The Letters of Wyndham Lewis.* London, Methuen & Co. Ltd, 1963; Norfolk, Conn., New Directions, 1963. (Referred to in this book as *Letters.*)

Rosenthal, Raymond (ed.), *A Soldier of Humor and Selected Writings.* New York, New American Library, 1966. This paperback is also available in Britain.

Tomlin, E. W. F. (ed.), *Wyndham Lewis: an Anthology of his Prose.* London, Methuen & Co. Ltd., 1969.

SOME BRITISH PUBLICATIONS IN WHICH LEWIS'S ART CRITICISM APPEARED

The Athenaeum (1828–1921), ed., 1919–21, John Middleton Murry.

The Bookman (1891–1934), ed., 1930–34, Hugh Ross Williamson.

The Calendar of Modern Letters (1925–27), eds. Edgell Rickword and Douglas Garman.

The Criterion (1922–39), ed. T. S. Eliot.

Drawing and Design (1917–29), ed., 1927–29, Gerald Reitlinger.

The English Review (1908–37), founded by Ford Madox Hueffer (later Ford); ed., 1910–25, Austin Harrison.

The Pavilion: a Contemporary Collection of British Art and Architecture (1946), ed. Myfanwy Evans.

INDEX OF ARTISTS